Japonisme in Western Painting
from Whistler to Matisse

Degas, Toulouse-Lautrec and Van Gogh found their best sources of influence in Japanese art: this fact has now permeated the art history of the period at all levels. In the light of recent research, however, these artists are no longer to be regarded as special cases but as the tip of a long-submerged iceberg. It has now become clear that 'Japonisme' – the inspiration of Japanese subject-matter and of Japanese design – is an important and indeed essential ingredient of Classical Modernism in painting. Active and original artists from all over Europe, and as far afield as Russia and the United States, discovered in the coloured woodcuts of Japan the inspiration that nourished their own creativity.

This richly illustrated study, first published in German in 1980, reveals a continuous and irreversible evolutionary process, based on an inner necessity. This is the first comprehensive history of Japonisme, which deals in depth with the methods by which the Japanese influence was transmitted – through exhibitions, collections, museums, and critical writings – and thus it reveals the sources that created the historic metamorphosis of Western art, from depiction to sign.

CAMBRIDGE STUDIES IN THE HISTORY OF ART

Edited by FRANCIS HASKELL
Professor in the History of Art, University of Oxford
and NICHOLAS PENNY
Clore Curator of Renaissance Art, National Gallery, London

Cambridge Studies in the History of Art is a series of carefully selected original monographs and more general publications, aimed primarily at professional art historians, their students, and scholars in related subjects. The series embraces a broad range of topics from all branches of art history, and demonstrates a wide variety of approaches and methods.

Titles in the series:

El Greco and his Patrons: Three Major Projects
RICHARD G. MANN

A Bibliography of Salon Criticism in Second Empire Paris
Compiled by CHRISTOPHER PARSONS and MARTHA WARD

Giotto and the Language of Gesture
MOSHE BARASCH

The Oriental Obsession: Islamic Inspiration in British and American Art and Architecture 1500–1920
JOHN SWEETMAN

Power and Display in the Seventeenth Century: the Arts and their Patrons in Modena and Ferrara
JANET SOUTHORN

Marcantonio Franceschini and the Liechtensteins: Prince Johann Adam Andreas and the Decoration of the Liechtenstein Garden Palace at Rossau-Vienna
DWIGHT C. MILLER

Pavel Kuznetsov: His Life and Art
PETER STUPPLES

Palma Vecchio
PHILIP RYLANDS

Japonisme in Western Painting from Whistler to Matisse
KLAUS BERGER

Japonisme
in Western Painting from
Whistler to Matisse

KLAUS BERGER

Translated by David Britt

The right of the
University of Cambridge
to print and sell
all manner of books
was granted by
Henry VIII in 1534.
The University has printed
and published continuously
since 1584.

CAMBRIDGE UNIVERSITY PRESS

Cambridge
New York Port Chester
Melbourne Sydney

Published by the Press Syndicate of the University of Cambridge
The Pitt Building, Trumpington Street, Cambridge CB2 1RP
40 West 20th Street, New York, NY 10011-4211, USA
10 Stamford Road, Oakleigh, Melbourne 3166, Australia

Originally published in German as Japonismus in der westlichen Malerei 1860–1920
by Prestel-Verlag München 1980
and © Prestel-Verlag München
First published in English by Cambridge University Press 1992 as Japonisme in Western Painting
from Whistler to Matisse
English translation © Cambridge University Press 1992

Printed in Great Britain by Butler & Tanner Ltd, Frome and London

A catalogue record for this book is available from the British Library

Library of Congress cataloguing in publication data

Berger, Klaus, 1901–
[Japonismus in der westlichen Malerei. English]
Japonisme in Western painting from Whistler to Matisse/Klaus Berger; translated by David Britt.
 p. cm. – (Cambridge studies in the history of art)
Translation of: Japonismus in der westlichen Malerei.
Includes bibliographical references and index.
ISBN 0–521–37321–2
1. Art, Modern – 19th century – Japanese influences. 2. Art.
Modern – 20th century – Japanese influences. I. Title. II. Series.
N6447.B4813 1992760'.09'034 – dc20 90–2639CIP

ISBN 0 521 36321 2 hardback

To Dietrich Seckel

CONTENTS

ILLUSTRATIONS

1. The background

New ancestors

When I said that Japonisme was in the process of revolutionizing the vision of the European peoples, I meant that Japonisme brought to Europe a new sense of colour, a new decorative system, and, if you like, a poetic imagination in the invention of the *objet d'art,* which never existed even in the most perfect medieval or Renaissance pieces.
(Edmond de Goncourt, *Mémoires de la vie littéraire,* Paris 1956, vol. 3, 334.)

When Goncourt wrote these words in his journal on 9 April 1884, he was defining the importance of a movement which had begun to shake the foundations of European art and artistic taste. The influence of Japanese art undermined all illusionistic representation and opened up entirely new prospects for the creation of a new visual reality, a modern style.

Goncourt's assertion is astonishing, not to say clairvoyant: from tiny beginnings he unfolds immense perspectives. For what he had actually seen by 1884 went no further than small-scale decorative objects from the Far East – mere trinkets, *bibelots* as he called them – together with some Japanese colour woodcuts. Even here, however, he could cite only a chance selection of late works ranging from Kitagawa Utamaro to Andō Hiroshige: the earlier, so-called Primitive prints that were to have so decisive an influence in the West were still entirely unknown. In 1884, it took little short of a sixth sense to see the influence of Japanese art as anything more than sporadic and incidental.

It must be stressed that Goncourt was not talking about the mere adoption of Japanese motifs. He was fully aware that a decisive shift in taste was taking place, and that it opened up unimagined possibilities of new form that would influence the whole Western world. From the vantage-point of 1884, he was anticipating an evolutionary process which was to subject pictorial art to a succession of upheavals that culminated in a shift of Copernican proportions. His perception, rooted in the exclusive world of Parisian collectors and underground avant-garde artists, extended to embrace 'the vision of the European peoples'. With hindsight, it is clear how right he was.

This was not the first time in the history of art that a change of direction had been stimulated, encouraged, enriched – and legitimized – by the discovery of elective affinities in some remote culture. Not only in the Renaissance and Neoclassicism but at many other crucial points in history, the rediscovery of the past had been a spur to innovation and originality. In the nineteenth century, one 'revival' followed another, from Romanesque to Gothic, from Baroque to Rococo: not only in derivative and

lifeless architecture or in academic brushmanship, but pre-eminently in the finest achievements of the art of painting, where we find Ingres looking back to Bronzino, Delacroix to Rubens, Courbet to Ribera, Manet to Goya and Velázquez. Examples might be quoted at length.

In these cases, however, the ancestors involved belonged to the same European tradition. Such apparent exceptions as the Chinoiserie of the Rococo, the 'Turquerie' of the Brighton Pavilion, or the 'Orientalism' of the Romantics, went no further, on the whole, than a superficial imitation of costume, settings, or poorly understood detail; they had at least as much to do with fashion as with art.

The arrival of Japanese woodcuts in the West, their circulation and the response they elicited from the avant-garde painters, was a very different matter. Here outside influences encountered an inner preparedness. The new 'ancestors' were taken very seriously: on the one hand, they appeared as saviours at a moment of serious crisis, on the other they were welcomed as the harbingers of a coming era of world (or universal) art. As sociopolitical circumstances changed, so too did cultural conditions, and with them the symbolic expressive content of art. Even the later incorporation of Black African sculpture in Cubism would have been unthinkable without the previous phenomenon of Japonisme: geometrical abstraction comes after decorative simplification.

The crisis in Western painting which opened the way to the Japanese visual influx can be elucidated under four headings: style, philosophy, cultural politics and formal design.

Style

The stylistic aspect is the most important, but it is complex and not easy to summarize. We shall constantly return to it from different points of view.

Auguste Renoir, referring to the time when Edmond de Goncourt made the journal entry quoted above, declared: 'I had come to the end of Impressionism and was forced to see that I could neither paint nor draw. In a word, I was in a blind alley' (Ambroise Vollard, *En écoutant Cézanne, Degas, Renoir,* Paris 1950, 213). Renoir was stating the same critique of Impressionism that Fritz Novotny was to sum up by saying that, in Impressionism, form was concealed by a naturalism that seemed too strong, too 'inartistic'. This was the end of an epoch. No way ahead was visible, only a radical metamorphosis and a new start. And, before the century was out, the Viennese art historian Franz Wickhoff came to the following conclusion:

To their astonishment, those artists in London and Paris who in the second half of the nineteenth century were at the forefront of the modern movement realized that much of what they had pursued had been achieved by the Japanese; that the Japanese, a nation whose artistic sensibility could be matched only by that of the ancient Greeks, had anticipated the movement of European art. ('Kunst und Kunsthandwerk', *Die Jugend,* 1898.)

By the time Japonisme emerged, representation in nineteenth-century art had indeed run a full gamut: from the early, 'linear', structurally based phase of Neoclassicism

to the Impressionist dissolution of form in a tissue of flecks of colour; from tactile values to visual values; from a closed form to an open, and eventually to a dissolving, form. An evolution of this sort is an entirely normal phenomenon. There are, broadly speaking, three directly analogous progressions in the history of art: in Antiquity, from the blockiness of Egyptian art to the loose, painterly handling of Roman landscape frescoes; in the Middle Ages, from the tectonic emphasis of Ottonian art to the flamboyance of late Gothic; and in later times, from early Renaissance linearity to the sparkling web of light spun by the Rococo. The wheel turns full circle, but more rapidly each time. At every crisis, a new vehicle, a new culture, a radically changed society, makes its appearance.

Seen in this light, the crisis of late nineteenth-century art was no superficial accident but an inner necessity. The only problem was where to make a new start. All that could have been predicted, with any certainty, was that the future would show crucial points of difference from the period just past: it must mark a fundamental departure from outworn historicism. Such a shift could not happen overnight; its stages spanned a number of generations. What emerged at the end was a completely new and original visual form. Naturalistic illusionism had given way to decorative design.

The new tendencies set themselves off from the more or less official art of the Salon and attached themselves to the avant-garde, a previously unknown phenomenon which meant – as José Ortega y Gasset perceived – that there now existed two parallel, warring cultures.

How Japonisme – the recognition, admiration, adoption, and reinterpretation of an Eastern way of seeing – came to assume this liberating, fostering role, it is the purpose of this study to investigate. The working out of this process, over a span of five decades, and ultimately all across Europe, is a chapter of art history that has hitherto received too little attention – although many studies of detail exist, and even schoolbooks now tell of the Japanese enthusiasms of the Impressionists, of Edgar Degas and of Vincent van Gogh.

It can only have been the nature of the Japanese artistic principles involved – with something to offer both to 'late' Impressionism and to the innovatory styles that followed – that caused such momentous consequences to spring from such small beginnings. By comparison with the older Japanese painting and sculpture that remained entirely unknown in the West, the colour woodcuts of the '*ukiyo-e*' ('Floating World') movement, with their brief evolutionary span of 150 years, represented a very limited range of work. And yet they had an immediate and spectacular impact, because they offered not simply new stimuli but an unfamiliar and forgotten form of vision, one that might be defined as 'decorative organization'. The term 'decorative', in this sense, has nothing whatever to do with adornment or ornament, but with the artistic attitude that, according to Heinrich Wölfflin (*Kunstgeschichtliche Grundbegriffe*, 246), 'is tied to specific decorative schemas' and is to be distinguished from illustration, content, expression and significance.

At a time when illusionistic detail threatened to shatter the image into a collection of fragments, the yearning for unity and concentration was correspondingly intensified.

And where were new guides to be found? As far away as possible, in time and space. This explains, stylistically speaking, the urge to return to source – or, to use the learned name, to the archaic – that remains with us to this day.

The first Japanese woodcuts to be discovered were barely half a century old and represented a 'late' phase; it was therefore only natural to delve further and further into the past, right back to the 'Primitives'. This was part of the Modernist demand for spontaneity and naivety, a demand that exists, as Renato Poggioli says, precisely because these are qualities that the Moderns have lost for ever (*The Theory of the Avantgarde,* Cambridge, Mass., 1968, 181).

The constant talk in the literature of 'Japanese influence', without any attempt at detailed definition, is consequently misleading and explains nothing. The word 'Japanese' does not represent a single, static identity but something that, in itself, has undergone a long and varied evolution. Its various phases have influenced the West in very different ways. Japonisme is not one phenomenon but several: Katsushika Hokusai's influence differs from Utamaro's, and Utamaro's in turn differs widely from that of the artists discovered at a later stage: the Primitives, Hishikawa Moronobu or Kaigetsudō. There are many stylistic levels within Japanese art, to which the West responded in highly diverse ways. The word 'Japanese' meant something quite different to Edouard Manet from what it meant to Van Gogh, or to Henri de Toulouse-Lautrec, to Gustav Klimt or to George Grosz. These issues have seldom been examined in the right light.

Philosophy

It is a quite separate question whether Japanese models were correctly understood, whether they meant what the West thought they meant. Even if, from an art-historical perspective, an error was made – an issue that does not need to be decided here – this was, in stylistic terms, a fruitful misunderstanding. The new artistic discoveries gave rise to the visual form appropriate to modern conditions.

Japanese art itself was not simply a product of artistic attitudes and formal principles: it was embedded in a highly specific pattern of life and thought that found expression through Shintoism and Buddhism. Monotheism is foreign to both; so too are religious dogma, philosophical system-building, and even the distinction between good and evil. The individual seems to dissolve in an all-encompassing existential haze. Analytical and rational thinking recede, but an intuitive sensibility emerges to illuminate the subtlest nuances of human existence. There were available, in nineteenth-century Europe, innumerable literary documents reflecting the life and thought of the East, ranging from legends, histories and novels to scriptures and treatises on aesthetics. Curiously, however, these had very little influence outside academic circles. Even the philosophy of Schopenhauer, based on the idea of emancipation from the Will, and published as early as 1819, opened no doors to the wisdom of the East – at least, not among artists.

The great vogue of Japonisme at the end of the nineteenth century reached only

the fields of craft design, painting and the graphic arts. In literature it provided no more than a touch of local colour. There is, for instance, no sign of Buddhist influence. The only leading figure in Paris who took an active interest in the sources of the newly discovered forms of art – the religions of the East – was Emile Guimet. But even he saw them as a 'mute accompaniment' to aesthetic phenomena, and the outcome of his endeavours was the foundation of a museum, which bears his name, and the organization of the first conference of Orientalists. The philosophical encounter with the East took place only on the level of scholarship. It was not until a century later, with the Abstract Expressionism of Mark Tobey, Franz Kline, Julius Bissier and others, that structures inspired by Zen were to appear in Western painting.

Cultural politics

Nevertheless, the advance of Japanese motifs and cultural elements in Europe from 1862 onwards was not without influence on the art of the West. Both source culture and target culture evolved in ways that fostered this influence. The Japanese cultural offensive at the successive Universal Exhibitions, and the performances of touring dance and theatre groups, found a response in the curiosity of those Western travellers who visited the colourful East and never tired of describing its wonders. The accounts given by John La Farge, Emile Guimet, Pierre Loti, Lafcadio Hearn, Paul Claudel and others reached an enormous readership and played a part in widening cultural, political and also economic horizons. The taste for things Japanese showed itself in a succession of novels, plays, and operas set in the Land of the Rising Sun; in the importation of Far Eastern decorative objects; and in their imitation on a massive scale, so that every society lady had her *salon japonais*.

True, these practices or malpractices were mainly restricted to Paris; but then Paris, in those days, was still the World. It is true, too, that this wave of Japonisme was already exhausted by the time the true artistic influence of Japan reached its climax. But it prepared the way for this influence in many respects: by displacing the imitation of period 'styles', it made room for the new taste and thereby also for the recognition – or at least for the suspicion – that the isolation of the European tradition could and must give way to an artistic freedom and a modernity of expression founded on worldwide cultural exchanges.

Design and form

The arrival of Japanese art, and of Japanese coloured woodcuts in particular, opened new horizons. Why, for example, should the representation of a landscape be based on photographic fidelity and completeness? Was the duplication of Nature really the supreme and only law of painting? Simply by being asked, such questions revealed the possibility of a negative answer, and led towards the threshold of a new way of seeing.

The Impressionists' interest in expanding space, in an expanded angle of sight, in

an atmospheric blending of objects, and in the pursuit of incompleteness and open form, has already been ascribed to the stimulus of Japanese prints. These demonstrated the possibilities of displacement, twisting, abbreviation and free expansion of 'objective' space: that is, of a coexistence of different scales – without, of course, a trace of Impressionism.

The next generation, which aimed for strict order and structurally based design, turned to the East once more and discovered decorative sequences that offered a number of aids to the elimination of naturalism and the use of abstracting basic forms. The power of line, expression through the arabesque, planar tension, rhythm conveyed through patterning, dissection of colour, discontinuity: all these – even if not ultimately exclusive to Japan – came to the West from Japan. Japonisme became a kind of challenge and stimulus: it served as a trigger and a lever, in areas where there can be no question of direct imitation.

Artistic, cultural and social upheavals

Here our first aspect, the objective aspect of style, chimes with our last, the subjective aspect of formal design; any cultural and political factors are accessory rather than active. It is the strength of Japonisme, and at the same time its limitation, that it first manifested itself as an artistic and visual phenomenon and was barely affected by the substance of the Japanese way of life. What counted was not the culture of Japan, or even the objective history of Japanese art, but purely and simply those things that artists in Paris wanted to see and were capable of seeing.

What they saw, initially, was the woodcuts of the 'late' Hokusai and nothing else. From 1874 onwards, Hiroshige's landscapes were added. Those who received and passed on these stimuli were artists, critics, collectors, dealers and connoisseurs; they were not art historians. The exploration of the history of Japanese art, back to the religious art of the early Middle Ages, did not start until Japonisme in art was a thing of the past. Our main concern is therefore with identifying those Japanese works that aroused interest, and with seeing how they were received, seen and used, rather than with their place in the evolution of their native tradition.

Seen in the perspective of the long tradition of Japanese art, Hokusai is the last and certainly not the greatest figure; but his importance in Japonisme – the response to Japanese forms of vision – would be hard to over-estimate. This function of Japonisme must be clearly distinguished from Japanese art and its own values. In one case, we are talking about the facts and values of Oriental art history; in the other we are dealing with evaluations, tastes and reorientations at a moment of stylistic crisis in European art.

It follows that the history of Japonisme must be studied on a number of levels. The stylistic and artistic issues of transposing Japaneseness into the art of the West are certainly of fundamental importance, but they crystallized through contact with kindred tendencies within the decorative arts and in the general evolution of taste and even of fashion. It takes all this to add up to a fair view of the pattern formed by

Japonisme. In this respect, the subject goes far beyond the boundaries of art in the narrow sense of the word.

Perhaps it may be as well to indicate at the outset the extent of the importance of 'fashion' in the Parisian society of the period. From the time of the Universal Exhibition of 1867, at which the Japanese pavilion aroused more attention than any other, things Japanese remained a constantly growing preoccupation for two full decades, especially among the feminine leaders of fashion. It all started with kimonos and fans; no boudoir of any pretensions could be without them. Then came lacquer cabinets, tea-caddies, folding screens. Then porcelain tea services, and brooches and pendants set in gold and silver. According to need, any of these could be obtained as Japanese originals; or as French 'adaptations' by first-class craftsmen; or, before long, as cheap imitations from the Paris department stores. No store catalogue was without its Japanese section.

Oriental dance groups enjoyed tremendous popularity. The members of the Jinglar club met in Oriental dress to eat Japanese food as a preparation for their aesthetic deliberations. Novels on Japanese themes and travel books about Japan were much in demand. In 1863, in a series of four paintings on the theme of the Prodigal Son, the painter James Jacques Joseph Tissot interpreted the protagonist's 'journey into a far country' as a visit to a Japanese tea room. The response was so sensational that Tissot brought out etchings of the subject [55] and painted a similar version of the same subject eighteen years later. An observer was able to sum up, in 1879: 'Japonisme is the idolatry of our time, and it is to be hoped that it will be the artistic religion of the future.' (Cited in Yvonne Thirion, 'L'Influence de l'estampe Japonaise sur la peinture française dans la seconde moitié du XIXe siècle: thèse soutenue à l'Ecole du Louvre, 1947/1948', *Musées de France*, October 1948, 229.)

Developments in the applied arts went far beyond such comparatively superficial phenomena. Here serious and purposeful attempts were being made to elevate Western taste and improve, or at least maintain, the quality that was threatened by machine production; and the Japanese were cited as examples worthy of imitation. The universal exhibitions held in London in 1862 and in Paris in 1867 provided the impetus for what might be called an Arts and Crafts movement on a European scale. The results in all fields of activity, and particularly in ceramics and metalwork, are well known; they lie outside the scope of this book.

This reform movement, the first phase of Japonisme, was still tainted by a residue of historicism. Although the demand for better 'design' was heard on all sides, the direction was not yet clear. There was, it is true, a reform of art education, reducing the emphasis on the mechanical imitation of former styles and encouraging students to design freely for themselves; it is true, too, that exhibitions and the new museums of decorative arts showed all kinds of new products that were well received by an elite public; but the most important process of those decades was one of reception and response: the influx of Japanese works – exquisitely decorated lacquerware, sword hilts, porcelain vases, flower baskets – which in the Orient were recognized not as minor art forms but as the work of the greatest artists.

The Parisian taste that refined itself through its contact with works of this kind found expression in a whole series of first-class private collections. This became possible after Japan, as a result of the Meiji Revolution of 1868, opened itself up to international markets, and after France had recovered from the aftermath of the lost war of 1870. No city in the world could match the profusion and quality of Japanese decorative art that was to be found in Paris in the 1880s and 1890s.

Such are the prevailing conditions that govern the approach taken in this study. The situation in Paris – as the central location – demands to be illuminated in all its many-layered reality: the collections, the critics, the dealers and above all the artists; their interests, their aims, their results and their means, as revealed in exhibitions and publications. A parallel evolution in England, in a totally different artistic climate, generated a different set of conditions. There Japonisme entered a new phase as a result of a closer association not only between France and England but between Japanese prints and the decorative arts, and the avant-garde in painting finally shook off the burden of illusionism. This new phase was marked by a totally flat, planar quality, by an enhanced emphasis on the decorative, and by the apotheosis of the poster; it had close links with Art Nouveau, and with the varied impulses known in Germany as *Stilkunst* (see Chapter 16). Its spread to Belgium, Holland, Central Europe, Scandinavia and even Russia, under very different aspects, brings the influence of Japan right down to the threshold of the First World War; meanwhile, an exhaustive critical and historical study of the Japanese print was under way.

Perhaps it is only at a distance of three generations that the quality of this imported Japanese art, and the potential that emerged from it, can truly be seen in context, and that this chronicle of Japonisme – the first, to our knowledge – can be attempted.

The history of the collection of *ukiyo-e* woodcuts in Europe has yet to be written, but some of the materials for it are already to be found. Many interested painters made study collections of their own, although it has turned out to be virtually impossible to reconstruct these. Others gained access to public and private collections, especially in Paris; conclusions may be drawn from the stimuli that impelled them to do so. The major exhibitions of Japanese prints in the 1870s, 1880s and 1890s, which served to reflect both Eastern and Western artistic concerns, offer a fairly clear index of changes within the avant-garde art of the time. Contemporary critical essays, books and periodicals serve to illuminate the field in which the Japanese 'influence' operated.

All this, however, applies with any certainty only to the first and second generations. After the decorative principle had been introduced into art by such pioneers as James McNeill Whistler, Degas, Manet, and even Monet – and after a whole new field of art had been opened up by 'Symbolists' and poster artists – their successors no longer had so clear a vision of their Japanese sources. Often, indeed, they had those sources only at second hand; or they had come to take them for granted. This scatter effect, especially beyond France, was at least equal in importance to the initial breakthrough; and it can be traced through the works it produced, as well as through the response to them. The act of 'tracing' in such cases is actually more like peeling away and dissecting; and this may be one of the reasons why Japonisme has seldom been taken

in as a whole and has gained proper recognition only through a number of peak achievements. In fact, it was like an underground movement, erupting into view untidily and surprisingly, rather than a strategically planned offensive.

Again, the mere existence of Japanese artistic sources means nothing so long as it cannot be shown that they really were used, and how. In Leiden, from early in the nineteenth century, there existed an extensive collection of *ukiyo-e* woodcuts which were treated as an ethnographical curiosity; no artist – not even Van Gogh, who lived close by – troubled to look at them. It was not until much later that he reached the point at which the decorative message of Japanese art came as a help and a revelation to him. Again, there were Japanese prints on the Paris auction market from 1850 onwards, but nobody saw them as anything more than exotic oddities.

In order to assess the Japanese influence on modern painting accurately, it is necessary to bear in mind that this was not a passive process of reception but the active operation of a triggering factor. The way leads from the imitation of individual motifs to stylistic assimilation, and from there to creative transformation. For this reason, it will be necessary to move on two levels at once: that of the influx of Japanese material, and that of the purely Western artistic and formal problems involved in the abandonment of illusionism. Only the interplay of these two levels can set this dramatic chapter of modern art in a new light.

2. Beginnings

First manifestations

The Japanese vision is foreign – and indeed diametrically opposed – to illusionism. Under the heading of illusionism we must classify all attempts to achieve a deceptive resemblance in the reproduction of detail without reference to composition, structure, or any canon. *Trompe-l'œil* has reappeared in art from time to time ever since late Antiquity, but it was not until the nineteenth century that, probably under the conscious or unconscious impact of photography, it took up so dominant a position that all the artist's formal preoccupations were ultimately displaced. A varying degree of illusionism is quite normal; only its hypertrophic growth marked the terminal crisis of the epoch. It was not until illusionism started to become suspect in the eyes of Western painters – until it had started to decline, or its elimination had become an objective – that the way could be opened to the acceptance of Eastern art.

When did this moment arrive? With every new movement, the first steps are shrouded in mist and uncertainty. There are many successive phases; and, by the time the great renewal becomes open and manifest, the interesting germination stage has already been lost to view beneath a mass of new growth.

In the present context, the painting of Courbet appears as the final culmination of 'fidelity to nature': of an art that seeks to capture the immediacy of experience and banish the clichés of pseudo-Classicism and pseudo-Romanticism. After Courbet – and to some extent even with Courbet – this attitude ceased to be vital and forward-looking and gave way to a vulgar picture-postcard mentality. Nature and art – the natural and the artistic – are not identical; and so the need arose for a new pair of glasses, a fresh and unjaded form of visualization. Because naturalism had declared itself to be more or less identical to illusionism, it was under constant threat from its 'mechanical' rival, photography. The scene was set for the demolition of illusionism, and with it for the appearance of things Japanese.

That is what happened. A number of events that centre upon the year 1862 mark the perceptible upbeat. There are earlier signs, but they belong to pre-history; of them more anon.

The opening of La Jonque Chinoise, an Oriental curio shop, at 220 rue de Rivoli, in the heart of Paris, provided a visible base, a meeting place, for many of the pioneers and pace-setters of Japonisme. The proprietors, Monsieur and Madame Desoye, had returned from a trip to the Far East, where they had presumably made good business contacts, with a rich stock of merchandise, and the business seems to have been highly

successful. After the husband's death in 1873, his widow carried it on, according to the Bottin directory, until 1887. The precise nature of the Desoyes' stock-in-trade can no longer be established with certainty. Undoubtedly, tea, tea-caddies, fans and items of that kind made up a large proportion of what was sold.

La Jonque Chinoise was not – whatever Goncourt may have said – identical with La Porte Chinoise, in the Rue Vivienne, which was an antique business, and even more popular with the Japonistes in general. (It was not until Geneviève Allemand produced her Ecole du Louvre thesis in 1964 that the confusion of the two was finally laid to rest.) The more select small-scale items were, especially later on, sold by specialist dealers.

According to François Fosca (*De Diderot à Valéry*, Paris 1960, 353), Japanese prints sold for two, three or four francs, and exceptional items for five. Among the buyers whose names are on record were the painters Whistler, Degas, Carolus-Duran, Manet, Monet, Tissot and Henri Fantin-Latour; the writers Charles Baudelaire, Edmond and Jules de Goncourt, Philippe Burty, Emile Zola, Edmond Duranty and Jules Champfleury; the director of the Sèvres porcelain factory, Marc-Louis-Emanuel Solon; and the curator of the Louvre, Villot.

All of these played a more or less important role in the development of Japonisme, but four figures must be singled out for special mention. What they have in common is that they found their way to the woodcuts by way of an interest in Japanese decorative art. They bridged the gulf that separated decorative and fine art and gained a comprehensive view which enabled them to lay the foundations of the second and incomparably more important phase of Japonisme in Europe. These four were Edmond de Goncourt (born 1822), Philippe Burty (born 1830), Félix Bracquemond (born 1833) and Ernest Chesneau (born 1833).

Edmond de Goncourt's claim to be regarded as the father, inventor or discoverer of Japonisme has not stood up to close scrutiny. The critical literature reveals that his case for priority rests entirely on his own later testimony, and that he antedated the crucial facts (Roger Marx, 'Les Goncourt et l'art', in his *Maîtres d'hier et d'aujourd'hui*, Paris 1914, 1–46; François Fosca, *Edmond et Jules de Goncourt*, Paris 1941, ch. 12, and *De Diderot à Valéry*, Paris 1960, 232–56; and above all W. Leonard Schwarz, 'The Priority of Goncourt's Discovery of Japanese Art', *Publications of the Modern Language Association*, New York 1927, vol. 42, no. 3).

Here are the arguments: we read in his *La Maison d'un artiste* (vol. 1, 208–9) that he and his brother Jules (1830–70) acquired their first Japanese albums in 1852; however, this book was published only in 1881. The preface to *Chérie*, of 1884, states that the action of the brothers' novel *En 18 . . .*, of 1851, was set in a Paris drawing-room containing Japanese objects, but includes no mention, let alone description, of Japanese woodcuts. La Porte Chinoise is said by Goncourt to have opened its doors in 1860, but in fact it did so only in 1862. A chronic addiction to antedating seems to be at work here. A celebrated diary entry, dated 29 October 1868, reads as follows:

The taste for Chinoiserie, and for Japonaiserie! We were among the first to have it. A taste that nowadays is manifest everywhere and in everyone, even in imbeciles and in bourgeois women: who

has felt, preached and publicized it more than we have? Who was it who reacted with excitement to the first Japanese albums and had the courage to buy them? (Ibid., vol. 2, 465.)

This outburst is rather devalued by the fact that it was published only in 1888, when many other Japonistes were already at work.

The Goncourts's earliest published reference to Japanese prints appears in the novel *Manette Salomon,* of 1867, in a description of an artist's studio. The trouble here is that Burty had already shown his print collection at the 1867 Universal Exhibition. Edmond de Goncourt's own collection was begun only in the 1870s, when he bought prints from Philippe Sichel, a dealer who visited Japan in 1874. In Goncourt's diary for 13 May 1888, there is a sentence that gives the game away:

There is no doubt that it was really Philippe Sichel's visit, and later that of [Samuel] Bing, that gave Europe a closer acquaintance with Japan and gave currency in the West to the art of the Land of the Rising Sun. (Ibid., vol. 3, 786.)

All this is no mere chronological pedantry: the fact is that the year 1870 marks a great divide. Before that date there were pioneers and visionaries; after that date there were inheritors, users, experts.

Goncourt must nevertheless be recognized as an important collector, the author of a novel (*Manette Salomon*) set in the milieu of Parisian Japonisme, and of pioneer monographs on Utamaro and Hokusai. There are also many entries in the journal – although these were published much later, and in an evidently much-edited form – and records of conversations in his celebrated and much-frequented salon. All this made him the most noticed interpreter of Japanese art, at least as far as his own generation was concerned.

What was his motivation? In the introduction to his book on Utamaro he wrote:

It has been a fascinating task to unfold the intimate history of the women and the objects of the eighteenth century ... and to take the humane century that I love – humane for the peoples of both hemispheres – and to investigate the history of Japanese art, just as I have written the social and artistic history of France in the eighteenth century and during the Revolution. (Edmond de Goncourt, *Outamaro*, Paris 1891.)

The repeated reference to the 'humane century' gives the key: this is a Rococo view of a scene of silken gallantry, focusing on the master whose prints record the life of the 'green houses of assignation' of eighteenth-century Edo. Goncourt's originality lies above all in the perception that all arts are related – East and West, decorative ceramics and decorative Japanese woodcuts – and that they are to be classified, in Bing's words, 'not according to local schools but according to affinities of sentiment. For [Goncourt], these culminate in the sole ideal of the French Rococo, with its refined taste: polished, neat, pretty, appealing to the eye or sensuous to the touch.'

This revelation of a Rococo phase in Japanese culture and art, comparable in charm and elegance only to the French, is Goncourt's enduring contribution; but at the same time it reveals his limitations. It shows the first stirrings of a comparative approach to art, as well as Goncourt's own openness to contemporary Impressionism; but at

the same time it betrays his determination to overlook everything that does not fit into his particular image of Japan.

The role of Goncourt's friend Burty was quite a different one. His claim to a place in the annals of Japonisme is not based on any original theory or outstanding discoveries. In countless articles, he discussed the 'Masters and Minor Masters' – to borrow the title of one of his books of collected essays – of French painting between 1855 and 1875; he organized valuable exhibitions, wrote forewords to catalogues, and developed his eye for essentials through his own activity as a collector. In his own lifetime, Burty was known for his eclectic tastes, and he acquired Japanese albums (by Hokusai) at a very early stage; he lent eight prints from them to the 1867 Universal Exhibition. In the following years he showed himself a keen and catholic collector, and he must be regarded as one of the earliest and most active Japonistes. His collection of more than 2,500 objects, including 600 illustrated books of widely varying merit, was accessible to the Goncourt brothers and served, at least until 1875, as the main source of their information.

A series of articles on Japonisme that Burty wrote in 1872 for the periodical *Renaissance littéraire et artistique,* recently unearthed by Gabriel Paul Weisberg, reveals an amiable Romantic who finds balm for the soul in Japanese curios. If the early stages of Japonisme must be defined in terms of one man, then his is the name that first comes to mind. His learning and his collection were readily made available to all, and the auction of his estate in 1891 came as a revelation to a new generation.

Burty's friend, the artist and printmaker Félix Bracquemond, was another who claimed to have 'discovered' Japanese woodcuts. According to Léon Bénédite (*Gazette des Beaux-Arts,* February 1905) and to numerous subsequent authors, Bracquemond was at his printer's one day when he came across a Japanese album that had been used as packing material for imported porcelain. He did not rest until he had the little book, which was Hokusai's *Manga,* in his own possession; he carried it round with him and showed it with pride to all the artists that he met.

Recalling this event half a century later, Bracquemond dated it to the year 1856, thus claiming a ten-year start on the Goncourts. Another chronicler, Chesneau (*Gazette des Beaux-Arts,* 1879), without mentioning the name of the person involved, gave the date as 1862, only sixteen years before his date of writing. The truth of the matter, according to Yvonne Thirion (*Cahiers de l'Association Internationale des Etudes Françaises,* 25 June 1960), is probably that Bracquemond's priority is genuine, but that the later date is the accurate one. Even supposing that the event did take place six years earlier, it had absolutely no impact before 1862. From every aspect the present study confirms this conclusion.

It should be remembered that *Manga* and the other instructional albums that Bracquemond consulted – Hokusai's *Kwacho Gwafu* and albums by Hiroshige, Isai and Hokusen (see Gabriel Weisberg, in cat. *Japonisme,* Cleveland Museum of Art, 1975, 7) – contained only isolated motifs such as plants, living creatures, especially birds, and women's costumes, and that their influence is therefore to be found in the decorative arts. These 'fragmentary' examples of Japanese art could have no impact

on Western pictorial concepts. This had to wait until Japanese pictorial compositions gained recognition.

In Bracquemond's own work, the effect became evident only four years later, when he used motifs from *Manga* on a famous service of porcelain which attracted much attention at the 1867 Universal Exhibition [1]. These sketches are the first visual manifestation of Japanese vision through Western eyes: two-dimensionality, absence of modelling, heraldic patterning and outline combined with great textural animation. This was no mere reproduction but a genuine transposition into another medium. The Japanese stimulus had prompted Bracquemond to a greater show of originality than he ever achieved before or after, in the course of a career that concentrated too exclusively on printmaking as reproduction.

Historically speaking, Bracquemond's importance was as a stimulus, and a source of technical assistance, to his artist friends – all of whom became Japonistes. In the late 1880s, according to Christopher Gray, it was he who initiated Paul Gauguin into ceramic sculpture. Another of his historical claims to fame is the foundation of a Society of Etchers (Société des Aquafortistes), another event that took place in 1862. At a moment when printmaking had declined into a technique for the reproduction

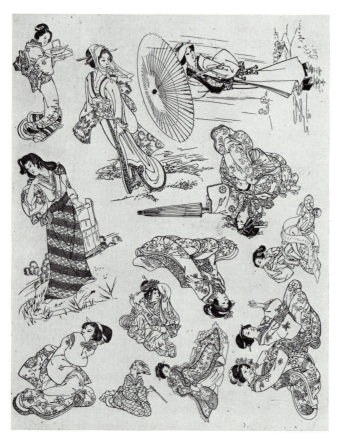

1
Félix Bracquemond.
Sketches after Hokusai's *Manga*, 1866

of paintings, this was to open the way to its revival as a medium for original artistic creation.

Astutely, Bracquemond turned not to the professional etchers, with their narrowly specialized technique, but to painters, whose artistic imagination the new art needed most of all. Degas, Fantin-Latour, Manet, Whistler, Eugène Boudin, Johan Barthold Jongkind and Camille Pissarro were among them: the very same individuals who exhibited at the *Salon des Refusés* of 1863, and who were the motive forces of the avant-garde in the following decade. All were touched by Japonisme to a greater or lesser degree, and may be regarded as pioneers of the great flowering of printmaking that marks the last third of the century. The albums of their work published by the Société des Aquafortistes provided a visible platform for the new tendencies in art, independent of the established distribution network.

However, in spite of the indefatigable efforts of the publisher, Alfred Cadart, and in spite of the perceptive critical response of Burty, Baudelaire and Théophile Gautier, the public gave little support to the artists' efforts. The series lasted for only six years, and even its successor, *L'Illustration nouvelle*, met with a disappointing response in spite of many concessions to public taste. Even so, the movement lived on underground until 1881 and laid the foundations for new advances.

The last of these four Japanese-inspired leaders of taste – and today probably the least remembered – was Ernest Chesneau. He was the first art historian to concern himself with the nature of Japanese art as revealed through comparison with that of other nations, and to examine its influence on contemporary Europe; not content with names and dates, he was the first to adopt a stylistic approach. He made a clear distinction between Japanese and Chinese characteristics, marking the end of the habit of lumping them together under the heading of 'Far Eastern'. His writings are the clearest index of the evolving state of knowledge and opinion among collectors and artists in the early decades of Japonisme.

Although both Goncourt and Bracquemond were Chesneau's friends, he assigned neither of them the priority in the 'discovery' of Japanese art: he tells us that in 1862 Whistler and Alfred Stevens drew simultaneous inspiration from Japanese albums that came in through the port of Le Havre. They admired in Japanese prints 'compositional surprises, knowledge of form, tonal richness, originality of painterly effect: in short, simplicity in the use of means' (Chesneau, 'Exposition universelle. Le Japon à Paris', *Gazette des Beaux-Arts,* 1878, 385ff.).

At the Japanese pavilion at the 1878 Universal Exhibition, wrote Chesneau, all the objects on show sold at 'fabulous prices' because they were superior in elegance of design and decorative taste to all others; painters were inspired, not to imitate specific Japanese ideas but to 'assimilate' them, each in his own way. This, for Chesneau, represented not so much an influence as a confirmation of their own sensibility and their own vision of nature. He defined the basic concepts of Japanese printmaking – he was probably the first in the West to do so – as displacement of the centre, abandonment of equilibrium and stability, asymmetry and flat tones. Clearly, he was still judging by Western criteria, so that what was new in Japanese art could

be defined only by a negative: displacement, abandonment, absence of symmetry.

Chesneau also clearly saw the lesson of the Japanese example from the point of view of the relationship between art and industry. In a lecture, he called on French craftsmen not simply to imitate the art of the Far East but 'to apply it, to extend it, to perfect it, to adapt it to our needs'. At the same time he admitted: 'Japanese art is not merely decorators' art: it has the ambition, the elevation and the superiority of great art' (Ernest Chesneau, *L'Art japonais,* Paris 1869, 22). This was an amazing insight for the year 1869, and one that no one else could match.

By 1878, Chesneau had reached the point where he could define the structure of Japonisme itself, among its complex of collectors, critics, dealers, craftspeople and artists: 'The taste for Japanese art took root in Paris through our artists; it then communicated itself to the collectors and society figures, and subsequently to the artistic craft industry.' With this statement he placed a compass in our hands which later investigators have either overlooked or failed to use.

The four versions of the 'discovery' of Japonisme centre about the year 1862, but it would be wrong to dismiss or underestimate its earlier manifestations. Roger Marx, a well-informed and critical observer, included Baudelaire (with Burty) among the few mid-century *japonisants*. And although there is not much to be found in the documentary record, it would be wrong to overlook the poet's role behind the scenes: he had an intuitive response to the decorative quality and the super-naturalism of the East, which were already the cornerstones of his view of art. Baudelaire's taste was born of observation; this emerges from a letter he wrote to Arsène Houssaye in the summer or autumn of 1861:

I have had a packet of *japonneries* in my possession for a long time now. I share them with my friends, and I have kept three of them for you. They are not bad at all (the Japanese equivalents of Epinal prints, two sous apiece in Edo). On rag paper and in bamboo or Chinese red lacquer frames, they are highly effective. (*Lettres 1841–1866,* Paris 1906, 322.)

It was only natural that these Japanese impressions should appeal to the poet of the evanescent beauty of modern life. The name *ukiyo-e* itself means 'the image of the vanishing (fleeting or floating) world'. Not only the realm of the courtesans, with their fantastic costumes and gestures, but equally the whole erotic ambience, the dandified elegance, the hallucinatory world of the actors, the exotic scenery, must have strongly appealed to Baudelaire's imagination. But it is impossible to go further and say which were the prints that appealed to him in particular. At La Porte Chinoise, he must have seen what other customers saw and knew; but, by the time the historical mists began to clear from early Japonisme, his part in it was already at an end. In April 1864 he left Paris, never to return except as a dying man.

How far back his interest began is impossible to determine: it may have been as early as the middle of the century. Scattered and highly imprecise entries in unillustrated catalogues reveal that Far Eastern works were coming up for auction from the 1850s onwards. A typical entry from the massive catalogue collection of the Bibliothèque Nationale reads as follows:

Catalogue de vente, 3/4 XII 1860: Collection anonyme, estampes 'chinoises'. Rochoux, marchand d'estampes ...

N° 332: Dessins chinois: oiseaux de diverses espèces. 5 dessins très finis.

N° 333: Plantes à fleurs, branches d'arbustes à fleurs. 10 jolis dessins très finis et d'un charmant coloris.

[Sale Catalogue, 3 and 4 December 1860: Unnamed Collection, 'Chinese' prints. Rochoux, print dealer ...

No. 332: Chinese drawings: birds of various species. 5 highly finished drawings.

No. 333: Flowering plants, branches of flowering shrubs. 10 pretty drawings, highly finished, delightful colouring.]

Whether these were really Chinese or Japanese prints matters less than the proof that such works were, firstly, available and, secondly, treated with scant respect. They can only have been regarded as curiosities.

The search for the sources of Japonisme has been extended back to the beginning of the century. In 1812, the collection of a Dutchman, Isaac Titsingh, was sold off in Paris. He was in charge of the Dutch trading post in Nagasaki, the only 'bridge' between Japan and Europe, and must have owned Japanese illustrated books. The very fact that information is so sparse and contradictory proves that – although commercial and cultural links between East and West were never entirely broken – European eyes had not yet been sufficiently opened to accept impulses from the East that could be transposed into Western art.

The earliest signs of change were probably not in the work of Bracquemond at all but in another direction altogether: in the work of the Barbizon landscape painter Théodore Rousseau. His friend and biographer, Alfred Sensier, in a highly detailed monograph, gives a comprehensive account of the crisis that befell the artist in the last half-decade of his career. It particularly affected one painting, *The Village* (*Le village de Becquigny*), which now hangs in the Frick Collection in New York. Sensier tells us that in 1863, under the influence of (unspecified) Japanese woodcuts, Rousseau took up this painting, completed several years previously, and totally reworked it:

He utterly changed the harmony in *Le village*. Where the sky had been gentle and Northern, he made it as blue as the vivid sapphires of the Orient, or as the glowing flames of the Northern Lights. He changed the sky utterly, repainted its reflections and its lights, and left only the outlines of the old village standing. All but the fixed forms of the mere configurations became Japanese through the style [*le mode*] of colouring. (*Souvenirs sur Th. Rousseau*, Paris 1872, 272.)

At the next Salon, the painting was presented to the public; and such were the protests, even from otherwise well-disposed critics, that the painter, after vainly defending his new vision, finally yielded to customer pressure and restored the old 'naturalistic' version of the painting, in which it has come down to us.

For want of visible evidence, Rousseau's Japonisme can thus be documented only through his theoretical insights. What he sought was to unite the observation of detail in a given landscape with an overall conception in which inspiration and simplified order came into their own. In Japanese art he found an almost entirely unshaded

colour scale in watercolour tones and a planar, not to say flat, form of image. In the eyes of the critics, his reworked painting lacked modelling; it was too bright, too unified in tone, and fragmented into tiny, unpleasantly regular dabs of colour: 'There it was, strange, difficult and violent; the impression of flickering light without contrast, without the opposition of clear-cut shadows' (Chesneau, cited by Prosper Dorbec, *L'Art du paysage en France*, Paris 1925, 128).

This sounds exactly like a description of an Impressionist vision such as Monet was to produce at least ten years later; especially when we find Rousseau himself repeatedly referring to light as a universal active principle ('cette agence universelle lumineuse'). Was this, therefore, the first instance of Japanese art not only penetrating into European art but changing it? It is possible; but the question must remain open. No other visible evidence of Rousseau's breakthrough has been preserved. In the last three years of his life he had, for personal and financial reasons, little taste for experimentation. Only one sketch from this period, *Stand of Tall Trees in Macherin Wood, Barbizon*, has been preserved in a photogravure reproduction (Prosper Dorbec, *Théodore Rousseau*, Paris 1910, 73); in monochrome, it has such a structural emphasis and arabesque simplification as almost to remind one of Gauguin's generation of Post-Impressionists. Here as elsewhere, in the crisis of illusionism, the Japanese vision was a lifebelt. Many perceived it; but who was the first to grasp it?

Depiction, imagination and visualization: Lecoq de Boisbaudran

One last factor requires to be mentioned, which casts a sharp light on the predicament of late naturalism. Drawing direct from nature had of course been promoted to the status of an uncontested dogma. But one isolated voice was raised against it. Horace Lecoq de Boisbaudran reminded his contemporaries that alongside the depictive drawing of objects there had always been, and would always be, another way: that of stimulating the imagination through the training of the visual memory. Was it by coincidence that in 1862 a book written by Lecoq de Boisbaudran some years earlier, *L'Education de la mémoire pittoresque et la formation de l'artiste*, was brought out in a new edition and, it seems, attracted immediate attention? The author was in charge of a class for drawing from memory at the Ecole des Arts Décoratifs. His students included many who were soon to be members of the avant-garde: Fantin-Latour, Whistler and Auguste Rodin were among them.

At first sight, all this has not much to do with Japonisme. But at a critical moment it strengthened the resolve of those who wanted to escape from the mere copying of nature. A vantage-point had been created from which the essential features of any artistic creation would emerge clearly: the features characteristic of visual memory. The effect of this was to direct the artist's interest to structural relationships, just as in pre-naturalistic times. Lecoq de Boisbaudran's method promoted the free unfolding of an inner vision:

For once these faculties have been strengthened by systematic training, they will furnish the imagination, for its unending creativeness, from a storehouse of ideas that are clearer cut, more lasting, and more responsive to its will ...

Memory and imagination are so closely linked that imagination can only use what memory has to offer her, producing, like chemistry from known elements, results completely new. (*The Training of the Memory in Art and the Education of the Artist*, London 1914, 22–3, 21.)

Clearly, Lecoq de Boisbaudran's intention was not to provide a recipe but to open an access. 'Memory', he stressed, 'is [not mind or] imagination, still less is it genius. It is indeed a very valuable servant to them all, but it would be ridiculous to pretend that it can create them or do their work' (ibid., 15). The objective he kept before him was a new technique of formal creation – 'interpretations, equivalents, and abstractions' – whereby the artist might ultimately express not so much the thing itself as its spirit ('exprimer enfin moins la chose que son esprit').

Lecoq de Boisbaudran (who was forced out of his teaching post, not long afterwards, by a campaign of intrigue and defamation) had produced a book whose interest went far beyond its narrow instructional purpose. On the one hand, it perfectly defined the impasse in which late naturalism and sterile academicism alike now found themselves. On the other hand, it struck a note that was soon to be taken up by the avant-garde. This is all the more surprising if we consider that Lecoq was no revolutionary but a preserver of a sound old tradition. One is impelled to the conclusion that the time was ripe for a decisive change. Japanese artistic principles emerged as the liberating factor, the stimulus that led to a new figuration.

3. The pre-Impressionist pioneers

Such was the atmosphere in which the three pioneers of Japonisme, Manet, Whistler and Degas, evolved to maturity – or rather in which each of them, in his own way, achieved the breakthrough from optical perception to formal creation: a new mode of seeing.

Edouard Manet (1832–83)

Seen in historical perspective, Manet's art faces both ways. In its concern with modern living, it looks towards visible nature and belongs to the tradition of tonal painting which stretches from the Venetian School, by way of the Baroque, to Delacroix, Corot and Courbet. Colour is modelled in transitions of light and shade; three-dimensional bodies are inserted into an aerial perspective and articulated in recession, and in parallel zones, through compositional elements.

This inheritance is plain enough; it is the contribution of Manet's artistic 'forebears', Velázquez and Frans Hals. But there is another and very different side to his art: one that disturbed, confused and irritated his contemporaries. When Courbet said that Manet's paintings looked like playing cards, flat and devoid of rounded forms, he was unwittingly defining their real innovatory achievement: expansive, rhythmically organized planes of colour with sharp contrasts, long sweeping outlines, space analysed into layers of relief. The result tends more towards stylization – the emphasis being on artistic expression – than towards any form of 'correct', illusionistic depiction. These anti-realistic features were felt to be even more revolutionary than the artist's unorthodox themes.

Manet marked the onset of a historical process that continues to this day. The picture was transformed from a depiction of external reality – subjective or otherwise – into an autonomous object. It now had an existence of its own, governed principally by the concern with creative expression. Previously, art had tended to respond to social change by an iconographic shift; now the emphasis shifted to execution. The battle-lines of change in art became increasingly remote from those of society and politics. Although Manet certainly presented his own reality – the world evoked by Baudelaire, 'la vie moderne du flâneur', as against Courbet's 'vulgar' realism – Lionello Venturi gives him no credit for the creation of a 'new myth': 'Manet disregarded not only reality but also beauty . . . he only organizes the impressions received from reality and thereby creates impressions coherent in themselves without modification through

checking them either against reality or against ideal beauty' (*Four Steps Toward Modern Art*, New York 1956, 51–2).

The old conventional signs for space – the handling of solids, linear perspective, modelling through light and colour – were abandoned, and new ones appeared. It would be more correct to say that a slow, gradual process of transformation was now under way. The painters, groups, movements and styles that have succeeded each other over the last hundred years often seem to contradict and annul each other: Impressionism, Post-Impressionism, Art Nouveau, Fauvism, Expressionism, and so on. It is only in retrospect that the thread of continuity becomes apparent; the tentative pursuit of a new reality which is then mastered with new formal tools.

Manet's 'deviation' may now seem minimal, but it was the decisive move, and with it the rejection of illusionism became manifest. This move was not the work of a fumbler, unable to paint or draw, as most of his critical contemporaries thought; nor did it spring from the iron will of a turbulent spirit who sought to be revolutionary at all costs, but from the subtle eye of the heir to a bourgeois artistic tradition.

Manet's originality, his invention, is not in any way minimized by a reference to the features he owed to the Japanese. Such, at least, was the view taken by Emile Zola, who in 1867, in his capacity as an art critic, devoted a study to his misunderstood, ostracized friend and to the modern artistic vision in general: 'Manet provides a wealth of tones and sets them in a correct relation to each other. This art of simplification is to be likened to that of Japanese prints; they resemble it in their strange elegance and magnificent patches of colour' (*Mes Haines*, Paris 1925, 345).

It comes as no surprise to find the pioneer of the experimental method drawing attention to his friend's use of simplification; but the allusion to Japanese stylization is astonishing. Zola may have been prompted here by Manet himself. For the link between Japanese influence and the retreat from illusionism is something that later critics – Venturi and Bernard Dorival among them – long failed to recognize. Even in 1948, Yvonne Thirion said in her study of the influence of Japanese prints (*Musées de France*, October 1948, 231): 'Whatever anyone may say, Manet's work really owes nothing to Japanese prints.' The unmistakable Japanese allusions in his work, especially in the portrait of Zola, were dismissed as mere reflections of a passing fashion, just so long as critics continued to seek the essence of his art in realistic illusionism.

Eventually, Manet's role came to be better understood, and his modern feeling for colour, space and figuration, his pursuit of artistic equivalents, were seen as the inception of a style that extended as far as Matisse. It was then that the importance of his sources of inspiration appeared in a new light. The borderline position of his art, between traditional illusionism and revolutionary stylization, between naturalism and anti-naturalism, has led critics to concentrate on the sources that are crucial from their own point of view: Spain here, Japan there. So long as Manet continued to be seen in the context of naturalism, the Japanese undertones remained an irksome, subordinate, superficial feature. As soon as he could be seen as the pioneer of a new artistic vision, those same undertones suddenly took on a central significance. It was

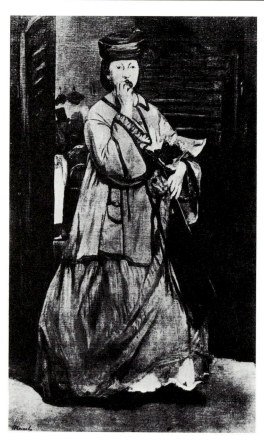

2 Edouard Manet.
Street Singer, 1862

not that the Japanese influence had been discovered overnight, and the artist's position reassessed in consequence, but the exact converse: the reassessment of the artist's 'style' led to the search for unfamiliar or hidden sources.

In this process, the first historian to subject the situation to close scrutiny was probably Henri Focillon, who said in 1921:

Japanese graphic art electrified Western artists, the would-be renewers of the art of painting, by its sheer *modernism*: by which I mean its interest in contemporary life, its charm, its audacity, its play of line, its expression of animated, overflowing life, of the instant that comes and is gone; through its fresh colour tones, unburdened and unfalsified by any trace of a shadow; and finally through its modelling, hinted at but never represented. Never had the aesthetic values of painting been more boldly revised: for ever since the Italian Renaissance Alberti's formula had prevailed, whereby the art of painting must pursue sculptural roundness and the illusion of the third dimension. (*Actes du Congrès de l'Histoiré de l'Art*, Paris 1921, vol. 1, 367–76.)

The key painting, for Focillon, is Manet's *Olympia*, in which the areas of black appear not as dirty shadows but as notes in a colour harmony in which graphic elements are as clearly marked as plastic ones. For which reason, in his view, Manet's close ties with Japan are even more clearly detectable in his etchings than in his paintings.

Focillon's insights were further developed by Nils Gösta Sandblad (*Manet: Three Studies in Artistic Conception*, Lund 1954), who brilliantly analysed the process by which Japonisme became a mainstay of Manet's stylized, anti-realistic art. Without overlooking Manet's realistic aspect as a 'painter of modern life', Sandblad showed how his form of representation tilted away from prosaic reportage and – with the aid of Japanese techniques – towards poetic vision.

Sandblad distinguished three stages of integration in Manet's work. The first, exemplified by *The Old Musician* and the *Street Singer* of 1862 [2], is still heavily imbued with realism. But the atmosphere, the grasp of modern, 'accidental', casual poses, recalls Hokusai; so, even more, do the isolated figures. Their unbroken outlines and colour planes mark unmediated contrasts of light and dark as they move, or rather freeze, against a flat background.

It was in the very next year, 1863, that *Le Déjeuner sur l'herbe*, and more particularly *Olympia*, marked a second step: the whole picture was subsumed, according to Sandblad, into a broad, decorative unity, to which all the passages of painting within it were subordinated. In other words, the representation is visually equivalent to a tapestry. In the absence of shadow, the ornamentally conceived line takes the lead in the organization of the painting and endows the depicted scene with a chilly transparency. In the same way, the dramatic interplay of warm and cold colours is reconciled through concentration on the single, flat picture plane. Sandblad rightly points out that a vision of this kind is prefigured in the etching *The Toilette* of 1862.

The third and final step became possible immediately after Manet's visit to Spain, where he had satisfied his craving for painterly values by steeping himself in Velázquez. He now turned to a stricter emphasis on the 'singing line', a play of line, conceived in ornamental terms, framed by a totally planar concept. *The Fifer* hangs in airless space as a flat arabesque, demarcated by a black outline which finds an illusionistic pretext in the trouser seam, while a tiny cast shadow forms a last bridge to the world of modelling and tonal painting. Similarly, *The Balcony* and *Emile Zola* [18] – colourful though they are – can and must be interpreted in graphic terms; and it is certainly no coincidence that Manet's output of prints reached its climax at exactly the same time. *The Cats' Rendezvous* [5], although in black and white, is perhaps the best example of his stylistic synthesis, in which the Japanese element is certainly not the least important. A first sketch of *The Cats* [4] already reveals the artist's interest in the simplifying arabesque, used without detailed modelling.

It is necessary, even so, to go beyond Sandblad's brilliant pioneer work: for one thing, he concerned himself only with the works of the 1860s, and for another Manet's drawings and prints, long neglected and undervalued, may be regarded as the key to his mode of visual representation as a whole. They reveal, more clearly than the paintings, what the French call Manet's *graphisme* – the structuring of form which even in painted works determines the rhythm and organization of areas of colour. In drawing, the surface of the paper became an active factor in the evocation of the image; and in the same way painting took the fact of its own two-dimensionality as the essential element to which all others were subordinated. Manet was unconsciously

3 Edouard Manet. *A Spaniard*, c. 1862

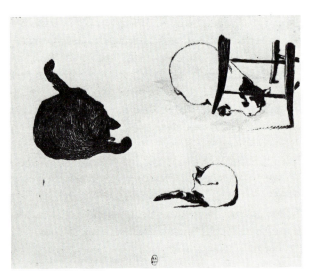

4 Edouard Manet, *The Cats*, 1868–9

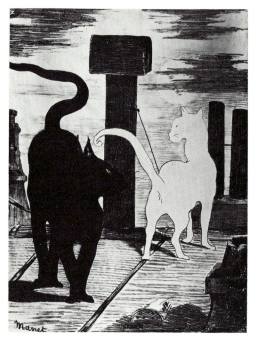

5 Edouard Manet. *The Cats' Rendezvous*, 1868

establishing the principle later enunciated by Maurice Denis, that a painting is basically an organization of form and colour on a surface, before it starts to be a representation of any particular object. With Manet, the long years of peepshow illusionism ended, and modern decorative 'visibility' began.

In this endeavour, Manet enjoyed the inspiration and example of Japanese art. Here, in an attractive but wholly alien visual world, he found all the stylistic resources that mattered to him: lively outline, rhythmic structure, respect for flatness, symphonic colour, frozen movement. It has been said of Manet that he transformed every scene, every portrait, every landscape, into a still-life; but almost the same can be said of the Japanese woodcut. In Japanese art, he observed the rhythmic patterns and arabesques of colours and tones that cover the image and draw the viewer's attention at least as much to its decorative beauty as to its function in the representation of a real scene. He found figures, too, that were as motionless and unanimated as those in an icon, or in one of the Italian 'Primitives' that he had admired and sketched even as a beginner. The ornamental power of the black outline round the figures of the Oirans, the courtesans of the Yoshimura in Tokyo, must have confirmed him in his own pre-dilection for a silhouette-like outline – and in his cultivation of black as a kind of ground-bass.

These observations on Manet as a *japonisant* refer mainly to the 1860s, when his paintings went hand in hand with etchings and lithographs. Spanish motifs [3] were constantly present and served as a cover, so that lay people and critics did not always notice the Japanese influence that transformed, for instance, Goya's *Execution of the Insurgents on 3 May* into the *Execution of Emperor Maximilian*, in which – as Jean Leymarie puts it – drama had become geometry. Manet's Japonisme in general is neither systematic nor apparent at first glance; it works underground, allowing him to undermine and transform his realistic inheritance.

This process can be especially clearly traced in Manet's etchings, through the successive states of his plates. The process of simplification towards pure pattern emerges more and more sharply, because the form is not the product of plastic modelling but of the relationship between areas of light and dark (Curt Glaser). Background and figure are seen more and more as a whole. The last reworking almost always represents the ultimate stylization in Japanese terms: as in *The Dead Torero* [6]. Despite the total commercial failure of his prints – the number sold in his lifetime can almost be counted on the fingers of two hands – Manet constantly returned to the medium: for this was where he experimented.

In painting, in the last decade of his career, he turned increasingly towards the *plein-air* approach, perhaps – although not necessarily – under the influence of his Impressionist friends. The firm outlines and the use of black as the ground-bass of the colour orchestration receded, and a more open composition enhanced the brilliance of his vision. Japanese influence and *graphisme* in general accordingly seemed to recede: what had really happened, however, was that the balance had shifted.

By comparison with *Luncheon in the Studio*, of 1868 [7], the *Café Place du Théâtre*

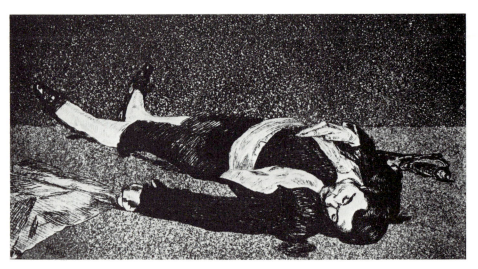

6 Edouard Manet. *The Dead Torero*, 1867–8.

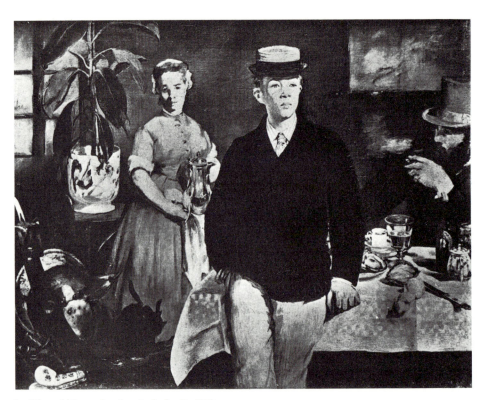

7 Edouard Manet. *Luncheon in the Studio*, 1868

Français, of 1881 [I], is on the whole lighter and more brightly atmospheric in tone — it is a pastel, painted over in oil. Only in a few passages of the background does the figuration blend with the ambient tones, and then without disrupting the structural order of the picture. Patterning is imposed, much as in the earlier work, except that it works through the textural infilling of the figures rather than through their outlines. How could any such vision have existed without an exact and intelligent understanding of the Japanese way of seeing? If nothing else, such details as the cropping of the male figure on the right and of the chair-backs in the foreground and on the left reveal the truth at once. A reciprocal influence from Degas is also in operation here.

The prime evidence for the continued existence of Manet's Japonisme is stylistic; but documentary support is provided by the Japanese motifs that constantly reappear and even grow in prominence. In the early period, in 1864, there was the portrait of *Zacharie Astruc*, with an album of Japanese woodcuts on the sitter's table; in 1868, there was that of *Emile Zola* [18]. The Japanese print in the background of this work [19] is not by Utamaro but by Kuniaki II, a very late minor master; it actually dates from 1860, and according to E. P. Wiese ('Source problems in Manet's Early Paintings', diss. Harvard, 1959) it represents the wrestler Onaruto Nadacmon. A third work, *Repose* of 1869, with its Japanese screen, was followed in a new phase of his career by *The Dog Tama*, of 1875, with its Japanese doll; *Nana*, of 1877, with its Japanese silk wall hanging; and finally *Daisies*, a pastel of 1880, which is on a fan. Japanese objects of all kinds are constantly there in his backgrounds, as can be seen, although they serve only as accessories, to mark an allusion to the fashions of the time.

The situation in Manet's graphic work is quite different. As Focillon was the first to point out, there are quotations from Hokusai's *Manga* at the end of Manet's first phase, in the etchings *The Cats*, of 1868 (Guérin 52 [4]), and *The Cat and the Flowers*, of 1869 (Guérin 53). With the coming of the new decade, which Sandblad, oddly, describes as the 'post-Japanese period' (*Manet*, 116), the concrete marks of an intimate knowledge of Japanese prints become more frequent.

In 1872, Manet's friend and biographer, Théodore Duret, returned from the East with a large collection of Japanese albums, which he later bequeathed to the Bibliothèque Nationale. Manet undoubtedly knew this collection very well, and much better than that of Bracquemond, which he saw only sporadically. Grouped together on a sheet of studies dating from 1875 (Guérin 84) are sketches of Duret's Japanese dog, Tama, a raven, and a number of Japanese characters. A contemporaneous drawing of a salamander and a bee (Louvre, Cabinet des Dessins) is a detailed copy of a sheet from the second volume of *Manga*; and a vignette of lotus leaves for Mallarmé's *L'Après-midi d'un faune* is taken from the first volume [8, 9], as Anne Coffin Hanson has shown (*Art Bulletin*, 1971, 544, 545).

Aside from the direct quotations, there are echoes of the Japanese tendency toward decorative patterning and calligraphic decoration. Sandblad was the first to attribute the magnificent simplification of the profile of *Charles Baudelaire*, and the timeless dignity to which he rises in the later state of the etching (Guérin 31 [10, 11], to Japanese influence. The profile of *Eva Gonzalès*, of 1870 (Guérin 56), with its fine

8 Edouard Manet. *Lotus*, vignette for
Stéphane Mallarmé's *L'Après-midi d'un
faune*, 1876

9 Katsushika Hokusai. *Lotus*, from
Manga, 1812

10 Edouard Manet. *Baudelaire in
Profile with Hat*, 1869

11 Edouard Manet. *Baudelaire, Three-
Quarter Face*, 1869

linearity, is not far from the same spirit. It marks the last point in Manet's career at
which a bridge exists between printmaking and painting.

Subsequently, in the 'painterly' period of Manet's work, we find the strange shift
of balance that has already been mentioned. It is as if painting and printmaking had
proceeded on separate but parallel courses. In printmaking, simplification and the
active relationship between pattern and ground were to progress further. In the
individual prints of 1871, *The Queue at the Butcher's Shop* (etching, Guérin 58 [12])
and *Civil War* (lithograph, Guérin 75 [13]) it serves to elevate casual reportage to a
timeless level. The tiny illustrations intended for Charles Cros's *Le Fleuve* (etchings,
1874, Guérin 63 a-h [14, 15]) and for Edgar Allen Poe's 'The Raven' (*Le Corbeau*,
drawings for lithography, 1875, Guérin 84–86d [16, 17]) have a heraldic monu-
mentality and an abstract, archaic quality that suggest that the artist had seen

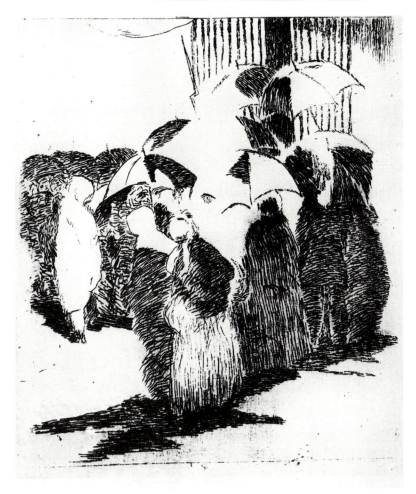

12 Edouard Manet. *The Queue at the Butcher's Shop,* 1871

'Primitive' Japanese prints from the period of Torii Kiyonobu I. In his *Critique d'avant-garde* (Paris 1885, 179), Théodore Duret was to survey the work of the precursors of Hokusai, including Ōoka Shumboku, the six albums of whose *Gwa-shi-kai-yo* of 1753, with their 'unsurpassable perfection in the rendering of flowers, birds, animals, and bamboo shoots', might well have served as a stimulus to Manet. These advanced graphic works of Manet's are closer to Toulouse-Lautrec – who worked almost two decades later – than to Manet's own Impressionist contemporaries, Monet and Pissarro. 'To find forms,' as Lautrec wrote to Daniel de Monfreid on 12 October 1897, was the common objective.

There can therefore be no doubt that Manet was aware of Bracquemond's discovery at an early stage, that he was actually the first who fully comprehended its scope, and that it remained before him as a guide throughout his artistic career. His direct quotations of individual motifs are indications – although not proofs – that this was

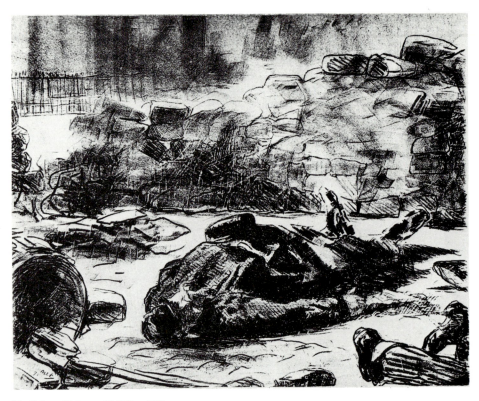

13 Edouard Manet. *Civil War*, 1871

the case. Artistically speaking, the paintings or the prints never actually look Japanese, as those influenced by Spain look Spanish. The Japanese quality in Manet is entirely a matter of interpretation, and is often masked. Even where the influence is evident, it remains difficult to point to a specific source.

Manet grasped the nature of the Japanese eye intuitively rather than from any detailed study of individual works. In the 1860s, access to Japanese prints was still a rather hit-and-miss affair. Volumes of Hokusai's *Manga* were in circulation, but the latest work of a late and derivative successor might have an equal impact on a receptive mind. We do not know what Manet actually saw on his visits to La Porte Chinoise, any more than we know what his friend Baudelaire might have shown him; but it is unlikely that he encountered the masterpieces of *ukiyo-e*.

At the 1867 Universal Exhibition, Japanese crafts were the great attraction, but there was only one showcase of woodcuts, made up of Hokusai's *Manga*, lent by Burty at the very last minute. Duret tells us that Manet fully shared the admiration which led Duret himself to embark on a collection of his own (*Livres et albums illustrés du Japon Réunis et catalogués par Th. Duret à la Bibliothèque Nationale*, Paris, 1900, Introduction). This collection was to be the painter's main source of knowledge of Japanese art in the last decade of his career. And, of course, there was always

14 Edouard Manet. *The Mountain*, 1874

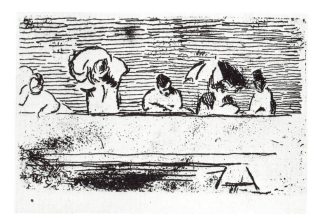

15 Edouard Manet, *The Parapet*, 1874

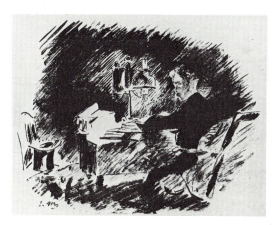

16 Edouard Manet. *Under the Lamp*, 1875

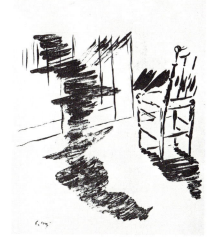

17 Edouard Manet. *The Chair*, 1875

Bracquemond, friend, tireless technical helper and craftsman, the champion of true Japanese expression, the 'discoverer' of Hokusai. It is impossible to overlook his role; but it is also all too easy to over-estimate it, unless one takes proper note of the conventionality of his own work. Manet himself, we learn from the catalogue of his estate, owned no prints: only one 'Chinese screen' is listed, probably the one that appears in the portrait of Zola, which he painted in his own studio.

It transpires, therefore, that what Manet took from Japan was essentially a general idea of possibilities. In a sense, he looked straight through Hokusai, a late artist whose work shows much more spatial depth than that of his predecessors. *The Fifer*, with his flat silhouette, reminds one much more of a Japanese primitive: someone like Kaigetsudō. Whether Manet ever actually saw any of Kaigetsudō's work, and if so where, is and must remain a mystery.

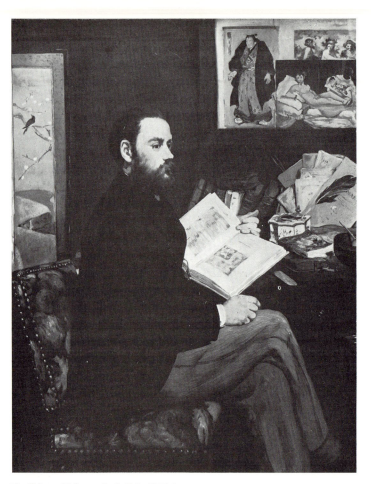

18 Edouard Manet. *Emile Zola*, 1867–8

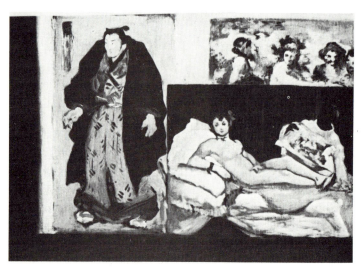

19 Detail of previous illustration

From first to last, of course, Manet was a great colourist, and in this respect he owed little or nothing to Far Eastern woodcuts. What he derived from the Japanese consisted above all in the relationship of colour to form, in the structuring of his pictorial space, and in the elaboration of a new kind of formative intention. The resulting *planar* quality is his greatest contribution, in stylistic terms, to modern art. It comes as no surprise to find that this was precisely the quality that was cited against him, as a fault, by generations of critics. Hindsight clarifies; hindsight gives us a view, not only of a single artist, but of a whole period.

What was most needed, at that crisis in the history of art, was not so much an enhancement of the tonal resources of painting as a new start, the beginning of a fresh cycle, a 'primitivism', which – as always – would base itself on drawing and structure. To his contemporaries, Manet was at best the last of the tonal painters; to the generation that followed, he was the pioneer of a new art in which the paintbrush had become a drawing tool.

James Abbott McNeill Whistler (1834–1903)

The planar quality that Manet derived from the Japanese, Whistler borrowed from them, for his decorative synthesis, in a much more explicit and radical fashion. Born in America, he grew up in Russia and in England; but it was in Paris that he spent his formative years as a painter, and it was here that he underwent the decisive experiences of his life. He and his friends were overwhelmed by the impact of Velázquez, and of their discovery of Japanese woodcuts. In Fantin-Latour's group portrait of 1864, *Homage to Delacroix* [20], Whistler appears alongside Manet, Baudelaire and Bracquemond. His ties with the same circle remained close for as long as he lived in Paris, and continued after he moved to London in 1859, remaining a frequent visitor to the Continent. Delâtre printed Whistler's early etchings, and Bracquemond was a friend. He was a regular customer at La Porte Chinoise.

Whistler was thus familiar – through his own eyes and through those of his artist friends – with all the Japanese influences that Paris had to offer. His unique advantage was that he supplemented all this through the discoveries that he was concurrently making in England. There he was without a rival, as the first and for the time being the only painter who could draw inspiration from Japanese art.

According to James Laver (*Whistler*, London 1930, 1950) and Denys Sutton (*Nocturne*, London 1963), Japanese artifacts, mostly decorative objects and illustrated books of scientific or ethnographic interest, reached London in the 1850s. However, the Japanese works of art that were shown in London's second Great Exhibition, that of 1862, seem to have had no particular influence on the artistic community. Whistler began his own collection of 'blue and white' porcelain, screens, costumes and woodcuts by buying from Farmer & Rogers' Oriental Warehouse; this was the firm that had bought up the exhibits after the 1862 Exhibition closed, and the predecessor of the department store Liberty's, which opened its doors in 1875. Liberty's was the focus of the Aesthetic Movement that was to hold the country in thrall for a quarter of a

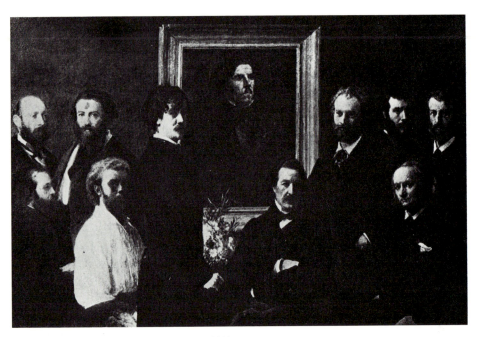

20 Henri Fantin-Latour. *Homage to Delacroix*, 1864

century, and a producer of exquisite 'Oriental' textiles and interior decor that enjoyed an international reputation.

A consultant to Liberty's in its early days was Edward William Godwin (1833–86), who, with others, firmly steered it towards an appreciation of Japanese taste. This largely forgotten architect and designer – a pioneer of functionalism, a critic of the officially sanctioned eclecticism, and the polar opposite of the 'Gothic' Arts and Crafts Movement – interests us here by virtue of his association with Whistler. Who was the giver and who the receiver is hard to tell, but the relationship was important to both men.

It is known that in 1862, the year of the Great Exhibition, Godwin was decorating his own house in Bristol with Japanese woodcuts. A year later he met Whistler. In the early 1870s, he designed wallpapers with peacock patterns and other Japanese motifs and wrote on the constructional principles of Japanese architecture. In 1876, he built Whistler a house without cornices, 'a kind of box with delicate surfaces and receding articulations, as if it had renounced any traditional Occidental notion of tectonic arrangement' (Robert Schmutzler, *Art Nouveau* [Stuttgart 1962], London and New York 1978, 28). Two years later, at the Paris Universal Exhibition, he showed an interior decorated by Whistler in yellow and gold. After Godwin's death, Whistler married his widow.

The tangible fruit of this friendship, on Whistler's side, was the Peacock Room of 1876–7 [28]. This belongs to the second phase of his career, in which he produced the *Nocturnes* and *Portraits* that were his most successful works – successful in the

sense that in the decades that followed they carried his fame to many international exhibitions and won him acclaim and medals in Brussels, Munich, Paris, Amsterdam, Antwerp, Vienna and at one of the first Venice Biennali. In this connection it is remarkable that this artist, a member of the avant-garde who achieved wide recognition in his own lifetime, should subsequently have been so much forgotten that, for instance, his work was absent from the wide-ranging Paris exhibition of *Sources of Modern Art* (*Sources du XXe siècle*, 1960–1), even though its organizers laid particular emphasis on the decorative.

In contrast to Manet's planar emphasis, Whistler stressed *decorative form*, a concept which became central to his art, and which remained inseparable from the influence of Japan. Decorative form was and has remained a controversial subject, and its prestige has varied greatly. In Western art, down to the dawn of the nineteenth century, decorative form was not an issue at all: it was taken for granted. Alongside the depictive function, every painting and every sculpture possessed a decorative function: the delight in line, rhythm, colour choice and harmony, spatial layering, compression or expansion, elegance, order, clarity. All these were aesthetic qualities. The individual work was simultaneously viewed as a part of a larger whole: the space in which it was situated, the church, the château, the city. The implicit decorative unity of art – of all the arts – was the norm, an established fact that was subsequently lost from view, obscured by the Industrial Revolution, by the rise of museum culture, and by academicism.

Decorative effect had always been an issue of degree and emphasis, not of principle. In successive 'late phases' – such as Hellenism, Flamboyant Gothic and Rococo – the emphasis shifted in the direction of consciously ornamental adornment, as against archaic simplicity and classical equilibrium. It was not until the nineteenth century brought an artificial separation of one art from another that the word 'decorative' acquired those overtones of triviality, of low craftsmanship, of 'applied' art, that still adhere to it today. The debased and circumscribed productions of the bric-à-brac industry have nothing to do with the true nature of decorative art; and indeed painters and sculptors, in the nineteenth-century interregnum, constantly longed for the walls and spaces to which they felt their works belonged – in other words, for a decorative context.

Whistler stood at the beginning of a movement which gradually brought the arts back together, and which found successive fulfilment in Art Nouveau, in the Bauhaus, and even in the recent art of 'environments'. This explains, at least in part, the great public response that his art enjoyed at the turn of the century, the stimulus that it represented even to such comparatively late artists as Georges Seurat, Aubrey Beardsley, Ferdinand Hodler and Gustav Klimt. It was Whistler who rehabilitated the principle which Werner Weisbach has called 'artistic taste' (*Kunstgeschmack*), and which has to be clearly distinct from its much-decried counterpart, 'fashionable taste'.

In his pursuit of decorative unity, Whistler might well have looked to the European past; it would have been possible for him to hanker, like John Ruskin and the Pre-Raphaelites, for a revival of the conditions that produced the Gothic. His originality

lies in the fact that, instead, he opened his mind to the nascent influence of Japonisme, and that he recognized and developed its decorative potential. Japanese culture had never perpetrated, or tolerated, a separation of the decorative from the rest of art. Craftsmen, artists and public were never confined in watertight compartments but lived in the unitary space of a truly artistic culture, the only one that still existed in Whistler's own day, and does so in part even today. Whistler was actually in little danger of romanticizing the past: his early days in Paris had been spent in Courbet's circle, with its entirely contemporary naturalism. He never looked backward but outward. Japanese art was exactly what he needed.

Whistler's career, in so far as it coincides with his identification with Japan – his contemporaries were already referring to him as a 'Japanese painter' – can be divided into three stages, early, high and late. After his early rejection of Courbet's example, his new orientation showed itself in paintings crammed with Japanese motifs. *The Golden Screen: Caprice in Purple and Gold*, of 1864 [II], is a case in point. Its charm resides principally in the way it illustrates a certain studied Japanese taste: the kimono, the screen, a few leaves from Hiroshige's *Famous Views from More than Sixty Provinces*, a curious chair or stool more likely to have been designed by his friend Godwin than by a Japanese. A bewildering profusion of objects, patterns and colours is held within a set of verticals, horizontals and assorted diagonals. The most curious thing about the work is its spatial arrangement. Is this a frontal view or a top view? How deep is it? Is the woman sitting on a rug on the floor, and how far back does the screen go, especially to the left? The still-life of flowers at the lower left-hand corner still belongs to the naturalistic tradition of Manet, Courbet and a long line of predecessors.

It is only when we look at the resulting mosaic of colour, preferably upside-down, that we glimpse something vital. The combination of lemon yellow with various greens and blues, balanced by black, red and a soft beige, and grouped around the silhouetted profile of the girl: all this is a genuinely new tonal scale that the painter has assembled, as a 'caprice', from a variety of Japanese prints. He is still tentatively reaching out for Oriental delights. The Japanese elements here are fragmentary, externally seen and more or less artificially brought together. If Whistler had done no more than this, he would have remained on the level of a Tissot or a Stevens and would have left no lasting influence behind him. But this 'caprice' stage was necessary before he could press further forward.

Much the same can be said of almost all his paintings of the early and mid 1860s: they surprise by their use of Japanese objects and the resulting perfumed and cultivated atmosphere; they are bewildering in their spatial construction and often astonishing in their choice of colour. They include *The Princess from the Land of Porcelain, The Lange Lijzen of the Six Marks: Purple and Rose*, and *The Little White Girl: Symphony in White No. 2.*

A clear turning-point was marked by the summer of 1865, which he spent – paradoxically enough – in the company of Courbet. By comparison with the *Breton Coast* of 1861 [21], the seascape *Trouville* of 1865 [22] has lost all its descriptive detail, together with its variety of colour, in favour of a decorative emphasis: a *Harmony in*

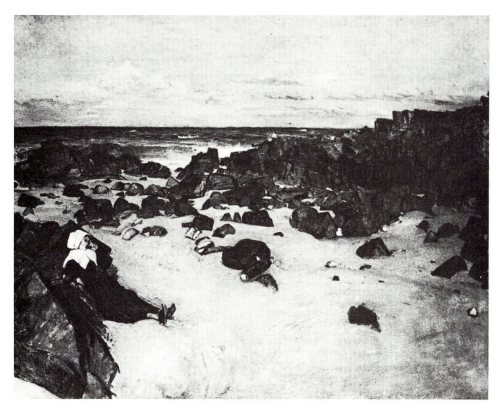

21 James McNeill Whistler. *Breton Coast*, 1861

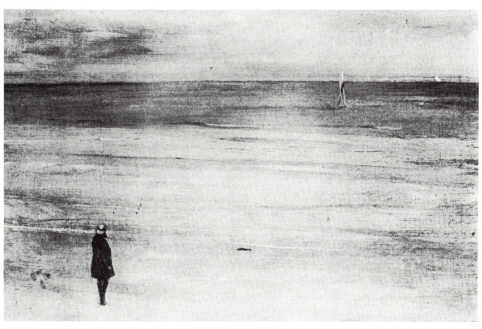

22 James McNeill Whistler. *Trouville: Harmony in Blue and Silver*, 1865

Blue and Silver, to give the work its proper title. This work, unfortunately none too well preserved, points in a new direction. It no longer follows nature but, as it were, looks through it to express the simplified rhythmic interaction of two colours and the two basic dimensions, vertical and horizontal. The improbably high horizon line underscores the intention of the design. All this is not Japanese, exactly, but there is much here to suggest that the painter had now looked at the Hiroshige albums with new eyes.

The figure paintings of the same period reveal a similar evolutionary process. *Purple and Rose*, with its realistic cataloguing of Japanese objects, was followed, one year later, by *Symphony in White No. 2*, a work of flatness and formal simplification. The long-drawn-out, classical line in this painting has been seen as an echo of Ingres' *Madame Moitessier*; and its mood has been likened to the Pre-Raphaelite ideal of Dante Gabriel Rossetti. But beneath all this are the first stirrings of a concern with the Japanese decorative sense. Whistler now stood at a crosssroads. Leaving contradictory influences (Courbet, Ingres, Rossetti) behind him, he now espoused the course that was to condition the evolution of his art for years to come: the inspiration of Japan.

The seascapes painted in Valparaiso in 1866 and 1867 began the transformation of nature into poetry and vision and found their climax in the celebrated *Nocturnes* of the 1870s. Whistler had broken through to a decorative style that was entirely his own and without parallel either in England or in France. He had transcended illusionistic vision, with its delight in detail, and he showed the way to absorb newly understood aspects of Japanese art. For him, the artist was not simply the recorder of the details of Nature but the 'designer of rare and quaint patterns', the 'deviser of the beautiful':

Nature contains the elements, in colour and form, of all pictures, as the keyboard contains the notes of all music.

But the artist is born to pick and choose, and group with science, these elements, that the result may be beautiful – as the musician gathers his notes, and forms his chords, until he bring forth from chaos glorious harmony . . .

Nature is usually wrong: . . . seldom does Nature succeed in producing a picture. ('Mr Whistler's "Ten O'Clock" ', in Whistler, *The Gentle Art of Making Enemies*, London 1890, 139, 142–3.)

The belief that art is superior to nature was not original to Whistler. As Denys Sutton tells us, Baudelaire, Gautier and Walter Pater had preceded him and pioneered the cult of *l'art pour l'art*: Art for Art's Sake. But this was probably the first creative embodiment of the theory of 'pure' art; and that was the decisive step. It was Whistler's genius to realize that in Japanese prints he had found the means by which he might, by a succession of laborious steps, approach his objective.

First, as has been shown, came the simple presentation of Japanese objects seen in an almost naturalistic way. Bracquemond, La Porte Chinoise and the Paris circle provided him with these things. His acquaintance with Hiroshige, whom he quoted in *The Golden Screen*, and who was still unknown in Paris, must stem from another source, undoubtedly in London. His biographer, Joseph Pennell, supplies a hint as

to how Whistler became a collector and connoisseur of Japanese prints: 'A little shop in the Strand was one of their favourite haunts, another was near London Bridge, where a Japanese print was given away with a pound of tea' (E. R. and J. Pennell, *The Life of James McNeill Whistler*, London 1908, vol. 1, 117).

His companions on these expeditions, at least in the early days, were Dante Gabriel Rossetti, the Pre-Raphaelite, and his brother William Michael, who confirms that Whistler was the first, as early as 1863, to draw attention to Japanese prints and to display them triumphantly – without, however, meeting with any response or comprehension. The Pre-Raphaelites had very little to offer Whistler. They saw art as a function of moral feeling; he saw it as a realm of beauty that must constantly be renewed and confirmed by new original creations. They regarded Japanese art as distasteful, or at best as an exotic curiosity; but to him it was a new embodiment of beauty, the key to a new language of form, which gave untrammelled expression to a new poetic content and a new epoch. The realistic theme now – as Werner Haftmann has pointed out – took second place to the abstract colour chord: *Harmony in Grey and Green, Symphony in White, Nocturne in Blue and Gold, Arrangement in Grey and Black*. And so Whistler succeeded in 'devising' his enchantment, along the Thames or by the silent canals of Venice.

The progress, consolidation and evolution of this practice of art were accompanied by a progressively wider and deeper knowledge of Japanese prints and insight into their spirit. Whistler found it necessary not only to look at them but to possess them for concentrated study. After his first collection was lost in his bankruptcy at the end of the 1870s, he made a second collection which eventually passed from his estate to the Burrell Collection in Glasgow and to the British Museum. Between the two lies the transition from his second or high style, as represented by the *Nocturnes*, to the late phase that was ushered in by the etchings done in Venice.

It is an intriguing conjecture – it can never be anything more – that his stylistic development was, if not governed, at least accompanied by a changing selection of Japanese models. In the first collection, begun in 1863, he took as his main exemplar not Hokusai (as was the case in Paris) but the landscapes of Hiroshige, which he can claim to have been the first to discover. A number of them are clearly identifiable in *The Golden Screen* [II], signed in 1864; on the Continent, according to Burty, they were not known until 1875. Whistler's disciple, Ralph Curtis, told Pennell: 'From Hiroshige especially he appears to have assimilated those nicely weighed laws of balance in design, the tender chords of colour and unconventional arrangements which have long since become vulgarized – even to the posters of *l'art nouveau*.' (Pennell, *Life of Whistler*, vol. 1, 274.)

Alongside Hiroshige, the latecomer, Whistler also looked to Torii Kiyonaga, the master of the classical style. There can be no doubt of this: not only did Whistler own a number of his prints, but his debt is clearly revealed in a work such as *The Balcony: Variations in Flesh Colour and Gold* [23], which is usually dated to 1868, in the transition to the mature period. The source in this case is Kiyonaga's *Tea House, Shinagawa* [24].

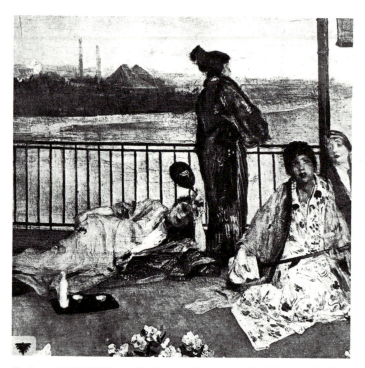

23 James McNeill Whistler. *The Balcony: Variations in Flesh Colour and Gold,* 24 Torii Kiyonaga. *Tea House, Shinagawa,* 1784
1867–68

Even though Whistler's four figures are Japanese in costume and posture, the pictorial idea is a piece of free reinterpretation. The totally surface-bound treatment is accompanied by unified and simplified outlines, which become silhouettes encased by the dominant verticals and horizontals concentrated in the decorative railing. The foreground drops away abruptly, and the flower arrangement has been denaturalized almost into an ornament; this is the style that achieves even greater unity and compression in the later *Nocturnes*. The rhythm, built up from abstract patterns, stems from Japan, as does the way in which the scene itself is built upward from the base instead of in recession. The traditional foreshortening of space with a perspectival focus is eliminated, and the way is left open for a new spatial concept made up of purely decorative signs. *The Balcony*, removed from the banks of the Thames, draws its life from the artist's capacity to transmute as well as to invent.

In the *Nocturnes* of the 1870s, content recedes still further, in favour of a subtler elaboration and balancing of form, and of a more poetic or musicial, not to say abstract, expression. Titles such as *Harmony, Symphony, Variations, Arrangement* – used, significantly, even for portrait studies – point to the artist's essential intention. It is characteristic, too, that the artist's signature is replaced by the butterfly emblem, in all its 'Japanese' variations.

Equally important, in these works, is the new role assigned to colour. Initially

bright and fully modelled, it now reduces itself more and more to a few choice, subtle tones that emerge from twilight and set a mood increasingly remote from the actual colour of the object; the effect, once more, is the creation of a pellucid, newly envisioned reality.

This simplification of colour is unimaginable without the example of Hiroshige; and the presentation of the motif by a surprising arabesque, usually in the foreground of the landscape, is entirely derived from him. But the stiffer, flatter stratification of space comes from another source. Hiroshige, already infected by the European models introduced by the Dutch, mostly proceeds in diagonal recession; but in Whistler's *Nocturnes* this recession has been intercepted and cut short. Like the 'classicist', Kiyonaga, Whistler builds up his vision in two parallel bands of space. None of this is to be taken to mean that he has a recipe whereby he takes x units of one Japanese artist and combines them with y elements of another to produce a new result. It is merely a statement of his points of departure; his ultimate achievement places him in the very forefront of European art.

In his own time, Whistler was often seen as no more than a pallid aesthete. In fact, however, he pointed the way to an art that would not rest content with following and illustrating life but would set out to interpret, spiritualize and direct it by demonstrating a new order and a new design. It is no wonder that Ruskin, with his backward-looking ethic of craftsmanship, rejected him. No wonder, either, that the Continental artists of Symbolism and Art Nouveau saw him as a figure who was a whole generation ahead of his time, and who prefigured their own ideas and dreams.

Our two pairs of illustrations [25, 26, 27, III] illustrate Japanese inspiration and Western response far better than any lengthy theoretical exposition of the kind that Whistler was happy to avoid. What he called his 'Japanese method' – about which he was protective, almost secretive – consisted in composing, not *in* space, but *with* space (Louis Aubert), in order to show how objects take on form just where they are concretely to be seen, not as isolated models abstractly thrust into the centre of the picture. Count Harry Kessler once gave a penetrating analysis of this visual process:

Whistler sees the parts of every visual image as organized into a system with a centre of gravity, around which the rest crystallizes in accordance with a kind of optical equilibrium. In other words, he senses in every object an optical accent, an emphasis that has nothing to do with its literary 'significance' but emerges from the succession of sensations – lines, tones, colours, forms – that make up the object for the eye. The dominance of light then leads Whistler to harmonies of white on white, black on black, in which even the last vestiges of colour, the neutral tones, are almost abolished in favour of a single tonality which expresses degrees of light. ('Whistler', *Kunst und Künstler*, 1904, vol. 3, 454.)

The idea of rendering optical appearances, as opposed to tactile volume, echoes the aims of the Impressionist movement, even though the means employed are entirely different and there is no question, for instance, of colour division.

Whistler himself only once, to my knowledge, described his 'decorative method' in any detail. This was in an early letter to Fantin-Latour, in September 1868:

25 Andō Hiroshige. *Ryogoku Bridge*, 1831

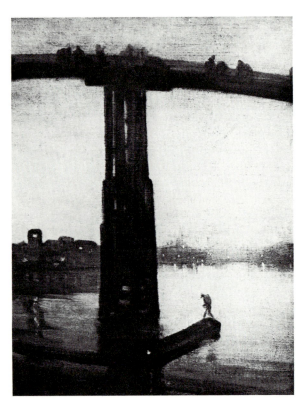

26 James McNeill Whistler. *Old Battersea Bridge:
Nocturne in Blue and Gold*, 1872–5

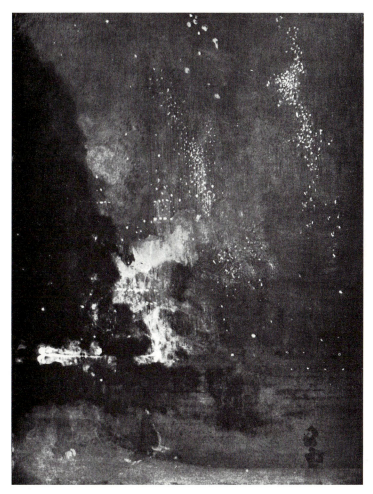

27 James McNeill Whistler. *The Falling Rocket: Nocturne in Black and Gold*, 1874

On any given canvas the colours must, so to speak, be embroidered on; that is, the same colour must reappear at intervals, like a single thread in an embroidery. The others follow suit, according to their importance, so that the whole makes a harmonious pattern. See how adept the Japanese are at doing this! They never seek contrast but, quite the reverse, repetition. (Washington, D. C., Library of Congress.)

The new form thus has three aspects: space, light and colour. Composing with space; optical emphasis; painting like embroidery. A century later, one can see that it may have been not so much Whistler's eccentric behaviour as his avant-garde insights that accounted for the repeated scandals of his career.

His ideas on decoration on a larger scale are still more surprising, although here the visual and critical rcords are highly fragmentary. At every one of his exhibitions, Whistler paid the closest attention to decor, both colour and textile hangings, and

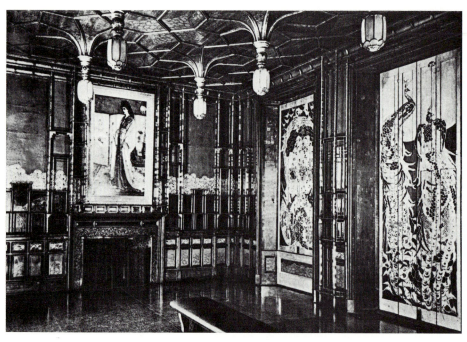

28 James McNeill Whistler. *The Peacock Room: Harmony in Blue and Gold*, 1876–7

supervised every detail. Every painting had a right to an aesthetic setting of its own, to show it at its best; and a tightly packed wall was anathema. The information given by Pennell is, however, far too vague and general to enable us to picture the effect with any precision.

In the decoration of his own various homes and studios, Whistler missed not a detail in the endeavour to achieve harmony and simplicity. In an age when kitsch was triumphant, and when people of the 'better sort' crammed their dwellings ceiling-high with objects of all kinds, periods and countries, Whistler's ideas were as revolutionary as they now seem modern. They were naturally inspired by Japan, which had never lost its old domestic culture and whose decorative principles were even then being studied at source by travellers and made available in the West through sumptuous publications. Blue and white porcelain vases from the Far East, lined up against the wall, with a few Japanese woodcuts, formed as it were the rhythmic backbone which gave the room its character. As in Japan, furniture was kept to a minimum.

The only example of Whistler's decorative taste to have survived intact is *The Peacock Room: Harmony in Blue and Gold* [28], now in the Freer Gallery of Art in Washington. It was designed in the 1870s as a setting for an existing painting, *The Princess from the Land of Porcelain*, of 1864. The canvases and painted ceilings of the Renaissance and the Baroque were created for a specific space; they belong to that space and form a unity with it. Here this relationship is reversed, and the space and

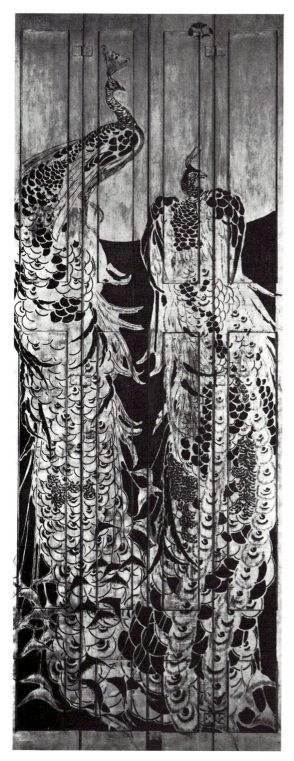

29 Detail of previous illustration

30 Torii Kiyonobu. *Eagle and Monkey*, c. 1720

31 E. W. Godwin. *Peacock* wallpaper, 1876

its decor are designed to set off a specific painting. The result is a magical ensemble. When Whistler's paintings are seen in public alongside those of other painters, their unity of tone, to the point of monotony, often taxes the viewer's attentiveness and his capacity for admiration. In *The Peacock Room*, on the other hand, every viewer is drawn into the solemn spell of an encompassing new reality.

A windowless room. Against the deep turquoise-blue wall, decorative surface mouldings stand out, horizontal and vertical, in a lively rhythm. Rectangular compartments in a variety of sizes suggest a springing ornamental movement, while the perfect symmetry of the forms on each wall, and on facing walls, conveys great tranquillity. The four mural panels bearing the peacock motif [29] are at least as conspicuous to the eye as the painting of the Princess (*Rose and Silver*): each more than twice the size of the portrait, they absorb it into the overall context. The spatial order, based on ornament, verges on the monumental. The repetition, the seriality, that Whistler admired in Japanese art has here been largely accomplished. And the fourfold peacock motif, used by Godwin in a wallpaper design [31], is of course also Japanese in inspiration. Even so, the result has been totally translated into Western terms. No room in the Far East offers even the remotest parallel to this.

The Peacock Room, the first integrated ornamental interior since the Rococo, marked the inception of a true style, which can be traced through to the hall of Joseph Hoffmann's Palais Stoclet in Brussels (1905–11). In this decorative portion of his work, Whistler was not so isolated as he was in painting – as Schmutzler has shown, a number of members of the Arts and Crafts and even Pre-Raphaelite movements drew inspiration from Japanese decorative motifs in book-bindings and the like – but there exists no total work of art, no *Gesamtkunstwerk*, to compare with the Peacock Room. The comparison of one of the mural panels with a print by Torii Kiyonobu II [29, 30] clearly shows the extent to which Whistler's ornamental repetitions and pattern-ground contrasts are inspired by the 'early' Japanese artists.

While Whistler is here anticipating the problems, and even some of the results, of Art Nouveau, in the etchings made in Venice he aligns himself with the Impressionists. The essence of these graphic impressions emerges when they are seen in conjunction not only with the paintings of his French friends but with the prints of his own early period. *The Little Lagoon*, of 1880 [32], has fused the motif into a vertical view in which water, land and sky flow into each other on a flat surface. A decentralized, non-directional movement keeps the image in tension, 'empty' though it is in literal terms. The sparse network of lines no longer has the function of defining the objects: it dissolves them into short strokes that bunch or separate to form differing graphic signs. Whistler is not really concerned with objective topographical correctness but only with translation, original vision, artistic purity. It is fascinating to watch the line omitting the outlines altogether, leaping, dancing, fining itself down, and thus forming itself into a 'capricious shorthand of drawing' (Curt Glaser, *Die Kunst Ostasiens*, Leipzig 1913, 125) which marks one of the supreme achievements of European printmaking.

Whistler's debt to Japanese perspective emerges from a comparison of *The Little*

 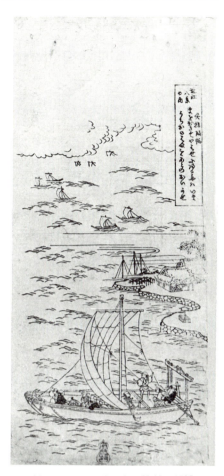

32 James McNeill Whistler. *The Little Lagoon*, 1879–80 33 Okumura Masanobu. *Omi Hakkei*, 1725

Lagoon with a print by Okumura Masanobu [33], an early master who worked almost a century before those artists, such as Hokusai and Hiroshige, who were 'infected' by Europe. The two prints agree in the use of 'signs', of verticality, of residual *graphismes*; but there is absolutely no affinity between them in their use of light and air, which in Whistler's case is entirely Impressionistic. The 'fading of tonality' (Henning Bock, in cat. *James McNeill Whistler, 1834–1903*, Nationalgalerie S.M.P.K., Berlin 1969) stems entirely from the genius of Whistler. This was the achievement on which, in their own prints, Toulouse-Lautrec and Edouard Vuillard were to build.

Edgar Degas (1834–1917)

'Degas mocking Whistler,' noted Daniel Halévy in his memoirs apropos of the meeting between the two in Dieppe (*Degas parle*, Paris and Geneva 1960, 178). What separated them was the American's decorative *Kunstgeschmack*, the 'artistic taste' which the

Frenchman saw no call to cultivate. For him there was only one reality, which was enshrined in the tradition of French painting and drawing, and which was founded on a single principle: Nature is always right. Whistler's originality was derived from art; the uniqueness of Degas rested on his optical penetration of the essence of metropolitan life, for which he created a new and meaningful expressive form.

His approach was based on drawing, as conceived by Ingres, and this was also the source of his interest in the newly evolving phenomenon of photography. Himself a keen photographer, he developed some of his paintings from photographs. The photograph was there as an aid to composition, but even more as reference material for a newly discovered, living, unposed reality, and for the revision of outworn artistic conventions. In it, the raw material of life had already been captured, 'graphically', and *suggested* in an unhackneyed medium.

As Otto Stelzer has convincingly demonstrated (*Kunst und Photographie*, Munich 1966, 132–7), Degas did not fall victim to photography; he 'outsmarted' it. Photography aided him to 'dispose of certain spatial conventions' and to 'extract new aspects from the world of objects'; but the fact remains that it 'knows only an unlimited series of gradations of grey tones, but no such thing as an outline'. And that, I think, is the decisive point. Photography, in spite or because of all the technical shortcomings that it had at that time, undoubtedly operated as a powerful stimulus: top views, distortions of perspective, underexposure, shaky focus, blurring, figures half out of frame, and so on. But 'the monstrous enlargement of body parts and objects placed too close to the objective lens' serves only to underline the old-established fact that the world and the 'objective' camera are not so objective after all, but need elucidation, imagination, vision, style. Or, as Wilhelm Busch put it: 'Nothing looks like it is.'

Degas certainly took photography very seriously, but only as a means of transition. Stylistically, he took Ingres as his point of departure, and he never abandoned modelling in the round, although he turned increasingly to Japanese linearity, together with many of its implications. The stimulus of photography and Degas' Japonisme cannot be played off against each other, as Stelzer seeks to do; they lie on different planes. Even the sensational studies of motion, especially of human beings and horses, which Eadweard Muybridge circulated in Paris in 1878, cannot have had a revolutionary impact on Degas but rather an confirmatory one; he had already, considerably earlier, emancipated himself from conventional European ways of seeing and moved towards those of Japan. The photograph may have been the point of departure in a given case, in the sense of a psychological stimulus; but the translation of 'Japanese' pictorial design into his own terms is something more: it is an goal in itself. What lies between the two is the artistic creation.

This is confirmed by Degas's own Japanese collection, which was remarkable not only for its size (at least 117 items in the auction catalogue of his estate) but equally for its quality. To Degas, his prints were not simply objects of study: he lived with them. A rare print, Kiyonaga's *Women's Bath* [48], hung in his bedroom. With pride, he showed the great connoisseur Raymond Koechlin an erotic album by Moronobu that he had managed to acquire (Koechlin, *Souvenirs d'un vieil amateur d'art de*

l'Extrême-Orient, Paris 1930, 580). When he called on his close friend Alexis Rouart [128], he was able to select for close study, from the thousand or so prints in Rouart's collection, those that he did not possess himself. For the rest, of course, he had access to all the countless *ukiyo-e* treasures in the Paris collections of his day.

Here, for the first time, was a Western artist who had not merely seen this or that Japanese print, who did not depend on the luck of a chance encounter, but who had a critical overview of the whole formal universe of Japan and made a systematic study of its problems and their solutions. What did not interest him he did not collect. With the single exception of Nishikawa Sukenobu, the early styles were unrepresented. Suzuki Harunobu and Tōshūsai Sharaku were excluded, but the masters of the harmonious line were there: Kiyonaga, Utamaro, and among their followers Katsukawa Shunshō, Kubota Shunman, Utagawa Toyokuni, Chōkōsai Eisho and Kikugawa Eizan. It comes as a surprise to find that Degas owned fifteen representations of fish, birds and flowers; even more so to find forty-two landscapes by Hiroshige. Remarkably, Hokusai was very poorly represented. According to Yujiro Shinoda (*Degas: Der Einzug des Japanischen in die französische Malerei*, diss. Cologne, Tokyo 1957), Hokusai is to be regarded as Degas' major Japanese inspiration; so we can only assume that Degas relied on the Rouart collection, in which this artist featured very strongly.

It will always be a difficult undertaking to define an exact Japanese 'source' for a given European work. At most, one can expect to offer or suggest a synthesis of different sources. The process of artistic creation is a complex one, and proof lies purely in the suggestive power of a visual impression. Of the forty-eight pairs of works illustrated by Shinoda, some are much more convincing than others, because he tends to concentrate on individual motifs rather than on their place in a stylistic development. Degas's artistic career spanned more than forty years, in the course of which, from early naturalism to late Post-Impressionism, Japanese influence meant many different things to him and brought him a succession of important insights. So it is necessary to take a number of cross-sections through his output, in various directions, in order to distinguish the specific shifts that resulted from changes in his way of seeing. Curiously, these shifts match the decades: the 1860s, the 1870s, the 1880s and the 1890s. Each reflects an encounter with a new set of Japanese sources that came to him, in some cases, through external events such as exhibitions, personal contacts or new information. What changed, every time, was not so much his motifs – racehorses, portraits, dancers, women bathing – as the way he dealt with them, how the figures held still or moved, or were seen frontally or from above, emerging from the surface or modifying the space.

What is visible throughout his work from the 1860s onwards – although not from 1856 onwards, the date when his friend Bracquemond claimed to have discovered Japan – is the technique of cropping the scene, the apparently fortuitous framing, the knack of catching reality on the wing, the element of surprise, the interesting view. In this sense, Degas was the artist who took the *ukiyo-e* woodcut and evolved from it the modern form of 'perspective' to which the art of film owes a great deal. The evolution of his work cannot be explained as an accumulation of disjunct, curious or

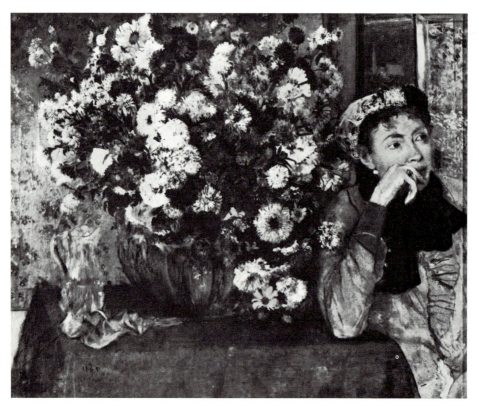

34 Edgar Degas. *Woman with Chrysanthemums,* 1865

inspired ideas, but only as a logical progression along a chosen path, with a constant succession of new discoveries in the representation of a dynamic space.

As a starting-point we may take the *Woman with Chrysanthemums,* of 1865 [34]. A shallow pictorial space, parallel to the picture plane, is mainly filled by a colourful mass of autumnal blooms, accompanied on the right by a female figure in a housecoat. In a languid, dreamy pose, her hand artlessly resting against her chin, she looks away, out of the picture. Only a part of her upper body is seen; the rest is cut off by the frame, as is most of the table on which the flower vase stands. Repose and relaxation are precisely balanced against acute concentration; the fleeting moment against duration; painting against drawing. This portrait of a certain Madame Hertel expands into a genre piece, almost a still-life; the person is enriched by an added dimension, that of the space she inhabits.

Woman with Chrysanthemums precisely marks the watershed between realistic or illusionistic detail and Impressionist vision. Aside from its intrinsic value, the work is interesting because it stands at a critical juncture in Degas's artistic development. Behind him lay the classicizing historical scenes, with their Ingres-like construction, and the dark, naturalistic portraits of family and friends. Here, perhaps under the influence of Manet and his circle, there is a first reference to modern life; and in the

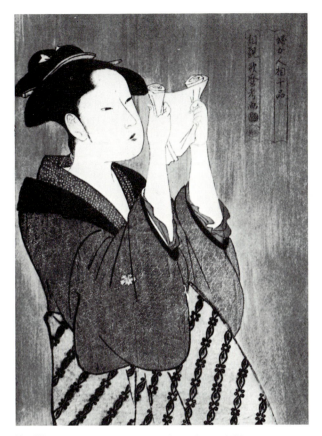

35 Kitagawa Utamaro. *Woman Reading a Letter*, 1791

depiction of the figure there is something Japanese: not only is she displaced to one side, but she is looking away, out of the picture, and her body is cropped in such a 'fortuitous' way as to lose much of its importance in the overall effect, so that the emphasis shifts to the decorative flower arrangement. This sort of thing does not happen either in the classical tradition nor in the naturalistic portrait. It leads to a 'deportraitization' of the portrait, which, according to Shinoda, 'through the viewer's participative experience of the scene, shifts the emphasis to the reproduction of a mood' (*Einzug des Japanischen*, 18). The new artistic vision, with its unaccustomed aspects, is indeed conveyed to the viewer through a shock derived from Japanese techniques: the decentralization of the field of view, the dissolution of the composition and the apparently fortuitous framing.

At this stage of his career, Degas was working towards what was to become Impressionism, and stood closer to it than ever before or after. It was an approach that had Japanese precedents: Shinoda tells us that 'Utamaro, for example, in his cycle *Ten Physiognomies of Woman*, portrayed a number of women in different genre poses, reading [35] or after the bath: all presented as nothing else than an unpretentious sketch from life' (ibid., 20–1).

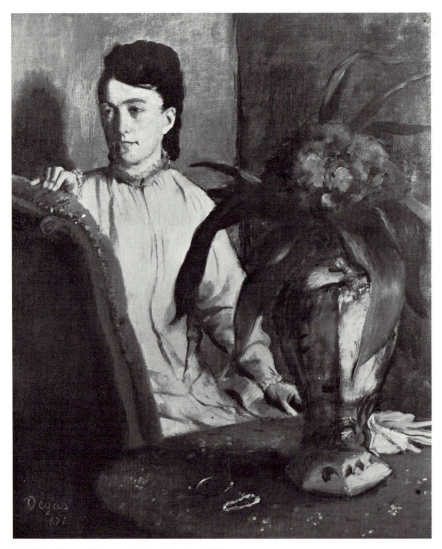

36 Edgar Degas. *Woman with Porcelain Vase*, 1872

The further development of the genre-portrait can be seen in two paintings, one painted seven years later than *Woman with Chrysanthemums* and the other seven years later again: *Woman with Porcelain Vase*, 1872 [36] and *Diego Martelli*, of 1879 [37]. In *Woman with Vase*, the space is dominated by the massive arabesque of the flower vase which rises on the right-hand side, slightly cropped at the edge of the picture, and the diagonal of the chair-back on the left. Together with the table, which is seen slightly from above, both serve to shift the figure up and back. Although the woman, seated opposite a window, forms the most brightly lit part of the picture, the objects that conduct the eye towards her are nearly as prominent. The shallow relief composition of *Woman with Chrysanthemums* is replaced by a spiralling movement

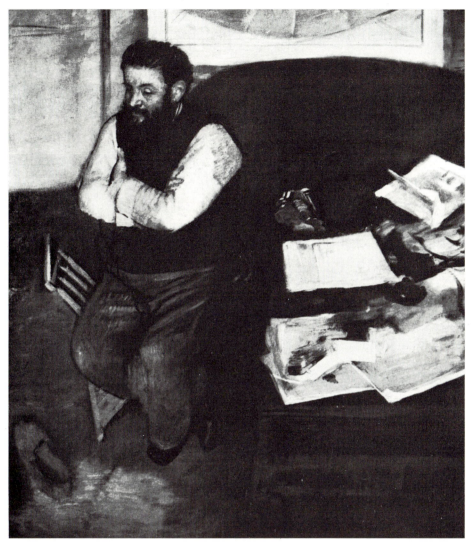

37 Edgar Degas. *Diego Martelli*, 1879

into which the various factors of form, colour, space, character and mood are subsumed, thus transcending the naturalism of photographic detail.

This 'arabesque stage' corresponds to further discoveries in Japanese art. Even if we knew nothing of the relation between this work and, for instance, Utamaro's *A Mother Bathing Her Son* [IV], such contemporary works by Degas as *The Cotton Exchange, New Orleans* [38], *Carriage at the Races, Place de la Concorde* [40] or *The Dance Studio* [44] would reveal his active desire to learn from the Japanese and would enable us to trace his progressive creation of an Impressionist atmosphere through groups of figures in space.

The portrait of *Diego Martelli* [37], of 1879, marks another leap forward: here the illusionistic elements recede still further. What first strikes the eye is the rhythmic, almost abstract design of the work, its structured, definite, large-formed vision. The traditional peepshow space has been systematically wrecked. In place of the frontal view with its illusionistic side-effects, we may analyse this penetration of pictorial space only by assuming a simultaneous view from above and from one side. None of the rules of conventional centralized perspective can be made to fit. There is much more to the picture than a disruption of space, however: it has been revolutionized by an entirely new spatial experience, or rather a changed spatial concept. The common notion of taking in the scene at a glance has been abandoned in favour of an optical scheme that builds the image up from a number of disparate spatial elements.

The bulky, seated figure of the sitter – an Italian art critic – takes the lion's share of the left-hand half of the picture; on the right, the table with its cloth and papers stretches colourfully from the foreground far into the top right-hand corner, boldly cropped, and stresses the flatness of the image. The viewpoint here is almost directly above, so that the contrast with the figure – already evident in colour and in form – is further emphasized. We are faced by a dramatic construction that emerges, not from material and content, but directly from a new vision of space and figuration, a new reading of what is seen.

This portrait marked a decisive turning-point in the art of Degas: with its unconventional viewing angles, it set itself free from naturalistic reproduction and opened the way to creative imagination. Critics have drawn attention to this crucial development from various aspects: Roger Fry speaks of the use of sharply isolated forms and patterns, while Paul-André Lemoisne points to the abandonment of the horizon line, the vertical structure of the picture, and the juxtaposition of pure colour tones.

Degas, in fact, was transcending the illusionism of his own earlier attempts at naturalism, an illusionism from which even Impressionism never entirely escaped. He was, in fact, a pioneer of Post-Impressionism, who reached the crucial turning-point several years before Cézanne and Monet – not to speak of Seurat, Gauguin and Van Gogh.

Clearly, this new orientation was entirely in keeping with the message of Japanese prints. The disposition of accents in the late prints of Utamaro, the intersecting and cropping of figure, space, depth and colour, is ample proof of this. This is no mere parallelism but inspiration based on active interest, as is shown by the fact that the same fourth Impressionist exhibition, that of 1879, which included *Diego Martelli* also included five 'Japanese' fans painted by Degas himself. Even though these do not feature the same pictorial problems and solutions that appear in *Diego Martelli*, we may surely conclude that at this moment the old illusionistic vision, which to varying degrees had accompanied painting ever since the Renaissance, had finally broken down.

Degas's move from an illusionistic to a 'Japanese' pictorial method manifested itself not only in single figures but also in scenes and group compositions. In the early stages, the new insights were sometimes so embedded in photographic and illusionistic

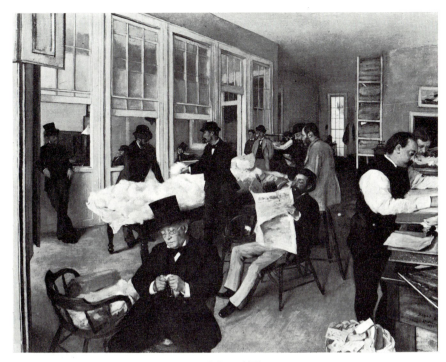

38 Edgar Degas. *The Cotton Exchange, New Orleans*, 1873

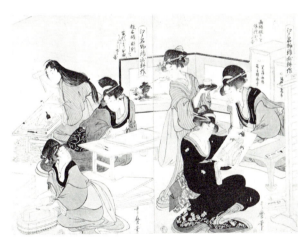

39 Kitagawa Utamaro. *The Making of Colour Woodcuts*, c. 1802

elements as to be hard to detect. On the face of it, *The Cotton Exchange, New Orleans* [38] is a straightforward piece of reportage, showing what the painter saw when he crossed the ocean to visit his American relations. But a comparison with Utamaro's *The Making of Colour Woodcuts* [39] reveals a number of striking parallels, including the rhythmic contrasts of dark and light patterns, the high and frontal viewpoint, the foreground filled with a scattering of figures and objects, the open termination marked

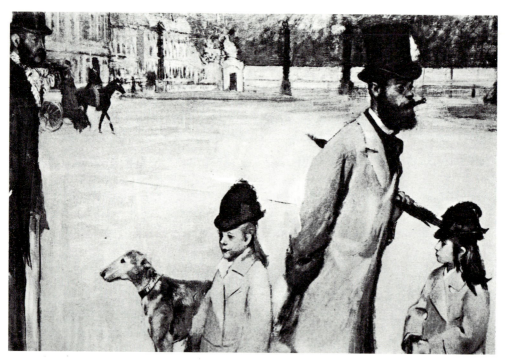

40 Edgar Degas. *Place de la Concorde* (*Vicomte Ludovic Lepic and his Daughters*), 1873–4

by rectilinear barriers in one case and a folding screen in the other, and the groups of figures in arabesque-like combinations. In both cases we see a real scene that has been rendered transparent, and at the same time alienated from itself, by an odd and unusual viewpoint.

An almost exactly contemporaneous work is *Place de la Concorde* [40], which Lemoisne describes as 'bizarre' and 'shocking in its audacity' (*Degas et son œuvre*, Paris 1954, 76). Audacious it certainly is, with its figures arranged around a great empty expanse of city square, its contrasts of scale between the tiny objects that close off the view at the top and the huge outline in the right foreground, and its cropping below and to the left. This painting without a middle ground, in which the background becomes the top, is worked out without anything that could be called a motif in the conventional sense of the word. Of course, photography, with its propensity to distort, will be cited as a stimulus; especially as 'instantaneous photographs' were the sensation of the moment. But although some individual elements are seen in a thoroughly 'photographic' way – the figure on the left, especially; the children; the father caught with his umbrella under his arm – no photographer could then have taken such a picture.

From our Western standpoint we might say, with Pierre Francastel, that here the artist has created 'arbitrary connections between elements borrowed from reality' (*Art et technique aux 19ᵉ et 20ᵉ siècles*, Paris 1956, 187). This 'arbitrary' intervention

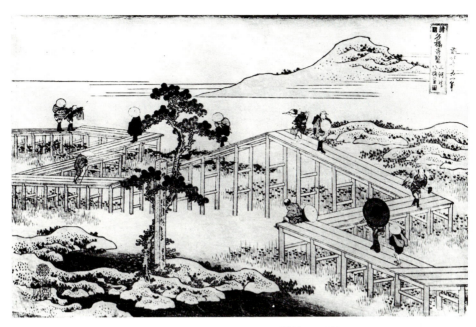

41 Katsushika Hokusai. *The Yatsubashi Bridge in the Province of Mikawa, 1827–30*

supersedes the Renaissance conventions of composition and spatial representation and opens the way to freedom, to a new vision which actually finds a precedent in the Far East. From the Japanese standpoint, we see a vision at work which creates a new entity from the coexistence of separate 'realistic' entities. What has changed is not the observation of reality so much as the relationship between the components of that reality. The symmetrical Western pattern, with its central axis and perspectival foreshortening, is replaced by a dynamic and rhythmic equilibrium of patterns on the picture plane. The objective reference is maintained; but the emphasis is shifted to the structure, even the construction. This is characteristic of Japanese prints in every period, from the earliest primitives to the last 'realistic' works of Hiroshige and Kunisada.

This, then, was the common denominator, the true motive force, of the new form of visualization; the 'errors' of instantaneous photography served only to give encouragement to an artist who already knew exactly what he was doing. It is therefore unimportant whether Degas actually owned any Japanese prints by 1873 – a matter on which no information is or can become available – but it is certain that it was precisely at that moment that Hokusai came as a revelation to him, as to many other artists, the more certainly as Hokusai's prints were then easily available for inspection in Paris. *The Yatsubashi Bridge in the Province of Mikawa* [41] is reproduced here by way of analogy, nothing more. It is certainly not *the* source of inspiration for *Place de la Concorde*, but it illustrates the principle of decentralization with its attendant openness, dispersed forms and empty zones.

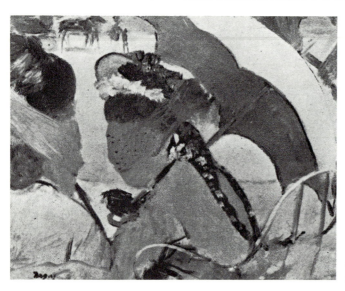

42 Edgar Degas. *At the
Races, Before the Start*, 1878

The further process of Japanization of figures in exteriors can be seen in the painting *At the Races, Before the Start*, of 1878 [42]. The dizzying spatial sensation, here as in the almost contemporaneous *Diego Martelli*, is anchored structurally by the use of a massive arabesque in which we can distinguish the outlines of the sunshade and the lady's head. Here, probably for the first time, the relationship between objective reality and pictorial unity is totally reversed: first the structure falls into a pattern, and then the realistic parts become legible.

Fritz Novotny has pointed out that, strictly speaking, every realistic painting of any quality displays a certain element of 'small-scale structure' (*Kleinstruktur*). This is particularly evident in all Degas' works before this period. But with *At the Races, Before the Start*, the breakthrough to 'large-scale structure' was a fact, and illusionism had been routed once and for all. The legibility of the picture depends on a new sensation of space that makes it possible, as it were, to see round corners, and also on a new kind of drawing that respects the surface, with its newly discovered potential for rhythm and pattern. The colour – unrealistic, unmodelled, opaque – subordinates itself to these concerns.

It is certainly not too far-fetched to recall that in 1878 the Paris collections of Japanese art were engaged in their great period of expansion, and the star of Utamaro was in the ascendant. A print like *The Two Beauties at their Toilet* [43], with its twisting of space, cropping and rhythmic patterning, demonstrates the force of the inspiration.

The visual revolution that Degas accomplished can be traced through all his themes, but best of all in the ballet scenes and the studio nudes. This is not because they are the most popular of his works, but because, through a succession of metamorphoses, they most intensively reflect his new visual concerns: the dancers from about 1880 until 1907, the nudes from 1872 until 1905. Out of this long evolutionary sequence I

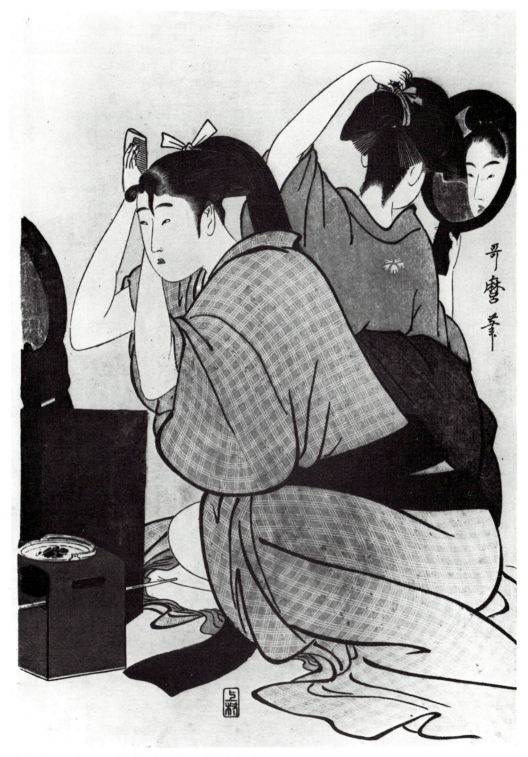

43 Kitagawa Utamaro. *The Two Beauties at their Toilet*, 1790

choose three examples to clarify the transformation that took place over the two decisive decades.

The Dance Studio (*Le foyer de la danse à l'Opéra de la rue Le Peletier*), of 1872 [44] presents an almost naturalistic scene, with a slightly high viewpoint. In spite of the large void in the centre – as in the contemporaneous *Place de la Concorde* – the space is still, just, 'measurable'. Two decades later, a comparable view, *The Dance Room*, painted according to Lemoisne in 1891 or thereabouts [45], transforms the scene into an image whose abstract design immediately catches the eye, overriding both subject detail and overall illusionistic legibility. What appears is a dynamic space that seems to swing round like a stage revolve, with large dancers creating arabesques on the right and a rhythmic sequence of girls poised on one leg in the background, or rather at top left. The empty dance floor acts not as the space between the figures but as the central spatial motif that clarifies the functions of the two groups. In other words, the composition requires the viewer to do something for himself: it forces him to peer round a corner. How much this extension of space owes to the Japanese, and to Utamaro in particular, is a point that needs no labouring. The empty part of the

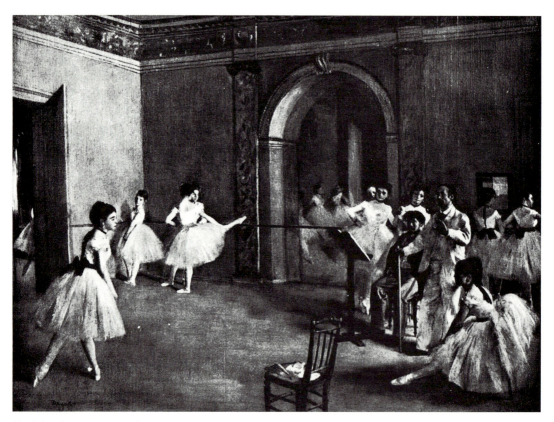

44 Edgar Degas. *The Dance Studio*, 1872

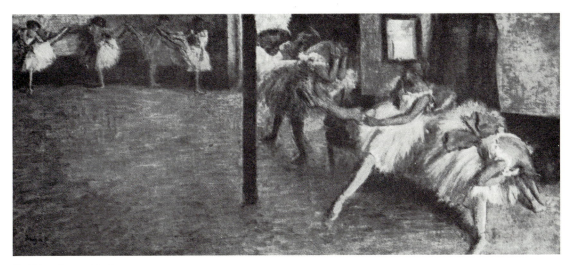

45 Edgar Degas. *The Dance Room*, 1891

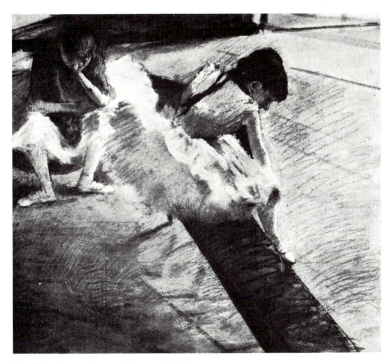

46 Edgar Degas. *Dancers Resting*, 1881–5

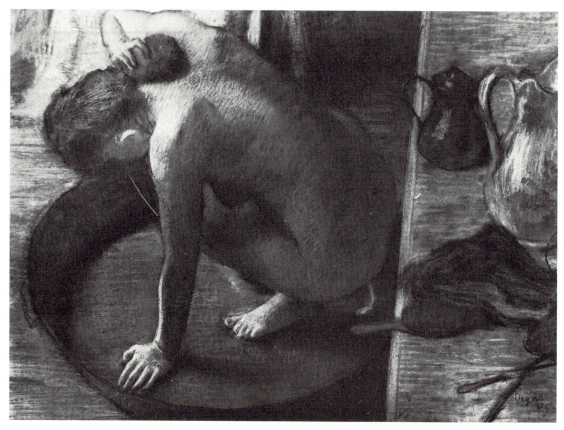

47 Edgar Degas. *The Tub*, 1886

image, unimportant in Western tradition, has, for the vision of the East, an immense active quality, seen as a negative pattern [see 46, IV].

In between these two works, there is *Dancers Resting*, which according to Lemoisne was painted between 1881 and 1885 [46]. Here the empty surface, as a spatial element, has already become the hero of the piece: it occupies almost two-thirds of the painting and is emphasized by the surprise effect of the bold diagonal of the bench. With works like this, it is evident that Degas was in the forefront of Post-Impressionism. It is clear, too, why Gauguin saw him as the liberator from illusionism: Degas worked his way from Ingres-like beginnings, past Impressionism, to a new pictorial structure.

The theme of women bathing, which Degas embarked on later in his career, has one great advantage over any other; this is that the artist himself, through his instructions to the model, can control or even create the object that he paints. From the outset, the subject is contrived, artificial, and thus unnatural. A pastel such as *The Tub*, of 1886 [47], still models the body through chiaroscuro; but the sharp outline, the 'arranged' pose, the steep downward angle of view past the dressing table, and

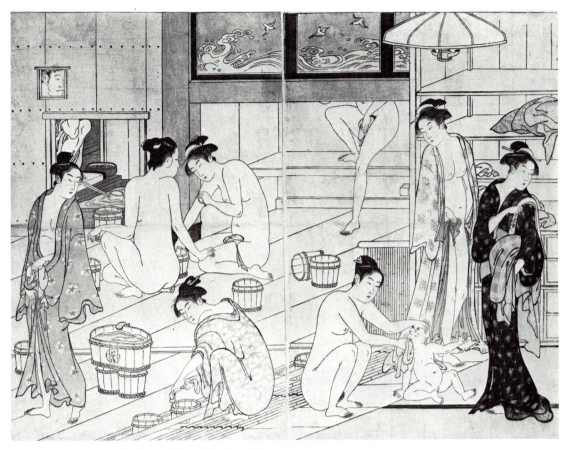

48 Torii Kiyonaga. *Women's Bath*, c. 1780

the sharp contrast with a background form – here the bathtub itself – are entirely in keeping with Japanese precedent.

The print by Kiyonaga, *Women's Bath* [48], which Degas himself owned and which is now in Boston, contains eight different poses, all of which supplied Degas with inspiration. It would be hard to find a Western photograph that could have done the same for him. Admittedly, he first made his studies from life – in Paris brothels – and only then brought them into line with his Japanese precedents, which he did not copy. But it is fascinating to observe the close analogy between the disruptive handling of space in the Western pastel and in the Eastern woodcut: in Kiyonaga three spatial compartments inserted horizontally in the principal space, in Degas the dressing table with its vertically cropped still-life.

One example more demands to be discussed, because it is incontrovertible down to the last detail. Utamaro's *Woman Bathing* [49] reappears several times in the monumental pastels of the early 1890s: the motif is adopted as a near-identical

silhouette in *The Bather* [50], and reappears in reverse, but now in the same Japanese narrow vertical format (approximately 3:2), in *After the Bath* [51].

These few examples, which might be supplemented by many more, surely suffice to document the Japanese vision in the work of Degas. It reveals itself in the choice of motif, in the 'general linear arabesque' (Paul Valéry), and in the emphasis on drawing even in the exploration of a new sensation of space. These elements came to the fore in very different ways in the course of thirty years of evolution; and they never, perhaps, found their way to a perfect synthesis. That would have entailed an ultimate leap into abstraction, which Degas – with his neoclassical inheritance and his illustrative roots – never could or never would take. All of which goes to explain his interest in the experimental evolution of photography; hence, too, his enormous – acknowledged or unacknowledged – influence on such utterly disparate figures as Manet, Gauguin and Pierre Bonnard.

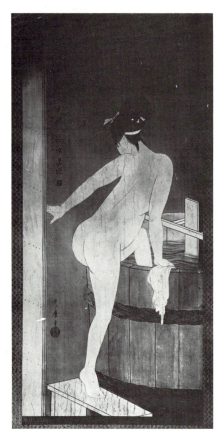

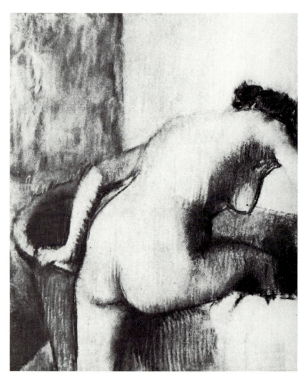

49 Kitagawa Utamaro. *Woman Bathing*, c. 1788 50 Edgar Degas. *The Bather*, 1890

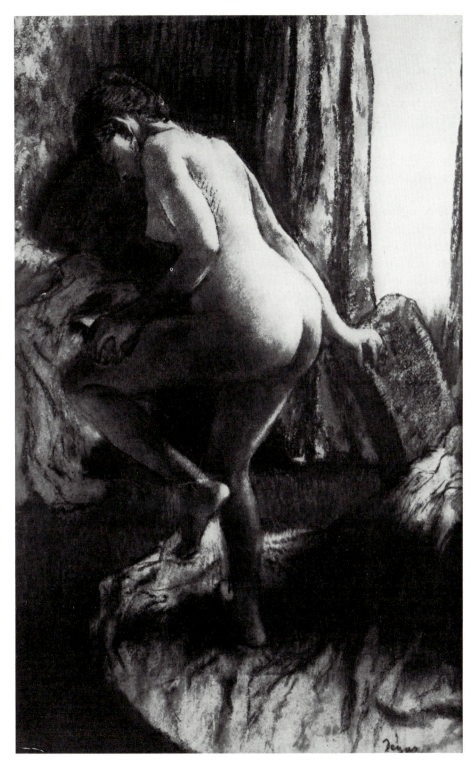

51 Edgar Degas. *After the Bath*, 1890

4. The fashion for things Japanese, 1867–1888

Design: 'Arts and Crafts' and interior decoration

Between the almost invisible pioneer work of the precursors, from the early 1860s onwards, and the emergence of full-blown Japonisme in painting, another process intervened: the great wave of Japanese and Japanese-inspired decorative art that began with the Paris Universal Exhibition of 1867 and lasted for nearly four decades. This is relevant to the 'high art' of painting in two respects: in terms of production and of response.

In terms of production, European craftsmanship was fertilized by the knowledge of Japanese models. Ceramics, both glazed and unglazed, glasswork, furniture and jewellery blossomed; lacquer and sword-ornaments were admired, without inspiring any notable emulation. In the West, the Industrial Revolution, and the copying of historical styles, had debased the quality of all these items. Now they were suddenly valued again.

Mere imitation was the exception rather than the rule: generally speaking, Japanese work with its superior technical finesse and truth to materials served to liberate the creative imagination. Instead of imitation, there was inspiration and transposition. This was true in two senses. Firstly, in design, the influence took one of two forms: either 'functional', with respect for surface and outline, or else intuitive and imaginative, not to say fantastic, with the S-shaped line as the favourite ornamental motif. Secondly, the Japanese use of colour – its power and brilliance, and its unexpected combinations – was grasped as an expressive force and detached from any mere illustrative role. A further theoretical distinction may be made between a structural tendency and a more uninhibited, freehand tendency; but in practice the two very often merge.

In Japan, objects had a place and purpose of their own within an artistic culture; now they were transformed into isolated ornamental pieces. An empty vase, for instance, is inconceivable in a functioning Japanese house: it comes to life through being used for *ikebana*, ritual flower arrangement. In the West, an entirely new area of activity came into being: this was *Kunstgewerbe*, the 'industrial arts' or the Arts and Crafts. It inserted itself between a dying craftsmanship and the 'high' art of painting, sculpture and architecture; and it prepared a place for what we now call Design. In the East, the makers of finely crafted utensils were members of the same class of craftsmen as the artists responsible for woodcuts, sculptures and buildings. Decorative design was taken for granted as part of the tradition.

With the influx of Japanese art into the West, this rapprochement between fine and decorative art produced a variety of changes. Such was the enhanced prestige of decoration that, for a time, depictive painting receded somewhat into the background and lost some of its former prominence. The industrial arts came into their own: Henry van de Velde and Otto Eckmann, along with many others, gave up painting in order to devote themselves to decorative work. Conversely, a glassworker, such as Louis Comfort Tiffany or Emile Gallé, or a jeweller, such as René Lalique, might create pictorial images that carried him into an area hitherto closed to the decorative artist: that of 'true poetic effect'. These men responded intuitively, not only to the Eastern equivalents of their own arts, but to motifs and stylistic ideas derived from the Japanese woodcut. The interlocking of pictorial and craft design under the common banner of decorative form was something for which Asia supplied a precedent: one of the greatest Japanese artists, Ogata Kōrin, counted figurative designs for lacquerware among his supreme achievements.

In terms of response, European collectors reflected the same close association between decorative objects and decoratively conceived woodcuts. One art had prepared the way for the other; and all the great Parisian collectors were just as interested in objects as in prints. This applies even to the earliest group, that associated with the names of Burty, Goncourt, Charles Gillot, Louis Gonse, Henri Vever, Daniel Haviland, even Alexis Rouart and Théodore Duret. These collections were being systematically built up from 1880 at the latest; those of Burty and Goncourt from 1873.

The strongest stimulus was that of the Universal Exhibition of 1878, at which the decorative work in the Japanese pavilion caused a sensation. In accordance with Japanese prejudice, woodcuts were excluded as 'vulgar'. But two dealers, Philippe Sichel and Samuel Bing, had already been to Japan to see for themselves, and, having settled in Paris, had become the main sources for collectors of decorative art and prints. They were joined by a Japanese, Tadamasa Hayashi, a self-taught connoisseur who came to Paris as an assistant to the Japanese commissioner at the 1878 exhibition and subsequently found a rich field for his expertise: first in selling off the 1878 exhibits, then as adviser to such figures as Goncourt and Gonse, and above all as the great middleman who, through his agents, particularly his wife, was able to extract a seemingly inexhaustible supply of high-quality items from collections in the distant East and deliver them to his eager clients. It was through his activities, and those of Bing, that Japonisme finally found its feet. To this day, his stamp on a print is a guarantee of authenticity and quality.

Carried on the back of the craft movement, a Japanese trend arose which spread far beyond the art collectors to encompass one level of the population after another, until it reached the department stores. This process started with export goods, made in Japan and readily adapted to fit the new European taste (or the Japanese idea of that taste). Then, however, as the demand rose, the articles were made in Europe itself, and later in America. No one can have any idea of the extent of all these solemn fripperies who has not come across the catalogues issued by the new Paris department

stores between 1867 and 1888. The market was flooded with kimonos, with porcelain and other ceramics, and with chests, boxes, canisters and flasks in wood, metal and other materials. In the Belle Epoque, bourgeois households and fashion-conscious ladies could indulge in *japonaiserie* to the exact degree that their purses permitted, ranging from the real thing, by way of the exquisite Western workmanship of Lalique, Gallé and Tiffany, to mass-produced goods.

Fashionable painters: Stevens, Chase, Tissot

In Paris, that amiable society painter, Alfred Stevens, reflected the Japanese fashion in the intimate refinement of such works as *The Japanese Dress* [52] or *The Lady in Pink* [53]. In Stevens' paintings, garments in the Japanese style are usually worn by young ladies whose kimonos, or whose non-functioning Japanese bibelots, convey that they are culturally abreast of the times, and that they have their share in life's elegances, comforts and luxuries. If we reflect that this painter was able to stick to his own speciality, through thick and thin, for the last four decades of the nineteenth century, this says a great deal for his professionalism but perhaps even more for the persistence of the Japanese mode.

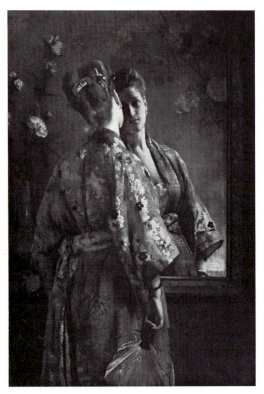

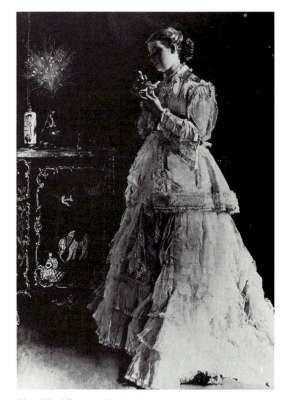

52 Alfred Stevens. *The Japanese Dress*, c. 1880 53 Alfred Stevens. *The Lady in Pink*, c. 1880

Stevens and Whistler had in common not only the fact that they met at La Porte Chinoise but a shared curiosity about the decorative art of the East. And so Whistler, after the naturalistic works of his youth, was able in *The Golden Screen* [II] not only to address the problems of two-dimensional form but to surprise the London public with the decorative elegance of an exotic interior, with all the necessary ingredients. What cultivated English contemporary, after the catastrophic decline in taste so recently revealed at the 1862 Great Exhibition, could fail to be dazzled by this enchanting atmosphere? Who could fail to find in this young lady, surrounded by choice Japanese stuffs, hues and objects, a summons to the life of a dandy?

Stevens had certainly preceded Whistler in the use of Oriental motifs; but there was a great difference between the contexts in which the two artists worked. On the Continent, the *Salon des Refusés* of 1863 was still highly topical; and all the artistic storms of recent years were matters of general interest to society. A Parisian lady, painted in a Japanese costume, would be noticed with interest and approval, but would not cause a sensation. Things were very different in London: artistic life, where it existed at all, was very much subordinated to the workaday world of commerce. After the tedium of academic art, with its moralistic and Romantic subjects, and after the pedantry of the Pre-Raphaelite reformers, here was Whistler, fresh from the Continent, with all its manifold trends; and this was the painting with which he introduced himself. It was a challenge, and it was perceived as such: as the gesture of an eccentric. From it, in the course of the years that followed, there emerged what William Gaunt called 'the strange contortion known as English Aestheticism' (*The Aesthetic Adventure*, Harmondsworth 1957, 51).

Whether *The Golden Screen* had any real artistic influence is quite a different question. For it would certainly not have had, if Whistler himself had not subsequently gone very much further in the interpretation of Japanese principles.

An amusing echo of the painting appears in *The Japanese Woodcut* [54], by the American portrait painter William Merritt Chase (1849–1916). Chase turned up all over Europe; he lived in Munich from 1872 onwards, later moving to Venice and to London. He travelled in Holland with his admired mentor, Whistler, and painted a portrait of him that was accepted for exhibition by *Les XX* in Brussels in 1886. The painting reproduced here shows how closely he depended on his original: the strict profile view; the triangular construction of the seated figure; the screen closing off the background; even the brightly patterned kimono and the way the girl is gazing at the Japanese print. Here is a documentary record of the degree to which the eccentric had become socially acceptable, and the recourse to Japanese accessories had become a mark of culture.

Something very similar happens in Monet's *Madame Monet in a Japanese Dress* (*La Japonaise*), of 1876 [69]. Some whimsical impulse led the painter to show his wife Camille both as a blonde and as a Japanese fan dancer. The painting is unique, not only among Monet's rare figure compositions, but in his whole œuvre. Apart from the costume, and the fans that bob like balls across the background, this painting is about as un-Japanese as it could possibly be, even though Monet frequently dem-

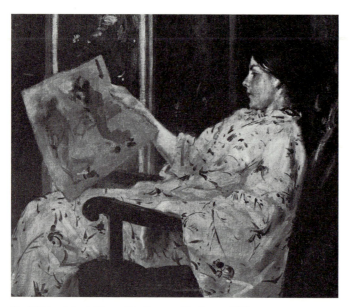

54 William Merrit Chase. *The Japanese Woodcut,* c. 1903

onstrated his attachment to Japanese formal principles in the works that preceded and followed it. Was this a joke at the public's expense? Or was it a tour de force, to show that he could do anything that a fashionable painter – a Tissot, say – could do? The unusual, rather loud colouring of Monet's painting is more reminiscent of Tissot than of anybody: as can be seen in the Museum of Fine Arts in Boston, where it hangs next to a Tissot of a circus. In fact, at the second Impressionist exhibition, *La Japonaise* earned Monet one of his greatest successes. It sold immediately, and at a good price.

Any film-maker in search of the best single source for images of Victorian society in England and in France could do no better than to borrow the vision, and the subject matter, of James Jacques Joseph Tissot (1836–1902). By no means an outstanding talent, this artist has enjoyed a posthumous reputation, and a recent revival, that are entirely understandable. He recorded much that would otherwise have been lost. He was the hero, the witness, and almost the victim of the *Vulgar Society* after which James Laver, in 1936, named the first book to be written about him. The Japanese aroma was another aspect that he was quick to absorb. In the background of the portrait of him by his friend Degas, there is a large picture of Japanese dancing girls.

Tissot was an habitué of La Porte Chinoise; he knew the Goncourts, and by 1870 he had certainly painted his *Lady in Japanese Costume* (last seen on the New York art market). Like the figure by Stevens, but unlike those of Whistler and Chase, this figure is standing, half length. Unlike all three, she looks straight out at the viewer, presenting two vases as if alluding to some story connected with them. The tiny fish in a glass bowl, and the branches, leaves and flowers in the conservatory, all tend to animate the image rather than to lend it any tranquil Japanese atmosphere.

55 James Tissot. *In a Far Country*, 1880

Tissot's presentation of the Prodigal Son's adventure *In a Far Country*, here located in a Japanese tea house [55], is similarly full of motion, action and animated variety. The feeling, once more, is Victorian rather than Biblical or Japanese. But perhaps it was just this clash of cultures that made the work such a popular success. Tissot himself must have suspected as much: he constantly introduced Japanese objects into his paintings as accessories, as in *Young Women Looking at Japanese Objects* (1869, private collection, Cincinnati, Ohio) or *Japanese Lady in the Bath* (1869, Musée des Beaux-Arts, Dijon). Whether he did anything to promote understanding of the creative principle underlying Japonisme is quite another matter. It is certain that he illustrated its amusing side better than anyone.

5. Monet through six decades

With Claude Monet, Japonisme took on an entirely new face. Whereas Whistler extracted from Hiroshige's landscapes the poetry of his *nocturnes* and seascapes, Monet found in Japan a means of concentrating his impressions of Nature. In his work, Impressionist imaginative form evolved out of illusionism and long remained tied to the object – until, even here, freedom prevailed. The sixty years of Monet's artistic career clearly illustrate the successive stages of this undeviating progression. He was familiar with Japanese art from the very start, and at every crisis it helped him to muster the courage to take the decisive step.

The date of Monet's 'discovery' of the Japanese woodcut is and must remain uncertain. According to that literary enthusiast, Octave Mirbeau (in *La 628–E8*, Paris 1908, 206–10), Monet saw his first Japanese prints in 1856, at the age of sixteen, in Holland, where stacks of them were being used as packing paper. This is just another romantic tale, not exactly calculated to reveal the inner necessity of Japanese influence. There is no evidence that Monet visited Holland at that time. He did go there, but in 1871 and 1872, and then he may well have bought prints; but his attention had already been drawn to them at La Porte Chinoise before the Franco-Prussian War of 1870, perhaps by Manet and Whistler. This also tallies better with the version given by Gustave Geffroy and Jean-Pierre Hoschedé, who were close to the artist and probably heard it from his own lips.

It is astonishing, all the same, how tenaciously such romantic legends cling to life. Thus, John Richardson, in the otherwise excellent catalogue of the Monet exhibition mounted by the Arts Council of Great Britain in 1957, repeats that Monet bought his first Japanese prints in 1856, but shifts the location to Le Havre. In 1856, if there is any inner logic in art history, Monet cannot possibly have 'seen' them in any real sense.

If we look at Monet's artistic evolution as a whole, we find a joyous experimentation with Japanese pictorial techniques – on the margins, as it were – around 1870. As his Impressionism came to maturity, through contacts with the other members of the group, he embarked on a new path: open form, the predominance of small-scale structure, the atmospheric envelope resolved into pure colours, intensified illusionistic effects. All these are elements that have nothing to do with Japonisme, and indeed are directly opposed to it.

It was only in the 1880s, with the crisis of Impressionism so convincingly analysed by Fritz Novotny ('Die Reaktion gegen den Impressionismus in den achtziger Jahren', in Novotny, *Über das Elementare in der Kunstgeschichte und andere Aufsätze*, Vienna

1968), that Japonisme in Monet's work took on a new face. New functions were assigned to it, new formal resolutions offered themselves. It is all too easy to forget that this Post-Impressionist career of Monet's lasted for forty-three years and ran parallel for a quarter of a century with that of, say, Vassily Kandinsky.

Without over-simplification, it will be necessary to define three phases, three fresh impulses, as Japonisme penetrated progressively further into the actual process of formal creation. First, Monet's concern in the 1880s was simply to give structure to the illusionistic image, to underpin it in tectonic and chromatic terms. Second, the serial paintings of the decade that followed marked a further step away from natural profusion towards artistic simplification, consolidation and enlargement. Third, in the waterlily paintings of the new century, an almost magical metamorphosis into an art of tapestry took place.

Critical opinion long tended to follow Zola and Lionello Venturi ('Claude Monet', in Venturi, *Impressionists and Symbolists,* New York 1950, 49–79) in dismissing Monet's late art as a phenomenon of decadence, a decline into mere decoration. It was only comparatively recently that Douglas Cooper and William Seitz proposed a positive assessment. But even they could only guess at the degree to which the artist's evolution depended on the knowledge of Japanese sources; for it is only recently that Monet's concrete relationship with the Japanese woodcut has been clarified.

Monet's Japanese collection

While Monet was transforming the garden of his newly acquired house at Giverny-sur-Epte into an enchanted 'Japanese' landscape, with waterlily pools and humpback bridges, indoors he was accumulating, from 1883 onwards, a collection of Japanese woodcuts unmatched in quality and in quantity by any other painter. His connoisseurship was founded on two friendships: with his neighbour, Henri Vever, one of the major collectors of Japanese art (8,000 items), who lived in the Château de Noyer on the banks of the Seine; and with a mutual friend, Kojiro Matsukata, a Japanese patron, collector and entrepreneur who had made his home in France. As time wore on, and Monet prospered, his ambitions as a collector grew, and we can assume that by the turn of the century there was not one sought-after woodcut that was beyond his reach.

Monet was particularly impressed by the first major exhibition of Hiroshige and Utamaro, organized by Bing in 1893. These two were the best-represented artists in his own collection, which has survived intact to this day and which, after long remaining inaccessible, can now be seen at Giverny. It includes fifty-two works by Hiroshige and thirty-three by Utamaro. The presence of three prints by Sharaku, an artist unappreciated in France until a late date, suggests that Monet continued to add to the collection well into the new century. According to his stepson, Jean-Pierre Hoschedé, his principal source of supply – after the legendary Dutch grocer of his youth – was Bing. Another was Hayashi, whose stamp is to be found on many prints.

It is no surprise, in view of the character of Monet's art, to find that, alongside

Hiroshige, the other great landscape artist, Hokusai, is represented by twenty-two prints. What is surprising is that the 229 works contain so many images of beautiful women – Oirans (courtesans) and others – and that these belong stylistically to the earlier, 'classical' period in which structure and decorative flatness were predominant. This should be borne in mind in any consideration of Monet's Post-Impressionism of the 1880s. These sources made it easier for him to abandon the naturalism with which the Impressionist vision is still entangled; these works hung behind glass in his dining room, and he saw them at least three times in every day.

An evolution spanning six decades

To return to Monet's own paintings: a first 'Japanese' phase can be detected in his early works, from 1866 through to the inauguration of the Impressionist group in 1873. Following on from the Barbizon school – and influenced both by the still-dark tonal painting of Courbet and by the *plein-air* painting of Boudin and Jongkind, with its open, sketchy, watercolour-like vision – he evolved a proto-Impressionism which manifested itself to varying degrees in forest landscapes, in townscapes and finally in atmospheric, watery subjects. There are traces of Japonisme everywhere, not yet in the overall treatment but in the use of individual elements. These traces are thus no more than a veil cast over the slow emergence of the central issues of Impressionism, such as atmosphere, dissection of colour and dissolution of outline.

From Monet's output during this period we shall select six paintings to illustrate his tentative moves in various directions and into various pictorial genres. They are:

(1) 1866: *Jardin de l'Infante* [56]
(2) 1870: *Two Ladies on the Beach at Trouville* [57]
(3) 1871: *Camille on the Canapé* [58]
(4) 1871: *Westminster Bridge* (Astor Collection, London)
(5) 1871: *Canal in Holland* (Private Collection, Zürich)
(6) 1873: *Boulevard des Capucines* [59]

The first and last works in this group show the evolution of the townscape over a span of seven years. *Jardin de l'Infante* [56] shows a marked vertical displacement of the viewpoint by comparison with the view from the same point that unfortunately the Louvre authorities would not allow me to photograph. In spite of its overall naturalism and use of tonal modelling, it is marked by a high, panorama-like view with a lightening and widening of the area of sky. This shrinking of topographical detail in favour of the general impression is a reminder of Hiroshige. To this, *Boulevard des Capucines* [59] adds the elimination of the horizon, the lightened Impressionist palette, the autonomous brushstroke, the atmospheric setting: this time in a horizontal format on which are superimposed, in an entirely Japanese way, the rhythmic brushstrokes delineating the passers-by and above all the two spectators, high up on the right-hand edge and cropped in the Japanese style. The miniature silhouettes represent the inception of a new mode of seeing that was destined to become dominant. Their

56 Claude Monet. *Jardin de l'Infante*, 1866

function is to keep the painting flat, to mark a point of concentration, and to block any recession in depth. Splendid and novel though this perspective may be, it fails to prevent a tug-of-war between two different orientations. It opens up a new sensation of space, and at the same time it betrays an unease, a kind of vertigo, confusion, ambivalence.

Painting at Trouville in the summer of 1870 [57], Monet finds his true element in a landscape dominated by water: the sea coast. In accordance with the emergent principles of Impressionism, the horizon opens out; outlines and colours blur and melt in the play of light; and, in spite – or because – of this, the silhouette of Camille (the figure on the left) is prominently thrust forward, still further magnified by the arabesque of the sunshade and the chair-back, boldly cropped in 'Japanese' style at the bottom – and to left and right as well. Why? Surely in order to keep the eye resting on the picture plane (the foreground), and curb its tendency to slip away into illusionistic recession.

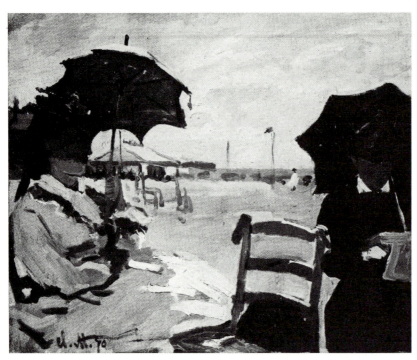

57 Claude Monet. *Two Ladies on the Beach at Trouville,* 1870

These paintings need only be compared with those of Boudin – who was painting on the same spot, alongside Monet, at the very same time – to see that in Boudin's case Nature, with its small interpolated figures, is being 'copied', however grandly; in the Monet, on the other hand, a formal creation strives to transcend mere illusion.

Monet's vision was still a twofold one; and in the decade that followed he was to move in the direction of the Impressionist softening of form. But even at this early stage he must have been aware that Nature, with its powerful colour sensations, was pulling him in one direction and the organizing impulse in another; only the Japanese could release him from the dilemma.

The works painted in England and Holland in the following year make it clear that he was still concerned with the same problem, and that this was not restricted to the unique and contingent setting of Trouville beach. In the London view, *Westminster Bridge,* there are no more looming figures in the foreground, but the view is chosen in such a way that the timber framework of a landing-stage, with its strong horizontals and verticals and its dark colours, parallel to the edges of the painting, attracts the eye and holds the misty river landscape in check. Where but in Hiroshige or Hokusai is a precedent to be found for this? This work need only be compared with another, by Alfred Sisley, painted in the same year, a few bridges along from Westminster, and placed opposite this one in John Rewald's *The History of Impressionism* (New York 1946); in it, all has dissolved into an Impressionist soup. This is not meant by

way of reproach or criticism, only to emphasize the fortuitous nature of the 'natural' raw material of the painting.

In the same year, 1871, Monet lent his structural, organizational vision to the subject of a *Canal in Holland*. The strongly outlined barges in the foreground strip take up half the width of the painting, and together with the vertical masts they set up a structural tension which goes far beyond that of the London painting and counterbalances the indistinctness of the background. It is tempting to say that in this work the painter has taken a step forward in the use of his Japanese techniques, especially as the unusually elongated horizontal format (34 × 73 cm/13.4 × 28.7 in.) is borrowed from Japan.

If *Argenteuil,* painted in the following year, is seen in this context, it becomes all too clear that Monet has turned away from rhythmic linear patterning to revert, for a whole decade, to the illusionistic play of light. The masts of the boat swim in an atmospheric haze that deprives them of their compositional force; their reflection in the water is even more dispersed; and the wavy forms between them, with only the remotest echo of Japanese calligraphy, are without any important accent. The painting has dissolved into its own atmosphere.

If we agree with Henri Focillon (*Hokusai*, Paris 1925, 143) that 'the blue landscapes of Hokusai' supplied a precedent for the elimination of the eternal shadows that had hitherto 'smoked out' the entire Western tradition, and if we ascribe the new, watercolour-like, transparent quality of Monet's brushwork entirely to Japanese influence, then we are forced to the conclusion that, even in the high Impressionist decade of the 1870s, Japanese art still cast its spell, though in a generalized sense that is hard to pin down. After all, Sisley, who knew Japonisme only at second hand, arrived at entirely analogous Impressionistic formulations.

For Monet, as for others, there is an exception to every rule. *The Banks of the Seine,* painted at Vétheuil in 1878 (Musée Marmottan, Paris; a variant in Durand-Ruel Collection, Paris), shows a visual 'grid' that could hardly be more Japanese; but for the time being it had no successors.

In Monet's portraits and figure subjects, too, Japonisme seems to have been latent. Such caricatures as have survived from his early period in Le Havre are too few and scattered to tell us much about the evolution of his way of representing the figure. A large number of paintings were left with his friend Pissarro when Monet left for England in 1870 and subsequently lost as a result of the Franco-Prussian war; there may well have been many portraits among them. One interesting work is *Camille on the Canapé,* of 1872 [58]: the severe silhouette, the asymmetrical construction, with the verticals of curtain and window placed far over to the right, the sofa cropped at its left with its prominent arabesque, the elongated horizontal format, the 'frozen' gesture, the intimate atmosphere, and the decorative colouring are features that look forward to the Japonisme of Vuillard and come comparatively close to the exactly contemporaneous *Woman with Porcelain Vase* [36] of Degas.

Monet's bravura piece of 1876, *Madame Monet in a Japanese Dress* [69], has already been discussed as a document of fashionable Japanese enthusiasm. Inconsistent in its

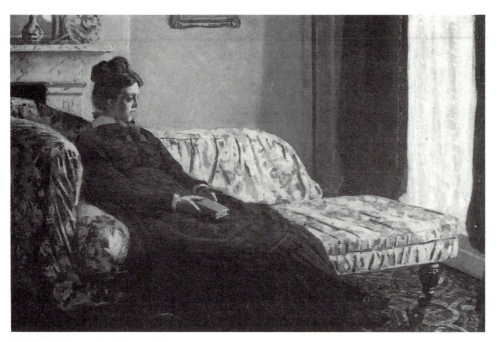

58 Claude Monet. *Camille on the Canapé*, 1871

use of flat and modelled forms, and of loud and muted colour chords, it is spatially unclear. Its allusions to Japonisme are fragmentary (in the rhythmic drawing of the floor mats, or in the cropping of the fans). After he painted it, his interest in the figure seems to have waned, although Pierre Francastel (*L'Impressionnisme*, Paris 1937, 27) is able to cite at least five later figure paintings, mostly portraits of members of his family. All of this suggests that high Impressionism tended to suppress and depress Japanese influence. It was only with the decline of Impressionism that there was new scope for Japonisme. Not until after the break-up of the Impressionist group, with which Monet exhibited for the last time in 1882, did a decisive Japanese influence become apparent in his work. This was the exact moment when he was beginning to assemble his Oriental print collection in his new house at Giverny. It would be idle to debate whether the change in his style was a result of the new source of inspiration, or whether a stylistic crisis led him to look for new sources. These are two sides of the same coin. Additionally, the following chapter will show that by this time Japonisme, known to initiates for more than two decades, could no longer be overlooked by anyone who was capable of drawing support and inspiration from it.

The 1880s, for Monet, were years of solitary decision. He was striving for a synthesis of his own two natures: on one hand the observation of Nature, as it appears through the vibration of light in every place and at every hour and minute; and on the other hand design, the forcible extraction of form and colour, the poetic intensity that simplifies and unifies. Few critics have failed to register this shift; but for some it

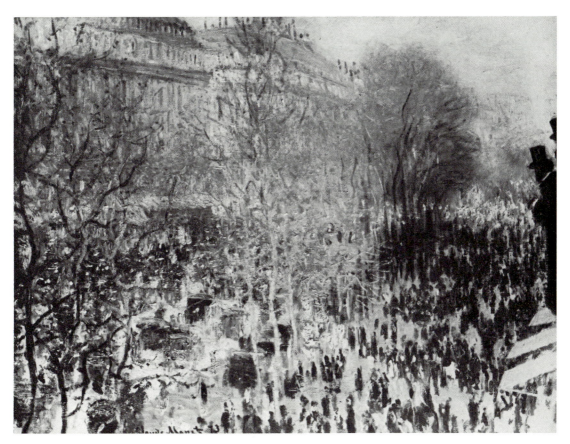

59 Claude Monet. *Boulevard des Capucines,* 1873

represents a sacrifice of Monet's mastery of Nature in return for cheap decorative effects – decadence, in other words – and for others it opens the way to a vision in which the parts and the whole are reunited and illusion gives way to style. Cézanne's alleged remark that Monet was 'only an eye, but what an eye!' is entirely correct in its application to his Impressionist period. But when that was over, it would have been more correct to say 'eye and mind'.

To the degree to which we accept this view of the later Monet, which was that of Kandinsky and the Abstract Expressionists, we become better able to comprehend exactly how Japanese art could come to his rescue. This provides an example, hard to match elsewhere, of the way in which a profound penetration of Nature need not inevitably lead to naturalism but can very well combine with what is known as decorative organization, pictorial invention, the transposition of space into two dimensions: or, to adopt a more up-to-date formulation, consistency of design.

Monet's new pictorial resources did not come to him overnight, but gradually, throughout the decade; until, with the serial paintings of the early 1890s, a new Monet

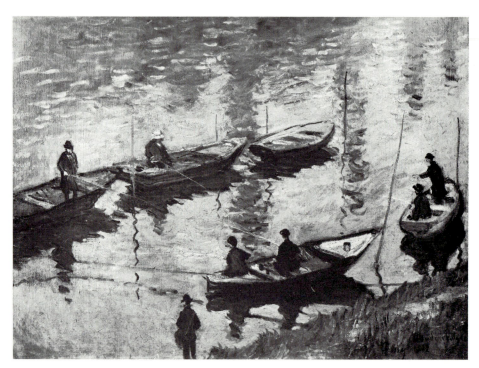

60 Claude Monet. *Anglers on the Seine near Poissy,* 1882

stood revealed. His successive travels mark successive redefinitions of landscape, each bringing new means of representation borrowed from Japanese art.

This process was heralded by *Anglers on the Seine near Poissy,* of 1882 [60]: predominantly Impressionistic, its basic green divided into many flecks, modelled by light and ranging as far as a spot of pink here or yellow there. The figures of the anglers, in precise, unblurred outlines, are novel and distinctive, as are the six vertical posts in the water, which structure the entire painting from left to right. These signs are anything but Impressionist; they might – but need not – be Japanese. It is only when one adds the loss of the horizon through upward displacement, and the use of the high viewpoint to create an entirely novel sensation of space, that it becomes apparent how far we have been taken into a Japanese visual world.

During the four following summers, Monet was increasingly drawn to the seaside, and particularly to Etretat [61]. The view of the imposing rocky promontory, the Manneporte [62], with its unforgettable profile, provided a constantly renewed challenge to pit the hard outline of the rock against the 'infinite' element of the amorphous, light-saturated sea. Painting assumes the function of responding to Nature as drama; with Japanese help, it does so in an increasingly trenchant way. A simple juxtaposition of a series of these paintings suffices to convey a clear idea of the process through which the painter not only circles round his motif but comes closer and closer to the core of the problem, which is to structure a view by using colour alone, and to convert

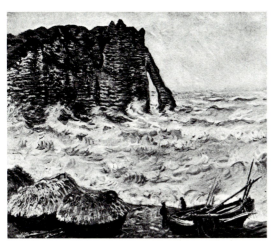

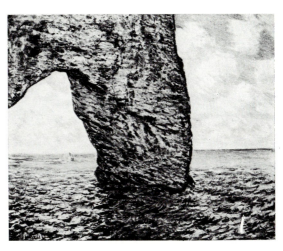

61 Claude Monet. *Storm off Etretat*, 1883

62 Claude Monet. *The Manneporte, off Etretat*, 1885

a fleeting impression into a lasting vision. Monet's own Hiroshige prints, many of which are views of rocks in the sea, undoubtedly showed him the way.

In the earliest works in this group, painted in 1883 [61], a whole panorama appears, with boats and boathouses on the beach in the foreground, a raging sea, and the ungainly mass of the Manneporte on the horizon; or the same in a calm sea, with an apparently random scattering of sailing boats. The effect is one of photographic identifiability. Two years on, however, at the end of the series [62], the transformation is total. The image concentrates on the monumental form of the rock, in impressive outline, with sea all around, and cropped with such 'Japanese' boldness that one is reminded of an abstract form. The surface of the painting is boldly divided into a few massive segments. Colour is governed by what William Seitz calls 'Monet's increasing tendency to ignore local, theoretically invariable color tones in favor of the induced coloration of the total environment' (catalogue *Claude Monet, Seasons and Moments*, The Metropolitan Museum of Art, New York, published Garden City, N.J., 1960, 19).

All the forms take their life from shimmering, glittering particles of colour. The brushstrokes become smaller and smaller, so that the light becomes more intense. The shift away from illusionistic depiction, and towards organization through colour, has gone further than ever before, so that the two seem to hang in balance.

In 1886, Monet visited Belle-Ile, off the Breton coast, with its sharply profiled rocks rising sheer from the ocean, and returned with a whole series of variations which mark the next step in his new metamorphic process. Here there is documentary evidence that he saw the Breton landscape through the eyes of Hiroshige: the specific 'Japanese source' in question was and is in his own collection. *The Naruto Whirlpool* [63] is a late work, made up of three vertical strips fastened together. It is marked by a wide angle of sight, a consistently high viewpoint, the almost cut-out contours of

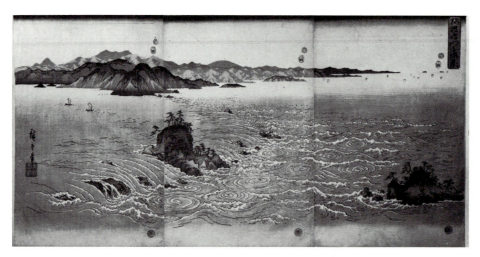

63 Andō Hiroshige. *The Naruto Whirlpool*, 1857

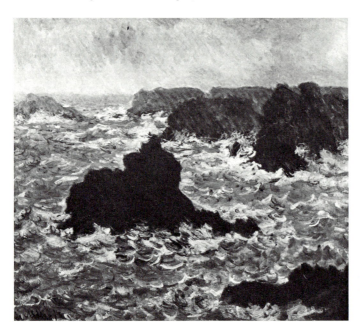

64
Claude Monet.
Belle-Ile-en-Mer,
1886

the rocky islets, uniformity of tone over wide areas, and an ornamental, rhythmic organization of the wide expanse of sea.

 This is a combination that never appears in Dutch art, in Jongkind, or in Courbet; but this is the combination that appears, transposed into the colouring of Brittany, in the painting *Belle-Ile-en-Mer* [64], once owned by Monet's Japanese friend and admirer Matsukata. Here a new unity has been achieved between the recession of the sea and the surface of the painting; between the depiction of the object and the

65
Claude Monet.
Juan-les-Pins,
1888

unity of conception; between colour and form; between chromatic organization and composition; between prose and poetry. By comparison with the preceding Etretat works, this painting has a freedom and animation that betrays none of the rigours of its making, in stormy weather. When shown at the Munich exhibition *Weltkulturen und moderne Kunst* in 1972 (cat. no. 697, colour plate on page 217), it revealed itself as perhaps the supreme example of a Japonisme that operates not on the level of imitation but on that of creation.

My last example from the 1800s is *Juan-les-Pins*, of 1888 [65]. Here the long quest for the character and light of the Mediterranean coast has evolved into a final form based on the rhythmic grid effect, certainly borrowed from Hokusai, of the enclosing group of trees. Once found, this way of structuring a purely chromatic motif which eludes linear form seems satisfying and convincing; but before the discovery of Japanese art no one seems to have thought of it – certainly never with this degree of thoroughness and consistency. Here, in discovering rhythmic and geometric sim-plification, Monet is giving expression to his own latent propensity for the decorative.

In the serial paintings of the following decade, the manifold hints and complexities of these new artistic truths came to their full maturity. In itself, the idea of variations on a single theme derived from Japan: from such works as Hokusai's *Waterfalls, Bridges* and *Thirty-Six Views of Fuji;* or Hiroshige's *Fifty-Three Stations on the Tokaido Road* and *Eight Views of Lake Biwa*. These must have given Monet the idea of going one step further and showing a single motif, and a single composition, in

successive variations of lighting and mood. The series of *Grainstacks* and *Poplars*, both of 1891, were followed by *Rouen Cathedral* (1892–4), *Mount Kolsaas* in Norway (1898), *Charing Cross Bridge, Waterloo Bridge, The Houses of Parliament* and other London views (1903–4), and finally *The Waterlilies* at Giverny, which he painted in many series from 1900 to the 1920s: to the very end, in fact.

This development was not entirely unprecedented. Ever since the crisis of the 1880s, and even before, Monet had been painting works in sets grouped around a single motif, such as *Gare Saint-Lazare, The Thaw* (*La débâcle*), *Varengeville*, and so on. In those sets, however, each painting exists in isolation; the serial paintings of the 1890s all refer to each other. They were not painted successively but literally side by side. In the case of the *Grainstacks*, one would need to see all eighteen works in one place in order to gain any valid idea of the overall vision they represent. Sadly, they have never been shown together. Over twenty paintings – Seitz says there are more than thirty – deal with the Rouen theme; on London there are forty-five according to Cooper and 100 according to Seitz.

As the Rouen series evolved, the object increasingly receded, to leave the surface free for the play of 'a palette of diamonds and precious stones' (Monet's own words). From an intensive close-up vision – so close that the cathedral façade never appears as a whole, and the framing is cinematic – what emerges is abstraction. Of course, Monet never gave up observing his subject as it changed over the days and the hours, with his easel in front of him; but it does not necessarily follow that he really reproduced the coming and going of light from his own observation. Not only is it known that he increasingly tended to 'finish' his paintings in the studio; but it is an incontrovertible fact that from a naturalistic standpoint the colours themselves are false, exaggerated, invented.

Kenneth Clark, no admirer of the late style as a whole, notes indignantly that Monet 'did not really believe that cathedrals looked like melting ice-creams' (*Landscape into Art*, London 1950; U.S. title, *Landscape Painting*, New York 1950, 94). Of course not, even for one moment: he took on himself the freedom to follow his own imagination, and he manifested this – surely unconsciously – by using 'unreal' colour tones. In the same way, Hiroshige, for example, used a highly specific colour scale that no modern colour film can imitate.

Monet's symphonies of colour arose from feelings that were aroused by the object but had nothing to do with reproducing it. His aim, increasingly, was a decorative organization that now applied to the whole painting, whereas previously it had ventured to show itself only in parts and single motifs. The same goes for the form of objects: painterly though the treatment is – and every line seems completely washed out – the form conveys the salient texture of mortar and stone, and its verticals stress the geometric structure. This, too, is an abstraction that imposes itself on the 'natural'.

Some years earlier, in the *Grainstacks in Summer* [66], Monet had taken the step from Nature-oriented to picture-oriented painting. Kandinsky, the father of 'the Spiritual in Art', has left an account of the effect that this had on him. He wrote in 1895:

66
Claude Monet.
Grainstacks in Summer
1891

Suddenly, for the first time, I saw a 'picture'. That it was a haystack, the catalogue informed me, I could not recognize it ... But what was absolutely clear to me was the unsuspected power, previously hidden from me, of the palette, which surpassed all my dreams. Painting took on a fabulous strength and splendor. And at the same time, unconsciously, the object was discredited as an indispensable element of the picture. (Cited by Seitz, *Claude Monet, Seasons and Moments*, 1960, 25.)

This discrediting of the object is accentuated when the whole series is seen together. The object recedes further and further, and what remains is the ebb and flow of unrealistic colour tones on a surface like a projection screen, which registers only pyramidal forms and a horizontal line that no longer stands for a horizon. The colours, and their modelling by light, may not stem from Japan; but this compressed space certainly does. We are reminded not so much of the deep space in landscapes by Hiroshige or Hokusai as of the fragments of landscape in the figure studies by Harunobu, say, that Monet knew and even owned. The high viewpoint tends to confirm this impression; it is not, of course, a conclusive proof.

It may, on the other hand, be said of *Four Poplars* [67] that so bold a choice of detail, leaving only part of the trunks and their reflection in the water to make the trees recognizable as such, can only be Japanese in origin, because such things had never previously existed in the West. In the East, such a vision is entirely normal: one has only to think of Kiyonaga's *Women's Bath* [48], where one of the figures is indicated only by her legs. Monet's almost square (Japanese!) format, using a close viewpoint, isolates, as Seitz accurately says, 'the lower section of the trunks, the horizontal river bank and the reflected image in a two-dimensional geometrical design spaced with obsessive care and parallel to the canvas surface'. The strict rhythmic repetition and the superimposed colour scheme, with its lively, pastel-like, 'abstract' islands of colour, point in the same direction. The poetry of such works does not stem from the mood of a French summer landscape but more and more from the orchestration of colour and form by the eye of a great artist and optical pioneer.

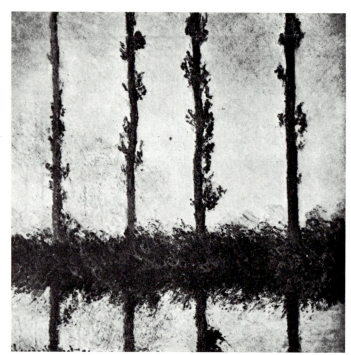

67
Claude Monet.
Four Poplars.
1891

At this stage of his career, in the mid 1880s, Monet was no longer so isolated as might appear. Concurrently with the breakthroughs represented by the Etretat and Belle-Ile paintings, Seurat was painting *La Grande Jatte*. And Gauguin's *Vision after the Sermon* [103] actually predates *Four Poplars*. Both artists shared Monet's rejection of the illusionistic aspect of Impressionism, and even though their objectives were different, their means and their Japanese sources were close to his. It is important not to overlook the existence of this new Post-Impressionist situation; for Monet was part of it, and cannot be trapped in the schematic model of the 1870s style. The fact that he stayed longer with illusionism – with Nature, as he himself claimed – makes it easier for us as late observers to follow the new developments in his work in a kind of slow motion.

All that has been said about the other series applies with greater force to the London paintings. Here the Japanese precedents in the work of Whistler [26] had certainly made a contribution. But there was more to it than that. Right to the end, Monet needed a natural pretext (or should we say a pretext in Nature?) before pursuing his own vision of colour. He was incapable of becoming a non-objective painter, or even of moving in that direction. The London fog, however, offered him the justification for making his painting one degree less object-based. In bodying forth his dreams under the guise of 'things seen', he went as far as the opacity of townscape permitted. And in London he could go further than he could elsewhere.

A final word should be said about the part of Monet's output that covers a quarter

of a century, after 1900, and which bears the generic title of *The Waterlilies* [V, VI]. This refers not only to the famous frieze-like decor of the Orangerie des Tuileries in Paris but also to the countless studies and variants in triptych form, and to the paintings of the Japanese footbridge and of irises, wisterias and weeping willows, which have been shown as a whole only since 1971, at the Musée Marmottan in Paris: the works that reveal the late style of the master's last quarter-century and crown a career that spans more than sixty-five years.

With these works, Monet reached the third and last stage of the process by which he absorbed the influence of Japan. If we regard the 'quotations' of kimonos and Japanese articles by Stevens, Bracquemond, Tissot, by the early Whistler and by Monet himself as the first stage, then the adaptation of Japanese motifs marks the next lengthy segment of the process; in the last stage, a purely stylistic interpretation and transposition completely dissolves and transcends the Japanese raw material. By the time Monet reached that stage, far into the new century, the situation in the West as a whole had evolved so far that its discussion must be reserved for a later chapter.

6. Critics, connoisseurs and dealers as leaders of taste, 1870–1880

Critical reception of Japanese art

The artists so far discussed had their initial encounter with Japan in the 1860s, through isolated contacts with Japanese colour prints, or through La Porte Chinoise, or through the Japanese pavilion at the Universal Exhibition of 1867, or through an encounter with Burty. Even Whistler, in London, can have owned only a scattering of prints or albums at this stage. Not only was the range of works known in the West small but – apart from a few volumes of Hokusai's *Manga* – there had been no attempt at selection or classification by theme, quality, period or artist. There were no exhibitions, no books or articles, nowhere to turn for expert assistance. The avant-garde artists had only luck and intuition to rely on.

All this changed radically in the 1870s. In Japan itself, the Meiji Revolution of 1868 caused a social upheaval that led to many previously closely guarded collections being opened up and cast onto the market: mostly fine lacquerware, ceramics and metalwork, sword-hilts being particularly important. Woodcuts, on the other hand, were regarded in Japan as products of a late and 'vulgar' age – a kind of folk art – and little prized. It was only later, after their enormous success in Europe, that their status gradually improved. None of these objects found a quick or automatic way to the West: the channels of trade evolved only gradually.

It was the pioneer work of Théodore Duret (1838–1927) that led to a decisive step forward. This *amateur*, collector and critic – a friend of Manet's and later of the Impressionists – had been so much involved in certain political events during the Paris Commune as to make a lengthy absence from his native country advisable. In 1873, therefore, together with his friend, the banker Henri Cernuschi (1821–96), another left-wing sympathizer, who had fled from Italy after the Revolution of 1848, Duret decided to travel in the Far East. In his own words:

I recalled that I had derived great pleasure from the sight of a number of Japanese albums in a showcase at the Universal Exhibition of 1867: they belonged to Philippe Burty. And then the idea occurred to me of looking for illustrated books [in Japan] in person. At that time, in 1873, Burty and Goncourt were the only ones to have taken a systematic interest in Japanese objets d'art, including albums and prints...

It was not until 1880, in London, that I made the acquaintance of Dr [William] Anderson. The study of his collection opened my eyes to artists hitherto unknown to me. (*Gazette des Beaux-Arts*, August 1882, 121, 122.)

This was not Duret's first trip across the Channel. A visit to the Great Exhibition of

1862 in London had whetted his interest in Japan, and a journey undertaken in pursuit of his father's business interests had taken him to Japan itself shortly afterwards. (See *Dictionnaire de biographie française*, ed. Roman d'Amat, Paris 1970, vol. 12, 755.) Here, for the first time, we have reliable documentation of contacts between Paris and Japan and England. For, although Paris was to remain for many years the centre of Japonisme in the arts, it was in London that a bent for systematic research and the ability to draw practical conclusions for Western craftsmen were more strongly developed from as early as 1862.

The 1,350 albums which Duret brought back from Japan, and which are still together in the Bibliothèque Nationale, enabled him to evolve from a mere *amateur* to a true connoisseur; and by the early 1880s – long before Goncourt – he had a number of publications to his name which demonstrate his insight. The mere collector had become an eloquent art critic.

Duret's originality resides in his early recognition and demonstration of those features that link the Japanese artists – Hokusai above all – with the contemporary Impressionists and with Whistler: 'To all that the Impressionists owed to their forerunners, the influence of Japanese art was added' (*Critique d'avant-garde*, Paris 1885, 64). While landscape painting had hitherto been dominated by the half-tones of a grey or brown 'sauce', and 'the painter always lied', it had now, he said, become possible to use fresh tones, a bold red for a roof, a white wall, a yellow country road, blue water. The Japanese use of colour, initially regarded as gaudy (*bariolage*), was now showing itself to be vigorous truth to nature. It was Japanese colour alone that had given Impressionism the courage 'to develop its own originality and to abandon itself to its own subjective perceptions'. And so the way was open to a modern invention based on sensibility, and at the same time the means were provided to 'fix a personal vision on the canvas'.

It is interesting that Duret here sees Impressionism purely as a subjective naturalism with the emphasis on colour; the often-praised 'nuance', or tonal mobility, is ignored or marginalized. It all goes to show that one perceives only what one is able or willing to see. Or, if you like, that identical Japanese sources can receive different interpretations at different times and thus lead to different results.

Unlike Duret, Philippe Sichel went to Japan as a dealer, probably the first to do so. He and his brother landed at Nagasaki, not in 1873, as Louis Gonse later maintained (*Gazette des Beaux-Arts*, July 1881, 101), but in March of the following year. After a campaign of plunder lasting six months, they sailed for home with 'more than 5,000 objects, packed in 450 chests'. This information comes from Sichel's own account of the visit, published in 1883 under the title *Notes d'un bibeloteur au Japon*. Here is another concrete and specific description of the early stages of the Japan trade, a topic that is all too often obscured by the mists of enthusiasm. Sichel tells of his contacts with Japanese dealers, none of whom could give him any information whatever about the date, style, attribution or quality of the objects on offer. Of particular interest from our present point of view is the fact that he succeeded in acquiring a whole stack of illustrated albums representing actors, evidently by Shunshō and his circle – five

hundred books – for $30 all in; he then sold them in Paris for thirty francs apiece, to yield a profit ratio of 10,000 per cent.

Sichel is not a prominent figure in the history of Japonisme; he always remained somewhat in the background. His main claim to fame is as the principal source of material for the enormous Goncourt collection, at least in its first decade. His role as mediator between two continents was filled, after about 1884, by Tadamasa Hayashi, a more complex, enterprising and powerful personality.

Samuel Bing and Le Japon Artistique

In Samuel Bing, from 1871 onwards, the Paris scene gained a figure whose ideas, choices and business activities were central to the influence and public acceptance of Japonisme. Without him – and this is no exaggeration – things would have turned out quite differently. In Hamburg, where he grew up, Bing ran a workshop making glazed tiles; from this he derived his interest in Oriental ceramics and decorative objects, and also the sure taste and judgment that he soon applied to other fields, and in particular to the colour woodcut. Both in ceramics and in prints, Bing became a critic and a historian of the highest rank, whose expertise spanned more than three decades.

In the shop that he opened in Paris in 1875, he learned to distinguish Chinese from Japanese ceramics, and within Japanese ware the fine quality of the 'classic' product from the modern 'export ware'. His fame spread rapidly; Goncourt soon discovered him and paid him a visit. Three years later, his fast-growing ceramic collection was the sensation of the Universal Exhibition. In 1880, as we learn from his own account (*Le Japon Artistique/Artistic Japan*, no. 14, 1889), he undertook a long study trip to the Far East. In Peking he saw objects of a quality that no Westerner had set eyes on before. In 1883 he made a major contribution to the *Exposition rétrospective de l'art japonais* organized by Louis Gonse. Among the thousands of objets d'art of all kinds in that exhibition, the experts singled out the six hundred from his collection for special praise. The same Gonse, for his own monumental book, *L'Art japonais*, commissioned Bing to write the chapter on the history of ceramic art.

He showed equal enthusiasm, acumen and method in his exploration of the colour woodcut. Whereas Burty, Bracquemond, and even Duret and Gonse, had seen Hokusai as the acme of Japanese pictorial design, Bing was able to take a far wider view. He saw the Japanese artistic vision in terms of an evolutionary hierarchy, in which Hokusai no longer reigned alone or even supreme.

Among many insights for which Bing must take the credit is the realization that Utamaro was a 'classical' master. In the first exhibition of his own print collection, in 1888, the lion's share of space went to Utamaro; this was, in effect, that artist's introduction to a wider public. Utamaro had, of course, previously taken the attention of a few collectors and artists, and his work was known to such connoisseurs as Hayashi and Anderson. But, since his visit to Japan, Bing had added more and more Utamaro prints and albums to his collection and could claim to have given this artist his rightful

position at last. One striking fact: in 1885 Utamaro's print *Fisherwomen of Awabi* could still be bought, Goncourt tells us, for forty francs; in the Burty auction of 1891 it was sold for 1,050 francs! Even the perennially impecunious Gauguin thought himself lucky, according to his biographer Jean Rotonchamp, to secure a less well-known print by this artist for 300 francs.

The year 1888 also marks the point at which Bing's endeavours culminated in the publication of *Le Japon Artistique*. This richly illustrated monthly appeared, as planned, in French, German and English editions for three years. It combined its editor's two great interests, in decorative art and in prints, with the goal of demonstrating the salutary teaching of Japan: back to Nature, following the example of the Japanese. Its distinguished list of contributors made it a prestigious platform for Japonisme, and it documented Japanese inspiration in every aspect of design, including architecture and the theatre. Both in its luxury edition, printed on *papier Japon*, and in its inexpensive popular edition, the magazine had an astonishingly far-reaching influence on both sides of the Atlantic, and craftspeople and artists alike regarded it as a near-indispensable work of reference. It was a major source for the work of Van Gogh, Seurat, Toulouse-Lautrec, the Nabis and others; as late as 1906, Gustav Klimt in Vienna bought a complete run of the magazine. The publication of *Le Japon Artistique* brought Japonisme into a new, and possibly the most important, phase of its existence, in relation both to 'applied' and to 'fine' art.

The opening up of Japan to the outside world, and the social upheaval of the Meiji Revolution, had the consequence that a vast quantity of unfamiliar objects in ceramics, lacquerware and metal was unloaded onto the Western market at a time when the receptivity of that market was at its highest. After every conceivable Western historical 'style' had been imitated, Japanese art provided a new stimulus. Soon, as the Universal Exhibition of 1878 showed all too clearly, this influence in its turn was debased to the level of fashion and cheap mass production. It became the function of *Le Japon Artistique* to set a new course, and to show that the principles of Japanese design embodied not merely the latest fashion but the salvation of Europe from the disease of historicism.

To this end, Bing enlisted contributors who were passionately committed to the reform of the arts and crafts, and who were capable of seeing Japanese design not as just another pattern for imitation but as a creative principle. Alongside the collectors – such essentially backward-looking figures as Goncourt, Gonse and Burty – he turned to reformers like Roger Marx in France, Justus Brinckmann in Germany and Arthur Lasenby Liberty in England. Even more than the texts, it was the plates, over 300 of them in all, mostly reproduced in colour from classic Japanese originals, that constituted a primer of the new Western design which a few years later, in 1893, was to inspire Bing himself to found a new gallery: the Salon de l'Art Nouveau.

In the introductory issue of *Le Japon Artistique: documents d'art et d'industrie*, Bing wrote:

In the new forms of art which have come to us from the uttermost parts of the East, we see something more than a Platonic feast set before our contemplative dilettanti, we find in them

examples worthy to be followed in every respect, not, indeed, worthy to uproot the foundations of the old aesthetic edifice which exists, but fitted to add a fresh force to those forces which we have appropriated to ourselves in all past time and brought to the support and aid of our national genius . . .

And at last of any novel addition [*l'inédit*] there appeared to be no chance, when all at once, from behind the barriers which a small insular people had erected around themselves with jealous care, a fresh form of art, quite startling in its novelty, revealed itself . . .

Within the last few years extensive and successful research has brought the finest models of Japanese industry to western countries . . . Especial care therefore ought now to be given to the selection of subjects which lend themselves readily to the requirements and customs of our western culture, with scrupulous avoidance of all those which would encourage mere trick, or degrading imitation . . . Our producers will not we trust allow such valuable resources to remain unutilized, for there is not one among technical designers, book illustrators, architects, decorators, manufacturers of papers, printers, weavers, potters, bronze-workers or goldsmiths, and even the workers in the numberless small industries, who may not derive benefit from consulting a collection which will form a repertory of centuries of Japanese fine art.

It will not suffice, however, merely to borrow the designs of these models; they must be thoroughly analysed and studied, with a view to arriving at their original conception . . . Undoubtedly to discerning minds their aspect will suggest extremely serious reflections upon the fundamental principles of ornament as compared with the traditions of our own schools. For whilst strict limits have been placed, by the rigorous laws which we call our 'styles', on the bounds within which our imagination has been permitted to wander, and whilst our industrial arts have in consequence assumed a stiff and conventional character destructive to the boldness of originality, Japan appears to have indulged in freedom from and laxity of rules and method. Not that the artist emancipates himself from all rule, or ever lets his fancy wander at haphazard. Far from this; the constant guide whose indications he follows is called 'Nature'; she is his sole, his revered teacher, and her precepts form the inexhaustible source of his inspiration . . .

Under such influences the lifeless stiffness to which our technical designers have hitherto so rigidly adhered will be relaxed by degrees, and our productions will become animated by the breath of real life that constitutes the secret charm of every achievement of Japanese Art. (*Artistic Japan, a Monthly Illustrated Journal of Arts and Industries*, Compiled by S. Bing, no. 1, London 1888, vol. 1, 3–5.)

Here Bing was clearly opening the door to the Art Nouveau to which he increasingly devoted himself in the last decade of his life. An article by Robert Koch ('Bing – Art Nouveau', *Gazette des Beaux-Arts*, March 1959) casts light on his endeavours. It was at this point that Japonisme came of age. Soon, the members of the Post-Impressionist avante-gàrde – Beardsley, Bonnard, Frank Brangwyn, Maurice Denis, Fernand Khnopff, Paul Ranson, Ker-Xavier Roussel, Paul Sérusier, Paul Signac, Toulouse-Lautrec, Vuillard, Whistler and others – were receiving commissions for original work.

The other aspect of the influence of *Le Japon Artistique* concerned the Japanese print. Almost 200 full-page plates in a quarto format, chosen for their artistic quality from the great masters of many periods and representative of the widest range of subject-matter, opened a panorama of Japanese art such as had hitherto been inaccessible even to the closest observer of the Paris scene. It now became an accepted fact that Japan had not simply produced *one* genius, in the person of Hokusai, but a whole visual culture that had much to say to the West.

The magazine's policy was defined and explained, in retrospect, by the critic Roger Marx as follows:

to extend and to increase the knowledge of an art as yet only partially popularized, to affirm the charm of an aesthetic sympathy, to indicate the aim of an influence which is continually on the increase...

The sentiment of the gracefulness, at times hieratic, of the attitudes of women, the taste for facts signified by gesture, a certain perspective manner by which nature seems to be taken in at a bird's-eye view like a projection drawing; finally, the desire to render groups, the denseness of crowds, the swell of humanity with the seemingly impossible magnitude of the foregrounds (which photography proves to be exact), is not the origin of all these to be sought amongst the Japanese? Or again, who can deny that their kakémonos, prints, and albums have driven us to appreciate more highly the power of expression which lies in line, in silhouette, the charm of simplified indications, reduced to the strictly essential, if they have not awakened our consciences to all the life, the realism and the reverie, which may be contained within a rapidly traced outline? And as these rapid draughtsmen were at the same time lovers of colour and of sunlight, it was their lot to appeal to the painters and wood-engravers of the West on behalf of atmosphere and pale harmonies, to open their eyes to the play of the phenomena of light, to egg them on to the rendering of passing effects, the fugitive and peculiar nature of which seemed always to defy all attempts to set them down, and thus the artists of Japan have every right to rank, according to the equitable verdict of Duret, Duranty and J. K. Huysmans, amongst the promoters of impressionism. (*Artistic Japan*, no. 36, 1891, vol. 6, 460, 464–5.)

The reference to Huysmans, the author of *A rebours*, is surprising, because in all his critical writings he never gave a positive account of Impressionism itself, and he mentioned Japanese art just once. Edmond Duranty, on the other hand, was indeed the first critic to draw the far from self-evident connection between Japonisme and the Impressionists. As early as 1876, discussing the second Impressionist exhibition, he wrote:

Proceeding from one intuition to the next, [the Impressionists] have succeeded in analysing the sunlight into its rays, its elements, and in restoring its unity through the overall harmony of its rainbow hues [*irisations*] as they interact on the canvas. The subtlety of the eye, the telling colour, gives a truly extraordinary result. Not even the most ingenious physicist could fault their analysis of light. In this connection the Japanese have been mentioned, with the suggestion that these painters were only imitating the colour impressions on paper that are made in Japan. The idea was to round the Cape of Good Hope in art. That is the way to the Far East, isn't it? If the instinct of the peoples of Asia, living as they do beneath a constantly dazzling sun, led them to reproduce the perception to which they were constantly exposed – in other words to light, flat, wonderfully lively tones with an even luminous intensity – then why not consult this same instinct, which has succeeded in observing the sunlight at its source? Has not the lively, slanting, mobile eye of the Chinese and Japanese succeeded in mingling the great din of colour with subtle, sweet, neutral, wonderful harmonies of tone? (*La Nouvelle Peinture*, Paris 1876, 39.)

This was written nine years after *Manette Salomon*; even so, the journalistic alertness that led the Goncourts to hail the impending 'victory of Japonisme' is worlds apart from the critical analysis of artistic elements that Duranty attempts here, apparently for the first time.

Back to Samuel Bing. Early in 1890, while the series of *Le Japon Artistique* was still in progress, he organized at the Ecole des Beaux-Arts an exhibition of Japanese prints that was the most important and the most comprehensive ever held. Its 725 separate prints and 428 illustrated books spanned the two centuries of the history of Japanese prints, *ukiyo-e*. The outstanding pieces from Bing's own collection formed the nucleus. They were supplemented by works from other Parisian sources, among them the collections of Burty, who contributed thirty-six mostly late works, and Goncourt, with only seven: in Burty's case the policy of the collection, and in Goncourt's its quality, were out of keeping with the aims of the exhibition. Other contributions came from such well-known collectors as Gillot, Hayashi, Vever, Taigny and Gonse.

A characteristic and unprecedented feature of Bing's exhibition was its emphasis on stylistic criteria. Prints were no longer categorized into Women, Actors, Landscapes, Flowers and Animals, but into a sequence of historical phases that reflected changes in ways of seeing. Naturally there was no question of dethroning, or even belittling, so 'realistic' a late figure as Hokusai: his long and varied career was splendidly represented in more than 200 exhibits. But it is interesting to find that the 'decorative' – and far less prolific – Utamaro occupied second place with 100 exhibits.

The emphasis was shifting back towards the 'classical' period of the eighteenth century, and, not counting the 'impressionistic' landscapist Hiroshige (with sixty exhibits), the next in line were figures like Harunobu and Kiyonaga, with nearly ninety prints and albums between them, who had previously perhaps been mere names, but who were now emerging as clearly defined figures in their own right. The same goes for a whole series of other artists of the same middle period. Where else had anyone ever seen twenty-six outstanding Shunshōs in one place? Where else had it ever been possible to gain the impression that there were not only a few highly interesting Japanese illustrators but far more than a hundred, each with a face of his own and a place in an evolution that proceeded from stylization towards illusionism?

Even more sensational, because more influential, was the section containing the early woodcuts, the so-called primitives, who even before 1760, in the black and white (often hand-coloured) prints of Moronobu and the Torii, achieved a powerful, semi-abstract form of representation. Their work had hitherto been dismissed, where it had been noticed at all, as a crude early phase. Here, however, in a sizeable section containing thirty-two prints and seventy-seven illustrated books, they struck the modern, Post-Impressionist artists as a new discovery, a revelation that would aid them in transcending illusionism.

Works of this kind had been shown two years earlier in the Burlington Club exhibition in London, but not as a group: they had been mingled with other 'pictorial documents of the land, manners and customs' of an exotic people. In England, with the single exception of Whistler, contemporary artists remained uninfluenced. It was in France that a stylistic upheaval now ensued which involved Monet, Gauguin, Toulouse-Lautrec, the Nabis, and the whole poster movement, and which spread, from 1890 onwards, across the Continent of Europe.

This is not to say that all this new activity was unleashed by this one exhibition; but the exhibition was a symptom of, and a stimulus to, a new openness to Japanese art in general and to its newly discovered 'primitive' aspects in particular. Its organizer, Bing, had established his credentials not only as an important leader of taste but as a pathfinder for avant-garde art. He now set about consolidating his triumph through a number of smaller exhibitions: his exhibition of part of his own collection in 1888, with special reference to Utamaro, was followed by a Hokusai show in London in 1890. Two years on, in 1892, he organized the whole Japanese section of the fifth Paris *Blanc et Noir* exhibition of international printmaking, followed the next year by a show of Utamaro and Hiroshige at the Galeries Durand-Ruel. In 1894, his whole collection was shown at the Boston Museum of Fine Arts under the patronage of Ernest Fenollosa, a world authority on Japanese art.

Aside from his leading role in creating circumstances in which Japanese art could actually be seen, Bing's writings are also worthy of notice. With their clearly formulated insights, keen artistic sensibility and avoidance of hollow phrases, they are still worth reading to this day. Besides the printed report on a research trip that he made to America in 1896, on behalf of the French government, to discuss advanced architecture and design (in which he laid great stress on the work of John Richardson and Louis Sullivan), there are, to my knowledge, nine articles and catalogue introductions. Of these, three deal with Art Nouveau and decorative art in the 1890s: these are the catalogue of his own exhibition, *Art Nouveau*, 1895–6; an article, 'Wohin treiben wir?' (*Dekorative Kunst*, 1897–8); and finally a retrospective view of the Art Nouveau movement in *Architectural Record* (vol. 12, 1902). But for our present purposes, his six articles on the arts of Japan, and on prints in particular, are particularly important. The programme that he prefaced to the first edition of *Le Japon Artistique* has already been mentioned; he followed it with a far-reaching historical survey in nos. 13 and 14 of the same journal.

His preface to the catalogue of the big exhibition of 1890, which established the position of the Japanese 'primitives', is of particular interest. Its strategic effect on contemporary art will be discussed in context in a later chapter. Here, two brief quotations will serve at least to indicate Bing's bold new view of the situation: 'The time seems to have come to recognize this art, now that it has become possible to identify the various stages of its evolution, from the beginnings to the modern period.' Bing seems almost to be holding up an objective for contemporary artists to aim at, when he writes of the 'primitive' artist Moronobu: 'In no later period does one find a line so rich, powerful and sure. His graphic compositions have the roundness of a bas-relief. The line alone speaks, but it says everything; it conveys the form better than the most skilful shadow and tonal modelling.'

One thinks of Toulouse-Lautrec, who naturally saw the exhibition.

Bing's next two essays were concerned with the artists whose relative importance became a touchstone of artistic allegiance: Utamaro (*The Studio*, no. 4, February 1895) and Hokusai (*La Revue Blanche*, nos. 64, 65, 68, 1896). Almost at the same time, Edmond de Goncourt was writing his books on the same two artists, in which he

sought to enlist them on his side. It is impossible to rule out an element of rivalry between the novelist and the critic. With elaborate tact, Bing made it clear that his rival had simply appropriated the factual material that he himself, at his own expense, had commissioned a Japanese representative to find for him in Japan itself:

While he was sending me his detailed reports, Jijima, not content with this proof of his abilities, showed himself to be more ingenious still. After taking the liberal expressions of my gratitude and instantly converting them into ready coin, he devised a novel means of supplementing them. As the facts became clearer and took more concrete shape, Jijima collected them into a substantial compilation, gave it the title of *Biography of Hokusai*, and had it printed out there. And while I was engaged in patiently coordinating all this, studying the connections between some detail of Hokusai's life and the corresponding productions of his art, or establishing the links, fortuitous or intentional, which led to some miraculous evolutionary change within the artist's enormous œuvre, copies of the little Japanese book crossed the ocean and came into the hands of M. Hayashi, who, impelled by his obliging disposition and by his natural desire to assist such a friend as M. Goncourt, made a faithful translation of it for the benefit of our illustrious author.

For the public, of course, this incident represents the purest profit. We shall have the delight of one more important work by this great writer, better by a thousand times than my unworthy pen, to shed upon this new and curious subject all the elegant magic of his art. And for my own part, in availing myself of the hospitable pages of this journal to offer its readers the fruits of my former studies, corroborated by the facts that have been elucidated in recent years, I am only too happy to find myself exceptionally well placed to attest to the authenticity of the story that is told in the Goncourt volume. With all my heart, I wish it all the dazzling success that has crowned the most brilliant works of this master writer. (*La Revue Blanche*, 1896, 101.)

This savage polemic is quoted here in full, in order to show how the Japonistes divided themselves, right from the start, into separate camps that by no means always remained on good terms. Is it a coincidence that Bing chose to voice his resentment against Goncourt, who was suspected of anti-semitism, at the very height of the Dreyfus case, and in the *Revue Blanche*, which Thadée Natanson had turned into a mouthpiece for the friends of that innocent officer? Is it a coincidence that the pacemaker of the second wave of Japonisme dissociated himself with such relish from the backward-looking Rococo Japoniste? Both admired the wonders of Japanese art; and, ironically enough, Bing's last published word on Japonisme was the catalogue introduction for the posthumous auction of Goncourt's estate.

Hayashi, Guimet, Portier, Père Tanguy

The only figure of comparable stature to Bing was Tadamasa Hayashi (1854–1906), a younger man and a native of Japan. Hayashi made an important and durable contribution to the understanding and connoisseurship of Japanese works of art. To this day, collectors take especial pride on owning any print that bears the stamp of his collection. Like Bing, he spanned both the first and second waves of Parisian Japonisme; like Bing, he owned a gallery in the district between Montmartre and the *grand boulevards*. The close proximity and covert rivalry between these two remarkable dealers was probably a factor in the great surge of enthusiasm for Oriental art.

Hayashi, a trained printer, came to Paris as a young man in 1878 to work for Wakai, the Japanese commissioner at the Universal Exhibition. He went on to spend a whole decade in selling off the enormously valuable objects left behind after the exhibition closed. His artistic insight, linguistic talent, adaptability and business acumen turned this self-educated man, with amazing speed, into a master expert. In Japan, as mentioned before, he employed members of his family as agents, who combed the country from end to end to secure the most far-flung treasures – ceramics, metalwork, painting, prints and sculptures – which this supremely knowledgeable dealer then passed on to Western collectors. For three years he acted as consultant to Gonse, the author of the first history of Japanese art and the organizer of a wide-ranging Japanese exhibition in Paris in 1883, featuring decorative objets d'art. In the following year Hayashi received the accolade, as it were, of a mention in Goncourt's diary.

For the Universal Exhibition of 1900, he became Commissioner General of the much-admired Japanese section, and he published a lavish survey volume on Japanese art which is full of matter and information but has no trace of the evolutionary logic that meant so much to Bing. Not long after this, Hayashi sold off his stock and his private collection and returned to Japan. In size, variety and quality, this auction was a major event. Collectors from all over the world vied with each other for the objects on sale. In prints alone, not only were the rarest and finest pieces brought together – including twenty-four Sharakus – but there were many of the early works that were now so much in demand: eleven prints and thirty books by Morunobu, forty-nine prints and seventeen books by Harunobu.

Bing worked long and hard to create a bridge between Japanese art and contemporary Western art, and was later praised – and mocked – as the apostle of the 'Yacht Style' (another of the many names for Art Nouveau); but Hayashi played a totally different role. Although he was familiar with the French art of his time, and his house in Tokyo contained decorations by Henri Rivière and works by Degas and Monet, he is remembered as a virtually infallible connoisseur of individual Japanese objects and as a near-inexhaustible source of quality merchandise. In this respect, he was probably the best teacher that the Japonistes ever had.

A completely different face of Japonisme in the same period is shown by Emile Guimet (1836–1918). A member of the same generation as Burty, Bracquemond, Chesneau and Bing, he was an industrialist who developed an interest in Eastern religions when he went to Egypt on business; from there he turned his attention to Japan, which he visited as early as 1875. He was there for three months, during which he made a special study of the temples in the company of the French painter Félix Régamey, with whom he published an interesting travel book (*Promenades japonaises*, Paris 1878). Although Japanese prints escaped his notice, he was probably the first to collect religious art as such. He turned his collection into the museum which still bears his name, at first in Lyon and one year later, in 1889, in Paris. Guimet was the first to give museum status to Oriental art, and implicitly challenged the world's public museums of art to follow suit. To this day, the Musée Guimet in Paris is a centre for that portion of the art public that can see beyond the classical and

Renaissance tradition. With its didactic purpose, it contrasts sharply with the private connoisseurship of Goncourt, who wrote in his will:

It is my wish that my drawings, my prints, my bibelots, my books, in fact all the objets d'art that have made the happiness of my life, shall not be exposed to the sepulchre of a museum and the inane gaze of an indifferent beholder. I wish them all to come under the auctioneer's hammer, so that in every case the enjoyment that their acquisition has given to me may pass to an inheritor of my taste. (Holograph facsimile in auction catalogue *Objets d'art japonais et chinois composant la collection des Goncourt*, Hôtel Drouot, Paris, 8–13 March 1897, before page 1.)

This review of the principal figures, with their very different concerns and interests, may be supplemented by two men who, although less influential, serve to enrich the overall pattern.

André Portier was a colour merchant, who also sold paintings on commission. Early in his career he had a house in the country at Bourron, not far from Fontainebleau, and was friendly with the Barbizon painters. In Paris he lived in Montmartre, at 54 rue Lepic, the same address as Vincent van Gogh and his brother Theo. There he turned his attention to the newer painters, including Toulouse-Lautrec; and, although not many additional details are known, it is certain that Toulouse-Lautrec bought his best Japanese prints from Portier. Gotthard Jedlicka tells us that, as well as Hiroshige and Hokusai, these included works that in 1887 were less familiar, by Harunobu, Kiyonaga, Toyokuni and Utamaro. Portier's connection with Van Gogh and Toulouse-Lautrec makes him a noteworthy marginal figure.

An even remoter historical figure is that of another colourman, Père Tanguy. Two versions of his portrait by Van Gogh, with their colourful backgrounds of Japanese prints [88, 89] document the significant advance in understanding of the Japanese vision that had taken place since Manet's *Emile Zola* [18], around two decades earlier. It is highly characteristic that the figure and its setting have merged into a single plane. The artist is less concerned with giving an exact likeness of his friend than with, as Werner Weisbach put it, 'what Tanguy *meant* to him and to his fellow painters' (*Vincent van Gogh, Kunst und Schicksal*, Basel 1951, vol. 2, 36). For Van Gogh, this significance lies in the reference to the Japanese sources vital to his artistic expression.

Does this mean that this modest colourman – who occasionally accepted the blackballed paintings of Cézanne, Gauguin, Bernard and Vincent himself to sell on consignment – also sold Japanese prints? That is quite another question. As no definite information – and indeed no information of any kind – is available on the subject, it is tempting to conclude that Van Gogh's *Père Tanguy* is a portrait of a symbolic Japoniste. His shop served as the meeting-point of the avant-garde artists who joined together under the banner of Japonisme, just as La Porte Chinoise had done in the previous generation. By a curious coincidence, La Porte Chinoise closed down in 1887, just at the time when Van Gogh created this new symbol of Japonisme. Whether old Tanguy was really a motive force in all this is rather doubtful.

All in all, then, the participants in the Parisian Japonisme of the crucial years

between 1880 and 1900 present a wide range of interests, ideas, and characters: as varied as the manifold aspects of Japanese prints and the prospects that they offered to the artists who pressed forward towards a new beginning.

Reception of Japanese art in England

The picture in England in the same period was very different. The manifold varieties of Parisian taste shrink into a single family, by comparison with what was going on in London. There, from the start, the world of the 'applied' arts was dominated by a pragmatic frame of mind directed towards taking advantage of the practical and technical lessons that were there to be learnt from the Japanese.

The Great Exhibition of 1862 set the ball rolling with a much-admired Japanese section; from that moment on, craft designers, both traditionalists and reformers, were under notice to achieve greater simplicity. The impulse came from the Far East, but also from other sources: the Middle Ages, for instance, and India. In England, machine production had already developed so far that hand craftsmanship, where it survived at all, had been forced into an almost hopeless defensive position. In contrast to the Continent, the relationships between artists and craftsmen had been so largely destroyed that conscious acts of cultural policy were necessary to counter the decline in quality occasioned by mass production. This decisive role was played by a succession of theoretical and didactic books which conveyed, to producers and consumers alike, a new social concern and readiness for reform: although theory and practice by no means always coincided.

The 'House Beautiful', with all its decorative concomitants, was an English invention that eventually conquered the whole of middle-class Europe. William Morris has taken his place in history as one of the most influential figures in the reform of design. The characteristic style of the 'artist-designers', dominant in England in the last quarter of the nineteenth century, was led, elaborated and steered through to its triumph by Morris. After the superb accounts of this process given by Nikolaus Pevsner (*Pioneers of Modern Design*, London 1936), Stephan Tschudi Madsen (*Sources of Art Nouveau*, New York 1956) and Robert Schmutzler (*Art Nouveau* [Stuttgart 1962], London and New York 1978), we need not concern ourselves, in the present context, with individual design problems and their solutions. It is enough to point to the fact that Morris, in spite of his 'Gothic' (and anti-machine) attitudes, was able to build on the work of a generation of forerunners who represent a crucial 'intermediate phase in which, during the process of long years, a synthesis of the Japanese and the European elements had been achieved' (Schmutzler, *Art Nouveau*, 21).

A steady stream of didactic works appeared in London from the middle of the century onwards. Here is a list of the most important ones, with dates:

1856 Owen Jones, *A Grammar of Ornament*
1859 Christopher Dresser, *The Unity of Variety*
1862 Christopher Dresser, *The Art of Decorative Design*

1862 Christopher Dresser, *The Development of Ornamental Art*
1863 Rutherford Alcock, *The Capital of the Tycoon*
1867 Charles Eastlake, *Hints on Household Taste*
1870 Christopher Dresser, *Principles in Design*
1874–6 Christopher Dresser, *Studies in Design*
1877 E. W. Godwin, *Art Furniture from Design*
1878 Mrs H. R. Haweis, *The Art of Beauty*
1878 Rutherford Alcock, *Art and Art Industries in Japan*
1880 Thomas W. Outler, *A Grammar of Japanese Ornament and Design*
1882 Christopher Dresser, *Japan: its Architecture, Art and Art Manufactures*
1882 Walter Hamilton, *The Aesthetic Movement in England*
1884 George Ashdown Audsley, *The Ornamental Arts of Japan*
1886 Christopher Dresser, *Modern Ornamentation*

The titles alone reveal the programme: to save industrial mass production from the menace of kitsch. The aim was to achieve 'decent' designs through respect for material, for scale, for line, for 'clean' ornament. In book illustration, for example, what was sought was the essential form, instead of the rendering of a host of details. In wall hangings, wallpapers, carpets, furniture and decorated textiles, the two-dimensional surface must come into its own, and the looming floral bouquet must be transformed into a flat pattern. Any 'healthy' historical prototype might be enlisted to this end, and the newly opened South Kensington (now Victoria and Albert) Museum made such prototypes readily accessible.

For such purposes, Japanese design was as good as any other; indeed, the fact that it was novel, unhackneyed, lively and attractive gave it a considerable advantage. The reformers built Japonisme into their theories of reform. In France, and most clearly in the work of Bing, the decorative principles of Art Nouveau evolved out of a familiarity with Japanese art; but the English teachers, with their head start, were able to absorb Japanese design into their curriculum as they went along. The emphasis differed, although the contrast was by no means so sharp in practice; and, even before 1890, there was a certain amount of interchange between the two countries.

Among the Englishmen who deserve mention here as links between the Arts and Crafts and Japonisme, two are of particular interest: Sir Rutherford Alcock (1809–97) and Christopher Dresser (1834–1904). Alcock, who went to Tokyo as British Consul in 1859, organized the important Japanese section of the 1862 Great Exhibition. In doing so, he was responding to the strong impression that Japanese art had made upon him. It is all the more astonishing, therefore, to read his account of the subject in his later, well-informed book. He finds interesting and instructive only the craft objects, for:

Of high art, such as has been cultivated in Europe since the dark ages, the Japanese know nothing ... In architecture, the Japanese, like their neighbours the Chinese, have produced scarcely anything...

They can make no pretension to compete with the Art of Europe, in what constitutes a picture,

whether of landscape or of figures. The pictorial side of Art is in a comparatively undeveloped state among the Japanese, though power of expression, combined with simplicity of treatment, is a characteristic of Japanese Art. (*Art and Art Industries in Japan*, London 1878, 15–16, 214.)

On the positive side, he notes, 'all branches of Japanese Art, apart from their popular picture-books, are decorative in their main purpose' (ibid., 237).

It is from this standpoint that Alcock examines Japanese woodcuts, which he classifies into two groups purely on grounds of content: (1) 'reproductions of common nature' and (2) 'the supernatural'. The objection to the latter is that they indulge in '*bizarre* invention', whereas the former depict daily life and natural objects. He goes on to say, however, that the demarcation between 'marketable' and 'speculative' art is not always very clear.

A very similar tone is to be found in the work of Dresser, who was probably the leading figure among those who linked the theory and practice of the new design movement with Japanese ideas. The author of six widely read books on craft design and the use of ornament, he was himself a considerable designer, a man of taste and versatility, and taught botany at the School of Design at the South Kensington Museum. Dresser went on an official study mission to Japan in 1876, and six years later he published the well-documented book that was to serve as a vade-mecum to the working architects and ornamental designers of his own generation and beyond. From our present point of view, it is largely irrelevant that he had a better understanding than Alcock of Far Eastern architecture and its structural patterns: the striking fact is that, just like Alcock, he had no eye for the truly artistic values of Japanese prints and painting.

In his *Japan: its Architecture, Art and Art Manufactures* (London 1882, 319), Dresser admired Japanese illustrations of flowers and birds on the grounds that they 'make drawings live': in other words, from a purely illusionistic standpoint. For the rest, however, he found nothing to commend: 'Japanese drawings are at best but sketches' – no great praise, coming from him. He values Japanese painters and draughtsmen, in spite of their 'strange and abnormal manner', for their 'keen perception', their 'quaintness of rendering' and their dexterity. There is no room for misunderstanding here: Dresser's admiration of Japanese art rests on the applicability of its patterns, and of its interpretation of nature, to Western arts and crafts. Woodcuts, like other works, are judged solely from this point of view; and although the book illustrates details of flowers, leaves, birds and the like from the later masters, no artist, not even Hokusai, is anywhere mentioned by name. The anonymity of design has no truck with the aesthetes and their cult of the individual.

The productions of the Arts and Crafts movement matched its theoretical insights; but there was a strong desire to see its exotic exemplars in the flesh, as it were. The fulfilment of this desire is recounted in *The Liberty Story*, told with great charm by James Laver (privately printed, London 1959). Its hero, Arthur Lasenby Liberty, was a resourceful and enterprising young man who joined the respected firm of Farmer & Rogers, importers of Indian shawls and textiles, at exactly the right historical

moment. The Great Exhibition of 1862 had just closed, and the firm had signed a contract to liquidate the sensational objects that had been shown in the Japanese section of the exhibition. To this end it had to open an Oriental warehouse, and Liberty was put in charge. Such was its success that in 1875 Liberty set up in business on his own.

His later fame, which does not concern us here, was based on the quality of his own workshops: the dyeing of imported cloth, the printing of modern textile patterns, and sound craftsmanship of all kinds. In the early, heroic days, however, Liberty's was the one and only place where the celebrated 'handmade' Japanese articles could be admired and acquired. There, at 218 Regent Street, was the visible centre that combined the roles performed in Paris by La Porte Chinoise, Hayashi and Bing. It was frequented by everyone who had even the remotest interest in art or in what became known as the Aesthetic Movement: Morris, Ruskin, Carlyle, the Rossettis, the architect Norman Shaw, Whistler, G. F. Watts, Edward Burne-Jones, Frederick Leighton, John Everett Millais, even Lawrence Alma Tadema. All this interest revolved around decorative objects: 'blue and white' vases, fans, textiles, lacquer boxes, lampshades and so on. But as for the fine art of the East, its imaginative forms, as manifested in painting and in graphic art: all this, on that comfort-loving island, was quite another matter.

Japanese woodcuts had been known in England since that memorable second Great Exhibition of 1862. The National Art Library, in the Victoria and Albert Museum, bought them avidly. It soon held the largest collection in the country, but one very different in emphasis from any of its Continental counterparts. Its Keeper, Edward F. Strange, defined its policy:

A collection of Japanese colour prints may be made from either of two points of view. That of the amateur will be so chosen as to include good examples of each artist of importance ... perhaps the most typical collection of this class was that of M. Hayashi, sold in Paris in June, 1902. This contained a large number of prints by men who ... belong to the earlier schools; little or nothing is known about them, and their work has small practical value for the student or designer. On the other hand, the Library possesses very large numbers of prints by later men, who have not generally been deemed worthy of the attention of the collector. These prints are richer in colour than those just referred to: they are filled with examples of costume, furniture, and all sorts of utensils; and if they are inferior in absolute artistic merit, they are of inestimably greater utility for these reasons to ... the book illustrator ... the designer ... and lastly the sociologist ... There are illustrations of architecture, of domestic interiors, of arms and armour, of lacquer, metalwork, musical instruments, and details of dress and articles of personal adornment, all set forth in such a way as to show not only their form but their daily uses.

The greater part of the collection has been acquired for the sake of subject only ... the collection, then, is essentially one to be used, and not hoarded simply for the satisfaction of the curious. (*Japanese Colour Prints*, London 1904, 1–2.)

One might have expected a print collection to take us outside the realm of Arts and Crafts altogether: not so in this case. It was not until after the turn of the century that the British Museum set up a rival collection, closer to the artistic criteria employed by Hayashi.

Private collections of smaller size and good quality existed from the later 1870s onwards, inspired by Paris, and as a reflection of the cultivated personalities of their owners. London never had a *japonisant* subculture like that of Paris, because there never was any response from contemporary English artists.

True, the Pre-Raphaelites and the other painters listed above bought bibelots from Liberty's, and later from Murray Marks, to adorn their studios; but what Dante Gabriel Rossetti thought of Japanese art, and in particular of the woodcuts, of which he owned some examples by Kuniyoshi and Hiroshige, we learn from his brother William Michael:

Rossetti was equally astonished and delighted with Japanese designs; their enormous energy, their instinct for whatever savours of life and movement, their exquisite superiority to symmetry in decorative form, their magic of touch and impeccability of the execution, carried him away. Assuredly, he did not suppose that the facial angle of the 'eternal feminine' of Japan, as represented (and very untruthfully represented) by her admiring countrymen, is to be accepted as the line of beauty; nor were his previous impressions revised as to how a human leg or arm or torso is constructed... Upon the colouring of the prints he looked with great satisfaction, as having qualities of force and saliency which no other nation could bring into play with equal effect; he said, however, that the colouring is somewhat harsh – which is true of a large number of Japanese works, though not of all. (*Some Reminiscences*, London 1906, vol. 1, 276–7.)

This was the same William Michael Rossetti who had earlier written of the lack of 'moral beauty', indeed the 'atrocity', of Japanese art, and who had described the feeling for beauty as 'a feeling really alien from the Japanese mind ... beauty does not present itself to that mind as an intrinsic element of art, or almost of nature' (*Fine Art, Chiefly Contemporary*, London 1867, 386). The critic here stands condemned out of his own mouth. This is a judgment that casts more light on the Pre-Raphaelites and their philosophy than on Japanese art. These artists were effective adversaries of Salon art, but they were quite incapable of joining the mainstream of the European avant-garde.

In spite of this resistance to the aesthetic culture and pictorial art of Japan in the name of moral beauty, there are crossovers between Pre-Raphaelitism and Japonisme even in the work of Rossetti; but they exist on the level of craft design, not on that of pictorial construction. Rossetti was no stranger to the applied arts, and his binding for Swinburne's *Atalanta in Calydon* [68], of 1865, is a fine example of the Far Eastern taste. To find a Japanese influence on pictorial form in England, we must wait for the next generation, discussed in a later chapter.

The Universal Exhibitions

In our review of the shift in taste towards Japanese principles we must finally turn to the Universal Exhibitions of the second half of the nineteenth century. At more or less regular intervals, these documented the growth of international contacts in industry, trade, travel, culture, art and human interests in general. These were the nodal points, the platforms on which achievements were placed on show, hopes and

68
Dante Gabriel Rossetti.
Binding for Algernon Charles
Swinburne's *Atalanta in Calydon,*
1865

prospects were aired, and the curiosity of a huge public – large as never before since the ancient world – was awakened. On a merely quantitative level, the attendance figures themselves show this: the Paris exhibition of 1867 reported 6,805,969 visitors; the next, eleven years later, already had 13,000,000; that of 1889 had no less than 32,000,000; and that of 1900 reached 50,800,801. (See exhibition catalogue *Weltausstellungen im 19. Jahrhundert*, Neue Sammlung, Munich 1973.) This figure should be compared with the total population of France at that time, which was 38,850,000.

In all this, Japanese art was one sensation among many; but a sensation it was, from the very start. The craft products, lacquer boxes, ceramics and decorative work, were most admired, and they soon became part of Western fashion. Prints were less noticed by the public at large; and such interest as there was on the part of the elite probably depended on prior knowledge. At the Great Exhibition of 1862, in London, Japanese prints figured as folk art and served as a foil to the Japanese crafts; they had been supplied, as we have seen, by Alcock, British Consul in Tokyo. Even in Paris, five years later, decorative objects dominated, but now they were accompanied by French-made 'adaptations': Bracquemond's porcelain, Charles Christofle's gold jewellery and Martz's jewels. The seven Japanese albums from the collection of the art critic Burty were an afterthought.

The 1878 Universal Exhibition in Paris was dominated by Japonisme. The Japanese

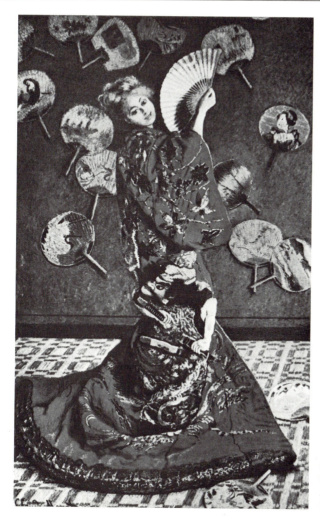

69
Claude Monet.
Madame Monet in a Japanese Dress,
1876

pavilion, organized by the Japanese themselves, was the sensation of the show. Its many superb decorative pieces found the public, the craft trades, and the expanding world of mass production in a receptive mood. Japanese decorative art, from ceramics to kimonos, fans and bibelots, became socially acceptable. It became, as people would say today, a status symbol. The bourgeoisie was divided into subclasses defined by categories of Japanese design: the relevant indicators were the possession of fine imported ware, of cheap Japanese ersatz ware, or of European imitations. All this is wonderfully reflected in the paintings of Whistler [II], Tissot [55], Stevens [52, 53], Chase [54] and Monet [69]. On this first wave of 'exotic' Japonisme rode the objects of decorative art, now transformed into commodities. The craze lasted for more than a decade.

It was the next Universal Exhibition, that of 1889, that marked the crisis, made it

public, and opened the way for the second Japonisme, which through Art Nouveau led to the emergence of *Stilkunst* and Modernist design. The 1880s must be regarded as a period of ferment. In every area of taste, among collectors, scholars, artists and dealers, tradition was shaken to its foundations. With the search for new foundations, the Japanese contribution itself was transformed from an exotic stimulus to a constructive precedent. This is the subject of the chapters that follow.

The 1889 exhibition revealed nothing of Japanese graphic art that had not previously been visible in Parisian private collections, and in that of Louis Gonse in particular. It did, however, mark a stage in the process of popularization; and, on a different level, it presented the work of Emile Gallé, that tireless deviser of modern decorative forms derived from the spirit of Japan.

7. The contribution of the scholars, 1879–1886

Once Baudelaire, Burty, Goncourt and others had expressed their enthusiasm for Japanese prints, and coveted woodcuts and albums had begun to find their way to London and Paris in increasing quantities, people wanted to know more about their origins and the artists who had made them. There was an awareness that this was a field rich in artistic and iconographic interest. Just as, in retrospect, the whole of early German painting gradually emerged from the giant shadow of Dürer, there now emerged from the shadow of Hokusai a wider evolutionary spectrum of Japanese forms of vision.

It is curious to find how long scholarship stayed on a purely visual level, both in exhibitions and in the collections of private individuals and dealers. The literature dates from a later period. Mention has already been made of the few essays by Guimet, Chesneau and Duret: these men were *amateurs* and critics in the best sense, who relied on their own artistic sensibility, and their eye appreciated applied and figurative art alike.

It was not until shortly before the coming of the second wave of Japonisme that critical acumen was supplemented by knowledge. The specialist made his appearance. The first in the field was a British surgeon, William Anderson, with his *History of Japanese Pictorial Art* (Transactions of the Asiatic Society in Japan, London 1878), a historical survey which he followed eight years later with a study in more depth, *The Pictorial Arts of Japan* (London 1886). Then, in 1888, he organized an extensive exhibition at the Burlington Fine Arts Club – the first ever held in the British Isles – which showed Japanese prints in all their variety. His knowledge was based mainly on his own collection, which he had assembled in Japan during many years' residence in the country as Medical Officer to the British Legation. As no such thing as art history existed in Japan, and *ukiyo-e* art was despised there, the scale of Anderson's single-handed pioneer achievement would be hard to overestimate.

It is characteristic of this scientifically trained scholar that he approached his material not primarily from the viewpoint of artistic expression, but according to technical and practical criteria, as a pictorial account of the land and the people, their customs and habits. Starting in the ninth century, he distinguished seven successive periods of Japanese pictorial art, of which each, according to him, reproduced objects and human beings more accurately than the one before. This philosophy of progress, with photography as its implicit goal, need not distract us: it actually constituted the strength of his position. Anderson was undoubtedly the first Westerner to present a panoramic account of Japanese pictorial art in all its richness and variety.

Anderson's work aroused the admiration even of the French aesthetes. Duret visited him in London in 1880 and admitted: 'The study of his collection opened my eyes to artists hitherto unknown to me.' He was well in advance of the investigative zeal even of Bing and Hayashi, and for the English-speaking world his publications remained basic to the study, collection and connoisseurship of Japanese art – and of prints in particular – well into the twentieth century.

The corresponding figure on the Continent was Louis Gonse (1846–1921). Half a century later, a latter-day Japoniste, Raymond Koechlin, described him as 'the leading spirit of the first Japonisme'. His massive book, published in two volumes in Paris in 1885, keeps the promise of its title: *L'Art japonais*. Here, for the first time, all realms of art, from painting and print to the various art manufactures and even architecture, are covered from a consistent viewpoint and in chronological arrangement. The individual pieces in various materials and techniques, assembled by the collectors as curiosities, here become a whole. We are conscious of a unifying vision. This aesthetic organization is Gonse's original achievement. He sets out his programme as follows:

The history of painting in Japan, more than anywhere else, is the history of art itself. Only the study of its progress, its developments and its transformations can cast light on the history of those secondary arts that we call *decorative arts* and bring us to a close acquaintanceship with Japanese taste. Painting is the key, without which all the rest remains hidden from our view. The whole of art has emerged from painting and is subordinated to it. (*L'Art japonais*, Paris 1885, 1.5.)

Here is Gonse on an individual case:

Kōrin, already mentioned as the master of lacquer, is perhaps the most personal and original of all the painters of Nippon; he is the most Japanese of all the Japanese. His style is like no one else's, and is disconcerting at first sight to a European eye. He is the antithesis of our tastes and our habits. This is the acme of Impressionism, or so at least it seems; for his mode of depiction is loose, light and smooth; his brushstroke is surprisingly gentle, convoluted and yet relaxed. Kōrin's drawing is always strange and unexpected: his motifs, which are highly personal and indeed unique in Japanese art, are of a startling, even rather awkward naivety; but one soon grows used to it, and one has only to make the effort to adopt the viewpoint of the Japanese aesthetic to find in his work a charm and an inexpressibly delicate taste, an indefinably harmonious, fluid rhythm, that is captivating. Beneath often childlike appearances, one discovers a superb mastery of form, a sureness in synthesis, that no one else in Japanese art has ever possessed, and which particularly suits the requirements of decorative art ... I confess that Kōrin's art, which initially caused me some disquiet, now gives me the subtlest pleasure. (Ibid., vol. 1, 58–9.)

It is evident from the text of Gonse's book, and from this extract in particular, that Gonse set himself two tasks that had never been performed before. The first was to give a systematic presentation of all the tendencies and artists in the field, in evolutionary sequence, where previously there had been, more or less, a mosaic of individual objects: in other words, to write a *history* of art; in spite of many disagreements, he shared this aim with his contemporary, Anderson. The second task was to evaluate these phenomena in artistic terms: to write a history of *art*, a branch of the universal art history in which Gonse had been trained. He did not hesitate, for instance, to compare Hokusai's position in relation to the 'high' artists to his period to that of

Daumier or Gavarni in relation to contemporary winners of the academic *Prix de Rome*.

It was inevitable that such a study, explaining Japanese art in terms of the decorative spirit, should have a powerful influence on those young artists who, like Seurat, Van Gogh and Gauguin, were casting around for examples to follow in transcending illusionistic depiction. It was equally inevitable that so bold a synthesis would encounter criticism from all sides. Specialists in one or the other branch of 'art manufactures' made themselves heard, and especially those who could point to a technical inaccuracy here or a misspelt Japanese name there. Such things are virtually unavoidable, but pardonable, in any survey that breaks new ground on such a scale. Factual knowledge constantly progresses; one book is superseded by the next; but the underlying aesthetic may be more durable. This is what has happened to Gonse's book. No one is going to use it as a guide today, but it keeps its value as a representative of a particular approach: works of art are presented chronologically and historically, but they are evaluated from the point of view of *taste*.

Even some of the criticisms that Gonse's views encountered on grounds of taste are revealing. Edmond Goncourt, for instance, saw the younger man's work as a threat to his own taste for Japanese bibelots and Rococo amusements, and also to his status as the Pope of Japonisme. He wrote in his journal of 25 January 1883: 'There is, among the collectors of *japonaiseries*, an insupportably pretentious, credulous fool; his name is Gonse.' (*Mémoires de la vie littéraire*, Paris 1956, vol. 3, 231). It was a collision between two conceptions of taste.

Such disagreements shrank into insignificance from the vantage point of a generation later, when Oskar Münsterberg, all Germanic profundity, wrote in his history of Japanese art:

Goncourt and a circle of modern artists in Paris found in Japanese art a magnificence of colour and imaginative stimulus that spurred them to wild enthusiasm. No one explored the profundity of the moral ideals, or studied the historical development of the foreign culture [*sic*]; it was enough to luxuriate in the splendid idiosyncrasy of Japanese art, to remain on the superficial level of decorative aesthetic effect. This artistic sensibility found expression in the large two-volume work by Gonse. (Oskar Münsterberg, *Japanische Kunstgeschichte*, Brunswick 1907, vol. 2, part 3.)

In France itself, Gonse's subjective, 'Impressionistic' approach came under critical fire from members of the Symbolist generation. Teodor de Wyzewa (1862–1917), in a study of Japanese painting written in 1890, acknowledged Gonse's pioneer achievements in extracting from the baffling chaos of Japanese schools and manners, 'by a kind of intuition', order, clarity and a sense of value. But he went on to brand it as Gonse's 'greatest error' that he

does not sufficiently show the inner connection between Japanese art and the race that has created it ... for the essential qualities of Japanese art depend above all on the artists' view of the world. What we need above all, and what the historians have withheld from us, is an understanding of the principal characteristics of the *Japanese soul*. (Teodor de Wyzewa, *Peintres de jadis et d'aujourd'hui*, Paris 1903, 228.)

Taste versus soul, impression versus expression: the same antitheses, in a different context, underlie the fiercest of all the attacks on Gonse. This came from Ernest Fenollosa (1853–1908). His booklet of nearly sixty pages, under the title *Review of the Chapter on Painting in Gonse's L'Art Japonais* (Boston 1885), was the first work of an investigator who was to evolve a new image of Far Eastern art and culture, and to do more for its dissemination, both in Japan and in America, than any of the other figures discussed here.

'The western world', proclaimed this New Englander, seven years after he had let down roots in Japan and made himself into the defender and preserver of its cultural tradition, 'has yet to learn in what the true Eastern painting consists. It is not merely in externals and technique, which are easily understood. It is in the greatness of heart and mind, which are hardly understood at all. The capacity of a painting is measured by its spiritual depth' (ibid., 22).

The decisive event of Fenollosa's life was his encounter with the early temple art of Japan; its protection and appreciation became his life's work, in which he ran counter to all the modernizing impulses of the Meiji period. His impassioned defence of the Japanese Buddhist tradition gained him an appointment as 'Commissioner of Fine Arts to the Japanese Government'.

In 1890 he went as a Curator to the Museum of Fine Arts in Boston, and there he founded what is probably the finest department of East Asian art in the Western world. A marital tragedy, followed by divorce, shattered his career. A man who at thirty had been described as the 'greatest living expert on Japanese painting' ended his working life on the lecture circuit, addressing ladies' luncheon clubs and adult education conventions. In Japan he was given the burial of a Buddhist monk.

Gonse's criteria were, inevitably, anathema to such a man. He was particularly incensed by Gonse's admiration for so late a phenomenon as the colour woodcuts, by 'his Hokusai-crowned pagoda of generalizations', as he somewhat peevishly called it (ibid., 21). The whole conflict revolved round the figure of Hokusai, '*le vieux fou du dessin*', an artist comparable in approach, imagination and powers of observation only to Daumier. For Gonse, writing from a Parisian perspective, Hokusai was one of the greatest artists of all time, the 'painter of life', in whom the whole of Japanese art found its ultimate fulfilment. For Fenollosa, on the other hand, the emphasis must lie on the earlier, and especially the Buddhist, religious art that he knew so well; and from that viewpoint nothing could be 'more vulgar, rough, and unlovely' (ibid. 22) than Hokusai's 'beastly obscenities', or than the 'materialistic gaiety' (ibid., 29) of late *ukiyo-e* artists:

Clever undoubtedly they may often be in externals; but however it might appear in their engravings, in their paintings their conception, touch, and general technique are without refinement or depth ... the heart at least must be pure, and the purity must become an external fact and manifest to all eyes, before transcendent excellence can be allowed. (Ibid., 33.)

Hokusai's painting is vulgar, not because it deals with vulgar subjects, nor because he was not a man of rank, but because it is vulgar in its manner, and almost always in its conception. We grant

readily that he is a designer of great originality and vigour, that his printed books are marvels of technical skill, that his range of subject is wider than that of any other artist, and finally, that his art is, as M. Gonse says, more human ... But ... Hokusai ... was of coarse-grain, and became at best only a caricaturist. (Ibid., 45.)

And that is about the most he is able to concede. Elsewhere the attack intensifies step by step, and in his fury he turns everything to black and white:

our author's [Gonse's] eyes are blind ... he has to learn much more about Eastern excellencies in order to distinguish what is proper and pure in them from the qualities of alien schools ... We are constantly provoked with him for vacillating between two entirely irreconcilable standards. (Ibid., 44.)

Gonse may, in principle, concede that there is a 'beauty in abstract brush-strokes' (ibid., 21), but 'those sloppy, unformed brush-marks [are] the farthest removed from all that is beautiful in calligraphy' (ibid., 46). The outcome is that the much-praised master of the woodcut is not only relegated to the lower end of the scale, as a base sub-artist, but expelled from the august company altogether, with the words: 'It is [a] great delusion to say with M. Gonse that Hokusai represents a pure Japanese art without mixture' (ibid., 48). He is of 'mongrel breed': to Hell with him!

This mixture of moral, theological and political values with purely artistic ones was Fenollosa's forte; but it left him wide open to attack. Even so neutral a colleague as Brinckmann, the pioneer of Japonisme in Germany, concluded that while Fenollosa may have been better informed, Gonse was the better judge of art.

Even so, Fenollosa's puritanism played a decisive part in directing Western eyes to the great temple painting of Japan and – surely against his own intention – in establishing that for Eastern art, as for Western art, more than one criterion of value exists, and that a single, rigid yardstick is not enough. He did not, in any case, succeed in destroying the popularity of those colour woodcuts that had already reached Europe. They continued to arrive in ever-growing streams, not only in France but in all other Western countries. By the turn of the century they had unleashed an artistic revolution such as Fenollosa had never dreamed of. Even he, in later years, had second thoughts about Whistler, the once-despised aesthete:

The two great streams, Europe and Asia, after remaining isolated from each other for so many millennia, were reunited in fruitful and final community at the end of the nineteenth century. The future historian will look back at the year 1860 as a nexus and turning-point in the evolution of world art. Whistler stands for ever at the confluence of the two great continental streams. He is the heart, the all-embracing interpreter of the East to the West and of the West to the East. (*Pacific Era*, 1 November 1907, 174.)

So the *ukiyo-e* woodcuts had a part to play after all? Fenollosa finally capitulated in his posthumous work, *Epochs of Chinese and Japanese Art* (New York 1912/1963, vol. 2, 201): 'through his matchless fecundity, [Hokusai] is one of the world's most notable masters'.

8. The crisis of Impressionism in the 1880s

Fashion, connoisseurs and critics thus all played their part in transforming, over two decades, the sudden enthusiasm of a small avant-garde into the tidal wave that was Japonisme. In order to understand the next step, we must turn once more to the artists.

We saw in the case of Monet how much his early work, with its vertical structuring, owed to Japanese art, and how, in the high Impressionism of the 1870s, this source of inspiration receded. For the progressive conversion of linear structure into light-bearing particles of colour, for painterly dissolution of form and fluidity of motion, even Hiroshige could supply no precedent. It was not until Monet and Renoir reached the crisis which led to a revival of structural issues that Japanese prints, now far better known than before, once more offered an example to follow. Degas, on the other hand, the great outsider of the Impressionist movement, had no reason to be so keenly aware of a break: with an eye to the Japanese artists, he was able to proceed step by step through the transition from imitating reality to inventing it (the phrase is Werner Hofmann's).

Paul Cézanne (1839–1906)

In Cézanne's case, the artistic relationship with Japan was much more obscure. It might appear that he made the transition from his 'baroque' and Impressionistic early work to the structural form of his later works without the aid, or even the knowledge, of any Japanese element. Joachim Gasquet, in the Boswellian role that he assumes in his rather melodramatic narrative, records from the lips of the master himself: 'Chinese? Japanese? Don't know them, never saw them.' Elsewhere Gasquet records that Cézanne dismissed their handling with the words 'shrill as a poster, as if painted through a stencil, like a rubber stamp. And totally lifeless' (*Cézanne*, 2nd edn, Paris 1926, 90, 167).

How are these two remarks – the only comments on this topic in Gasquet's whole fat book – to be reconciled? Clearly, Cézanne was no collector of Japanese prints; equally clearly, he did not, as others did, follow the emergence of Japanese art in Paris, stage by stage. This was an artist who admired Puget and Michelangelo for their sculptural volume: he was temperamentally incapable of adopting Japanese prints as his ideal. Even so, Gasquet's book reveals that Cézanne created an extremely wide-ranging 'imaginary museum' for himself, and that he traced every possible artistic connection, from the ancient Egyptians to his own shallow contemporary, Félix Ziem.

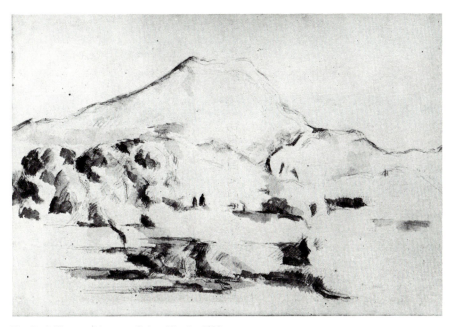

70 Paul Cézanne. *Montagne Sainte-Victoire*, 1890

He paid closer attention than any of his fellow painters to what was going on in art around him. How could he possibly have overlooked Japanese art? Might it be that the worthy Gasquet was led astray by his own literary ideas? Or did the artist deliberately draw a veil, rather as Manet once told Baudelaire that he had never seen a painting by Goya?

The fact is that Cézanne was friendly with Monet and Duret, both enthusiastic partisans of Japonisme, and that he was Monet's guest at Giverny; what is more, the two most important events in the history of Japonisme – the exhibitions organized by Gonse in 1883 and by Bing in 1890 – were immediately followed by major stylistic changes in Cézanne's work which correspond to no known alternative sources of inspiration. On biographical evidence alone, we must conclude that Cézanne perceived Japonisme as, at least, an available possibility. How far this went, only the analysis of his works themselves can show.

To take the most conspicuous element first; his pictorial treatment of the Montagne Sainte-Victoire. For almost the whole of the last quarter-century of his life, his attention was absorbed by the shape of that sacred mountain, which had been before his eyes since his youth. As Fritz Novotny has shown, no subject provides a clearer illustration of the evolving interconnection in Cézanne's 'elemental' mature style between pictorial space and picture plane. The rocky massif emerges in its basic forms, increasingly grand, looming, majestic, as the emphasis shifts away from the foreground and towards a surface tissue of colour.

Almost all the critics agree that the shift from Cézanne's 'classical' structural phase to his later, 'crystallized' phase (Roger Fry) took place around 1890. This was also

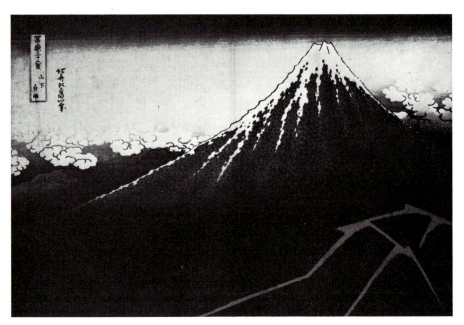

71 Katsushika Hokusai. *Mount Fuji in a Storm*, 1823–32

the date of a turning-point in Monet's art, with the inception of his serial paintings; and it was also the moment when, at Bing's exhibition, Japanese prints were to be seen in greater profusion than ever before or since – including the *Thirty-Six Views* and *Hundred Views of Mount Fuji*, by Hokusai [71]. There can be no question here of direct influence from Monet or from Hokusai, either in the means employed or in the choice of goal. Monet, the Impressionist, was moving towards a shimmering light into which colour and object alike were absorbed; Cézanne towards the enduring painterly structure behind which illusionistic space dwindles and disintegrates, and chromatic space becomes monumental. Hokusai stood half-way between the two; his graphic techniques of representation had nothing in common with either. However, his serial vision of the motif, combining the solid outline of the mountain with arabesque-like planar strips in the foreground, had set a precedent of unity in multiplicity which confirmed and inspired both Western artists in their own chosen courses.

From that moment on, Cézanne studied this one mountain more often and more intensely than any other artist has ever studied a mountain. Its looming, constantly enlarged outline supplied him with a melodic theme which constantly offered him new pictorial motifs, and whose elements he integrated more and more firmly in his chromatic structure. When he set out to turn away from the 'photographic' image of reality, to weaken perspective, in order to realize his pictorial idea – the terminology comes, once more, from Novotny – Japanese art showed him the possibility, if not the direction, of what may be called a 'free scale', in which above and below, before and behind, large and small, become fluid, interchangeable, freely recombinable, as

elements of the formal design. The beholder is not immobile: as he cannot at once survey the whole landscape, he slowly and gradually feels for its various aspects and combines them into a unity in his mind's eye; and from the imitation of Nature he derives the ability to complete it. In just the same way, the *Thirty-Six Views of Mount Fuji* combine to form a composite image, based on the optic of the traditional *emakimono* or scroll paintings, in which mountains, valleys and rivers unroll before the beholder's eye as in a film.

This analogy between Cézanne and Far Eastern art was not lost on Novotny, or on Pierre Duthuit (*Chinese Mysticism and Modern Painting*, London 1936), or yet on Liliane Guerry (*Cézanne et l'expression de l'espace*, Paris 1950, 123–4). All three, without suggesting a point of contact, linked Cézanne with the Chinese ink painting of the Sung Dynasty; but there is no possibility that he could have seen this, or anything like it, even in reproduction. Francastel, more practically, thinks of Hokusai. The distance between the latter-day Japanese and the early Chinese artist is enormous – for us as late observers, versed in the history of art – but the artist can draw large-scale conclusions from a lesser work, if he must. Scholarly exactitude and artistic intuition are not one and the same, even though we try to reconcile them as far as we can. Cézanne's later style cannot and must not be *explained* by an East Asian model; but it does make sense to suppose that he underwent the inspiration of that form of vision through Hokusai.

Both Fry and Venturi take a similar line when they link the late work of Cézanne not genetically with Far Eastern art, but phenomenologically with the nature of the watercolour medium. Here a light touch of colour makes it possible to convey a hint rather than a worked-out form, so that the paper that shows through (or remains blank) serves both as a picture plane and as a link between the separate sectors of colour. The colour elements thus set up a visual rhythm of their own that transposes the image into a musical, abstract sphere; it is distanced from illusionistic reality without abandoning the object. Even those watercolours that consist of only a few light brushstrokes set up a rhythmical organization with which they structure not only the picture plane but the pictorial space. This visual transposition, according to Fry, belongs to a world of 'spiritual values, incommensurate but parallel with the actual world' (*Cézanne*, New York 1927, 69). And so there emerges, as described by Venturi, a constant flux of pictorial configurations; he considers the watercolours [70] to be the finest achievements of Cézanne's formal invention, and to have blazed a trail for the oil paintings.

The dreamlike quality of which Venturi speaks, or Fry's spiritual quality, or the monumentality evoked by Novotny, are all terms that point in a metaphysical direction that had been lost in the West at least since the Middle Ages, but for which the art of East Asia, which was now slowly coming to be known in the West, had a parallel to offer. Cézanne never went beyond what Novotny calls a 'suspended definition of meaning'; but in his last period he certainly did borrow certain formal elements from that source. Probably the most extreme and convincing example is the watercolour *Mont de Cengle*, dated 1895 [72].

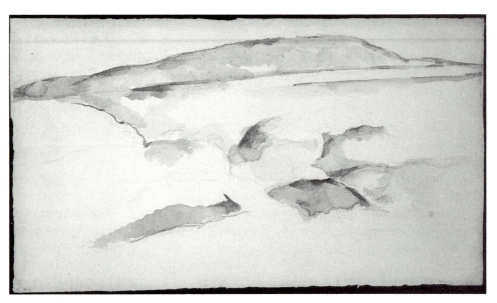

72 Paul Cézanne. *Mont de Cengle*, 1895

In the same year in which he showed his work in an Impressionist group exhibition for the last time, the movement away from Impressionism became evident in his work, nowhere more clearly than in a portrait, *Madame Cézanne in a Red Armchair*, of 1877 [73]. Here there is none of the soft, floating quality, the atmospheric envelope, the fluid space, the interplay of forms, visible in the portraits of the previous ten years or so. Instead, the sitter seems completely rigid in her attitude and in the gesture of face and hands; she seems pinned down in a pictorial space which is pressed up against the picture surface. The muted colours, and the arabesque articulation of the surface, structure the portrait with an abstract order that removes it from the atmospheric world altogether. Everything subordinates itself to this central concern: the face becomes a mask, and the forward projection of the knees is almost entirely concealed by the curveless stripes of the skirt. The units of the wallpaper pattern – especially as colour – supply an unmistakable decorative accent; their arrangement, three on the left and one on the right, helps to emphasize the asymmetry of the pictorial construction. This monumental interpretation of the motif has little or nothing to do with illusionistic 'likeness'. It bears the message of an entirely different formal world.

But what was the new impetus that came to Cézanne so suddenly? Any Japanese elements that may be detected in it are hardly likely to have reached him direct: the intermediary must have been Manet, who had worked out analogous representational devices for himself. Compare Manet's painting *The Railroad* of 1873 (National Gallery of Art, Washington, D.C.) – the picture space compressed by the arabesque of the railing, the two bodies thrust together, the rhythmic organization of sharp colour contrasts. *The Plum* (Paul Mellon Collection, Upperville, Va.), which is contemporaneous with Cézanne's picture, offers a similar parallel.

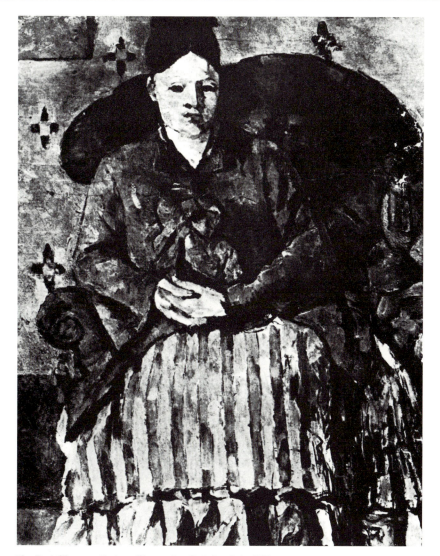

73 Paul Cézanne. *Madame Cézanne in a Red Armchair*, 1877

In Cézanne's work, isolated Japanese-style motifs, not affecting the overall structure, first appeared in a number of landscapes of L'Estaque that can be securely dated to the summer of 1876; revealingly, they were painted immediately after a long stay in Paris. *L'Estaque, Evening Mood* [74] shows a sharply outlined outcrop of rock very much in the manner of Hiroshige II [75]. An analogous work is *The Gulf of Marseille as Seen from L'Estaque* (The Metropolitan Museum of Art, New York), which unfolds not in horizontal recession but upwards. The marked asymmetry of the composition, with its silhouette effects, is the unmistakable hallmark of this phase in Cézanne's work, the phase in which he transcended Impressionism, and which opened the way to his 'great' style.

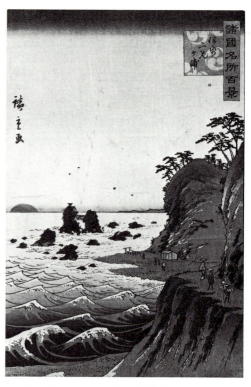

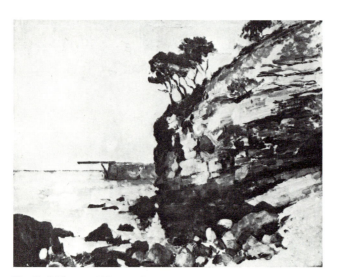

74 Paul Cézanne. *L'Estaque, Evening Mood*, 1876 75 Hiroshige II. *Futami Bay*, 1859–61

If we turn from the 1877 portrait [73] to a notable later example of the same theme, *Madame Cézanne in a Yellow Armchair* [76], a product of Cézanne's 'crystallized' period of the early 1890s, the Japanese impetus – here a direct one – can no longer be denied. The intermediary here might have been a portrait by Chōbunsai Eishi or his school, such as Rekisentei Eiri's *The Reciter Tomimoto Buzen II* [VII]. The great simplification and flattening of modelling and colour, the structural anchoring of the figure against the edges of the picture, the horizontal weighting combined with a diagonal accent; but above all the anchoring of the picture plane in the pictorial space, the all-pervading chromatic and formal structure, the concentrated power combined with expressive restraint: all this is in the Japanese work. To suppose that Cézanne was influenced by the Japanese work at some intermediate stage is not to belittle his original achievement: however parallel the problems, the results are poles apart. No one is going to describe *The Reciter* as the source without which Madame Cézanne's portrait could never have been painted.

It was during these same years that Cézanne's painful struggle was rewarded by so many works that have become 'classics'. In the landscapes, and above all in the *Woman with Coffee-Pot* and *Portrait of Gustave Geffroy*, he seemed at last to have made his breakthrough. The reasons for this remain complex, but they surely become clearer

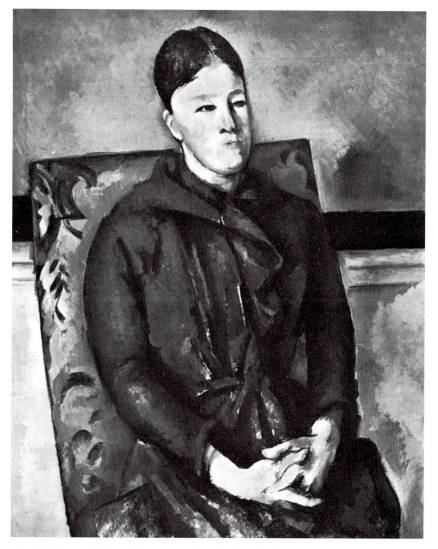

76 Paul Cézanne. *Madame Cézanne in a Yellow Armchair*, 1890

if the often-neglected encounter with the principles of Japanese drawing is taken into consideration.

With this cautious formulation we must let matters rest; for there is no documentary evidence as to what Cézanne actually saw or what he derived from it.

Georges Seurat (1859–91)

Here the situation is very different: Seurat spent the crucial decade of the 1880s entirely in Paris; he could not fail to be aware of Japonisme in all its multifarious

guises; and he was on friendly terms with at least two individuals whose interest in Japanese art is well documented.

The first of these was Gustave Kahn. Radical advocate of Symbolism in literature, art and music, aggressive editor of the journal of a younger generation, *La Vogue*, Kahn was a consistent advocate of Seurat's art who later edited an edition of his drawings. Sven Lövgren, in his brilliant study of *The Genesis of Modernism* (Stockholm 1959), has sketched a lively portrait of Kahn's important and often overlooked role in art criticism. In Kahn's apartment in the Rue de la Trémoille, full of avant-garde paintings, drawings and prints, there were certainly also Japanese albums, as we learn from Félix Fénéon (*Œuvres*, Paris, 1948, 229).

Seurat's other *japonisant* friend was that 'lapidary critic' (Mallarmé's description), Fénéon himself. Fénéon's much-quoted study, *Les Impressionnistes en 1886*, afforded a first substantial analysis of 'Divisionist' art and at once established him as a commanding presence in the art world. Two years later, in his reviews of the Paris international print exhibition, *Blanc et Noir*, and in other articles, he showed his intimate knowledge of the Japanese masters. He intended to travel to the Far East, in order to study its art at source and write a book about it, but never did so (*Œuvres*, 56, 129).

Seurat's other contacts with the Japanese vision took place through his acquaintanceships with Van Gogh, Toulouse-Lautrec and, initially, Gauguin.

Seurat's meteoric career, in which he transcended Impressionism, his fantastic evolution from one work to the next in the course of one brief decade, have left the critics with a number of puzzles to solve. As is well known, it was his comrade-in-arms, Paul Signac, in his book *D'Eugène Delacroix au Néo-Impressionnisme* (Paris 1899), who drew attention to Seurat's technique of 'Divisionism' or 'Luminarism': the analysis of coloured configurations into dots of primary colour in order to create what Signac called an optical mixture, thus creating a luminous effect of incomparable beauty and harmony, far superior to any pigmentary mixture of colours on a palette. It is implicit in Signac's choice of title that 'the much-maligned method [of Seurat and his friends] is entirely in keeping with tradition; that it was intuitively grasped – and came close to being formulated – by Delacroix, and that it was inevitably destined to be the successor to Impressionism' (ibid., 1). Seurat's originality, according to Signac, thus consisted in his having restored, or even enhanced, the luminous power of colour that had been lost by the academic painters: he was the successor to the *colorisme* of Delacroix.

For Robert Rey, on the other hand, Seurat's significance is rooted in the fact that he went beyond the fleeting, evanescent perceptions of naturalism and Impressionism and organized his areas of paint in accordance with a harmony based on the rational clarity of number and geometric order, in accordance with a 'geometrical key'. Seurat's art thus appears as the bridge between his own antecedents – Poussin and the ancients – and the Cubists of the following generation.

Seurat certainly agreed with the theoretician David Sutter, whose work he constantly studied, and who wrote: 'All rules are derived from the laws of Nature themselves;

nothing is more easily recognized; nothing is more indispensable. Everything in art rests on Will.' (Cited in Robert Rey, *La Peinture française à la fin du XIX^e siècle. La Renaissance du sentiment classique*, Paris [1931], 128.) But did this mean that the answer lay in the past, and that those eternal laws of harmony could never yield a new music? Did it mean that the synthesis between Ingres and Delacroix could be achieved without a new, integrative element?

There have been constant efforts to relate Seurat's rhythmic formal construction to Piero della Francesca or other fifteenth-century painters, to Egyptian reliefs, or to Byzantine mosaics, but no one seems to have had the idea of investigating his relationship to the Japonisme of his own period, even though his friend Signac actually named 'Oriental tradition' as the prime source of his inspiration (*D'Eugène Delacroix . . .*, 67) and went on to say: 'There are people who cannot tell a Hokusai from a Hiroshige . . . a Monet from a Pissarro; let these amateurs complete their own artistic education' (ibid., 71).

It was not until our own day that the issue was raised, by Henri Dorra, author of a fundamental work on Seurat. In an article on Seurat's Japonisme, Dorra and Sheila C. Askin (*Gazette des Beaux-Arts*, January 1969, 81–94) show a number of parallels, formal and motivic, between Seurat's landscapes and prints by both Hiroshige and Hokusai: these include the use of arbitrary shadows to set up rhythmic contrasts between strips of light and dark; a dark foreground area sharply set off from a light background by an 'elegant curve'; replacement of the atmospheric envelope of Impressionism by a vibrant curvilinear pattern [77, 78]; trees seen sharply silhouetted against water and sky; clouds as rhythmic figurations in wavy bands; the representation of spatial recession through an additive sequence of colour planes from the lower edge to the top of the image [79], leading to a bird's-eye view. Between every work and the one that follows [77, 79], there thus arises a further 'stage of abstraction'. In the last three years of his life, Seurat did not paint a single picture without Japanese features clearly visible to an attentive viewer; and they are progressively more strongly integrated in the pictorial structure.

It is interesting to see that these references are principally to Hiroshige, the 'late' master of *ukiyo-e* who not only accomplished the transition from traditional figure subjects to landscape but himself underwent a strong Western influence. It was Hiroshige, real differences notwithstanding, who had offered the French Impressionists examples of work that they could read in an 'Impressionist' way; Seurat, however, concentrated on the stylized aspects of his art. Incidentally, Monet himself had anticipated Seurat in this same change of direction, not long before, when in the Etretat paintings of 1883 [61] he used the form of the rock as a structural element. Seurat might thus be said to have developed this particular Japanese element at both first and second hand. We are forced to agree with Signac when he sees him as continuing the Impressionist vision; but he also transcended it.

So much for the landscapes that he painted in the summers by the sea, with their 'Japanese' elements incorporated 'from memory', as it were, from originals seen in Paris. In the large figure compositions, a completely different method emerges. It has

77
Georges Seurat.
*Le Bec du Hoc,
Grandcamp,* 1885

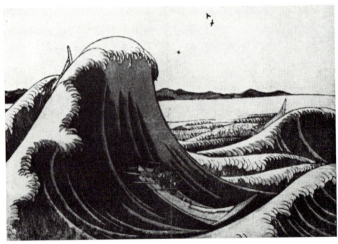

78
Katsushika Hokusai.
*A Boat Battling
Against the Waves,*
1834

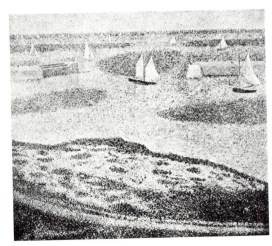

79
Georges Seurat.
Fishing Boats at Port-en-Bessin,
1888

often been remarked how secretive Seurat was over the preparation and elaboration of his paintings, immersing himself in theories of chromatic, luminous, linear and compositional structure of which William I. Homer (*Seurat and the Science of Painting*, Cambridge, Mass. 1964) has made a comprehensive study. Sutter, and the more backward-looking academician, Charles Blanc, were primary sources. They pointed, for instance, to the repetition of gestures in Eyptian reliefs, and to the importance of the silhouette for rhythmic design; they pointed the way to a style that would concentrate on the durable and the essential and would transcend both the transitory impression and the impression of the transitory.

It is certain that Seurat derived some fundamental insights from such sources; but these insights cannot have been the crucial ones, because he was incapable of being a Neo-Egyptian, or a Neo-Anything. For his own personal breakthrough he needed something that he could never find in books: something in the air, which crystallized only in the last two or three years of his life, and which he kept as a kind of secret. This was Japan.

To trace this, one might analyse his last works – and in particular the large compositions, each of which took him nearly a year to assemble – in reverse order. The later ones show Japanese influences more clearly than the earlier ones; but, even in these, the first signs can clearly be seen. What is apparent here is not – as in the landscapes, which are essentially 'occasional' works – formal devices and motifs alone, but the structure itself that uses these devices and subordinates them, in a truly revolutionary way, to a new conception of space.

No work by Seurat reveals this better than his last completed painting, *Le Chahut* of 1889–90 [80]. Where does the Japanese element lie? Certainly not in the content; there is nothing in Japanese art to compare with this music-hall scene. The theme, that of Paris night life, is one first explored by Degas in *Le café-concert des Ambassadeurs* (1876). The idea of Degas as the inspirer of Seurat's Japonisme is indicative, but no more: the younger artist carried rhythmic stylization far further. Robert Rey illustrates his discussion of this 'mysterious work' (*La Peinture française*, 125–7) with two linear diagrams on which the painting could be superimposed in order to demonstrate its perfect regularity and beauty.

One resolves itself completely into a system of straight lines related by the Golden Section and the right angle, in accord with the ancient Neo-Platonic canon: no less than twenty such relationships are demonstrated. The second diagram is the one that interests us here [81]. In thirteen concentric curves, segments of both circles and ellipses, the whole dance scene is held together by a geometrically disposed focus, like the hub of a wheel. All the movements in the painting, which look as if they have been frozen in mid-flight, refer to that focus; it is an 'abstract' vision that sets them vibrating, dancing, moving in a three-dimensional space closely allied to the picture plane.

A print from Utamaro's *Ten Truly Feminine Accomplishments* [82] lends itself to an entirely analogous interpretation. The rhythmic strips come to life in the interplay of curves and circles which all indicate a single focus, just where the maid's left hand

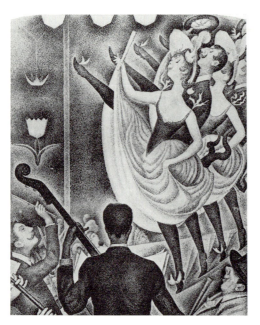

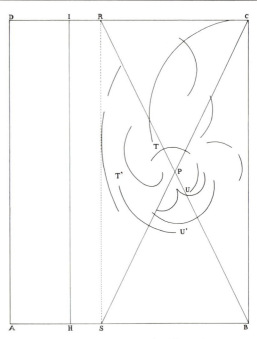

80 Georges Seurat. *Le Chahut*, 1889–90

81 Geometrical key to the preceding illustration

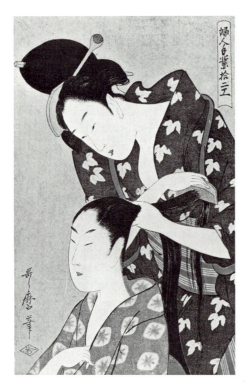

82
Kitagawa Utamaro.
*Ten Truly Feminine
Accomplishments: Hairdressing,*
1801–3

touches the lady's hair, and where many different textures meet. There is nothing in any Greek or Egyptian source to resemble this harmony between rest and movement, this freedom of viewpoint. As in the work by Seurat, the figures no longer seem to belong to a single continuous space – the perspectival box – but move on sightlines of their own; unless, that is, we choose to see them as surface arabesques. The tautness of the drawing sets up a vibration in the elastic space and creates a new reality which is held in suspense: which is, in the strongest sense of the word, decorative. This power of elementary construction is more crucial, in both works, than is the intensity of the colour.

If more proof were to be required: all the eyes and ears in *Le Chahut* are stylized into a hook-like stroke that is exactly in the manner of Utamaro.

Seurat was no mere imitator of the Japanese, and his interest in them long remained concealed: he himself, indeed, was at some pains to conceal it. As a result, this, of all his works, was long regarded as the most 'anomalous'. It showed a transition from illusionism to stylization; but what did that stylization consist of? Its flatness and its emphasis on outline, even its rhythmic repetitiveness, could readily be traced back to more or less well-known sources, whether in Egypt or elsewhere in so-called Primitive art. But there remained an awkward gap, not covered by these sources: and that, of course, was Japan.

What Japanese art did Seurat see? He deserves credit for having advanced from the late art of Hiroshige to the 'classical' vision of earlier times, and in the process he drew considerably closer to an alternative version of 'primitivism', the early printmakers of Japan. Is it a coincidence that he was working on the composition of *Le Chahut*, at exactly the same time, in 1888, as Bing was presenting Utamaro to the Parisian public for the first time? It has more than once been said that in the poster-like grotesquerie of this painting Seurat was moving in the direction of Art Nouveau, 'although his paintings, with their crystalline structure, set him totally apart from it' (Robert Schmutzler, *Art Nouveau – Jugendstil*, Stuttgart 1962, 168); but when the Japanese dimension of his work stands revealed it can be seen that he actually stood on the threshold of the new artistic vision, and that he was one of those who assisted at its birth.

There is no point in speculating on what Seurat might have accomplished if he had lived longer. But it was the earlier works, *Bathing at Asnières* and *La Grande Jatte*, painted before his encounter with Japanese prints, whose solemn, elevated atmosphere so endeared them to many of the adherents of literary Symbolism that Seurat was already being called the Mallarmé of painting. With *Le Chahut*, however, and with the Japanese elements that it contains, he opened a door to the decorative stylization of Art Nouveau. It was a door that he was never to pass through.

Vincent van Gogh (1853–90)

'The more you see things with a Japanese eye, the more subtly you perceive colour' (*Lettres de Vincent Van Gogh à son frère Théo*, ed. Georges Philippart, Paris 1937,

Letter 500). 'You know, here I feel myself to be in Japan' (Letter 468). 'Japanese woodcuts, when once you love them, you never regret it' (Letter 483). 'Do you see, what these simple Japanese teach us almost amounts to a religion' (Letter 572). These few quotations amount to a confession of faith on the part of the most thoroughgoing exponent of Japonisme among the younger painters, Vincent van Gogh. To call this a confession of faith is no exaggeration; for what he sought, and ultimately found, was not only the solution of artistic problems but a religious, political and social guide for life.

It is impossible to imagine Van Gogh's artistic career without the relationship with Japanese prints. Not only did he discover them at the very moment when his own work attained self-confidence and maturity: he clung to them until the very end of his career – which lasted barely more than five years in all. Van Gogh literally lived with Japanese prints. He studied them at every available opportunity, collected them with his own modest means, organized an exhibition, took every opportunity to try to convince his fellow painters in Paris of their importance, and constantly reverted to the subject in his letters. It is no wonder, therefore, that we are so well informed on the subject. He painted copies of three Japanese woodcuts in oils, reinterpreting them in the process, and in many of his own works he used Japanese techniques in order to express what was closest to his own heart.

All this might be expected to supply us with a catechism for the encounter between Japanese and European art at a critical moment. It might seem that a clear connecting line could be drawn from Vincent's underlying impulses, by way of his 'sources', to his world-famous works, thus showing us, once for all, how the Japanese influence really worked. After all, unlike almost all the other artists involved, he made no attempt to conceal his Japanese sources and indeed proclaimed them. It looks rather as if, for once, all the pieces of the puzzle are within reach and have only to be fitted together.

Nothing could be further from the truth. Vincent was a special – indeed a unique – case. He had a message, rooted in the 'ultimate mysteries of existence', which shone through his art and also through his earlier life. His French artistic contemporaries – all the figures so far discussed – were professional painters who regarded art and formal creation as their central concern and who approached philosophical or social issues from that specialized viewpoint; Van Gogh's situation was exactly the reverse. As an artist, he was an amateur (in the best sense of the word), profoundly disturbed on a basic human level, who used his paintings to forge an instrument for the expression of his own isolation. Others proceeded from outside to inside; he embodied the modern human creature, looking from inside to outside, from soul to object. In his own words, he was 'determined to break through the invisible iron wall that stands between what one feels and what one can do'. Like his contemporaries, he sought to advance from Impressionist 'appearances' to something primeval and 'primitive'; but he did so from an entirely different starting-point, with a personal temperament under constant strain, and with unparalleled explosive force.

To analyse the artistic essence and importance of Van Gogh would go far beyond

the scope of this account; we are concerned here only with the role played by Japanese art in his achievement. Even so, it is necessary to dwell for a moment on two other forces that affected him.

It was the subject matter of mid-century realism – the plight of the oppressed and abused, the earthbound peasants and the workers, the potato-eaters and the careworn miner (*At the Gates of Eternity*) – that impelled him to leave his missionary work and turn to art. This was an inner voice that was never stilled; on the contrary, it intensified in the very last year of his life, when he turned to variations on *The Sower* and other social themes of Millet's, which he intensified still further with his own newly acquired expressive power. It was the urgency of the message of art that hurled him from one phase of his artistic evolution into the next. This was the inescapable foundation of his work.

This basic element was, however, overlaid by another. The experience of Paris freed Van Gogh from the confines of Dutch provincialism and opened up the world of colour. The dark, earthy tones and the merely illustrative, depictive approach of his Dutch period could no longer suffice when all around was the enchantment, the organ music, of blue and red and yellow. He learnt this in the two years of exper-imentation he spent in Paris in 1886–8. And it made little or no difference to him whether it was Monet or Seurat or Bernard or Monticelli or Delacroix who showed him the way, or whether their various colour theories negated or complemented each other. For him, colour was not a realm in itself but a resource that he encountered on his way: a new instrument with which to express his inner anguish. Viewed from an art-historical perspective, his years in Paris are rather confused, hard to disentangle, vacillatory, highly uneven in intention and fulfilment, so that Kurt Badt was able to say, with a trace of exaggeration: 'What he did at that time is among his weakest work' (*Die Farbenlehre van Goghs*, Cologne 1962, 58).

It was on these two levels, that of realism and that of receptivity to colour, that he encountered the revelation of Japanese woodcuts – or rather the new dimension that Japanese art was increasingly to mean to him. The details, the dates and the extent of this discovery are known for Van Gogh as for no other artist; they emerge from his correspondence and can in some cases be supplemented by reference to the works themselves, although – and this is the strange thing – there is not a single case in which the path from a Japanese original to a specific pictorial conception of Van Gogh's can be traced.

Van Gogh's Japonisme was first chronicled in an excellently documented survey by Marc-Edo Tralbaut (in the journal *Mededeelingen – Dienst Schoone Kunsten*, nos. 1, 2, The Hague, 1954). The prelude is barely detectable. In a letter from The Hague in the summer of 1883 (Letter 299), Van Gogh mentioned a reproduction of a drawing by Félix Régamey, 'who often reproduces Japanese things'. Régamey had in fact been Guimet's companion on his travels in the Far East and had illustrated the resulting book with sketches of local colour. These are not very Japanese-looking. Vincent mentions them, no more, and with due detachment.

A first sign of receptivity to things Japanese appears in a letter written from Antwerp

in November 1885 (Letter 437). This is revealing in three ways. The initial note is struck by a quotation from Goncourt: 'Japonaiserie forever!' It is not surprising that Vincent had found his way to this particular writer, the first to combine modernity with a taste for Japanese design; or that his access to the subject was by way of literature. Whether his brother had sent him a book from Paris, or whether he discovered Goncourt – who became his favourite writer – for himself, remains an open question. He followed the Goncourt quotation, by way of illustration, with a brief description of life in the port of Antwerp, which reminds him of a Japanese print, 'fantastic, strange ... with figures in constant motion'. Lastly, he revealed that he had pinned up on the wall of his studio some little Japanese prints, girls in gardens and on the shore, horsemen, flowers and blossoming branches: 'they *amuse* me a lot.' Clearly, these were still no more than curios, and they did not touch him very closely.

All this changed when he arrived in Paris, in February 1886, and during the two years that he then spent there. There are no letters that date from this period, but there are many indications that Japanese art now impressed itself very forcibly on him, and that he wrestled with it, not only as raw material but as form. His encounters with other artists certainly contributed to this. At the studio of Fernand Cormon he met Toulouse-Lautrec, who painted his portrait. He knew many other avant-garde painters through his brother Theo, who worked at the Galerie Boussod-Valadon; he discussed Japanese art with Monet; at Père Tanguy's, he could see pictures – such as those of Cézanne – that were not always easily accessible. In June 1888, he summarized what he had learned: 'Japanese painting is loved, its influence is felt; all the Impressionists have this in common.'

It was probably through his brother that he met Samuel Bing, whose gallery, as we have seen, was the headquarters of Japonisme (see Chapter 6). Nowhere in the world could he have seen more or better Japanese material. With characteristic intensity, he used the opportunity to the full and spent days on end in close study of the *crépons*, as he called them, that filled Bing's shop from cellar to attic. It was there that Van Gogh transformed himself from a dilettante into a connoisseur. He learned to distinguish the individual Japanese schools, artists and often individual works. He formed his own judgment of their value and of their significance to himself; later, referring to Hokusai, he confidently assigned him to *la vraie période*, the true period (Letter 510), and wrote to his brother from Arles to urge him to buy at least a few of the '300 [*sic*] prints of his Mount Fuji series' that he had seen, foreseeing that they would rise in price – a strikingly accurate prophecy. He told Theo to exchange them for works by Parisian artists such as Monet. Vincent communicated his enthusiasm to other painters, including Emile Bernard, Alexander Reid, John Russell and Louis Anquetin, and took them along to Bing's warehouse.

Clearly, he also bought prints for his own collection. Tralbaut estimates his outlay at 250 francs. This was a great deal of money: it was enough to keep him for five months. But there is no reason to dismiss the possibility that Theo agreed to spend the money. The only curious thing is that the Van Gogh collection, still in existence

today, contains not one print of Bing's quality, and not one single Hokusai; a number of the prints and illustrated albums demonstrably derive from a cheaper source, as they bear the stamp of Decelle in the Rue Vivienne.

The items in Van Gogh's *ukiyo-e* collection are more remarkable for their quantity and diversity of theme than for their quality. Apart from the fourteen prints that he gave or bequeathed to Dr Paul Gachet, at Auvers-sur-Oise, at the end of his life, all are now in the Rijksmuseum Vincent van Gogh in Amsterdam, which they reached either in direct succession from Vincent – by way of Theo, Théo's widow and Théo's son (297 items) – or by way of Vincent's younger sister Wil (144 items). The world of women, theatrical scenes, actors, the circus atmosphere, landscapes, flowers, birds and illustrated tales are the predominant themes of the prints, and there are about twenty albums. All are late prints and reprints: none date from before Vincent's own birth in 1853. The artists best represented are Hiroshige, Kunisada and Kuniyoshi, the colorful, exuberant, 'baroque' narrative artists of the last phase.

This may well be the place for a brief digression on the evolution of the Japanese woodcut, as it appeared from a Parisian viewpoint in the later nineteenth century. The key is provided by Bing's preface to *Maîtres de l'estampe japonaise*, the catalogue of the comprehensive exhibition that he organized in 1890. In it he distinguishes four periods. The first, 'primitive' period, that of Moronobu, is marked by a highly developed, harmonious rhythm of line and outline, by firm strokes in relief, and by the use of black and white alone. Colour makes a first hesitant appearance with Kiyonobu, before true colour printing appears in 1760, and with it a balance between form and colour that characterizes the second, 'classical' period, from Harunobu and Kiyonaga to Shunshō and Utamaro. Third, in the beginning of the nineteenth century the 'immortal' Hokusai and the prolific landscapist Hiroshige grew ever more colourful, more animated and more realistic. Finally, there is a loss of refinement, manifested in a variegated appearance, and, despite the persisting influence of the good tradition, excessive concessions are made to popular demand.

The European response to these successive phases took place in reverse chronological order. Just as Dürer was initially thought of as *the* Old German master, Hokusai was initially seen as the sole representative of the Japanese vision. This Oriental Daumier has remained secure on his throne ever since 1862 or thereabouts, and he is likely to remain so. He and his lesser followers will never be obscured, if only because of the sheer volume of their production; their interest goes beyond mere local colour, and despite their inclination towards illustrative illusionism there is much in them that is authentically Japanese.

This was enough for Van Gogh. He had no need to concern himself with the subtler earlier masters who had become known in the West since 1862: Utamaro, Kiyonaga, and the 'primitives', with their stylizations and abstractions, who could be of little use to him in confronting his own problems. In order to engage in a dialogue with them, he would first have had to strengthen his grasp of his own objectives and his own style. And so his personal collection contained only the later masters, with their touch of illusionism, which he could take up in his own expressive vein. These were

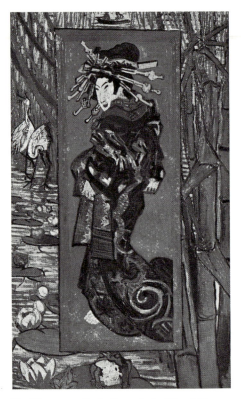

83 Vincent van Gogh. *Japonaiserie: Oiran (After Eisen)*, 1887

84 Keisai Eisen. *Actor as an Oiran*, after 1830

bound to be the artists he loved best. And the prosaic argument that they were the only artists whose works he and Theo could afford therefore becomes irrelevant.

For the rest, similar conclusions may be reached from a completely different direction: Theo's employer at Boussod et Valadon was the editor of a magazine, *Paris illustré*, which published a special issue on Japan at 1 May 1886. The text was written by Hayashi, whom we know already; the illustrations reproduce, in a sort of historical longitudinal section, woodcuts by Kōrin, Harunobu, Toyokuni, Utamaro, Hokusai and Keisai Eisen. All the periods were thus represented. But which was Vincent's favourite? He owned a copy of the issue, of course, and studied it closely; it is still to be found in the Rijksmuseum Vincent van Gogh. But it was only the last print in the sequence, a portrait of an actor by the minor nineteenth-century master Eisen (then usually transcribed as Yeisen), that interested him enough to copy it as a painting [83, 84].

The Japanese artist encloses the figure, heraldically, within rhythmically divided outlines which are enclosed in turn within a narrow rectangle, nearly three times as high as it is wide; Van Gogh, by contrast, situates his copy in the centre of a kind of tapestry of flowers and grasses, extends the space above, below and beside the actor, and endows him with a sculptural volume that is clearly marked in the hands, foot,

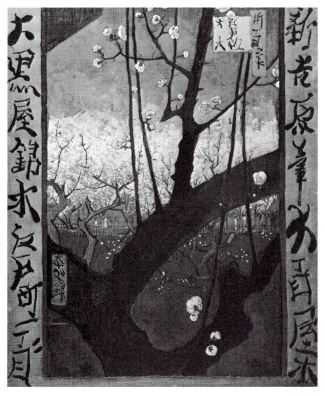

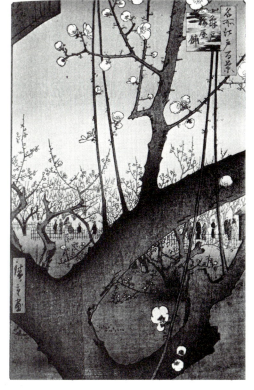

85 Vincent van Gogh. *The Tree (after Hiroshige)*, 1887 86 Andō Hiroshige. *Plum Tree in Bloom,* 1857

neck, even the mouth. The shadow-puppet has changed into a marionette, with spatial depth and more 'realistically' credible colours. The magical distancing effect has disappeared, without being replaced by any other source of energy. Perhaps this should be regarded as something of an elementary school exercise – especially as the added border strips contain a number of details from prints chosen at random.

Van Gogh's transposition of Japanese art works far better in two later works. *The Tree (after Hiroshige)* [85, 86] still alters the format to something more customary in the West – the relationship between height and width is brought closer to the Golden Section – but the bright orange framing strip and the added, entirely random Japanese characters point in a new direction that lies beyond both Western and Eastern traditions. The exaggeration of the graphic arabesque, and the dense, ungradated, masses of paint, combine to destroy the Japanese equilibrium between drawn framework and rhythmic colour. The result is a kind of explosion that opens the way to Expressionism. The gnarled black bough screams aloud; the scattered blossoms are trapped between those fateful black tracks and the red wall of the sky. Whereas in the Japanese work everything expands into space, here it is confined, shut off, dramatically exaggerated. The curves and the verticals seem to fight each other, and the green

87 Vincent van Gogh. *Père
Tanguy*, 1887

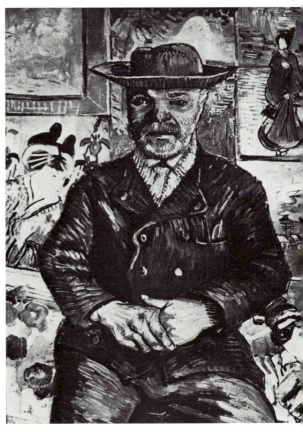

88 Vincent van Gogh. *Père
Tanguy*, 1887

configuration below thrusts against the upper red quarter, conveying the suspense of
a conflict that still hangs in the balance.

At about the same time, in the summer of 1887, Vincent set about making his own
version of another print by Hiroshige, *The Ohashi Bridge in the Rain* (Rijksmuseum
Vincent van Gogh, Amsterdam). Here, too, a dramatic emphasis is achieved by
'trapping' the comparatively impressionistic scene within a strip of poison-green,
which is surrounded in its turn by two red stripes, and by making the opposition
between formless atmosphere and the over-articulated structure of the bridge almost
appear to be a *leitmotiv*. One almost feels like asking what the unfortunate people in
the picture have done to deserve such an elemental onslaught.

Towards the end of Van Gogh's stay in Paris, he painted the two versions of *Père
Tanguy* [87, 88], with their Japanese backgrounds. His work contains no more
conclusive testimony to the impact of Japonisme than these two paintings, seen
alongside a portrait of the same sitter painted at the beginning of the same year [89].

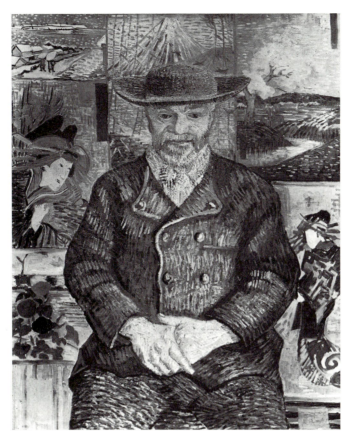

89 Vincent van Gogh. *Père Tanguy*, 1887

In this, the representation is in a form customary in Western tradition: a head-and-shoulders image, based on tonal modelling, with an illusion of space, psychologically penetrating, located in space very much as a contemporary of Corot might have done, were it not for a few bright touches of colour that point in the direction of early Impressionism.

Then comes the great leap: the metamorphosis of a genial modern individual into an icon [87]. The silhouetted, isolated figure is set down on the picture plane in a purely frontal view. Rhythmic accents in the outline, the curve of the coat-hem, the 'geometric' sequence of the buttons, even the oblong parallel blue brushstrokes, all point away from photographic illusion and towards an abstract interpretation. If we add to this the background, built up as if from scraps of tapestry, with its patterns strongly suggestive of Japan, it becomes clear that a new form of expression has emerged from a totally changed imaginative world. The primary colours speak straight from the tube: the forceful red, distributed across the entire surface without illustrative

pretext, and the yellows, blues and greens that compete with it as the representatives of supersensual, spiritual forces, a message from another realm. True, the painting still shows inconsistencies, such as the way in which the figure is 'stitched' into the background; and yet the very roughness with which it is thrown together generates a feeling of profound agitation.

In the later version [88], the same elements find an even more wild and uninhibited expression. Of the five Japanese prints used in the first painting – all of which can be identified – only two remain, one after Hokusai and the other after the very late Toyokuni III. The rest have been replaced by prints from the same later period but with stronger contrasts of colour. And this is the pattern of this 'revision' in general: where in the first version decorative and expressive elements remain in balance, here a tempest of emotion scatters the colours and tears apart the natural forms. For the first time, we recognize the Van Gogh of the later, Provençal works. The simplified triangle of Père Tanguy's face, with its almost monochrome skin tone, has become a veritable battlefield of aggressive colours. The green moustache; the lips fragmented into fiery red and sulphurous yellow, and split by a hook-shaped black chasm; the eyes as if swollen and inflamed, starting bloodshot from their dark sockets; the harsh red outlines around the blue coat; the hands fragmented into green and red and white and black, with brushstrokes flickering like flames in every direction: all this suggests, as much and as little as words can suggest, something of the new expressive impulse that is here using Japanese art as a springboard. What is Japanese here is not only the prints in the background – the iconographic allusions, as it were – but above all the twofold picture plane, with its components unconnected and juxtaposed without transitions, and the tension and intensity that all this creates.

Again, a comparison with Manet's *Emile Zola* [18] can help: in that work, the Japanese screen and print were simple factual references to the presence of a new visual world both for the sitter, as a critic, and for the painter. In *Père Tanguy*, however, the Oriental accessories are no mere documentary record of the sitter's shop: they derive from the artist's invention, from his own spiritual world and from his own artistic necessity.

This painting, in its expressive audacity, is an exception even for the late phase of Van Gogh's stay in Paris. Another work, painted immediately after it, is *The Italian Woman* (Musée d'Orsay, Paris), which is assumed to be a portrait of Agostina Segatori, owner of Le Tambourin, the café where Vincent held his exhibition of Japanese prints in 1887. In its strange mixture of inspiration from Whistler, Seurat and the Japanese (Katsukawa Shunei comes to mind here), this points in a completely different, and entirely decorative, direction. But it did not mark the beginning of a lasting tendency within Van Gogh's work.

Van Gogh's Japonisme can be fully understood only by emancipating oneself from the increasingly and regrettably popular approach of motif-hunting. His true and exclusive debt to the Japanese does not lie in the motifs he adopted but in the influence of their way of seeing, not by way of imitation but in the realization that traditional illusionism can be relativized and broken through, and that behind it another reality

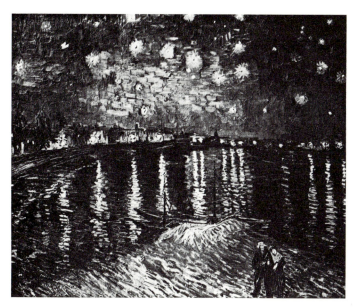

90
Vincent van Gogh.
Starry Night, 1888

emerges which makes it possible to express the psychic realm with greater accuracy: 'When one sees things with an eye schooled by the Japanese, one feels colours quite differently' (Letter 500).

One might have hoped to find that Van Gogh's large collection of Japanese woodcuts provided him with a rich store of motifs. But, if the question is posed in that way, there is no answer. One of the few instances where such a connection can be traced leads to quite different conclusions. The painting *Starry Night* [90] must be seen in conjunction with a woodcut by Hiroshige II which Vincent is known to have possessed [91], and which actually bears the same title.

In the recession in four parallel layers, and in the distracting detail, this late Japanese artist shows his usual degree of contamination by Western art; but Van Gogh takes the constellation of twinkling stars (not very evident in our reproduction), the illuminated masts, the rhythmically aligned lanterns, the powerful contrast between light and dark, as components from which to build and develop his own vision on the banks of the Rhône. What is surprising is just how much he has been able to absorb: the four layers, the human figures in the foreground (or is it just the lower edge?), the vertical articulation in the middle ground, the scattered lamps, and so on. But in the process the whole enterprise has been stood on its head. A record of a midnight festival has been transformed into a cosmic event. The stars, which in the Japanese work are simply recorded, are metamorphosed into blazing gems, far above their natural size, in order, as Van Gogh himself explained, 'to feel clearly the stars and the infinite in the height. Then, in spite of everything, life is enchanted' (Letter 520). The Japanese had opened the door to this enchantment; he had only to pass through.

Several works of the same period – September 1888 – reflect the same compulsion to set aside the perspectival view of Nature and to press forward, with spatial

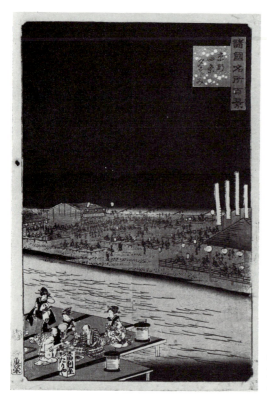

91
Hiroshige II.
Starry Night

imagination and suggestive colour, into new realms of artistic representation. In every one of these paintings, formal borrowings from Japan will be found. Whether in *Vincent's House in Arles* (Rijksmuseum Vincent van Gogh, Amsterdam), with its high viewpoint, its wide angle of sight and its unmodelled areas of colour in the unusual combination of yellow, blue and green; or in *The Night Café* (Yale University Art Gallery, New Haven, Conn.), with the arabesque of the foreground chair, cropped in the way used by Degas, and the weird way in which the yellow floor runs away into a hole at the end; or in *Café in the Evening* (Rijksmuseum Kröller-Müller, Otterlo), with its bold confrontation between the starry blue sky and the improbably aggressive counter-thrust of the tilted yellow café terrace: in every case there are stylistic echoes of Japanese prints, but no motifs.

This is nowhere clearer, perhaps, than in *Les Alyscamps* [92], where the 'grid' of blue tree-trunks, without crowns or roots, creates a structured space and joins with the yellow on the ground and the red of the female figure to frame the green central strip lined with sarcophagi. No other painter in the world could have captured and conveyed the magic of this incomparable street of sepulchres, the way in which it seems to lead right out of our world. But could Van Gogh have painted it if he had never seen a Japanese print?

Again, could he ever have conceived the expansion, the bending, the wrenching

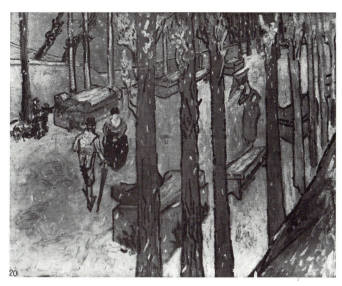

92
Vincent van Gogh.
Les Alyscamps, 1888

open of space that is perhaps best illustrated in the *Steps to the Bridge at Trinquetaille* [93], without having discovered the relativity of traditional perspectival space through his encounter with the Japanese way of seeing? It is perfectly true that in the prints he admired there were no works of engineering and no architecture; but did not the stimulus come from the way in which – in Utamaro, and above all in the 'primitives' – the spatial relationship of the figures to each other becomes, at least in our eyes, unstable, converting above and below, before and behind, into shifting categories [82, 150]? And so Van Gogh has transformed a fairly humdrum utilitarian structure into a stairway to heaven, with all the tiny figures who aspire to – and who can or cannot make – the ascent. Each of the seemingly endless succession of green and blue steps becomes an embodiment of the artist's oppressive vision of life.

Often, and particularly in the works of the Arles period, this spatial use of colour had the fortunate effect of enabling him, as it were, to explore the world of his imagination through one dimension after another. Again, none of this was *caused* by Japanese prints: what they did was to give him the necessary encouragement to develop a sense of space not only out of linear drawing but out of colour itself. In this sense, Van Gogh's vision might be described as that of a new Baroque.

Alongside all this there was a separate tendency towards a spatial vacuum – or, to put it more positively, towards the surface arabesque. *Almond Branches in Blossom* [VIII] stands more or less at the end of this series. Here the Japanese connection is a direct one, and Van Gogh's source is clear. The first issue of Bing's magazine, *Le Japon Artistique*, had on its cover a blossoming twig closely related to this one. We know, from more than one reference in the letters, that Van Gogh owned a copy of the issue. In the early 1880s, Monet had drawn inspiration from Hokusai's ornamentally conceived flower pieces, arum lilies and azaleas; and this was the direction in which Van Gogh too now moved, with his harder, knottier view of bends and joins. His

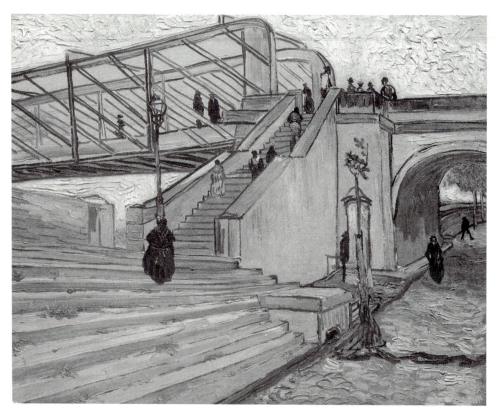

93 Vincent van Gogh. *Steps to the Bridge at Trinquetaille*, 1888

emphasis shifts more and more to structural drawing, and to the autonomous rhythm of the contoured outlines: colour almost becomes an accessory.

This graphic style is particularly marked in the portraits. In *L'Arlésienne* [94], one of five versions on which he spent a long time, the bent and unbent sleeves, headdress, fichu and chair-back are transformed into an ornamental configuration so flat and so abstract that the analogy of Harunobu's *Girl Painting a Flower Arrangement* [95] springs to mind – especially if we know that Van Gogh had just received the July 1888 number of *Le Japon Artistique*, containing a reproduction of that very print. We may also safely assume that Bing's huge stock of prints had confronted him with many even closer 'likenesses' by Shunchō. What is important is not to identify *the* motif that inspired him but to indicate the direction from which *outline as character* came to him. What he then made of it is quite a different matter.

The impact of the Japanese outline portrait on Van Gogh can be gauged by the fact that, although portraiture had never been his main concern, it now suddenly came to dominate his work. Between the July of 1888 and the following January, the catalogue raisonné lists the following: *The Mousmee, Girl on Pink Ground, The Postman Roulin, Self-Portrait, Young Man in Cap, The Actor, Camille Roulin* [96], *Armand Roulin* and *The Nursemaid*: in all these he is concerned less with likeness than with

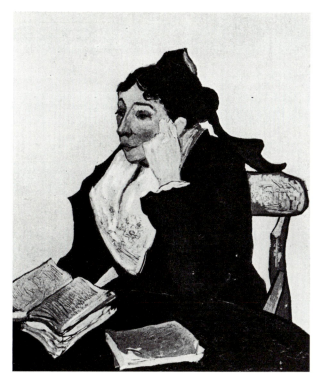

94
Vincent van Gogh.
L'Arlésienne, 1888

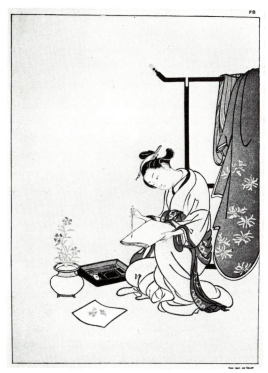

95
Suzuki Harunobu. *Girl Painting a Flower Arrangement*, c. 1768.

96
Vincent van Gogh.
Camille Roulin, 1888

extracting the essence from the stylized outline; and each of them exists in a number of versions – at least two, and rising to five – in which he strives for the utmost concentration and definition.

Another idea that made Van Gogh a forerunner of Art Nouveau was his feeling for the ensemble. He wrote to Theo (Letter 576): 'If you arrange them [the paintings] as follows, so that the *Berceuse* hangs in the middle and the paintings of sunflowers to right and left, you will have a kind of triptych ... then they will work much more strongly through the proximity of the yellows ... Give resonance to one canvas through the one that hangs beside it.'

This needs no commentary; it only goes to show the inadequacy of the label of Expressionism when applied to Van Gogh; a decorative effect often appeals just as much to him as it does to his allies Seurat and Gauguin. Similarly, the slogan of a 'new meaning of colour' has caused Van Gogh's contribution to the art of drawing to be largely overlooked; in fact, it is a highly important one. Our concern here is not with drawings made as sketches or studies for paintings, or else as renderings of them, but with drawing in its own right, as an autonomous art which pursues different means and ends from those of painting, and which derives from a different imaginative form. Interestingly, although there exist many accounts of the evolution of painting from Antiquity to Jackson Pollock, there are still none of the evolution of drawing as such.

97
Vincent van Gogh. *Garden in Provence*, 1888

In the process by which Van Gogh transposes the pictorial imagination into terms of drawing, Japanese art constitutes the most important – and indeed the only – propulsive force. It would be a mistake to seek to minimize the importance of this fact, as some might do, by ascribing 'immortality' to his paintings alone. Van Gogh stood at the dawn of a graphic age, and it was through his drawing that he influenced a continuing evolutionary process whose consequences are still with us.

Van Gogh's incursion into the world of autonomous drawing – *le dessin exagéré*, as he himself called it – is marked by an approach to objects through their material structure, as a mosaic interplay of minimal factors. This microscopic exploration of the grain of things is a process that does not lead, as one might have supposed, to a photographic realism, but on the contrary to a stronger imagination, to style, to stylization; for the permutations are infinite [97]. 'Things here have so much style,' was Van Gogh's own comment. But if things really did have more style in Provence than elsewhere, then an artist's eye was needed to reveal, to extract, that style and to develop appropriate techniques of representation.

He learned these techniques, once more, from Hokusai and his predecessors. In their works – as Siegfried Wichmann has shown in the exhibition catalogue *Weltkulturen und moderne Kunst* (Munich 1972) – this system of dots, lines and dashes, this 'point-scattering technique', is central to the process of pictorial concentration [98]. And this was Van Gogh's point of departure. The combination of concrete objectivity and abstract ornamentation in Hokusai inspires and encourages him to develop, step by step, a 'rhythm like a magnetic field' (Wichmann) that converts his 'charged mood' into signs.

Dietrich Seckel has pointed out to me how this transposition of appearances into elementary graphic signs can indeed be traced to a long-established Japanese and Chinese tradition. The *Houses Surrounded by Reeds* [99], from the so-called *Long*

98
Katsushika Hokusai.
Enlarged detail from *One Hundred Views of Mount Fuji*, 1835

99
Sesshū.
Houses surrounded by Reeds,
1486

100
Vincent van Gogh.
*Street at Les Saintes-
Maries,* 1888

101
Vincent van Gogh.
Washerwomen, 1888

Landscape Scroll of 1486 by Sesshū (1420–1506), might almost have served as a model for Van Gogh's style of drawing. It shows 'abstracting', and hence visionary, formulas for a number of objects such as roof-tiles, branches, twigs, rocks and reeds: an accumulation of microstructures. This method originated in China in the later Sung period (twelfth and thirteenth centuries) and was transplanted to Japan by the Zen monks, one of whom was Sesshū. In the Chinese manuals of painting (such as *The Garden of Mustardseed*, 1679–1701), and in the Japanese picture books (*ehon*) produced throughout the Tokugawa period (1603–1868), this strictly formalized 'formal texture' was codified and, in the woodcut, extended until its final flowering in Hokusai. Did Vincent know only his work, or did he, perhaps in Bing's shop, study that of Hokusai's forerunners?

Through the chronological sequence of the Provençal drawings, it is possible to trace Van Gogh's discovery of what to him was the essence of drawing. *Street at Les Saintes-Maries* [100], of June 1888, already has great richness of texture; but the dots, strokes and curves are still attached to realistic objects or imposed on them. Pictorial recession still disrupts the unity of the drawing; and the sky is a great white hole in its formal structure. This drawing is still half-way to being the idea for a painting; and a closely related painting does exist.

In the slightly later *Washerwomen* [101], the grip of illusionistic perspective has been loosened; the image draws its life from the rhythmic animation of the surfaces which seamlessly occupy the entire field of view. Our attention is distracted from the mere impression of Nature and turned toward the expression of content. All is subordinated to a two-dimensional rhythm, and the essence of drawing is emphasized as seldom before.

One further step is shown in a work such as the *Garden in Provence* [97], still of 1888. Here no trace of a white hole remains; all 'natural' clues to orientation, either in height or in recession, have been removed; and the world we see is a changed and almost an abstract one. With these infinitely diverse pothooks, dashes and dots, created entirely through variations in pen pressure and spacing, there appears a pictorial equivalent of eternal incompletability that has no parallel in earlier Western art. This spaceless space, and this metaphysical script, open the way to the art of the new century.

There is yet another new impetus in *Wild Vegetation* [102]. All is now in motion, pulsating freely and rhythmically in unimagined profusion, as at the first Creation – and as if half a millennium of Western efforts to achieve a perspectival depiction of reality were now a thing of the past. In its uncompromising magnificence, the drawing also has a hint of twilight about it. The crystalline sharpness of the *Garden in Provence* is absent. The work, like its creator, is doomed to remain for ever fragmented.

It has often been said that Van Gogh, as a Northerner, had adopted expressive exaggeration even before his Paris period, and that he then simply continued in the same path. But how, in this case, did he achieve a style, in his very last drawings, which dispenses with central axial structure, a horizontal field of vision, tonal modelling

102
Vincent van Gogh.
Wild Vegetation, 1888

and saturated shading and sees the world in planar terms as a cropped detail? This can be understood only in the light of his Japanese sources.

Paul Gauguin (*1848–1903*)

'It's curious: here Vincent feels prompted to paint like Daumier, while I see colourful Puvis de Chavannes motifs, in Japanese.' The words are those of Paul Gauguin, written from Arles. It was a somewhat distorted view, adopted in order to distance himself from his rival and to underline the ambivalence of the friendship between these two very different artists: one who followed Nature, even to the point of caricature, and one supersubtle stylist.

It was inevitable, perhaps, that Gauguin would see matters in this way. It was not long since he had made his own breakthrough from Impressionistic beginnings to a form of representation that was all his own. And what was the nature of this new insight of his, this revelation, or, if you like, this epoch-making invention? None of the numerous monographs on this artist, and no history of modern art, can afford to ignore *The Vision after the Sermon* [103]. A group of Breton peasant women in their traditional coifs are shown, either in sharply outlined back view or in profile, pressed against the picture plane at the bottom and at the sides. In the upper part of the painting, still very much in two dimensions, Jacob is seen wrestling with the angel in a meadow that is not coloured green but complementary red, behind a curved length of tree-trunk, cut short like a railing.

What an array of alienating, distancing devices! How wooden the result, judged by

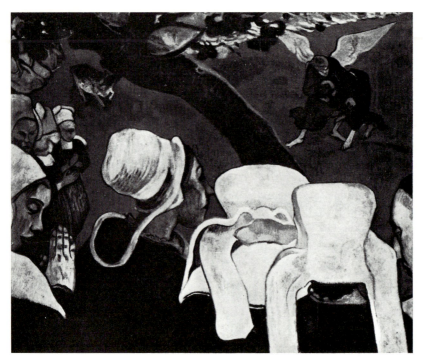

103 Paul Gauguin. *The Vision after the Sermon*, 1888

any nineteenth-century standard! It is precisely for this quality that some admire the
unspoilt devotion of these pious souls and the way in which the transcendental event,
the struggle with the winged superior being, is confined to a separate level of
representation; and this they call *Symbolism*. Others, meanwhile, emphasize in this
representation the rejection of contemporary reportage, its timeless, enduring, primal
quality, its remoteness from all the ills of the present age, its openness to a magical
world; and they rejoice in its *Primitivism*. Others (or are they the same people?)
trace the rhythmically ordered outlines, the simplified formal universe, the strong,
functional colours, unknown since the leaded church windows of the Middle Ages;
and they encapsulate their admiration in the word *Cloisonnisme*. Others, again, have
discovered how the new intensity of theme and formal design relates to the Far East,
and speak of *Japonisme*: the way the colour zone separates itself from the framework
of drawing, the way this structure tautens the picture plane into flattened arabesques,
the active interchange between pattern and ground.

 All this combines to give the work its special importance, both historical and artistic.
The curtain of illusionistic depiction has been lifted, and the realm of abstraction is
revealed in the interlocking of symbol and decorative form. And this is the true
innovation: the way in which the metaphysical side of human existence emerges from
the shadows and leaves its unmistakable mark.

 In an intensive study (in *Gazette des Beaux-Arts*, 1956, 94–114), Yvonne Thirion

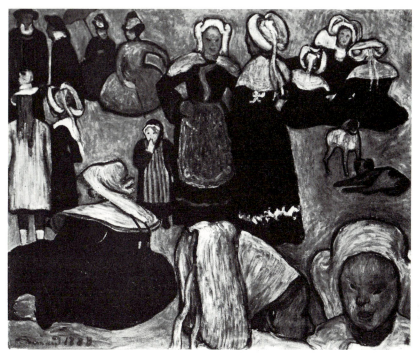

104 Emile Bernard. *Breton Women in a Meadow*, 1888

has investigated the influence of Japanese prints on Gauguin. She rightly sees this as the 'hitherto so much overlooked' nucleus of his 'synthetic and symbolic' art. Symbolism, according to her, came to Gauguin through an article by the music critic Edouard Dujardin, who condemned the mere reproduction of Nature in the name of a new *construction intellectuelle* – a term which in this case is equivalent to *Weltbild* or image of the world – and sought to define the true essence of things through simplification of line and colour. A comparatively tame application of this principle, again according to Thirion, was passed on to Gauguin, in the guise of the programme of Synthetism, by Emile Bernard, a precocious young painter whom he met by chance at Pont-Aven: it emerged from discussions between the two men, and above all from Bernard's painting *Breton Women in a Meadow* [104]. The third factor in Thirion's account is a Japanese album, a volume of Hokusai's *Manga*, which Gauguin had brought to Pont-Aven from Paris, and with whose aid he was enabled to design *The Vision after the Sermon* with a high viewpoint, and thus to perfect the Synthetist style – while Bernard, for all his Cloisonnisme, remained trapped in a traditional frontal view.

Such, undoubtedly, was the sequence of events. The story can, however, be further analysed, in which case it yields the following findings, which John Rewald first set out in that tour de force of detection, his *History of Post-Impressionism*:

(1) Van Gogh mounts a small exhibition of Japanese woodcuts at the Café Tambourin in 1887.

(2) Louis Anquetin, a now forgotten painter, is induced by this to paint his *Avenue Clichy, Variant of Blues* (1887): unified in colour, confused in its handling of space.
(3) Edouard Dujardin deduces from this work his theory of Cloisonnisme, which he publishes in the *Revue Indépendante* (March 1888).
(4) Bernard thereupon paints his *Breton Women in a Meadow* (early summer of 1888) and appears with it at Pont-Aven in midsummer.
(5) In the late summer, Gauguin, who has been at Pont-Aven since February 1888, and who has a volume of *Manga* in his luggage, paints his own version of the new style: *The Vision after the Sermon*.
(6) Bernard and Gauguin quarrel; after Gauguin's death, Bernard gives his side of the story in the *Mercure de France* for 1903.

So much for the facts. Their interpretation is an utterly different matter. Do the isolated achievements of two mediocre artists, unmatched by anything else in their careers, plus a programme inserted between them by an adroit writer, amount to a proof that Gauguin depended on them? Can a few trees really make it so impossible to see the wood?

This was, in fact, by no means the first time that the illusionism of the Impressionists had been called into question. Jean Moréas's *Manifeste symboliste* of 1886 had immediately attracted a whole group of writers; and Gauguin himself, in a much-quoted letter of 1885, had mooted the possibility of an intelligent art that would include the supernatural. The philosophical roots of a metaphysical culture go back not just to Baudelaire but to Plato and Neoplatonism. What counted, of course, was the need to find a way to translate this unseen world into visible terms.

Here theory did not help, and some spark of intuition was required in order to turn a hypothesis into living art. This is the Achilles heel of all Symbolism, past, present and future. Gauguin was no exception: what mattered in his case was not the quality of his theories, whether borrowed or home-grown, but his visible development of them: how he revealed 'in the outward sign, an inner state' (Werner Hofmann).

It is certainly true that in the years 1888 and 1889 Gauguin achieved an especial intensity in reconciling symbolic content with Japanese-influenced visual form; but it takes a degree of wilful myopia to follow Mademoiselle Thirion in reducing the whole issue to seven paintings over two years, and in ignoring everything in his earlier and later work that belongs to the same context. As if Gauguin needed the help of Louis Anquetin and Emile Bernard before he could become Gauguin!

The interaction of decorative form and rhythmic movement fascinated Gauguin from the very start, and at once brought him under the spell of the *japonisant* Degas. In a painting of 1884, *Peonies* (private collection, USA), not only is the dancer adjusting her shoe in the background a 'quotation' from the older artist, but the whole composition is so asymmetrical that one is reminded of Degas' *Woman with Chrysanthemums* [34].

Gauguin's own *Still-Life with Horse's Head* [105] goes one step further. In the way

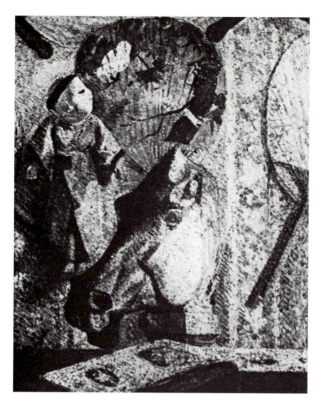

105
Paul Gauguin.
Still-Life with Horse's Head,
1887

in which it is assembled, in the disjoining of the objects and their fantastic, non-directional juxtaposition, it presents an entirely personal way of transcending reality. Spatially confined and compact, with a fairy-tale simplification of colour, this is an alternative world through which we glimpse a number of entirely prosaic oddments: a damaged horse's head, a fan, a doll. Nothing is illustrative; nothing can easily be read into the picture: and yet this is an allusion to the 'transient, fleeting world' – to borrow the meaning of the word *ukiyo-e.*

This is a work that could only have been painted by someone whose contact with Japanese art went far beyond Hokusai or Hiroshige; but it would be no easy matter to point to a specific source in the 'primitive' period. Still-lifes are extremely rare. And a greeting card (*surimono*), such as those by Sunman (suggested as a source by Siegfried Wichmann), would not have been accessible to Gauguin at that time: even Bing and Hayashi possessed none. All this only underlines the 'Japanese' cast of Gauguin's imagination and the extraordinary intuitive vision that was later to enable him to strike a primitive spark from the few remaining decorative motifs of the lost Maori culture.

By contrast with Van Gogh's empathetic involvement with the Far East, Gauguin was concerned with its essence. This painting may be regarded as a record of the Japanese inspiration on Gauguin for three reasons: because it corresponds to his

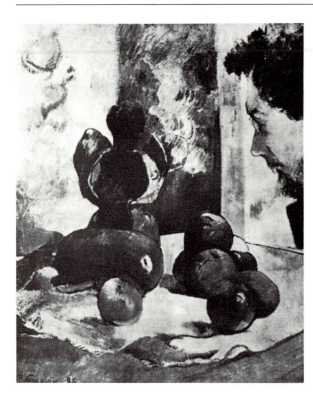

106
Paul Gauguin.
*Still-Life with the
Profile of
Charles Laval,* 1886

nascent 'fantasy of primal spontaneity' ('*Wunschbild der Ursprünglichkeit*', Werner Hofmann), a fantasy that is not necessarily all that primitive; because this combination of cropping, space, plane and discontinuity could have had no other source at that time; and finally because there is no good reason to exclude this long-undocumented, but signed, painting from the canon of his work. *Still-Life with Horse's Head* was to become a cornerstone of his visual approach before the temptations of literary Symbolism reached him. The proposed dating of 1885 should therefore be brought forward a little, to the end of 1887 or even the beginning of 1888. In those years, in which every month counts, his familiarity with Japanese prints grew at an incredible rate. For more than one reason, it would be entirely plausible to find him painting a work like this immediately after he returned from Martinique in 1887.

The transition from the influence of Degas to the vision developed here is plausibly bridged by the *Still-Life with the Profile of Charles Laval*, of 1886 [106] and the *Dance of the Four Breton Girls*, of the same year. Both still combine recession in depth with surface rhythm, a receding force with an upward one, objective reality with invented pattern, modelling colour with abstracting colour: in other words, both still juxtapose reportage and dream. Here Gauguin stands at the crossroads, still under the wing of his admired masters, Degas and Cézanne, but ready to enter a new realm that he conceives as 'the Primitive'. He found the way into this new realm not – as he probably hoped – through the visit to Martinique but through his growing appreciation of the Japanese prints that he saw in Paris.

Here he had all the opportunities that had become available since the 1883 exhibition: he had access not only to the collections of Bracquemond, who had helped him with his early ceramics, and of Burty, but in all probability also to those of Gonse and Goncourt. What, if anything, he saw of the collections of Degas and Monet (he had been exhibiting with the Impressionists since 1880) is not recorded. Among the dealers, he was in touch with Portier, with Theo van Gogh and with Theo's successor, Maurice Joyant. For any receptive artist of that time, it was actually harder to avoid *ukiyo-e* prints than to find them. He certainly did not, in any case, need the youthful Bernard to reveal the nature of Japanese art to him at Pont-Aven in 1888, whatever else he may have owed to Bernard in connection with the evolution of Cloisonnisme.

Gauguin's Japonisme thus showed itself as soon as he turned away from his early amateur painting, with its burden of illusionism, and allowed himself to be led by Degas to the source that confirmed him in his goal of 'Primitivism' and furnished him with the optical means to give it expression. He was feeling his way towards a new world of figuration, and it was the Japanese who gave him courage.

At the same time, however, there was a lurking menace of literary illustration, occult signification, a Symbolism without convincing symbols. Emile Bernard and Maurice Denis, lesser men than Gauguin, were not always able to steer clear of the pitfalls that lie in the path of a programmatic Catholic art in our age of religious doubt. And Gauguin himself, in many of his Tahiti paintings, was to indulge in portentous vernacular (Maori) titles of the sort that cry out for philosophical exegesis. The sceptical Pissarro remarked:

I do not criticize Gauguin for having painted a rose background; nor do I object to the two struggling fighters and the Breton peasants in the foreground ... I criticize him for not applying his synthesis to our modern philosophy, which is absolutely social, anti-authoritarian and anti-mystical. – There is where the problem becomes serious. This is a step backwards; Gauguin is not a seer, he is a schemer. (*Letters to His Son Lucien*, New York and London 1943, 164).

Japanese prints thus did Gauguin another service: they not only gave him the courage to develop his style in the direction of patterned structure, with all that entails; they kept him in check when The Symbol, mysterious and formless, threatened to lead him astray.

It may have been partly for this reason that he wanted not only to see his Japanese sources from time to time but to possess them as a kind of talisman and reference. From 1888 until his death – that is to say, for three-quarters of his significant career – he can be shown to have had Japanese prints in his possession. We have already mentioned the volume of Hokusai's *Manga* that he took with him to Pont-Aven; and he owned one Utamaro print that he valued as highly as one of his own paintings. He saw the newly discovered Utamaro not simply as the chronicler of the 'Green Houses' of Edō – which was how Goncourt was to see him – but as the master of a near-monumental figurative art, with a degree of stylistic simplification that came close to Gauguin's own idea of the Primitive. That Utamaro's art was a mature or even an over-refined one seems not to have bothered him; in Robert Goldwater's judgment

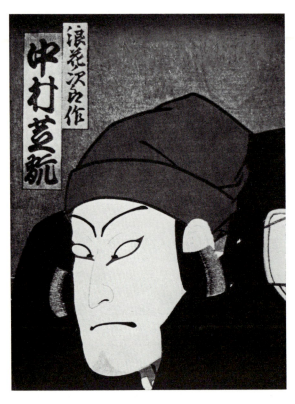

107
Utagawa Kunishika.
The Actor Sakata Hangoro, after 1830

(*Primitivism in Modern Art*, New York 1966), he never achieved an objectively correct view of the nature of primitive art. But that was his privilege as a creative artist.

From Rotonchamp's description we know that Gauguin was surrounded in his Paris studio by a 'whole frieze' of Japanese prints, and that these were by Utamaro, by Hokusai and by Kunishika, a follower of Kunisada. This chimes remarkably well with the tendencies that can be deduced from his own numerous *japonisant* paintings. Very broadly, from Utamaro he takes large figures which dominate the picture area; from Hokusai, smaller figures inset in landscapes or other settings; from the artists of Kunisada's circle, genre scenes. Their stylistic features, however, often cross over and mingle. But it would be pedantic and pointless to trawl his paintings, detail by detail, for Japanese motifs and then give the concrete source for every one. That sort of mechanical method is least of all applicable to Gauguin, whose aesthetic is precisely based on hints and allusions and disdains discursive description. That was the way he worked; but the intuitive approach did not prevent him from becoming a connoisseur as well as a user of 'kindred' works of art.

It is, however, possible to distinguish three distinct levels on which Japanese influence operates in Gauguin's paintings. The first is that of direct quotation, when an *ukiyo-e* print actually appears in the picture. It can also be an amalgam: in *Still-Life with Japanese Woodcut* (IX), he combines two originals to produce a more perfect harmony of rhythm and colour. First he takes the features and waving hair of the

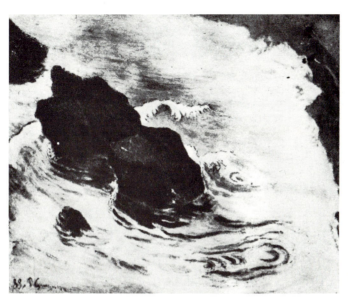

108
Paul Gauguin.
The Wave, 1888

actor from *Nakamura Shikan VI in the Role of Hige no Ikyû* (in the famous Kabuki play *Sukoroku*, 1861), by Toyohara Kunishika (1835–1900). The gesticulating hands and the forward lean of the upper part of the body are eliminated. To give more weight and emphasis to the actor's expression, Gauguin uses another work which he himself probably owned: *The Actor Sakata Hangoro* by Utagawa Kunishika (1786–1864, also known as Toyokuni III; 107). It is superbly set in its frame. Thus not one but two Japanese woodcuts went into the Western artist's still-life.

There are, on the other hand, numerous paintings 'in the manner' of a particular Japanese master. Here Hiroshige makes an appearance, alongside those already named. The definitive Japanese landscape artist, at least as far as influence in the West is concerned, Hiroshige had already had a revolutionary impact on Whistler and on Monet; and it was through Monet that he reached Gauguin. *The Wave* [108] is seen entirely through the eye of the Japanese artist [63]: top view, spatial cropping, reduced colour range, ornamented line, objects as demarcated patterns.

The symbolic, as distinct from the psychological, portrait was another conception that reached Gauguin from two directions: by way of Degas [34, 36] and by way of Utamaro [35, IV], as can be seen from a number of self-portraits and from the portrait of the painter Władysław Ślewiński [109]: the cropping of the image at the edges, the asymmetry of the structure, the break-up of spatial continuity through a simultaneous frontal and top view, and in consequence the imaginary, symbolic world in which the subject exists. A portrait of another painter, *Jacobus Meyer de Haan* [110], goes one step further in this direction, with its diagonal split in the pictorial space, its rhythmic organization, and its contrasting, elemental areas of colour. One has only to compare this work with Degas's use of a similar motif (*The Tub* [47]), to see how the abstract

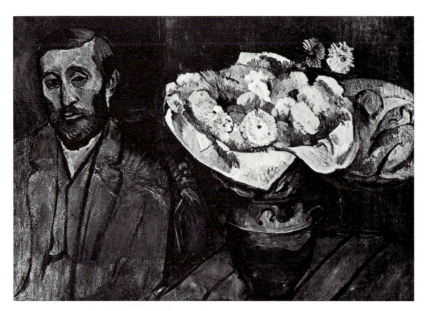

109 Paul Gauguin *Władysław Ślewiński*, 1890

110
Paul Gauguin.
Jacobus Meyer de Haan,
1889

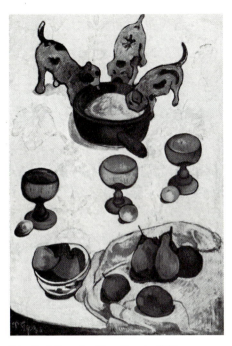

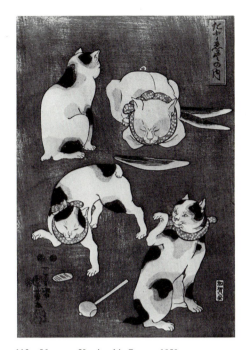

111 Paul Gauguin. *Three Puppies*, 1888

112 Utagawa Kuniyoshi. *Cats*, c. 1850

tension found in Utamaro, the decorative detachment, the play of curves and lines, have here contributed to a highly original pictorial expression. Not only the outer features are there, but also the mystic, daemonic essence of the sitter's slightly crazed personality.

Still-life took Gauguin further. There were no iconographical precedents for this in *ukiyo-e* – aside from a few *surimono* – and so this subject offered the greatest appeal and the greatest scope to his imagination, simply because here the choice of the object lies entirely in the artist's hands. Cézanne, among his own contemporaries, showed him the scope that still-life offers for breaking away from illusionistic depiction and building a world of one's own. But Cézanne famously declared that Gauguin did not understand him; and this was entirely mutual. For it is in still-life that the style, the personal vision, is most clearly marked, and so it was here that the two artists were, inevitably, poles apart.

In *Three Puppies* [111], Gauguin's Cloisonnisme, Japonisme and Primitivism appear in full clarity. Mademoiselle Thirion supplies a direct Japanese precedent, a print by Kuniyoshi [112]; if this is the source (and why not?), Gauguin's work clearly exemplifies the workings of inspiration as distinct from imitation. Kuniyoshi, the last belated representative of *ukiyo-e*, who remained active until 1861, presents us with more than a trivial feline scene; he conveys enough Oriental stylistic traits to appeal to the Westerner's exoticism: graphic two-dimensionality, the absence of shadows, the play of black patches on a light ground. But Gauguin has extracted and transformed all this. Relying on the cryptic significance of the number three, he divides the scene into

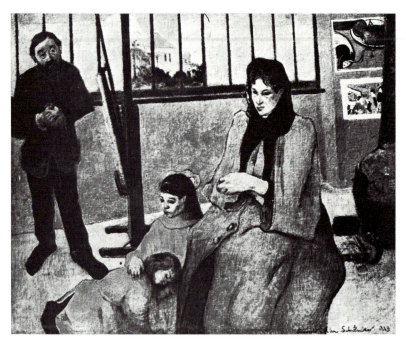

113 Paul Gauguin. *The Schuffenecker Family*, 1889

three zones. The idea of triplicity pursues us in the presentation of the puppies, the goblets, the apples, the leaf patterns, in the restricted palette, in the zigzag of the implicit diagonals, in the scale of the segmental curves, in the grouping (converging animals, goblets in a row, disc-like fruits). Instead of a window on the world, we are confronted with the magical interconnection of all things, manifested in a visual language for which the Japanese have supplied the grammar and the modern Symbolist the vocabulary.

With this formal creation, Gauguin opened the door to the poster style of the decade that followed, and simultaneously provided an extreme instance of his own anti-naturalism. There are not many others in his work. Did he perhaps admit to himself that – convincing though this is as an expression of the Primitive, and of primal spontaneity – Symbolism has lured him into a trap? For this work stands exactly on the frontier of the contemplative, the impenetrable and the abstruse. Literary exegetes came along afterwards to interpret the secret, and to identify the triad as the leaders of the Symbolist movement, Gauguin, Bernard and Denis, or the zones of life as vegetable, animal and spiritual; and whatever other mystical ideas blossomed under the aegis of the well-organized *Rose + Croix* movement and its prophet, Sâr Péladan.

Gaguin kept out of all this, and shortly after *Three Puppies* he showed himself in a completely new light, in *The Schuffenecker Family* [113]. It would be vain to look for hidden depths or occult significance in this work; indeed, he comes close to an

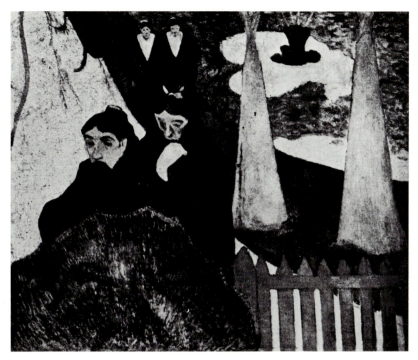

114　Paul Gauguin. *Women in the Hospital Garden*, 1888

existential view in this group portrait of the isolation of the modern individual. One automatically thinks of Degas [37, 40]: it was he who, with the help from the Japanese, had ventured on the first step, dispensing with the peepshow stage and the mere impression. Gauguin, however, was not merely continuing this process but marking a decisive shift towards abstraction, towards a rhythmic spatial organization and surface patterning. The curves sing: not like Utamaro's curves, but they do sing. The outlines vibrate; the verticals and horizontals underpin the architecture of the composition and determine the cropping of the objects. The colours are simple and severe: devoid of melodic charm, perhaps, but endowed with a symphonic richness, and with accents that no longer depend on illustrative criteria.

It is easy to see how the traditional idea of the group portrait has been shattered; harder to see the workings of a new discipline. The germ of the composition of Gauguin's later Tahiti paintings, and of those of the Nabis, is unmistakably present; but the deliberate Primitivism may still seem distracting, even chaotic. The good Schuffenecker is shown at half the scale used for his wife and children; he seems to hang in the studio space, frozen in his pose. What kind of chair or bench is the rest of the family sitting on? The state of existence that is formulated here is somehow pre-real. The subject is as if transported to a dreamland (Joseph Gantner), or, as Henri Focillon puts it (in *La Vie des formes*, Paris 1947, 158), this is one of those 'compositions without objects, combining objects that are de-composed'. It points the

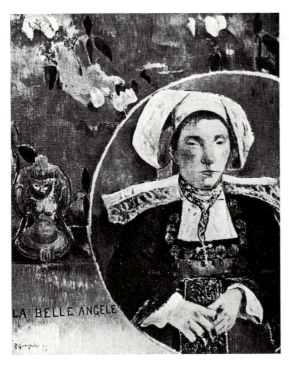

115
Paul Gauguin.
La Belle Angèle, 1889

way to the twentieth century, to the new (non-psychological) human image, the new space, the new discontinuity.

The counterpart of this work, transposed to an exterior space, is to be found in *Women in the Hospital Garden* [114]. In the distancing of an illusionistic representation, and in rhythmic and chromatic abstraction, it goes further than any of his other works, before or after. Might this be because it was intended as a challenge to Van Gogh, who painted the same subject in his own way at exactly the same time? This may be an argument, but it does not touch the core of the matter: the two artists were, and always had been, totally different. The fact that they shared a predilection for Japanese sources proves only that those sources served not as a canon to be imitated but as pointers to individual transformative creation. What Van Gogh found in Japanese art was not what Gauguin found there.

In this painting it is impossible to miss the Japanese-influenced stylization, but equally impossible to point to any specific Japanese artist as its source. However, anyone who looks through a succession of *ukiyo-e* prints of the mature classical period before 1780, the age of Shunshō and his predecessors, will find many examples of isolated rhythmic patterning and arabesque-like accents. It may be objected that similar features occur in other works of non-European art; but in 1888 these were either unknown or without influence. What is interesting about Gauguin's painting, aside from its formal aspects, is the ornamentalization of the figures, their incorporation in a system of stylized trees, fences and other objects which serve to distance them

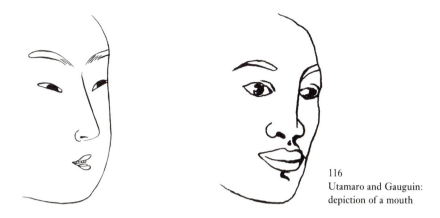

116
Utamaro and Gauguin:
depiction of a mouth

from psychological detail and integrate them in a world-view that is religious in the widest sense of the word.

The same tendency is evident in the famous *La Belle Angèle* [115]. The first to identify its origin was Van Gogh, who wrote on 5 September of the year in which it was painted, 1889: 'There is a portrait set down on the surface like the big head in Japanese *crépons*. There is the head-and-shoulders of the sitter and with it the whole background' (Letter 604). It was no coincidence that Degas, Gauguin's mentor in matters Japanese, then bought the picture.

The device of the painting within a painting, with its surprise format, is derived from Oriental fan painting. Always customary in the 'private' world of *surimono*, it underwent radical development from Shunshō onward, initially in its specialized traditional role and subsequently as a means of emphasizing the grotesque performance of an actor, his flight into the world of second sight. Gauguin adopted it as an alternative approach to the 'inner portrait'. If we compare the *tondo* form commonly used in the Italian Renaissance, as a symbol of perfection and completion, with this drastically cropped, compressed, icon-rigid figure, the extreme nature of Gauguin's enterprise here becomes evident. The contrast between areas of rich ornamentation and passage of bare colour gradually reveals the enormous mental tension that at first sight we do not expect to find in this Primitivist peasant portrait.

There is another symptom of Japonisme here: the formulaic simplification of the ears, nose and mouth. The illusionistic nineteenth century had seen an anatomically precise treatment of ears and especially lips; the Japanese, especially from Utamaro onward, developed shorthand signs for these parts that have nothing to do with the shapes that appear in a photograph. Any child can recognize an Utamaro print, without looking at the signature, just by the consistently identical drawing of the mouth. Gauguin, too, employed a formula in *The Schuffenecker Family* [113], although later, in Tahiti, he went back to physiognomical 'accuracy' [116]. In the formulation of his 'symbolic' human image, this artist exploited his Japanese sources to the limit. In Tahiti, other aims came to the fore, and he replaced one concept of 'Primitivism'

with another: for 'Primitivism' is what Gauguin always saw in Japanese woodcuts, for all their subtle refinement.

In still-life, the absence of a Japanese source and the admired achievement of Cézanne were probably the factors that stood longest in Gauguin's way. Even so, it is clear enough that in his conquest of this virgin erritory he used *ukiyo-e* prints as something of a Trojan horse. In *Still-Life with Japanese Woodcut* [IX], the two tendencies are still at war; two dimensions versus three, as it were. Kunishika's print of *The Actor Hige no Ikyu*, on the wall, was not in itself an iconographical novelty. There had been Japanese quotations in Gauguin's own previous still-life, as in *Apples with Vase* of 1888 (private collection, Zürich) and the *Vase of Flowers* of 1889 (Ny Carlsberg Glyptothek, Copenhagen). The marking of the horizon and the central axis, the forward and backward jumps, were anything but revolutionary. Only a viewer who concentrates exclusively on the motif – as critics so often do today – will see the Japanese face in the background as a sign of total conversion to modernity.

In fact, this work is only a prelude to that conversion, which it foreshadows more in its colouring than in its treatment of space. The flag-like division into a pink zone and a yellow zone, marked by red, white and blue accents, sets up a strange flickering, a restless wandering of the eye from one object to another, an almost mystical tension. And if we add to this that the flower vase, the Japanese woodcut and the 'Peruvian' pot symbolize the three pillars of Gauguin's art – the Cézannian past, the Breton present and the Tahitian future – the work is revealed as an emblem whose ramifications embrace the whole of his œuvre while maintaining the centrality of the Japanese element.

After this interlude, it is perhaps the *Still-Life with Ham* of 1889 [117] that most magnificently explores the inspiration of the Far East. Without a quotation, without a programme, without a technical influence, it embodies the spirit of the new tendency, a spirit that has been thoroughly absorbed. This explains why later, in the South Seas, Gauguin turned to other concerns: once he had achieved a perfect integration, he could at best continue it, but never improve on it. Here everything is conjoined: in formal terms, the planar space, the musical division, the transformation of the object into an arabesque with a strong presence of its own, the abstract rhythm, the decorative colour; in terms of content the enchantment of everyday things. All these are elements which had came to him from the Japanese experience, and which he was now able to transmute with total freedom. The symbolic content, the alternative reality, is entirely contained in what can be seen, and no 'explanation' is needed.

At exactly this stage in his career, and at the height of his powers, Gauguin underwent the crucial experience of the Universal Exhibition of 1889 and discovered the existence of the 'world art' that was presented there for the first time in history, with all its reflections of 'primitive' life and creativity. After Peru, Brittany and Japan, he now encountered the art of Java, Egypt and even Archaic Greece. His 'Romantic Primitivism', as Goldwater labels it, allowed him – unburdened by archaeology and ethnology – to pursue his own intuition and find the values that were important, even

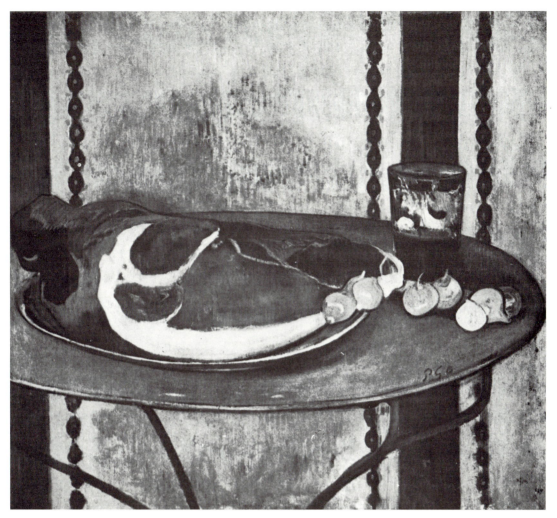

117 Paul Gauguin. *Still-Life with Ham,* 1889

vital, to him. In practical terms this means that Gauguin's initial concept of the Primitive was expanded to include a number of separate 'primitive' possibilities.

However, he never forgot the Japanese element; for him this had been, intuitively again, the first weapon that had come to hand to shatter the bonds of central perspective, foreshortening, cast shadows and tonal colour, and thus to transcend a superficial, sham reality. In his later work, there are constant traces of a stylization that would have been unthinkable without his Japanese sources, however much the overtones of the work may point in a quite different direction and reflect far stronger attractions from elsewhere. Two examples will suffice. The *Sacred Temple* of 1892 [118] ventures on a view in deep recession, but – as with Hiroshige – pulls it up against the foreground plane through an abstract, alienating, emphatic pattern.

118 Paul Gauguin. *Sacred Temple*, 1892

Nevermore [119], which bears the late date of 1897, is a work in which Gauguin seems, as so often, to be exposing himself to the perils of narrative folklore. Almost apologetically, he gives the following explanation:

Through a simple nude, I wanted to sugest a certain luxury from the barbaric past. The whole is steeped in dark, deliberately sad colours. No velvets and silks, no batiste or gold, convey the feeling of luxury: only the *matière*, made rich by the artist's hand. No bunkum . . . The human dream alone has filled the dwelling with fantastic life.

 For a title, *Nevermore*; not Edgar Poe's raven, but the devil's bird that lurks in wait. (*Lettres de Paul Gauguin à Georges Daniel de Monfreid*, Paris 1918, letter xxviii, 185.)

In order to convey an allegorical 'meaning' of this kind, he turned once more to the panacea of Japanese design. Where else could he have found a way to bind the rounded body to the picture plane between a rhythmically organized, ornamented back wall and a patterned foreground blanket? Without the Japanese example, how could he have contrived the interplay of the curves with the intersected verticals so as to lighten the philosophical burden? In this work, Gauguin has succeeded in infusing exoticism

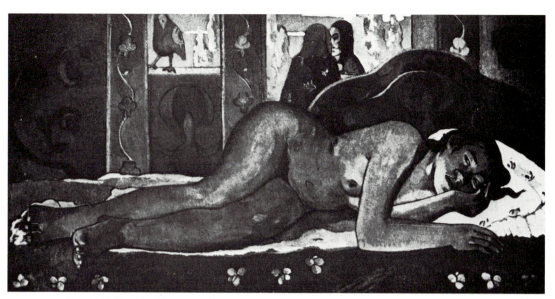

119 Paul Gauguin. *Nevermore*, 1897

with artistic expression, in bringing his own 'earthly paradise' convincingly close to the viewer, and in incorporating it in the edifice of modern art.

If Gauguin marks the consummation of the nineteenth-century Primitivist under-ground – its most prominent representatives being the Barbizon painters, a few followers of Ingres, the German Nazarener and the English Pre-Raphaelites – this is primarily because of his radical rejection of naturalism. But to do this required not only instinct, intuition and experience on Gauguin's part but also a theory, a group of fellow campaigners, the consciousness of a collapsing world, and above all unhackneyed sources. To find all these through his encounter with the Japanese vision, and to adapt that vision to create a 'modernist' Primitivism, even though in itself it is not a primitive vision at all: that was Gauguin's first great achievement. The second was that, once launched into this new world, he (almost always) resisted the lure of the illustrative and never lost sight of the compensating factor of style (in his case, the decorative).

The third, and in the present context the most far-reaching, of Gauguin's achieve-ments was his discovery of new depths in Japonisme. He incorporated not just a borrowed motif here or there, a gesture, a group of figures, a quotation; not just a new optic, abolishing the central axis together with foreshortening and peephole perspective; but above all a changed interplay of colour and form in themselves, an openness towards abstraction that led him into a realm of art that did not repeat external reality – did not even reproduce it – but coexisted with it in a state of sovereign autonomy. A new content evolved from the new form, not vice versa. And this was because he never – or only occasionally – relied on a single Japanese artist but increasingly kept in view the sum total, the *quintessence* of Japanese art, its

dialectical possibilities, from Utamaro to Kunishika: not in order to follow them but in order to use them as a springboard.

Gauguin opened a door to freedom, a door that led to Art Nouveau and Jugendstil first of all. Through tendencies as diverse as the Nabis, the Fauves and De Stijl, his work showed the way to the art of the new century. In the role played by Japonisme in the West, he was therefore the figure of the greatest strategic importance, and he became the founder of a 'revolutionary' – and often imperfectly understood – tradition.

When Count Harry Kessler, that herald of Modernism, was intending to discuss these and kindred issues in a lecture, his friend Hugo von Hofmannsthal wrote on 5 March 1907 to warn him off:

If you can, please avoid saying anything specific on Gauguin and painting, but range as widely as you can over the cultural situation at the present moment. That would be a relief. The time is not yet ripe – even for opposition purely on grounds of painting. (Hugo von Hofmannsthal and Harry Graf Kessler, *Briefwechsel 1898–1929*, Frankfurt a.M. 1968, Letter 147.)

9. Symbolism, Archaism, Japonisme

The discovery of Japanese woodcuts in the West was exclusively a matter of form; in consequence, only a formalist could suppose it to have been a central and decisive event in the evolution of modern art. That, at least, is one conclusion that might be drawn from the foregoing account of the subject; but it would be an entirely wrong conclusion. For form in itself reveals a new view of the world and of the interconnection of things. A changed representation of space implies – indeed, accurately reflects – a changed world-view, with all its contents.

Even Pierre Francastel, a sociologist of art who normally has little time for periodic classifications *à la* Wölfflin, is forced to concede that the rise of a modern art saturated with Japonisme represented a new departure, entirely analogous to the onset of the Renaissance, and that this held out the prospect of a total restructuring of life and art. As he puts it, the new space and the new pictorial language open up a new truth. The path thus leads from spatial perception to world-view and not vice versa: 'The fundamental discovery, which marked the real break, came at the moment when, as in the Quattrocento, artists discovered that the universe could no longer be expanded by replacing the picturesque décor but, on the contrary, by exploring its most intimate structures' (*Art et société*, Paris 1951, 163).

Modern art is not an instrument for the recording and illustration of some extraneous 'modern' substance: it is the model of that substance. Its visibility – as Konrad Fiedler realized a century ago – is itself a form of perception, an indispensable basis of any cultural identity. The structure of the visible must remain the point of departure, not by way of limitation to formal concerns but in order to grasp how this or that content can be attached to it or integrated within it. This applies particularly to a period of transition and transformation, such as the one under discussion.

The artists were in fact the first to sense the direction in which the modern age was moving. As Francastel rightly says, they made the transition from a descriptive universe to a universe of signs, an *univers chiffré*, which achieves unity, 'suggestively', only in our imagination. Space as form is not a timeless datum but is constantly being reinvented or recreated. Instead of embracing the whole, modern civilization concentrates on the parts and their interconnections. The old scenic space – illusionism – has given way to a conception in which the 'mystery of detail' is there to be explored and a new pictorial language must be evolved. We have seen how this imperative applied first to the pioneers – Manet, Whistler, Degas and Monet – then to the four Post-Impressionists, as they made their discoveries in a logical and of course unconscious progression.

Some artists treated Japanese art as just another exotic stimulus; but those who mattered were those who progressed from motivic sources and elements to a new integration: from the Japanese stimulus to Japonisme. And integration in this sense is the *Leitmotiv*, the criterion by which the countless external demands on art should be judged and the various programmes understood.

Symbolism

I have already spoken of Symbolism. To some degree, all art that goes beyond *Trompe-l'œil* is symbolic; every touch of fantasy points in that direction. In Bosch or in Goya, symbolic content does nothing to impair artistic quality. Gustave Moreau, however, who seeks to persuade us – in Degas's deadly phrase – that the Gods of Antiquity wore heavy gold watch-chains, remains trapped in the kingdom of Ersatz, a laughing-stock to a legion of artistic cripples. The symbolic and the Symbolistic are by no means identical.

When a number of writers, including Jean Moréas, Albert Aurier and Charles Morice, endeavoured to align literary Symbolism with painting, and even with music, something curious happened. If Symbolism was to be an autonomous movement, and not simply a new name for an old thing, it needed to rest upon a theory or a doctrine, whether explicit or implicit. This created a dilemma. According to Joseph Bédier and Paul Hazard, authors of a fairly authoritative literary history (*Histoire de la littérature française illustrée*, Paris [1923–4] 1955), there were, in fact not one but three currents within Symbolism:

(1) those who shattered the old poetic form, from Tristan Corbière to René Ghil
(2) those who pursued the mystery that resides in ordinary language, from Verlaine and Rimbaud to Francis Jammes
(3) the engineers of pure poetry, from Mallarmé to Valéry.

Guy Michaud, too, who devotes a three-volume work to the poetic message of Symbolism (*Message poétique du Symbolisme*, Paris 1947), refers to a number of tendencies which he sees as finally united in the 'discovery of the formula'.

This would seem to offer an exceptional opportunity to reveal the structural relationships between those tendencies and to press on from there to parallel structures in other Symbolist arts. Such a unified theory of Symbolism would enable structural links to be traced not only from literature to visual art but also from art to literature; without it, art would be relegated to the status of a merely ancillary, illustrative activity. Unfortunately, however, all attempts to do this have foundered in the morass of individual biography. The issue, for instance, of the true relationship between Gauguin and Morice, the co-author of *Noa-Noa*, remains unclarified.

The truth is that the whole problem of the relations – if any – between artistic and literary Symbolism has still to be faced. We learn that Mallarmé 'encountered' Redon, Gauguin and Vuillard; but his equal, if not greater, receptivity to the Impressionism

of Manet and Berthe Morisot is not mentioned. Whether Gauguin, Bernard, Redon or Puvis de Chavannes represents the purest embodiment of Symbolist values, and to what degree: all these are fundamental questions, and while they remain unanswered the whole issue of Symbolism in art remains in suspense. It is possible to name individual Symbolists; but Symbolism itself is a chimaera. Maurice Denis was able to look at the whole complex with the eye of hindsight and twist it into a form of 'Traditionalism'. Perhaps Paul Verlaine, himself a Symbolist, was right when he declared: 'There are as many Symbolists as there are symbols. The symbol is a metaphor; it is, simply, the Poetic.'

The only attempt to go beyond the level of mere biography was made by Albert Aurier, in his much-quoted essay on Gauguin in the *Mercure de France* for 1891. When Aurier called for the work of art to be 'idea-oriented [*idéiste*], Symbolistic, synthetic, subjective and decorative, all at once', he was pointing in the right direction; but his article gives us only the headings, for which the text is lacking. Instead of an analysis of visibly present works, Aurier offers nothing but an arid deductive process. We are not shown the issues that confronted the artist – Japonisme, for instance – or his immediate objectives; instead we are shown his ultimate, and perhaps his loftiest, goals, as they might appear to the visionary gaze of an Emanuel Swedenborg, in a sphere in which objects truly become signs, 'letters in a vast alphabet which genius alone can decipher' (Albert Aurier, *Œuvres posthumes*, Paris 1893, 213).

Aurier's article represents a beginning, but no more; and he overshoots his target by considering the end in isolation from the means. If we turn Aurier's axioms back to front – so that the decorative stands first, followed by the subjective, the synthetic, and so on – it becomes possible to appreciate the primary role of Japonisme, and of the 'Primitivisms' that followed it: without them, no Symbolist and *idéiste* art would ever have been possible. As is well known, Gauguin accepted the idea of a process of *synthèse* only with a touch of mockery, calling it *sintaize*.

And what of another exposition, that given by Paul Sérusier when he passed on the message of Gauguin to the Nabis? His *A B C de la peinture* admittedly dates from a late period of his life (Paris 1921); in it, the early gospel of Pont-Aven tends to be crowded out by the sacred geometry of ancient Egypt, as interpreted by the School of Beuron. Even so, Sérusier has retained four fundamental principles, further emphasized by Maurice Denis in his substantial commentary. These are:

(1) a rhythmic arrangement of the colours on the picture plane
(2) a commitment against naturalism and in favour of the primacy of composition and feeling
(3) characterful drawing, including the decorative arabesque and caricatural exaggeration
(4) bright, clear colours in the harmony of neighbouring, not complementary, tones.

Sérusier approached spiritual meaning not through the content of the painting – its theme – but through its formal structure. For he knew: 'Good thoughts and good qualities can be presented only through their formal equivalents. Only an artist can

perceive them. Everyone is born with this ability; personal effort can develop it, but a bad education can destroy it.'

Art must therefore be not Symbolistic but symbolic: 'Art is a universal language which expresses itself in symbols.' Rightly, Sérusier refused to overstate the oft-invoked ability of the various arts to shed light on each other (Oskar Waltzel's 'reciprocal illumination'): 'There were symbolistic, that is idea-oriented artists and musicians; there was an age and a climate favourable to the Ideal, and from these the Pont-Aven painters derived a stimulus.' But no more: 'The literary aspect of painting can exist only as a pretext; wherever it predominates there is a decline into mere illustration' (*A B C de la peinture*, 23, 33, 39, 51).

To us, such statements may look like truisms; but there existed then, as now, tendencies in art whose theory and practice alike show that Sérusier had good cause to write as he did.

When we apply his categories to our present theme, it emerges that the pictorial structures derived from Japan, in plane, form and colour, had a much more decisive and constructive influence on modern painting than any ideology. The Modernist revolution was not made by the programmes of Impressionism, Post-Impressionism, Symbolism and the rest: these were ancillary phenomena at best, although they certainly paved the way for the acceptance of new subject-matter. Similarly, visual art acquired its kinship with literature, theatre, philosophy, technology and so on, as well as its relation to a new public, not from chance encounters and other accidents of biography but from the structural correspondences first sensed by Baudelaire.

The misunderstanding sprang from the fact that, perhaps inevitably, these innovations could not be described otherwise than as *deviations from an illusionistic norm*, such as abstraction, distortion, fragmentation, discontinuity, unfinishability. From the outset, they were thus burdened with negative epithets that failed to reveal adequately what was new, revolutionary and creative in them. Their positive aspect, which is a matter for structural analysis, was first obscurely sensed and then gradually recognized as it became clear that the message of Japanese art was something that needed to be integrated in the work at a basic level. This was the foundation on which the new art would be built.

But, it will be objected, how can the Japanese element have been responsible, when a similar transformation was evident in literature, the theatre and other fields? The answer has already been given, implicitly, a number of times. This is not a matter of adopting and copying the motifs, the content or the final forms of Japanese art, but of interpreting and sometimes misinterpreting them with a view to their integration in European art. This was a renewal, a process by which the static illusionism of centralized perspective was transcended. Parallel tendencies were certainly present in other areas of culture: they can be traced in language, music and philosophy, where they also promoted structural dislocations; but all had one thing in common: they were nourished by sources outside the recent tradition of Western civilization. If a common basis for them has to be defined, then it will be found in the terms 'Primitivism' and 'Archaism'.

Archaism

The recourse to the East, in the crisis of Western art, sprang from a desire to return to source, to rediscover a primal spontaneity. The *ukiyo-e* prints satisfied that desire, because they were considered 'primitive', whether they actually were or not. There is abundant evidence for this. Suddenly there was a way of seeing, and of interpreting what was seen, that departed from the entrenched schemata of academic tradition.

Archaism manifested itself in many ways just at the moment when its first wave, known as Japonisme, was making itself felt; and the artistic upheavals of the late 1880s find an echo in many related fields. Art history itself was discovering new and 'archaic' areas of interest. Gaston Diehl's work, *Ravenna*, was the first to open up the field of Byzantine art and its problems, to regard the abstracting flatness of the mosaics not as the result of a lack of ability to imitate, a decay of the naturalism of the ancient world, but – almost – as a valid principle in its own terms. Diehl's publication date of 1886 coincides beautifully with Seurat's adoption of a mosaic-like style. Which is not to imply that the pictorial form was directly influenced by the book.

In classical archaeology, too, the focus of interest was constantly moving farther back, from the fourth to the fifth and finally to the 'Archaic' sixth century B.C., until, by the turn of the century, Egyptian art, with all its abstractions, was vastly admired, if not actually ranked higher than classical art. As early as 1890, Edmond Pottier ('Grèce et Japon', *Gazette des Beaux-Arts*) had likened Greek vase-painting to Japanese woodcuts. He saw in both a two-dimensional style that deliberately held aloof from illusionistic conceptions.

The Viennese school of art history was active in the same decade. Franz Wickhoff and, even more markedly, Alois Riegl (*Stilfragen*, 1893), take the art of Late Antiquity and the Early Middle Ages as their point of departure, but this leads them on to a review of the artistic values enshrined in a wide variety of styles. The monopoly of the Graeco-Roman and Renaissance traditions, based on illusionism in three dimensions, was broken, and the criterion of one-track evolutionary progress was abandoned. Riegl defined the work of art as the 'result of a specific and purposeful *will to art*, which prevails in a conflict with utilitarian function, with raw material, and with technique' (*Stilfragen*). He aimed to establish concrete categories of value that would transcend the individual; and beyond them he looked for immutable laws of evolutionary change. He succeeded in defining a series of concepts that made it possible to compare the styles of different periods and to eliminate qualitative distinctions between them. In this pluralistic view, no style could any longer be defined as primitive or as decadent, and thus as necessarily inferior.

When Riegl applied his criteria to the contemporary situation, it was not difficult to identify and assess the stylistic change that was taking place. In 1904, in an article on 'Art-lovers, Ancient and Modern', he analysed the 'optical subjectivism' (i.e. Impressionism) of the recent past and continued:

I am convinced that art will call a halt even before an extreme is reached; and the symptoms of this are already evident. Can it be a coincidence that such an artist as [Jan] Toorop – for whom, more

than anyone, the thing to be represented evaporates into a pretext for a mood – endows these things with external forms derived from Ancient Egyptian art, which represents the diametrical opposite of modern optical-subjectivist art, namely naked tactile objectivism? How are we to explain the fundamental role of line – the basic tactile element – in modern decorative art, except as an instinctive attempt on our artists' part to compensate for an extreme of arbitrariness on the one side by an equally extreme rigour on the other? ('Über antike und moderne Kunstfreunde', *Gesammelte Aufsätze*, Augsburg 1929, 205–6.)

Riegl thus seems to have been the first not only to see the (allegedly incomprehensible) intentions of modern art as a whole but to justify them in the context of art history. To borrow from a 'kindred' tendency remote in time and space – and Ancient Egyptian or Japanese art would both count as 'archaic' – is to him not a sign of weakness or a mere coincidence but the result of an inner necessity. Archaism thus appears in a new light: as the engine of a necessary stylistic change. It is significant that Archaism as seen by Riegl is rooted not in some vague cosmic sentiment *à la* Rousseau but in the structure and the essence of art itself. This constitutes Riegl's overwhelming importance; and his ideas, though watered down in many different ways, long remained influential.

The view of Japonisme presented here, which sees it as an early stage of Primitivism, is completed and confirmed by two figures, Odilon Redon and James Ensor, who never actually adopted a specific form of Archaism, and who were thus enabled to see the Far Eastern gospel in a completely different light. Neither of them ever sought to escape from the world of foreground appearances through a visual grammar revised with Japanese assistance. They were not, initially at least, inspired by a new vision of space, colour or form but by their own sensibility: a psychic substance, so to speak, which projected itself onto what was seen but also onto the literary and musical realms. Both, for all their differences, had a number of things in common. The written word and the sound of music came naturally to them; both were deeply committed to Edgar Allen Poe's kingdom of the imagination; and both found that expression in graphic media came naturally to them. On the way from their invisible visions to visible artistic form, both found their way to Japanese art. But with them it is seen from the other side: the daemonic quality, the magical metamorphosis, is their primary concern, and spatial dislocation is only a consequence.

Odilon Redon (1840–1916)

An inward-looking artist, Redon waited to be overcome by 'inner turmoil' ('l'ébullition mentale', his own phrase), surrendered to his nightmare, and only then turned to the specific sources of forms that people his airless spaces with incongruous figures: flying heads, chimaeras, creatures between heaven and hell, between planet and beast. In his earliest cycles of lithographs, elements of the European iconographic heritage, from the early Italian painters to Goya and such French Romantic illustrators as Grandville, merge into a stylistic *pot-pourri* (this is not intended as a criticism of its quality).

120 Odilon Redon. *The Breath that Impels Living Beings,* 1882

This pattern is startlingly broken by two prints that involve clear spatial distortion and fragmentation of objects: *The Angel of Certainties* and *The Breath that Impels Living Beings* [120], from the series *To Edgar Poe*, of 1882. Where does this come from? When we find in subsequent works an ever closer succession of bolder and bolder imaginative creations – dream figures coined with total conviction, logic in illogic – then the source of the artist's inspiration is no longer in doubt: once more, it is Japan. Compare *Then There Appears a Singular Being ...* [121], of 1888, with Hokusai's woodcut *The Spirit of Sarayashiki*, 1830 [122].

Caricature has its source in the essence of the fantastic, and leads in turn to the paraphrasing, distorting and transposing of the 'natural' into the supernatural and the infernal. In caricature, the characteristic detail is extracted and projected with expressionistic exaggeration. In the late nineteenth century, having remained a tolerated 'minor art' within the Western tradition ever since Leonardo and Dürer, caricature received a new impetus from the rising tide of anti-naturalism. A print by Hokusai, such as the one shown in plate 122, opened up a new dimension: it came as a messenger from a less disenchanted, less industrialized world, and evoked a grand,

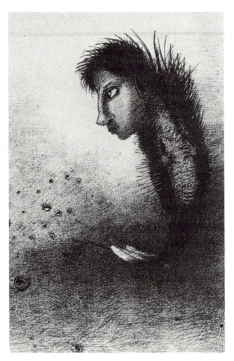

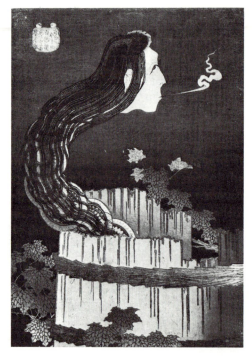

121 Odilon Redon. *Then There Appears a Singular Being with a Man's Head on a Fish's Body*, 1888

122 Katsushika Hokusai. *The Spirit of Sarayashiki*, 1830

spontaneous *frisson* that the West could not achieve. It was less of a conscious, synthetic construction, because its cultural context made it more credible. The spirit of Sarayashiki was not a figment of anyone's imagination: he had really come back from the dead.

It is no wonder that Redon kept as close to the daemonic 'reality' of the image as ever he could. His Japonisme sprang from the object, and not, as with other artists, from a concern with a new conception of space, or with the ready-made anti-illusionism of the 'archaic'. This is not to say that he was unaware of the work of his avant-garde colleagues, Seurat and Gauguin above all; but his primary emphasis was different. It is true that Redon went on to make the two-dimensional treatment of space more and more his own; but he never made it a dogma, and exceptions remained possible. On the one hand, the decorative principle rooted in the artistic innovations of Seurat and Gauguin found a continuation in the 'painterly' art of Fauvism; on the other, the expressive intensity of Redon's drawings showed the way to Expressionism and Surrealism. Both tendencies drew nourishment from the Japanese woodcut, but what they took from it differed, and was differently seen.

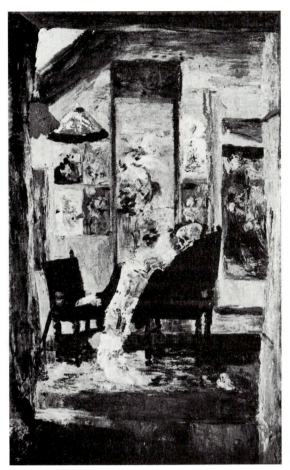

123
James Ensor. *Skeleton Looking
at Chinoiseries*, 1885

James Ensor (1860–1949)

Although his output as a painter was considerable, Ensor's roots lay in drawing and printmaking. He grew up with Japanese woodcuts, which were sold in his mother's curio shop in Ostend alongside seashells and souvenirs of all kinds. The idea of using them as a source of artistic inspiration could not occur to him so long as he maintained his early preoccupation with atmospheric light conditions in landscapes, seascapes and *intimiste* interiors. What was it that made him turn, at the age of twenty-five, to fantasy, grotesqueries, and graphic abstraction? Awareness of a haunted universe (Jean Cassou), or of the two aspects of existence, visible and magical? What lay behind this interpenetration of dream and reality? For Ensor never abandoned his loyalty to concrete physical substance. No biographer has been able to supply a psychological, let alone an artistic explanation.

The fact is that his breakthrough to a brighter painting style, incorporating his central symbols of the mask, the skeleton and the Japanese object, exactly coincided

124 James Ensor. *The Temptation of Christ*, 1888

125 Detail of preceding illustration

with the onset of his astonishing output of prints: over a hundred in a single decade, at the end of which his work began to disintegrate, although he soldiered on for another half-century. Ensor's painting *Skeleton Looking at Chinoiseries*, of 1885 [123] stands on the borderline, exactly at the beginning of the crucial period. The Other World emerges from the forms of this world through the oddness of the formats, the faded colours, the magical atmosphere. The Japanese accessories in this work (not Chinoiseries at all) are like the keys to an alternative realm, and the whole dreamlike scene is rendered in graphic, angular terms.

It therefore comes as no surprise to find the artist taking a step further, one year later, in his graphic work. Increasingly, his line makes it possible to approach objects not by tracing round them as outlines, but by making them transparent through their inner structure; by subordinating them to a language of signs which transposes them onto another plane of reality.

The Temptation of Christ [124] dates from 1888, probably the high point of Ensor's artistic career, the year of his major painting, *The Entry of Christ into Brussels in the Year 1888* (J. Paul Getty Museum, Malibu, California). When a detail is isolated from this tiny print (80 × 120 mm/3.1 × 4.7 in.) and looked at with the magnification

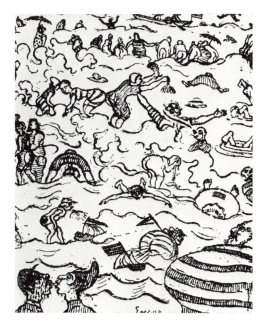

126 James Ensor. *Bathing at Ostend*, 1899

127 James Ensor. *Devils Assailing Angels and Archangels*, 1888

of the inner eye [125], the resulting vision seems to have little or nothing in common with the original townscape. These arabesques, pothooks, curves and circumflexes are almost like Japanese characters; and, in a completely different sense, they open the gates of the underworld. It is not too much to ascribe the origin of this linear system without outlines to Japanese inspiration, and specifically to that of Hokusai [98]. Van Gogh had already made use of this; but Ensor, with his unmatched graphic skill, had here gone much further and turned the Japanese inspiration into an incomparable achievement of his own.

Incomparable, also, in that he could not maintain such intensity for long. In the print *Bathing at Ostend*, of 1899 [126], the tension is lacking, and the scene reverts to reportage and illustration. The gates of the mystery of objects and beings were now closed; for Ensor, they seldom if ever opened again.

His vital influence on a number of the greatest draughtsmen of our century, including Paul Klee, Alfred Kubin and George Grosz, stems from the etchings he produced during the brief period when he was truly a man obsessed. He was obsessed by the promptings of Japan, and obsessed by an interpretation of reality that looked through the skin of illusionism to the struggling creature beneath in its agony or its triumph. This daemonic Expressionism of Ensor's is magnificently evident in the etching *Devils Assailing Angels and Archangels*, of 1888 [127]. As the subject demands, it combines the wildest fantasies of a Bruegel with the richest texture of form and line, but with a sense of two-dimensionality that was unknown before the advent of Japanese art.

10. The great Parisian collections, 1878–1905

Nineteenth-century Parisian collections of Japanese prints were very different from those that were scattered across the rest of the world. Elsewhere such collections were curiosities; in Paris they were the expression of a refined and modern artistic taste. Elsewhere they may have owned their existence to the ethnographic or botanical interests of an isolated scholar; Paris witnessed the sociocultural phenomenon of keen competition on grounds of artistic quality.

Collectors of art were nothing new. Collecting was an aristocratic sport that the monarchs of past centuries had handed down to their bourgeois successors. The nineteenth-century age of enterprise, with its historicism, Romanticism and exoticism, and its burgeoning prosperity, opened up one new area of collecting after another. When the Far East at long last became accessible, it was inevitable that Japanese art, and the easily portable colour prints above all, would stream into the West.

Looked at from the outside, this makes sense in terms of mercantile politics. But it was not quite so simple as that. Where Japan was concerned, the export trade in art depended on many other factors. And its incomparable flowering in Paris in the last quarter of the nineteenth century had other sources that went far beyond the narrow world of art collection. One need only think, by comparison, of the present-day situation in America, where magnificent collections of Japanese art have found their way into the Boston and Chicago museums, and where they inspire no Japonisme in present-day art. We read in a catalogue of 1971: 'The notion has gained currency in recent years that *ukiyo-e* is a static field, that everything there is to be known about it has already been said. As a result, young people are not entering the field' (exhibition catalogue, *Ukiyo-e Prints and Paintings*, Art Institute of Chicago, Chicago 1971, 30).

What is unique in Paris is the interaction of discerning collectors, intelligent dealers, enquiring artists, sympathetic critics, and the whole cultivated, high-strung atmosphere of the 'Capital of the Nineteenth Century'. The fact that this historic opportunity remained open for as long as it did – thirty years – and that so many individualists were able to coexist so harmoniously verges on the miraculous. It is significant that one of the principal figures involved, Henri Vever, described himself in the report of a governmental art committee not as a 'collector' but as an *amateur d'art*; this was almost an aristocratic privilege. It is equally characteristic that such figures as Burty, Goncourt, Bing and Hayashi should have already come to our notice in other contexts, as critics, writers and agents.

It comes as a surprise to find that, in the wake of such varied calamities as the lost war of 1870–1, the economic depression of 1874, the stock-exchange crash of 1882,

the Boulanger scandal of 1889 and the Dreyfus affair of 1898, Japonisme as a formal entity survived unscathed. Entity is the only possible word for it: it was typified by its lack of any kind of organization. Although it is certain that every individual Japoniste knew and consulted many others – and they all lived within a very few square miles in the heart of Paris – not everyone knew everyone else. The only occasion on which almost all of them assembled in one place at one time was at the very end: when the great collections were auctioned off in the early years of the present century.

How did Japonisme come to evolve so rapidly, last so long, and inspire so many to active participation as collectors? There is more than one answer to this. First there were the personalities of those involved. The prevalent type among them possessed four characteristics to a marked degree: entrepreneurial spirit, a developed artistic sensibility, a nose for coming trends, and an appreciation of decorative ensemble. The only parallel, a very loose one, might be with the founders of the *Werkbund* in Central Europe a generation later. For these Parisians were as firmly grounded in the world of craftsmanship as in that of art; perhaps without realizing it, they were looking for a bridge to link the two. They admired Japanese ceramics, precious lacquer, exquisite metalwork from sword-hilts to jewellery; and all these were represented in their collections alongside prints. They chose their objects for quality, rarity, luxury.

Profiles of four principal collectors will exemplify the overall picture.

Charles Gillot

Gillot began his Japanese collection only in the 1880s; Goncourt, in the private journal in which he never minced his words, described it as 'the most perfect, the most refined' of all (16 December 1895). Gillot created the first total representation of *ukiyo-e* art, incorporating the best prints of the great masters, in all phases of development and with a particularly significant emphasis on the previously often overlooked 'primitives'. Where else could one have seen 28 works by Moronobu and 70 by Harunobu together? The 'classical' stage was equally well represented, with 55 Kiyonagas, 62 Koriyūsais and 106 Utamaros. But to find no less than 27 of the rare works of Sharaku is amazing: this 'expressionist' artist was long neglected, especially in France. Hokusai with 193 prints, and Hiroshige with 76, gave an excellent impression of the work of those two late masters. As quality is not measurable, one can only rely on the judgment of the experts of the time; but the character of a collection is importantly revealed by the coverage of the various periods within it. Gillot had 470 late works, 596 'classics' and an amazing 247 'primitives'.

This reveals the change that had taken place in the taste of this second generation, not only the growth of knowledge but the shift of emphasis to the early period, the pre-illusionistic forms of representation that chimed so well with the work of the avant-garde in France. In the absence of comparative criteria of value, Gaston Migeon tells us, the earlier collections of Burty and Goncourt were based simply on the collectors' subjective choice: the giant figure of Hokusai still put all the others in the

shade, and the meagrely represented Moronobu (five prints in Burty's collection) was dismissed as 'still rather archaic', i.e. wooden. Burty's assessment of the successive periods, as reflected in the purely quantitative balance of his collection, was the reverse of Gillot's: he had 535 late works, only 54 'classics' and 35 'primitives'.

A comparison with the figures for Gillot's collection will give a clear picture of the nature of the second wave of Japonisme, which he represented. The growth of interest in the earlier, pre-illusionistic artists found a parallel in the endeavours of the French avant-garde to escape from illusionistic representation and to achieve both style and stylization. The discovery of the Japanese 'primitives' opened the way to Art Nouveau, Jugendstil and the new century.

Who was Charles Gillot? What was it that gave him the ability to blaze a new trail? He was the director of a leading art-printing house which was involved in superseding the steel engraving and in pioneering modern techniques of reproduction. His father, Firmin Gillot, was famous as the inventor of *gillotage*, the technique on which the etched zinc process block, with its comparatively accurate reproduction of colours, is based. Charles Gillot put this technique at the service of Japonisme, and his reproductive work included all the illustrations for Bing's *Le Japon Artistique*. These are of a quality that remains entirely acceptable today, almost a century later.

In 1894, to make Japanese art available to a wider public, Gillot published eight albums of examples from his own collection, arranged according to subject: plants, flowers, birds, animals and fishes. This suggests that the appreciation of the Japanese artistic vision had spread outward from the elite and the avant-garde and had become an object of popular education.

Gillot was praised as one who recognized the power of the 'sacred character', the archaic and the robust, wherever it appeared: in early *ukiyo-e* works, in ancient Buddhist sculpture, in masks, in lacquer paintings or in Assyrian relief sculptures. In those decisive years of the 1890s, he occupied a vantage-point from which he could survey – and almost combine into a unified perspective – an advanced capitalist manufacturing business, efficient production methods, an artistic taste that went beyond historicism and even reached the art of the avant-garde. Gillot's secure grounding in Japanese art remained at the core of all his varied initiatives; it also coloured his personal relationships. He was a frequent dinner guest of Bing's, together with his fellow collectors of Japanese art, Vever, Koechlin and Migeon, and the painters Whistler, Albert Besnard and Frits Thaulow (Gauguin's brother-in-law).

It may seem surprising that Gillot, a man of far from unlimited means, was able to build so magnificent a collection: the truth is that he made a very early start, under the impact of the 1878 Universal Exhibition, and that he was, above all, the classic instance of the collector who hardly ever puts a foot wrong. Although he was in constant touch with the 'experts' – the dealers and the critics – and asked their advice in individual cases, the decisions that governed the growth and direction of his collection relied on his taste and judgment alone, at a time when the field of choice was almost unlimited.

The Gillot collection was dispersed at an auction in 1904, followed by another in

1908. In size, in price-levels and in fame it did not equal the Hayashi auction shortly before, but it certainly played a more important part in the spread of Japonisme. The Gillot sale was the signal for the process by which most of the major private collections left Paris within a single decade. Central Europe and America now entered the field. The Berlin museum collection, for example, acquired most of its finest pieces in this way, and more than one German private collection received a major impetus. In short, the whole world reaped the benefit of Gillot's zeal as a collector. There is probably no major collection of Japanese prints today that does not contain at least a few impressions formerly owned by him.

Henri Vever (1854–1942)

The opposite fate befell the works collected by Vever. They temporarily disappeared from view. Moved from Paris to Bordeaux during the First World War, the collection apparently passed as a whole, sight unseen, to Baron Kojiro Matsukata, who presented it to the National Museum in Tokyo. Matsukata was an industrial magnate whose motives, according to James A. Michener, were not so much artistic as patriotic. He collected not only Japanese art but also the most superb works of the French Impressionists, a fact for which Claude Monet, his neighbour at Giverny, was largely responsible.

The experts rated the Vever collection as highly as any of its great contemporaries, although this is hard to substantiate from documentary evidence. No catalogue ever appeared, whereas the auction lists of the Hayashi, Gillot, Barbouteau and Rouart collections (together with the catalogues of Koechlin's exhibitions of 1909–14) have remained the prime records of Japonisme in Paris. With 8,000 items, Vever's was certainly the largest nineteenth-century collection (comparative figures: Barbouteau 3,000, Hayashi 1,800, Gillot 1,300 plus, Rouart 1,000).

There is, however, no need to travel to Japan to gain an idea of this collector's enthusiasm and of its particular intentions. The evolution of his taste can actually be reconstructed from Parisian sources. Early on, exactly eleven years after he started collecting, 227 of his finest pieces went on show at the 1892 *Salon des Champs-Elysées*. Although the best-represented artists were still Hokusai, with 31 prints, and Hiroshige with 24, Utamaro was close behind with 22, and the trend towards the earlier masters was already evident: 20 Haronobus, eleven Shunshōs, four Toyonobus. It is significant that even at this early stage there were also five Sharakus: much was to depend on this name in the years that followed.

Sharaku had been completely absent from Burty's collection just one year previously; and in Bing's great exhibition, *Maîtres de l'estampe japonaise*, at the Ecole des Beaux-Arts in 1890, he was represented by five albums – all from Bing's own gallery – and two separate prints. Were these bought by Vever? It seems that one of them certainly was: *Two Actors in Female Roles* was reproduced five years later in Woldemar von Seidlitz's *Geschichte des japanischen Farbholzschnitts* (Dresden 1897; 2nd edn 1910), with an acknowledgment to Vever. This book remains the richest source of

documentation of the quality of Vever's collection: forty-six items are produced, mostly from the early period. Clearly, Seidlitz, a highly competent judge, considered them the best available. P.-A. Lemoisne, in his outline of the subject, *L'Estampe japonaise* (Paris 1914, with thirty-two illustrations), was another author who drew upon the Vever collection.

A clearer overall view of the collection may be derived from the catalogues, inspired by Raymond Koechlin and compiled by Charles Vignier and M. Inada, of the six great *ukiyo-e* exhibitions at the Musée des Arts Décoratifs in Paris shortly before the First World War (*Estampes japonaises au Musée des Arts décoratifs*, Paris 1909–14). These volumes reflect the sunset glow of a heroic age. Everything of enduring value that remained in France after the dispersal of several major collections (Burty, Goncourt, Hayashi, Gillot, Barbouteau, Rouart) was displayed from the viewpoint of a new generation and commemorated in these monumental catalogues. Vever's collection formed the backbone of these exhibitions; indeed, it is impossible to imagine them without it. He contributed 95 of the 325 'primitives'; 60 of the 306 Utamaros; and no less than 67 of the 105 Sharakus. It is thus by no means an exaggeration to credit him with having 'promoted' that great master; especially as a German writer, pastor Julius Kurth, had been able to list only 59 works in an allegedly 'comprehensive' catalogue of the artist's works published a year before (2nd edn, Munich 1922).

The causes of Vever's brilliant success as a collector are complex and have their roots both in his personality and in the specific situation. His thirty-four active years – ending at the age of sixty in 1914, and followed by twenty-eight years of retirement – coincided with a highly propitious period. They overlapped all three phases of Japonisme, and Vever turned all three to his advantage. First he boldly picked the plums of Goncourt's collection, then he took the opportunity presented by Hayashi's sale to fill the gaps. These same opportunities were available to all his contemporaries, but Vever had the advantages of tireless enthusiasm, growing knowledge and maturing judgment; at each stage, clearly, the financial resources were also there.

Born in Metz, in Lorraine, Vever came of a respected family of jewellers; he left Metz as a young man when the city was occupied by the Germans. Moving to Paris, he achieved a leading position in the jewellery trade and became known for his insistence on combining craftsmanship with artistic quality. It is entirely in character that in 1908 he should have enshrined his knowledge in a three-volume work, *L'Histoire de la bijouterie française au XIX^e siècle*, in which he gave due space to the Japanese contribution and to Art Nouveau. Like Gillot, he was a representative of the progressive conservative type that was an expanding force in society right up to the turn of the century. It occupied a privileged niche, combining craftsmanship with artistic values and modern business methods, while remaining independent of the new forces of industry and banking; and it found a perfect visual foil in the Japanese repertoire of images, both popular and elegant, both realistic and stylized.

Vever's passion for collecting led to a posthumous surprise. In 1975, almost sixty years after his collection had disappeared from view, and thirty-three years after Vever's death, the London auction house of Sotheby's caused a sensation by announc-

ing a sale of 'The Vever Collection'. How could this be? It transpired that, in his long retirement, Vever had quietly built up an unpublicized second collection that was the equal of the first in quality. The finest pieces, over a thousand of them, were reproduced in a sumptuous three-volume catalogue, with an introduction by Jack Hillier, which reflects a last glimmer of the wisdom of an age in which Japanese pictorial design had a central importance.

Pierre Barbouteau

Barbouteau's collection, and its fate, present a telling contrast with Vever's Olympian calm, care and sureness of touch. As a collection, it lacked any balance between the spheres of life in which the collector moved, and the result was turbulence.

This collection, which came on to the market in 1904, the same year as Gillot's, was that of a man who was completely unknown to his fellow collectors, an outsider, an art-world misfit. Barbouteau wanted to be taken much more seriously than the others; he wanted to be known as the 'Vasari of *ukiyo-e*', contributing great new insights and revisions to the better understanding of the woodcut masters and their complicated groupings, schools and cliques. His catalogue, lavishly produced in two substantial volumes, contained full biographies of the artists, based – according to the preface – on previously unknown Japanese sources; and these were announced as the prelude to a forthcoming comprehensive work. The sale of the collection, indeed, was intended simply to finance the necessary research.

However, the auction was such a failure – poor prices and a bad press – that the second part of it was moved from Paris to Amsterdam. It took two further auctions and a whole decade to dispose of the entire collection. The promised standard work, when it finally appeared under the title of *Les Peintres populaires du Japon*, remained incomplete and has consequently been of little use either as a scholarly instrument or even as a reflection of the cultural context that produced it; although it does contain a quantity of information on which other students of the period have been able to build. Its date of publication, 1914, was an unfortunate one, both too early and too late.

The Barbouteau collection was marked by two salient features. Firstly, all the items in it had been acquired directly in Japan, which Barbouteau visited on business from 1886 onwards; they never passed through the filter of Sichel, Bing or Hayashi. Secondly, the paintings – *kakemono* and *makimono* – were almost equal in prominence to the prints. But, however historically justified and objectively right such an approach may be, the paintings were never fully accepted in the world of the Parisian aesthetes whose Japanese enthusiasm was in any case on the wane. Barbouteau's work thus laid itself open to criticism from all sides, not so much because its quality was uneven as for reasons of cultural sociology: he failed to conform adequately to the rules of the game, as understood in Paris.

In fact, however, his achievement was one of which any European collector might be proud to this day. He had sixteen Sharakus, as well as a representative selection

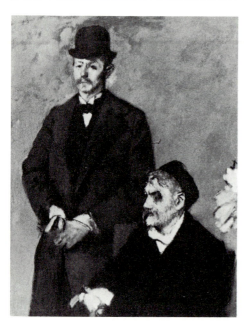

128
Edgar Degas.
Henri and Alexis Rouart, 1895

of Utamaros and Hokusais; but an abundance of Hiroshiges and previously unknown minor late masters had the effect of depressing prices so much that in many cases it was possible to pick up a small masterpiece for thirty-five francs.

While the other collections of Japanese art reflected the personality of the collectors and also their links with contemporary artists, Barbouteau has remained totally obscure. No one has revealed where his financial resources came from.

Alexis and Henri Rouart

Our last representative collectors are the Rouarts, Alexis and his son Henri. Alexis Rouart came of an old Parisian family in which the connection between wealth, connoisseurship and social success was hereditary. As an obituarist put it, his active life, as an inventive engineer, belonged to science; his inner life belonged to art. His house in the Rue de Lisbonne, adjoining the Parc Monceau, was like a museum, hung ceiling-high with paintings from Millet to Cézanne. Degas, despite his reclusive habits, was a regular visitor; he and Rouart were old school friends, and it was at Rouart's table that Degas launched some of his most celebrated shafts of wit. He painted a portrait of *Henri and Alexis Rouart* [128] in 1895.

Did Degas perhaps give his friend the idea of collecting Japanese prints? It is possible, even probable; these were a late addition to Rouart's collection, where they first appeared around the time when the painter's means were no longer sufficient for him to add to his own collection. The special status of the small number of Japanese works in the Rouart collection is underlined by the fact that they were withdrawn

from auction in 1912 and passed *en bloc* to the American agent and print expert, Frederick Gookin, who sold them off in New York a decade later.

What should we expect to find in the collection of such a person as Rouart: a collection that marked, in a sense, the passing of one kind of Japonisme? Certainly not a demonstration in favour of the 'primitives' or against the late masters. Rouart provided no experiments and no bold discoveries, but an engineer's precision in showing just what can be achieved. Every one of his prints was absolutely sound and in a much better condition than most of the slightly wilted blooms that typify the Parisian strain of Japonisme.

Rouart's main emphasis was on Utamaro, Hokusai and Hiroshige. He was determined enough to acquire *The Procession of the Koreans*, a rare Utamaro, even though it was said to cost the horrifying sum of 10,000 gold francs; it was an essential component of the whole. The assembly of the Rouart collection marked the end of the avant-garde status of Japanese woodcuts; they now counted as part of the universally valid patrimony of art.

These four examples by no means exhaust the range of collecting activity. To such famous names as those of the dealers, Bing and Hayashi, there should be added those of Gonse, Haviland, Camondo, Vignier and many smaller collectors. But none of these ever built a bridge to the evolving world of contemporary art; they were simply expanding the field of collecting. The only exception is Maurice Manzi; but his influence on Toulouse-Lautrec already points forward to another period.

More than the sum of the individual collections, it was the artistic climate, a kind of fever, that drove dealers, exhibition organizers, collectors, artists, to more and more concentration, competition and publicity, and created a unique sensation. In the early 1890s it attracted all those, within and far beyond the borders of France, who were striving for a new art. It took up some of the characteristics of French nineteenth-century culture as a whole: its constant capacity for renewal and – at the end of the cycle – its readiness to embark on a new tradition. Japonisme arose at the junction of historicism, exoticism and archaism; its source was not an idea, or ideas, but the perception of a new pictorial language. Japonisme was by no means identical with Japanese art; but that art had first to be known, before it could be interpreted and transformed.

11. Japanese exhibitions in Paris, 1883–1900: the discovery of the 'primitives'

Collecting and exhibiting are like communicating tubes: their influence is mutual. If there were no collections, no exhibition could take place; and the exhibition, in its turn, is a stimulus to collection. This inextricable bond makes it virtually impossible to specify an exact birth-date for Japonisme: it was a phenomenon that grew out of the stimulus of exoticism in general, which transferred itself to the Far East, specialized in Japan, and then further specialized by separating prints and paintings from objets d'art.

This progressive narrowing of focus went on to endow successive Japanese exhibitions in late nineteenth-century Paris with an extraordinary artistic and historical importance. Their unity of intention was the result not of an arbitrary fashion but of a deep-seated need to explore the roots and the intricacies of this 'other' art. Without this, and without the crisis in Western art, there could never have emerged so durable, so widespread and so respected a movement. Japonisme was a force whose time had come.

Its pre-history was a protracted and hesitant process which began no later than the Universal Exhibition of 1867. There – as in London in 1862, and as in Paris in 1878 – Japan was represented by a heterogeneous array of such artisanal and industrial products as were thought likely to boost its export trade. Only the practised eye of an Ernest Chesneau was able to pick out the aesthetic values buried in the mass of material, in a subtle analysis ('Le Japon à Paris', *Gazette des Beaux-Arts*, 1878), and to identify the lessons of decorative quality that the West might learn. For the public at large, however, such displays were, as their organizers intended them to be, landmarks in international competition. The call for selectivity was heeded only by a much smaller public, which was able to detect in Japanese craftsmanship 'the essence of natural forms as well as the taste' (Chesneau) that had vanished from the historicist products of the West.

Five years from 1878 sufficed to turn these first stimuli into a whole group of ambitious private collections. The collectors' initial concern was with the beauty of function as manifested in Japanese objets d'art; but colour woodcuts soon began to emerge as a sideline. And so, in 1883, Louis Gonse, the author of the first coherent account of Japanese art in France (contemporary, as we have seen, with that of Anderson in England), was able to open an exhibition of Japanese art that attracted more attention than any previous showing, if only because it was held in the elegant rooms of the Galerie Georges Petit: *Exposition rétrospective de l'art japonais*.

Not only was the public completely different from that of the Universal Exhibitions – consisting as it did of the art world, high society, and snobs in general – but the objects on show already reflected the adaptation of the Western eye to the new

artistic stimulus. Attention had been transferred from its 'exotic' strangeness to its exquisite workmanship and subtlety of form. It was this pursuit of quality that aroused the competitive sprit. What is surprising about the 1883 exhibition is the number of exhibitors who were already competing with each other: or, to put it another way, the alacrity with which a multitude of collectors had taken up the challenge of Japan. There is no need to list all the names here; nor is it any longer possible to determine the level of quality. The strength of the new enthusiasm emerges from the mere fact that the exhibition included a total of 3,333 objects from twenty-six collections.

What interests us is the effect of the exhibition in three directions. Firstly, the launching of a solid tradition of collecting Japanese ceramic art in particular, which to this day has remained an entrenched province of world art; secondly, the inflationary wave of cheap Japanese imitations that, inevitably, flooded the department stores and shortly went the way of all fashions; thirdly, and vitally, the recognition of colour woodcuts as true works of art, as the backbone of a new aesthetic.

Here, for the first time, Japanese prints were seen, not as mere ethnographic curiosities, folk art or botanical illustrations (their status in England at that time), but as testimonies to a vision totally different from that of the Western tradition. The exhibition revealed, however, how hesitantly this aspect was still recognized. Although there was no lack of pictures to hang on walls, such as scroll paintings, *kakemono* and *makimono*, free-standing screens and fans, these seem to have been presented for the sake of their decorative charm rather than in full recognition of their 'revolutionary' form of representation.

Gonse's exhibition incorporated just two collections that contained colour wood-cuts – separate prints and albums – in any quantity, and both of these belonged to art critics: Théodore Duret and Gonse himself. These men knew what they were aiming at, and were engaged in showing in their published writing why the decorative principle is not simply a quality attached to this or that Oriental object but represents the lifeline, the central principle, of a distinct world of art that is fully manifested only in pictures, and above all in prints. Their total reliance on one late artist, Hokusai – with only an incidental mention of his forefathers, a Shunshō or a Harunobu – counts for less than the fact that they were working towards a systematic presentation and representation of Japanese prints as such.

Nor did this remain on the level of theory: a whole new generation of collectors now appeared – Gillot, Vever, Haviland and many more modest figures – who brought to its fruition the second Japonisme. Gaston Migeon was quick to recognize the importance of this second phase. In his preface to the catalogue of the 1904 Gillot auction, he strikingly points the contrast between these collectors and their pre-decessors: Burty is described as a 'diviner', an intuitive collector with psychic gifts but inchoate ideas, and Goncourt as a person who obstinately closed his eyes to the greatness of the earlier Japanese epochs.

The early 1880s were the turning-point. Japonisme now revealed its true significance, both in depth and in extent, for artists, critics, collectors, exhibitors and dealers, and for the cultivated public. For the first time the almost subterranean, separate

streams of the two preceding decades combined to form a great river. Gonse's exhibition of 1883, which documented this process, coincided almost to the day with the foundation of the *Salon des Indépendants*. There, in the Divisionism of Seurat, the change from a Nature seen more or less illusionistically to a conscious process of formal creation underpinned by structure became manifest. There is no evidence to show how far the painter of *La Grande Jatte* was directly influenced by Gonse's exhibition. He might equally well have seen Japanese prints elsewhere, in a private collection; but one has only to look through his own drawings to come to the conclusion that the date certainly fits.

Vincent van Gogh was not yet in Paris, but after his arrival, three years later, he seems to have had the feeling that he had missed something important; for in 1887 he decided to hold an exhibition of his own at Le Tambourin, a café on the Boulevard de Clichy. The show consisted entirely of colour woodcuts; this was the first time in history that they had been exhibited independently, in their own right. Only an artist would have dared to do it. However, little or nothing is known of the identity, quantity or provenance of the prints on show; even Rewald has found no documentation. It was probably a fairly modest exhibition, put on for the benefit of those who were half converted already – fellow avant-garde artists like Anquetin, Bernard and perhaps Toulouse-Lautrec – but with no public response. It deserves mention only as a signal, an encouragement to the Post-Impressionist artists who were just beginning to emerge.

Things were very different when it came to the next major event, the international *Blanc et Noir* exhibition of the autumn of 1888. For the first time in one of these shows, a section of Japanese prints was included, contributed by Samuel Bing. Among the fifty works on show, a number of outstanding works by Utamaro aroused the greatest interest, as Bing had intended; he wanted to 'launch' this artist in order to challenge Hokusai's monopoly. For the public, this represented the unveiling of a new dimension in *ukiyo-e* art. The critic Félix Fénéon, in that almost stenographic diction of his, described it accurately as 'expansive and refined . . . emptied of incidental accessories . . . design in great curves in gentle, exquisite colours' (*Œuvres*, Paris 1948, 147, 148).

Utamaro's star was never to fade, at least among French collectors. His faintly mannered 'formalism' was strongly in keeping with the new generation's longing for style. A space 'emptied of incidental accessories' henceforth became a hallmark of Degas's style, clearly evident in his ballet paintings. Which is not to say that Degas took his cue from this exhibition: he had other sources.

Gauguin, however, must have seen the show immediately before he left to join Van Gogh in Provence, and it clearly prompted him to add Utamaro to his two existing admired sources, Hokusai and Kunisada. We learn from a letter to Schuffenecker that it was on 8 October 1888, during the run of the exhibition, that he completed the Japanese-influenced *Self-Portrait*: the 'emptied' space and the curvilinear construction are unmistakable. By the next year he was himself the owner of several Utamaros, which he used to adorn his studio *chez* Schuffenecker (Jean de Rotonchamp, *Paul Gauguin*, Paris 1925, 77).

Japonisme was spreading like a fever, and had already reached neighbouring countries. In London, also in 1888, the Burlington Fine Arts Club exhibited the collection of William Anderson, with its particular emphasis on the illustrated book; and only a few months later an exhibition of Japanese art was presented at the Cercle Artistique in Brussels. Even in New York, in 1889, the exclusive Grolier Club held an exhibition of Japanese prints which gave it a point of contact, one might say, with the new movement; unfortunately we do not know what was shown. It is no surprise to find that the 1889 Universal Exhibition in Paris, next to the newly erected Eiffel Tower, included more Japanese art: what was exhibited was basically a variation on Louis Gonse's showing of six years earlier.

The great event, the decisive turning-point in the history of Japonisme, was the exhibition *Maîtres de l'estampe japonaise*, organized by Bing at the Ecole des Beaux-Arts, Paris, from 25 April to 22 May 1890. It can be said without fear of exaggeration that from that time forward the whole world of French and indeed European art took on another cast. The Japanese sources had previously been accessible only to avant-garde artists and to exceptionally enlightened collectors; now the situation changed utterly. In the decade that followed it became harder for an avant-garde artist to avoid the lure of Japanese art than to succumb to it.

The extraordinary success, the great significance, of this event is due to at least two separate factors: the first is the care and experience, the understanding and the sensitivity, that Bing lavished on its organization; the second is its timeliness, the ripeness of the moment in contemporary art, which may be described with a degree of simplification as the watershed between an age of painterly texture and one of graphic structure.

For his exhibition, Gonse had had to take what he could get; Bing, seven years later, could choose what he needed. Gonse had based himself on existing collections, adding their contents together; but Bing had a comprehensive view of his own to rely on, and could 'compose' his material in accordance with that. In 1883, the prints had been arranged under the same roof as craft objects, according to the ideas or the whims of the lenders; in 1890 the installation was stage-managed by one man, who set out to present the art of the *ukiyo-e* woodcut, and that alone, within an evolutionary, historical structure. Public awareness had already been extended from the late masters of the nineteenth century, Hokusai, Hiroshige and Kunisada, to the members of the preceding, 'classical' generations, Kiyonaga and Utamaro. Now a whole new stratum was added, that of nearly a hundred years of work by earlier, 'primitive' artists, from Moronobu to Harunobu. It was the achievement of the 1890 exhibition, one which would be hard to over-estimate, that it showed the 'primitives' alongside all the others: it showed, in fact, the full range of *ukiyo-e*.

Apart from 428 illustrated books, 725 individual prints were on show, 145 of which date from the 'primitive' period. However much these may have varied among themselves, all transcended the illusion of a receding space and gave the graphic structure its full expressive power. In a twenty-four-page introduction, Bing gave an excellent analysis of the stylistic issues involved. Of the earliest master, Moronobu,

he wrote: 'At no later time can one find a richer, livelier, firmer stroke. His graphic compositions are as sculptural as reliefs. The stroke speaks alone, but says it all; the stroke alone suffices to convey form, far better than the most skilful shading.'

It is no wonder that such sources were received by the younger generation of artists like a revelation. They, and the public, had been adequately prepared; for the monthly issues of *Le Japon Artistique*, published since 1888 by the same Bing, were in everyone's hands.

No other exhibition of Japanese art was so much visited by artists as this; every individual was able to choose the source that mattered to him from the abundance of styles and painters on offer. Among the elder generation of painters, Pissarro, Monet and Degas are known to have visited the exhibition; so, surely, did Redon, Gauguin and Seurat. Signac and Henri-Edmond Cross, the two Divisionists, reveal its influence in their works. Van Gogh, passing through Paris on his way from Provence to his last home at Auvers-sur-Oise, certainly did not miss the opportunity to see it; nor did Toulouse-Lautrec, Félicien Rops, or Henri Rivière, the 'Paris Hokusai'. Among the younger artists, there were especially the Nabis: Maurice Denis, Pierre Bonnard, Edouard Vuillard, Paul Ranson, Georges Lacombe, Ker-Xavier Roussel, and their friend Félix Vallotton.

These artists were joined by numerous visitors from abroad and foreign residents in Paris: the Italian Giuseppe de Nittis and the American Mary Cassatt, both intimate friends of Degas; Eugène Grasset from Switzerland; Alfons Mucha from Prague; Charles Rennie Mackintosh from Scotland; Jan Toorop from Holland; Edvard Munch from Norway; and the Germans Ludwig von Hofmann, Walter Leistikow, Fritz Erler and August Endell. Mackintosh, Toorop, Munch, and the four Germans soon returned to their own countries and there sowed the seeds of Japanese stylization, producing some slightly mutated growths. They were under the spell of the power of line that they had discovered in the Japanese 'primitives'.

No other Japanese exhibition had anything like this effect; no other had more momentous consequences. In the five years that followed, there were nine more exhibitions. Bing's expansionist spirit led him to show his best Hokusais in London (1890), and his masterpieces in Boston (1894); simultaneously, local initiatives arose, as in Antwerp (1892), London (1893) and Dresden (1895), with a view to catching up with Paris. Suddenly, these 'exotic' products had become the latest thing in art and a burning topic of wide interest.

At the heart of it all, in Paris, events followed closely upon each other. In 1891 came the first posthumous auction of a large private collection, that of Burty with 2,500 items, an event that by all accounts attracted enormous attention. One Utamaro print reached the fabulous price, for the period, of 1,050 gold francs. In the following year, 1892, Vever's and Bing's collections – the ultimate in quality – were placed on show at another international *Blanc et Noir* exhibition, at the *Salon des Champs-Elysées*. Meanwhile, Duret left his own collection to the Bibliothèque Nationale; this consisted not of individual prints but of illustrated books and albums, representing the popular, not to say plebeian, aspect of *ukiyo-e*. Illustrations had been shown from

the first, alongside other prints; but this separate treatment represented a further step in the 'focusing' of *ukiyo-e* art. These albums were certainly not without influence on the great flowering of European book illustration and design that took place in the years that followed.

The last notable event of those five momentous years was not one that surprised by its sheer audacity, after all that had gone before; but its strategic importance was exceptional. In 1893, Bing, once more, organized an exhibition of Utamaro and Hiroshige at the gallery of Durand-Ruel, the great impresario of the Impressionists. The intimate contact between modern art and Japan, previously known only to the avant-garde artists themselves, now became evident to a wider public. What was more: all those artists, collectors, critics and gallery directors from Holland, Belgium and Central Europe who had missed the great event at the Ecole des Beaux-Arts, three years previously, now had a splendid opportunity to bring themselves up to date. The results were apparent in all those countries almost at once, in the shape of the rise of Jugendstil and Art Nouveau.

In Paris itself, the wave of Japonisme had peaked. There continued to be many opportunities, both public and private, to see fine *ukiyo-e* prints; but they no longer made history. The Japanese section in the woodcut exhibition held by the Ecole des Beaux-Arts in 1902 was Bing's swan-song. The auctions of the great collections – Goncourt in 1897 and Hayashi in 1902 – were preceded by a number of public open days, but this was also the moment when the works themselves began to drift away from the Parisian centre to Germany and soon also to America. The focus of interest began to shift to other regions of 'primal spontaneity', which were now promoted from the realm of ethnography to that of art: Japanese temple painting, Chinese sculpture, Persian miniatures and African or Oceanic carvings. The vogue of the *ukiyo-e* woodcut subsided, at least in France.

Elsewhere, on the other hand, its impact was conspicuous. Under the aegis of Fenollosa – who had only recently scorned the 'materialistic gaiety' of *ukiyo-e*, as against high art – it made its triumphal entry into New York in 1896 with an exhibition, *Masters of Ukiyo-e*. Before the turn of the century, there followed the first two exhibitions in Japan itself, marking the rehabilitation of works that Fenollosa himself had previously considered 'beastly obscenities'. In Dresden, in 1897, the Kupferstichkabinett – whose director, Woldemar von Seidlitz, was an enthusiastic Japoniste – showed its own recent Japanese acquisitions; and shortly afterwards the Galerie Arnold, in the same city, followed suit.

The first decade of the new century provided the following major exhibitions (as defined by a mention in the literature): February 1900, Secession, Vienna; 1905, Kunstgewerbemuseum, Berlin; 1909, Städelsches Institut, Frankfurt am Main, a show of the largest German collection, that of Frau Straus-Negbaur. These represent only the peaks, the documented events. How many small exhibitions of more local interest took place in the wide swathe of territory bounded by Genoa, Prague, St Petersburg, Stockholm and Hamburg can only be guessed from the surviving traces that occasionally, fortuitously, come to light.

12. The second wave of Japonisme

Bing's historic exhibition, *Maîtres de l'estampe japonaise*, in 1890, coincided with a great stylistic shift in European art. If it did not cause that shift, it did give it a powerful impulse forward. A painterly age was succeeded by a graphic age; in Wölfflin's basic terms, a late art was succeeded by a linear fresh start. In the case of Japonisme, which continued to form the backbone of the new movement, this meant that the later sources, Hokusai and Kunishika, were, by inner necessity, supplemented or supplanted by the 'primitives'. These artists thus made their appearance on the scene at the right moment. Moronobu's curvilinear structure paved the way for the convoluted arabesque of Jugendstil and Art Nouveau; his abstract linear patterns led to the posters of Toulouse-Lautrec and the ornamental patterning of Gustav Klimt.

Another factor must be added: from this point onwards, artists could still draw on Japonisme directly, but an additional avenue emerged, that of transmission at second hand. The works of the pioneers – Manet, Degas, Whistler and the rest – were studied by younger artists who had never actually seen a Japanese print in their lives. This indirect Japanese inspiration became increasingly widespread, in many permutations, and often mingled with the direct influence. Only by seeing the movement as a whole, and tracing it from its earliest beginnings, can its later ramifications be properly assessed and the Japanese element detected where the biographical record ignores or even denies it.

The new wave of Japonisme thus took on a new face, very different from what had gone before. There were new spokesmen, new objectives, new artists. An interesting insight into this atmosphere is afforded by Raymond Koechlin (born 1861) in a memoir privately published in 1931, *Souvenirs d'un vieil amateur d'art de l'Extrême-Orient*. Knowing nothing of Goncourt's book *La Maison d'un artiste*, or of Gonse's exhibition, Koechlin was a law student when the impact of Japanese art struck him, as he tells us, like a bolt from the blue: it was love at first sight.

This experience, which came to him on a visit to Bing's exhibition in 1890, changed Koechlin's whole life and made him, as soon as he inherited some money, a major collector of 'archaic' art and particularly of Japanese 'primitives'. His greatest find, at a riverside bookstall in Paris, consisted of six prints by Kaigetsudō (out of the thirty-nine then known to exist). His great success was the series of six Japanese print exhibitions that he organized at the Musée des Arts Décoratifs in Paris before the First World War, in which the 'primitives' received the position that was their due. His major claim to fame resides in his close and friendly contacts with the younger converts to Japonisme among the German museum directors: Brinckmann in

Hamburg, Seidlitz in Dresden, Otto Kümmel in Berlin. In retrospect, Koechlin can be seen to have acted as an intermediary in the spread of Japonisme from its Parisian roots to the European success that expressed itself, above all, in Art Nouveau and Jugendstil.

But first we must look at another figure who owed his conversion to that same exhibition of Bing's in 1890: the novelist and art critic Gustave Geffroy (1855–1926). Geffroy looked to Goncourt as his master, was close to Zola and to Georges Clemenceau, and evolved his aesthetic vocabulary from the legacy of Baudelaire. His principal work of criticism consists of *La Vie artistique*, a chronicle of events in the art world which he wrote from 1890 until 1903, and which, published every year or so in book form, occupies eight volumes. In it Geffroy sought to bring out the figures and the events that constituted, for him, 'l'art moderne'. His eloquence was much admired, and he had a wide public; it may be, indeed, that he did more than any other writer, not only to gain – belated – recognition for the Impressionists, but also to cast a favourable light on the Post-Impressionist artists and the decorative revolution of Art Nouveau. His friend Cézanne commemorated him in a portrait; Toulouse-Lautrec illustrated his book on Yvette Guilbert; and his commentary on the great Japanese exhibition of 1890 was one of the most perceptive critical texts of the whole movement.

It would be pointless to look in Geffroy for theoretical reflections on the significance of the Japanese example of modern art. That was not the way he worked. His intention was to enshrine the new discoveries among the 'beacons' (*phares*; the word is Baudelaire's) of art, and to show them as they really were: for him, their evocation of essential character in Nature, suffused with a poetic glow, was something that the West had never achieved. In all this, Geffroy widened the horizons of contemporary French art criticism, which – then as now – often contented itself with the naive response, 'Oh, how beautiful!' ('Ah, que c'est beau!')

With Geffroy it became clear that Japonisme had emerged from its avant-garde status, for critics as for artists, and entered the phase of recognition, the classical phase, if you like. It was his achievement to have unveiled a new sensibility, bringing it out from the dungeons of the avant-garde into the broad light of day.

His penetrating analytical gifts are typified by his fifty-page review of the epoch-making exhibition of 1890:

One leaves with the sense of having discovered a far-away region where, initially, everything appeared to the prejudiced European eye like a chimaera, or at least like the offspring of a paradoxical fancy; but as one penetrates further into this extraordinary world of signs it all becomes a reality of a rather complex kind, flamboyant and intimate by turns. Here is a complete civilization, with superb decorative features, yet subtle in its idiosyncrasies. An art which resembles no other, and which springs directly from the imagination and the craftsmanship of the Far East ...

Perhaps the work of the Japanese draughtsmen can be defined by saying that the lines with which they reproduce objects are always directed solely to the essential. A jutting platform, a river-bed, the profile of a mountain, are the visual keys to broad, far-flung landscapes which extend from a precisely observed foreground to a remote horizon. One wave stands for the whole sea ...

To represent figures, too, they have found specific lines, which summarize the movement ...
They constantly seek and find one single significant detail that can stand for all the others. They
have even contrived to form the human body out of a single wavy line.

This is the lesson that remains from this exhibition. It should, even so, be taken up only in such
a way that it does not lead to pastiche. How frightful, if our painters were to snatch ineptly at
techniques with which, over there, everything can be expressed and the whole world enclosed
within tiny dimensions! (*La Vie artistique*, vol. 1, Paris 1890, 166–18.)

Geffroy returned more than once to the topic of the Japanese as a model for imitation.
In a review of an exhibition in November 1892, he defined the goals of the new
tendencies that followed Impressionism as 'synthèse linéaire' and 'tachisme violent',
but hastened to add that none of this was by any means a new invention. Many
'Primitives', Ingres, and of course the Japanese above all, should be named:

The Japanese have set down their figures as if they sprang like an arabesque from a single stroke,
the most caressing, the most mobile of all. The Japanese, Ingres and Manet have set the flat pigment
down on the surface and have emphasized its value in creating harmony, all with a felicitousness
as rare as their understanding is total. (*La Vie artistique*, vol. 2, Paris 1892, 380)

In spite of this, or rather because of it, he felt constrained to issue a warning against
a spurious Primitivism, and clearly saw the perils of any routine formula that might
be created if the Symbolists, and especially the *Rose + Croix* painters, 'who call
themselves idealists, are unable to find the necessary *contact between their convictions
and Nature* ... What many of them present to us is not living art but artificial art'
(ibid., 384).

Henri Rivière (1864–1951)

Geffroy was naming no names, but might Rivière have been one of those he had in
mind? No other artist of the time came as close as Rivière to the Japanese sources,
and to the work of Hokusai in particular. Did he perhaps come too close? Were the
ties between a new vision and a new sense of life in him too weak? Or were they, on
the contrary, too emphatic, too close to the mystical interpretation of the Breton
landscape and the primitive fatalism of its inhabitants?

Whatever reservations we might have about Rivière today, his contemporaries
responded to him with respect, even enthusiasm. Leading critics, such as Roger Marx
and Arsène Alexandre, regarded him as an artist in the forefront of the avant-garde,
and *La Libre Esthétique*, in Brussels, repeatedly invited him to its exclusive exhibitions.
At the turn of the century, aged thirty-five, he was feted in St Petersburg at the first
official manifestation of the World of Art group, *Mir Iskusstva*; he was admired by
Alexandre Benois, and was thus in at the very start of the momentous process of
artistic interchange between France and Russia.

Rivière held the stage as the principal representative of a new aesthetic, in marked
contrast to the obscurity of a number of much greater artists. At that time, who had
ever heard of van Gogh, Gauguin, Seurat or Cézanne? Rivière's name was to be heard
on all sides. The fame of the cabaret, Le Chat Noir, was partly due to his shadow

129 Henri Rivière. *Wave Study*, c. 1892.

theatre, initially in black and white but soon augmented by moving coloured pro-jections of clouds and landscapes. As a stage decorator for the Théatre Antoine, he gained access to the literary avant-garde that presented Henrik Ibsen and Gerhart Hauptmann as an antidote to boulevard comedy. From there he moved into printmak-ing, in which, at last, he could fully develop his own individuality.

The decisive year for him was 1890, the year in which he not only saw Japanese prints at Bing's great exhibition but also discovered for himself the untouched, mysterious landscape of Brittany. Thenceforward this tireless craftsman produced a succession of woodcuts, each of which, like those of Japan, required up to twelve blocks to achieve the desired colour effect. *Thirty-Six Views of the Eiffel Tower* (after Hokusai's *Thirty-Six Views of Fuji*), *The Sea*, *Wave Studies* and *Breton Landscapes* were among the series that inspired the critics to hail him as the 'saviour of the original print'. His two-dimensional, wall-like approach made it possible, they said, to extract the remembered melody of objects from Nature and to translate it into a visual music of outlines and nuances of colour. This definition of the issue, in itself, proves all over again that an Age of Line had truly begun, that a new language, defined in decorative terms, was the objective, and that Rivière's intentions were of the best. Indeed, no one can deny that he meant well: what is in doubt is the degree to which he realized his aims.

Significantly, these first attempts remain among his best work. The *Wave Study* of c. 1892 [129], a watercolour done as a study for a woodcut, shows his creative process

130 Henri Rivière. *Ile des Cygnes*, 1900

at work: he started out, on the model of Hokusai's *Manga*, by reducing his perceptual field to a number of specific basic types – the wave, the tree, the cliff, the rock, the heath – which figured as 'frameworks'. These were subjected – according to his biographer, Georges Toudouze – to four 'overall effects' in all, namely sunlight, dawn, dusk and fog, because these reflect 'the regular motions of the harmony of the world, with their all-encompassing laws, and affect beings and forms which emerge in a few synthetic but entirely visual types' (*Henri Rivière*, Paris 1907, 112). Toudouze's metaphysical explanation will not satisfy everyone; but its reference to a 'second Nature' and its symbolic character is entirely in keeping with the yearnings of the time.

If Rivière had been able to pursue his visions, in all their density, beyond these four woodcut cycles, who knows how far he would have been able to go in his role as a pioneer? In fact, however, he very soon succumbed to the temptation to translate his pictorial ideas, more quickly, more easily, and more profitably, into large coloured lithographs; and he descended to the level of routine. His lithographs, done partly with classroom walls in mind, represent a clear move in the direction of the postcard industry. *Ile des Cygnes*, of 1900, one of his *Parisian Landscapes* (no less than 52.5×82 cm / 20.7×32.3 in. in size), is a characteristic example [130]. It is worth making the comparison with Hokusai, Rivière's Japanese 'source' [131].

Rivière had made a threefold promise: a revival of printmaking, with the woodcut drawn, cut and printed by one artist; Japanese inspiration; and his own intensified 'inner' wisdom. He was only ever able to make a beginning: fulfilment eluded him, and he founded no tradition. But then, how seldom accomplishment matches desire!

131 Katsushika Hokusai. *The Station of Hodogaya*, 1823–9

Mary Cassatt (1844–1926)

Between Hokusai and Rivière stands Whistler; and in the same way the Japonisme of
Mary Cassatt could not be explained without her teacher, Degas. Like Degas, she
drew inspiration not from Hokusai but from the masters of the 'classical' generation.
She bought prints by Utamaro and Eishi in considerable quantity and decorated her
studio with them: not only for the sake of their motifs, with their predominance of
large-scale female figures, but still more out of stylistic *pietas*.

Compare, for instance, *The Lamp*, of 1891 [132], with Utamaro's *The Song after
the Bath*, of 1798 [133]. However different the end result, the design problems are
the same. The near plane of the image, at the bottom edge, is acknowledged, indeed
emphasized; spatial recession is kept under strict control, is restricted to a shallow
scenic relief, and unfolds vertically; the space in both cases is clinched by arabesque-
like curves; there are contrasts of texture (fan, dress pattern, table rectangle, lampshade
in one case, musical instrument, bathrobe, coiffure, screen with kimono in the other).
In both works, the whole is structured with curves and vertical and horizontal axes,
and decorated with a tissue of delicate, shimmering islands of colour. The outline of
the figure dominates the accessories and creates a state of suspension, an equilibrium,
a mood precisely intermediate between action and repose.

One thing is curious: through Degas and Monet, if not otherwise, Mary Cassatt
was familiar with Japanese prints almost from the moment when they first came on
the scene; but it was not until a whole decade later that Bing's great exhibition of
1890, *Les Maîtres de l'estampe japonaise*, gave her the impetus to produce her best
work, which she then did within a single period of twelve months. At a stroke, her
years of interesting technical experiment were rewarded with perfection, both in her

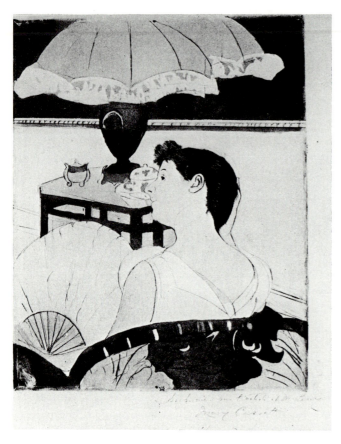

132
Mary Cassatt.
The Lamp, 1891

pastels and in her colour etchings. In these she went over the plates with aquatint to evoke the effect of an ink wash and finished them with drypoint, thus satisfying the demands of painterly Impressionism, with its delicate surface handling, at the same time as those of the outline-stressed, stylizing tendencies that succeeded it.

In stylistic terms, therefore, she stood, with Degas, at the point where a way out of the Impressionist visual world was sought and found through drawing. At this historic turning-point, her inspiration bore comparison with that of her avant-garde colleagues. In spite of the modest range of her repertoire, in spite of its limitation to the intimate relation between mother and child – the Madonna of the *Belle Epoque* – Mary Cassatt's work, and above all her graphic work, has an exemplary significance. Maintaining her roots in illusionistic depiction, and without any concessions to revolutionary abstraction, she struck a spark of her own from a visual world that was given to her (neither invented nor symbolically intensified). Her means to this end were the arabesque and a spatial twisting and displacement that creates a magical evocation of volume.

Compare her colour etching, *The Bath*, of 1891, in the last of no less than eleven states [134], with a similar motif in Utamaro (*A Mother Bathing her Son* [IV]), to see

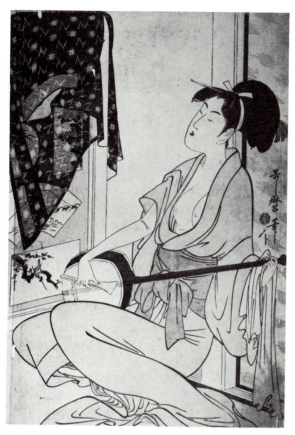

133
Kitagawa Utamaro. *The Song after the Bath,*
1798

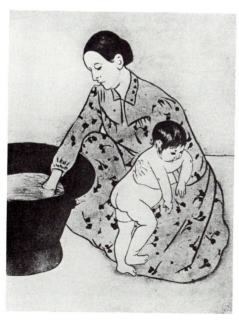

134
Mary Cassatt.
The Bath, 1891

what a good pupil she was: no superficial borrowings, no repetition, but an under-standing that came from within. In every gesture, every expression, every nuance of mood, the Japanese setting is transformed into a characteristically Western scene. And yet, to a practised eye, the source of her inspiration is clear enough: it is one that does not diminish the artist but ennobles her.

Eugène Grasset (1841–1927)

Grasset's work fits in from a completely different angle. Like Mary Cassatt, he was a member of the older generation and came to Paris from abroad, Switzerland in his case. But his roots were not in painting, and he had virtually no contact with avant-garde painters, or even with printmakers. From the outset he concentrated on 'applied' art, and on book illustration in particular, and attained a commanding position in the field of poster design in that critical first half of the 1890s when Art Nouveau was reaching its full development.

To what extent he was dependent – as Robert Schmutzler suggests – on Dresser, and on developments in England, remains a matter of controversy. What happened would be better described as a convergence; Grasset had been studying the graphic expression of the Japanese more closely than any of his continental colleagues. His work represented a current that ran parallel to 'high' art until, in Art Nouveau, the two were united.

The fact that poster design then suddenly found itself at the forefront of modern art was certainly partly Grasset's achievement; as was its rapid expansion both in Europe and in America. Grasset was not a founder, certainly; but he had considerable influence, and made an individual contribution of his own to the history of Japonisme. At a late date, in 1905, he published a textbook, *Méthode de composition ornementale*, which found its way into many art classes; it was a didactic work, and by then its message no longer posed a threat to anyone.

The curve, as the expression of movement and life, was the *Leitmotiv* of Grasset's rather eclectic approach to design. Whether it was a Celtic, Gothic or Japanese curve did not matter very much to him, as long as he could place a clearly outlined figure in front of an ornamentally varied ground. Consistently, his posters contain two spatial layers; and this has been regarded, with some justification, as his contribution to Art Nouveau. But it was specifically after Bing's Japanese exhibition of 1890 that he began the process of consolidation of form that ultimately eliminated historicism from his work once and for all.

In the poster *Four-Leaf Clover* [135], lettering and image, dark and light areas, verticals and horizontals, are held together by a few flowing curves. The ornament, focused on the plant emblem, constitutes the pictorial space, usurping the place of illusionistic spatial recession: like a true mural panel again. A new regularity of form becomes evident, and is reflected by the restricted colour scheme of red, orange, blue, dark grey and black. In another poster, the colour harmony is the rare combination

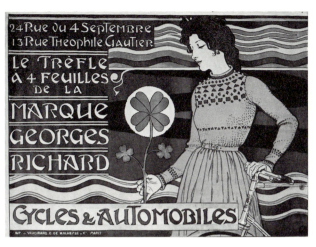

135 Eugène Grasset. *Four-Leaf Clover*, 1899

136 Eugène Grasset. *Ornamental Composition*, 1905

of gold, green and black: an orchestration designed to emphasize the distancing of the vision from photographic 'correctness'.

In his stained glass, particularly, Grasset quite often referred to Gothic precedents, naturally so; and there were times when a 'medieval' fantasy carried him into remote regions. But he was too much aware of the disciplined structure of the 'new' reality not to acknowledge the unique consistency and depth of Japanese design, and he gave it pride of place over all his other sources. Here, for him, lay the core of the new design, in the use of line as a representation of force, movement and life; witness his *Ornamental Composition* [136]. The deliberate asymmetry of the *Four-Leaf Clover* poster, its undulating lines, its format, its cropping, its ornamentation, its abstract presentation of the object: all this is nourished by the artist's familiarity with the universe of Japanese art. This is the sole determining impulse; the rest is no more than a historical prompting.

Henri de Toulouse-Lautrec (1864–1901)

If planar abstraction were the sole criterion of Japanese influence, then Toulouse-Lautrec would certainly have to take a back seat: he was quite happy to foreshorten in depth. But by transforming reality into a graphic phenomenon, with the aid of a sign system inspired by (not taken from) the Japanese, he became the supreme master of line in his own day. It is true that Degas had preceded him in the use of *graphismes*, pattern-like signs; but in Degas's painting these were only an added feature: the drawn structure was a means, and the painted picture was the end. With Lautrec, this relationship was reversed. Many of his motifs first appeared as paintings, which served as preliminary studies for the final form, the lithograph; and Lautrec has gone down in history not as a painter but as an incomparable graphic artist.

137
Félicien Rops.
Japanese Fantasy, 1876

The Japanese showed him the way to extract the definitive form with ever-growing urgency, not through this or that technical device but through interweaving and concentration. This radical approach of his continued to exert an influence almost down to our own day, long after his Art Nouveau and Expressionist legacy was a thing of the past. Henri Matisse, Ernst Ludwig Kirchner, George Grosz and Pablo Picasso, utterly different though they are from each other, all have him as a point of reference.

Lautrec himself had no ancestors to refer to, except the Japanese. Other sources of Primitivism that appealed to his contempories – Celtic, Rococo, Gothic, Pre-Raphaelite, John Flaxman or William Blake – meant nothing to him. And what of his nineteenth-century French predecessors? Certainly, there is no overlooking Daumier, whose reductive, shorthand line had set an example: but Daumier's was a vision without eroticism, one that *followed* developments in society; in terms of content, it was reactive rather than active. Again, Degas had invented a whole realm of unfamiliar figures, and a language of signs with which to show them; but they remained a cool and sober classification into types. With Félicien Rops the demonic realm of the erotic made its appearance, but its expression tended to remain entangled in conventional stylistic clichés. When Rops turned to Japanese sources – which he did at a very early date – this was by way [137] of a documentary record: it is hard to detect any sign of an impulse to interpret them in his own way.

In relation to these precursors, it was Lautrec's unique achievement that he brought into the open a previously obscured realm of existence – if he did not actually discover or even invent it – and gave it dynamic life while simultaneously evolving a dazzling language of signs by which to represent it. In Focillon's dense formulation: 'He belongs to the spiritual family of those to whom the form of life, the inner mechanisms of beings, are a coded language full of the most poetic secrets. Nothing is irrelevant in this tissue of arabesques, tensed and relaxed by the action' (*De Callot à Lautrec*, Paris 1957, 148).

Whereas his predecessors remained confined to illustration or regarded black-and-white basically as a dependency of painting, Lautrec achieved a pure graphic art, autonomous and truly free. In answer to those who persist in seeing him as above all the chronicler of the *fin-de-siècle* pleasure industry, or as the *enfant terrible* of a decadent society, or as a reporter with a keen photographic eye, it is best to stick to the bare facts. Anyone who supposes that La Goulue, Jane Avril and all the other figures that he immortalized were the big stars of Parisian night life is in for a disappointment. They existed in flesh and blood, and they were talked of for a season or two; but as monarchs of their world they were purely the invention of the painter. La Goulue (in English, The Glutton) was described by one who saw her, André Warnod, as follows:

She had dancing in her bones, it must be admitted, and the impudence with which she flaunted her wildly dissolute life certainly contributed to her success. But Lautrec manufactured a legend for her; he developed her type into an image; he endowed the face of a perfectly ordinary girl with a painful, proud, insolent expression, where in reality she was no more than shameless and crudely sensual. (*Les Peintres de Montmartre*, Paris 1928, 34.)

Lautrec was not concerned with mere depiction but with, in Curt Glaser's phrase, 'conjuring fantastic beings into two dimensions'. By comparison with Daumier's invention of Robert Macaire, the type of the unscrupulous criminal, Lautrec's 'models', in their eloquent gestures and fetishistic symbols, have an effervescent graphic presence and an inventive range of suggestion. This is a new pictorial language, which derives unprecedented potential from the use of abstraction.

It was Lautrec's friend Maurice Joyant, in his monograph of 1926–7, who gave the most perceptive account of the artist's Japanese sources. Almost all the countless other commentators have contented themselves with a brief and generalized reference. Joyant, however, was an art dealer and a connoisseur of Japanese prints, as was his partner Maurice Manzi (1849–1915), an old friend of Manet and Degas and himself the owner of a choice collection: its catalogue lists, among other things, 8 prints by Mesanobu, 52 by Harunobu, 26 by Morii Bunchō, 14 by Katsukawa Shunei, 20 by Kiyonaga, 4 by Sharaku, 6 by Eishi and 113 by Utamaro.

As easily as 1891, Lautrec had full access to Duret's collection, because Joyant, who had just succeeded Theo van Gogh as manager of Boussod & Valadon, had it in his care for a time. Lautrec did not only look at it; he made a keen study of it. It revealed to him a new and otherwise rather neglected aspect of Japanese art: the illustrated books and albums which contained a much higher proportion of work in black and white than did the separate prints. As a draughtsman, Lautrec certainly appreciated the presence, among the 581 items in Duret's collection, not merely of 108 Hokusais but of exceptionally fine volumes by Moronobu (53) and Kiyonaga (17). Duret had been working on the quality and scope of his collection since 1872, and had benefited from the experience of Anderson and of Ernest Satow. He finally bequeathed it to the Bibliothèque Nationale.

To gain a full view of the Japanese resources available to Lautrec, it will be necessary

to take at least four steps backward. He was a frequent visitor to Bing's 1890 exhibition, *Les Maîtres de l'estampe japonaise*, at the Ecole des Beaux-Arts, as he had been to Bing's Utamaro show in 1888. All this is reflected in his work. He had certainly seen the exhibition organized in 1887 by his friend Van Gogh, in company with Emile Bernard and Anquetin, both of whom he had first met four years previously at Cormon's studio, and who in turn had certainly taken him along, in 1883, to see the flat planar colour of Hokusai, on show at the Galerie Georges Petit in Gonse's *Exposition rétrospective de l'art japonais*.

Since 1887, Lautrec had also been in contact with André Portier. This was the dealer who lived at 54 rue Lepic in Montmartre, in the same building as Vincent and Theo van Gogh; he had been responsible for selling to German collections a number of the works left in Manet's studio at his death. Lautrec met him through Vincent and bought prints from him – or else, as Perruchot tells us, exchanged them for works of his own. There is, however, no record of the size or the content of Lautrec's own collection: the prints themselves were eventually either lost or, at best, passed on to Manzi or another. The twenty-one photographs of Japanese erotica from his collection, still preserved in the Bibliothèque Nationale, do not give a representative idea of his wide artistic interests: they show a creature, half woman and half devil, copulating with a rat, an elephant, a monkey and so on. They give no clue to the nature of his Japanese inspiration.

Lautrec's contacts with Japanese art may be summarized, this time in chronological order, as follows:

(1) 1883: Gonse's exhibition; Lautrec taken there by Bernard and Anquetin; mostly works by Hokusai
(2) 1887: Van Gogh's exhibition; mostly late works
(3) 1888: Bing's Utamaro exhibition
(4) 1890: Bing's exhibition at Ecole des Beaux-Arts
(5) 1891: Joyant at Boussod et Valadon; Duret's illustrated books
(6) 1894: Manzi and Joyant at their own gallery; 'primitives'

This hypothetical sequence has been reconstructed from scattered pieces of information (for phases 5 and 6); from his relationships to fellow artists known to be interested in Japan (for phases 1 and 2); and from the prevalent *ukiyo-e* climate (for phases 3 and 4). Its accuracy can be verified only through an examination of his evolution as an artist.

Three periods are identifiable in Lautrec's relationship to Japanese art. The first, which might be called the pre-graphic period, lasted for seven years, and consisted of isolated attempts to escape from illusionistic modelling through concentration on outline or through the omission of background recession. This was prompted by Degas, himself a *japonisant*, and by Lautrec's own studies from such Japanese prints as he happened to see. *A Seated Woman in Lost Profile*, of 1883 (Albi, Musée Toulouse-Lautrec) is the earliest extant example and comes direct from Hokusai's *Manga*. A series of ballet pictures of 1885–6 shows his reverence for his own master; they almost

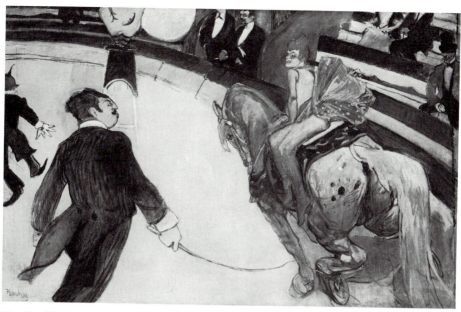

138 Henri de Toulouse-Lautrec. *At the Cirque Fernando*, 1888

look like variations on Degas. The *Portrait of Emile Bernard*, of 1885 (Tate Gallery, London), recalls Degas' knack of displacing his portraits to one side and bringing into play the relationship between the solid figure and the void of the background.

The *Portrait of Vincent van Gogh*, of 1887, inaugurating the second period, is the first work to show Lautrec not as a pupil and a follower but as a creator in his own right. With a certain justification, some have seen in it echoes of Seurat and also of Van Gogh himself; but the Japanese elements are at least as strong. They emerge in the contast between the sitter's foreground silhouette, with accompanying curves, and the rectilinear surface articulation in the background above; and in the way in which the colour patterns in yellow, blue and green set up a separate and autonomous rhythmic composition and thus present a twin-layered, coded space. One has only to see this pastel upside down to gain a better idea of its abstract qualities, distanced from all illusionism. It represents the moment when a second reality breaks out of the cocoon of the traditional, rounded, tactile portrait and sets out in the direction of the Japanese decorative organization exemplified by the female figures of Utamaro.

Barely a year later, Lautrec painted a bare-back rider, *At the Cirque Fernando* [138], an experiment in a totally different direction. No pictorial source offers itself for this work. The analogy that most readily presents itself is that of the bold composition that had given Degas, nine years earlier, his *Miss Lala at the Cirque Fernando* (National Gallery, London): not in the motif itself but in the outlining of the figure, and above all in the *perspective cavalière*, the high viewpoint that impels the space, defined by curves and lines, into an animated motion that draws the viewer in. The same happens with Lautrec, except that he has progressed one step further away from the atmospheric

139
Henri de Toulouse-Lautrec.
*The Bay of Arcachon
from the Yacht 'Cocorico',*
1889

and towards the graphic framework. The great bare expanse of ground is almost as emphatic as the infilling of the figures. Degas' suspended space has given way to a rising planar space full of powerful tensions. The mosaic of colour has emancipated itself still further from the line, emphasizing its own rhythm. The unwonted viewpoint and the departure from conventional perspective through exaggerated foreshortening lead to a new pictorial language, with fresh elements in both the grammar of colour and the syntax of forms.

It was only in Lautrec's last works, over ten years later, that this method was to undergo further development. Meanwhile, Van Gogh was exploding the old space, by very similar means [101], at exactly the same time as Lautrec. The underlying factor in both cases seems certain to be the treatment of space in pre-Hokusai Japanese art; this is so even though the subject-matter itself is entirely un-Japanese.

As a last example of this period, in which Lautrec was approaching the Japanese treatment of space, as it were, from all directions at once, we should look at *The Bay of Arcachon from the Yacht 'Cocorico'*, of 1889 [139]. This has a small 'landscape' format, unique in his work and thus marked out as an 'object lesson'. The plunging perspective – or 'leaping-off view', as Wichmann calls it – sets the truncated bow of the boat in bold silhouette against the horizon, thus bringing the distant part of the scene up against the foreground and rendering the image so abstract as to be removed from the realm of Nature into that of Design. The atmospheric colour is controlled, even dominated, by graphic signs. It may be that Lautrec had found this device in Japanese art, particularly in Hokusai's two series of *Thirty-Six Views of Fuji* and *One Hundred Views of Fuji*. Lautrec was clearly fascinated by this elasticity of space. It reappears, in many guises, as a *Leitmotiv* in his work right through to the end, long after he abandoned the subject of landscape.

After a series of such experimental works, Lautrec showed his hand with comparative suddenness. The year was 1891, shortly after he saw the big Japanese exhibition and discovered in the Parisian world of pleasure the curious milieu that he was to make his own. Both these together – and of course his contacts with such likeminded artists as the Nabis, Van Gogh and Anquetin – helped him in moving to a style of his own, which rested on the isolation of the graphic, linear rhythm from segment-like areas of colour. The figurative representation was carried by two distinct abstractions: caricatural drawing and fanciful colour. His mature painting, that of his third period, which covered the ten remaining years of his life, operated in just this area: between painting with a drawn or sign-like emphasis, on one hand, and *graphismes* based on colour, on the other. It was an inspiration which also continued with constant variations in the work of the Nabis, and as late as Raoul Dufy.

The shift is unmistakably apparent in Lautrec's first posters, from 1891 on. These marked a revolution in a craft that had lapsed into routine. For a quarter of a century, Jules Chéret (1836–1933) had enlivened the Paris street scene with a total output of over 1,000 posters; his colourful, amusing lithographs advertised products of all kinds, from cigarette papers, kerosene and aperitifs to nightspots and theatrical performances. In words and images, they set out to convey as much direct information as possible [140]. And then along came Lautrec and gave the whole art a decisive twist. His *Moulin Rouge* poster [141] was produced exactly two years after Chéret's *Bal au Moulin Rouge* [140]; the comparison is therefore a valid and compelling one. On one side, both text and scene overcharged with detail, confusing and hard to absorb; on the other, tight concentration on simple flat patterns, 'singing' lines and a few leading colours. What Lautrec provides in this expressive design is a dramatization of his own experience, as John Barnicoat observes (*A Concise History of Posters*, London 1972). An applied, utilitarian art has become a freely creative graphic wall image.

This was a decisive breakthrough indeed: what prompted it? The Japanese connection is abundantly obvious. Among the nineteen prints by Eishi (1756–1829) shown by Bing in 1890, one, No. 339, seems from the description to have resembled *A Beauty as the Poetess Ono no Komachi* [146]. Compare a work by Harunobu such as *Lovers with Cat* [150] – the laconic titles in the Ecole des Beaux-Arts catalogue permit no precise identification of the one Lautrec saw there – and we have most of the necessary ingredients for an insight into Lautrec's inspiration.

What counts, of course, is what he made of them. Of all the *japonisant* artists, Lautrec is probably the one who penetrated most deeply into the spirit of his Japanese sources, and – for that very reason – the one who handled them with the greatest creative freedom.

Three problems were basic to him: the rhythmic shaping of the surface; the connection between two-dimensional surface and three-dimensional depth; and the incorporation of lettering in the design itself. In all three respects, Japanese art gave him a first impetus and the means to develop an artistic handwriting of his own. From the outset, he was aware that this handwriting must be *a new shorthand*, on a par with those created by Goya and Daumier, those 'beacons' in former ages of social turmoil.

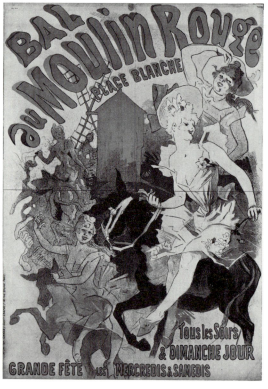

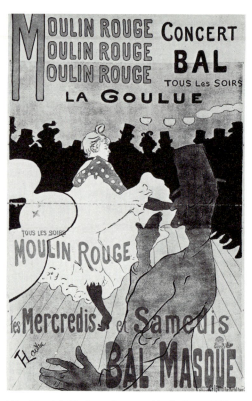

140 Jules Chéret. *Bal au Moulin Rouge,* 1889

141 Henri de Toulouse-Lautrec. *Moulin Rouge,* 1891

The signs and abbreviations that Lautrec struggled to achieve were aimed at the hint
that would convince, the conclusive suggestion.

Nothing illustrates this better than his sketch for the *Moulin Rouge* poster [142].
Not only does it bear no resemblance to any other nineteenth-century work, but
Lautrec's illusionist predecessors would have found it simply 'illegible': apart perhaps
from the single large outline of Valentin le Désossé, they would have discerned only
jumbled fragments of bodies and a spatial chaos. And yet, for Lautrec, the whole
structure of the work is intuitively present. His three fundamental problems, listed
above, have already been solved: the final poster adds only an additional emphasis.
Even though the colour, a major vehicle of rhythmic organization, still seems rather
sporadic, the outlines and their neighbouring planes are all virtually in their final
places. An interplay of curves and arabesques swings from one edge to the other and
is taken up by the downward-slipping counter-curves of the man's figure, ending in
his hand-gesture and almost closing the circle that rings La Goulue's high-kicking
leg. And this proclaims the central motif like an exclamation mark: La Goulue, the
star dancer, and her partner. The crowded Moulin Rouge with its dizzying lights is
only the setting from which the magical event, the central phenomenon, emerges: La
Goulue dances here.

Colour plates

I Edouard Manet. *Café Place du Théâtre Français*, 1881

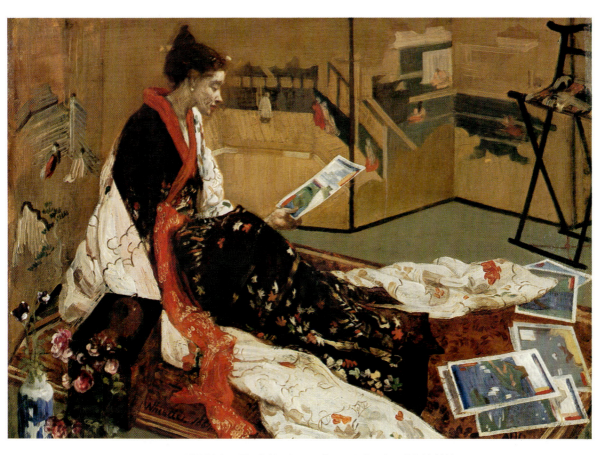

II James McNeill Whistler. *The Golden Screen: Caprice in Purple and Gold,* 1864

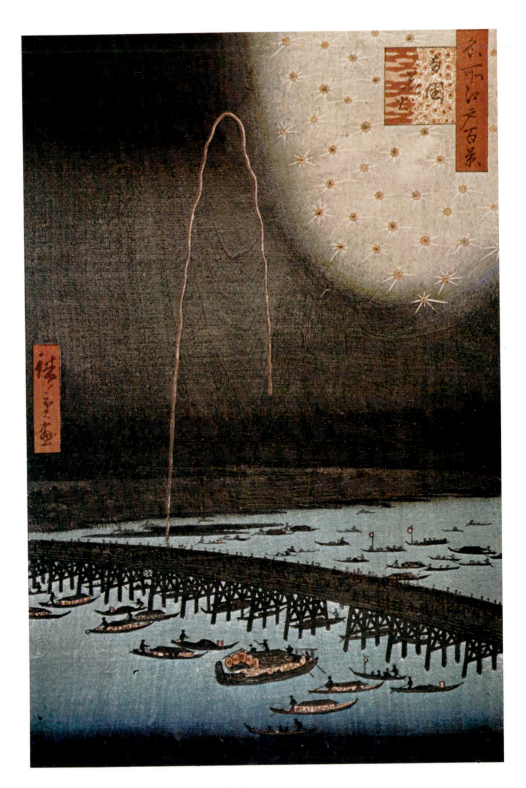

III Andrō Hiroshige. *Fireworks at Ryogoku*, 1856–58

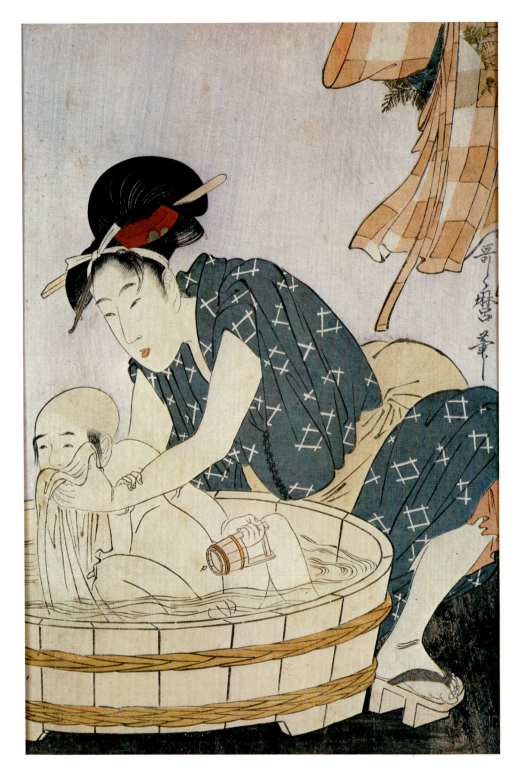

IV Kitagawa Utamaro. *A Mother Bathing Her Son,* c. 1804

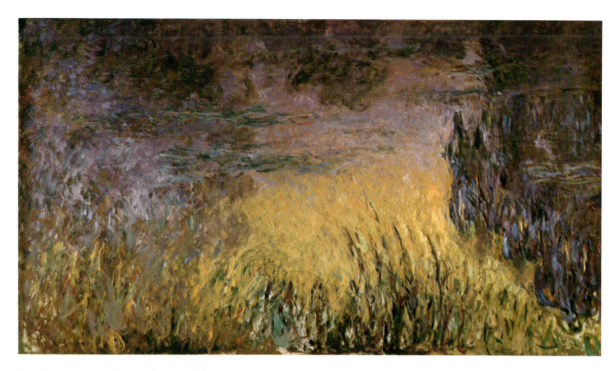

V Claude Monet. *Waterlilies, Sunset,* 1914–18

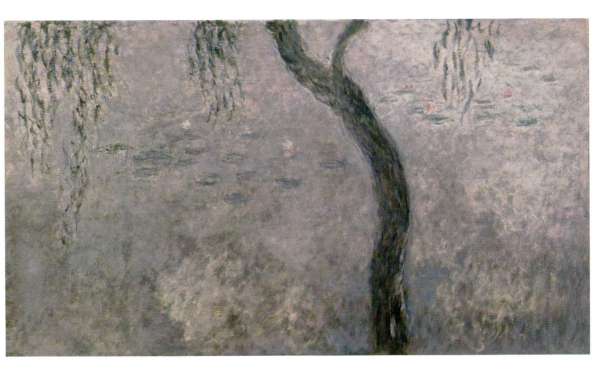

VI Claude Monet. *Waterlilies: The Two Willows*, 1914–18

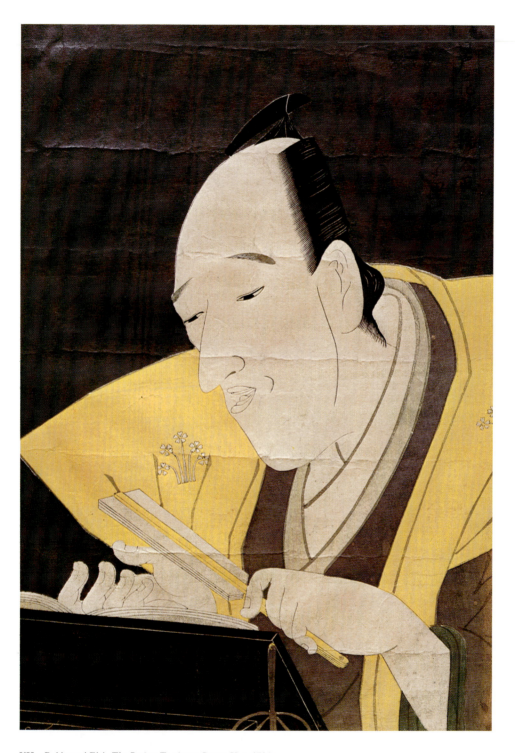

VII Rekisentei Eiri. *The Reciter Tomimoto Buzen II*, c. 1794

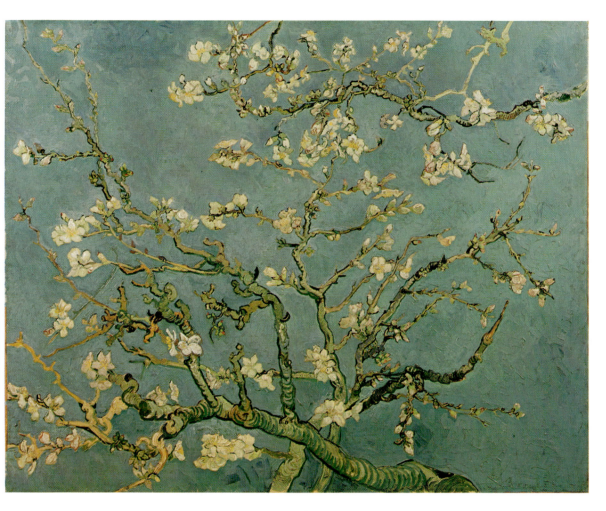

VIII Vincent van Gogh. *Almond Branches in Blossom*, 1890

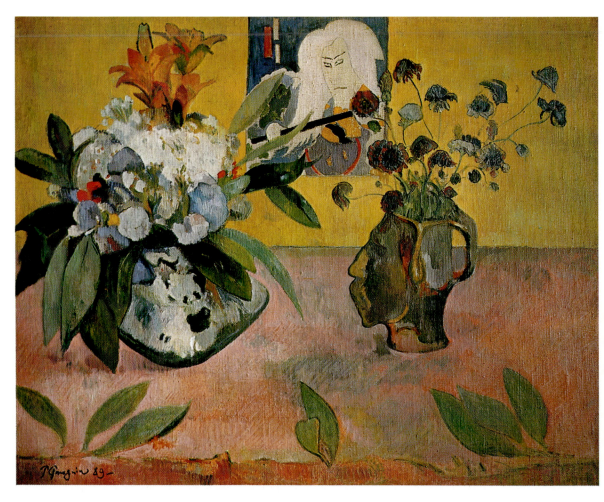

IX Paul Gauguin. *Still-Life with Japanese Woodcut*, 1889

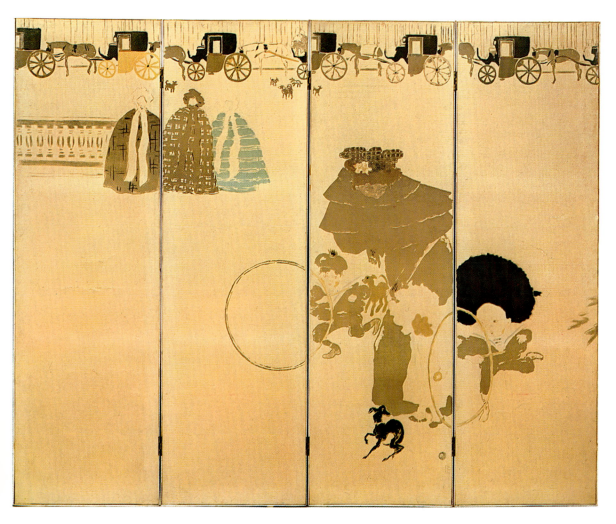

X Pierre Bonnard. *Nursemaids' Promenade, Frieze of Cabs*, 1899

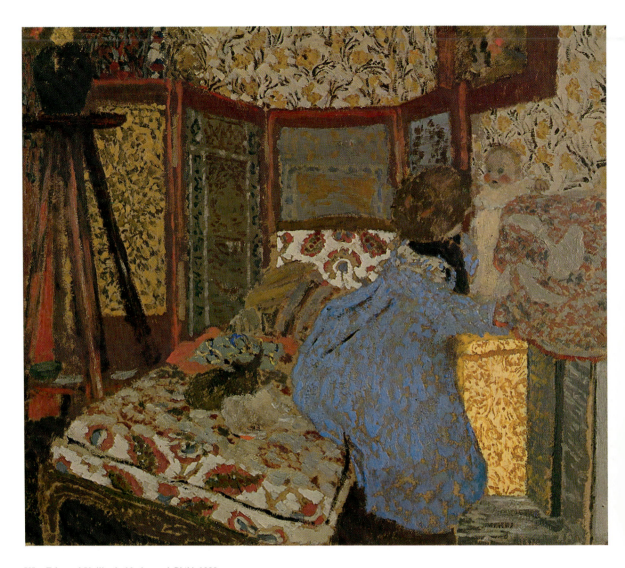

XI Edouard Vuillard. *Mother and Child*, 1899

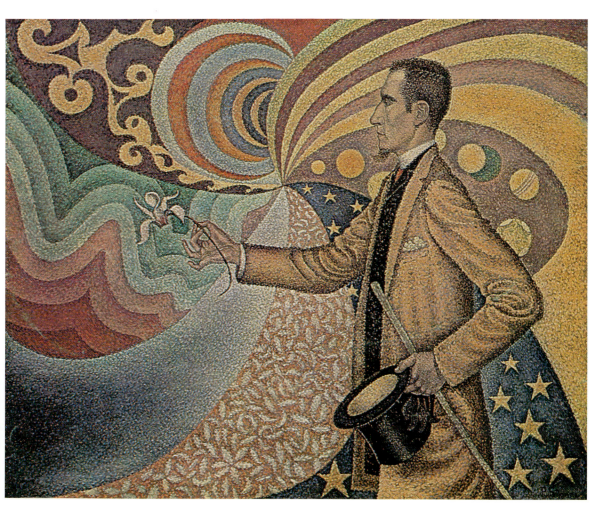

XII Paul Signac. *Félix Fénéon*, 1890

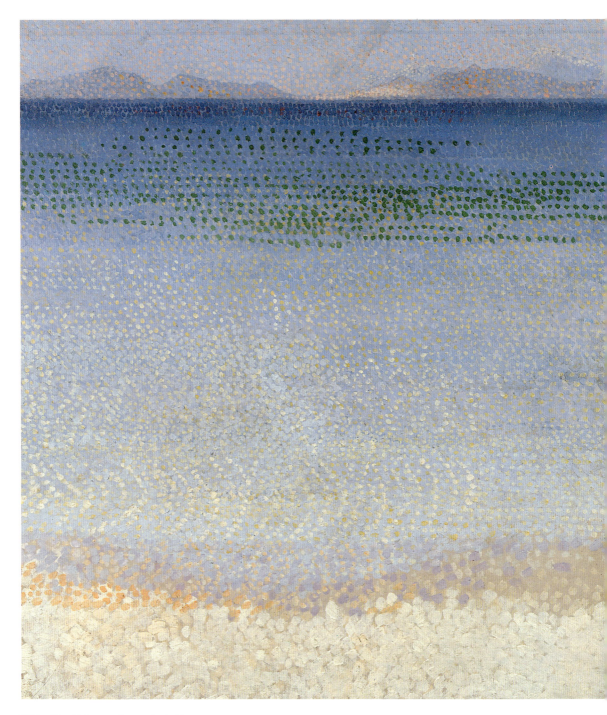

XIII Henri-Edmond Cross. *The Golden Isles*, 1891–92

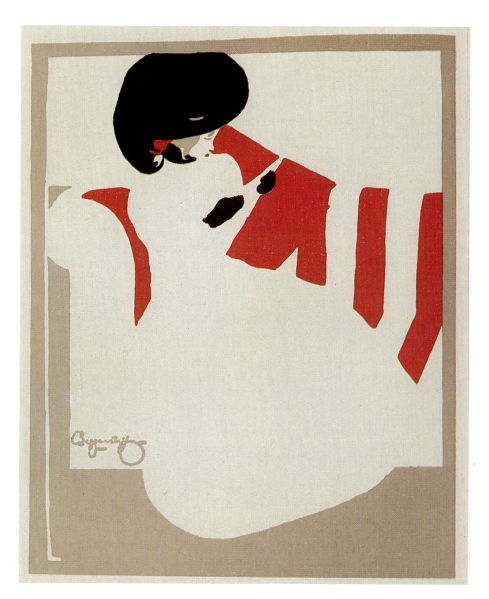

XIV Beggarstaff Brothers. *Girl on a Sofa*, 1895

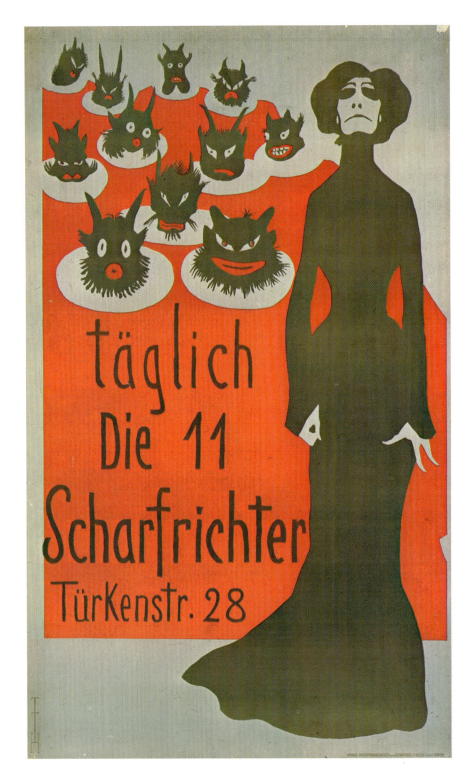

XV Thomas Theodor Heine. *The Eleven Headsmen*, 1900

142
Henri de Toulouse-Lautrec.
Sketch for *Moulin Rouge,*
1891

The final poster goes only one small step further in the direction of abstraction: the scene as a whole is more firmly bounded and given a structural emphasis by being cropped on three sides. The rhythmic arrangement of the spectators in the background – at the top, that is – has also been tightened and regularized, as has the row of lamps above their heads: hatching disappears in favour of unshaded, unified planes of colour. Only the pattern on La Goulue's dress is added, quite in the Japanese way. Above all, the arabesque of the high-kicking leg has been strengthened and made even more convincing. Finally, the colour accents emphasize all these tendencies: from a traditional point of view they are so 'unreal', glaring, shocking, that they seem to come from another world altogether.

The diagonal lines on the floor replace the verticals in the sketch and create a convincing spatial relief, a stratification in four levels, from the gesticulating Valentin on the right to the chandelier on the left, to La Goulue dancing in the middle, and to the border of silhouetted spectators. In spite of the spatial recession, the stage has been moved to the near edge of the picture. The second and third dimensions no longer clash. Although the means differ, this too comes from the Japanese.

Finally, the incorporation of the lettering in the image reveals an intention, a first attempt. The lines are stiff and mechanical; they do not mesh compositionally with the rest. This contrast produces a strengthened, box-like setting for the image, but it does little to unify the whole: little, at any rate, by comparison with what Lautrec achieves in later posters.

The degree to which not only the overall conception but also decisive details spring

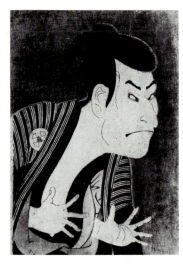

143
Henri de Toulouse-
Lautrec. *La Goulue,
Study of Head in
Profile*, 1891

144
Tōshūsai Sharaku.
*The Actor Otani Oniji
II in the Role of a
Servant*, 1794

from Japanese inspiration is evident from *La Goulue, Study of Head in Profile* [143].
Seen slightly from below, sharply outlined against a black background, she is strongly –
too strongly? – reminiscent of a striking 'expressionistic' study of an actor by Sharaku
[144], with a related approach and a similar abbreviated language of signs for such
features as eyebrows, eyes and hairstyle.

Just as the Western response to Japanese woodcuts began in general with late works
incorporating three or more layers of spatial recession (Hokusai), and then progressed
to an appreciation of the 'classical' vision of Utamaro, with its confined stage space
and, normally, only two planes of relief – so too did Lautrec. After the La Goulue
poster, with its spatial recession, he turned, almost as a matter of stylistic necessity,
to a more strongly planar approach.

As early as 1892, a colour lithograph, *The Englishman at the Moulin Rouge* [145],
showed what was happening. The whole scene is given in one of the very first close-
ups in art, anticipating the cinematic vision by several decades. The image is cropped
hard on all four sides, so that it seems to extend far beyond its own edges; the scale
has become larger and more dynamic, especially through the curves which represent
moving, flowing lines of force; they have started to swell and contract. For all the
calm of the scene, a suppressed tremor runs through the whole image, inflecting even
the horizontals and verticals. In compositional terms, there is no escaping the way in
which, by comparison with the earlier phase, the single dominant figure is now more
compellingly incorporated in the whole and sweeps the two ladies into its diagonal
movement: this seamless, decorative mural image embodies a new pictorial idiom.

There is no missing the new resources that are applied here: the contours of the
colour areas have taken on colours of their own, green and brown, with black used
only where the figure of the Englishman contrasts in colour with the background
behind him. This, of course, comes from the Japanese, Utamaro and Eishi [146] in

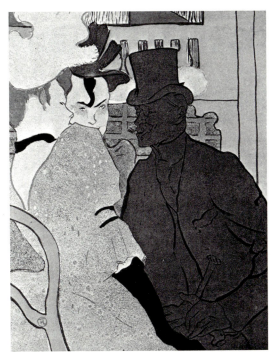

145
Henri de Toulouse-Lautrec.
The Englishman at the Moulin Rouge,
1892

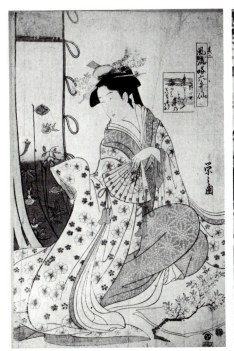

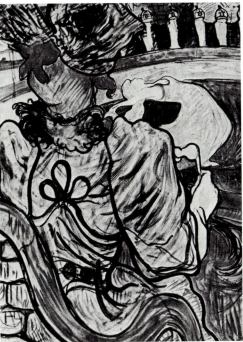

146 Chōbunsai Eishi. *A Beauty as the Poetess Ono
no Komachi,* 1795

147 Henri de Toulouse-Lautrec. *At the New Circus,* 1892

particular. The Japanese artists, however, draw the contour as a unified, 'decorative' line; the European seeks expression through an animated line. The two polar opposites, diametrical extremes of decorative design, are thus revealed. In the use of the arabesque, too, the relationship and also the contrast between East and West becomes apparent: the symbol-laden, emphasized, fetishized streaks of black in Lautrec – the gloves, the kiss-curl, the choker – have a very different function from the discreet, but similarly emphasized, hairstyles of the Japanese beauties.

Finally, Lautrec's drawing of hands and facial features – his physiognomical punch-lines – is unthinkable without the Japanese precedent. The Englishman's eye and mouth are not anatomically but 'calligraphically' defined. Instead of eyeball, eyelid, eyelash and eyebrow in precise detail or tonal modelling, we are confronted with an abstract play of curves such as we find in Utamaro (for instance in *Gontarō of Isami-Dōri*, Museum of Fine Arts, Boston).

On balance, it seems that Lautrec derived from his study of Manzi's collection the realization of just how much could be derived from the 'stylized' art that came before Hokusai. One thing here, another there: Sharaku, Eishi, Harunobu. That he did not lapse into a form of eclecticism, or into mere *japonaiserie*, was the result of his penetrating gift of observation, which he was able to match so exactly to his Oriental 'sources' that the seams never show. He never used them as schemas, only as a source of impetus. Wherever possible, the decoratively ornamental was transposed into the decoratively expressive. Not that this can ever be a hard-and-fast programme: it is a problem that changes with every new poster, every new lithograph.

With his next project we are able to watch him at work. *At the New Circus* [147] is fairly certain to have been painted either as a design for an unexecuted poster or for a Tiffany stained-glass window. The subject is here initially structured as a space-filling arabesque, a highly cinematic view. The circus scene, with the dancer in the ring and the five starched shirtfronts in the background, is almost obscured by the vast system of curves that makes up the figure of the lady spectator. She is the true theme of the work. This event, which it would be impossible to convey from a different viewpoint, is not the objective circus scene but the experience of it, distanced by a decorative interpretation. Lautrec is expressing the psychic reality of his scene in a way that drives him straight into the arms of his contemporaries, the Symbolists and proto-Expressionists, and away from 'realistic' illusionism.

True enough, this gorgeous scenery brings him to a point which in terms of content is far removed from the restrained emotion of Japan, but which would be inconceivable in the absence of a Japanese 'primitive' source. Here one thinks of Torii Kiyomasu I (active c. 1700) and is gratified to find that he was represented in Manzi's collection. In his prints of dancers and actors, one or more large figures are drawn in black curves, set in confined spaces and coloured by hand; however heavily they may stand out from the suggested spatial ground, the parallel is there (*Two Actors*, The Metropolitan Museum of Art, New York).

Strongly though the Japanese artists emphasize black as a colour, orchestrating it in every register, the figure of Jane Avril in the celebrated poster *Divan Japonais* [148]

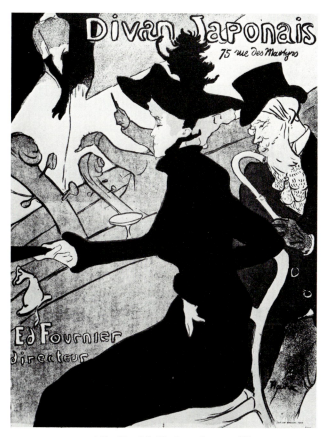

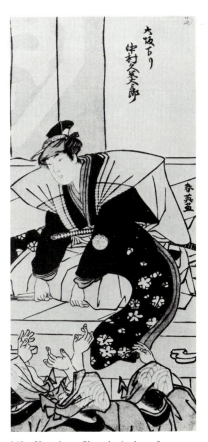

148 Henri de Toulouse-Lautrec. *Divan Japonais*, 1892–3

149 Katsukawa Shunei. *Applause for Nakamura Kumetarō II*, 1790

goes further. One is certainly reminded of Katsukawa Shunei, and particularly of his *Applause for Nakamura Kumetarō II* [149], a print that is known to have been owned by Hayashi. The dominant curved black area, set off by flickering hands, nestling against and embedded in the successive layers of space seen above, with written characters to mark a contrasting direction: all these reappear in Lautrec. But the way in which he derives space from line, the way the curved outlines converge in the central figure and radiate in turn from her, the whole network of electric tensions between the stage, the orchestra, the gentleman and the elegant silhouette of Lautrec's Queen of the Night: all these endow this masterpiece, for all its stylization, with a sense of mobility unmatched in any art, East or West. Figures, gestures and abstractions of colour and form unite in a web of condensed, super-naturalistic reality that exists only here. Such is the power of Lautrec's imagination that it is by his truth that we measure the essence of the Belle Epoque, and not vice versa.

It was Lautrec's constant endeavour to cut across the wide area between abstract arabesque and observed animation; again and again he circled round the problem,

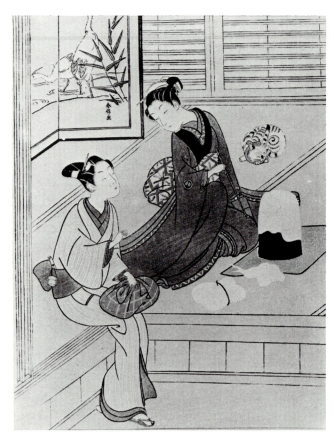

150
Suzuki Harunobu.
Lovers with Cat,
c. 1765

first in one direction and then in the other. In the poster *Jane Avril* [151] he
plays with three elements: surface rhythm, the union of surface and depth, and the
incorporation of the written sign. Here, spatial layers and figures do not interlock; the
component building blocks are heraldically isolated: the dancer, the lettering and the
musical instrument all relate only to the recessive movement of the green diagonals.
In Japanese terms, this marks a further step backwards to the archaic vision of the
'primitives'. One is reminded of Shigenobu or Toyonobu (see Harold P. Stern, *Master
Prints of Japan*, New York 1969, plates 35, 39).

 One feature that has no precedent in their work is the way in which the neck of the
double-bass is combined with the framing of the image. Novotny considers this
'ornamentalization' to be a fault: in his view, the unduly objective figure of the dancer
and the spatial opening do not chime with the 'hybrid' ornamental configuration that
occupies the lower right-hand corner of the poster. Did Lautrec himself perhaps feel
that here two paths diverge instead of uniting? In any case, in the same year, he once
more tackled the same problem from a different angle.

 In the lithograph *Loïe Fuller* [152] he packs ornament into representation and
makes them coincide. The resulting arabesque is the most abstract of all, but at the

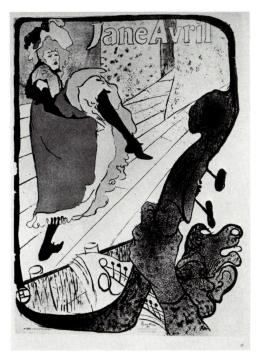

151
Henri de Toulouse-Lautrec.
Jane Avril, Jardin de Paris, 1893

152 Henri de Toulouse-Lautrec. *Loïe Fuller*, 1893

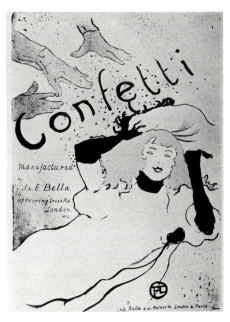

153 Henri de Toulouse-Lautrec. *Confetti*, 1893

same time it reflects the lively impression that Fuller created as she danced with her veils beneath electric spotlights that constantly changed colour. Her dance eluded static representation, though many artists were inspired to try. Only Lautrec could find the means to create an adequate symbol, a pictorial language, for the movement that dissolved form: a more convincing symbol than the attempts of the Futurists, twenty years later.

The vision of the dancer is set in an atmosphere that resembles the 'sacred distance' of Eastern art, although it is impossible to point to a single source. But if we consider that Lautrec was as familiar with the bold arabesques of such early *ukiyo-e* masters as Kiyonobu I (illustrated in Stern, *Master Prints*, plate 10) as he was with the dotted surface treatment of Hokusai (*Master Prints*, plates 140, 141, 143, 145), we begin to detect the elements of a synthesis – quite inconceivable in Japan itself – between early and late stylistic elements. Through a highly refined spatter technique, different in every single copy, he was able to combine painting with printing. None of this is meant to explain away his achievement: on the contrary, it becomes all the more astonishing if one realizes that two entirely disparate Eastern stylistic devices, and other elements besides, have been used to mark a unique advance for the Western avant-garde. The work's lapidary power is not belittled but enhanced.

With the poster *Confetti* [153], of 1894, Lautrec's Japonisme reached its peak, in the sense that all the audacious devices, all the 'grammatical' problems, of the new graphic language interact here with ease and dazzling simplicity. The experience gained in the foregoing works is both contained and superseded in this poster, which can be read either in abstract or in representational terms. The loose lettering does not contrast with the figure but relates to it in direction, in colour and in space. Even the spattered colour has nothing precious about it: it serves to bring the confetti closer to us. The structuring of the surface by the great curve that runs from top left to centre right and then to bottom left; the openness on all four sides, which is to say the cropping or choice of detail; the rhythm of the black accents; the ochreous arabesque of the hair; the limitation to three colours; finally the way the figure advances towards us: all this seems to happen so 'naturally' that one almost forgets the supreme art that lies behind it. And this is the highest praise: this work represents a summit.

There is no need to look further in Lautrec's work, whether in lithographs, posters or paintings, for signs of his Japanese roots. Down to the time of *Confetti*, those roots were numerous and highly visible; thereafter they were increasingly concealed. By this time they were so much part of him that he was able to use them to tackle a succession of new themes – the theatre, circus people, the brothel, singers – and find their vital nerve. The Japanese element – or let us rather say the potential impact of Japanese shorthand on Western art – never again left him: in later years it was, however, increasingly transmuted. One reason for this may well be that Lautrec had no need to restrict himself to the example of Hokusai or Utamaro or Kiyonaga: more than any of his predecessors, he had made so close a study of *ukiyo-e* that he had its whole range at his fingertips.

Down to this point, the assimilation of Japanese influences had proceeded through

the replacement of one source by another, as Western understanding slowly spread from the illusionistic Hokusai to his 'classical' predecessors and then eventually to the 'primitives'; such channels of influence often came to be added together, as they were in the case of Degas. In the early 1890s there arose a changed structure: an *additive* process gave way to a process of *integration*. In Lautrec's posters, and in Art Nouveau in general, Japanese art was played upon like an organ, with various stops pulled out in succession and superimposed on each other. This was not eclecticism but an interweaving of different modes of vision: something like it may be observed at all the great turning-points of artistic evolution.

The Nabis

These artists went one step further in this direction than Lautrec. The art of Pierre Bonnard (1867–1947) is praised for its ability to attain its greatest triumphs through serendipity, taking the chances offered by a lucky accident. Critics have described his work as an enchanted version of the world of appearances, and as an act of invention in the presence of Nature; his fellow artists, at the point of creation, named him 'le Nabi très japonard'.

Like Lautrec, Bonnard was interested in the expressive use of the decorative, even of the ornamental; he tried his hand at posters and recognized the exemplary value of colour lithographs. His folding screens [X], book illustrations, marionettes and stage sets pointed in the direction of the 'applied' branches of art, the meeting-point of Art Nouveau, Classic Modernism and Japonisme. His connections with the literary circle that centred on *La Revue Blanche*, that Dreyfusard journal of the avant-garde – and also with Mallarmé – reveal another dimension in this subtle, painterly painter.

All this goes to show, as Bonnard himself admitted, how complex were the ways and means by which an artist could link himself to a great tradition. 'I still hover between allusive intimacy and decoration, as ever. One does not change,' he wrote to George Besson almost at the end of his career (quoted by Stanislas Fumet, *Formes et Couleurs*, 1944, no. 2).

He tended to hover, too, in his relation to the Japanese woodcut; or rather, perhaps, he used it as a springboard. He differed from Lautrec in expression, in subject-matter and in temperament; but in their relation to Japanese pictorial sources they were not far apart. Not only did both encounter Japanese art in the same half-decade, from 1891 onwards, before allowing it to become a background presence thereafter: both also shared the opening of the new space with its relation to the plane and to the figures. Bonnard would never have been able to continue developing his own painterly magic, as he did in a career that spanned more than half a century, without a graphic – and in this case a Japanese – structure as a point of reference.

In contrast to Lautrec, who proceeded more tentatively, Bonnard responded directly to the signal. *The Morning Gown* [154], of 1891, is the first manifestation of the overwhelming experience of Japanese art, which he had encountered in Bing's exhibition of the previous year. The attraction of the newly discovered Japanese 'primitives'

154
Pierre Bonnard.
The Morning Gown, 1891

is unmistakable. Heraldically simplified, in monumental outline, the upright figure is virtually pasted to the surface of the painting.

A comparison with Manet's *Fifer*, a similarly silhouetted vertical figure, reveals the transformation that had befallen the Japanese inspiration in the course of a quarter of a century. Manet sets the figure up in front of an atmospherically vague background of shifting tones; he hints, at least, at an axial line. Bonnard, the Nabi, has the figure inset in the picture surface, which even crops it at the sides; it seems as if rolled flat. In the face, half-concealed in profile, it loses its individuality; and in the garment laden with ornament it loses its corporeal presence. Were it not for the flower pattern on the left, itself reduced to ornament, it would be possible to speak of a single flat layer, without either spatial depth or sculptural form, dominated by the abstract

155 Pierre Bonnard.
The Check Blouse, 1892

organization of rhythmic arabesques, curves and tones. Only the differently patterned
upper areas suggest something of a Before and Behind. Mood, perfume and music
seem to eliminate the bodily presence and simultaneously to pour out across the visible
edge of the painting. The unusually tall and narrow format, three times as high as it
is wide, is borrowed from Japanese pillar prints.

Bonnard seldom went to such extremes again: *The Check Blouse,* of the following
year [155] is only twice as high as it is wide. In other respects, however, it even more
clearly reveals the new lessons that have been learned. The pictorial space is more
richly articulated, with three or even four shallow layers, both before and behind the
central object, which is the blouse. It is not seen in terms of rigid, centralized
perspective but of 'mobile perspective' (the phrase is Dietrich Seckel's). The fore-
ground, with the table and the objects on it, is seen from above; then comes the cat,
a frontal silhouette; then the woman, seen slightly from below, and the wall as a flat
background pattern. So the viewer's eye moves around the image and endows the
space with an elastic reality which at the same time is elaborately structured. The
layers contrast through their differing textures, patterns or densities of colour. It
seems as though the pictorial space were engaged in vibrating forward and back,
towards and away from the picture plane; as if this were setting up a network of
structures and rhythms into which the colours fit themselves.

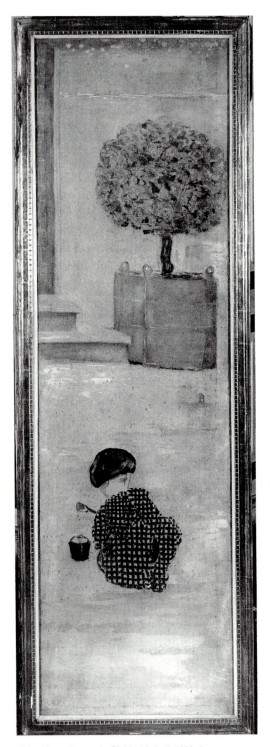

156 Pierre Bonnard. *Child with Pail*, 1892–3

Even so, the Japanese simplification of pictorial space retained its hold on him through these same years: as in *Child with Pail* [156], which can be dated to 1892–3. In its composition, which builds up not from foreground to background but from bottom to top without overlaps; in its accentuation of pattern and ground; in its contrasts of vertical and horizontal; in short, in its dynamic use of static structural elements, this reveals a completely new pictorial language.

Bonnard remained faithful to this same compositional principle for the rest of his career, which means for the next fifty-five years, in spite of the enormous evolution and alteration that his palette underwent during that time. His symphonies of colour are quite another story: they can only be understood as part of a European tradition that runs from Corot to Monet, and are not at all dependent on the East. However, the network of structures remains detectable, though often obscured by the colour harmonies.

Around 1915, Rewald tells us, Bonnard seemed about to succumb after all to the temptations of atmospheric colour; this led to a crisis from which he recovered only – as he himself admitted to his nephew, Charles Terrasse – through the discipline of drawing. The subsequent reinforcement of the structure of his paintings, admittedly only in a changed sense, was the result of a renewed Japanese impulse. The evidence for this, however, is indirect and inferential.

In Bonnard's early period, in the 1890s, whenever the single figure, or a scene with few figures in it, is dominant, the allusion to the Japanese 'primitives' is unmistakable [156]. This artistic vision, as we have seen, came to him in the course of that pivotal event for all avant-garde artists, the exhibition *Les Maîtres de l'estampe Japonaise*, of 1890. There can be no doubt that Bonnard received his first impetus there [X].

Whether he then started to collect on his own account is not known. Later, however, he admitted to having picked up Japanese prints for 'a few sous' (Claude Terrasse, *Bonnard*, Paris 1947, 24). This must refer to the very late *ukiyo-e* masters; for the great names already commanded considerable prices. According to Bernard Dorival (*Revue du Louvre et des Musées de France*, 1969, no. 1, 21–4), the inventory of his estate included 'woodcuts by Hiroshige, Kuniyoshi, Kunisada and Yoshikuri [Yoshikuni?]'. If Bonnard bought these at or before the time of his 1915 crisis – at a time when, thanks to Koechlin, six exhibitions in as many years had presented the whole of *ukiyo-e* art once more to the Parisian public – the problem of his compositional renascence is solved.

Once again, it was to be the Japanese who showed him the way. The late masters whose prints he owned summarized many of their predecessors' insights in their own way, but abandoned the traditional parallel perspective under Western influence and replaced it by a view in recession with abrupt overlappings. Kuniyoshi, in his *Kabuki Scene* [157], a print that Bonnard owned, uses a composition with a diagonal emphasis which respects both recession and the flatness of the surface; on it he superimposes a richly orchestrated welter of patterns. Bonnard's close friend Maurice Denis, after his crisis, operated in the same way, although with a totally different effect. Bonnard's own *Still-life with Basket of Bananas*, of 1923 [158], is just one of many examples of

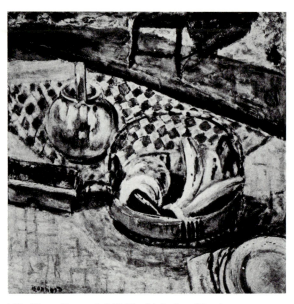

157 Utagawa Kuniyoshi. *Kabuki Scene*, c. 1840 158 Pierre Bonnard. *Still-life with Basket of Bananas*, 1923

the way in which he constructed the 'systematically fragmented space' (Pierre Francastel) that coexisted in his work with a magical network of colour and a dreamlike sense of intimacy. Bonnard thus represents one of the high points of Japonisme, in the sense that in his work the roots of his Japanese inspiration were totally absorbed and transposed: so much so that they ultimately became almost unidentifiable.

By contrast, Edouard Vuillard (1868–1940) might rather harshly be described as Japonisme's first deserter. In his early period, when he worked side by side with Bonnard, no one understood and absorbed the lesson of the East better than he; later, no one more comprehensively switched back to Western illusionism, with all that entails. This is not intended to imply a value judgment. What is surprising is the way in which, for almost a decade, Vuillard continued to weave the same enchantment, particularly in interiors, through countless variations drawn entirely from his own visual memory. For it seems as though he needed to forget the impression of what he saw before he could construct the picture. One is reminded of Proust's remark on the paintings of Vermeer: 'These are fragments of the same world, always the same table, the same carpet, the same woman, the same unique beauty, for all the genius with which, each time, they are re-created' (*A la recherche du temps perdu*, Paris 1956, vol. 3, 377–8).

It is the artist's invention that operates, every time. This contradicts the statement of Jacques Salomon, whose claim to authority was the fact that he was the artist's nephew by marriage, and who declared: 'Vuillard invented nothing.' Salomon must have been thinking of iconography, not of art, and restricting himself to the late phase at that.

Vuillard's break with his Nabi beginnings was certainly dramatic, but nothing comparable to the sudden catastrophic loss of quality that afflicted many of his contemporaries – including Anquetin, Bernard, Denis and Sérusier – after the turn of the century. And indeed Curt Schweicher, analysing Vuillard's style in depth (*Die Bildraumgestaltung, das Dekorative und das Ornamentale im Werke von Edouard Vuillard* [diss. Zürich], Trier 1949), was able to point to a continuity in the artist's work that lasted through this major shift at the turn of the century.

What concerns us in the present context is not this perception so much as Schweicher's critical approach, his crisp definitions and subtle analysis of detail, so that his work may be considered as the starting-point of serious research on Vuillard. Later came the penetrating study by Ursula Perucchi-Petri, *Die Nabis und Japan* (Munich 1976). Here, in solid analyses of the work, in a study of the numerous surviving sketches, and in a laborious reconstruction of Bonnard's, Vuillard's and Denis's collections of Japanese art, the new pictorial language of the Nabis is as clearly expounded as one could possibly wish. Nevertheless, we can follow the basic lines of Schweicher's account: the decisive categories in Vuillard's art are space and decorative design.

The last decade of the nineteenth century, the Nabi period as such, is summed up by Schweicher as follows: denial of pictorial volume; resolution of the interior space into a series of compartments; reduction of the representational content to two planes or flat layers; ornament as background; emphasis on graphic traits. (Even after 1900, when recession in depth and the wide-angle view came to dominate, the plane retained its significance, and the painting was still related as a work akin to pictorial tapestry.) One might add that this effort to relate, or even to subordinate, the pictorial space to the plane is something that Vuillard had in common with all the avant-garde artists of the time, from Degas to Redon, Lautrec and the other Nabis.

What is unique to Vuillard is the way in which he relates the decorative to the ornamental. Schweicher deserves credit for having seen more clearly in this respect than many other scholars, who had tended to confuse the two categories and, worse, to regard them as purely playful, arty-crafty, extraneous elements. He defines the decorative as a design principle which serves to define the large-scale and small-scale structure that makes the work a *Gestalt*: a whole greater than the sum of its parts. The ornamental, by contrast, is something that can be added in – as it is in Vuillard – and which remains additive: a set of parts.

In order to grasp the essence of Vuillard's style, Schweicher takes as his point of departure the artist's panels (*panneaux*), decorative wall decorations in several parts, of which there are about fifty. This is what he says: each individual panel, as an element in a cycle, demands to be completed by the components of the other panels. This defines their 'open' style. The surface seems to be in a state of flux; the frame has no binding power. Even the easel paintings are asymmetrical in a way that allows one to postulate a pendant for every image. The cropping seems highly arbitrary: it leaves the impression of an endless melody. The formats are also extraordinary. The exaggerated width or height emphasizes the sense of urgency and transitoriness. (It

is worth noting, here, that the image in two, three, five or six parts is an idea borrowed from Japanese woodcuts and folding screens, and so are the unusual formats: the Japanese pillar print is in the proportion 6:1, measuring 70×12 cm / 27.6×4.7 in.)

The decorative, says Schweicher, has here become a value that ties the elements within the picture both to each other and to the objects in the room outside. Strips and curves sweep across the surface, guiding the viewer's wandering eye. (This is also derived from the Japanese, it seems to me; but of this more anon.)

What is highly original, and without points of comparison elsewhere, is the incorporation of the ornamental in decorative structuring. By this, Schweicher means an autonomous process: the abstraction of specific form into ornament. The planar compartments are not simply juxtaposed as planes of colour but brought alive through the use of ornament: the various ornamental motifs in the picture plane are varied, transformed, and played off against each other, like musical subjects and counter-subjects. This reaches an extreme in the abstract convolutions of the arabesque. As a result, ornamental content replaces narrative content.

So much for Schweicher's analysis. It must be added that no analogy to this deductive process is to be found either in Eastern or in Western art. Ornaments often appear in *ukiyo-e* woodcuts of all periods; but they never permeate or overlie the picture plane.

It now becomes possible to gain a clearer idea of Vuillard's art in the context of its evolution and of its relationship to the other Nabis and to the Japanese. In 1891, directly after his conversion from the traditional painting that he had been practising since 1888, a few months after Bing's Japanese exhibition, and only a few weeks after Bonnard's *Morning Gown* [154], he produced the bold composition *In Bed* [159]. No work in the whole of Nabi art is so radical in its transformation of illusionistic representation into a near-abstract, rhythmic planar construction. At first sight, one is almost reminded of an early Mondrian, thirty years before its time.

There is something similar in Torii Kiyoshige, a mid-eighteenth-century 'primitive' [160], and also in his contemporary Torii Kiyotada; both artists were represented in Bing's collection and in the 1890 exhibition. The affinity is not one of motif or of mood: the point of comparison lies in the independence of the structure from the objects represented. The way in which, in Vuillard as in Kiyoshige, the few curves are tied into the structure of mostly rectilinear lines of force and fill out the whole surface of the image; the way in which the abstract compartments alone determine the distribution of colour, pointing to a remote reality, a reality beyond reality: all this gives Vuillard's picture a pioneer quality that has no parallel in the art of the time. Even Lautrec's advance was in a completely different direction.

There exist a number of abstractions created in the same period that are similar though perhaps less subtle; but by the following year Vuillard's style had changed – once more, we must add, with the aid of the Japanese – to introduce the integration of the ornamental with the decorative, as observed by Schweicher. From the point of view of stylistic history, this represents a reversal, if not a regression. Ever since Manet, the Japanese influence had tended away from illusionism and towards elements

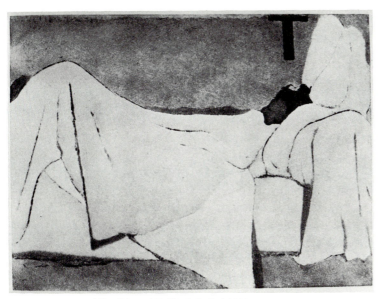

159 Edouard Vuillard. *In Bed*, 1891

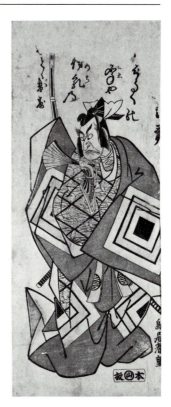

160
Torii Kiyoshige.
Shibaraku Scene, 1754

of abstraction; here it was operating in the reverse direction, towards phenomenal appearances. It now became characteristic of Vuillard's vision that, in the words of Fritz Hermann (*Die 'Revue Blanche' und die Nabis* [Diss. Zürich], Munich 1959, 231), 'his eyes were opened to the rich ornament and the arabesque quality of our everyday world'. His means and his ends changed places.

Vuillard's interest in the *intimité* of his familiar environment – his mother's dressmaking workshop, the family drawing-rooms of his bourgeois friends – revealed to him the decorative quality, the style and the stylization that existed in his own everyday life, and led him to combine the decorative with the ornamental in creating its optical equivalent. From a sociological point of view, this marked the retreat of the rebellious avant-garde into secure possession; the transition from youthful turbulence to maturity and fulfilment. Vuillard had arrived, and he was only twenty-four years old.

His motifs did not follow Impressionism, whose demise was still recent history, into the open air but went back to an older tradition of the interior; and their ancestry may well include Manet's *Luncheon in the Studio* [7] or Degas's *Bellelli Family*, with its use of a wallpaper pattern. Other reminiscences come to mind; Claude Roger-Marx tells us that 'In these panels there exists a kind of silence, an order, a controlled flicker, which at times recalls an admittedly milder Seurat; although Vuillard never attains the hieratic style and the tight coherence of the painter of *La Grande Jatte*' (*Vuillard et son temps*, Paris 1945, 124).

This was the context in which, in 1896, Vuillard painted *The Work Table*, one of four decorative panels for a Dr Vasquez, now in the Musée du Petit-Palais in Paris [161]. This work stands precisely on the borderline between his early abstractions and his later naturalism. In European terms, it reveals traces of a wide variety of influences, from Manet to Degas, Gauguin and Seurat; in the light of its Japanese 'ancestors', too, it must be seen as the autonomous product of a wide spread of sources. One thinks first of the style of Okumura Masanobu (1686–1764), who, of all the early masters, was the one who led the transition from the monumental creations of Kaigetsudō to a more delicate approach. Masanobu's print *Lady Ukifune*, of 1740 [162], a river landscape with a drifting boat, comes very close to Vuillard's structure: the steep upright format; the layering from bottom to top, instead of from near to far; the horizontal and vertical strips relieved by ornamental curves, in the bare trunk and spreading branches in one case and in the draped dress and the outlines of the figures in the other. The 'open' composition, cropped by the edge of the picture rather than terminated, is also common to both artists.

Ornament played a part in Far Eastern graphic art from the very start, in the use of ornamental silk textiles and garments; it found a place in every Japanese style, from the linear drawing of the beginnings to the more painterly middle and late periods. It was, however, at the very end of the evolutionary process that ornament took the lead, overwhelmed the figures and their material setting, and imposed on them its own formal principles. The apparent disorder within order, the spell that Japanese art casts on reality, is active here.

In Kunisada's *Shower of Rain on the Way Home* [163], one of those works that could be had for a few sous, the space and even the image of the body are replaced by a dozen or more segments of colour and pattern. The scene has been transformed into a system of multicoloured ornamental fragments: a kaleidoscope. A multitude of rhythmically varied curves without a single horizontal or vertical, without a centre of gravity, combine to create a whole, a *Gestalt*, which is one single arabesque. This is a sequence of ornament with an unshakable inner necessity of its own; although Western eyes may take time to accustom themselves to the sign system involved.

Vuillard received a tremendous impetus from this emancipation of the ornamental world and recognized its inner validity, even though he did not abandon tectonic organization; what he did instead was to build 'ornamental islands' into his decorative system. To assess his relationship to his sources, one must first recognize, however, that the loud colour scale of the late Japanese artists – their stark blues and greens, for instance – did not appeal to him. For this he turned to a third source: the soft colour harmonies of Utamaro [IV] served him, as they served more than one of his Parisian predecessors, as a key to the mood of intimacy.

All in all, then, Vuillard achieved a creative amalgam of three completely different Japanese stylistic phases. Before the 1890s – that is, before the art of *ukiyo-e* was known in *all* its evolutionary phases – a synthesis of this kind would have been unthinkable for any artist, however able.

Was Vuillard's synthesis of different Western traditions and Eastern forms of vision

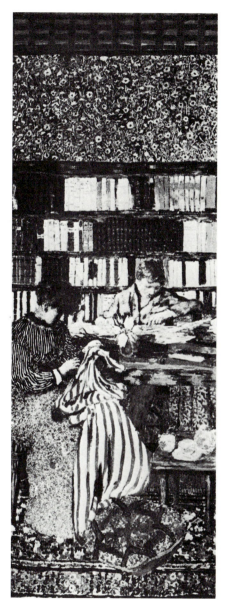

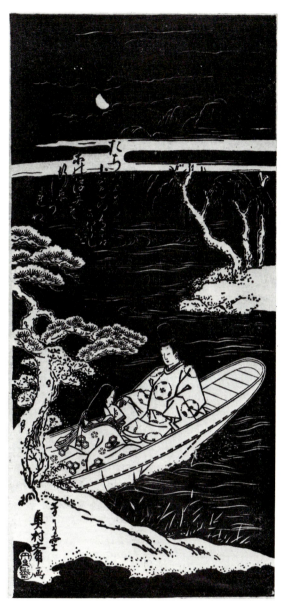

161 Edouard Vuillard. *The Work Table*, 1896

162 Okumura Masanobu. *Lady Ukifune*, c. 1740

163
Utagawa Kunisada.
Shower of Rain on the Way Home,
c. 1850

restricted to the *panneau*, a form of mural decoration with laws and potentials of its own? What happened in his concurrent easel paintings? There, in fact, he had if anything more freedom. *Mother and Child* [XI] is a case in point. The format itself, almost a square, comes closer to Japanese than to European conventions. The scene itself might have tempted the artist into banal sentimentality, or led him to follow the Western tradition of the Madonna: he did neither. The bodies of both figures are 'hidden' by an accumulation of planar patterns, fragments and colours; these not only fill the entire picture area but are intersected by the edges in every direction, so that it seems as though they go on for ever. The folding screen gives some intimation of a background, but it would be impossible to gain any precise idea of the nature of the space.

How deep is the room? How wide? Not all the patterned surfaces, especially in the lower right-hand quarter of the painting, can even be located with any certainty. The play and interplay of ornament has engulfed the forms far more thoroughly even than in the panels. In sheer ornamental confusion – the term is not meant as a reproach – Vuillard yields nothing to Kunisada [163]. Only the screen still reminds us of his decorative organization; only the colour harmonies, through Utamaro, recall Vuillard's own magic.

Not all of Vuillard's paintings of the 1890s are based on the same complicated recipe for the amalgamation of three Japanese sources; but over and over again he invented a new visual fairy-tale. There is food for thought in his decision, at the turn of the century, to abandon this form of vision and turn to a naturalistic depiction of

people and of the details of their chosen environments. Was it that his ornamental invention had begun to flag? Was it his encounter, through Lucie Hessel, with the *grande bourgeoisie*, 'a largely Jewish section of Parisian society, in which the doctor, the merchant banker, the editor of the best new magazine, the playwright, the amusing kept woman and the rising politician enjoy one another's company' (John Russell, *Edouard Vuillard*, London and San Francisco 1971, 58)? At the time of writing the artist's diaries were still under lock and key; until they are published the question must remain open, unless we choose to rely on the irrelevancies of the sociologists and psychoanalysts.

A last example comes from Vuillard's graphic art. Here, in the regrettably few colour lithographs that he produced at the turn of the century, there is a hint of a farewell to decorative abstraction; the feeling for subtlety and refinement encounters the new freedom inherent in the medium. *The Birth of Annette*, of 1899, is perhaps more intensely imbued with the Japanese spirit than any other work. A marriage of West and East has been achieved. With its great open planes and the ornamented forms that contrast with them, the print yields a structure of pattern and ground, of Yang and Yin. The last trace of ornamental space-filling has disappeared. The timeless transparency of the intimate everyday event, under a magical pictorial spell, has never been better captured. A whole universe is conveyed through simple fragments and their rhythmic organization. It is an unsurpassable farewell.

No single specific source can be named: this is the perfect transposition of the Japanese essence. Whereas many others took their inspiration from one *ukiyo-e* master or another, and often derived no more from it than something vaguely Japanese, an artist is at work here who knows the sum of all possibilities, from the 'primitives' to Kunisada, and who has extracted an essence that has a good proportion of Utamaro in it.

Maurice Denis and Georges Lacombe would deserve discussion here only if this book were exclusively devoted to the aftermath of the 1890 exhibition. Denis, like all the Nabis, certainly subscribed to Japonisme, but to him this was only one of many versions of Primitivism, and far from the most important. He was also the first artist to turn to a pallid Catholic classicism, although once upon a time he had been able to toss off so charming a pictorial idea as *Madame Ranson with Cat* [164]: poster-like simplification, echoes of Art Nouveau, *japonisant* colour. At exactly the same period, in 1892, Georges Lacombe (1868–1916), the 'unknown' Nabi, who always refused to sell his work, infused the *Play of the Waves* [165] with Oriental ornamental patterning. What could better have conveyed the opening of a new artistic world for the younger generation? The result is not a great work of art; but it unmistakably bears witness to the power and topicality of Japonisme at a precise moment in time.

Félix Vallotton (1865–1925)

With Vallotton, a whole new view of Japanese art became possible. He followed the Japanese masters in using the woodcut medium; this might seem an obvious course

165 Georges Lacombe. *Play of the Waves*, 1892

164
Maurice Denis.
Madame Ranson with Cat, c. 1892

to take, but woodcut is a medium that has always entailed entirely different problems in the West. Technique, while not unimportant, remains as always subordinate to vision, to style; and in the West etching, and later lithography, have always had greater currency, both among draughtsmen and among painters. Revivals of the ancient art of the woodcut, and of wood engraving, have never amounted to more than a brief interlude; especially as, in the West, the question of incorporating colour tends not to arise.

Vallotton's decision was therefore not a natural one but a heroic one; it went right against the grain. He did not allow himself to be sidetracked into an experiment with colour but set out at once, and without hesitation, to tackle the central graphic problem, the art of the black-and-white woodcut, which had reached a prodigious zenith in the work of the Japanese 'primitives'. And so he, too, owed much to the 1890 exhibition, in which such works were shown for the first time.

If one surveys Vallotton's graphic work, most of it produced in the 1890s, it is astonishing to find with what logic, consistency and speed he passed through the various stages, from traditional depictive vision to stylistic originality. His earliest etchings are reminiscent of the Barbizon School and of Charles Méryon. Alongside and after these came the lithographs, the series of *Past, Present and Future Immortals*, with their penchant for acute, sharp characterization and near-caricature in the

enlarged heads, in the tradition of Daumier. Then came his series of zincographs, *Paris Intense*, a 'physiology of street life'. These already show him in his element: the space is compressed, the figures cut out like patterns. But it was not until he took up the woodcut medium that he succeeded in rising, with sovereign assurance, above the level of craftsmanship, and in finding an entirely free interpretation of his subject.

Monte Rosa, of 1892 [166], looks at first glance like a simple sketch, in which much has been left out: it seems to fit effortlessly into the Western tradition of drawing. Only on close study does it reveal an image infused with life, in which every stroke and every tiny curve is seen to be vital for the construction of the whole. Nothing is approximate. Its debt to the Japanese emerges only on reflection. In Dietrich Seckel's excellent formulation:

the East Asian artist uses the terse, allusive hint; he understands the art of omission as few other artists do ... Almost everything seems to point beyond its own bounds, to transcend its present state. Hence the framelessness, the impression of all-pervasive mood and of infinite space. This constant implication of something beyond, this hint that there is more, this cosmic and vital rhythm, pulsing through all things, can be so intensely felt only because so much is left out, because so much is left to our imagination. The form is not so much a complete record (and thus a limiting conclusion) as a guide to the process of extension and completion that takes place in the infinite spaces of the Not Shown. The multiplicity of appearances is filtered down to its pure essentials; but this reduction, however drastic, does not mean any loss of sensory presence: rather an intensification of the power of the image and the acquisition of a definitive essential form. Sketchy, fleeting and provisional though this may seem, it springs from a strict mental penetration of the object, an artistic discipline: and this in itself is what makes it so well suited to the expression of ultimate insights. (*Einführung in die Kunst Ostasiens*, Munich 1960, 373–5).

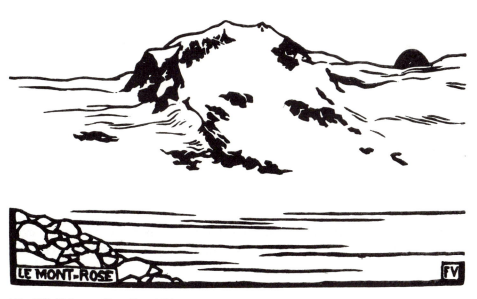

166 Félix Vallotton. *Monte Rosa*, 1892

All the elements are thus combined in this print: absence of framing, rhythmical organization, opening up of space, and in addition, in keeping with the original purpose of graphic art, transposition into two dimensions. Only an artist who had understood the silhouette style of Masanobu [162] could have applied this bold formula to a pure landscape. Here, in the cutting away of the printing surface, in which nine-tenths and more remain white and generate a dynamic interplay with the rhythmically mobile black patterns – in these snows with their aspect of eternity – Vallotton achieved the best possible graphic fusion of Asia and Europe. He had reached a plateau on which he himself could find no response; and he never went further, although he had blazed the trail that the youthful Mondrian was to follow in his *Dune* series of 1909–10 [167].

All the greater, by contrast, was Vallotton's success with those of his woodcuts that might be described, using the title of one of his series, as *Intimités* or scenes from private life. A good example is *Indolence*, of 1896 [168]. It would not be easy to find a kindred motif or a similar mood in *ukiyo-e* prints; but the contrast between black and white, the division of the surface into patterned segments, the top view, the movement in two diagonal directions and the way in which all the parts hang unified in suspense, the unreality imposed on the location in spite of all the sharpness of detail, are all so emphatic that a Japanese point of comparison becomes essential.

This time we need to go one step further back in the history of *ukiyo-e*, to the early master Torii Kiyonobu II. Admittedly, *The Actor Iseburo*, in a woodcut of 1726 [169],

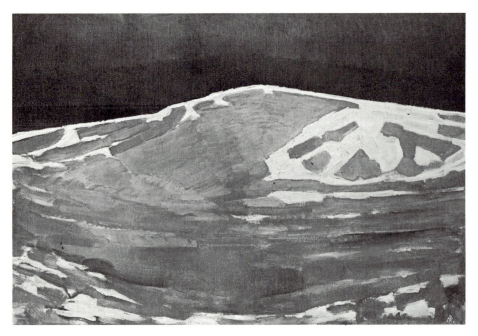

167 Piet Mondrian. *Dune V*, 1909–10

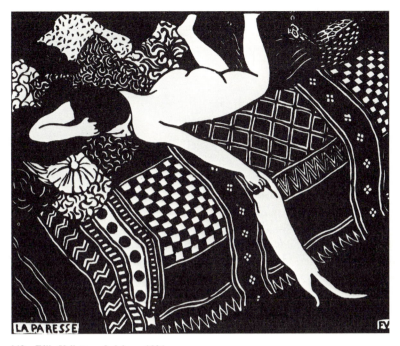

168 Félix Vallotton. *Indolence*, 1896

printed in black and white and then hand-coloured, is engaged in a wild dance; but the structuring of texture-filled and empty segments, and above all the diagonal emphasis, is so strongly reminiscent of *Indolence* as to impose the awareness of a parallel. How could one miss the introduction of large black 'islands' within which objects merge, such as the girl's hair and the counterpane in the Vallotton, or the man's quiff of hair and coat-lining in the Kiyonobu? In both cases this happens precisely at important spatial intersections, vital for the articulation of the scene. None of this is meant to imply that the Western work can be 'derived' from the Eastern; far from it: the latter struck the spark of a highly original creation.

That was certainly the way Vallotton's contemporaries saw it. He soon received commissions to work for German as well as French magazines. Within a few years, the black-and-white woodcut *à la* Vallotton fired the enthusiasm of a whole generation of graphic artists. From *The Studio* (London) to *Pan* (Berlin) and *Die Jugend* (Munich), his works were sought after and much praised.

However, prints remain in the minority in Vallotton's œuvre. He saw himself essentially as a painter, and concentrated, as far as he was able, on painting. This is not the place to debate the value of these works. It is, however, worth pointing out that, especially in the early years, which coincided with that decisive decade of the 1890s, Japanese inspiration was at work here also. *Bathing on a Summer Evening*, of 1892 [170], with its rhythmic arrangement of hieratically outlined figures in a landscape that seems to hinge upwards, reminds us more of Seurat's *La Grande Jatte* than of

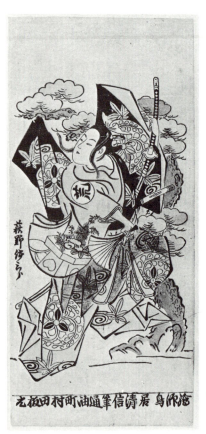

169
Torii Kiyonobu II.
The Actor Iseburo, 1726

any other contemporary work. Emphasized by linear means, some of the figures are distributed across the composition as pillar-like verticals that lend it a central and lateral structural emphasis; others are strung out as curvilinear forms, combining to form a convoluted figuration that twines its way through the entire scene. The whole is captured in a kind of suspended animation, underlined by the abstract structural framework of verticals and horizontals (in the wall and steps) set against curves.

The same idea is to be found in a print by Utamaro, *The Bath* [171], from the Camondo collection, now in the Musée Guimet, Paris. All the figures are assembled from curves and 'cut out' of the background; the posts and boards, with their abstract, almost geometric verticals and horizontals, counterbalance the curves, much as in the Vallotton. Common features are the hinged space, with a top view in the foreground and a view from below in the remoter, which is to say the upper, part. In the Utamaro, too, the conspicuous heads of black hair form a wavy line that runs through the whole scene; a number of his squatting, seated and standing women undergo changes in the Swiss artist's work that give them more familiar 'Western' poses.

The relationship is revealed above all by the drawing of a number of details; the way the hair, in both works, caps the face like a wig; the way the Parisian girls almost

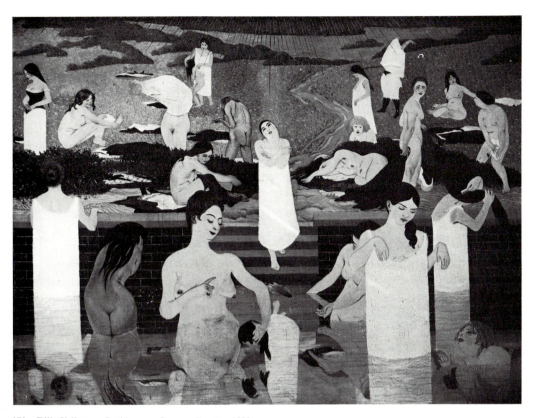

170 Félix Vallotton. *Bathing on a Summer Evening*, 1892

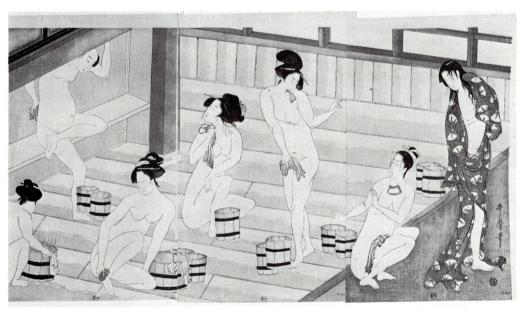

171 Kitagawa Utamaro. *The Bath*

all take on Japanese features, as with the girl in the foreground whose splayed breasts set up a play of curves that is in no way inferior to that of the Japanese. And the longer one studies the details in this way, the clearer the conclusion: once more, the study of Japanese prints did not create the Western painting but undoubtedly acted as the stimulus that prompted it.

Paul Signac (1863–1935)

Two other artists concern us here, among those who came to maturity in that fruitful decade of the 1890s: Paul Signac and Henri-Edmond Cross. Both might have been discussed in conjunction with Seurat, as both were continuators of his work; but this would have distracted attention from their response to the Japanese explosion of the early 1890s.

In the extensive literature, this aspect of Signac's work has almost always been neglected; and yet there can be no doubt that his *Félix Fénéon* [XII], a portrait painted in 1890, was actually the very first Japanese-inspired abstract painting. Even before Bing's 1890 exhibition closed, Signac the artist was in correspondence with his friend and prospective sitter; apart from Arsène Alexandre, Fénéon was the only critic who liked his work. Instead of an accurate likeness, Signac promised him *un Félix décoratif*.

This painting holds a decisive position in Signac's work. In pursuit of the optical and aesthetic researches of Charles Henry, a Sorbonne professor, and of his intellectual forebears – Charles Blanc, Eugène Chevreul, Hermann Helmholtz, Ogden Rood – Signac went even further than Seurat. He set out to develop a harmonious relationship from the *dynamogénie* of colours and lines, and to give this an absolute primacy even when it ran counter to the accidental, 'photographic' phenomena of Nature. It was abstraction versus depiction: an issue that was already concerning Seurat in his last works, as we have seen. But whereas there, as in *Le Chahut* [80], the given object was made to adapt itself or submit itself to the abstract form, here, as soon as any conflict arose, it was for the object to disappear or be relegated to the sidelines.

Determined though Signac was to proceed on this path, no aesthetician could supply him with a recipe to tell him what to do. Some creative spark was needed; and in the given circumstances it could only come from the Japanese. This being so, it comes as a particular stroke of good fortune that the artist's granddaughter and biographer, Françoise Cachin, has discovered a document of the highest importance in his own archives (*Revue de l'Art*, 1969, no. 6, 91). This is a sheet from a contemporary Japanese album of textile patterns, doubtless intended for the benefit of those who embroidered kimonos [172]. As Signac was able to see similar patterns in Bing's magazine *Le Japon Artistique*, almost every month from 1888 to 1891, it becomes easier to understand why an especially abstract ornament such as this, discovered in a junk-shop, inspired him to such a bold stroke of imaginative creation.

In the rhythmic segmentation of colour and form, he follows his source fairly closely, while dispensing with a number of Japanese emblems and intensifying the contrasts – entirely in keeping with the ideas of Charles Henry – by introducing a

172
Japanese kimono patterns,
c. 1860

new Oriental pattern in the upper left corner. The way in which he then incorporates the profile of Fénéon, a hieratic figure in 'archaic' pose, with his top hat in one hand and an orchid in the other, creates an entirely unprecedented degree of synthesis, opening the way to Robert Delaunay's Orphic Cubism – as Francastel has already pointed out (*Du Cubisme à l'art abstrait*, Paris 1957, 17) – as well as to Mondrian and to Klimt. This was Signac's most forward-looking work. The uncomprehending laughter with which it was greeted by the critics and the public led him to pull back, at least in the sense that he never again painted so uncompromising an abstraction.

One thing must, however, be clearly borne in mind. This work is not a game played with a casually chosen pattern-card, but a formal and expressive statement. Negatively, it marks a rejection of the psychological and/or photographic likeness; positively, its 'unnatural', ritualistic pose is a direct allusion to the work of the sitter, who was indeed as well versed in 'the rhythmic significance of dimensions and angles, tones and hues' as the subtitle of the painting suggests. That is the meaning of the background pattern, and the fact that it is a specific quotation from the world of Japanese ornament serves to underline its avant-garde nature. What distinguishes this work from all others is the way it points to a metamorphosis of the decorative arts towards the free invention of expressive forms. It was a pointer that was to be better understood as the new century got under way.

Even in his own artistic speciality, the seascape, Signac never forgot the importance of creating a *Gestalt*, even after the orthodox application of Charles Henry's theories began to recede somewhat. He wrote in his journal on 10 April 1899: 'It is always the same theory: to take the elements of the composition from Nature, but then to handle them in accordance with one's own will.' And on 2 April 1899: 'Our gift of observation

173
Paul Signac.
Boats in the Sun, 1891

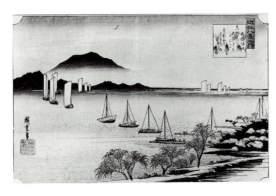

174
Andō Hiroshige.
*Sailing Boats Returning
to Yabase*, c. 1834

from Nature is a pretty uncertain thing; I consider it indispensable to transform and
to invent' (*Gazette des Beaux-Arts*, vol. 42, July–August 1953, 56).

Signac's application of such perceptions as this may be clearly seen in *Boats in the
Sun* [173]. Sky and sea, harmoniously distributed, recall that the title was formerly
Adagio Opus 221, like that of an abstract piece of music. The rhythm of the horizontal
boats with their constantly varied twin masts 'evokes a veritable sea symphony' (Lucie
Cousturier). One is almost reminded of the notes in a musical score. The artist
organizes and controls the raw material of Nature. Signac must surely have had
Japanese artists in mind here: Hiroshige's *Sailing Boats Returning to Yabase*, for
example, from the series *Eight Views of Lake Biwa* [174]. Here the vision is highly
'impressionistic' and 'fortuitous', with illusionistic recession and transient atmospheric
effects, but the sailing boats in their three groups form a rhythmic sectional motif.

This must so have struck Signac that he developed it in his own way, consolidated it and extended it over his whole composition.

The analogy is not contrived; in Signac's work, especially over the two decades from 1890, it would be hard to find a single picture that would reveal itself, under close examination, to be totally free of Japanese influence. After that – as with almost all the artists involved – the influence became increasingly a hidden one. Its work was done.

Henri-Edmond Cross (1856–1910)

Cross moved in a different direction from Signac. *The Golden Isles*, of 1891–2 [XIII], shows the awakening power of Japonisme with exceptional clarity. Cross's beginnings lay in a belated Impressionism, from which he made a decisive switch to a structure-based Divisionism. It was not, therefore, the work of Seurat, which had been in the public domain since 1886 at the latest, but the encounter with the East at the age of thirty-five, that opened Cross's eyes to the new poetry of the sea that Seurat had made possible. Even his figure paintings, such as the *Portrait of Madame Cross*, show a similar two-dimensional decorative approach, with a multitude of arabesques.

In *The Golden Isles*, Cross succeeded in a bold experiment that was to remain unique in his work. The objective content of the painting shrinks; even the coast in the foreground disappears. The recession of the sea runs high up the canvas, bounded only by a horizon exactly parallel to the upper edge. This unbounded, frameless view is a spatial experience that has no parallel in Seurat, in Signac, or in any other earlier artist, but which is echoed in twentieth-century art. It evokes an abstraction that comes close to music; its resonance in the viewer's mind is different from any that a simple impression could create. This is enhanced by the surface organization of almost geometrically distributed dots in a rare colour combination, black, blue and gold. The texture of the surface of the sea is reminiscent of another recently discovered version of 'Primitivism', that of the Byzantine mosaics; but the overall effect, with its combination of suspense and transparency in the pattern, could only have been achieved by an artist familar with Japanese textiles. No specific 'source' can be cited, and certainly none from the history of *ukiyo-e*.

This may well be a sign that the massive influence of the Japanese woodcut had run its course and was now diluted and mixed with other influences. In France, at any rate, it persisted in only a few representatives of the next generation. Thenceforward, Japonisme in painting was mainly to be found in the neighbouring countries.

Art Nouveau

The discussion so far has mainly concerned the influences of Japanese figuration and composition on Western painting and graphic art; there is a further dimension to all this in the decorative arts. Japanese objets d'art in metal, porcelain, pottery, textiles and lacquer had been prized in France and England for at least as long as had coloured

prints. Goncourt prided himself greatly on his collection of 'bibelots'; and Gonse, in his 1883 history of Japanese art, devoted most of his space to them. They were admired, collected and imitated on all sides. Their influence became fashionable, with some disastrous consequences, although they had a salutary effect on work of a number of individual craftsmen. However, all this remains entirely marginal to the present discussion, because its represents a parallel evolution that remained without influence on 'high' art.

The climate changed decisively with the appearance of Art Nouveau in the early 1890s. From many strands, a new entity was to arise: a movement, a style, a way of life, a culture, an enterprise that belonged to modern times. In Paris, Samuel Bing, connoisseur and champion of all things Japanese, set out to give practical effect to his understanding of the new European expressive form. His periodical publication, *Le Japon Artistique*, was intended to point the way. He himself opened a workshop and encouraged a whole phalanx of like-minded painters by giving them decorative commissions and thus affording them access to the world of design. The isolated field of arts and crafts was to become the pacemaker of a decoratively oriented *Gesamtkunst*: Total Art. All the individual efforts came together under the banner of Design. In an impressive book, Schmutzler has described the origins, variations and ambitions of this international stylistic endeavour. Rightly, he includes painting and graphic art in the horizontal perspective of Art Nouveau. The perspective of Japonisme, however, is a vertical one, in which painting, with its revolutionary imaginative form, must occupy the central position and the rest must be seen as an extension of it. Japonisme, with its long prehistory, lasted on into Art Nouveau.

This can be illustrated in the person of Hector Guimard (1867–1942), the creator of the Paris Metro station entrances and the architect of a number of apartment blocks. Guimard came to architecture through the design of such things as wallpapers, stained glass and balustrades, based on the 'pure line' of Japanese art. What concerns us in the present context is not so much his role in modern architecture, or his association with the Belgian architect Victor Horta, as the connection he established with Japanese sources and with the more abstract of the painters of Japonisme. He was in contact with Signac, who published a sympathetic account of his Castel Béranger, the first *Gesamtkunstwerk*, or work of Total Art, in France (*La Revue Blanche*, no. 58, 1899, 159ff.). On all sides there were efforts to tear down the wall that separated the different genres of art; Japonisme was present beneath the surface, in yet another new guise, that of a gateway to abstraction. What mattered now was its spirit, its essence, not individual motifs. 'Sources' as such surfaced only occasionally.

Horta, the inventor of Art Nouveau, is said to have explained to his admirer Guimard, when the latter visited him in Brussels, that in his own decorative work leaves and flower motifs had been eliminated, because only the stalk was interesting (L.-C. Boileau, *Architecture*, 15 April 1899). He might have gone on to point out the origin of the linear patterning, the whiplash lines, the flexible, dynamic, vital configurations, with which he went beyond spatial design to give his buildings a face: that origin lay in Japan.

175
Hector Guimard.
*Project for a Heating Grille,*c. 1899

The same certainly goes for Guimard. If we start out not from his buildings and his Metro entrances but from his sketches and designs – the workings of his imagination at the stage of 'prefiguration' – then, once again, the Japanese roots become highly visible. The *Project for a Heating Grille*, of c. 1899 [175], is certainly closer to the background of Signac's *Félix Fénéon* [XII] than it is to any industrial design. Although it would be hard to point to a specific Japanese source here – the relationship between Japanese teacher and Western pupil changes radically from this point on – both designs unmistakably point to the elimination of physical volume, the interpenetration of pattern and ground, and the expressive power of line. Reviewing a Guimard exhibition in New York, Doré Ashton remarked:

Line in Guimard, just as in his Japanese guides, is a living incarnation of natural laws. Thus, in an old Japanese manual, there is a catalogue of eighteen different types of line, with such descriptions as 'floating silk threads', 'ropes', 'water lines' or 'bent metal wire'. This latter was particularly subtly used by Guimard, who had an inborn sense of the inner tension of line. (*Le Monde*, 22 May 1970.)

With this in mind, if we look through the hundreds of illustrations in *Le Japon Artistique*, which Guimard certainly knew, we find that almost every issue has plant and flower images with an emphasis on stalk forms – gourd, fern, iris, chrysanthemum, peony – in every nuance from the 'record of Nature' to the strictest stylization. But this degree of abstraction is nowhere to be found. There are cases in which different motifs are juxtaposed or mingled so as to set up a figure–ground relationship, with twining branches, swallows, butterflies or open fans set out like emblems or heraldic charges against check, cobweb, grille and other patterns; but, even here, abstraction is nowhere carried to such lengths as in the Guimard design, in which the object has been entirely obscured by the arabesque.

It was Guimard who took this last step, or leap – perhaps encouraged by the theories of Charles Henry and by Emile Bernard's wallhangings – as early as 1888. Even so, however, there exists in the work of Toyonobu, a mid-eighteenth-century successor of Moronobu's, a *Geisha with Flowering Cherry Tree* (catalogue *Ukiyo-e Prints*, Art Institute of Chicago, 1971, no. 190) with a background curtain pattern of a rhythmic power and force of contrast that came close to the work of the Art Nouveau master.

Guimard's integration of abstract linear patterning followed a series of designs for windows and wallpaper for Castel Béranger, in which the floral pattern is arranged in the two-dimensional way appropriate to a wallpaper, and its figurative sources, a marbled stalk form and a stylized animal, are still recognizable (catalogue *Trois siècles de papier peint*, Musée des Arts Décoratifs, Paris 1967, no. 381; Hector Guimard, *Le Castel Béranger*, Paris 1898, especially plates 37, 55). The derivation from Japanese designs for textiles, combs and heraldic emblems is barely concealed. Duret's collection of Japanese illustrated books had been given to the Bibliothèque Nationale a few years before; it contains eleven works that deal with the ornamentation of ceremonial garments, including one each by Moronobu's celebrated contemporaries Takaghi and Yusen (1691). It is easy to imagine how delighted Guimard must have been by this 'primitive' ornament.

All this only goes to emphasize that in the age of *Stilkunst*, in craft design as elsewhere, Japonisme cast off all the dross of historicism, exoticism and imitation. The major and minor arts now marched in the same direction: through formal design, they pointed to a new, festive, exalted way of life.

13. Japanese prints in Western museums

One might have expected the entry of Japanese prints into Western public collections to give a great impetus to Japonisme. It did nothing of the sort. In France, at any rate, it came at a time when Japonisme as a source of inspiration for the avant-garde painters was losing its dominance, or else being forced to share it with other 'primitive' forms of world art. The limelight was shifting to Islamic, to Byzantine and later to African art. The museums were thus too late; inevitably so, for is it not their primary duty to preserve, to conserve, to educate? Any stimulus they can offer to the future of art is bound to be an incidental and inadvertent one.

Paris

The first public collection of Japanese art on the Continent of Europe was at the Bibliothèque Nationale. It owed its existence to the fact that in 1892 Théodore Duret had presented the illustrated books and albums – not the separate prints – from his collection to that institution; he also compiled a catalogue, which was published at the turn of the century. The 600 or so items represent a splendid and representative, but naturally also a comparatively random, selection from a field of art which it is practically impossible to cover adequately, and which is very often neglected. The same distinction applies, in fact, to Western graphic art: illustrated books interest only the connoisseur and the specialist, and individual prints work better in public exhibitions, where people want to see framed pictures.

Separate prints were collected elsewhere, in the Louvre and at the Musée des Arts Décoratifs. The Louvre collection was started in the following year, 1893, with a modest holding of fifty or so prints. These were donated, as is customary in France, by the great collectors of the day, with a view to obtaining some official recognition of their private zeal. Over the years, the collection grew, by the same means, to a thousand and more items; it was never regarded as comparable in importance to the museum's other treasures and remained a study collection for specialists, even after Count Isaac de Camondo contributed about 500 prints of very high quality. It eventually went to join the Oriental collections of the Musée Guimet. No catalogue ever appeared. The Musée des Arts Décoratifs, too, had no more than a modest and mediocre showing by comparison with the large private collections.

All this was a symptom of the weakening of the vogue of Japonisme in France, as it transferred itself to the English-speaking world and to Central Europe. It was to these countries that many pieces from the Parisian collections now found their way.

London

In Great Britain, the leading collection was that of the Victoria and Albert Museum. By 1886, 20,000 Japanese prints had been acquired, and they were made available to the public in 1893. As we have seen, however, the emphasis was not on quality or representativeness but on practical value for those learning to be craftsmen and designers, as well as for the illustrator, the poster designer, the student of architecture, the sociologist and the ethnographer. Accordingly, Sharaku, for instance, was not represented at all, and the field was dominated by such artists as Toyokuni and Kuniyoshi.

An object lesson for the Arts and Crafts; a weapon in the craftsman's armoury: in the context of the English cultural scene, in a world of craft and industry where good taste was valued as a competitive asset, this was inevitable. It is important to be reminded, in our present context, that there is more than one Japonisme, and that they can sometimes be wholly different; that one and the same object might mean totally different things in France and in England.

As time went on, this stark antithesis between the practical, craft approach and the contemplative, pictorial approach was modified to the extent that the British Museum, more or less by way of compensation, assembled an impressive collection of prints and paintings in which the criterion was artistic quality. This did not happen until after the turn of the century, when Laurence Binyon, a connoisseur and researcher of some distinction, took charge there and was able to make some fortunate purchases. Some of these came from the collections that were being broken up in Paris, but most came from English sources: from Ernest Hart (1902), Arthur Morrison (1906), Samuel Tuke (1907) and Ernest Satow (1907–9). A national response that had started in 1860 with a few scattered prints, and had been carefully nurtured over the years by Anderson, had now developed to the point where Japanese art was more accessible in London than anywhere else in the West. Whether this had any influence on English art, and if so how much influence, must be examined elsewhere.

The United States

This is the place to recount the astonishing and bewildering fortunes of the Japanese woodcut in the United States of America. It is probable that in the museums of Boston, Chicago and New York alone – not to speak of Worcester, Hartford, Springfield, Cambridge, Kansas City and Charleston – there are more and better examples of the Japanese woodcut than in the whole of Europe and Japan put together. But according to Louis V. Ledoux and James A. Michener, two American collectors who ought to know, these riches have remained unexploited and inaccessible. America, wrote Ledoux in 1941, had done little or nothing to describe or publish the treasures in its public or private collections (*Japanese Prints in the Occident*, Tokyo 1941, 19). And Michener declared:

Through the curious chances of history, America is the curator of one of the world's loveliest arts. I can therefore use only one word to describe our lack of attention to the amazing riches we have

stumbled upon. It is shocking. We have hoarded these prints for nearly half a century, and in spite of the work of a pitifully few devoted public servants, the prints remain today ill housed, poorly catalogued, unknown to the public and ignored by scholars. (*The Floating World*, New York 1954, vii.)

The picture has not changed much to this day.

Generally speaking, what happened in the United States paralleled events in England. In cultural matters, as elsewhere, the Anglo-Saxon mentality has more faith in private than in public initiatives. Business people with enormous fortunes see art collecting as a road to fame and glory, as well as a reminder of their cultural responsibilities.

It was not by accident that Boston, rather than the West Coast, became the outpost of East Asian art on the North American continent. The capital city of New England attracted the wealth that flowed from the trading activities of the clipper ships. And it needed only the spark of the Columbian World's Fair of 1893 (which took place in Chicago) to fire the enthusiasm of rival private collectors for the new commercial and artistic territory of Japan. This development will be described in the following chapter.

Here it is necessary to emphasize that in America the 'fabulous' artistic treasures of Japan were all collected by private initiative, and that they reached the museums only twenty years or so later. Not even the presence of the supposedly greatest authority of the age, Ernest Fenollosa, as Curator of East Asian Art at the Boston Museum of Fine Arts for five years (1890–5) alters the picture significantly. Fenollosa was a motive force and an adviser to the millionaires who did the collecting, but he did not live to see the fruits of his endeavours collected together in one place. This happened only in 1921, when the incomparable Spaulding collection entered the Boston museum to join the Sturgess Bigelow collection (donated a decade before) and that of Fenollosa himself.

Chicago went a different way in building its own unique collection. This remains supreme, not in quantity or in comprehensiveness but in its presentation of the exquisite, and far from primitive, Japanese 'primitives'. No collection anywhere has so many or such good prints by the forerunners of Harunobu. The great financier, Clarence Buckingham, considered no print beyond his reach, however rare and however dizzily high the price, just so long as it brought him closer to his goal. In the eyes of a connoisseur, his 1,400 prints probably equal Boston's 23,000. It was after Buckingham's death in 1913 that the collection entered the Chicago museum, where it set the keynote of a careful and measured acquisitions policy.

The third major centre is located at the Metropolitan Museum of Art, New York. This has always been a place where graphic art – first Western and then Japanese – has been made readily accessible to the public. From 1894, when the heyday of the Paris collections began to draw to a close, gifts, bequests, collections and purchases began to swell the museum's holdings. Its 3,000 and more prints, and between 50 and 75 illustrated books, came to represent probably the best single source for an overview of *ukiyo-e* art; and another was built up in the New York Public Library. Any designer in search of information on decorative motifs and design principles has been able to

find what he needs here, just as in the Victoria and Albert in London; anyone in search of enlightenment can do the same. What is on offer is magnificent; whether the demand for it exists is another question.

Japanese woodcuts did not reach America by accident. The Paris collections of Burty, Goncourt and especially Hayashi came under the hammer shortly after the turn of the century, and many of their prints found their way across the Atlantic. In Japan itself, where international trade was booming, the firm of Yamanaka & Co. specialized in the export of works of art and judged the market shrewdly enough to open a branch in Boston in 1892 and another in New York in the following year; a London branch opened in 1902. The door was wide open.

Germany and Austria

Things developed quite differently in Germany, which absorbed most of the works that became dispensable in Paris. There it was far-sighted museum people who showed the way to collectors and artists alike; without Brinckmann in Hamburg, Seidlitz in Dresden and Peter Jessen in Berlin, Japonisme would never have found a foothold. These men saw themselves primarily as educators, in the best sense of the word. Brinckmann and Seidlitz both launched their missionary activities by writing textbooks on Japanese art before going on to build up the public collections.

Hamburg had the initial advantage of its position as a great seaport. Very like Boston, it was open to international trade and to the lure of 'exotic' imports. By sheer force of personality, Brinckmann succeeded from 1877 onwards in building up a universally admired arts and crafts museum, the Museum für Kunst und Gewerbe; there he established high standards of quality and set out to do justice to the role that Japan could play in such a process. He was on friendly terms with his fellow townsman, Bing; and from 1896 onward he lost no opportunity of adding to his department of Japanese woodcuts, both individual prints and illustrated books, by buying from the celebrated collections of Bing, Goncourt, Hayashi and others.

By the turn of the century, despite the modest means at his disposal, Brinckmann had assembled nearly 2,000 items. What counted, for him, was not quantity but quality. Every single print, it has been said, was bought with a specific purpose in mind. The criteria that mattered were not those of content, as required by craft designers, but those of artistic merit; although care was taken to ensure that there were enough plant motifs to satisfy the contemporary requirements of Art Nouveau. Brinckmann thus adopted a position that bridged, as it were, the gap between those of the craft reformers and those of the artistic harbingers of Modernism. He had trained in Vienna, at the first Continental museum of arts and crafts, the Museum für angewandte Kunst, where he had recognized the superiority of Japanese design. Once he had his own museum to run, he made it an essential task to demonstrate that superiority.

Seidlitz in Dresden came to Japanese art not through Arts and Crafts but through art history, which was now expanding on many fronts beyond its traditional concern

with the supposed European monopoly of civilization. After working on Leonardo da Vinci and on German Renaissance prints, he approached his new field with methodical scholarship. As a result, his *Geschichte des japanischen Farbholzschnittes*, first published in 1897, went into three editions over the next quarter-century, was translated into French and English, and may be regarded as the most-read work on the subject. Although it is outdated in many details, often leans heavily on Fenollosa, and reproduces only examples from Parisian collections, its clarity and its concern with aesthetic issues have given it a lasting appeal to the lay reader.

Having thus secured his academic base, Seidlitz went on to build up the collection of his own museum, taking every opportunity afforded by the Parisian auctions and stretching his budget to the limit. The Dresden print room, the Kupferstichkabinett, thus acquired a moderately sized but sound selection of Japanese woodcuts. Characteristically, Seidlitz purchased the complete graphic work of Toulouse-Lautrec at the same time, a bold step into unexplored territory.

Developments in booming, expanding Berlin were on a far larger scale. The 'major public collection of East Asian graphic art in Germany', as Rudolf Bernoulli called it in a book of selected reproductions (*Ausgewählte Meisterwerke in der Bibliothek für Kunst und Gewerbe in Berlin*, Plauen 1923, 1), owed its existence entirely to one man, Peter Jessen. The story, as told in Bernoulli's book, is eventful, not to say improbable. Shortly after the opening of Japan to outside trade in 1868, 'enterprising merchants' presented the Bibliothek für Kunst und Gewerbe (which is now the Kunstbibliothek) with numerous Japanese prints of nature studies; the quality left much to be desired. A sister – or rather rival – institution, the Kupferstichkabinett in the Kaiser-Friedrich-Museum, came off rather better when, in 1895, it inherited the Rudolf Springer collection of 200 colour woodcuts and 100 illustrated books, 'mostly of mediocre quality, but still by well-known masters'. Other donations followed; but the director of the Museum could see no artistic value in such things and refused to have any truck with them.

These two false starts, together with the foundation by the Hayashi auction in Paris, prompted Jessen to take the plunge at the next opportunity. In 1904, at the Gillot auction in Paris, he acted decisively, bought for the Bibliothek für Kunst und Gewerbe more than a hundred outstanding prints, found patrons to fund the cost, and a year later was able to present his new acquisitions to an astonished Berlin public. The ice was broken, and the collection could thenceforth be built up systematically with help from State funds; in 1912 Jessen went on a purchasing trip to Japan. In 1914 the war called a temporary halt. After the two collections had been combined in the Bibliothek für Kunst und Gewerbe, and the inferior prints separated out into a study collection, the result was an excellent show collection of 4,000 prints. Its acquisitions policy was defined by the lapidary statement: 'Works of art should only secondarily be objects of scholarly enquiry. First and foremost, they are sources of aesthetic enjoyment' (Bernoulli, *Meisterwerke*, 19).

The latent tension between two criteria of interest in Japanese imagery – technical and imitative on one hand, artistic and creative on the other – is everywhere evident

in the growth of the Oriental departments of Western museums; as we have seen, they swung first in one direction and then in the other. In Japan itself, this tension could not exist, because the distinction between high and applied art was never an issue. Accordingly, in Europe, there was an attempt to compromise by departing from the quasi-historicist, 'exotic' approach to Japanese art and recognizing it as a source of style. Thus, in Berlin in 1907, Otto Kümmel took East Asian art out of the Museum für Völkerkunde, the home of ethnography, and set up a Museum für Ostasiatische Kunst. This process occupied the half-century that ended with the First World War.

The relationship between colour woodcuts and the applied arts in public collections marks the stages of this process. In Berlin, after a comparatively late start, the balance swung towards aesthetics more strongly than elsewhere; Vienna provides an early example of the opposite tendency. The Österreichisches Museum für Kunst und Industrie was set up in 1864, on the model of the Victoria and Albert, and after the Vienna Universal Exhibition of 1873 it was opened to the products of Japanese art and craftsmanship. Even so, the Viennese public had a long time to wait – thirty-three years, to be precise – before it saw its first Japanese woodcuts: just twenty-seven of them, in 1897.

Shortly afterwards, Seidlitz of Dresden, as a guest contributor to the Vienna museum's house monthly (*Kunst und Kunsthandwerk*, 1898), pointed out 'the significance of the Japanese woodcut for our time' in an article that led to the appearance in the museum, in September 1899, of a much-noticed, highly representative showing of 150 works. These came from Dresden, lent by the art dealer Ernst Arnold, and attracted considerable attention. At long last, a department of Japanese prints was set up in the museum itself, and with the aid of a shrewd acquisitions policy and a number of donations – among them 3,000 works from the Anton Exner collection, in 1946 – this has grown into a truly representative collection.

Impact of museum collections

Many other accounts of Japanese prints in public collections might be appended here, from Angers and Toulouse, by way of Bremen, Breslau and Cologne, to Prague and Stockholm. A survey of all the museums in Central Europe, even the smallest, that collected *ukiyo-e* prints and objects of Japanese design, is afforded by Petra Hinz in a Munich dissertation submitted in 1982: 'Der Japonismus in Graphik, Zeichnung und Malerei in deutschsprachigen Ländern um 1900.' These collections owed their existence partly to the commitment of individual amateurs and curators, and partly to the whims of fate. Many of them still slumber in their portfolios and drawers; others are brought out from time to time and shown in exhibitions. In general, it is possible to distinguish between two types of collection, both of which – as we have seen – emerged in the late nineteenth century: on the one hand, collections made with the applied arts in mind – separate motifs, models for craft work, neat design – and on the other hand fine art collections of prints as examples of the significant use of colour and composition. Seldom is the divorce between the two types so clear as it is

in London, where the Victoria and Albert Museum has dedicated itself to one purpose and the British Museum to the other. In most cases, the two aspects are commingled.

These museum holdings have, so to speak, two concentric bands of influence. The first consists of their educational value. In the English-speaking countries – and especially in America, where many museums have a specially appointed Curator of Education – care is taken to ensure that the sleep of the collections does not remain undisturbed. What school visits and adult education courses actually achieve in specific cases is not easy to assess. Since the Second World War, if not for longer, popular illustrated publications have had at least as great a didactic value as originals shut away in museums.

From the point of view of Japonisme, of course, it is the second band of influence that counts. What sort of impetus have public collections given to modern art? Here, too, no very clear answer can be given. Artists tend to follow their own instinct in new directions; rather than copy the Japanese sources, they turn to them for confirmation and encouragement. The visible results, even so, must be described as modest. On the other hand, it must be recognized, with some benefit of hindsight, that the places where Japanese art is to be seen in museums have been the centres of crystallization of modern Japonisme. This applies to Boston, London, Paris and Berlin. In Hamburg, the impact was very slight, and in Munich artists must have derived their 'Japanese' inspiration from other sources. The calculation is not at all an easy one. It is equally important to take into consideration the influence of the avant-garde, with its *japonisant* tendencies, on the acquisitions made by museums. Events in Paris illustrate this most clearly.

With all due reluctance to generalize, one is drawn to the following conclusion: the entry of Japanese prints, and especially those of the early, 'primitive' periods, into museums forms part of the phenomenon of Japonisme. The relationship between these collections and the aspirations of the avant-garde is best described as a reciprocal one.

14. The situation in England and America

However hard one tries to maintain the historical distinction between Japonisme in fine art and Japonisme in applied art, the two constantly intertwine. This is particularly so in the case of England, where the conflict between craft and industry, with all its effects on taste, was most speedily and drastically evident.

Late Whistler

In the *Peacock Room* of 1876 [28] and in several other projects, Whistler was concerned to place his paintings in a decorative setting, however firmly he may have distanced himself from the Arts and Crafts movement and from Ruskin and Morris. We have already pursued his development as far as the Venetian etchings and pastels and analysed the way in which his vision evolved parallel to Impressionism (Chapter 3). In the last two decades of his life, from the middle of the 1880s onwards, he took a new turn which pointed to Post-Impressionism or even to Symbolism. The derided loner had suddenly become a central figure, who gathered about him not so much disciples as a host of followers and admirers all over the Continent.

The little painting, *The Old Grocer*, which probably dates from the very late 1880s [176], gives a good idea of his new artistic concerns. The scene is shown in a flat, frontal view and distanced, with a tendency towards geometrical abstraction, by vertical and horizontal emphases. It is composed of frame-like configurations and embodies a structure that has something dreamlike and visionary about it: geometry as a way to a second reality, beyond the mere impression of Nature.

A series of other works of the same period, in a wide variety of techniques, suggest that what is operating here is not a casual impression but a new method of formal creation, a new vision and a new insight: away from light, towards graphic form, with a subdued and ancillary use of colour to point to the harmony between organization and meaning. No wonder that the Nabis took an interest; no wonder, too, that Whistler's message of the *intime* was well understood at all the exhibitions to which he sent his works. Whistler himself was well aware that he had reached a new stage in the development of his art, as he told an interviewer:

First you see me at work on the Thames (producing one of the famous series) ... There, you see, everything is sacrificed to exactitude of outline. Presently, and almost unconsciously, I begin to criticize myself, and to feel the craving of the artist for form and colour. The result was the second stage, which my enemies call inchoate, and I call Impressionism. The third stage I have shown you. In that I have endeavoured to combine stages one and two. You have the elaboration of the

176 James McNeill Whistler. *The Old Grocer*, c. 1890

first stage, and the quality of the second stage. (*Pall Mall Gazette*, 4 March 1890, quoted by E. R. and J. Pennell, *The Life of James McNeill Whistler*, London 1908, vol. 2, 84.)

Characteristically, after losing his first Japanese collection through the bankruptcy in 1879, Whistler assembled a new collection a decade later; in doing so, he returned – as emerges from information kindly supplied by Professor Andrew McLaren Young – to his first loves, Shunshō, Kiyonaga, Utamaro, Eisho, Toyokuni, Hiroshige and Kunisada. The lesson of Japan is not easily detectable in the late phase of his work: it is more concealed and impossible to attach to specific sources. Still, it was not for nothing that he maintained a lifelong cult of Japan; at the very least, his Utamaros taught him to *select*, and to subordinate his observation of Nature to the structuring influence of pattern. By working through the overt Japonisme of his first two periods, he was ultimately able to internalize it. How else could we explain the concordance between his results and those of his Continental colleagues whose works sprang directly from the Paris exhibition of 1890?

The Whistler revival of the turn of the century included many artists who were never reached by any direct Japanese influence. In New York and Philadelphia, in 1971, there was an exhibition, *From Realism to Symbolism. Whistler and his World*, covering sixty-four painters who were in varying degrees of personal contact with the master. If the selection had been made on stylistic grounds, one or more of these might have been eliminated; but many others, and not only in Great Britain, would have been included as his artistic heirs. For in the 1890s a great artistic revival took place in the countries that appeared, from the Parisian standpoint, to be peripheral, and especially in those to which Impressionism had never found its way. And so

Whistler's life, already so rich in paradoxes, yields one more: that this individualistic American seemed to the English to be the representative of French art, that in France he was seen as an ambassador of British art, and that he finally emerged as an 'international' European who had absorbed the Japanese artistic perception. The concrete influence of Whistler's vision in Holland, Belgium, Scandinavia, Germany and Austria would be a fascinating study in itself; but it would require a whole book to do it justice.

Whistler's adherents in Great Britain were mainly outsiders of one kind or another: such men as the Australian, Mortimer Menpes (1860–1938), who was his factotum and the author of an interesting memoir; Joseph Pennell from Philadelphia (1857–1926), a graphic artist and his biographer; and George Henry (1858–1943), a leading representative of the Glasgow School of painting. Menpes and Henry both visited Japan and thereby intensified the Whistlerian tone of their work – after a chill had set into their personal relations with the master. Walter Richard Sickert (1860–1942), the most important and the most original of his followers, was born in Munich of Danish ancestry. Though he was subsequently inspired by the example of Degas to seek inspiration in London night life, and though he broke with Whistler after fifteen years of friendship, he stayed faithful to his teacher's vision, in word and image, to the end of his long life, and thereby did something to sustain the quality of English painting in a lean period.

Many of these artists had their Japonisme at second hand, but they did much to transform Whistler's pioneering inspiration into an international currency, a comprehensible mode of seeing; and in the process they helped to ensure the genuine survival of a nineteenth-century mode of painting.

Aubrey Beardsley (1872–98)

Matters were very different when it came to the *sensualité perfide* (Focillon's phrase) of the Japanese-influenced drawing of Aubrey Beardsley. 'Beardsley,' wrote Julius Meier-Graefe in his *Entwicklungsgeschichte der modernen Kunst* (Stuttgart 1904, vol. 2, 605), 'owned the most beautiful Japanese woodcuts one could see in London, all of them of the most detailed eroticism. They were hanging in simple frames on delicately shaded wallpaper – all of them indecent, the wildest visions of Utamaro. Seen from a distance, however, they appeared very dainty, clear, and harmless.' (Quoted by Robert Schmutzler, *Art Nouveau* [Stuttgart 1962], New York and London 1978, 122.)

It is a pity that Meier-Graefe did not go into more detail. As well as the 'classical' Utamaro, there must also have been late erotica in the vein of Kuniyoshi, Kunisada and Eisen as well as early, 'primitive' work by Kiyonobu (1664–1729) and Moronobu (1618–1703) – if, as it seems, these were among the sources of inspiration that nourished Beardsley's genius. His stylistic evolution moved with lightning swiftness, as if he had known how much he had to pack into a lifetime of twenty-five years and a creative career of just five.

In an œuvre of a thousand or so drawings, more than 350 belong to his first and almost fortuitous commission, a new edition in 1893 of Sir Thomas Malory's *Morte d'Arthur* (writtten c. 1470). The supreme achievements of the art of book production, as revived by William Morris and his fellow Pre-Raphaelites, were the luxury editions of the Kelmscott Press, with their woodcut illustrations; other publishers now decided to follow them with cheaper publications in the same vein, illustrated by original drawings mechanically reproduced as line cuts. The chosen illustrator for Malory was an artist barely twenty years old in 1893, Aubrey Beardsley. Whether it was, as his biographers allege, the need to economize on labour that led him increasingly to eliminate drawing inside outlines, is a question that need not be answered here.

By the end of this marathon work [208], he stood revealed as a master of pure outline such as the West had never seen. 'The quality of his line [is not] of a very high order; his precision is not infrequently mechanical ... he converts [drawing] from a line expressive of muscular tension and virile force into one expressive of corruption and decay.' That was the opinion of Roger Fry, who wrote in 1904 (*Vision and Design*, London 1937, 191), from the standpoint of a more classical aesthetic, and thereby indirectly acknowledged new criteria of value for Beardsley. Fry was by no means blind to his qualities: 'Closely connected with [his] power of invention is the real beauty of his spacing, the admirable planning of masses of black and white ... If Beardsley was corrupt, he was certainly sincere in his corruption' (ibid., 193).

Fry's criticism was that Beardsley no longer pursued the depiction of Nature but the expression of something within, the 'nightmare of his own imagination'. For Fry, the journey towards abstraction was a journey in the wrong direction, and that was all there was to it.

This is an issue that need no longer concern us today, any more than the Victorian attitudes that underlie puritan morality and its mirror image, the pursuit of the excesses of 'Evil'. All this is the province of the historian of morals. What is seen as good or evil in art, three generations later, is something quite different. Even erotic and pornographic art have become a fact of life, and the only question is whether they are good or bad. It might be added that it was Beardsley himself who, if he did not invent erotic art, did create a platform for it. He liberated it from stylistically irrelevant disguises and from the mere interest in libidinous subject-matter, and made contact with the new formal language of Art Nouveau, the prelude to the structured art of modern times. His vocabulary was the 'decorative'; his medium was the drawing of pure line, which was being rediscovered on all sides. His method was Japonisme.

Beardsley's new formal idiom began to emerge even before work on *Le Morte d'Arthur* was finished. The Japanese element is impossible to miss. It dominates the rest of his working life, initially clearly visible, later veiled, and transformed with the aid of other 'sources'. This is a wholly natural process that we have already observed elsewhere.

The original drawing, dated 1893, for the frontispiece of *The Wonderful History of Virgilius, the Sorcerer of Rome*, published by David Nutt [177], stands at the beginning of the series. By comparison with a work of the later Japanese artist Kuniyoshi, such

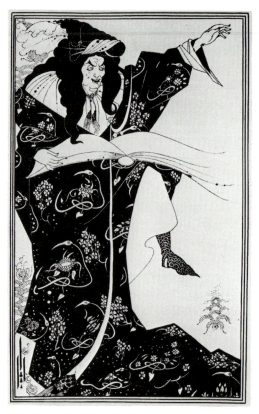

177 Aubrey Beardsley. *Virgilius, the Sorcerer of Rome*, c. 1893

178 Utagawa Kuniyoshi. *Kōno Moronao, the Rogue*, 1847

as *Kōno Moronao, the Rogue*, of 1847 [178], the affinity in the use of a silhouetted form is immediately apparent. Suppression of perspectival depth, a flattened black figure isolated against its white ground, rhythmic and geometric articulation, a textile pattern as an organizational device, and the way in which the face is included within the ornamental black-and-white configuration: all these are present in both. Even the eyebrows and mouth, in Beardsley's drawing, are no longer drawn in an organic, anatomical spirit but transformed into ornament. Indeed, in the consistency with which the drawing is ornamentally organized from corner to corner, in the highly sophisticated distribution of the various patterns across the surface, in the literal concealment and distancing of the dramatic action behind a tension transposed into the pattern itself, Beardsley goes far beyond his source. This is not surprising, in that Kuniyoshi was the inheritor of a tradition, a successful 'applied artist', while Beardsley was a visionary, who had all the resources of his art at the tip of his pen and could instantly respond to a hint. The link with Kuniyoshi was proposed by Siegfried Wichmann (exhibition catalogue *Weltkulturen und Moderne Kunst*, Munich 1972, 270).

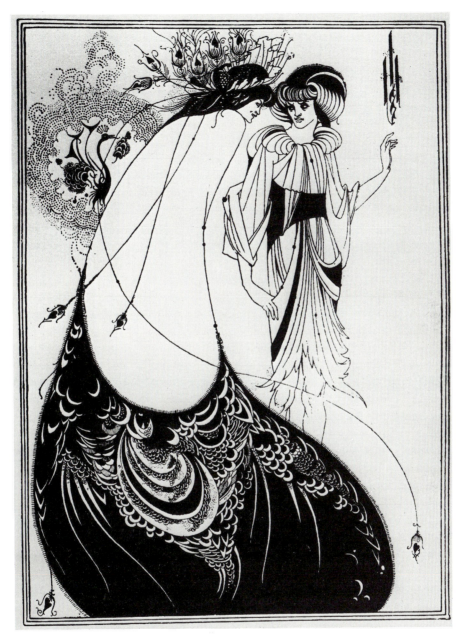

179 Aubrey Beardsley. *The Peacock Skirt*, 1893

Only a few weeks after *Virgilius*, Beardsley received a commission to make some
drawings to accompany Oscar Wilde's *Salomé* – these works can hardly be called
illustrations. They impelled him into a rapid evolution of his own style and made him
famous, even notorious, overnight.

The Peacock Skirt [179] shows him already treading new paths. The viewer's eye

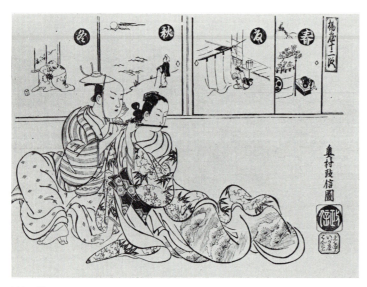

180 Okumura Masanobu. *In the Brothel XII (Ageya Juni Dan)*, c. 1730

181 Okumura Masanobu. *The Courtesan*, c. 1705

is no longer conducted through a basically directionless mosaic of ornaments; the construction is firmed up by an S-curve, thrice repeated. The surface is no longer dissected into small areas of black and white but subordinated to the contrast and the drama of large configurations: filled segments against unfilled segments, dark ornaments on a light ground against light ornaments on black. There is one single point at which all the vibrant curves are anchored together, and even the tiniest crescent ornaments refer to that point. The scene has, in other words, been transformed into a single ornamental configuration.

To emphasize this still further, the outlines of the mantle are lined with tooth-like strokes, and the body outlines do not follow human anatomy but abstract geometrical ideas of beauty. Even the arms are invisible. The encounter between the two figures is deprived of its intrinsic tension; their eyes barely meet, and the second, much smaller figure, that of the Princess, becomes a welcome means of varying and enriching the play of curves. Where does she stand in space? Strictly speaking, further back than the other; but every effort is made to avoid the disturbing effect of a spatial illusion.

The leap from *Virgilius* to this is so great, and the intervening time so short, that one is led to postulate an external stimulus of some kind. The peacock pattern certainly stemmed from Whistler. His *Peacock Room* [28] was still in London, and Beardsley not only studied and admired it but took from it the interchangeability of pattern colour and ground colour. But a far more direct access to the curvilinear black-and-white figures of Japanese art lies in the ornamental vision of Masanobu. One of his prints was probably among those observed by Meier-Graefe on his visit to Beardsley.

Masanobu's *In the Brothel* [180] is the twelfth scene in one of those albums for

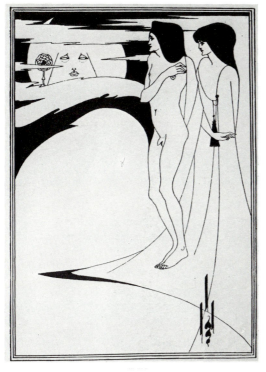

182
Aubrey Beardsley.
The Woman in the Moon, 1893

which he was famous. Here too, the undulating curves obscure the anatomy of the bodies; textile patterns are used to give rhythmic organization to the surface; and the wide expanses of white are used as an active element, as a 'ground'. But the comparison reveals just how much of an innovator Beardsley was. The black outlines no longer swell and contract; the forms no longer nestle into a spreading horizontal; all that remains is the glassy dream of a remote and enchanted world. Why should he not have seen a print by the same Japanese artist, *The Courtesan* [181], with its powerful reversal of black and white and the free and generous flow of its curves?

As far as the motif is concerned, no one is going to find much that is Japanese in *The Woman in the Moon* [182]. Isolated female nudes are rare enough in *ukiyo-e* prints; male ones are unknown. It would have been surprising if even Beardsley, with his keen appreciation of erotic art and literature, had succeeded in discovering anything of the kind. Will Rothenstein tells us: 'I had picked up a Japanese book in Paris, with pictures so outrageous that its possession was an embarrassment. It pleased Beardsley, however, so I gave it to him. The next time I went to see him, he had taken out the most indecent prints from the book and hung them round his bedroom' (*Men and Memories*, London 1931, 134).

The essence of this frontispiece to *Salomé*, unconnected to the text, is another play of black and white, this time with no ornamental patterning: a marked advance in the direction of abstract Form. From the pattern of curves emerge an outlined male figure

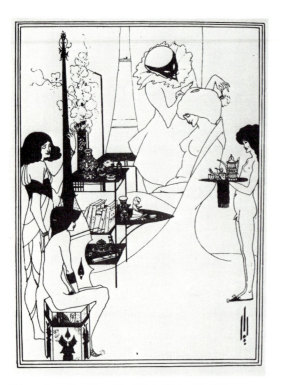

183 Aubrey Beardsley. *The Toilet of Salomé I*, 1893

184 Aubrey Beardsley. *The Toilet of Salomé II* (revised project), 1893

and the head of his female companion. They lack all individual expression; the drawing of eyes, nose and chin is formulaic in the Japanese manner. The white of the paper becomes the true object of the image, in which black abstract fragments seem to swim while maintaining a weird structure of their own. One is reminded of Moronobu, the true founder of *ukiyo-e*, and in particular of his *Street Scene from Yoshiwara* (Harold P. Stern, *Master Prints of Japan*, New York 1969, plate 2). There, however, what is taking place is a simplification or at most an abstract treatment of a real scene; Beardsley is inventing abstract forms. We must be quite clear about this: the historic step of abolishing objective reality was to have undreamt-of consequences for the whole of graphic art, and not only in England.

The variety of which this visual form – the white picture plane with its black 'islands' and long curves – is capable can be demonstrated by two successive drawings of *The Toilet of Salomé* [183, 184]. The first had to be withdrawn on moral grounds and was replaced by the second. Artistically, the change was very much for the better; the second drawing is perhaps Beardsley's finest achievement, and certainly one of the peaks of his œuvre. In the first version, the individual parts have a capricious and ornamental refinement, and there are jumps in the line, so that the elements need to be slowly pieced together; in the second a pure, even, sustained outline completely takes over.

This change corresponds to the definition of the transition from 'primitive' to 'classical' in Japanese printmaking given by Ludwig Bachhofer in *Die Kunst der japanischen Holzschnittmeister* (Munich 1922). In terms of Japanese precedents, this would suggest that Beardsley had turned from Masanobu to Utamaro; and this may very well have been the case. With his ready response and astonishing ability to transform his sources, this intuitive pathfinder of modern art had here taken a historic step. From the free, rhythmical balance of masses he had evolved, in Bachhofer's terms, a unified pictorial form with stability and system. In this tectonic structure, balance is paramount: balance between the black and white segments, and between the edge-bound horizontals and verticals on one hand and the curves on the other; balance in the handling of the scene itself, between snobbish elegance, modish decor, bitter-sweet fantasy and hints of pessimism.

Balance is Beardsley's strongest characteristic as a member of the Art Nouveau movement. This has to do not with the eccentricity of his motifs, but with his stylistic importance within the various currents and undertows. Schmutzler has categorized the tendencies based on curvilinear forms as 'High Art Nouveau' and contrasted them with the rectilinear framework of 'Late Art Nouveau'. The drawing from *Salomé* [184], which dates from 1893, represents the earliest example of a compromise between these two tendencies, which later became, respectively, the Franco-Belgian and Austro-Scottish varieties of Art Nouveau. Of course, this is just one drawing, and well ahead of its time; but it points the way. It serves to emphasize, once more, the key position occupied by Beardsley: with his manifold references to the art of the past, he marked the end of a century; with his liberation of drawing, he marked the beginning of a new century that was to emphasize structure not only in drawing but in painting. The exhaustion of ornament and the new linear emphasis in Beardsley's work mark the exact turning-point.

Of course, Beardsley's evolution did not stop there, in mid-air. Like others, he perceived the parallel between Japanese prints and certain aspects of Greek vase painting (or rather vase drawing); and he pursued it. He admired French Rococo book illustration, and early Italian engravings, and added them to his repertoire. In his last illustrations, those for *Lysistrata* – which he himself was to condemn on moral grounds – he took his cue from the phallic images of Utamaro. But none of this detracted from his fundamental insight into the linear style, or stylization, that could be derived from the early Japanese masters. They never ceased to nourish his invention and his power of design. A last example is the cover design for the first volume of *The Yellow Book*, of 1894, in an unaccustomed horizontal format [185].

Later developments in Britain

The situation in British art in the middle of the 1890s was marked by what one can only call a political tension, which was manifested in different attitudes to Japonisme. Firstly, there were Whistler and – after him, beside him – Beardsley, who were breaking away, with the help of East Asian artistic vision, from the perspectival depth

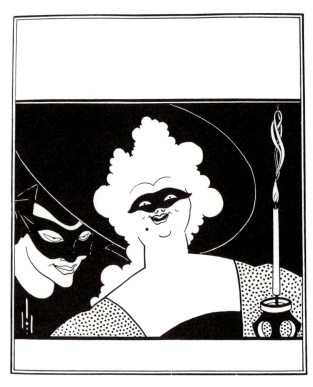

185
Aubrey Beardsley.
Cover for *The Yellow Book,*
Volume 1, 1894

of academic art and laying the foundations for a new age of formal creation. The new pictorial idiom, with its changed premises, was central to their work; ideology, content, morality or immorality, were secondary. What counted was the quality and denseness of the expression, the significant form. They were denigrated as adherents of 'Art for Art's Sake', or lampooned as Aesthetes. Their message was understood only on the Continent, where eyes were once again, after a long interval, turning to what was going on in English art. At home, however, Whistler (the 'Master with the Japanese Eyes') was hard put to it to recover from the opprobrium and financial ruin that followed his libel suit against the Pope of Art, Ruskin. He retreated to Paris.

His young admirer, Beardsley, fared no better. 'When, on April 5, 1895, Oscar Wilde was arrested, Beardsley's activities on *The Yellow Book* came to an end,' writes Robert Schmutzler, 'and his drawings were withdrawn from the press a few days before the appearance of the new issue.' Wilde had never contributed one line to *The Yellow Book*. 'The Wilde case ... sounded the alarm signal that the limit of the provocations that critics and public would accept had been crossed' (*Art Nouveau* [Stuttgart 1962] New York and London 1978, 123). Art was henceforth valid only within the bounds of current morality.

On the other side of the great divide, the heirs of the Pre-Raphaelites now had a clear run; it was their conception of Art Nouveau that prevailed. At this, the most important point of intersection of Art Nouveau and Japonisme, what matters is not

to contrast the two but to distinguish between them. Japonisme was a vertical phenomenon, running through a number of successive styles; Art Nouveau was a horizontal, chronologically limited phenomenon that embodied the aim of giving expression to a new experience of life. Its point of departure was not creative form but experience – into which Japonisme might or might not fit. Even Rossetti once designed a book binding in the Japanese spirit [68], without in any way compromising his own admiration for the Middle Ages.

Rossetti and his successors were primarily concerned with 'the symbolic and illustrative', rather than with 'formal homogeneity' (Schmutzler, *Art Nouveau*). A variety of sources – Blake, the Gothic, the Celtic world, the Rococo, Japan – combined to create the new experience. Was it really new, or was it a new version of the old eclecticism? How much nostalgic revivalism was there in this experience of theirs? The contrast is clear. Into a basically Japanese structure, Whistler and Beardsley gradually introduced 'kindred' decorative effects from other fields of art; on the Pre-Raphaelite side, a mélange of borrowings from 'sympathetic' and like-minded artistic tendencies was part of the programme from the very outset. The artistic discipline of formal coherence gave way to a wish-fulfilment fantasy of *Gesamtkunst*: old and new, dreams and fairy-tales, music, dance, literature, crafts, all went into the mix. True, William Morris made himself into the preacher of an aesthetic Socialism and produced, at his Kelmscott Press, perhaps the finest works of this style; but he failed, in that they never became accessible to the workers whom he wanted to reach but remained a luxury for an elite.

This is not to say that the English influence in Art Nouveau all over Europe should be minimized: on the contrary, it operated – and here lay its originality – from the bottom to the top of the traditional hierarchy of genres: starting in posters and decorative art and reaching the fine arts, and particularly painting. But apart from the heraldic emblems of Burne-Jones, what reached the Continent was above all the work of Beardsley and Whistler, with its strong Japanese element. It was their vision that imposed itself, while the good intentions and the vague inspirations of the 'Brotherhood' would not transplant; they remained tied to their provincial status.

In practice, this theoretical division into two factions, one consistent in its Japonisme and one eclectic, was not a hard-and-fast rule. Charles Ricketts, himself a keen collector of *ukiyo-e* prints, was 'abstract' enough to arouse considerable attention abroad; so did Walter Crane and a number of the *Yellow Book* illustrators. So, too, did such poster artists as the Beggarstaff Brothers – William Nicolson (1872–1949) and James Pryde (1866–1941) – with their access to contemporary tendencies in France. The Beggarstaffs' poster, *Girl on a Sofa*, of 1895 [XIV], with its square *japonisant* format, its strongly abstract pattern, its reductive use of colour and its strongly emphasized border strip, exerted considerable influence in Central and Eastern Europe. Without the power of formal creation, no mere feeling, however profound, could ever have enabled them to have such an effect.

Glasgow, the metropolis of Scotland, unexpectedly produced its own new version of Japonisme: the agitation of waves and curves gave way to the charm of the closed

circle, the upright straight line – alone and in series – and the frame-like shape. There became apparent a marked sense of what Novotny calls 'tectonics' (*Tektonik*): the adaptation of the pictorial space to the edges of the picture. Bachhofer, speaking of Japan, has this to say:

A feeling for the value of straight lines emerges, and this alone makes truly monumental creations possible ... everywhere there are parallels to the frame, which lend strength and power to the figures ... A whole new sense of firmness, for joints and their function, for the structural stability of what is seen: in a word, for what *is* (*Die Kunst der japanischen Holzschnittmeister*, Munich 1922, 83 ff.)

Charles Rennie Mackintosh (1868–1928) and Margaret Macdonald (1865–1933), who became his wife, joined with her sister and brother-in-law in a partnership in which, between the architect and the craft workers, it became possible to conceive a building from top to bottom as a decorative unity. From the articulation of the façade, interior spaces and walls down to the right place for every single item of furniture, every lamp and every ornament, all was directed towards stylistic unity and the synthesis of the arts. Simultaneous and parallel tendencies in the work of Guimard in France [175] and Henry van de Velde in Belgium show how urgent and how ubiquitous was the desire to reunite the arts, after their nineteenth-century fragmentation, into an accepted language of form and a shared mental attitude.

Boldly and intuitively, the Glasgow Four transcended the existing repertoire of Art Nouveau by replacing the flame-like curve with the straight line. The result was a visual surprise, a radically changed form of tension between the component parts. Here, at the turning-point between two epochs, it became evident that the curvature of High Art Nouveau was backward-looking, and that it was the straight line that pointed forward to the new century. Mackintosh's buildings led to the Bauhaus, and his decorative ideas sometimes remind us of Mondrian. The analogy with the end of the Middle Ages is an apt one: Flamboyant Gothic in the North was contemporaneous with the beginnings of 'closed form' in the Italian Renaissance. Similarly, as the eighteenth century waned, the last of the Rococo coexisted with the first signs of Neoclassicism.

A discussion of the architecture and design that emerged from this process falls outside the scope of this study; but in this instance, since the outcome was on the borderline of pictorial art, it is worth overstepping the bounds a little – as in the case of Guimard [175] – and presenting the new situation, as it were, through a parable: a menu card for a tea-room, designed by Margaret Macdonald in 1901 [186]. The image is no longer governed by thoughts, feelings or symbols: everything is subordinated to the 'tectonic' structure. A quadripartite slatted framework acts as the backbone of a subtle configuration of patterns: horizontals, a check, a rounded rose motif and an active, saturated, flat back space, supported by green and red accents and an enriched border. This is no empty formalism: for the curved silhouette of the girl and the isolated, stylized hand, precisely placed, emphasize the fragrance and superior quality of the refreshments on offer, far more strikingly than any illustration in photographic detail could ever do.

Margaret Macdonald and her partners were certainly aware of Japanese woodcuts, which can be seen in a photograph of Mackintosh's drawing office. But which woodcuts? One thinks first of Harunobu and his circle, in whose work the combination of girls, balcony grilles and planar foreshortening is not uncommon. A print by his contemporary Bunchō, *Night Scene with Girl and Cuckoo* [187], offers itself as a comparison: the similar upright format divides the surface into an opaque and a patterned section in both cases. The slatted motif appears in several variations; the vertical lines balance the horizontals; the light area of the girl's face is profiled against the dark ground; even the hand is isolated in a precious gesture. And the single Scottish rose corresponds in position and function to the Japanese mimosa bush. The most conclusive element in the parallel seems to be the relationship, in line with the new importance of the tectonic factor, between the rectilinear architecture and the curves of the human figure.

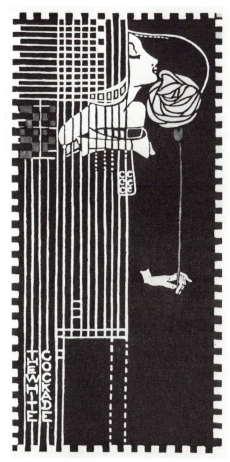

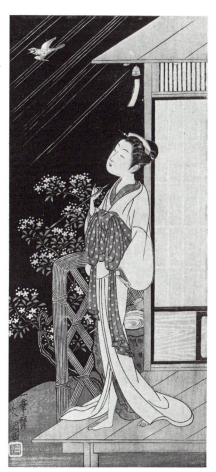

186 Margaret Macdonald Mackintosh. *Menu Card,* 1901

187 Mori Bunchō. *Night Scene with Girl and Cuckoo,* c. 1770

In London these Scottish artists met with a reaction that ranged from indifference to outright hostility; but at exhibitions in Munich, in Vienna (above all) and in Turin they enjoyed a positively sensational success. They became the true founders of what some critics have regarded as the late phase of Art Nouveau and others as the phase that superseded it. Both viewpoints are sustainable. For the emphasis on craft and decorative design at the expense of painting was not their invention; in the context of their time, their achievement lay in the re-establishment of the tectonic principle.

Nevertheless, as with every revolution, certain threads of continuity persisted. The Scots admired Beardsley and drew upon his vision. Rectilinear and curvilinear organization appear, together, in the second version of *The Toilet of Salomé* [184], even though curves still retain the upper hand; with Margaret Macdonald [186], the accent shifts to the vertical and horizontals, to which the curved forms are subordinate. This was the beginning of a shift of emphasis that was to manifest itself in every department of avant-garde art: the shift from the decorative to the constructive. Mackintosh was an architect first and foremost; and it was precisely for this reason that he was able to become a leader of the new design, with its tectonic emphasis.

The first great wave of Art Nouveau had been 'floral' in its orientation, and had admired and imitated Japanese textile patterns; the accent now shifted to the newly visible architecture of Japan, with its exploitation of the aesthetic possibilities of rectilinear framing [202]. In Christopher Dresser's *Japan: its Architecture, Art and Art Manufactures*, of 1882, the bible of Japonisme until the days of Whistler and Beardsley, architecture was represented only by a half-dozen or so text illustrations of a technical nature, while flower, bird and wave motifs were presented in many striking plates. There did, however, exist one source in which both curvilinear and rectilinear principles emerged with crystal clarity: and that was the Japanese woodcut. This provides one more manifestation of its importance as a repository of forms. Anyone with eyes to see could find there what he needed.

The Japanese, incidentally, are familiar with these same opposite modes of access to form from childhood onwards. As Henry P. Bowie points out (*On the Laws of Japanese Painting*, New York, [German edn 1950]), their *katakana* characters, simplified by the Chinese, consist of two or three brushstrokes each and are more or less rectilinear and angular; but the same sounds can be rendered in *hiragana* characters which are characterized by cursive, rounded forms.

Developments in the United States

Japonisme in the United States presented a totally different picture. It must not be forgotten that there, in purely geographical terms, East Asia is hardly any further off than Europe. Throughout the nineteenth century, however, North America had an open frontier to the West, and the pioneers had no time to bother with art. In the big cities of the East there appeared insular centres of culture, but no tradition of painting and no school. Almost every generation had to start again from scratch; the painters often went to Düsseldorf, Munich or Paris for their training, and when they got there

they played safe by going to the academic teachers. They collected their artistic equipment where they could find it. Like the settlers in the Midwest, artists led a basically nomadic existence. Competition was intense, and success went to the virtuoso. It was sensational themes that counted – as they tend to do in any country where the idea instinctively takes precedence over the art of painting, and where artistic judgments are coloured by considerations of money, class, race or psychoanalysis. No comparison with Italy or France was possible.

At the same time, museums spread across the land, fabulously endowed, in cities, colleges, universities. They supplied object lessons and showed not only samples of Western art from the Pharaohs to Picasso but, almost on an equal footing, ethnographical items from all over the world, from Mexico to Australia. Among these, Japanese graphic art took its place. It was magnificently represented, as described earlier; but its presence sprang from no inner need: it was seen, but it was not artistically 'used'. Japonisme as a force and as a movement, of the kind that existed in Europe, never existed in America; although a few isolated personalities played major parts in the discovery and understanding of Japanese art.

In 1869, John La Farge (1835–1910) founded the study of Japanese art in America with an article in which he gave an acute characterization of Hokusai. In it, he described him as an extraordinarily realistic observer but, on account of his obscenities, too far removed from the moral standards of a Christian society. Between this publication and the memorandum that La Farge wrote a quarter of a century later for Samuel Bing – who, on his study trip to the USA, had asked him about the decorative aspects of his own painting – there lay a remarkable career.

Brought up bilingual in French and English, trained as a lawyer, friend of such celebrated writers as Henry Adams and the brothers Henry and William James, La Farge underwent artistic influences as diverse as those of Chassériau, Couture, the Pre-Raphaelites and Millet in the course of his development into a 'highly realistic' painter. Early on, he also made the acquaintance of Japanese art, 'with some relation in my mind to decorative work'. In 1886 he was drawn to visit the native land of Harunobu, Koryūsai, Utamaro, Hokusai and Kuniyoshi, whose woodcuts found a place in his own collection. This was a man of considerable talent, with highly promising views and aspirations and an early insight into the teachings of the East.

If all this did not lead to results comparable with those achieved by Whistler, who was La Farge's exact contemporary, the cause was partly the undeveloped artistic culture of America, with its absence of stimulus; but the fault lay mainly in La Farge's own approach. He was too interested in literature and in religious issues, too eclectic and historical in his tastes, to assert his own character adequately. He turned to Japanese art for a model of realistic landscape and flower painting, and was then surprised when he found instead the priority of meaning, the lures of a 'mysterious symbolism'. His intellectual honesty led him into artistic dilemmas that he was unable to resolve. His constant reference to Japanese elements of all periods, without the ability to gather them into a unified formal language – as in the *Waterlilies* of 1870 [188] – demonstrates the temptations, and the perils, of this isolated and fragmentary

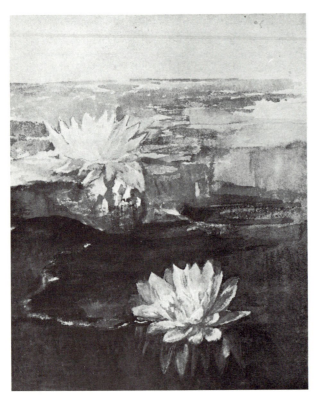

188
John La Farge.
Waterlilies, 1870

form of Japonisme. La Farge noted, of the failure of his first, abortive decorative project inspired by Japan, that it was too early for such an endeavour to awaken sympathy (family papers, Yale University Library, cited by Helene Barbara Weinberg, 'John La Farge', *American Art Journal*, May 1973, 62ff.)

Ambivalence and provincialism remained, at least until the time of the First World War, the crucial obstacles to any form of Japanese-inspired artistic renewal, such as had taken place in Europe. Anyone who wanted to participate had either to move to Europe, as Whistler and Mary Cassatt did, or else, like Maurice Prendergast, at least to train there. Progressive talents in America concerned themselves with naturalism, a tendency long superseded in Europe.

There was, however, no lack of opportunities to inform oneself on the artistic 'curiosities' of the Far East. At the World's Fairs in Philadelphia in 1876 and Chicago in 1893, these aroused the greatest interest. The evidence can be seen in a Japanese pavilion here, a Japanese garden there, installed by an admirer, and above all in the creation of outstanding private collections of Japanese woodcuts. As early as the 1880s, Sturgess Bigelow collected over 17,000 works in Japan itself: a bold beginning that was almost on a footing with the best of his Parisian rivals. In the course of just one generation, America amassed a treasure second to that of no other country in the world.

Behind all this stood one personality: that of Ernest Fenollosa, art politician, expert, aesthetician, and educator. In true American style, without trying to be all these things at once, he switched from one to another. Reference has already been made (Chapter 7) to the decisive five years in the middle of his life, 1890–5, in which he laid the foundations of the unsurpassable collections in Boston and of the reputation of the Museum of Fine Arts. This period was preceded and followed by two others, each of twelve years. In the first of these, he bestowed on the Japanese the gift of the preservation of their threatened artistic heritage, and in the process gained a first-hand knowledge of the true values of ancient Japanese painting. More and more, in the last period of his life, he manifested the 'conversion' that led him to recognize the value of the secular, 'democratic' art of *ukiyo-e*, and to make an almost visionary attempt to reconcile Western and Eastern ideals of art.

Fenollosa demanded of his contemporaries a shift to that Western art that could be most readily synthesized with Japanese quality. In a passage already quoted, he proclaimed: 'Whistler stands for ever at the meeting-place of the two great continental currents: he is the nexus, the generalizer, the translator of the East to the West and of the West to the East' (*Pacific Era*, no. 1, November 1907). He had come a long way from his earlier dismissal of the Parisian art world as 'disappointing'.

The divided and ambivalent nature of Fenollosa's view of art restricted even this superior spirit to a very circumscribed and short-lived influence. His extraordinary insight into what the Japanese view of art had to offer to the West remained no more than a fragment. The practical application, whereby the artistic imagination of the Japanese might educate, develop and deepen the Western understanding of art, found expression only in one textbook, *Composition*, written by his student, Arthur W. Dow, and published in 1899. This went through several editions; but did it steer art education into new paths?

Another great educator who demands to be considered is Frank Lloyd Wright (1867–1959). His discovery of Japanese architecture was an event of fundamental importance in the history of architectural Modernism; what concerns us here, is his interest in the Japanese woodcut. As is known, he gradually freed himself from the Art Nouveau style of his master, Louis Sullivan (1836–1924), by studying the totally alien structure of dwelling houses in far-off Japan. His first masterpiece, the Robie House of 1909 in Chicago [189], was the result of his first visit to the Far East. The open ground plan, the axial arrangement and flow of the rooms, the freely cantilevered roof, that made this 'Prairie House' into an organic spatial experience within an abstract design: all these were as revolutionary as they were prophetic. In its emphasis on the right angle, on tectonics and on structural purity, the design lies on the straight path that leads from the Glasgow Four to Mondrian – if one may for a moment compare an interior design, a building and a painting.

Wright's conception of architecture met with such total and obstinate rejection that he might well have abandoned his career there and then, had it not been for the Berlin publisher who brought out two portfolios of his work in 1910 and 1911; these earned him wide recognition and considerable influence among the European avant-garde.

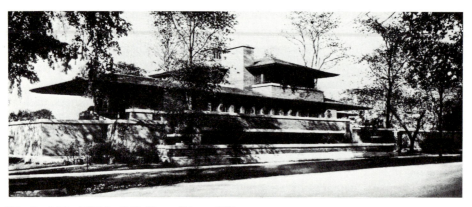

189 Frank Lloyd Wright. Robie House, Chicago, 1909

In America itself it was not until 1934, after an interim marked by a few minor commissions, that there began what Henry-Russell Hitchcock called 'almost a second career for Wright' (*Architecture of the Nineteenth and Twentieth Centuries*, London 1958, 327).

In those lean years he often visited Japan, and there he learned to appreciate Japanese graphic art as a lodestar, as a passion, as a visual education, and also as an object of value. As most of his fellow collectors have said nothing about their experiences, and as Wright was a man with a gift of words, the five essays republished in *The Japanese Print – an Interpretation* (New York 1967) deserve to be read; with one exception, they were written between 1912 and 1927. Wright confesses:

The print is more autobiographical [for me] than you may imagine. If Japanese prints were to be deducted from my education, I do not know what direction the whole might have taken. The gospel of elimination preached by the print came home to me in architecture as it came home to the French painters who developed Futurism and Cubism. Intrinsically, it lies at the bottom of all this so-called Modernism. Strangely unnoticed, uncredited. (Ibid., 91.)

This bridge from the modest Japanese woodcut to the objectives of Modernism is not only intuitively conceived but grows, for Wright, into a systematic presentation of the East Asian aesthetic, point by point: 'It awakens our artistic consciousness, or at least allows us to feel the disgrace of not realizing that we have none' (ibid., 73).

Wright spoke for the liberation of the creative power of art and against the literary and moralistic blankets that smother it. Seldom has Japan been so impressively or so knowledgeably held up as a model; seldom has there been so convincing an explanation of why this art and no other can point the way out of crisis. For this reason, the text of Wright's most important essay, written in 1912, is printed in Appendix 2 of this book.

Another of Wright's essays tells us how this admirer of Japanese prints became their promoter, even agent. William Spaulding, who like Fenollosa was a Bostonian, had long been an enthusiastic amateur of these works, without anything very much

to show for it. Then the art expert Frederick William Gookin introduced him to Wright, in whose collection he saw a selection of one hundred choice prints of actors. Spaulding made an offer for them on the spot. 'For various reasons', as the architect put it, he accepted, and a bargain was struck for $10,000. In 1916, Wright was able to set off on his fifth trip to the Land of the Rising Sun without financial worries.

Unexpectedly, a few days after this sale, Wright was offered and accepted another contract, under which Spaulding gave him full power of attorney to purchase more treasures for the collection. In five months' work he found so many unknown, first-class pieces that the intitial budget of $20,000 had to be multiplied by six and more. With a touch of pride, the impromptu trader remarked: 'I spent $125,000 of Spaulding's money for a collection of graphic art that is worth a million.' Every visitor to the Boston Museum of Fine Arts, to which that collection finally found its way, can confirm the fact. Every lover of Japanese art will take pleasure in the fact that this, the finest of all collections, was not assembled by a dealer but by a passionate admirer.

Between Fenollosa and Wright, between the Chicago World's Fair of 1893 and the Armory Show of 1913, America sought to find its place, artistically and politically, in the concert of Western nations. Contacts with other countries became more intensive. In painting, relations were maintained not only with the academic tendencies in France and Britain but also with members of the avant-garde.

Whistler probably had as many followers in the United States as he had in Europe, but they remained isolated and failed to form a school or movement. Accordingly, they were touched by the decorative vision in varying degrees and passed it on in diluted form to their own pupils. According to the exhibition catalogue, *From Realism and Symbolism. Whistler and his World* (Philadelphia 1971), this category includes nine painters and graphic artists; all were born before 1870, and most had their artistic 'awakening' around the turn of the century. They were: Frank Duveneck (1848–1919), William Merrit Chase (1849–1919 [54]), Thomas Wilmer Dewing (1851–1939), Julian Alden Weir (1952–1919 [191]), Joseph Pennell (1857–1926), Maurice Prendergast (1859–1924 [192]), James Wilson Morrice (1870–1953), and, in their early works only, Alfred Henry Maurer (1868–1932) and John Marin (1870–1953). A name that should be added to that list is that of George Luks (1867–1933). His delicate study of *Noontime, St Botolph Street*, painted c. 1900 [190], with its rhythmic alternation of light and shade and the metamorphosis of the subject into planar patterning, points to a direct Japanese source.

All these men were trained in Europe, mostly in Paris, or else underwent a decisive conversion while travelling there in later life. In Weir's *Reflections*, of 1896 [191], the relationship with Whistler is clear enough: in the emphasis on verticals and horizontals, the asymmetrical composition, the two-dimensional stylization. Even without prior knowledge of Weir's interest in Japanese prints, which he had plenty of opportunity to study in New York, it would be evident that they had been of much more help to him than his early teachers, Gérôme and Bastien-Lepage.

Maurice Prendergast, a Bostonian, extended the European connection. In *Evening*

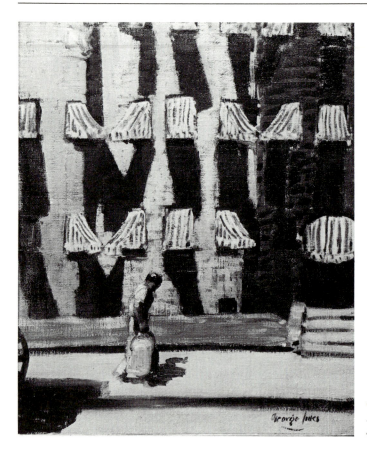

190
George Luks.
*Noontime, St Botolph
Street*, c. 1900

Shower, painted as early as 1892 [192], hints of Whistler and the Nabis combine into
a pleasing and highly independent personal voice. The silhouetted figure, the verticals,
the rhythmic arrangement of the lamps, the cropping of the scene: all this points to
stylistic origins close to the Japanese vision.

None of these painters ever made a reputation in Europe. Two figures who did
achieve this bring us close to the realm of the applied arts. Louis Comfort Tiffany,
with his celebrated lamps, remains outside our scope; but Will Bradley (1868–1962),
with his book illustrations and posters, fits well into a context that shows America
taking its place within universal Art Nouveau.

Bradley's poster, *The Blue Lady*, of 1894 [193], confirms that – as he himself tells
us – he already knew the work of Toulouse-Lautrec, Grasset, and above all Beardsley;
but his original synthesis refers back beyond these, to the Japanese *Urtext*. The
illustration as such – the image of a lady with a sharp and steady gaze – is held within
a design consisting exclusively of abstract elements. The arabesque-like stylization of
the face, the Japanese treatment of the hairstyle, the enclosing, tectonic verticals of
the trees, the horizon strip, the structurally important lettering: the appeal of the
poster is seen to lie not in the sentimental allure of the content but 'purely' in the

 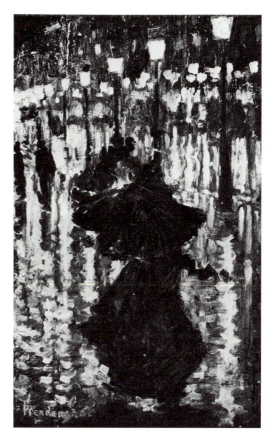

191 Julian Alden Weir. *Reflections*, 1896

192 Maurice Prendergast. *Evening Shower*, 1892

rhythm of the forms. The colours, too – white, black, blue and orange – are not intended to reproduce the natural colours of the things shown but to increase the tension of the pictorial idea.

These new harmonies soon made themselves heard, an ocean away. In 1894 the respected London journal, *The Studio*, ran an article on Bradley by Charles Hiatt, and in the two following years he accepted invitations to exhibit at *La Libre Esthétique* in Brussels, thus becoming an accepted member of the avant-garde. America had come many miles closer to the European centre of the art world.

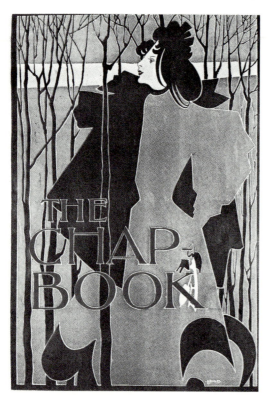

193
Will Bradley.
The Blue Lady, 1894

15. Art Nouveau and Symbolism in Belgium and Holland

Belgium and the avant-garde

Brussels turned out to be the capital of Art Nouveau, of Symbolism and of Modernism. What is the difference between these labels? Are not the same works of art often placed in more than one pigeon-hole at different times? The mists clear somewhat, perhaps, if we turn to the almost contemporaneous researches of Konrad Fiedler. In an essay on the origin of artistic activity, written in 1887, Fiedler distinguished between an artistic endeavour directed towards intellectual *meaning*, the 'interest of emotion and thought', and the attitude that aims for the *'perception of the visible phenomenon'*. From the 'utter chaos of uncomprehended processes' in Nature, the artist leads us to clarity and richness by isolating and developing the activity of our visual sense (Fiedler, *Schriften über Kunst*, Munich 1913, vol. 1, 194). There is a startling affinity here with Frank Lloyd Wright, who wrote in 1912 of the 'awakening of the artistic conscience' and of the 'spell-power in every geometrical form, which seems more or less a mystery' (*The Japanese Print*, New York 1967, 16).

The emphasis may lie on the illustrative or on the formative function, on art as meaning or on art as visualization, which thus emerge as diametrically opposite but potentially complementary attitudes. Cultural background or artistic foreground? The Symbolists based themselves on the former and proceeded to the latter from there, if at all. The practitioners of Art Nouveau, on the other hand, concerned themselves primarily with stylistic aspects, and only secondarily with the ideas contained in them, the iconography. This is why the same work, seen from different perspectives, may be assigned either to Symbolism or to Art Nouveau; and yet the two are by no means identical. How many 'symbolic' images are rich in ideas and impoverished in form; and how many perfect examples of Art Nouveau are without a vestige of symbolic depth!

The Japanese influence benefited Art Nouveau: it was a formal influence. But this style also fed on other sources, as we have seen – medieval, Irish, and so on – and Japonisme was simply the most radical, the most revolutionary, the most unadulterated of all.

To understand the situation in Brussels we must go back before the appearance of either Art Nouveau or Symbolism. In 1884, Octave Maus founded an artists' co-operative, *Les Vingt* (or *Les XX*), 'The Twenty', which invited avant-garde artists of all movements and nationalities to participate in its exhibitions: Impressionists, Whistler, Redon, Rops, Rossetti, and all four of the fathers of Modernism, Cézanne, Seurat, Gauguin and Van Gogh; not to speak of the younger generation. Many of the

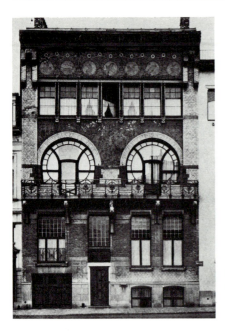

194
Paul Hankar.
Façade of Ciamberlani
Studio House, Brussels,
1897

foreign artists involved were 'discovered' by being exhibited at *Les Vingt* before they were known in their own countries. The retrospective account by Madeleine Octave Maus, *Trente ans de lutte pour l'art 1884–1914* (Brussels 1926), omits hardly a single name that mattered anywhere and at any time during that period.

This was the only forum for artists and art forms from all over Europe, the only place in which the most varied forms of Modernism could meet. Its work involved not only painters and graphic artists but representatives of music, poetry and criticism; and above all those of the world of design, the decorative and applied arts, hailed by Henry van de Velde as 'the Art of the Future'. The emphasis on design became even more marked after 1894, when *La Libre Esthétique*, successor body to *Les Vingt*, opened its doors even wider.

Japanese woodcuts were included along with everything else. A local patron of the arts, Adolphe Stoclet, contributed to the understanding of modern landscape art by showing Japanese and European works from his own collection side by side: the Japanese ranging from the early artist Utagawa Toyoharu to Hiroshige, the Europeans from Corot by way of Seurat and Vuillard to Matisse and Marquet.

Maus could not have continued and expanded such an undertaking for three whole decades if there had not existed in Belgium, despite 'official' opposition, a strong native avant-garde. The revolution in architecture brought about by the Art Nouveau works of Horta lies outside the scope of this book, although there is an unmistakable echo of Japan in the colouring of his glass walls and roofs. A much less well-known architect, Paul Hankar (1859–1901), showed a marked leaning towards Oriental decorative form. In his furniture designs, and especially in the façade of his studio house for the painter Ciamberlani [194], there is a structuring through vertical and

horizontal strips, with horseshoe arches and coloured decor, which overtly stresses his Japanese and Glaswegian sources. With a little imagination, this photograph, if held sideways, might almost be taken for an abstract version of an *ukiyo-e* print.

Henry van de Velde (1863–1957)

Van de Velde was the dominant avant-garde figure. He not only absorbed Japanese influences but used them as an impetus towards a new style; this led him away from painting into graphic art, applied art and architecture, and made him the spokesman of a new culture. His gift of conveying an electric emotional charge, combined with an extraordinary power of formulation, give him an influence far beyond his own considerable practical achievement. Van de Velde was privileged to be the first designer to operate on a European scale, with roots in Belgium and France, and an influence that extended through Germany, Holland, Switzerland and beyond. He spent unrewarding years training as a painter in the world of the Paris Salon until the impact of Seurat awoke him to his own individuality. This happened in the late 1880s. The indirect Japanese stimulus can be seen in the cool, asymmetrical, flattish structure of his few easel paintings, such as *Blankenberghe* [195].

It was, however, not until Japanese art reached Belgium that Van de Velde was

195 Henry van de Velde. *The Beach at Blankenberghe*, 1888

196
Henry van de Velde.
Ornament, 1893

able to absorb its full influence, which he did right on cue. After a small exhibition at the *Cercle Artistique* in Brussels, probably organized by Bing (1889), the first major showing took place in Antwerp, under the aegis of the *Association pour l'Art*, in 1891. Also in that year, a firm calling itself the Compagnie Japonaise started to sell goods imported through Liberty's of London. 'Freedom from stylistic imitation', Van de Velde notes in his autobiography, came upon him like a vision, and was a signal to give up painting and turn to the previously low-status area of craft design. His aim in life was thenceforward the artistic shaping of human environments. British and French avant-garde influences came respectively through two fellow-members of *Les Vingt:* Van de Velde's half-English friend Willy Finch and Théo van Rysselberghe. The common denominator was 'the revelation of the Japanese woodcut' (Henry van de Velde, *Geschichte meines Lebens*, ed. and tr. Hans Curjel, Munich 1962, 56).

In the very next year, he designed the tapestry *Guardian Angels*, in which the 'Daemon of Line' unites with Divisionist colour contrasts. At the same time he undertook the graphic design of a new Flemish magazine, *Van nu en straks* ('From Now On'), and created his own first works in the woodcut medium that had been used by his Oriental mentors themselves. One of these was *Ornament* [196], a 'decorative composition', as he himself was to call it, directed towards 'a free, aggressive play of line' (ibid., 63). Just how advanced it looked, how ahead of its time and how unconventional, can be measured by the fact that it was too much for even so shrewd and well-disposed a critic as Karl Scheffler, who described it as 'unfinished'. For Hans Curjel, sixty years later, it marked the breakthrough to Modernism, with 'a dynamic linear idiom based on an approach that reappears only two decades later, in the work

of Kandinsky and others' (introduction to Henry van de Velde, *Zum neuen Stil*, Munich 1955, 11).

Van de Velde had been overtaken by a sudden revelation, not of any ready-made canon of form, but of a new and intoxicating openness and dynamism. It was the opening he had been looking for, and it was the guide that led him, in the decades that followed, through the most varied forms of art. As late as 1910, in his essay, 'Die Linie', he expounded the meaning of the Japanese line as follows:

Lines as transpositions of gestures – that is the miracle ... in the exhilaration of discovering this ability to trace lines, human beings were induced to demand from lines the same kind of sensual pleasure as from dancing, fighting, caressing ... Linear sequence grows from the imperative need for rhythm ... In those [primeval] times, line and linear ornament possessed properties and powers that the less spontaneous sensibility of later ages transferred to pictorial representations ...

The informative line ... has a specific purpose and aspires to a perfection which is absolutely preordained and predefined, and which sees its fulfilment in representing naturalistic things in as real a way as possible ... The will to represent, the will to draw is the motive force ...

The emotive line, on the other hand, pursues an unspecific purpose; it freely disposes of its means. This is a power that arises spontaneously within us and strives for expression, that rises and falls, that glides and twists on its way, that elevates our souls into a state that only song and dance can evoke. (*Zum neuen Stil,* 181–95.)

After surveying the role of line in Egyptian, Mycenaean, Roman, Gothic and other art, Van de Velde continued:

This account would be incomplete if I were not to mention that, just as the Neo-Impressionists showed us the new line at a moment when no sign of it was to be found in architecture or in ornamental design, the *sudden revelation of Japanese art* aroused in us the sense of line. We found in it the feelings and the spiritual stimuli that we had untiringly sought in the music, the poetry and the dance of various countries.

It took the power of the Japanese line, the force of its rhythm and its accents, to arouse and influence us. Its rhythmic strength and intensity could not but awaken even the deepest sleepers. The wonders born of a well-judged balance between the subordination that can be demanded of line and the freedom that must be granted to it came to us as an overwhelming revelation: it was like a sudden blaze of sunlight emerging from thick cloud. The Japanese line brought salvation. Its reckless courage and the boldness of its gestures, picking on the most unexpected moments to introduce an emphasis; the powerful, haunting rhythm that carries brain and soul along like the clouds of incense that rise to the Buddhas – all this aroused our astonishment, and this strange astonishment fell on our reawakened longing for a fertility of our own like rain on the parched, yearning, concupiscent earth. (Ibid.)

This rhapsodic confession of faith on the part of a rationalist reveals how necessary it was, and is, to go back to the primitive function of ornament and liberate it from the travesty of adventitious, confectionery 'adornment'. Back to spontaneity of gesture, imprinting force and expressive signs: it is only 'false' ornament that has no place in the applied arts. With his reference to the 'new' Japanese line, which assigned its proper creative place to freedom of linear form, Van de Velde went straight to the heart of the matter, justifying his own adoption of the path that had led him to such notable achievements as his 1908 double title-page for Nietzsche's *Ecce homo* [197].

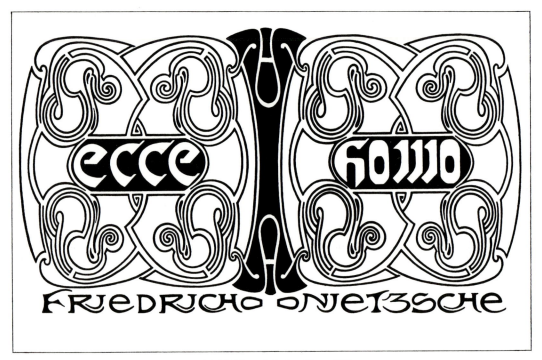

197 Henry van de Velde. Frontispiece for Friedrich Nietzsche's *Ecce Homo*, 1908

Others who went further along the same path included such interesting figures as
Théo van Rysselberghe (1862–1926) and Georges Lemmen (1865–1916), together
with Gisbert Combaz (1869–1941) in poster design, Willy Finch (1854–1930) and
Willy Schlobach. Among the painters, Gustav van de Woestyne (1881–1947) deserves
mention for his painting *Two Girls*, entirely based on a Japanese arabesque, and Frits
van de Berghe (1883–1939) for a *Room in White* which owes an equal debt to the
Japanese and to Whistler. And then, of course, there is the short-lived genius of Henri
Evenepoel (1873–1899); he cannot be assigned to Japonisme without qualification,
and certainly he owed much to the French vision, from Manet to Bonnard; but, for
all his realistic concerns, his art would be unthinkable without the filter of the abstract
line and the rhythmic alternation of light and dark, pattern and ground.

Fernand Khnopff (1858–1921) was a very different figure. A cerebral artist of the
older generation, an admirer of Gustave Moreau, of the English Pre-Raphaelites and
of the mystical *Rose + Croix* group, a literary and metaphysical Symbolist, a precursor
of the Surrealists: one might think that the Japanese formal repertoire would have
nothing to offer him. And yet, as a member of *Les Vingt* and later of *La Libre
Esthétique*, he used Japanese sources to add an exotic note to his visions.

Belgium is a small country, and art and literature, closely enmeshed, tend to appear
on the same platforms. The poet Emile Verhaeren, who published a volume of his
own poems, *Images japonaises* (Tokyo 1896), with illustrations by Munetaro Suzuki

under the pseudonym of Kwasson, had been a champion of Khnopff's work as early as 1887, and afforded him – if such a thing were necessary – an additional perspective on the Far East.

What first strikes one about Khnopff's work is his use of Japanese formats, sometimes approaching the square, sometimes extending into a narrow strip, almost 1:4. In his asymmetrical portraits, distanced by overlapping framework, he follows the *japonisant* aspects of Whistler. His suppression of depth and roundness sets him apart from the other Symbolists; he was thus, especially in the 1890s, touched by Japonisme but not deeply affected by it.

Holland

In Holland, artists did not await the summons of Art Nouveau and Symbolism before taking their cue from Japan. In the solid painting of Georg Hendrik Breitner (1857–1923), who was close to *Les Vingt* and also knew the Parisian atmosphere from 1884 onwards, there is no difficulty in seeing what Japonisme had to offer. To a close observation of Nature – which has sometimes caused him to be regarded as a late offshoot of Impressionism – Breitner added touches of decorative organization. The painting *The Earring* [198] is unmistakably 'constructed': the stressed horizontals and verticals are answered by curved outlines and an ornamental carpet. The rhythmic division into dark and light strips dominates the scene and even the 'mood'; it is stylized through a pattern–ground relationship.

One might be reminded of similar effects in Whistler or in Vuillard, but here another note is detectable: Breitner is referring directly to the Japanese, and specifically to the Antwerp exhibition of Japanese art in 1891 (some sources say 1892). Long awaited by those who knew what had been seen in Paris, or what had been published in the books of Gonse and others, this event seems to have had a powerful impact on artists of the most varied tendencies; and the first half of the 1890s, in Holland as in Belgium, was dominated by Japonisme.

In that same period, Breitner painted several variations on the subject of a lady in a kimono: not as a fashion-plate – in the manner of Alfred Stevens' *Japanese Dress* [52] – but as a pretext for a decorative composition. *Girl in a Red Kimono* [199] is an example of the way in which the movement of curves against straight lines, cool against warm colours, differing textile patterns against each other, almost abolishes thematic content and transposes it into another, poetic reality. Breitner's Impressionist realism became a form of Post-Impressionism and pointed in a direction in which Gauguin, for instance, had set out with totally different preconceptions. It reveals no symbolistic or proto-Expressionist undertones.

Such undertones are, however, strongly evident in the work of Breitner's exact contemporary Jan Toorop (1858–1928) and of Jan Thorn Prikker (1868–1932): the presence of Japonisme in artists of such contrasting beliefs is another indication that it was not an ideological but a purely artistic force.

Toorop's interest in archaic abstraction has often been ascribed to his birth and

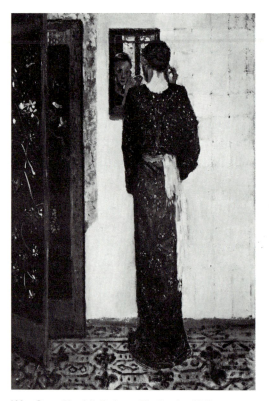

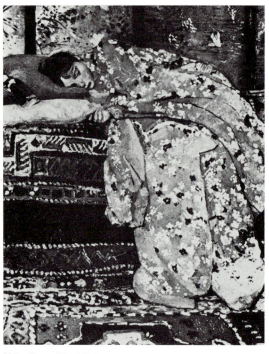

198 Georg Hendrik Breitner. *The Earring*, 1895 199 Georg Hendrik Breitner. *Girl in a Red Kimono*, 1893

childhood on Java, then a Dutch colony. The motifs of Javanese folk art are alleged to have inspired his idiosyncratic approach. Really? Why, in that case, did he adhere, until his thirty-third year, to a conventional illusionistic, naturalistic vision, as well as to the pseudo-Socialism of William Morris, before then suddenly undergoing a total change of heart? This happened precisely at the moment when the wave of Japonisme was at its height and was giving rise to all manner of avant-garde initiatives.

 No one is seriously going to maintain that the Antwerp exhibition (and that alone) converted Toorop overnight from a depicter of external Nature into the inventor of a dream-world. In an excellently documented book, *Het Fin de Siècle in de nederlandse Schilderkunst* (The Hague 1955), Bettina Polak describes the cultural atmosphere that surrounded him: everywhere – in poetry, in music, in the philosophy of the *Rose + Croix* – Symbolist tendencies were at work. True; but how can these in themselves account for his swing towards stylization in form and expression? Surely, it was his contact with Henry van de Velde, who was certainly no Symbolist, that revealed to him the new language of line: Japanese line. The transition to Toorop's new style precisely coincided with his better acquaintance with the documents on show in Antwerp. Symbolism did not 'produce' the new expressive form, as would

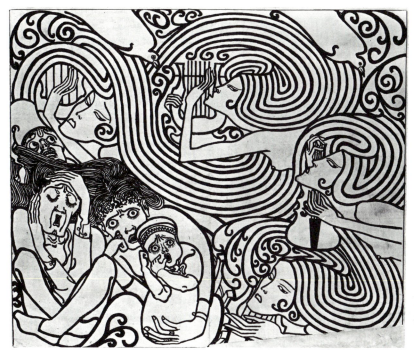

200 Jan Toorop. *Shipwreck*, 1895

appear from Polak's book, but quite the reverse: symbolism could emerge in his work only after the new formal defining force had been found.

The unique power of Japonisme has enjoyed no greater triumph than in the case of Toorop. If this artist had been fascinated 'all his life' by East Asian prints and textile patterns, as in Polak's account of him, why then did he take nearly fifteen years to shake off academicism, when the possibilities of decorative form had been available since Whistler and were perfectly well known to him? Toorop could avail himself of these possibilities only after Japanese prints had ceased to represent a hard-and-fast schema and he had become aware of their fertile, transformative power. Japonisme led in his case, as in others, to liberation, not to imitation.

A work of graphic art, Toorop's poster for Jan Wagenaar's cantata *Schipbreuk* (*Shipwreck*), of 1895 [200], shows this conversion to curves and nothing but curves at its most radical. Even the figures, though still identifiable as such, are caught up in an abstract play of lines that can be likened only to music. Space, colour and light are sacrificed to the arabesque. The line alone, in every key from the delicate single stroke to sheaves of sweeping curves, swells and contracts, forms islands of brilliant white and denser darkness, and sets up rhythmic relationships to which all the individual forms subordinate themselves in a vision bounded by a near-square. The detailed Japanese references emerge in the profile of the girl who emerges from the waves at far right, in the non-illusionistic drawing of the swivelling eye, in the

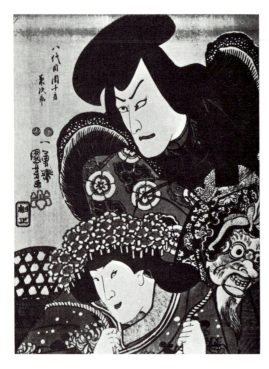

201
Utagawa Kuniyoshi.
Ichikawa Danjūro VIII,
1848

accumulation and compression of elements, in the multiplication of the curves and in the grotesquerie of the expression, all as they are to be found in Kuniyoshi: in, for instance, the print *Ichikawa Danjūro VIII* [201].

When looked at in conjunction with the work that Beardsley was doing at the same time, that of Toorop looks conservative. He was consistent in his use of an agitated, curved line, while the English artist anticipated later developments by using curves in counterpoint with 'tectonic' straight lines, both vertical and horizontal.

This was the course followed by Piet Mondrian (1872–1944) on the long road that took him to Neo-Plasticism and pure abstraction. In his far from straightforward progression from naturalistic beginnings in the 1890s to the total abandonment of the object in 1916 and the attainment of a new order in 1918, he passed through several stages, some of which sprang purely from inner necessity and some from the discovery of elective affinities with Van Gogh, Munch, the Divisionists, the Cubists and Kandinsky.

Among these encounters, his contact with Toorop was certainly not the least significant. For several years, beginning in 1908, the two artists summered together at Domberg on the island of Walcheren; and in 1910 both assumed leading roles in the artists' association *Moderne Kunstkring*. It was this friendship, therefore, that presided over the last phase before Mondrian's move to Paris in 1912 and his breakthrough to Cubism. His work at this time was marked by a gradual liberation from depiction and its replacement by a summarizing arabesque. This might well be called Mondrian's *japonisant* phase: no matter whether this characteristic was

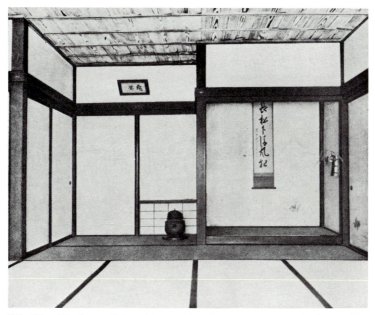

202 Bōsen Tea-Room, Kohoan House, Daitokuji Monastery, Kyoto, 1612 and 1793

principally derived from the example of Toorop or from a direct Japanese influence more apparent as a stylistic than a biographical event.

Dune V, of 1909–10 [167], is one of at least twelve variations on a theme, in which Mondrian circles round his subject as Monet and Hokusai had done before him. Increasing brilliance, leading to the triumph of pure colour; abandonment of tonal modelling; structuring in large areas, separation of the organization of colour from the structure of the drawing in pattern-like sequences: these new features, which established the primacy of the image over the depiction and the motif, might without difficulty be traced back to Toorop's *Shipwreck* [200], except that they had now been transposed from drawing to pure colour and that, beyond the visible curves, the 'tectonic' interplay of horizontal and vertical was echoed, as if from afar, in the width of the oblong format. This was like a translation of painting into musical terms; but it was not, yet, the adoption of an architectonic structure.

That last step was taken a decade later, with the disappearance of all curves and the appearance of areas of colour, bordered with heavy black outlines, as an embodiment of a purity of formal creation 'liberated from tragedy'. Konrad Fiedler, with his criterion of 'ultimate visibility', would have been content.

Mondrian's works after his breakthrough to abstraction suggest a new kind of Japanese reference, unconscious on Mondrian's part: it does not relate to woodcuts but to the basic idea of Japanese domestic architecture. The rhythmic use of standard components – squares, vertical or horizontal rectangles, narrow and wide proportions, standardized floor mats related to wall surfaces, the black 'sticks', vertical and hori-

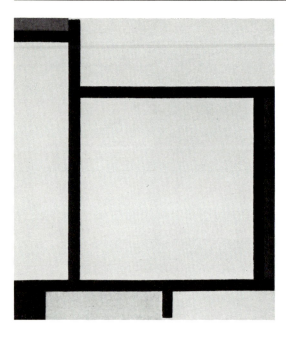

203
Piet Mondrian.
*Composition in Red,
Yellow and Blue,*
1921

zontal, in 'suspended equilibrium' (quoted from Piet Mondrian, *Neue Gestaltung*,
Bauhausbücher no. 5, Munich [1925], 55, 56, 49), and the avoidance of curves and
ornament: all these are already present in the Bōsen Tea-Room in Kyoto [202], albeit
arranged in a different relationship from the airless space of Mondrian's perfect square,
Composition in Red, Yellow and Blue, of 1921 [203].

In 1957, D. Gioseffi noted with intuitive accuracy that 'the true prehistory of
Mondrian after 1919 must be sought in the traditional architecture of Japan. Structure,
division of space, mood, certainly; but also the precision with which the wall unfolds
like a musical score' (quoted in Maria Grazia Ottolenghi, *L'opera completa di Mondrian*,
Milan 1974, 12).

Another artist who took Japanese art and Van de Velde as his starting-points was
Jan Thorn-Prikker. His ornaments for the book *Kwan Yin*, by his friend, the
Orientalist Henri Borel, document the Japanese influence; his path to applied art
documents the influence of Van de Velde. Like Toorop, he had Symbolist leanings;
but, whereas Toorop concentrated on the curvaceous organic line of early Art
Nouveau, Thorn-Prikker, ten years younger, tended from the outset to admit angular
forms as well. This offered him a longer evolutionary path, as we have seen from the
examples of late Beardsley, the Glasgow Four and Mondrian.

A subterranean contact with the art of the East ran through the greater part of his
life. The Antwerp exhibition was the event of his youth; he had a momentous
encounter with Toulouse-Lautrec in Brussels, where both men were showing their
works at *Les Vingt*; his private collection of Javanese batiks with their geometrical
patterns was admired by his friend Van de Velde. In later years he taught in Krefeld,

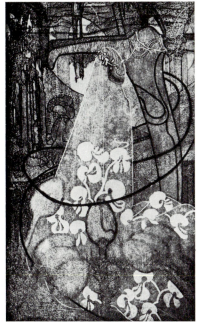 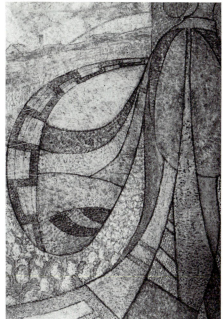

204 Jan Thorn-Prikker. *The Bride,* 1893

205 Jan Thorn-Prikker. Detail of *The Madonna of the Tulips,* 1894

where Friedrich Deneken, a pupil of Brinckmann's, had assembled a choice collection of Japanese woodcuts in the local museum.

Thorn-Prikker's early work of 1893, *The Bride* [204], was 'the most mysterious of all the paintings exhibited at *Les Vingt*' (Octave Maus). Behind a veil of symbolic obscuration and blond Divisionist colouring, it combines Japanese textile ornaments; vertical candles asymmetrically placed as a structural element; and then, as if in an overprinting, swelling black curves borrowed from Utamaro and ornamentally linked. The pictorial structure is cropped hard, below and right. There is no denying the Japanese origins of the work, although the translation is a free one and only an expert eye will detect the sources unaided. A detail from an almost contemporaneous painting, *The Madonna of the Tulips* [205], illustrates all these same features even more clearly; its differently textured segments hark forward to the stylistic devices used by Delaunay and other Cubists.

Achieving no success in Holland, Thorn-Prikker was invited to Germany, where he gave up painting altogether. At Krefeld, in the Rhineland, over a period of three decades – two-thirds of his active career – he worked as a modern decorative artist in stained glass, carpets and similar objects, both representational and purely abstract. His stained glass is a part of the history of German decorative art, markedly closer to the style of his Expressionist friends, August Macke and Franz Marc, than to the works of his own Dutch period.

16. Renewal in Central Europe

Pilgrims to Paris

Looking back from a distance of a quarter of a century, Meier-Graefe sketched the following picture of German artistic life in 1890:

It is impossible to overestimate the disarray that afflicted our artistic lines of communication. Toulouse-Lautrec, Vallotton, Odilon Redon, Axel Gallén, Vigeland, Beardsley, Gauguin and Munch, Puvis de Chavannes and Whistler, along with the German Romantics, were the most important sources of our awareness. We knew virtually nothing of Leibl and Trübner, and less still of Courbet. Menzel was despised. I knew Bonnard before I knew Manet, and Manet before I knew Delacroix. This disorientation explains quite a few of the mistakes that were later made by my generation. In 1890 our heads looked like a railway marshalling-yard in wartime. No one knew what was going out or coming in. Many signals from that latter-day *Sturm und Drang* period are still with us. In that universe of the aimless . . . (*Entwicklungsgeschichte der modernen Kunst*, Stuttgart 1904, vol. 2, 324.)

Even if we allow for an element of exaggeration in this picture of turmoil, disorientation and aimlessness, the contrast with France is evident at once: the absence of tradition and pictorial awareness had led to the predominance of a literary emphasis in painting, and to the isolation and marginalization of individual artistic endeavour.

Left to their own devices, artists looked westward for examples to follow, or else went straight to the hub of the art world, Paris, to study. There are no statistics, of course, but one thing is clear: the periodic migration of Central European artists to the French capital reached its peak around and shortly after 1890. A wind of renewal was blowing from there, and it was felt from afar. Many enrolled at the Académie Julian, without formalities, and undoubtedly also met Maurice Denis. What counted was not any programme of formal instruction but contacts with individuals and with the whole atmosphere of the French avant-garde. A list of these visitors would include most of the names that later became famous, from Van de Velde to Toorop, Leistikow, Munch, Vrubel, Wyspianski, Rippl-Ronei, Mucha, Hodler. Belgians, Dutchmen, Germans, Norwegians, Russians, Poles, Hungarians, Czechs, Swiss (reading clockwise from the north) were all represented. And the names cited by Meier-Graefe also show what they were looking for, and who were the models they wanted to approach: we have already encountered most of them as adherents of Japonisme.

Magazines and reformers

One source of Japonisme in Central, Northern and Eastern Europe was therefore Paris. Another resided in the public collections that were enriched, in the last five years of the century, with 'leaves from the floating world': Hamburg, Vienna, Berlin,

Dresden. The new magazines of the arts, *Pan, Die Insel, Jugend* and *Simplicissimus*, carried a breath of the East either directly or as refracted through the work of Whistler, Lautrec, Beardsley, Vallotton and others. Belatedly, perhaps, the Japanese sources were now available, here as elsewhere. Anyone who needed them could find them without difficulty.

The whole situation was nevertheless totally different from that in France. In Paris, despite wide variations of detail, the new formal language – the line, the arabesque and the use of flatness – was part of another reality, both social and artistic; naturalistic depiction had been thrust aside. But this foundation was completely missing in what became known in Germany by the vague term *Stilkunst*.

This tendency was carried forward, simultaneously and rapidly, by a whole range of ideas which can be summarized, according to Jost Hermand (*Stilkunst um 1900*, Berlin 1967) as follows: imperialism, racial pride, national will, religious culture, new vitality. *Stilkunst* evolved in three phases, again as defined by Hermand: aesthetic/ decorative, regional/vernacular, and craft-based/objective. The first of these three, and the most important from our present point of view, Hermand classifies under six headings: Neo-Impressionism, Jugendstil (Art Nouveau), Atmospheric Lyricism (*Stimmungslyrismus*), Symbolism, Vienna Secession and Decorativism. All this only goes to confirm, from a completely different angle, Meier-Graefe's impression of chaos. One of the prime causes of disorientation, in Hermand's view, was the idea that what was needed was 'not the establishment of a new world of values but originality at any price' (ibid., 245). A changed reality was obscured by a theatrical view of it; the new could barely be glimpsed behind a succession of ideological veils.

In such a situation, the help that the Japanese pictorial idiom had to offer was comparatively limited. Its form-creating function inevitably remained invisible to those who looked to art *exclusively* for the illustration of their own ideas and feelings. To proceed from content to form is a much riskier business than to proceed in the opposite direction. All this only goes to underline still more the role played by Van de Velde, the apostle of the Japanese line. His practical and objective (*sachlich*) design style cut through the false ideologies and became a lifebelt amid all the chaos. But his path led him away from painting and graphic art, and it was architecture and industry that reaped the benefits.

Painting and graphic art had to seek their own salvation. It is certainly no coincidence that none of the three outstanding figures – Munch, Hodler and Klimt – came from the territory of the German Reich, and that of painters born there, only second-rank figures were touched by Japonisme. It was only in graphic art, in accordance with national tradition, that the stylistic crisis led to achievements of lasting value.

Otto Eckmann (1865–1902) deserves the first mention. At a stroke, he brought Germany into step with the rest of Europe. Even before his polar opposite Van de Velde appeared on the scene, Eckmann had his own Road to Damascus and turned from illustrative, symbolic 'mood landscapes' to decorative invention. In 1894, this Academy-trained painter sold off the contents of his Munich studio in a 'posthumous auction' and returned to his native Hamburg to seek new objectives. There, under

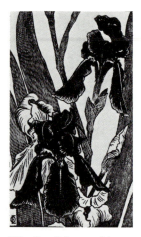

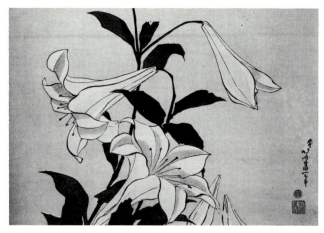

206 Otto Eckmann. *Irises*, 207 Katsushika Hokusai. *Lilies*, from the series *Large Flowers*, 1827–8
1895

the influence of the outstanding Japanese collection assembled by Justus Brinckmann at the Museum für Kunst und Gewerbe, he found his own direction, the so-called 'Floral Jugendstil'.

Eckmann's *Irises*, of 1895 [206], an immediate success when published in *Pan*, bears comparison with Hokusai's *Lilies* of 1827–8 [207], and actually uses the same medium, the colour woodcut. In both, the plant form has been studied with great realism and simultaneously reduced to essentials, retaining its roundness and its curvilinear outline and yet related as a pattern to its ground. The tonal treatment of the internal areas, with the addition of hatchings and short linear strokes, enhances the object; the rhythmic relation between pattern and ground, between empty and filled segments, is the province of subjective expression.

Both artists maintain a state of unstable equilibrium between representation of Nature and ornamental invention. But whereas, with the Japanese artist, an almost casual and comfortable arrangement appears to prevail, and is favoured by the horizontal format, the German maintains a tenser vertical movement which emphasizes the process of growth and movement. All the unfilled areas are like narrow vertical strips that aspire to escape upwards; in places they are halted by the filled forms of the blossoms, only to pass the obstacle and hasten on upwards. Tension and dynamism are everything. Although there is plenty of room for the flowers themselves, they seem crowded in by the moving elements, the stalks and stalk-like leaves; the vertical impulse seems to dominate everything.

This latent Expressionism is rare in Japanese art, where indeed it is unique to Sharaku. The 'Japanese line', an elegant, vibrant curve that runs along objects, has undergone a change of function in Eckmann's work: there emerges a linear tissue of outline and internal forms that both corresponds to the essence of the plant and expresses its growth, its energy.

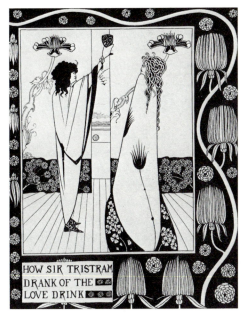

208
Aubrey Beardsley.
How Sir Tristram Drank of the Love Drink,
from *Le Morte d'Arthur,* 1893

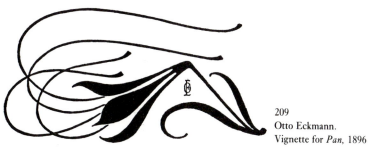

209
Otto Eckmann.
Vignette for *Pan,* 1896

Eckmann also departs clearly from his other great exemplar, Beardsley. One of the *Morte d'Arthur* illustrations [208], designed only two years before, and certainly known to Eckmann, goes much further in the direction of abstraction: at the right-hand and bottom edges Beardsley translates plant form into ornament and intensifies the decorative spell by the use of a black ground and a long, snaking, wavy line.

There can be no doubt that Eckmann derived a new stylizing impulse from this precedent, and from his work on furniture and tapestry design. A vignette for *Pan* (1896, vol. 2 [209]) shows Eckmann turning to the all-pervading ornamental style and endowing it at once with an individual handwriting quite distinct from the work of Van de Velde, the Glasgow Four and Lautrec. The elegant, rhythmically balanced, lightweight ductus owes much to Japanese calligraphy; it barely alludes to the natural form, which it dissolves in an arabesque, animating the surface in a delightful play of straight lines and curves, order and nonchalance. All illusionism, all reference to the photographic view of Nature, has vanished; and a magical realm of absolute line lies before us. The world stands transformed. It is no wonder that such an artist was

acclaimed by the new aesthetic elite; no wonder, too that his message never went beyond the few.

Eckmann nevertheless exerted an influence on a group of like-minded artists, especially in Munich: Hermann Obrist, August Endell, Bernhard Pankok, Peter Behrens, Richard Riemerschmid and others, all of whom outlived him and moved on with the *Deutscher Werkbund* into architecture and into Modernism. None of them remained untouched by the Japanese stimulus.

The popular counterpart to this whole trend is to be found in the illustrators who worked for the Munich periodical *Jugend* and, even more, for *Simplicissimus*. This latter journal, fed by a paradoxical combination of 'conservative attitudes and the spirit of opposition' (Wilhelm Hausenstein), was highly uneven both in quality and in importance; it reached a sale of 480,000 copies. Here, by contrast with the remote and elitist alienation of its Jugendstil contemporaries, was a comic and satirical view of the social and political events of the day; a breath of fresh air and originality in a notably stuffy atmosphere. The magazine's policy of simplicity in graphic style was in keeping with the stylized clarity that the age was beginning to demand.

As well as providing *Simplicissimus* with weekly pictorial comments on the events of the day, mostly tied to the running text, its contributing artists also worked on book illustrations and cover designs in a rather freer style, and entered the new-found world of posters, where the concentration of the image was decisive. 'Posters turned into an art gallery and became a picture book for the contemporary population at large' (Günter Busch). A new medium had been invented.

Heine and the art of the poster

Thomas Theodor Heine (1867–1948) set the pace of the rapid evolution of this new, utilitarian art; at least until the First World War, he remained the centre of the Munich circle. Line, planar quality, simplification of colour and ornamental handling were the elements through which he was able to endow an essay in social criticism, or a satirical characterization of a type, with a pictorial life of its own. Heine knew and mastered all the resources of his art, though he did not always apply them with equal strictness, occasionally allowing himself to be led astray by some representational detail. There are in his output some drawings of high quality, dead on target; but there are also some weaker ones that rely too heavily on the punchline.

Heine's own uncontested reputation was that of a courageous journalist – feared and admired by turns – as much as that of a unique caricaturist. His formal imagination seems to have undergone no detectable evolution. As the painter Lovis Corinth remarked, Heine could do anything he wanted to do, at any time. There can be no doubt that at the outset of his career, in 1896, he carefully surveyed the latest products of the graphic avant-garde: the drawings of Beardsley, then newly published, the posters of the Beggarstaffs, Lautrec for the boldness of his colour, and naturally the Japanese artists themselves. What emerged from this array of stimuli has a highly individual note of its own.

210
Thomas Theodor Heine.
Illustration for
Friedrich Hebbel's
Judith, 1908

The Eleven Headsmen (*Die Elf Scharfrichter*), of 1900 [XV], a poster for the Munich cabaret of that name, is typical of his style in its juxtaposition of disparate elements: the dominant, pillar-like vertical of the black-clad figure on the right; the grotesque devils in movement on their yellow ovals against the central area of red, with its horizontal lines of lettering to provide a second axis. All is harsh contrast; there is no sign of a reconciling, ingratiating line such as Lautrec and the Japanese artists loved. The outlines are anything but elegant and decorative; but then this is just what gives the poster its sharpness, its character. Such a work could certainly not have been made *before* those of the other artists mentioned; but it is not merely derivative. Components of many kinds have been united into a striking mosaic; and this applies to the undeniable Japanese element as it does to all the others.

Concrete sources are hard to specify, but some traits are fairly clear. The rhythmic arrangement and grotesque exaggeration of the heads of the eleven imps recalls Kuniyoshi's *Cats* [112]; and the way in which contrasting areas, in this case greenish, encroach on the image is often found in the later Toyokuni School. The mask-like stylization of the face, especially in the mouth, eyebrows and hair, is characteristic of the Katsukawa School, from Shunshō onwards. The stenographic treatment of the hands points to Harunobu; and the stylized monogram, vertically arranged, is the most reliable pointer to Japan of all (although imitated from Lautrec). And, all this notwithstanding, the whole is greater than the sum of the parts.

By contrast, it comes almost as a surprise to find an illustration by Heine, drawn for Friedrich Hebbel's play *Judith* [210], that relates to Beardsley even in the use of the same technique. The absence of colour lends extra weight to the lines: thick and thin, black and white, straight and wavy, gently curved and strongly bent, in pairs,

in sheaves, in arabesque-like curls. The space opens out far back in depth and yet cleaves to the picture plane. The compression is conveyed by the line and is particularly intense in the mask of the monster. One is reminded of the semi-abstract dramatic masks of actors by Sharaku; of Hokusai's visions of ghosts; of Sukenobu's or Hiroshige's starry skies. It is clear that this artist has seen and discarded much, and that in the process he has found himself. The final stage of Japonisme is already in sight. The penultimate act is here played out in such decisive terms that it can hold its own beside and after all other manifestations whatever. Beardsley's over-sophisticated cruelty is replaced by a magnificent theatrical effect. If only Thomas Theodor had worked as a stage designer!

It is tempting to go on to analyse the work of Heine's colleagues on *Simplicissimus*, and on *Pan* and its successor journal *Die Insel*: Bruno Paul, Olaf Gulbransson, Peter Behrens, Bernhard Pankok, Emil Rudolf Weiss, Marcus Behmer, Emil Preetorius. Each of them evolved a distinctive graphic style of his own; each based himself in his own way on the fundamentals of Japanese artistic vision, translated it into a design for print, and played his own part in opening up a long-submerged realm of art. What Morris had dreamed of, and had achieved only in a few luxury publications of a 'medieval' cast – namely the book and the poster as works of art – became a reality in Germany. Before the First World War, and indeed right down to the advent of Hitler, German graphic artists were producing practical, contemporary objects of high quality. The emphasis was markedly democratic (in contrast to the French productions of this kind, which tended more towards 'high', aristocratic, exclusive forms of art; exponents included Redon, Bonnard, Denis and later Maillol). The gap between high art and so-called real life had actually been narrowed.

This being so, it was entirely to be expected that a number of illustrators and designers turned to related fields: craft design, interior decoration and architecture. In the tension between aesthetic/decorative and practical/objective imperatives, they set out, as Willi Geismeier has put it, 'in their discontent with the state of society, to involve art in the function of creating social cohesion' (preface to exhibition catalogue *Stilkunst um 1900 in Deutschland*, East Berlin 1972, 15). It was just for this reason that the 'neutral' idiom of the Japanese lent itself to constantly renewed experimentation.

Studies and exhibitions

It may seem strange that such an approach emerged from Munich, where there was at that time no collection of Japanese prints; but this new world of form had penetrated German culture with great rapidity and from several directions at once: a whole generation after France and England, but with Teutonic thoroughness. We have already encountered the public-spirited museum curators, Brinckmann, Seidlitz and Jessen; it was Brinckmann's well-informed work, *Kunst und Handwerk in Japan*, that set the ball rolling on its publication in 1889, and found its way into every library. Four years later, in the first retrospective account of nineteenth-century art ever published (*Geschichte der Malerei des 19. Jahrhunderts*, 1893), Richard Muther devoted

a whole chapter to *ukiyo-e* and its influence; the book was widely noticed and was eventually translated into English.

Barely three years on, in 1896, Friedrich Deneken, the new museum director in Krefeld, not only encouraged two representatives of Japonisme, Toorop and Thorn-Prikker, to settle in the city but himself provided all book designers and illustrators with a magnificent object lesson in the hundred plates of his book *Japanische Motive für Flächenverzierung* [211], which was influential in all branches of decorative art. It acted as a continuation of Bing's Paris periodical, *Le Japon Artistique*.

In 1897 Seidlitz in Dresden produced his famous *Geschichte des japanischen Farbholzschnittes*, describing it as a history 'for our own time'; and in the following year he lectured in Vienna, in the same missionary spirit, on the 'significance of the Japanese woodcut for our time'. Printed in *Kunst und Kunsthandwerk*, this paved the way for the foundation of collections of Japanese prints in Vienna and in Berlin. Between 1895 and 1905, a succession of well-received exhibitions (Dresden 1895, 1897, 1902; Vienna 1900, Berlin 1905) afforded artists and public an insight into the whole field; they were promoted by artists' associations, or by the art trade, or by the museums. Before the turn of the century, Meier-Graefe published two 'primitive' woodcuts, by Kiyomasu and Kaigetsudō, in the periodical *Dekorative Kunst* (1899, no. 6), and pointed to their abstracting tendencies as a particularly suitable guide to modern design of all kinds. Finally, Friedrich Perzynski's intelligent and delightfully written essay *Der japanische Farbholzschnitt*, published in the well-known series *Die Kunst* in 1904, reached many artists and lay people. Once started, the ball kept rolling.

211 Friedrich Deneken. *Japanese Motif*, 1896 212 Walter Leistikow. *Grunewaldsee, Pond with Bridge*, 1907

Berlin and the Secessionists

The ball even rolled into the capital city of Prussia. This was dangerous territory. Kaiser Wilhelm II himself had decreed:

Any art that goes beyond the laws and bounds that I have indicated is not art but factory and trade work. Anyone who departs from the law of beauty, the feeling for aesthetics and harmony that fills the breast of every human being, and who concentrates on a specific tendency and a specific solution of a primarily technical problem, is guilty of a sin against the wellsprings of art. (Cited by W. Doede, *Berlin – Kunst und Künstler seit 1870*, Recklinghausen 1961.)

Provocative statements of this sort achieved more or less the exact opposite of their author's intentions. They united a disparate opposition, both social and stylistic, and led to the foundation of an anti-academic Secession on the model of Munich and Vienna. What happened next was described by Lovis Corinth:

Increasingly, the city of Berlin became a city of art; the lively controversy made its inhabitants aware of visual art for the first time, and they took sides for and against the Secession ... The word 'secession' always attracts the false interpretation that we, its founders, were the sworn foes of some dominant fashion in art; on the contrary, we separated ourselves [from the officially recognized artists] in order to have the freedom to speak up for any talent, whatever its tendency. (*Das Leben Walter Leistikows – ein Stück Berliner Kulturgeschichte*, Berlin 1910, 56, 82.)

In this liberal atmosphere, the artists set out to find their identity by associating themselves with the great European movements: admirers of Courbet's tonal painting, Naturalists, followers of Whistler (shown in Munich as far back as 1883), Impressionists, Post-Impressionists of various kinds, decorative artists who had heeded the call of Morris and other English designers – all these found a place in the Berlin Secession exhibitions. For a number of years, as Curt Glaser tells us, the Secession became the meeting-place of all creative forces. The struggle to find a new, a modern form of expression was initially more clearly evident in the work of the graphic artists than in that of the painters, and graphic art became the germ of the art of the future.

The figure of Walter Leistikow (1865–1908) cannot be overlooked in this connection. Not only was he the prime mover of the Secession group: his work was hailed by *The Studio* in London and even by *La Libre Esthétique* in Brussels, an unusual distinction. For all his great promise, this short-lived artist did not form a school; that would probably have been impossible. The work remained tied to a single theme, that of giving distinctive pictorial expression to the lakes and woodlands of the Berlin area itself, and sometimes also to those of Denmark. This in itself, in the Berlin context of the early 1900s, was a considerable step forward in the direction of decorative form. Leistikow did not live to pursue his line any further; and whether the burgeoning of Expressionism would have swept the ground from beneath his feet, or whether it would on the contrary have exerted a positive effect on him, is impossible to say. His 'stylistic convulsions' (Hans W. Singer) never found the right climate or the right moment.

Leistikow's career is interesting. He had an early contact with Maurice Denis, who influenced him both theoretically and by example. On a later visit to Paris, in 1893, the Japanese prints that he eagerly studied at Bing's brought about his conversion. He interprets *Grunewaldsee, Pond with Bridge* [212] no longer in photographic and illusionistic terms but as a formal structure: an alternative vision of Nature becomes visible through rhythmic sequence and repetition. Rows of trees and houses take on the look of arabesques and resonate through the picture; tapestry-like patterns fill the surface; full and empty forms are held in balance. The essence lies in these, not in any chance phenomenon. The colours seem to have been applied to an objective structure, not copied from Nature but dreamt up in a spirit of improbable simplification and radical contrast. What a surprise to see a yellow sky or red trees! It is as if Gauguin had not already evolved an entirely analogous vision.

Leistikow here clearly recalls Hiroshige, who in his good period, as in the *Eight Views of Kanazawa* of c. 1840, managed very similar colour shifts; these the Berliner had certainly seen. But how sensitively all this is transformed, and however abstract, how unmistakably he establishes the character of this unique, unappreciated landscape, so that it is hardly possible to see it with different eyes to this day! Leistikow set an example that deserved to put an end to *Heimatkunst*, back-home art, once and for all.

The resistance to Leistikow's work, as things were in Germany at that time, is easy to understand. When a painter moved towards applied art – as Van de Velde and Eckmann had done – that might be acceptable; but when another then took their decorative experience and applied it to pictorial art, then – it was felt – no good could possibly come of it: only the product of debased, because purely craftsmanlike, ideas of form.

It was probably the good fortune of Emil Orlik (1870–1932) that he concentrated on the graphic field and rarely painted a picture. He arrived in Berlin in 1905 to succeed Eckmann as a professor at the Staatliche Lehranstalt. He had already made a reputation for himself in his native Prague, in Vienna and in Munich; none knew better the technical subtleties and intuitive possibilities of every medium from etching to lithography; none was more at home in the freedom of graphic expression. There could have been no better teacher for the succeeding generations in this expanding branch of art. A virtuoso in the best sense of the word, Orlik was receptive to new impressions that came his way, to the people he met, to the countries and cities he visited, to the leading artists of his day.

His vivid portraits make up a major proportion of his work; in every respect he was a born portraitist. When in London, he saw the face of the city as Whistler saw it; when in Tokyo, like Hiroshige; when in Paris, fashionably, like Van Dongen. From the tonal, painterly vision of his early works there gradually emerged an outline-based style, marked by successive visits to England, France and Japan.

The Japanese prints he saw at Bing's (again) in Paris in 1898 led him to visit the Land of the Rising Sun for himself, to investigate the technique of the woodcut on the spot. Unlike Gauguin, who was determined to turn his back on the old continent, he was the one who sought to bring the linear secrets of the East back to Europe. The

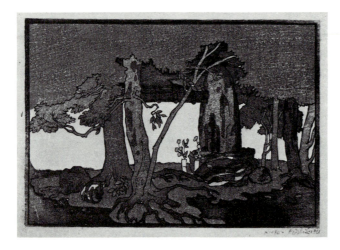

213　Emil Orlik. *Tree Trunks in Kyoto*, 1902

214　Emil Orlik. Illustration for Lafcadio Hearn's *Lotos*, 1904

role of Japanese art was decisive, not in supplanting other expressive resources but in extending their range in the direction of decorative, even ornamental abstraction.

Orlik brought back from Japan a colour woodcut, *Tree Trunks in Kyoto*, of 1901 [213], in which all the finesse of the Japanese vision is captured: its rhythmically structured line, its economy of colour, with green, red and yellow on a metallic grid. With great apparent ease, he has built a bridge to another culture thousands of miles away; for this is no mere copy but a Western interpretation.

In 1904 Orlik illustrated a book by a Westerner who had chosen to become a Japanese: *Lotos*, by Lafcadio Hearn [214]. This is a memorable piece of Japonisme from the hand of an artist who reveals, not for the only time, his limitless powers of empathy. It would be pointless and pedantic to look for a source in the work of this or that Japanese master. What convinces is the equilibrium between filled and empty spaces, the lightness of the flow of the curves, the delicacy of the transition between figure and ornament, the unity of technique, style and meaning. At the same time, one must realize how differently an Oriental artist would have done it. The legacy of Whistler's *Peacock Room* is apparent here, as well as the technique of Orlik's Viennese friends, the artists of *Ver Sacrum*, and even that of Klimt. Orlik does not fit into Impressionism, Jugendstil or Expressionism. And yet this latecomer established his own Japanese connection with perfect assurance. He had many pupils – of whom I shall mention here only Carl Thiemann and Walter Klemm – but no successors.

Vienna: Ver Sacrum, *Moser and Klimt*

Does *Impudent Weather* [215] look like a work from Austria? At the turn of the century, that country was host to a major exhibition of Japanese graphic art, as well as to a showing of work by the Glasgow four that embodied the same influence at

215
Kolo Moser.
Impudent Weather, 1903

second hand. This particular woodcut, by Koloman (Kolo) Moser (1868–1918), adorned the *Ver Sacrum* calendar for 1903. The Japanese influence is unmistakable: the square format, the ornamental framing, the way the figures are cut out and translated into a pattern, so radically that neither faces nor body-parts appear. All is left to the free line, the curves which are placed in 'tectonic' tension with the limiting horizontals and verticals. And then there are the colours: no longer illustrative but reduced to two tones, yellow and brown, allocated to the large solid areas and intensifying their contrasts. The frontier between object and abstraction has been reached. The Japanese source, the vibrant line of Utamaro, is impossible to miss, as is the tight drawing derived from Hodler or Margaret Macdonald [186]. And yet the soft colouring translates the unyielding Scots reserve into an elegant Viennese dialect.

An artist of modest stature, Moser flew high on the thermal currents of a new artistic climate; and they carried him even as far as painting – a rarity in his circle. Among the dozen or so illustrators and designers who vied with one another in making *Ver Sacrum* into a choice aesthetic product with an exquisite Scoto-Japanese flavour – to name only Josef Maria Auchentaller (1865–1949), Adolf Boehm (1861–1927), Nora Exner (1879–1915), Max Kurzweil (1867–1916) and C. O. Czeschka (1878–1960) – the switch to applied art and to craft design came naturally, and proved highly productive, as the achievements of the Wiener Werkstätte show; but in painting they tended to lag behind. Their visual imagination barely went beyond Whistler, and none could match Klimt.

The one exception was this same Kolo Moser, whose *Mountaintops under Snow* [216] is a remarkable achievement. In this Alpine landscape, seen through Japanese eyes, he succeeds in instilling the observed subject with abstract patterns and colours in an almost unprecedented way. Nature appears as a configuration formed according to the laws of art.

216
Kolo Moser.
Mountaintops under Snow,
c. 1900

This provides another key to the assessment of the Japanese influence as a whole. Ever since this had become linked with the decorative vision and with the eradication of illusionism – since Gauguin, in fact – it had been principally evident in graphic art. Understandably so, for the *ukiyo-e* impulse itself is exclusively contained in woodcuts. In graphic art, progress could continue, step by step, almost painlessly; new territory was opened up to a wide variety of talents. But more was needed before this 'Copernican' revolution could reach painting. The construction of a painting not only implies greater ambitions than does the execution of a graphic 'idea' – not only are there more masses to be balanced – but the vision comes from a greater depth. So it became almost a test of the graphic artist, whether he or she descended to applied art or ascended to painting.

This is not a value judgment, of course. A painted picture is not necessarily better than a piece of furniture or a fine ceramic object: and yet every single one of the significant pioneers involved – with the exception of Beardsley, whose career lasted only four years – included some experimental painting in his work. This is the context that lends significance to a painting like Moser's.

The same point is made even more clearly by the most important figure in Viennese art, Gustav Klimt (1862–1918), who went as far as monumental painting. Not that this fact adds to his statute in itself: what it proves is that he was able to transpose the decorative quality from small formats to the completely different conditions of a large wall. What made him capable of such a feat was his profound insight into the lessons of Japanese art. A comparison between two cartoons, *Medicine*, painted in 1897–8 for the ceiling of the great hall of the Vienna University [217], and *Fulfilment*, painted in 1905–9 for the frieze in the Palais Stoclet in Brussels [218], reveals just how far he had come in the intervening time. The earlier work, which was highly

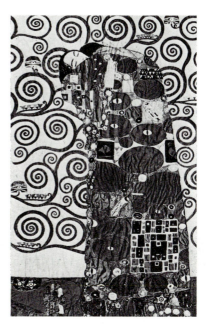

217 Gustav Klimt. *Medicine,* cartoon for Vienna
University, 1897–8

218 Gustav Klimt. *Fulfilment,* cartoon for
the Stoclet Frieze, 1905–9

controversial in theme but not in style, shows him firmly in the grip of illusionistic
representation and the illusion of three dimensions; two decades of his life were filled
with such works, and the catalogue raisonné contains over a hundred surviving
examples. The later work, by contrast, shows him in full possession of a new, 'icon-
like' sense of design.

In the interval between Klimt's work at the University and at the Palais Stoclet
there came not only the Japan exhibition at the Secession (1900) but a number of
remarkable individual shows that allowed the Viennese observer to scan the entire
Modernist horizon: Whistler, Khnopff, Vallotton, Toorop, Beardsley, Mackintosh/
Macdonald, and above all Hodler and Munch. In 1902, Klimt was one of the seventeen
members of the Vienna Secession who worked on the 'decorative panels' of the
Beethoven Frieze [219]. According to Johannes Dobai, this collective work represented
the 'fullest development of the later, Viennese variant of Jugendstil and the most
important attempt in contemporary European art to create a Symbolist *Gesamtkun-
stwerk*' (Fritz Novotny and Johannes Dobai, *Gustav Klimt,* Salzburg 1967, 386); its
godfathers were Mackintosh and Toorop. It was also in the interval between the
University and Palais Stoclet commissions that Klimt made his visit to Ravenna to
study the mosaics, an expression of a different form of archaism; this marked, for him,
the 'beginning of the strongly planar work with gold paint'.

Klimt affords the classic instance of a twofold Japanese influence, direct and
indirect. This is the key to the complex and extremely rapid artistic evolution of
his later career. In general terms, the extensive literature on his work sometimes

219
Gustav Klimt.
The Hostile Forces, panel
for the Beethoven frieze,
1902

acknowledges the existence of a Far Eastern 'stimulus', but this has yet to be traced in detail.

A considerable body of Klimt's work, about half of the whole, relies on traditional spatial depth, tonal modelling and illustrative motifs: this is, literally, nineteenth-century art. Quality aside, it belongs to the tradition of Hans Makart – that monarch of a shallow bourgeois taste – relieved by an occasional touch of Whistler. The cartoon for *Medicine* [217] reveals an optically and intellectually impenetrable chaos of ideas and rounded forms. Then comes the year 1900, and the exhibition of Japanese art from the Adolph Fischer collection; and from that moment on, square and strip forms become the rule. Stylization, linear simplification, ornamented planes, off-centre compositions – all the paraphernalia of an extreme formalism – manifest themselves in a relationship of tension with 'a never quite abandoned tie to naturalism' (Novotny and Dobai, *Klimt*, 36).

Early in the new century, Toorop (through a Vienna exhibition and a special number of *Ver Sacrum*), and other 'Symbolists' of a *japonisant* cast, lured Klimt in the direction of distanced allegorical form and the linking of form and idea. *The Hostile Forces,* painted for the Beethoven Frieze in 1902 [219], is intended as an allegorical evocation of the meaning of the Ninth Symphony. A bold endeavour that was never followed up; the *Gesamtkunstwerk* was to remain a dream.

It was only with Klimt's visit to the Ravenna mosaics, in 1903, that a new realm opened before him and he found the way to the magical use of gold and ornament that he was to make his own. Ravenna was not a random or an entirely instinctive

choice. In 1886, the French archaeologist Gaston Diehl, inspired by the new love of archaic form, had turned his attention to the forgotten treasures of Italy's eastern coastal marshes. In Vienna itself, Franz Wickhoff, a friend and courageous advocate of Klimt, and an admirer of Japanese art, defended the despised works of Late Antiquity in his book *Wiener Genesis* (1895); and it was also in the Austrian capital that Richard Muther, an able journalist and art historian with a good nose for topical issues, announced in an essay on Ravenna:

Antiquity in its Christian epoch still possessed the power of producing a whole new spatial art, and finding a classically perfect solution to entirely new problems of interior decoration. The mosaics in S. Apollinare Nuovo contain perhaps the greatest achievement of decorative art of all time ... What the modern Pointillists have found after laborious searching – the art of creating brilliance and plastic effect at a distance by juxtaposing flecks of unmixed colour – is something that the age of Late Antiquity took for granted. (*Studien und Kritiken*, Vienna 1901, vol. 2, 181–2.)

Can Klimt have been in any doubt, after reading such words, where to turn for release from his symbol-laden impasse?

Then began the period of the 'golden' pictures, introduced in 1905 by a new monumental commission more than fifteen metres (fifty feet) long; this was to be his last. It was the decoration of a dining room in the Palais Stoclet in Brussels. The work was executed in ceramic, by the Wiener Werkstätte, only in 1909. Nothing short of the creation of a new decorative style can explain the gap of four years between commission and completion of the cartoon. Too few preparatory sketches have survived to follow the development of the design, with its great *Tree of Life* [220]. But it is clear from biographical evidence what was in his mind during the period in which the work crystallized.

The commission dates from 1905. On 23 February 1906, Klimt bought a set of Bing's *Le Japon Artistique* from the Artaria bookshop in Vienna. Then he travelled to Brussels, where he had the opportunity to inspect and study Stoclet's Japanese collection, before travelling on to London to look at Whistler's *Peacock Room*. On 16 November 1906, he subscribed to a portfolio of Japanese erotica published privately by Piper in Munich: thirty-six woodcuts by Moronobu, Harunobu and Utamaro.

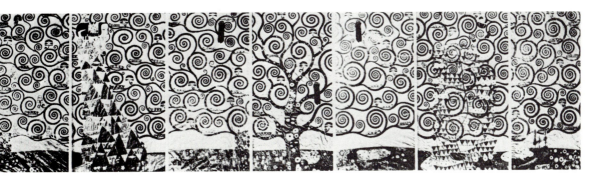

220 Gustav Klimt. *Tree of Life* with *Expectation*, cartoon for the Stoclet Frieze, 1905–9

Egon Schiele tells of a visit to Klimt on which he saw Japanese woodcuts and two large Chinese pictures close together in the studio; though this was not until 1911, when Klimt had moved to a new studio in Hietzing. Siegfried Wichmann (exhibition catalogue *Weltkulturen und moderne Kunst,* Munich 1972, 280) tells us that, after Kiyonaga, the best-represented artists in Klimt's collection were the latecomers Kuniyoshi and Kunisada, and stresses the importance of Japanese textile stencils, with their fabulous interpenetration of large and small-scale patterns. The magazine *Ver Sacrum,* edited by Klimt himself, had illustrated these on numerous occasions even before 1903, and the originals were in the Museum für angewandte Kunst in Vienna. The constant references to individual Egyptian or Minoan motifs need to be qualified by pointing to the overwhelmingly 'Japanese' climate of this phase in his life. Not a new discovery, for him: only the further unfurling of a wave; but its effect was now more intensive and more decisive than before. It now led him to his supreme individual achievements.

Unlike the Beethoven Frieze, with its basically figurative invention, the design of *The Tree of Life* [220] was approached from the decorative side. What Klimt did was to take an earlier image, drawn from Nature but rhythmically organized, *The Golden Apple Tree* (Novotny and Dobai, *Klimt,* plate 44), redraw it with a stricter form of stylization, and fit it into the surface of the wall as a spiral pattern in gold. The two figure groups nevertheless appear to stand out in relief, because they belong to a different combination of pattern and colour: ovals, squares, rectangles in black, grey, green, silver and gold on a pink ground. The dynamic contrast of colours and ornamental systems gives rise to an effect of advancing and retreating forms: an 'ornamental' space, held in suspense, that cannot be interpreted in terms of rational, finite central perspective. Siegfried Wichmann has rightly traced its origin to the patterning on Japanese kimonos.

Klimt turns this into a monumental mural image that combines reminiscences both of Ravenna and of Japanese scroll paintings. His invention consists in the genius with which he combines disparate elements. The colour woodcuts give him the idea of arranging the whole frieze rhythmically, like an altarpiece, in seven panels, each autonomous and at the same time leading into the next, just as the Japanese combine three, five or more prints into a whole. This adds weight and firmness to a space that remains in suspense. And this method of linking space and surface solves the central problem: to endow a specific theme with spatial unity through a combination of abstract and representational forms, and to bind it together harmoniously in form and colour. The crux is the transition between ornament and the organic form of the face and head; and here he once more takes his lead from the Japanese – as is seen in Kunisada's *The Actor Onoe Tamizō* [221], in which the mask is inlaid into the costume like the face of an icon. Overall, however, the hieratic atmosphere of *The Tree of Life* recalls the early Japanese masters rather than the late ones. Klimt knew them all.

His ability to pull out all these stops at once, which might have made him into a characterless and merely derivative artist, actually gave him all the instrumentation he needed to perfect his symphonic music in every sonority *between* grandiloquence

221
Utagawa Kunisada,
The Actor Onoe Tamizō,
c. 1815

and playfulness, without ever falling into either extreme. His idiosyncratic gift of combining ornamentalism with space, combined with the montage-like animation of abstract forms through representational ones, is probably his greatest single contribution to the art of monumental mural decoration. There is hardly another artist who owes his self-realization to Japanese art as Klimt does; for without this particular note Klimt would not be Klimt.

He founded no school. The wind was blowing the other way. His two 'successors', Oskar Kokoschka and Egon Schiele, were still under the decorative spell in 1908 and 1909, Kokoschka with his fan watercolours and Schiele with his postcard designs for the Wiener Werkstätte; but from that point onward their way led towards Expressionism, with its emphasis on convulsive movement and spatial depth.

The end of the Japanese influence appeared to be in sight; but this was not entirely so. From the subjective viewpoint of the creative artist, Kokoschka worked out a new interpretation of his own: no dependence on his predecessors, but a new and highly original insight into the lessons of Japan. Half a century later, Ludwig Goldscheider asked him whether in his early career he had not been led away from spatial depth by the influence of Klimt and of Japanese prints, 'which are two-dimensional':

That's not quite true. Japanese woodcuts do contain space, though expressed by uniform colour surfaces, achieving depth like stage flats; and there's space in Klimt's drawings and paintings too, except when he becomes completely decorative, and there he holds no interest for me. What I did learn from the Japanese, by the way, is something altogether different from arrangements in a plane or good taste in colour. The French pinched that from them. What I learned from them is rapid and precise observation of movement. The Japanese have the sharpest eyes in the whole history of painting. Every horse in their pictures jumps properly; every butterfly settles correctly on its petal;

every wood-cutter swings his adze as he should; indeed, every movement of man and beast is accurately reproduced. Movement! But movement exists only in space, in three-dimensional space. That's what I learned from the Japanese. (Ludwig Goldscheider, *Kokoschka*, London 1963, 7)

Klimt's role was a different one: it remained bound to the traditions of the great empire of Austria-Hungary, out of which he grew, and which he was able to transcend by finding an access to Modernism. Even though protest was not exactly his stock in trade, he went his own way and evolved a pictorial idiom which was bound to that of the avant-garde of his own day, but which remains unmistakable and alone: an end rather than a beginning.

There may be many reasons why Klimt towers above his Munich and Berlin contemporaries, but there is no reason to overlook the Viennese background: the art collections, including that of Japanese art; the critical support of Franz Wickhoff, Hermann Bahr and Ludwig Hevesi; the critique of contemporary civilization formulated by Arthur Schnitzler and Sigmund Freud; and, not least, the existence of a liberal and pleasure-loving bourgeoisie.

Switzerland

Klimt's Swiss friend, Ferdinand Hodler (1853–1958), is another artist whose work hardly seems to suggest a Japanese revelation, whether in its early tonal naturalism or in its later stylization. Hodler derived his 'tectonic' concerns and monumental aspirations from the Italian Primitives, from Hans von Marées, and from Puvis de Chavannes: so the critics say, and they are right. But it would be an injustice to Japonisme to reduce it to graceful ornamentalism, intriguing insight, elegant curvature, the habit of seeing in patterns, and the like. It has other, almost unlimited dimensions, which strong innovators have discovered and seized upon at moments of crisis.

222
Ferdinand Hodler.
Eurhythmy, 1895

223
Katsukawa Shunshō.
*Five Actors in the
Kabuki Play 'Karigane'*
1780

The turning-point in Hodler's art came, as is generally acknowledged in 1890, with his painting *Night* (Kunstmuseum, Bern) and his stay in Paris. The hidden parallelisms in Seurat's works, and the repetitions in the linear constructions of the Nabis, cannot have escaped his notice. But, aside from this indirect connection, he surely also became directly acquainted with Japanese prints themselves: at Bing's gallery, in the pages of Bing's publication, *Le Japon Artistique*, or even in Bing's great Japanese exhibition. When we compare his *Eurhythmy* of 1895 [222] with Shunshō's *Five Actors in the Kabuki Play 'Karigane'* [223], the affinity is striking. Shallow, bare strips of space, seen slightly from above, contain five silhouettes, marked by their costumes. Five verticals almost reach the upper edge of the image. There is a thinner figure in the centre, flanked by two who are fatter, or who at least take up a larger area, and a slimmer one at each end. The rhythmic relationship between empty and filled area is strictly controlled in both cases; nothing is left to chance.

The comparison ends there. The Swiss artist leads all his aged men in one direction, leftward out of the picture; his central figure, with both hands visible, stresses the drama of impending death; his faces, with their almost caricatural features, are subordinated to the idea. None of this has anything to do with the floated, ornamental, latticed, inwardly stressed and simultaneously liberated existence that the Japanese artist presents. The expression is totally different. And it may well be Hodler's greatest achievement to have realized that it was no longer enough to adapt to individual Japanese elements, or to feel a kinship with the Oriental way of life: what was needed was a new revelation of rhythmic order, in inner vision and multiplicity, that would banish naturalism.

Since the Renaissance, Western art had found a succession of heroic and monumental solutions to this recurrent problem; but it was one that the nineteenth century had failed to meet. To tackle it in a modern idiom was a challenge that Hodler could not resist. He circled around it again and again, in *The Disappointed* (1892, Kunstmuseum, Bern), *The Elect* (1893–4, Kunstmuseum, Bern), *Day* (1904–5, Kunsthaus, Zürich), *The Life-Weary* (1892, Neue Staatsgalerie, Munich), *Feeling* (1902–3, private collection), *Youth Admired by Women* (1903, Kunsthaus, Zürich) and other works, in which he developed his own design principle, that of parallelism. As he himself admitted:

In many of my paintings I have chosen four or five figures to express one and the same emotion, because I know that the repetition of one and the same thing deepens the impression. I tend to choose five because the odd number enhances the organization of a painting and creates a natural centre into which I can concentrate the expression of all five figures ... Clear forms, the simplest presentation, repetition of the motif. (Interview with Else Spiegel, *Wiener Feuilletons und Notizen-Correspondenz*, 21 January 1904)

Even if Hodler's heavy-handed rhetorical idealism sometimes stands in his way, and impairs his posthumous reputation, it is not his highly original use of Japonisme stylistic principles that is to blame: on the contrary, this is what makes it possible for him to bring idea and form closer together.

In the far less well-known works of the last decade of Hodler's life, he turned from

224
Ferdinand Hodler.
*Eiger, Mönch and
Jungfrau in Moonlight,*
1908

his high-flown allegories to landscapes of his native Switzerland. In their time, the Alps and the Alpine lakes have given us some stunning picture-postcards; but they have seldom found their way into art. It took Hodler to interpret the personality of individual peaks in terms of form and colour. From Cézanne's Montagne Sainte-Victoire [70] and Hiroshige's Fujiyama he turned to the outline of *The Mönch* (Schmidheny Collection, Heerburg); and with *Eiger, Mönch and Jungfrau in Moonlight,* of 1908 [224], he achieved an astonishingly stable pictorial structure. Japanese in its almost square format, in the economy of colour, in the decorative blend of ornamental and object-related forms, in the surface coherence of its spatial recession, in the essential simplification through the pattern-ground principle, the painting avoids the pitfalls of decorative craft design. The result is a magnificent synthesis, a new chapter for European landscape painting as a whole, magical and cosmic in its intensity – and unimaginable without the Japanese devices that underlie it. Even the gentle transitions of colour, *à la* Hiroshige, form part of this.

Still in the Switzerland of the 1900s, Augusto Giacometti (1877–1947) deserves mention for his painting *Night*, of 1903 [225]. Everything congregates on the surface: the frontal body, the head in pure profile, the arm and hand gestures, the fluttering ribbons. The high format, the asymmetrical position, the singing curves and counter-curves in their abstract interplay, the restriction of the palette to two tones, the textile ornament: all this points to Japonisme, seen through Art Nouveau spectacles. Giacometti himself would probably have laughed at such a suggestion, or just shaken his head. As one of those who had made the pilgrimage to Paris in the 1890s, the crucial period of Japonisme, he would have taken all this for granted and it would have seemed less noteworthy than his receptivity to other 'Primitive' influences, those of Grasset, Puvis de Chavannes and Fra Angelico.

Giacometti's interest was in the 'life of colour in itself', and – quite independently – in form. At the end of the First World War he found his way to abstract formal creations. Had he not been cramped by the narrow Swiss environment, who knows

225 Augusto Giacometti.
Night, 1903

how far this creator of extraordinary stained-glass windows might have progressed?
One is reminded of Thorn-Prikker.

Edvard Munch (1863–1944)

The role of Munch in modern art, his struggle to clarify the relationship between
meaning and form, his creation of symbolic forms derived from the spirit of the great
French artists of the turn of the century: all this belongs to art history and need not
be discussed here. It must be borne in mind that the German Romantics – to go
back no further – set out to give outer form to deep-seated feelings, and that they
mostly failed, because they got no further than intellectual allegory. The result was
stillborn. It was only with the collapse of illusionism that the wind changed, and that
wind blew from France. Late nineteenth-century artists made the pilgrimage there in
such numbers because they hoped to make the new language of signs their own and
turn it to their own 'spiritual' ends.

Munch was one artist who was constantly drawn to Paris throughout his years of
study and apprenticeship. After a short visit in 1885, he returned there to study in
1889; in the following year, after his father's death, he was back in France, and a year
later he was there again. The great success of his Berlin exhibition in 1892 led him
to settle there; but the longing for Paris had not left him. In every one of the following
four years, and on many later occasions, he divided his time between France and his

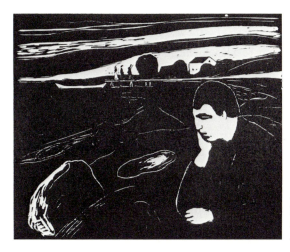

226
Edvard Munch.
*Evening on the Shore –
Melancholy,* 1901

native Norway. Each visit was like a further stage in the process of fitting his own tragic primal experience into the new forms: not setting it up in opposition to them.

The ideological and philosophical aspect of this process need not be considered here; our concern is with the underlying imaginative form, the grammar of vision. From one year to the next we can watch the crystallization of his personal style, especially in graphic art, as it loosened and clenched into a new density. Vallotton, Gauguin, Denis, Lautrec, Bonnard – remote though they were from his emotional and expressive concerns – came to his assistance here.

Does Munch's work relate to the Japanese source which is behind all these artists, and which set the whole modern movement in train? For lack of biographical evidence and of specific borrowings, we have nothing to go on but the style of the works themselves, especially the lithographs and woodcuts produced between 1896 and 1908, the period of his full maturity. Allegorical interpretations can be left out of account, just so long as we do not overlook the invariably concentrated formulation: for it is from this and from this alone that the symbolic content derives. This symbolism without symbols is the crucial factor: what leads him into an alternative reality is not the discovery of occult signs but the construction of a pictorial world. In discovering, varying and extending this fundamental layer, the Japanese certainly helped him with a process of what might be called analysis or dissection.

Evening on the Shore – Melancholy [226], a colour woodcut dating from 1901, derives its life from analysis into form and colour, analysis into filled and empty areas, into different patterns, colour zones, directional strokes. Although a similar tendency appeared in Gauguin (at about the same time, and certainly unbeknown to Munch); and although the tendency towards abstraction, primitive simplification and flatness was in the air, this pure note strongly suggests a return to the Japanese source. In itself, the detail of the stylized eyes and mouth recalls the shorthand signs that appear in the work of Sharaku or of Katsukawa Shunko. Nor must we be led astray by the totally dissimilar expressive content. How could so alert an artist, in a quest for the

hidden depths, have avoided the effects of a current that underlies the whole modern movement? Why was he drawn to the great metropolitan centres, over and over again, if not because he was constantly impelled to transform his inner life into something outside himself, and to intensify his own powers through comparison with others?

Die Brücke

Until recently, the German artists of the Dresden group, *Die Brücke* – Fritz Bleyl, Erich Heckel, Ernst Ludwig Kirchner, Max Pechstein and Karl Schmidt-Rottluff – were considered to be Munch's heirs. The documentary evidence shows, however, that they became aware of him only after their own individuality had fully evolved. Their paintings overflow with colour; their space is full of wave motion; the interstices, so vital to Munch, are of no importance to them. In Dresden, they did not visit Seidlitz's newly formed collection of Japanese woodcuts but went to the Museum für Völkerkunde to see African sculpture and relish its anatomical freedom. Even so, the Far East found their way into their work through the back door, not in painting but in the – to them – equally important field of printmaking, in which they produced work of great distinction.

In their revolt against the neatly pressed bourgeois world, there were, in Georg Schmidt's lapidary formulation, three goals: pure colour, pure line, pure surface. With pure colour, they were able to surrender to their own untrammelled vitality and hurl onto the canvas 'naked' colour chords. Rhythmic linear construction, on the other hand, needed more craftsmanship and more reflection. It became imperative to find some forebears – if only to depart from – and art-historical diligence has recently turned up a Japanese source. In an article, Günter Krüger brings to light the contribution of Bleyl, the forgotten founder member of the group ('Fritz Bleyl, Beiträge zum Werden und Zusammenschluss der Künstlergruppe *Brücke*', *Brücke-Archiv*, no. 2/3, Brücke Museum, Berlin 1968–9), and defines his main achievement: the discovery and reinterpretation of Japanese woodcuts.

This process may be traced from as early as 1904, shortly before *Die Brücke* came into being. In 1907, not long before he left the group to work in education, Bleyl did an ink drawing, *Woman on Meadow Path* [227]. Its closeness to Hokusai, in the calligraphic dot-and-dash system, the relationship between flat areas and space, the economy of means, are instantly apparent. Not content with this, Bleyl's biographer has looked through his subject's papers and found the exact sources: Perzynski's little illustrated book on Japanese woodcuts, together with specific illustrations from *Ver Sacrum* and *Die Insel*. Bleyl's artistic mentors ranged from Masanobu to Hokusai, and what he took from them was sometimes relief, sometimes powerful contrast, sometimes decorative stylization or surface vibrancy.

Bleyl's 'transpositions' of Japanese sources were echoed in the works of his colleagues in *Die Brücke*. His departure coincided with the influence of Klimt's drawing and the beginning of the group's true maturity. They all acted on impulse, not on preconceived programmes, and so it is no simple matter to disentangle the Japanese

227
Fritz Bleyl.
Woman on Meadow Path,
1907

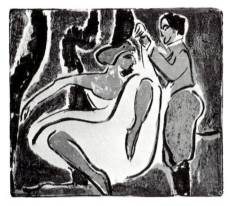

228 Ernst Ludwig Kirchner. *Russian Dancers*, 1907

229 Karl Schmidt-Rottluff. *Houses on the Mountainside*, 1910

element from the subsequent encounter with the art of Gauguin, Munch and Vallotton. But it is there all right, however much it becomes concealed as time goes on.

As late as 1924, Kirchner acquired Friedrich Succo's book *Toyokuni und seine Zeit*; and his hieroglyphic simplifications of movements and gestures (as in *Russian Dancers*, a colour lithograph of 1907 [228], with its play of curves and colour contrasts) are reminiscent of the same Toyokuni – if only one is prepared to look beneath the Japanese skin and take notice of the structure alone (right-hand wing of the triptych, *Girls in the Bath House*, illustrated in Sado Kikuchi, *Utagawa Toyokuni*, Tokyo 1957, plate 37).

Very different is *Houses on the Mountainside*, by Karl Schmidt-Rottluff, a woodcut of 1910 [229]. At the outermost limit of representational art, this work once more points to the potential value of Japanese inspiration; it can open so many doors – just so long as one takes no account of content or of the artist's temperament – because it restricts itself to means of representation, opening new paths to appearance. If it were not for the strips and ribbons of Eastern calligraphy, the almost abstract music of

light elements against dark, nothing could have brought this very ordinary landscape so close to essential form, to the *Gestalt*. A gateway opens upon a world of the mind.

The *Brücke* group chose to stay in this world, in harmony with Nature. In an age of social ferment and constantly worsening crisis, they were perhaps the last who could still cling to the profession of faith, 'Back to nature', and reach out their hands to all those kindred spirits who were still regarded as barbarians: not the Japanese alone but also the Etruscans, the Gypsies, the Egyptians, the South Sea islanders. Scanning the horizon with new instruments, over and over again, they espied one Primitivism after another and took it on board.

Others were to cross the great threshold and behold another world.

17. France after 1900

Monet's waterlilies

All the configurations of East Asian art retain a curious ability to communicate with a 'sphere' which encompasses them all, and to keep themselves open, mobile and in suspense . . . Framelessness . . . infinite space . . . A suggestion of the way in which the forms might be completed and extended in the open space of the undepicted . . . absence of perspective . . . weightlessness, transparency . . . space–time continuum . . . within a strictly controlled design, the appearance of lightness and grace . . . (Dietrich Seckel, *Einführung in die Kunst Ostasiens*, Munich 1960, 370.)

Point by point, this reads like an account of *Waterlilies* [V, VI] the crowning works of Monet's more than sixty years of work as an artist. More than any other work considered here, this series grows away from its Western context and towards that of East Asian art. This is not a matter of details, of motifs, or even of the grammar and syntax of a new language of form, but, in the true sense, of a rare *vision*. The eternal in the ephemeral world of times of day and times of year, the transformed 'Japanese' landscape of pools and floating blooms, as a symbol of the cosmos; a bluish, horizonless sheet of water, with its reflections of light: this is the 'sphere' in which infinite depth manifests itself as painted surface. This is a 'Frieze of Life' that does not move along, as with Hodler or Munch, in a tragic sense of anticipation, towards a single goal: it lingers and allows itself to be carried round, full circle, gently pulsating, like a musical theme with variations.

As we have seen (in Chapter 5), Monet succeeded, in the *Grainstacks*, *Poplars* and *Cathedral* series, in transcending the natural and constructing a picture out of an impression. After the turn of the century, the sixty-year-old artist prepared for the great synthesis. The completion of the mural cycle for the Orangerie (eight monumental horizontal strips consisting of 19 canvases, 1.95 m. / 77 in. high and a total of 91 m. / 300 ft long) marked the end of a quarter-century of struggle. Is this Expressionism or Impressionism? Does it not cling to the reality of the seen phenomenon? Does it not simultaneously express the poetic, not to say religious, aura of life, as it manifests itself only in moments of profound emotion? It is the surprising achievement of the artistic culture of France, and of that culture alone, that there is no Either/Or here, no conflict between inner and outer truths. It still remains possible to reconcile the two.

Claude Roger-Marx, in a 'Defence of the *Waterlilies*' that remains apposite to this day, gives an excellent account of the work:

Eight sheets of water, unbounded by any horizon line. But these waters are not to be seen simply as an element; they act like a mirror or a glass prism: their function is to support the heavens.

To describe this liquid poetry, to which Monet returns again and again, these tapestries in which the brushstroke has the suppleness of a wave and the suddenness of a rocket, it would be necessary to find a term like *verdure* ... Such is the magic of the theme that all is elusive, lustrous, slippery ...

How blinded by prejudice one would need to be, not to recognize the power of an inventor who ... leaves nothing, absolutely nothing, to chance; who has extracted, from so many transient days and seasons, these instants of eternity? (*Avant la destruction d'un monde*, Paris 1947, 44ff.)

Nearly forty years previously, his father, Roger Marx, writing of an exhibition of the very first waterlily paintings in 1909, before the main project was started, had not only given an account of these uncomprehended paintings *avant la lettre* but had induced the artist to make one of his rare explanatory statements:

These paintings ... came into being through the aid of solitude and silence, of an ardent, all-excluding concentration that borders on hypnosis ... I set up my easel facing the pool that refreshes and beautifies my garden. It is barely two hundred metres round, but its image evoked in you the idea of infinity. As in a microcosm, you saw the existence of the elements and the instability of the universe, which transforms itself, every minute, before our eyes ...

If you insist on forcing me into an affiliation with anyone else for the good of the cause, then compare me with the old Japanese masters; their exquisite taste has always delighted me, and I like the suggestive quality of their aesthetic, which evokes presence by a shadow and the whole by a part ... The vague and the indeterminate are expressive resources that have a *raison d'être* and qualities of their own; through them, the sensation is prolonged, and they form the symbol of continuity.

Monet went on to mention the idea that was to become a reality in the early 1920s:

I was once tempted to decorate a large room with this theme of the waterlilies; transferred to the walls, imposing its unity on all the surfaces, it would have created the illusion of an infinite whole, of a wave without a horizon or a shore; there, nerves overtaxed by work might have found repose, following the restful example of those still waters, and that room would have afforded its occupier a refuge where he could meditate in peace in the midst of a flower-filled aquarium ... I have been working for half a century, and soon I shall be sixty-nine years old; but my sensibility, far from waning, has become more acute with age. (Roger Marx, *Maîtres d'hier et d'aujourd'hui*, Paris 1914, 291ff.)

At eighty, when the plans for the great work in the Orangerie finally took shape, Monet's experience had grown even more. At the same time, a second factor was involved, one that has too often been overlooked in discussions of the birth of works of art: that of an admirably nourished imagination. From the turn of the century onwards, Monet painted many of his London paintings from memory, often several years after seeing the motif. The excellent documentation supplied by William C. Seitz, in his *Claude Monet, Seasons and Moments* (Garden City 1960), reveals that the critical moment of the completion of the monumental *Waterlilies*, in 1922, coincided fairly exactly with a severe eye condition, a double cataract, which made Monet almost blind. The cataract thus served the purpose of enabling him to withdraw even further from the mere act of looking and to give free rein to his imagination.

No one was more surprised than Monet himself when, after the operation, he beheld the transmogrified colours of this 'mysterious' decorative scheme, the unprecedented

richness of colour and texture, the unity of the whole. 'Wild landscapes of a febrile appearance, like hallucinations in impossible combinations of colour, all red, or all blue, but magnificent to behold', noted a visitor. With justice, Seitz likens these visions of the 'blind' Monet to the last quartets of the 'deaf' Beethoven. Long and rich observation, over many decades, promotes inward recollection and the rarest of syntheses.

Monet's specific points of departure can be identified from the contents of his own Japanese collection: Hiroshige's landscapes, of which he owned a number of examples: Hokusai's and Utagawa Toyohiro's forceful renderings of animals and plants; and the vibrant curves and rhythms of thirty-three of Utamaro's images of women and girls.

The third wave of Japonisme, which we have here to consider, was nourished by the six great exhibitions held at the Musée National des Arts Décoratifs, on the initiative of Raymond Koechlin, between 1909 and 1914. By that time, most of the original major collections had been dispersed abroad, and a new generation could barely remember that there had been a heyday of Japonisme in the early 1890s. Better prepared visually than their predecessors, the young did not come to marvel at the exoticism of it all but to receive a deeper impression altogether, a confirmation of the 'New Vision' that had already imposed itself in several areas of Modernism and had vanquished the illusionism of former times.

In the wake of Gauguin, Van Gogh, Seurat, the Divisionists, the Nabis, yet more versions of 'Primitivism' had reached the West, from Islamic and other portions of world art. It is characteristic of this late phase that all these influences and predilections tended to mingle, so that an artist's 'archaic' use of form could be regarded alternatively as a reference to the Italian Primitives, to folk art, and to the Far East. With the mingling of genres, naturally, the purity of derivations was impaired. It is consequently not surprising that this new wave of Japonisme involved not only the aged Monet but the Fauves, and Delaunay with his 'Orphism'. Once again, the reinterpreted example of Japan operated not to drive the styles apart but to hold them together.

Henri Matisse

For all the deep-rooted differences between the late Monet and the early Henri Matisse – who was working at exactly the same time – they had one thing in common: they operated on the same unconscious level between seeing and remembering, between appearance and formation, between the object and the vision, between the emotion and the sign. Both operated between the poles of impression and abstraction; both underplayed the note of expressiveness.

In the plentiful literature on Matisse, the outstanding work is that of Alfred H. Barr Jr., *Henri Matisse, his Art and his Public* (New York 1951, London 1975). With the aid of seven of the questionnaires so beloved of American researchers, Barr assembled the fullest imaginable factual documentation, although no one had the idea of asking the subject – or any of those around him – about the Japanese influence. Barr himself appears to have considered this insignificant: in his view, by comparison

with Ingres, Giotto, Duccio, Piero della Francesca and Classical Greece, any other stylistic affinities on Matisse's part could only have been superficial. This view is reflected in his remark: 'Japanese prints greatly influenced such artists as Degas, Whistler, Van Gogh and Bonnard, but their art remains essentially European' (*Henri Matisse*, 102).

This 'but' is unacceptable to anyone who knows the situation better. For influence does not imply total surrender to something outside oneself: it means the enhancement of one's own potential through the resources offered by a kindred spirit; it also implies assistance in finding oneself. In Pierre Francastel's apt formulation: 'What counts is not the elements but the process of integration, and one has only to pose the problem to see that modern art is not based, in essence, either on Japanese or Black art. What the Impressionists took from Japonisme they simply used to confirm direct observations of their own' (*Peinture et société*, Lyon 1951, 160).

And that was how it was with Matisse. How else could one explain his lively, and frequently overlooked, interest in Japan, which was so intense that in a time of great poverty he insisted on having Japanese prints in his possession and seeing them every day? Marguerite Duthuit, the painter's daughter, told me in a letter dated 19 December 1963:

In about 1903, my father bought some ordinary Japanese woodcuts, not always by the greatest artists but all with a harmonious freshness and liveliness. These were sold in the Rue de Seine: they were left in portfolios outside the shops, so they cannot have been considered particularly valuable. These little pictures were pinned to our walls, and there they faded and eventually vanished; they left a trace only in the memories of those who saw them and who chose to draw inspiration from them. From 1911 until 1914, again, my father fairly often saw valuable Japanese and Chinese collections at the dealer Charles Vignier's, but he never bought anything there and, to judge by his work, I don't really think he was influenced by them. Naturally, he visited all the museums frequently, and there were times when he went particularly often to the Guimet and the Cernuschi.

Vignier was a co-organizer of the big exhibitions that gave an impetus to this third Japonisme; in 1914 Matisse made no less than six etchings of the dealer's wife and daughter.

The most penetrating analysis of Matisse's Japonisme is that made in 1933 by Albert C. Barnes, who was also the owner of probably the greatest collection of his work, in Merion, Pennsylvania. Under the general heading of 'creative interpretation of tradition', Barnes displays sympathy, understanding and a degree of schoolmasterly precision in showing, from the works produced down to 1932, how 'the principal and most direct Oriental influence upon Matisse has been that of Japanese prints'. In Appendix 2, I have quoted a few pages from his *Matisse and the Japanese tradition*; he does not try to trace related motifs here and there, but to use basic artistic concepts, such as drawing, colour, modelling, line, light, space and composition, in order to show concretely what the artist owes to his Oriental sources and how he transforms them in order to develop his own essentially decorative art.

Two comparative illustrations from Barnes's book are reproduced here [230, 231];

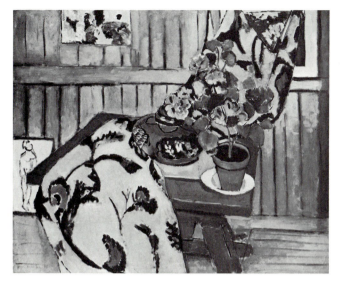

230 Henri Matisse. *Still-life with Geranium*, 1910 231 Utagawa Toyokuni. *Actor*

but, convincing though they are, these cannot possibly do justice to the complex process by which Matisse absorbed the Japanese influence. The spark of inspiration came from the very latest and cheapest prints, and from them Matisse developed a form of representation distinct from all previous forms of Japonisme. What he found there was no longer a set of specific motifs or compositional devices but the capacity to organize a surface through a rhythmic construction of pure colour, and so to present a vibrant space. In his own words: 'To render the connection, the relationship between objects through colour; colour as inner expression and not as description' (Matisse, *Ecrits et propos sur l'art*, Paris 1972, 132).

Matisse was quite capable of starting work on a painting such as *Le bonheur de vivre* (*The Happiness of Being Alive*), of 1905–6 (Barnes Foundation, Merion, Pa.), with a study that looked more like an abstract configuration or a carpet, in which he established the pictorial and chromatic accents before the 'theme' as such was determined (reproduced in Barnes, *Matisse*, 240). This early work makes it clear that he had left the old scenic space, and the space of the Impressionists, behind him in order to move forward to an emotional conception of space. There is no longer an objectively and geometrically defined 'place' but a field of tensions in which countless forces are moving: colours, patterns, arabesques, which are then precipitated as landscapes, still-lifes or portraits.

Then the most characteristic detail (Francastel), the purposeful fragment, takes the lead and conduces to a strict structuring; it structures reality with inner necessity. See how, in *Still-life with Geranium*, of 1910 [230], the space is built up from bottom to top, in the yellowish strip of floor with its horizontal marking underneath (not in front of) the vertically articulated wall. Against this, 'islands' of colour are defined: the

cloth with its bluish pattern, the three segments of pink table, the white plate, the violet flower-pot, the green leaves and pink flowers, the Japanese paintings on the wall: all reduced to ornamental fragments, whose organization, loosening and tightening, leads the eye on.

The viewer conditioned by photography may well find this painting difficult to read, until and unless he concentrates on the essence and the movement of the colours and patterns as such. This is something that hardly ever happens in the work of the Japanese artists; but it is entirely in their spirit. For in Utamaro and other 'classical' masters there is already a double-layered quality; first the depicted scene, and then – beneath it, as it were – the play of abstract colours and curves. This same delight in purely rhythmical structures is even more evident in the work of the Japanese 'primitives', although in their case colour is often absent.

The use of a number of disparate Japanese elements naturally did nothing to impair Matisse's individuality, and in no way placed him in danger of becoming – as Barr seems to have feared – a mere imitator of the Japanese. On the contrary: with his space lightly constructed with planar elements and his rhythmical construction of pure colour, Matisse's place was in the very forefront of the European avant-garde, conquering a new quality for planar structure. Modernism was approaching the end of its long quest.

It would be interesting to trace in detail how Matisse attached new inspirations to the basic Japanese inspiration at every turn – especially that of Islamic art, but also those of Archaic Greek vase-paintings, of Gauguin, and of Cézanne – and how at the end of his sixty-year career, in the great *papiers coupés* and in the murals at Vence, he attained a yet more radical fragmentation of arabesque, form and space. With his new, 'mobile', assembled space, Matisse leads us into a new realm. This is, according to Francastel, the model according to which our entire industrial society moves: an inhabited space full of functions, forces and energies – full of autonomous fragments – which supersedes the rigidity of the former scenic space.

Lastly, one more comparative motif: Matisse's *Apples*, a monotype of 1914 [232], and *Lucky Pearls*, a colour print with gold and silver made in 1836 by Suzuki Nanrei [233]. This surely shows how little danger there was that Matisse would turn into a Japanese.

Albert Marquet (1875–1947)

'Let me put it this way: when I see Hokusai I think of our own Marquet – and vice versa. By this I do not mean imitation of Hokusai but similarity.' Thus Matisse (*Ecrits et propos*, 159) defines the basis of his friend's work. For the work of Albert Marquet demands to be approached, not through his paintings and through debating whether the colourful Fauve paintings of his early period were later displaced or enriched by a grey tone-scale, or whether his well-known harbour and marine views change from place to place and from year to year, but by understanding how, over the decades,

232
Henri Matisse.
Apples, 1914

233
Suzuki Nanrei.
Lucky Pearls
(*Surimono*), 1836

the visual structure, the taking of each landscape, is underpinned by an organization based on *drawing*.

By contrast with Matisse, who starts out from colour and ends with drawing, in Marquet the linear arabesque is always the initial stimulus. Unfortunately, his output of ink drawings, which seems to have been vast, is neither accessible nor adequately published; but the few drawings that are known make it quite clear that Marquet sees, first and foremost, through Japanese eyes. The sketch *Handcart* [234] should be enough to convince anyone of this. Or the *Woman Walking into the Wind* [235], basically an arabesque with curves and living brushstrokes that grow thicker and thinner, leap across the paper, form merry little islands of black, or ring round islands of white. This is all decidedly Japanese, and would be unimaginable without the example of the Japanese india-ink sketches, and also of Hokusai.

If we then look at a comparable work by Hokusai himself, the *Gust of Wind* from

234
Albert Marquet.
Handcart, 1904

235 Albert Marquet. *Woman Walking into the Wind*, 1905

236 Katsushika Hokusai. *Gust of Wind*, right-hand side of a double leaf from *Manga*, 1829

the twelfth volume of *Manga* [236], then a gulf does open up. For all the simplification of his outline, the Japanese artist is much more varied, more minute and more realistic. An unprejudiced lay observer would probably consider Marquet's drawing more 'Japanese' than the Hokusais. And with some justification. With his predilection for 'primitive', sweeping simplification and his emphasis on the essential, Marquet comes closer than Hokusai to the early Japanese ink drawings. Our example, a work ascribed

237
Ascribed to Ashikaga Yoshimutsu.
The Poet Su Tung-po, 14th century

to Ashikaga Yoshimutsu, *The Poet Su Tung-po* [237], dates from the fourteenth century and is now in Tokyo (Akimoto collection); but in the 1900s there was certainly a work in a related style to be seen somewhere in Paris. As with Marquet, all depends on the flexible pressure of the brush, the relationship between dark and light segments, the magical transformation of the scene into an arabesque.

Here, therefore, at the end of nearly half a century of wide-ranging interest in the East, the wheel has come full circle. In order to capture on paper a girl he has seen buffeted by a high wind, a Parisian painter relies on a memory: a memory of a visual grammar that has its origin in Japan.

A work contemporaneous with Matisse's *Still-Life with Geranium* [230] is the *Interior with Yellow Door* [XVI] of Kees van Dongen (1897–1968), the only foreigner to join the Parisian Fauves. Before moving on, in the years before the First World War, to become the acclaimed portraitist of a 'decadent' society, Van Dongen here shows himself as an impulsive experimenter with liberated colour; space, expression and decorative quality are held in balance. And so the cycle is complete that runs from Ensor's 'reverie' [*Skeleton Looking at Chinoiseries*, 123] to conclude a quarter of a century later by opening the door to a new conception of form. Goncourt's prophecy had come true.

18. Closing strains

As the twentieth century moved into its second decade, the artistic atmosphere underwent a radical change, and not only in France. Japonisme, it would seem, had done its work. Photographic illusion had at last been vanquished, even in Salon painting. A variety of movements, in their own ways, had derived from Japan the capacity to transform the depicted world and its creatures into signs. The *Leitmotiv* in all this, for the artist, was the conquest or rediscovery of flatness, planar quality.

The movement that followed next, Cubism, pursued other objectives, under the influence of African sculpture: the projection of coloured volume onto the plane in order to tie the enduring properties of the objects into the space, and to create tactile archetypal forms. This shattering of figuration then led such artists as Delaunay, Kupka and Kandinsky beyond the abstracting process and into the creation of abstract, non-objective form.

In all this, no assistance from Japan was needed or desired. The new objectives of art clearly pointed into a completely different realm, with Kandinsky speaking in terms of 'an awakening, prophetic power' and 'the inner life of the picture' and calling for a 'language of the soul, springing from inner necessity' in which 'forms from the external world became superfluous for inward speech'. On the way to his goal, he acknowledged 'colours as living powers' (Kandinsky, *Über des Geistige in der Kunst*, Munich 1912, 9, 103, 104, 117). All this was a long way from Van de Velde's 'power of line'. Kandinsky's point of reference was a metaphysical one, and images of geishas and actors could not mean a lot to him.

Macke and Der Blaue Reiter

Even so, this was not a clean break with the past: only an attempt to separate a healthy tradition from one which had become contaminated. The celebrated *Almanach des Blauen Reiters*, edited by Kandinsky and Franz Marc, is known, among other things, for having discovered, or at least made accessible, a range of new 'Primitive' ancestors: old German woodcuts, children's drawings, folk art, Bavarian glass painting, Byzantine mosaics, *lubki* from Russia, African, Oceanic, Mexican and Alaskan sculptures, and El Greco, not forgetting Gauguin and Van Gogh. Japanese woodcuts, too, were enlisted as part of the prehistory of abstraction, although the seven examples shown in the *Almanach* are of very poor quality: all are either late reprints or European copies. This source was drying up, and from the first rank it had declined to the last.

Even so, Japanese art made its influence felt in the same circle for one last time in

the world of August Macke (1887–1914). The youngest member of *Der Blaue Reiter*, he was the polar opposite of the theoretician Kandinsky. By contrast with the Russian's pursuit of mysteries and wonders, his motive force was a joy in life that inspired him to an astonishing creativity. His chosen path did not lead from without to within: on the contrary, he had the gift of externalizing his own inner vitality in a rapid succession of works, in both oil and watercolour.

At the age of twenty, Macke was awakened by the experience of Paris, which emancipated him from the idol of his student days, Arnold Böcklin. He was drawn to the colour of reality, its sheer sensual magic, as he found it in Matisse and later in Delaunay, who 'started with the spatial Eiffel Tower while Kandinsky started off with gingerbread', as he told Marc in a letter (Gustav Vriesen, *August Macke*, Stuttgart 1957, 122, 123). Macke was endlessly fascinated by the world of Parisian painting, and went to Paris four times in five years. On his first visit, on Whit Monday, 1907, he wrote: 'It is hard to understand Manet, Monet, Whistler. But when one has experienced them it is like reaching the summit of a sunlit mountain. All is lightness, all is dancing' (ibid., 18).

He made an eager study of their formal repertoire, and found no difficulty in identifying the Japanese element that underlay it. At a dealer's, he fell in love with Hokusai's *Manga*, and his patron Bernhard Koehler, who was the uncle of his future wife, gave him all fifteen volumes as a present. These accompanied him for the rest of his short life and influenced him constantly, but in a sense subliminally: he wrote from Paris, on 25 July 1907: 'When you learn from the Japanese, there's no need to paint Japanese eyes on European faces. Aren't the Japanese miraculous!' (August Macke and Franz Marc, *Briefwechsel*, ed. Wolfgang Macke, Cologne 1964).

For all his love of colour, and of Cubist and Futurist experimentation, Macke's feeling for Japanese art, with its planar pictorial organization and arabesque-like abbreviation, never deserted him. A charcoal drawing, *Franz Marc's Cats*, of 1911 [238], shows how this governs his whole approach to the motif: stylization is not something to be subsequently imposed. This drawing casts another light on the crucial moment of suspense between abstraction within representation and pure abstract art: on one hand Macke, with Paris and its Japonisme, still clinging to the object; on the other the 'Asiatic' component of Kandinsky, with a radically new world of forms that could dispense, once and for all, with the *japonisant* imagination.

Between the two stands Franz Marc (1880–1916). His woodcut, *Tiger*, of 1912 [239], stands precisely on the borderline between object-related pictorial creation and abstract form. Here, the 'metamorphosis of the visible' (Rainer Maria Rilke) is taking place before our very eyes. Marc was attracted towards the abstract, for 'to the latter-day thinker, the abstract once more appears as the natural way of seeing, as the primary, intuitive vision' (*Hundert Aphorismen*, 1920). The curves and the black segments, pressed into the surface against the white ground, mingle with the recollection of ornamental bodily forms, as in the work of the early Japanese print-makers, Moronobu and others. Only, the tension is denser, more active; and the

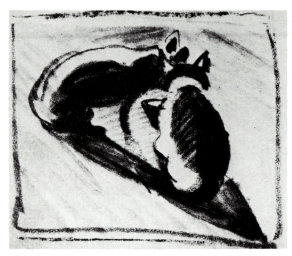

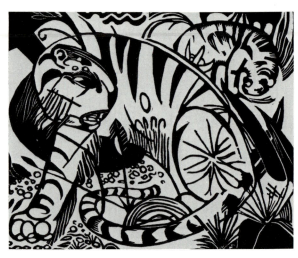

238 August Macke. *Franz Marc's Cats*, 1911 239 Franz Marc. *Tiger*, 1912

transformation goes in the opposite direction. This is the last stop before the seen world is abandoned, and with it the lessons of the Japanese woodcut.

From Douanier Rousseau to Picasso

It comes as a surprise, after this, to find that among the 'ancestors' featured in the *Almanach des Blauen Reiters* the contemporary Primitive, 'Douanier' Rousseau (1844–1910), is prominently featured: with seven works reproduced, he takes precedence over all modern artists whatever, including Marc and Kandinsky themselves. The trailblazers of Modernism, both in Kandinsky's Munich and in Delaunay's Paris, were unanimous in believing that this naive and unassuming Sunday painter had within him the language of the soul that is born of inner necessity; or (as Delaunay would have put it) the cosmic energy of light as creative principle.

Just as Delaunay himself only achieved his breakthrough, in the colour analyses of *Circular Forms* and *Windows* (1912), after a number of attempts which include a *Self-Portrait with Japanese Woodcut* (Gilles de la Tourette, *Robert Delaunay*, Paris 1950, plate 2), it should be realized that Rousseau too, for all his naivety, was influenced by Japanese graphic art. How could he have painted so astonishing and richly articulated a work as *War*, of 1894 [240], without the Japanese prints that no one in 1894 could possibly escape seeing? One thinks of such a scene as Kuniyoshi's triptych of 1850, *Kagekiyo Emerges from the Cavern* [241]. The format, the silhouette-like characterization, the derivation of the overall structure from the central figure, the great contrasts of colour, with acid tones and black accents: all this is found here and nowhere else.

The attraction that this entirely representational, although never naturalistic, painter held for the first abstract artists might at first sight seem surprising. Was this simply

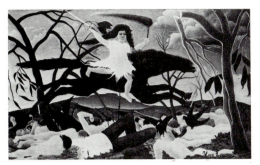

240 Henri Rousseau. *War*, 1894

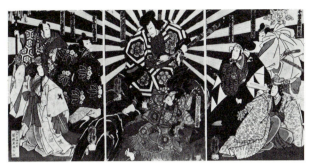

241 Utagawa Kuniyoshi. *Kagekiyo Emerges from the Cavern*, 1850

the affinity between extremes? Or did it spring from the realization that Rousseau, the Primitive, came closer to the frontiers of the attainable than the contemporary artist with his burden of theory; that, beyond the aesthetic debate between abstraction and representation, there still lay a sphere of pure artistic delight?

It would take us too far afield if we were to pursue the tangled paths of abstract painting over the next six decades, and to trace the sometimes manifest, but more often concealed, presence of Japanese art within it. One thing that is clear is that this presence was no longer based on externals – the two-dimensional organization of the Japanese woodcut – but on the religious imperatives of Zen: as in the work of Mark Tobey (1890–1976), with his respect for the highly charged void, or in that of Georges Mathieu (born 1921), who derives the elegant fluency of his ornamental 'script' from the study of Eastern calligraphy.

Nevertheless, especially in France, the enchanted world of Utamaro and Hokusai was not easily forgotten. No longer as a weapon of the avant-garde, as a guide to the conquest of an individual style, but as a beautiful monument to the transience of life, even in its wildest moments. In a series of four drawings, the eighty-nine-year-old Picasso paraphrased some erotic prints by Kiyonobu (illustrated in *Fleurs du Japon*, Geneva 1970, plates 13–37) and set before us the sexual *Embrace* [242] in vibrant curves and dark patterning, abstract and yet highly concrete.

Russia

On its migration eastward from London and Paris, Japonisme eventually reached Russia. It did so not through outstanding exhibitions or major collections but indirectly, hesitantly, by the back door.

The nineteenth century in Russia was an age of great literature, but art remained academic and illustrative, untouched by the reforming impulses that prevailed further West. This particular iron curtain was lifted a little by the solitary and unrecognized figure of Mikhail Vrubel (1856–1911). The Byzantine mosaics in Kiev revealed to Vrubel possibilities of a stylistic archaism that he was able to compare with the work of the French avant-garde, and of the Nabis in particular, in the course of two visits

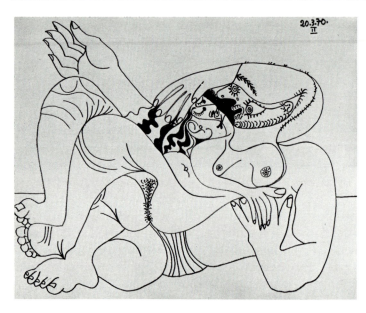

242
Pablo Picasso.
Embrace, 1970

to Paris, in 1892 and 1894. There is no documentary record of his reaction to Japanese prints, which were then at the peak of their influence; but, from that moment on, his compositions took on a decorative structure, planar, asymmetrical and symphonic in colour, with a Symbolist distancing. This was all the more so where he did not allow himself to be distracted by some thematic literary concern. *Balalaika*, of 1899, is a good example. It is clear that he was familiar with the work of Vallotton, Beardsley, Degas and the French Post-Impressionists in general.

Vrubel's richest source of information, however, was *Mir Iskusstva* ('World of Art'), an art magazine which organized regular exhibitions: these revealed 'the dynamic which impelled and directed painting in Russia during the next decade', as we read in the excellent account by Camilla Gray (*The Russian Experiment in Art*, London and New York [1962] 1986, 49).

It is impossible to imagine the encounter between Russian art and the West without the mentor of the *Mir Iskusstva* movement, the great impresario Sergei Diaghilev (1872–1929). When his avant-garde experiments with the Imperial Opera Ballet failed, he took a whole company abroad and amazed Europe and America. For two decades from 1909, Diaghilev's *ballets russes* added an important new province to the artistic life of the West.

Of course, ballet had a history of nearly five hundred years, in the various courts of Italy and France in particular; but in the age of illusionism this art had more or less sunk to the level of the *tableau vivant* and the waxwork. Interiors and landscapes were constructed in accordance with strict orthodox perspective, in order to resemble the objects of the real world as closely as possible. The scene-building was entrusted to artisans. And now along came the Russians and showed how a work of art with a

style of its own could emerge from the combination of operatic music, dance, stage picture and figuration. The stage designer, in his new capacity, set the tone for this total art. He must be a painter with a decorative bent who would set out, not to illustrate, but to provide optical equivalents for dance movements, music and action: a creator and an interpreter at one and the same time.

From 1890 onwards, efforts were made in Paris to liberate the theatre from the bonds of illusionism and restore the imagination to its rightful place; we remember the efforts of the Nabi painters (see Chapter 12). But it was Diaghilev who finally succeeded in winning over the public, on both sides of the ocean, to a world of rhythmic movement that appealed equally to the ear and the eye. Through a succession of historical upheavals and stylistic shifts, he kept that public with him. It was Diaghilev who secured for the Fifth Art a place in the Age of Democracy. He was able to remain receptive to one new style after another; and after initially working with Russian artists he successively persuaded the Italian Futurists, Picasso, Derain and Miró to take up this novel form of decorative work.

Where does Japonisme come in? In the early phase, before the First World War, especially, the style and the fame of the *ballets russes* were largely maintained by Léon Bakst (1866–1924). It was precisely because Bakst was no great easel painter that he was able to respond wholeheartedly to the unique demands of the new art and conquer a world of sound, movement and decorative imagery in all its dimensions. Precisely because he – to exaggerate slightly – had no clearly defined style of his own, he was able to adapt himself, with every new staging, to the essence of the work itself. Bakst surprises with everything he undertakes; but no one could accuse him of being eclectic. One thing is consistent in his work; his designs are based on watercolour, with its surface emphasis – or, if you like, on the patterning of woodcut.

That he knew the work of Beardsley and of Vallotton, and their Japonisme, is not in doubt. But their work was in black and white; the stimulus of colour must therefore have come to him directly from the Japanese. He can hardly have failed to notice that the first emissaries of the Far East had already arrived in Russia.

In 1903, the 'Contemporary Art' group in St Petersburg held an exhibition of Japanese woodcuts (according to Grigori J. Sternin, *Das Kunstleben Russlands an der Jahrhundertwende*, Dresden 1976, 291). The prints came from the Shcherbatov collection and from that of Igor Grabar, a painter and art critic who had prepared himself for a mediating role by long study visits to Paris and Munich, and who wrote a lengthy essay on the Japanese colour woodcut for the exhibition catalogue. In this, he laid particular stress on Utamaro, Hokusai and Hiroshige, and on their influence in the West.

Not much is known of the response to this exhibition among artists, critics or the public; and even less is known about the exhibition of Japanese art organized in 1896 by a sailor called Kitayev, which seems to have been on ethnographic lines and to have had an 'elementary didactic purpose'. The only information of any value on Grabar's exhibition comes from the painter A. P. Ostroumova-Lebedeva, who tells us in her memoirs:

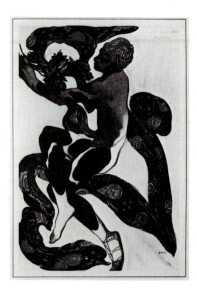

243
Léon Bakst.
The Faun, 1912

I had no knowledge of Japanese art before this. I spent many hours in the exhibition and was overwhelmed by the unfamiliar charm of the forms and colours ... I was fascinated by the strict realism, the style and the simplification, the world of fantasy and mysticism and the ability of the Japanese to capture on a sheet of paper the fleeting, momentary phenomena of the Nature around us ...

 At that period [1900–3], dealers from Japan appeared in Petersburg. They were selling woodcuts by the old Japanese masters ... What excited me about them was ... the combination of the real and the fantastic, the symbolic with the actual, and the extraordinary lightness with which they captured a fleeting movement. Every one of my friends wanted to acquire a good collection of woodcuts. The most enthusiastic collectors were, I remember, I. E. Grabar, S. P. Yaremich, V. J. Kirbatov and S. V. Lebedev ... Sometimes there were magnificent prints from the *Thirty-Six Views of Fuji* by the genius of Hokusai, outstanding views of *The Provinces of Edo and Kyoto*, by Hiroshige, graceful and exciting portrayals of women by Toyokuni, fantastic Kunisadas and Kuniyoshis, and other astonishing artists besides. (*Avtobiograficheskie zapiski*, Leningrad and Moscow [1935] 1945, 116–17, 272–3.)

Even supposing that the impact of Grabar's efforts was minimal, and that the efforts of the Japanese dealers in Petersburg were too sporadic, no artist as extraverted and as seismically sensitive as Bakst could have failed to respond to the superb exhibitions of Japanese woodcuts that were to be seen in Paris in the very years in which he worked for Diaghilev, year by year and style by style.

The Faun, of 1912 [243], a design for the ballet *L'Après-midi d'un faune*, is hard to assign to any concrete Japanese source, but it is also unimaginable without such a source. There is the pattern formed by the curved, agitated bands that define the picture area and interact with the white ground; the pattern-ground principle used by the Japanese from the early period to Utamaro; and the ornamental metamorphosis of all the forms.

 The dominant colour relationship of blue and green is highly unusual; it reminds

one of Matisse, and thus, indirectly, of Japan again. The whole way in which anatomical and organic forms are transformed, indeed magically metamorphosed, into a single great ornament, shows an affinity with many elements of Art Nouveau; but it carries them into a fourth dimension, that of rhythmic movement, while omitting the third, the 'cubic irritant'. In a number of his costumes for *Potiphar's Wife* (*The Decorative Art of Léon Bakst* [London 1914], New York 1972), Bakst showed further traces of Japonisme by decorating a blue costume with authentic Japanese ornaments in silver.

One has only to compare the *Faun*, as danced by the great Nijinsky, with one of Degas' dancers [46], to see how, fed by similar sources, the newly comprehended reality and its representation had been transformed over the intervening three decades. Degas still bases himself on the reality of the recession of a box-like space; that space exists beneath or behind the surface of the painting, and one can feel its presence, however twisted and elastic it may have become, like a solid object behind a pane of glass. The figures stand *in* the space. For Bakst, on the other hand, the space is created from the figures, or rather from the curves, signs and fragments of colour which, in their tension and dynamism, allow us to sense a movement in space. No wonder that the ballet, with its dancing, hovering animation, was congenial to such a vision, or even prompted it.

Bakst's origins lie among the last artistic currents of the nineteenth century, such as the Nabis; Natalia Goncharova (1881–1962) represents the link with the art of the new generation. With her extraordinary ornamental gift, her feeling for the archaic quality of the old Russian icons that had recently been rediscovered, with her admiration for Futurism, her understanding of Matisse's colour and movement, she inevitably attracted Diaghilev's attention when he decided to give a new and younger look to the work for which his company had been applauded all over Europe, from Madrid to Copenhagen.

With her costumes and sets for *Le Coq d'or* (1913–14), Goncharova inaugurated the second phase of the career of the *ballets russes*, that of 'poetic anti-realism'. She was widely praised for her 'extraordinarily vibrant power of colour', based on the contrast between scarlet and gold. At first sight, her *Design for an Act Drop for 'Le Coq d'or'*, of 1914, is more reminiscent of Far Eastern textile designs than of anything specifically Japanese. At this late stage in the history of Japonisme, a variety of inspirations are always detectable, although obscured to some extent by the artist's original synthesis. Even so, the pronounced pattern–ground relationship, the asymmetry and the interplay of object and abstraction, are unmistakable pointers to the basic principles of Japanese art.

This observation finds no echo in the extensive literature on Diaghilev or on Goncharova – to my knowledge, not one of the hundreds of publications concerns itself with their Japonisme – but the artist's active concern with Far Eastern art is a fact. At an exhibition entitled *Europa – due tra sogno e impegno* (Ravenna 1973), item 50 was one of her watercolours. In the form of a Japanese fan, the surface segments and areas of colour are so structured that the sketch is open to two alternative and

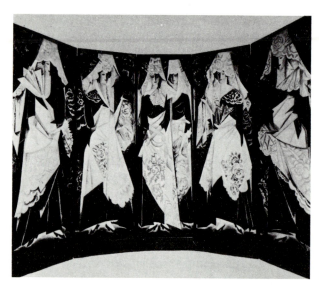

244
Natalia Goncharova.
Spanish Women, folding screen, 1920

simultaneous 'readings': as a reconstruction of a Japanese source, or as an entirely autonomous construction on the Russian artist's part. The bridge is there, however concealed from the majority of the critics. This is inevitable; for the mingling of disparate sources of inspiration in this last phase of Japonisme only goes to show that its work was done, and that it had succeeded in eliminating the last vestiges of illusionism.

The potential span of influence of a Japanese source, with its disarming capacity for metamorphosis, is demonstrated by a final and rather different example from Goncharova's mature years of travel: *Spanish Women*, of 1920, a five-part folding screen of unusually large size; 2.43 m. (8 ft) high and 3.85 m. (12 ft 7½ in.) wide [244]. Iconographically, the interest would appear to lie in the variations on the exquisite traditional costume worn by the six girls; in artistic conception, however, the sequential rhythm, the abstract effect of the segments of form, the interplay of the light and dark colours in the service of a peculiar pictorial space, reveal a formal imagination that would be unthinkable without a Japanese source. One is immediately reminded of Shunchō's *Five Actors in the Kabuki Play 'Karigane'* [223]. The concrete object is held in perfect equilibrium with the abstract design.

Few if any Japanese elements are to be found in the paintings of the Russian avant-garde of Cubists and Suprematists, even in those of Goncharova herself. Only the 'floating world' of the ballet could offer Japonisme one last chance.

For half a century, through a constant succession of metamorphoses, the new vision inspired by Japan contributed to the process of change in Western art; this most fundamental of all forms of 'Primitivism' drew other 'archaic' manifestations along in its wake and carried the new optic analysis of form and colour to its triumph. As time went on, it ceased to be the exclusive province of the great reformers of art who have

been discussed here. Everywhere and on every level, where living art sought to break free of the academic bonds of photographic realism, sooner or later the Japanese medicine was taken.

This process is exemplified in the career of George Grosz, as recounted in the German edition of his bitter autobiography. Grosz sat in the painting classes of the Dresden Academy, learning to paint academic garbage, until he saw the nonsense of it all and set out to study the basics of drawing by himself. And where did he turn?

Strange, strange: though I had encountered Daumier, Lautrec, Forain and the Japanese woodcut artists and draftsmen at a distance, I did not tread directly in their footsteps, but in devious ways in those of their lesser followers. Preetorius, for example, clearly derived from Hokusai; and the Viennese artist Julius Klinger, whose patterns I almost copied, and from whom I learned a certain way of drawing stylized shoes, derived from Aubrey Beardsley – but the real Beardsley left me strangely cold. I took the imitators more seriously than the creators. (*Ein Kleines Ja und ein grosses Nein*, Hamburg 1955, 93)

This marks the final triumph, and also the death-knell, of the Japanese influence – at least in painting and drawing, with which this study is concerned. The fundamental revolution in contemporary architecture, interiors, landscape gardening, ceramics, calligraphy and design in general – all inconceivable without Japanese inspiration – lies outside its scope.

Even so: the very last word comes from a highly surprising direction, that of Sergei Eisenstein and the Russian school of film montage. In three ways, this points beyond all that has gone before: a new medium, that of film; a new country, the Soviet Union, untouched in this case by the intermediary role that Paris had played, for example, in the work of Bakst and Goncharova; and a new Japanese source, the Kabuki theatre, a theme to which countless *ukiyo-e* prints of actors and scenes refer, but which they transpose into a graphic dimension.

Sergei Eisenstein (1898–1948) was not only the creator of six unforgettable films in the heroic age of the Seventh Art, from *The Battleship Potemkin* to *Que viva México*; he is perhaps less widely remembered as the man who laid the solid foundations of the aesthetics and theory of film. Its discovery as a unique and autonomous art, with its own laws, possibilities, means and objectives, is Eisenstein's achievement. He mocked the 'prehistoric' period of the art of film, 'when whole scenes were shot in one unedited sequence' (see Appendix 2, pp. 366–74).

Montage, for Eisenstein, is the vital nerve of the art of film. Motion pictures are not photographed theatre; they are a dynamic interpretation of processes, encapsulated in a sum of short fragments edited together into a kind of temporal collage. The 'collision' and 'overlapping' of images and parts of images, the 'presentation without transitions', enables the viewer to be 'gripped with rhythms' and the action to 'catch fire'. The content and the idea thus evolve from the visual, and not vice versa. As in every true art, *How* is as important as *What*. And this *How* is deduced from the process of perception, from the ideographic method that juxtaposes image with image, fragment with fragment, frame with frame: as in eighteenth-century Japanese prints, and as in the Kabuki theatre itself.

From the first, Eisenstein was interested in the Japanese hieroglyphic letters and signs, and consequently it was the visual experience of Kabuki that inspired his idea of the function of montage. Without realizing it, he was close to the filmic vision of a Toulouse-Lautrec, who was never able to set foot in a cinema. Also without realizing it, he was aligning himself with Francastel's theories of modern visual creation as a process of fragmentation, and with the *Gestalt* theory interpreted by Rudolf Arnheim in his book *Art and Visual Perception* (Los Angeles 1974).

And so, above and beyond his major role in the history of the silent film, Eisenstein emerges on a level at which the significance of Japanese art for the West can be clearly seen, for one last time, as that of a *visual design principle*. After that, with Zen, the impalpable Beyond casts its spell.

19. Retrospect

Ideology and imagination

Art, and the transformations that it underwent between Manet and Munch, can be regarded from many different angles. Who could deny that the art of the period expressed ideas, and that these ideas changed radically in the course of fifty years? Ideas of the relationship between men and the Cosmos; of his experience of Nature; of his attitude to modern science, to his environment and to technological progress; of the role of his inner life in the context of psychoanalysis and depth psychology; ideas, above all, that responded to a succession of massive social and political upheavals. But all these ideas, however important, belong to the history of culture in general and are no less manifest in literature, music, architecture, philosophy, and elsewhere. They preside over, or rather behind, all art: it is not always easy to see, in concrete cases, how the individual image emerges from them as a *function*.

Art theory, even where it has a basis in social criticism, has been too much concerned with setting itself apart from the general artistic aims and 'obfuscations' of bourgeois society, and has done no more than establish a set of negatives. Where it does get down to specifics, it often concerns itself only with the content, the concrete state of affairs contained within an image: the iconography, in fact. Such a theory rests content with the shell and hardly bothers with the kernel that actually makes art into art. In themselves, of course, the state of mind and the human experience contained in a work of art are highly interesting, indeed indispensable. But they are not enough. A history of taste entirely focused on the relationships between aesthetic, idealistic, psychological, sociological and economic factors would be illuminating in many ways; but no such history exists, and the idea shows no sign of catching on.

If the ideological approach, for all its limitations, still has a *raison d'être*, it ought to be particularly welcome in those contexts where ideology comes closest to art: in the tendencies, movements and cliques that proliferated more than ever in the period under consideration – the so-called 'Isms of Art' (Impressionism, Symbolism, Futurism, Expressionism and the rest). In many cases, these movements have left us programmes and manifestos in which we might expect to find a clear idea of what art was really all about at the time. Unfortunately, however, most of these were written after the event, with a view to justifying an existing initiative. Even the statements that came directly from the movements themselves were never a perfect match for the works of art. As ever, a yawning gap separated theory from practice. No string of

artistic proclamations, however valuable, is a substitute for the actual sequence of artistic events.

In view of these shortcomings, should we perhaps set all theories aside and stick to the bare facts of the biographies of individual artists? This too has been tried, with ludicrous results. With so vast a mass of available material, some principle of selection is needed, and this immediately brings us back into the domain of value judgments. But what sort of value?

The most obvious criterion would be dollars and cents. And why not? Since the moment when it first transpired that paintings are a safer form of investment than stocks in Krupp or General Motors, it has been hard to ignore the process by which a small bunch of art dealers has skilfully boosted the prices of one group of artists and deliberately neglected others. The art market is much better at manipulating our view of artistic significance and relative importance – through publicity, through planted articles in the press, through speculative coups and other devices – than the outsider would like to believe. And yet the market is anything but a reliable indicator: it values art strictly according to its usefulness for capitalist purposes, and coolly subordinates its value to those purposes.

However tempting and up-to-date it may seem to take one's artistic bearings from some outside point – to evaluate their sociological and psychological validity and justification, to examine their connection with ideas, iconography or commerce – one is always brought back to the heart of the matter. What is the essential imaginative creation? Where is the inner necessity? What sensory and visual conditions does a vision require? How does one rise from mere looking to true seeing? How must form and colour, space and rhythm, combine in a convincing order? These are essential questions. And they bring us back to the idea, so readily ignored today, of art as an autonomous, active, powerful force. This is certainly not meant as an encouragement to the sectarian rhetoric of 'Art for Art's Sake'; for this is a force that radiates in many realms. Even so, it remains necessary, first and foremost, to awaken the artistic understanding and to approach the history of art as a visual evolution.

The period under consideration strikingly illustrates the working of this principle. The banalities of so-called academic art, the proliferation of anecdotal trivia, the assumption that a tableau from a waxworks could be a painting, the perils of an amorphous illusionism – all this could be overcome only by a return to artistic fundamentals. Those fundamentals took a new form, initially borrowed from a remote form of art, but were not too remote in themselves to be traced through the archaisms native to Western culture, or to be reconciled with an up-to-date view of the world. This astonishing renewal of the Western visual sense, with all its implications and in all its stages, from early exoticism to the threshold of the abstract, is the theme of this study.

Japonisme: a continuous evolution?

The whole process is dominated by the decorative principle, or, more exactly, by the rebirth of the decorative principle. Fine art – pictorial art – can and must also be

decorative art: this permanently valid idea was repressed, or despised, only by an age of naturalism that had abandoned form. The decorative in art is not a question of an added curlicue here or an ornamental pattern there, but applies to the structuring and composition of the work as a whole through the resources of visual perception. Clearly distinct from such functions as illustration, purpose, content and meaning, the decorative is the lowest common denominator from which these other factors evolve. The attention that was paid in the later nineteenth century to decorative and sometimes also to ornamental factors was a natural reaction against a previous generation that had entirely ignored them.

The rebirth of art from the decorative spirit was prompted by the knowledge of Japanese woodcuts and their transposition, their incorporation, into the art of the West. Had these products of the East been no more than an empty sign language, however novel, they would have come and gone as rapidly as any other form of exoticism. But their influence continued for half a century, because they caused a visual revolution, or rather a revolution of the visual imagination. There were many reasons for this: one that is often overlooked is that Japanese graphic art, for all its astonishing formal qualities, does not merely lead to formalism but points quite realistically – even if not naturalistically – to a concrete reality. Not for nothing has Hokusai been likened to Daumier.

Another reason why Japonisme survived all the other exoticisms, primitivisms and archaisms of the period, and showed itself superior to them, is that in itself Japanese woodcuts possess a long and unbroken stylistic evolution. From the early 'linear' style of Kaigetsudō, by way of the 'classical' balance of Kiyonaga and Utamaro, to the 'painterly' art of Hokusai, Hiroshige and Kuniyoshi, we have an organic sequence. It was the incontestable achievement of Ludwig Bachhofer that he recognized and defined this 'inner logic of visual evolution'. The links in the chain fall into place.

The existence of this complete evolutionary sequence of *ukiyo-e* prints did the West an enormous service. The transition from the late style of the Impressionists to the new start made by the next generation – Post-Impressionism, Art Nouveau and Expressionism – marked a massive shift, comparable only with that between Late Antiquity and the Middle Ages, or between Gothic and Renaissance. This transition was made possible – or at least eased – by the way in which Japanese art was absorbed *in reverse chronological order*; for in it, both later and earlier visual forms are prefigured. Degas, Beardsley and Goncharova can all point to Japanese precedents; but each refers to a different stylistic epoch.

Once this sequential effect has been grasped, the inner necessity behind formal change becomes clear; and previously ignored figures begin to fit into the picture. Whoever would have thought of connecting Klimt, Hodler, or Munch with Japanese graphic art? The connection can be made only if one can see that Japonisme actually has a coherent history of its own. It did not impinge arbitrarily on the work of an artist here or there: it was the bracket that united all the various movements from which Modernism was to emerge.

To contest, or to belittle, the part played by ideology in art would be absurd. The history of Japonisme shows, however, that the forming, *shaping* power of art lies deeper. It spans all the ideologies, except that of obdurate academicism. It reaches across from the conservative aristocrat Manet to the mystic Toorop and to the militant revolutionary George Grosz. Whether left-wing or right-wing, art has first to satisfy the artistic demands imposed by the visual sense and by the context in which that sense operates. Without this understanding, for which Japonisme supplied the evidence, modern art would never have reached the twentieth century.

This is not to say that the Japanese vision created the new visual sense: here, for once, inner necessity and external opportunity coincided admirably. From this point of view, the whole of art since Manet appears in a new light. Where observers have hitherto seen one stylistic tendency after another, each obliterating its predecessor and pointing in a different direction, now an inner bond can be discerned. It is one that has been deliberately masked, in many cases; for artists have often been reluctant to acknowledge the existence of their Japanese 'arsenal'. When I asked Odilon Redon's son what were his father's precise Japanese sources, he bridled and declared: '*Mon père, vous savez, n'a imité personne, il était un artiste tout à fait original*': 'You see, my father didn't imitate anyone: he was a totally original artist.'

A word about the Japanese influence on the applied arts. It is true that more than one painter switched over to this other branch of art, and worked in both concurrently. The Japanese therapy worked as well against the decline of craftsmanship and the temptations of kitsch as it did against the decadence of the academies. Fine and applied art progressed towards the goal of reform, not along identical but certainly along parallel paths. In the heyday of Art Nouveau, as far as the public was concerned, the *Japonisme*-inclined painters were sailing under the same colours as the designers of distinctive craft objects. An affinity of taste brought the arts together; and, undeniably, each served to strengthen the resolve of the other. Beyond this, however, the world of 'art manufactures' followed paths and goals that were entirely its own. Textiles, ceramics, lacquer and metalwork had their own specific problems, which were at least as intimately concerned with truth to materials, technology and function as with pure form. Here there can be no question of a single, unbroken source of inspiration, as there can with the colour woodcuts.

Applied art evolved not in one great river but in a multitude of tributaries and branches; it had different creators, different clients; it was as closely involved with fashion as with craftsmanship, and it had peaks and troughs of its own. This said, there were many points of contact. Such a figure as Van de Velde surveyed a wide, all-encompassing horizon; for him, decorative art in all its aspects was not something separate from fine art, and he looked forward to their union in a new *Gestaltung*.

Whether the Western discovery of Japanese woodcuts in the nineteenth century occasioned the movement described here as Japonisme, or whether the crisis in Western painting made the aid of Japanese art imperative, is a question that might be debated without leading to any definite conclusion. There is something to be said for both answers: it all depends whether one takes one's stand on external facts or on

inner motivation. But it must be remembered how small was the base of knowledge on which the reform movement in the arts based itself. Samuel Bing, for instance, who was probably the leading expert on Japanese art in his day, seems from the catalogue of his 1890 exhibition to have thought that the whole of *ukiyo-e* could be summed up in the work of a dozen major artists and fifty or so very sparsely represented minor masters. By comparison with what is known today, he saw only the tip of the iceberg. But this is the remarkable thing: these pioneers were guided above all by artistic intuition, and this often proved a remarkably good guide.

The art historians began work only after the enthusiasm of the artists and pioneer collectors was past and the craze for Japanese home decoration had ground to a halt. What does a lover of the art really care if the prints of Hiroshige now have to be apportioned among three different masters? Or that Toyonobu contests Masanobu's authorship of an unsigned work? What he or she cares about is the value of the piece as art. The scholar, on the other hand, is concerned with the sure basis of facts and dates, and needs to understand the Japanese language and to study the literary sources. The value of the solid enrichment of our knowledge by Ernest Fenollosa, Woldemar von Seidlitz, Laurence Binyon, Otto Kümmel, Fritz Rumpf, Jack Hillier, Rose Hempel and others is impossible to exaggerate; but the early enthusiasm of the pioneers must not be forgotten. Without them, Japonisme would never have become a source of artistic inspiration.

20. Afterword

The indebtedness of Degas, Lautrec and Van Gogh to Japanese art is in all the school books by now. But they have tended to be seen as special cases, as exceptions who stand out from the general run of Western art history. It is only gradually, and since the 1960s in particular, that this impression has been corrected: a growing number of painters turn out to have looked to Japan for inspiration; and the word 'Japonisme' turns up everywhere.

A number of specialized studies and exhibitions reflect the expanded relevance of the term; and this new interest operates in a number of directions. First the facts must be established, the initial encounters with Japanese prints identified, and the sequence of dates and events worked out. Then attention turns to the components of the image and to the comparison of motifs, in a process of iconographical interpretation; and from this flow the cultural and sociological perspectives of the encounter between East and West. Finally, attention is drawn to the refinements of Japanese technique.

The study of chronology, iconography and manual skills is of course indispensable to the understanding of Japonisme; but these are not everything. This was not a case of imitation; indeed, it was 'influence' only in a highly qualified sense. This was inspiration and interpretation; the source and its metamorphosis: a process of artistic creation in which content was brought to life through form. For this reason stylistic analyses, it seems to me, have a central importance. The importance of style is as much individual and existential as it is social and evolutionary.

The response to the Japanese vision modified the relationship between content and form in Western art; and it bonded many isolated artistic figures into a continuing, irreversible evolutionary sequence that prefigured a new universe. Wherever the dead hand of academicism or naturalistic platitude threatened to paralyse the imagination, a Japanese inspiration intervened and loosened the grip of subject-matter. Grossly simplified, the central upheaval of modern art – which was both a gradual and a revolutionary process – was the move from depiction to the sign. In this move, Japonisme was an important motive force. It supplied sources, not blueprints, for the unfolding of new modes of formal creation.

But does not an approach of this kind isolate art from its cultural, historical and social context? Does not art also reflect and document the life and experience that lie outside art? It does, of course, and this is a perfectly legitimate function: as illustration in the widest sense, art follows social and political events, and can itself be summed up in art *history*. But its primary purpose is as a magical invention, beyond narrative:

art gives shape to the raw material of social facts, and the result is the history of *art*. In Eisenstein's pithy phrase: Through Art to Revolution.

One purpose of this book is to promote such a view of art. It sets out to show its topic, which is the integration of the Japanese vision into Western Modernism, not as a historical accident, fortunate or otherwise, nor yet as the sum of a collection of artists and movements, but in terms of the inner necessity which it embodied; and also to show why the ambivalence of the Japanese formal imagination provided so apt a means: Japonisme as the engine of evolution.

This has meant that this study could not be restricted to France. It was here, in the first phase of Japonisme, that the 'parallels' were most evident, and have proved hardest for posterity to ignore. The ensuing spread of Japonisme to the rest of Europe, and as far as Russia and America, and its effects in subsequent stylistic phases – the second-hand but far from degenerate Japonisme that is often hard to trace through the evidence of motifs alone – has never, to my knowledge, been described as a whole and in context. As a portion of a whole, a link in a logical chain, this 'second' Japonisme becomes comprehensible and important. It has hitherto been seen, from a purely pragmatic viewpoint, as a piecemeal collection of derivative products, and therefore as at best a curiosity; or else it has been totally ignored.

It may well be that I have left large tracts of territory unexplored: I have not aimed for completeness but have attempted to set out a few guidelines, so that Japonisme can be seen for what it was: a tool for the transformation of outworn traditions into that New Vision that characterizes – or might characterize – humankind in our century.

Appendix 1: Chronology

FRANCE, BRITAIN, UNITED STATES

1854	Japan opens up to the West. Commodore Perry appears in Yokohama Bay.
1856	Japanese prints reproduced for the first time in Washington. *Le Magasin Pittoresque* reproduces three pictures of Japanese hunting scenes. An article on Japanese painting appears in the *Illustrated London News* on 13 December.
1858	First French trade treaty with Japan.
1861	A number of reproductions from Hokusai's *Manga* appear in a book by Ambassador Baron de Chassiron: *Le Japon, la Chine et l'Inde*. Baudelaire already possesses Japanese prints.
1862	Japanese prints supplied by the British Consul in Tokyo, Sir Rutherford Alcock, are shown in London at the Great Exhibition. Félix Bracquemond discovers Hokusai's *Manga* (unless, that is, the correct date is 1856), and begins to influence Manet, Whistler and Degas.
	Desoye opens an Oriental curio shop, La Porte Chinoise, in the Rue Vivienne in Paris, where Whistler, Fantin-Latour, Goncourt, Baudelaire, Millet, Burty, Manet, Degas and Monet meet.
	Formation of the *Société des Aquafortistes*.
	Manet has probably encountered Japanese prints through Whistler and Burty, as can be seen from his *Street Singer*.
1863	Whistler moves from Paris to London.
1866	Zola praises Manet for his 'Japonisme'.
	Edmond de Goncourt mentions the Japanese 'genius' in his diary and publishes *Manette Salomon*.
1867	Universal Exhibition in Paris. Section for Japanese decorative art. French responses: Bracquemond's service of porcelain, goldsmith's work by Christofle, jewellery by Martz. No woodcuts on show apart from seven illustrated books from Burty's collection (which he began in 1863 or earlier).
	The *Jinglar* club, a dining club devoted to Japonisme, founded in Paris.
1868	After the Meiji Revolution in Japan, the better Japanese collections come on to the market. Publication of Ernest Chesneau's booklet, *L'Art japonais*.
1869	Lectures by Chesneau at the *Union Centrale des Beaux-Arts*, where an exhibition of Far Eastern art is held (400 examples of Japanese porcelain).
1871–2	Enrico Cernuschi and Théodore Duret bring back decorative art, porcelain and illustrated albums from their visit to Japan.

1872 Monet in Holland, where he might have seen works by Utamaro, Hokusai, Toyokuni and Sharaku.

1872–4 Burty publishes eleven articles on Japonisme in *La Renaissance littéraire et artistique*.

1873 Philippe Sichel brings back many works of art from Japan; most enter the Goncourt collection.

1874 31 March: Goncourt's diary records a visit to La Porte Chinoise.
Judith Gautier publishes her Japanese-inspired novel. *L'Usurpateur*.
Burty discovers Hiroshige.

1875 Emile Guimet and Guillaume Régamey in Japan.

1876 Universal exhibition in Philadelphia shows Japanese products.

1877 Whistler's *Peacock Room* in London.

1878 Universal exhibition in Paris; the apogee of Japonisme in the decorative arts. No prints on show. Hayashi arrives in Paris.
Guimet and Régamey publish *Promenades japonaises*, a travel book on Eastern religions.
Goncourt meets Watanabe through Burty and describes in his diary the technique of Japanese painting.
In the September issue of the *Gazette des Beaux-Arts*, Chesneau publishes his article *Le Japon à Paris*.
Whistler sues Ruskin for libel.

1879 'Japonisme is the idolatry of the moment; let us hope that it will be the artistic religion of the future' (Contemporary critic, quoted by Yvonne Thirion).
William Anderson publishes his *History of Japanese Pictorial Art*.

1880 Le Blanc de Vernet publishes two articles on Japanese art in *L'Art*.
Samuel Bing visits Japan and 'discovers' Utamaro.
Duret visits Anderson in London, studies his collection and extends his knowledge of Japanese art by encountering Moronobu, Kiyonaga and others.

1881 Goncourt publishes *La Maison d'un artiste*, including an account of his Japanese collection.

1882 Duret writes on illustrated albums, including those of Kiyonaga and Moronobu.
The major Parisian private collections of Japanese prints have been embarked on.
The British museum acquires the Anderson Collection.

1883 At the Galerie Georges Petit, Louis Gonse mounts the first exhibition of Japanese art from private collections in Paris under the title of *Exposition rétrospectif de l'art japonais*.
Gonse publishes the first edition of *L'Art japonais*.

1884 Fenollosa's review of Gonse's book is published in Boston and in Tokyo.
Goncourt proclaims the 'Victory of Japonisme'.
Ary Renan relates 'the present crisis in European art' to the advance of Japonisme.

1885	Duret publishes *Critique d'avant-garde*; Whistler publishes his *Ten o'Clock Lecture*.
1886	Second, revised edition of Gonse's *L'Art japonais*, extending the account of the print beyond Hokusai.
	The collector Pierre Barbouteau makes his first trip to Japan and brings back sixteen Sharakus.
	Anderson publishes *The Pictorial Arts of Japan*.
	In Antwerp, Van Gogh sees Japanese prints for the first time.
	Emile Bernard confesses: 'the study of Japanese prints led Anquetin and myself to simplicity, so that we were able to found Cloisonnisme.'
	The *Manifeste symboliste* of Jean Moréas.
	Paris illustré brings out a special number including woodcuts by Hiroshige and Eisen. Gaston Diehl publishes in Paris his *Ravenne, étude d'archéologie byzantine*, with its reference to a future 'Primitivism'.
1887	Almost unnoticed, Van Gogh puts on a small Japanese exhibition at the Café Le Tambourin, Avenue de Clichy, Paris.
1888	Whistler's *Ten O'Clock Lecture* appears in a French translation by Mallarmé and Francis Vielé-Griffin.
	The vogue of cheap Japanese objects is at an end.
	Bing publishes the first of the thirty-six monthly issues of *Le Japon Artistique* (edition in English as *Artistic Japan*); its chosen theme is 'Back to Nature by following the Japanese example'.
	Bing shows Japanese prints, especially those of Utamaro.
	Edouard Dujardin's article on Cloisonnisme in *La Revue Indépendante*.
	Van Gogh and Gauguin in Arles.
	Henri de Bourbon in Japan; his collection is today in the Museo Orientale in Venice.
	In London the Burlington Fine Arts Club shows an exhibition of Japanese prints and books. Catalogue by Anderson.
1889	Formation of the *Société des Peintres-Graveurs*.
	Gauguin buys a print by Utamaro for 300 gold francs.
	Universal exhibition in Paris. The collections of Gonse and others are represented.
1890	The great exhibition at the Ecole des Beaux-Arts, *Maîtres de l'estampe japonaise*, with 700 items, organized by Bing. Reviewed by Teodor de Wyzewa in *Revue des Deux Mondes* and by Gustave Geffroy in *L'Art*.
	Gauguin decorates his studio at Schuffenecker's with a 'frieze' of Hokusai and Utamaro prints.
	Bing mounts a Hokusai exhibition in London.
1891	Paris: the Natanson brothers start publishing *La Revue Blanche*.
	Whistler's *Arrangement in Grey and Black, Portrait of the Artist's Mother* bought for the Musée du Luxembourg in Paris.
	Albert Aurier applies the term *symboliste* to painting.

Edvard Munch in Paris.

First auction of a major collection of Japanese art: that of Burty, with 1,800 items. One Utamaro print fetches 1,050 gold francs.

Goncourt publishes his book on Utamaro, the 'Master of the Green Houses'.

1892 The great print exhibition *Blanc et Noir* includes a Japanese section from the Bing and Vever collections.

Geffroy expounds the principles of Japanese art in *La Vie artistique*.

Whistler shows his *Falling Rocket* at the Paris Salon.

Duret bequeaths his collection of Japanese albums to the Bibliothèque Nationale.

1893 Bing organizes an exhibition of Hiroshige and Utamaro at the Durand–Ruel gallery.

On the initiative of Gaston Migeon, the Musée du Louvre opens a department of Japanese prints.

Exhibition of Japanese illustrated books at the South Kensington Museum, London, organized by Edward F. Strange.

The Studio begins publication in London.

Universal exhibition in Chicago.

1894 Bing's collection of Japanese prints exhibited in Boston with an introduction by Ernest Fenollosa.

Bing publishes 'The Art of Utamaro' in *The Studio*.

1896 Fenollosa compiles the catalogue for a New York exhibition, *The Masters of Ukiyo-e*.

Goncourt's book on Hokusai.

La Revue Blanche publishes a series of articles on Hokusai by Bing.

1897 The Goncourt collection is exhibited and auctioned off in Paris.

1898 Gonse publishes 'L'Art japonais et son influence sur le goût européen' in *Revue des Arts Décoratifs*.

1900 The Paris universal exhibition shows ancient Japanese painting and brings *la vogue des estampes*, the print craze, to an end.

Duret publishes his catalogue of the Japanese illustrated books in the Bibliothèque Nationale.

1901 Fenollosa publishes *An Outline of the History of Wood Engraving*.

1902 The Hayashi collection is exhibited and auctioned off in Paris.

Print exhibition at the Ecole des Beaux-Arts, Paris, with Japanese section organized by Bing.

1904 Auction of the Gillot and Barbouteau collections. Important catalogue by Barbouteau.

1909–14 Six exhibitions at the Musée des Arts Décoratifs give an overview of the whole history of the Japanese woodcut. Organized by Raymond Koechlin, with 2,500 items. Highly important catalogues.

BELGIUM AND HOLLAND

1693	The German physician Engelbert Kaempfer brings a woodcut album by Ihara Saikaku back from Japan.
1779–85	Isaac Titsingh, director of the Dutch trading settlement in Nagasaki, takes an interest in Japanese art.
1812	In Paris, Titsingh publishes a book on Japanese industries, and his collection, including Japanese woodcuts, is auctioned off.
1837	Philipp Frantz von Siebold, a German doctor in the Dutch service in Japan, leaves his collection of Japanese prints to the ethnological museum in Leiden.
1852	Siebold's book *Nippon* published in Leiden.
1872	Monet in Holland, where he is said to have seen prints by Utamaro, Hokusai, Toyokuni and Sharaku.
1881	The periodical *L'Art Moderne* founded in Brussels.
1884	Whistler invited to participate in the first exhibition of *Les XX*.
1886	Whistler shows with *Les XX* again. Ensor expresses opposition. Van Gogh discovers Japanese prints in Antwerp.
1889	Bing organizes an exhibition of Japanese art at the *Cercle artistique* in Brussels.
1890	Six paintings by Van Gogh shown at *Les XX*.
1891	Brussels: the Compagnie Japonaise successfully shows Japanese objets d'art supplied by Liberty's of London.
1892	Exhibition of Japanese art in Antwerp, organized by *Association pour l'Art*.
1893	Flemish periodical *Van nu wen straks* founded. Jan Thorn-Prikker meets Henri de Toulouse-Lautrec when both exhibit at *Les XX*.
1910	At *La Libre Esthétique*, in Brussels, Adolphe Stoclet shows a selection from his Japanese print collection, which is restricted to landscapes.

CENTRAL EUROPE AND SCANDINAVIA

1775	The Swedish scientist C. P. Tunberg in Japan, where he collects prints among other things.
1873	Universal exhibition in Vienna, with a Japanese section (objets d'art only).
1882	Kunstgewerbemuseum, Berlin, shows Japanese pictorial art from the collection of Professor Gierke, Breslau.
1885	Karl Madsen publishes in Copenhagen his *Japansk Malerkonst*.
1888	Whistler exhibition at the Glaspalast, Munich.
1889	Justus Brinckmann publishes in Berlin his *Kunst und Handwerk in Japan*.
1891	Munch in Paris.
1892	Munch exhibition in Berlin. Walter Leistikow, Ludwig von Hoffmann and others form the *Vereinigung der XI*.

1893	Richard Muther's *Geschichte der Malerei des 19. Jahrhunderts* includes a whole chapter on *ukiyo-e* and its influence.
1894	Under Japanese influence, Otto Eckmann gives up painting, turns to applied art and disposes of all his paintings.
1895	Japanese art exhibition at Ernst Arnoldsche Hofkunsthandlung, Dresden.
1896	Justus Brinckmann, director of the Museum für Kunst und Gewerbe, Hamburg, and in contact with Hayashi since 1883, buys Japanese books, especially on plants, and acquires separate prints from Bing and others.
	Poster exhibition at Museum für Kunst und Gewerbe, Hamburg.
	The periodical *Simplicissimus* is founded in Munich, with Toorop, Félix Vallotton, Aubrey Beardsley, Thomas Theodor Heine and Olaf Gulbrandsson among its contributors.
	Friedrich Deneken publishes his *Japanische Motive für Flächenverzierung*.
1897	Woldemar von Seidlitz publishes his *Geschichte des japanischen Farbenholzschnitts* (second edition 1907, English edition 1910).
	Exhibition of objets d'art in Dresden.
	Foundation of the Vienna Secession.
1899	The Berlin museums begin to collect Japanese prints.
	In the periodical *Dekorative Kunst*, no. 6, Julius Meier-Graefe publishes two Japanese 'primitive' prints from the Bing collection (Kiyomasa and Kaigetsudō) with particular reference to contemporary tendencies in design.
1900	The Vienna Secession exhibits 114 Japanese prints; Sharaku and Utamaro are among the artists represented.
	The Glasgow group shows at the Vienna Secession.
1900–1	Emil Orlik in Japan.
1902	The periodical *Kunst und Künstler* founded in Berlin.
	Exhibition of Japanese prints in Dresden.
1904	Oskar Münsterberg's *Japanische Kunstgeschichte* and Friedrich Perzynski's *Japanische Holzschnitte* published.
1905	Special exhibition of Japanese colour prints at Kunstgewerbemuseum, Berlin.
1906	Gustav Klimt travels to Brussels and on to London, to study Whistler's *Peacock Room*. In Brussels he sees Stoclet's collection of Japanese prints.
1907	Klimt buys an album of facsimiles of Japanese erotica by Moronobu, Harunobo and Utamaro, published in Munich by Piper.
1909	The Städelsches Kunstinstitut in Frankfurt am Main exhibits the Straus-Negbaur collection of Japanese prints.

RUSSIA

1885 Konstantin Korovin, father of modern stage design, in Paris.

1890 Mikhail Vrubel identifies the true essence of Byzantine art as 'ornamental design with the emphasis on the wall surface'.

1892 and Vrubel in Paris.
1894

1896 Exhibition of the Kitayev collection of Japanese 'paintings, studies, sketches, woodcuts, colour photographs' at the Academy of Arts, St Petersburg.

1894– The periodical *Mir iskusstva* ('World of Art'), illustrating the work of
1904 Beardsley, Charles Rennie Mackintosh, Henry van de Velde, Monet and Degas.

1899 The first 'World of Art' exhibition shows Henri Rivière, Pierre Puvis de Chavannes, Arnold Böcklin and Whistler.

1900–3 Japanese dealers appear on the scene.

1903 Japanese woodcuts, mostly from the Shcherbatov and Igor Grabar collections, appear in the exhibition of the 'Contemporary Art' group in St Petersburg. In the catalogue is an extensive essay by Grabar on the nature of the Japanese woodcut and its influence on Western art.

1904 Sergei Shchukin buys works by Gauguin, Van Gogh and the Nabis.

1905 Second exhibition of the Kitayev collection at the 'Society for the Promotion of the Arts'.

1906 'World of Art' exhibition in St Petersburg. Natalia Goncharova's debut. Léon Bakst and Goncharova are represented in the Paris exhibition *Art russe*, organized by Sergei Diaghilev.

1908 Sergei Morozov visits Henri Matisse and begins his collection in Moscow. First 'Golden Fleece' exhibition in Moscow: 282 paintings by modern French artists.

1909 Diaghilev ballet enjoys its first triumph in Paris.

1910 The 'Knave of Hearts' exhibition in Moscow unites all the tendencies of the Russian avant-garde and demonstrates Russia's artistic autonomy.

1911 Matisse in Moscow to install his mural paintings in Shchukin's house. Goncharova's *Peasant Dance* in full-blown Primitivist style with 'Chinese, Byzantine and Futurist elements'.

1912 At *La Libre Esthétique* in Brussels, Bakst exhibits his designs for Diaghilev for the ballet *L'Après-midi d'un faune*.

1913 Goncharova's first stage designs for Diaghilev: *Le Coq d'or*.

1914 Goncharova leaves Russia to join the Diaghilev ballet.

1929 Sergei Eisenstein declares in an essay that Japanese art is based on the montage principle.

Appendix 2: Documentary texts

HERMANN BAHR

Japanese Exhibition: Sixth Exhibition of the Union of Austrian Artists, Secession (1900)
In the eighteenth century there was a short-lived Japanese mode, but it never went beyond playful curiosity, without touching European taste inwardly, let alone influencing our art. This happened later, after the great revolution that took place in Japan in the 1860s, and particularly after examples of Japanese painting were shown at the Paris Universal Exhibition of 1867 and aroused a veritable fever of enthusiasm among French painters. Since that time, we have had a Japonisme in all the arts, and it may probably be said that the whole of the painting, the whole of the decorative art, and also the whole of the literature of the last thirty years is impossible to understand without bearing in mind the influence of Japanese art.

What was it that endowed this form of art, alien and remote as it was from our art, with such enormous power? The first people to be struck by it, naturally, were the painters. With astonishment, they beheld a form of painting that negated and defied the basic principles of our own. There were no shadows, there was none of our perspective, there was no attempt at the illusion that we pursue, the illusion of physical appearance. With us, all the schools, however violently opposed to each other – all the movements in painting – were agreed on one thing: that their intention was to deceive the viewer, so that he would suppose himself to be looking at something real. And now here were these painters who made no attempt to create such a deception, who did not want their work to be taken for the persons themselves or the things themselves, and who presented it as nothing more or less than a representation.

Any European painter, on first acquaintance with such representations, inevitably found all his views shaken, all his habits upset, and was compelled suddenly to review all his ideas; from which it emerged that even our celebrated Truth is based only upon a convention, on a measure of agreement; that nobody is really deceived by a picture, even in Europe; and that – if it is part of the nature of art never to be reality itself but always the representation of reality – one surely has the right to exchange one convention, one measure of agreement, for another.

This was the first thing that the Japanese did for us: previously people had rebelled in little things; they gave us the courage to be revolutionary in big things. Every new resource that any age acquires in art eventually turns into an impediment; for no single period is permitted to have everything at once. Every new gain must be paid for by the loss of something old, as we read in the *Metamorphosis of Animals*: 'If you

see an especial advantage granted to any one creature, be sure to ask: where else does it suffer from deficiencies?'

But the fear of the certain losses that accompany a still doubtful gain then becomes so great that from time to time the arts require a powerful upheaval, from the foundations upwards, if they are not to remain totally rigid and immobile. Such a profound upheaval, running through all our conventions and routines, was the advent of Japanese art among us. It set us free and made us bold. Only then did we dare to thrust aside all that we had learned and to trust to our own eyes – which retained, of course, the privilege of going back at need to what had previously been learnt. Gradually, we had become slaves to our own means. We learned from the Japanese to use those means freely. The only law that still prevailed was to be that of the intention, the feeling, the whim of the artist himself.

The second thing that we owe to the Japanese is a new sense of colour. In this, they came at just the right moment. There had already been some venturesome souls, among the younger artists, who had had the impudence to look straight into the sun. People were beginning to find the twilight of the studio intolerable, and to throw the windows open. The air, the natural light, were being rediscovered. And then along came these incomparable musicians of colour and taught us to perceive tones and nuances that the European senses had for a century been too gross to detect.

This was not all: it took the Japanese to remind us of something that has been the essence of painting, and of art in general, in every great period. Our painting, and all our art, had, in its aspiration towards perfect illusion, completely forgotten that it is the finest effect of art to arouse and involve the imagination of the viewer. In the works of the so-called Naturalists there is a complete lack of what constitutes, perhaps, the supreme joy of art: the element of excitement. The whole magic of the Japanese artists consists in their highly refined art of creating excitement.

They resolve a mood into all its component elements, eliminate all that can be dispensed with, and indicate only the essence; but this they do with such force that it compels us to feel all there is to be felt. Peter Altenberg said once: 'The Japanese paint a flowering branch, and it is the whole Spring. Over here they paint the whole Spring, and it hardly adds up to one flowering branch. Wise economy is all!'

There is more to this than economy, however: it is the supreme artistic wisdom that we had lost since the Greek vase painting (the same thing that is invoked and desired so fervently in the correspondence between Goethe and Schiller): to reduce a mood, a character, an event, or whatever, to the one detail that has the power to evoke all the others in the viewer's imagination. This, of course, involves the strong feeling that the Japanese have of the cohesion of all beings: that primal sense of the world, to which the blossom, or an animal, a mountain, a cloud, and the beloved, are only metamorphoses of one and the same being (just as we find it in Goethe's *Westöstlicher Divan*: 'In all the elements, God's presence'). On a conceptual level, we have it too, but how seldom it becomes an inner, living, immediate reality!

A young Viennese, who has been in Japan, Mr Adolf Haeutler, once described in *Die Zeit* a visit to Suzuki Shonen, a celebrated painter in Kyoto. On the subject of

landscape, the Japanese said to him: 'Landscape as decor for man? No, that is no longer landscape, not an image of the time of year. If man in the landscape becomes anything more than one component of the Nature all around, then the feel of the landscape does not come through; and that is what really counts. If you want to give expression to the Soul of Autumn through painting, the human being can be no more than decor for the landscape: he can play no greater role than, for example, a strange shape of branch, growing out of a tree; or a grasshopper on a bare field; or at best a bird amid long-stemmed flowers. A girl in a rice field is no more than a peculiarly shaped portion of the rice field; when viewed against the Spring, or the Autumn, the human being in himself is very little: a touch of movement, a colour, nothing more. He must not have a soul of his own. He may be a cheerful piece of Spring, or a melancholy gesture of Autumn. That is all he should be.'

These few words contain the great secret of all art: that man is no more than a piece of Nature; that every piece of Nature is only a mood; that everything is simply a colourful expression of one and the same spirit.

This would be the point at which to discuss the Japanese influence as it extends beyond painting to all the arts, and indeed to our whole relationship to art. Not only would Impressionism in painting have been impossible without the Japanese (or at least it would have been quite different, and would have taken a thousand detours, lost its way and come to a halt a thousand times); not only do we owe the awakening of the decorative arts to the Japanese; but their example has given the most powerful twist to our whole literature. Knut Hamsun and Peter Altenberg would be unthinkable without Japonisme, and the whole circle that surrounds Stefan George is subject to Japanese influences, whether conscious or unconscious.

I believe that this development is far from concluded. We shall soon detect it, I think, in our own homes. The more the art of domestic living sets out to become subjective; the more we begin to regard the home as something essentially individual, something that must be a personal expression; the more we shall feel the need to make our furnishings more mobile, more mutable, so that they become capable of adapting to the occupant's every mood, or even whim; and then the time will have come to follow the light, supple example of the Japanese in our interiors. Then, I hope that the Japanese example can gradually take effect in the whole gradual progress of our aspiration towards culture, towards outer and inner refinement.

This, I think, is the way in which the public should seek to relate to the current Secession exhibition. It is good that we now at last have a chance to see genuine Japanese objects in a public place in Vienna. Mr Adolf Fischer, an enthusiastic collector and a profound connoisseur, who has made a name for himself through his writing on Japan, has earned our gratitude by organizing this exhibition. Our young painters will certainly receive the most powerful impressions; let us hope that they will be able to make good use of them. Let us also look forward to the most splendid effects in our applied arts. The public at large, however, will do best to approach these things with total naivety and allow them to take their effect. No need to trouble with historical knowledge. No need, for instance, to go to the length of making a

study of the evolution of the woodcut (although this exhibition provides a wonderful opportunity to do so). No need to linger over the understanding of techniques and manners. Let the public approach the exhibition as a whole, spontaneously, and absorb it as a whole. There are extraordinary experiences to be had here.

For my own part, I must admit that at the sight of these things I was several times on the verge of sadness. One is tempted to be a little ashamed of being a European. I do not mean this in an artistic but in a general human sense. What elevated conceptions of humanity emerge from these works, what morality, what propriety! Look at these earnest, solemnly inscrutable faces, expressing a visible resolve never to allow themselves to be carried away but always to maintain their inner life unalterably secret; and compare the unruly and boisterous antics of our people, who shamelessly turn every inner movement into a grimace!

Is it we or they who come closest to the classical essence that we find in the Greek statues? Who is it who better satisfies the demand that the Renaissance made of every educated person: the requirement of *gravità riposta, quella molle delicatura*, that settled gravity and gentle delicacy of which we read in Castiglione? How the ladies of the Green Houses are treated in these prints, with what respect for their mystery, with what delicacy! If one only reflects how the European behaves towards such individuals, on whom at times he focuses his passion, and whom he even makes the witnesses of his most intimate moments! And so we find certain civilized sentiments of great purity, such as we seldom encounter in European life, such as *pietas*, reverence, obedience, expressed in the tenderest, most inward way. After a time, one has the sensation of breathing a better air, among more decent people.

This is the same mood that Goethe described when speaking of a Chinese novel: 'These people think, act and feel almost exactly as we do, except that with them everything is clearer, purer and more moral. With them, all is decent, bourgeois, without great passions and surges of poetical feeling, and thus bears a great resemblance to my *Hermann und Dorothea*, or to the English novels of Richardson. The difference is that, with them, external Nature always has a life in common with the human figures. The goldfish are always to be heard splashing in the pools; in the branches there is always birdsong; the day is always bright and sunny; the night is always clear. There is much talk of the moon, but it does nothing to alter the landscape: its light is considered to be as bright as day. And the interiors of the houses are as neat and pretty as their pictures. For example: "I heard the sweet girls laugh, and when they came in sight of me they were seated on delicate cane chairs." And there at once you have the most charming situation; for it is impossible to think of cane chairs without the utmost lightness and gracefulness. And then countless legends, which always run alongside each other in the telling and are used, as it were, proverbially. For example, that of a girl who was so light and graceful on her feet that she could balance on a flower without snapping it off. And that of a young man who was so good and virtuous that in his thirtieth year he had the honour of conversing with the Emperor. And that of lovers who were so chaste, in a lengthy relationship, that once, when they were compelled by circumstances to spend a night in the same room, they stayed awake all

night, conversing, without ever touching one another. And countless other legends that all tend towards decency and morality. But it is through this strict restraint in all things that the Chinese Empire has preserved itself through thousands of years, and it will maintain itself by the same means.'

Secession, January 1900, 216–24

RICHARD MUTHER

The Japanese Exhibition of the Secession, February 1900
For a Japanese exhibition at the Vienna Secession three possible approaches offered themselves. The whole thing might have been designed as a 'Mood Picture of Japan'. Franz Hohenberger's Japanese works would have formed a prelude, and on entering the principal room it would have seemed as if we had suddenly stepped from the Wienzeile to Kyoto. There, before us, would have been a chrysanthemum grove. We should have stepped into a Japanese house and learned that what we are striving for today – the interpenetration of art and life – is taken for granted in the East. Nothing false, no empty illusion, nothing impersonal will do for these sons of a millennial civilization. Every utensil that they allow in their presence, every vase, every screen, must be a unique gem. Every picture is inseparable from its owner. Every flower that he selects is a part of himself. It would certainly have been no easy matter to present such an image of a whole civilization. But this sort of thing is just where the strength of the Secession lies. And the miraculous talent of Josef Hoffmann would have conquered all difficulties, as always.

If scholarly considerations were to prevail, then a historical approach would have been attractive. For it is strange how similar the evolutions of Japanese and European art have been. Until the seventeenth century, Europe and Asia were strictly separate worlds. There was no contact whatever. And yet each century seems to bear the mark of a similar mood: over here and over there, art displayed the same tendencies at the same time.

Until the fifteenth century the painting of Japan, like that of Europe, was a serious, hieratic, solemn art. As in Europe, the painters were monks. In their work they set out not to express anything personal but to create strictly cultic images. What Christ was to medieval European artists, Buddha was for the Japanese. With us it was the sufferer on the Cross, transfigured by his agony; with them it was Buddha, deep in unfathomable meditation on a gigantic lotus, immeasurably remote. In the fifteenth century, as in Europe, this serious and sublime mosaic style was replaced by a cheerful, conversational, narrative art. The subject-matter remained religious. But the artists were no longer monks; they were painters organized in guilds. Genre scenes, loosely attached to the central theme, were interspersed. The landscape background was rich. Graceful beasts lived their lives alongside the saints. In the sixteenth century, this many-figured variety crystallized into noble simplicity. The scene was developed succinctly, without digressions, in a few figures. In the centre, Buddha, majestically enthroned, with two saints at his sides: exactly the type of the *sacra conversazione* of

European altarpieces. And this solemn Cinquecento style veered in the seventeenth century towards the Baroque. The columns of the throne began to twist and turn. Whole architectures of clouds amassed themselves. The even articulation of the structure gave way to a free, painterly composition. Fruits, birds, flowers, fishes, all the incidental detail that the sixteenth century had banished for the sake of the grand manner, now found their way back in. And, as in Europe, this joy in incidentals led to the appearance of genre painting, landscape and animal painting as separate forms of art. What the names of Ostade, Ruysdael and de Heem signify in Holland, goes under the names of Tanyu, Motonobu and Okio in Japan. The eighteenth century kept to the same range of subject-matter; except that, as in the Rococo, the rough gave way to the smooth, the ponderous to the vaporous, health and strength to decadent over-refinement. The nineteenth century brought widespread popularization. An exclusive, aristocratic art became an art for all. It would have been instructive to show this parallel evolution of Japanese and European art with the aid of telling examples.

The third possible approach would have been that of showing, in a systematic exposition, the influence of the East on European creativity. For the Japanese, as is well known, are the ancestors of modern art. Like a *deus ex machina*, Japanese art has twice intervened in the history of European art, with revolutionary consequences each time.

The first was at the end of the seventeenth century. The first examples of Chinese and Japanese decorative art had been brought to Europe by Dutch merchants. The light tone of the porcelain, in particular, was very much liked, and it thenceforth dominated the colouring of interior decor and the tonal scale of paintings. Interior decoration had hitherto been dominated by gold and pompous red, brown wood and dark tapestries; now the walls were whitewashed, and the tapestries, the silken window drapes, the woodwork and the furnishing fabrics were light in colour. Paintings, formerly brown and oily, became light and delicate. But Japanese art taught the West a new compositional principle, as well. In the age of Louis XIV, all composition corresponded to his 'L'Etat, c'est moi': one central figure dominated all the others. After the Great King died, people longed for freedom. Ornament and arrangement were to take on a free, mobile swing, the fluid forms, the enchanting divagations, with which the sophisticated man of the world would circumvent the rules of etiquette. This unruly, capricious element was found in the work of the Japanese, who were oblivious of Europe's supreme law of beauty, that of symmetry. In Japan, everything that European artists were seeking had already been achieved. It was from Japanese objets d'art that such artists as Oppenort and Meissonier received their decisive inspiration. From Japanese colour prints, Watteau, Lancret and Pater derived their light, sparkling style.

The Japanese made their second appearance in the 1860s, and once again the circumstances were such that their coming was like a revelation. Our artists were looking for a new style in which to show modern life. As long as they had continued to follow the Old Masters in terms of content, they had been able to go on using the same system of line and colours. But as soon as they began to paint contemporary

subjects a discrepancy appeared between gallery tones and reality, between the old rules of composition and the tide of life. Either subjects had simply been juxtaposed in barbaric fashion, or the compositional principles of the Old Masters had been schematically transferred to the new subject-matter, with figures built up into groups and the principal figure neatly erected in the middle.

Now the aim was to arrange the elements of modern life into a picture in such a way that the organizing hand would not be detectable; to compose them, and yet to preserve their multiplicity. The issue of *plein-air* painting had come up. The Pre-Raphaelites had hinted at the artificiality of paintings that looked like 'gravy'; they had shown that one came closer to the truth of Nature by painting as far as possible in distinct, unbroken colours. But the results of their efforts were far from satisfying: a hard chequered appearance of colour with a garish effect. Their conscientious efforts to bring their works to completion had resulted in a dry, dead quality. Life had ossified; to paint the fragrant essence of things, the pulse of Nature, proved beyond them.

The strength of the Japanese lay in all these things. The liveliest colours, the subtlest effects of light were recreated in their colour woodcuts, and yet never painfully bright. Red and green trees, dark skies, glowing lanterns, yellow crescent moons, twinkling stars, white and pink spring blossoms, stark snow on delicate gardens: all this was shown. No discords, anywhere, but always soft, tender, brightly tinkling concords: all was held together by the great harmony, the ultimate object of all painting, that had been achieved by the Pre-Raphaelites not at all and by other artists only by attuning their work to a dark-brown scale. The Japanese led us away from brown and back to the fresh, radiant colours of Nature; they gave us the courage for a new and bold use of colour.

As much as the tonal subtlety, the fresh rightness of the pictures, their witty, tinglingly real organization, was admired. True, a number of artists had already freed themselves from the compositional schema. Constable had painted pictures that showed nothing but clouds and treetops. As early as the 1840s, Adolf Menzel had sometimes ruthlessly cropped through a head, or caused a figure to emerge into the pictorial space from the waist up. But all this seemed fairly tame by comparison with the unprecedented boldness of the Japanese artists. Here was a sense of space that arranged everything as if spontaneously and created an impression of distance. Often there was nothing in the picture but a twig with a bird on it, and yet the eye had the sensation of plunging across great expanses of landscape. Movements, twists and turns that in Europe only the snapshot was to reveal were captured with crisp immediacy.

A new world opened up, so outlandish, and yet so full of beauty, that the craze for Japonisme soon swept Paris. The Japanese taught that the painter's duty was not to give a prosaic depiction of a slice of reality but to operate with few resources, 'suggestively'. They taught that any object can be looked at in countless ways, and that it affords a different impression at every moment. Manet became the *maître impressionniste*. Whistler's miraculous knack of siting things in space goes back to the Japanese artists. Degas began to reproduce those fleeting motions that only the

sharpest eye can see and only the readiest pencil can capture. Spurning all the traditional rules of 'rounding off' and evenness, he created a new compositional principle to give the 'living points' only, following the Japanese. Monet painted his *Haystacks*, as Hokusai his *Hundred Views of Mount Fuji*. In a cycle of fifteen paintings, their motifs identical in terms of drawing, he showed the changes evoked by the hours and the seasons in one and the same piece of nature. The desire to endow paintings with the fresh fragrance and the light, resonant quality of Japanese woodcuts caused pastel and watercolour to come to the fore alongside the fat and greasy medium of oil painting. The colour print led in new directions.

And just as the Japanese provided the starting-point of the Impressionist movement, they also influenced the subsequent tendency towards decorative stylization. For the remarkable thing about this art is that it combines the most varied properties and makes it possible for everyone to derive completely different stimuli from it.

'Among the forms of painting,' wrote the Japanese scholar Shuzen in 1777 (according to Anderson), 'there is a kind that is called naturalistic, and in which it is deemed proper to form flowers and grasses, fishes and insects exactly in accordance with Nature. This is a particular style and is certainly not to be despised. But since it seeks only to show the forms of things, taking no account of the rules of art, it remains merely a commonplace and can make no claim to good taste. In painting in ancient times, the study of the art of outline and the laws of taste were maintained without any painstaking imitation of natural forms.'

These words contain the programme of contemporary European art. Just as they had already taught Europeans the Impressionist approach, the Japanese now taught them decorative design. For, acutely as they approach reality, they never see it simply with the eye of the copyist but with that of the aesthete, who does not seek to collect natural impressions but to arouse a mood through colours. Harmony in the juxtaposition of coloured planes, subordination of colour to decorative ends, the free, symphonic shaping of colouristic values – these are the things that emerged from the renewed study of the Japanese.

A further feature of their work that became important was this: that drawing is never sacrificed to colour. The Impressionists had dissolved all their lines in colour; now artists learned from Japanese prints to create the beauty of perfect balance between colour and drawing; they learned the expressive power of line, reduction to essentials, meaningful abbreviation; they saw that for the sake of the grand, clear overall effect much truth to nature must be sacrificed. The modern caricature, as it has evolved in *Die Jugend* and in *Simplicissimus*, is unthinkable without the Japanese example. The European poster has also come under Japanese influence, and seems to be the harbinger of a new, stylized monumental painting. And that the English Arts and Crafts, with their flower motif, their slender forms and light colours, have also been fertilized by Japan; or that our vases, Gallé's glass and many other things stem from the East, is even less in need of demonstration.

The Secession exhibition might have told us of all these things. It ought to have shown that Japonisme has become a part of our civilization; it ought to have shown

its enduring value as a component of the European artistic heritage. As I have said before, it is no longer enough just to make exhibitions. The matter in hand has to be endowed with meaning; questions of importance for our own artistic life must be brought to the fore.

It is to the credit of the Secession that it has interpreted the purpose of art exhibitions in this sense. Its recent graphic exhibition performed, in an exemplary fashion, its task of presenting a survey of the present-day state of the arts of line. This time, however, we do not gain the impression that matters have been so well planned. The herbarium scent of the museum, not the fresh breath of life, hangs in the air. Even the catalogue itself is a disappointment. For if catalogues have a purpose at all, their function can only be a didactic one. The visitor's interest in the objects on show must be aroused without making him too much aware of the didactic intention. Through familiar comparisons, the unfamiliar must be made comprehensible.

This Secession catalogue has an evil aftertaste of dead scholarship. True, on the very first page the working committee clearly sets out the significance of Japonisme for the contemporary artist. But then Mr Adolf Fischer takes over, and he spends forty-two pages listing the things he has placed on show, telling us that they are of such and such an age, and instructs us on technical matters. To what end? All this knowledge, if one has not got it already, is better acquired at home, from good books, than in an exhibition and from a confusing catalogue. Whether a piece is 'circa 500, circa 400 or circa 300' years old does not matter at all. For the age of collections of rarities is past. We no longer want scraps of knowledge, or textual connoisseurship, but ideas that give life.

And, just as the Secession has printed Mr Fischer's catalogue word for word, it has given him rather more of a free hand in arranging his objects than was good for the overall artistic impression. Seven hundred items are presented. Fewer would have been more. Is it not thoughtless to jumble together screens, bronzes, masks, woodcarvings, lacquer, vases and colour prints without thought of historical coherence? Is it not inept to pile up similar objects, such as sword hilts, in such masses that the eye, after it has looked at a dozen, eventually sees no more than a disc and a hole? The very lesson that the Japanese have taught us – the decorative effect, the artistic shaping of space, that is normally the Secession's great strength – is overwhelmed by a wilderness of particulars. There is a predominance of items that are mere curiosities, with only their age to recommend them; and the pieces that might have exemplified the relation between European and Japanese art are rare. One is left with the impression that the exhibition is not the work of a society of young artists but that of one old collector.

Is this the occasion to set forth all that one knows about Japanese art? The books of Anderson, Gonse, Edmond de Goncourt, Brinckmann and Seidlitz, Bing's serial publication and Muther's history of painting contain more on the subject than any review can offer. Or is one to criticize Mr Fischer's purchasing policy? If the State were the buyer, it would be a duty to stress that much of the material could be bettered by any good dealer in Japanese art. But, as a private man, Mr Fischer can buy whatever he likes. And as he has been kind enough to place his treasures before the

public, it would be a failure of tact to requite his kindness with a discourteous review.

It only remains to say that Koloman Moser has finely tuned the walls to the theme of Japonisme, and that the installation of the objects – as far as the sheer mass of them permits – is commendable. Since the universal exhibition of 1873, Vienna has had no opportunity to become acquainted with Japanese art on any large scale. For this reason, it was worthwhile to place the Fischer collection on display. But the Secession must never again defy the fundamental principle of its programme, which is that any material can spring to life only when informed by a modern spirit.

Richard Muther, *Studien und Kritiken*, Vienna 1900, vol. 1, 41–51

FRANK LLOYD WRIGHT

The Japanese Print

The unpretentious colored wood-cut of Japan, a thing of significant graven lines on delicate paper which has kissed the color from carved and variously tinted wooden blocks, is helpful in the practice of the fine arts, and may be construed with profit in other life-concerns as great.

It is a lesson especially valuable to the West because, in order to comprehend it at all, we must take a viewpoint unfamiliar to us as a people, and in particular to our artists – the purely aesthetic viewpoint. It is a safe means of inspiration for our artists because, while the methods are true methods, the resultant forms are utterly alien to such artistic tradition as we acknowledge and endeavor to make effective.

So, I will neglect the smattering of information as to artists and periods easily obtained from any one[1] of several available works on the subject and try to tell what these colored engravings are in themselves, and more particularly of their cultural use to us, in awakening the artistic conscience, or at least in making us feel the disgrace of not realizing the fact that we have none.

Go deep enough into your experience to find that beauty is in itself the finest kind of morality – ethical, purely – the essential fact, I mean, of all morals and manners – and you may personally feel in these aesthetic abstractions of the Japanese mind the innocent and vivid joy which, by reason of obviously established sentiment, is yours in the flowers of field or garden.

A flower is beautiful, we say – but why? Because in its geometry and in its sensuous qualities it is an embodiment and significant expression of that precious something in ourselves which we instinctively know to be Life, 'An eye looking out upon us from the great inner sea of beauty', a proof of the eternal harmony in the nature of a universe too vast and intimate and real for mere intellect to seize. Intuitively we grasp something of it when we affirm that 'the flower is beautiful'. And when we say, 'It is

[1] *Japanese Color Prints*, Von Seidlitz, best book extant on the subject. *The Masters of Ukioye* and *History of the Ukioye*, Ernest Fennollosa. *Japanese Illustrations*, Dr William Anderson. *Japanese Illustrations* and *Japanese Woodcuts*, E. S. Strange.

beautiful', we mean that the quality in us which is our very life recognizes itself there or at least what is its very own: so there vibrates in us a sympathetic chord struck mystically by the flower. Now, as it is with the flower, so is it with any work of art and to greater degree: because a work of fine art is a blossom of the human soul, and so more humanly intimate. In it we find the lineaments of man's thought and the exciting traces of man's feeling – so to say, the very human touch, offered to us in terms of the same qualities that make us exclaim that the flower is beautiful; and it is this quality of absolute and essential beauty in the result of the artist's creative efforts that is the Life of the work of art, more truly than any literal import or adventitious significance it may possess. But it is the quick, immediate perception of this subjective quality, or rather, perhaps, the ability to perceive it instinctively in the work of art, that is lacking in us – as a people. Failing in this perception we are untouched by the true vitalizing power of art, and remain outside the precincts of the temple, in a realm, literal, objective, realistic, therefore unreal. In art that which is really essential escapes us for lack of a 'disciplined power to see'.

The most important fact to realize in a study of this subject is that, with all its informal grace, Japanese art is a thoroughly structural art; fundamentally so in any and every medium. It is always, whatever else it is or is not, structural. The realization of the primary importance of this element of 'structure' is also at the very beginning of any real knowledge of design. And at the beginning of structure lies always and everywhere geometry. But, in this art, mathematics begins and ends here, as the mathematical begins and ends in music, however organically inherent here as there in the result.

But we have used the word structure, taking for granted that we agreed upon its meaning. The word structure is here used to designate an organic form, an organization in a very definite manner of parts or elements into a larger unity – a vital whole. So, in design, that element which we call its structure is primarily the pure form, as arranged or fashioned and grouped to 'build' the Idea; an idea which must always persuade us of its reasonableness. Geometry is the grammar, so to speak, of the form. It is its architectural principle. But there is a psychic correlation between the geometry of form and our associated ideas which constitutes its symbolic value. There resides always a certain 'spell-power' in any geometric form which seems more or less a mystery, and is, as we say, the soul of the thing. It would carry us far from our subject if we should endeavor to render an accurate, convincing account of the reason why certain geometric forms have come to symbolize for us and potently to suggest certain human ideas, moods and sentiments – as for instance: the circle, infinity; the triangle, structural unity; the spire, aspiration; the spiral, organic progress; the square, integrity. It is nevertheless a fact that more or less clearly in the subtle differentiations of these elemental geometric forms, we do sense a certain psychic quality which we may call the 'spell-power' of the form, and with which the artist freely plays, as much at home with it as the musician at his keyboard with his notes. A Japanese artist grasps form always by reaching underneath for its geometry. No matter how informal, vague, evanescent, the subject he is treating may seem to be, he recognizes and acknowledges

geometry as its aesthetic skeleton; that is to say – not its structural skeleton alone, but – by virtue of what we have termed the symbolic spell-power – it is also the suggestive soul of his work. A Japanese artist's power of geometrical analysis seems little short of miraculous. An essential geometry he sees in everything, only, perhaps, to let it vanish in mystery for the beholder of his finished work. But even so, escaping as it does at first the critical eye, its influence is the more felt. By this grasp of geometric form and sense of its symbol-value he has the secret of getting to the hidden core of reality. However fantastic his imaginative world may be it competes with the actual and subdues it by superior loveliness and human meaning. The forms, for instance, in the pine tree (as of every natural object on earth), the geometry that underlies and constitutes the peculiar pine character of the tree – what Plato meant by the eternal idea – he knows familiarly. The unseen is to him visible. A circle and a straight line or two, rhythmically repeated, prescribe for him its essentials perfectly. He knows its textures and color qualities as thoroughly. Having these by heart, he is master of the pine and builds trees to suit his purpose and feeling, each as truly a pine and a pine only as the one from which he wrung the secret. So, from flying bird to breaking wave, from Fujiyama to a petal of the blossoming cherry afloat upon the stream, he is master, free to create at will. Nor are these forms to him mere spectres, or flimsy guesses – not fictitious semblances, to which he can with impunity do violence. To him they are fundamental verities of structure, pre-existing and surviving particular embodiments in his material world.

What is true of the pine tree, for and by itself, is no less true in the relation of the tree to its environment. The Japanese artist studies pine tree nature not only in its import and bearing but lovingly understands it in its habitat and natural element as well – which, if the geometry be called the grammar, may by equal privilege of figurative speech be termed the syntax. To acquire this knowledge, he devotes himself to the tree, observes analytically yet sympathetically, then leaves it, and with his brush begins to feel for its attitude and intimate relations as he remembers them. He proceeds from visualized generals to definite particulars in this contemplative study and as soon as he has recognized really the first elements constituting the skeleton of the structure, which you may see laid bare in the analysis by Hokusai,[2] his progress in its grammar and syntax is rapid. The Japanese artist, by virtue of the shades of his ancestors, is born a trained observer; but only after a long series of patient studies does he consider that he knows his subject. However, he has naturally the ready ability to seize upon essentials, which is the prime condition of the artist's creative insight. Were all pine trees, then, to vanish suddenly from the earth, he could, from this knowledge, furnish plan and specification for the varied portrayal of a true species – because what he has learned and mastered and made his own is the specific and distinguishing nature of the pine tree. Using this word Nature in the Japanese sense I do not of course mean that outward aspect which strikes the eye as a visual image of a scene strikes the ground glass of a camera, but that inner harmony which penetrates the outward form

[2] A rare set of such analyses by Hokusai was exhibited at the Chicago Woman's Club when this paper was read.

or letter, and is its determining character; that quality in the thing (to repeat what we have said before) that is its significance and its Life for us – what Plato called (with reason, we see, psychological if not metaphysical) the 'eternal idea of the thing'.

We may refer, then, to the nature of a 'proposition' as we do to the nature of an animal, of a plant, of an atmosphere or a building material. Nature, in this sense, is not to be studied much in books. They are little more than the by-product of other men's ideas of the thing, which in order to distill from it his own particular sense of its intrinsic poetry the artist must know at first-hand. This poetry he must find in the thing for himself, the poetry it holds in reserve for him and him alone, and find it by patient, sympathetic study. This brings us to the aesthetics of Japanese art.

Ideas exist for us alone by virtue of form. The form can never be detached from the idea; the means must be perfectly adapted to the end. So in this art the problem of form and style is an organic problem solved easily and finally. Always we find the one line, the one arrangement that will exactly serve. It is a facile art, incapable of adequate analysis, for it is the felicity of an intuitive state of mind and must, on the part of the student, be similarly recognized by intuition.

These simple colored engravings are a language whose purpose is absolute beauty, inspired by the Japanese need of that precise expression of the beautiful, which is to him reality immeasurably more than the natural objects from which he wrested the secret of their being. This expression of the beautiful is inevitable and there inheres in the result that inevitableness which we feel in all things lovely. This process of wood block printing is but one modest medium by means of which he may express his sense of the universal nature of things, and which he justifies in his characteristic, highly expressive fashion.

So, these prints are designs, patterns, in themselves beautiful; and what other meanings they may have are merely incidental, interesting or curious by-products.

Broadly stated then, the first and supreme principle of Japanese aesthetics consists in stringent simplification by elimination of the insignificant, and a consequent emphasis of reality. The first prerequisite for the successful study of this strange art is to fix the fact in mind at the beginning that it is the sentiment of Nature alone which concerns the Japanese artist; the sentiment of Nature as beheld by him in those vital meanings which he alone seems to see and alone therefore endeavors to portray.

The Japanese, by means of this process – to him by this habit of study almost instinctive – casts a glamour over everything. He is a poet. Surely life in Old Japan must have been a perpetual communion with the divine heart of Nature. For Nippon drew its racial inspiration from, and framed its civilization in accord with, a native perception of Nature-law. Nippon made its body of morals and customs a strict conventionalization of her nature forms and processes; and therefore as a whole her civilization became a true work of art. No more valuable object lesson was ever afforded civilization than this instance of a people who have made of their land and the buildings upon it, of their gardens, their manners and garb, their utensils, adornments, and their very gods, a single consistent whole, inspired by a living sympathy with Nature as spontaneous as it was inevitable. To the smallest fraction

of Japanese lives what was divorced from Nature was reclaimed by Art, and so redeemed. And what was the rule thus established progressively in individual and social life, making of it in itself an art – a thing of strange and poignant beauty – dominated all popular art production also and furnished the criterion.

This process of elimination and of the insignificant we find to be the first and most important consideration for artists, after establishing the fundamental mathematics of structure. A Japanese may tell you what he knows in a single drawing, but never will he attempt to tell you all he knows. He is quite content to lay stress upon a simple element, insignificant enough perhaps until he has handled it; then (as we find again and again in the works of Korin and his school) the very slight means employed touches the soul of the subject so surely and intimately that while less would have failed of the intended effect, more would have been profane. This process of simplification is in a sense a dramatization of the subject, just as all Japanese ceremonials are the common offices and functions of their daily life delicately dramatized in little. The tea ceremony is an instance. Nothing more than the most gracefully perfect way of making and serving a cup of tea! Yet, often a more elegant and impressive ceremonial than a modern religious service. To dramatize is always to conventionalize; to conventionalize is, in a sense, to simplify; and so these drawings are all conventional patterns subtly geometrical, imbued at the same time with symbolic value, this symbolism honestly built upon a mathematical basis, as the woof of the weave is built upon the warp. It has little in common with the literal. It is more akin to a delicate musical instrument that needs no dampers or loud pedals. Fleshly shade and materialistic shadow are unnecessary to it, for in itself it is no more than pure living sentiment.

Were we to contrast the spiritual grace of simple wild flowers, with the material richness of doubled varieties under cultivation, we would institute a suggestive comparison of this unpretentious art of the East with the more pretentious art of the West. Where the art of Japan is a poetic symbol, much of ours is attempted realism, that succeeds only in being rather pitifully literal. Where the one is delicately sensuous, the other is only too apt to be stupidly sensual.

This intuition of the Japanese artist for dramatizing his subject is no finer than his touch and tact are unerring. He knows materials and never falsifies them. He knows his tools, and never abuses them. And this, too, just because he apprehends the secret of character at every chance contact with the actual. In the slight wash drawings of the Kakemono, we find a more sheer and delicate manifestation of reserve than in this more popular, and in a sense therefore, more vulgar form of expression. Always latent, however, in the slightest and seemingly most informal designs, in the least of these works as through the greatest, the geometric structure effects a potent spell. No composition can we find not affected by it and that does not bear this psychic spell meanwhile, as if unconscious of its precious burden, its efficient causes enwoven and subtly hid between the lines of its geometric forms. As the poor saint was believed to bear his mystic nimbus, so each humble masterpiece asserts its magic of invisible perfection. Yet, this mystery is conclusively reduced by Japanese masters to its

scientific elements, as exemplified by certain pages of textbooks by Hokusai, wherein the structural diagrams are clearly given, and transformation to material objects shown progressively step by step.

This primitive graphic art, like all true art, has limitations firmly fixed; in this case more narrowly fixed than in any art we know. Strictly within these limitations, however, the fertility and resource of the Japanese mind produced a range of aesthetic inventions that runs the whole gamut of sentiment, besides reproducing with faithfulness the costumes, manners and customs of a unique and remarkable civilization, constituting its most valuable real record, and without violating a single aesthetic tradition.

The faces in these drawings repel the novice and chill the student accustomed to less pure aesthetic abstractions; and the use of the human form in unrealistic fashion has often been explained on the ground of religious scruples. Nothing more than the aesthetic consideration involved is necessary to justify it. The faces in these drawings are 'in place', harmonious with the rest, and one may actually satisfy himself on the subject by observing how the tendency toward realism in the faces portrayed by Kiyonaga and Toyokuni vulgarized results artistically, introducing as they did, this element – no doubt, for the same reason that actors sometimes play to the applauding gallery. The faces as found in the prints of the great period were the Japanese countenance dramatized, to use the term once more. They were masks, conventions, the visual image of the ethnic character of a people varied by each artist for himself. A close student may identify the work of any particular artist by merely ascertaining his particular variation, the print being otherwise totally concealed. And although an actor was portrayed in many different roles, the individuality of the countenance, its character, was held throughout in the mask.

You may never fail to recognize Danjuro in all the various drawings by Shunsho and other artists that he inspired, and you may recognize others when you have made their acquaintance. But the means by which this was accomplished are so slight that the convention is scarcely disturbed, and no realism taints the result. A countenance drawn to please us would vulgarize the whole, for its realism would violate the aesthetic law of the structure. You find something like this typical face in the work of the pre-Raphaelites, Burne-Jones and Rossetti. These are often inanities as distressing as the more legitimate conventions of the Japanese are satisfying, because they were made in a more or less literal setting; the whole being inorganic and inconsistent. You will find something of this conventionalizing tendency employed more consistently and artistically in a Morris prose epic or verse tale, or in Spenser's *Faerie Queene* where raging knightly battles and frightful episodes move quietly remote and sedate across the enchanted reader's field of mental vision, affecting him simply by their picturesque outlines and charm of color, as might an old arras.

The use of color, always in the flat – that is, without chiaroscuro – plays a wonderful but natural part in the production of this art and is responsible largely for its charm. It is a means grasped and understood as perfectly as the rhythm of form and line, and it is made in its way as significant. It affords a means of emphasizing and differentiating

the forms themselves, at the same time that it is itself an element of the pattern. The blacks are always placed flat in the pattern, as pattern for its own sake – a design within a design. Comments are often made on the wonderfully successful use of masses of deep black, but the other colors at their command are used as successfully, according to the same method, to an identical if less emphatic effect.

As we see the prints today, it must be confessed that time has imbued the color with added charm. Old vegetable dyes, saturating and qualified by the soft texture of wonderful silken paper, soften and change with the sunlight of the moist climate, much as the colors in oriental rugs. Blues become beautiful yellows; purples soft browns; beni, or bright red fades to luminous pink; while a certain cool green together with the translucent greys and the brilliant red lead are unchangeable. The tenderness of tone found in fine prints is indescribable. This is, in great part, due to the action of time on the nature of the dye stuffs or pigments employed. When first printed, they were comparatively crude, and much of the credit formerly given by connoisseurs to the printer should be accredited to age. When first printed, also, there was a certain conventionalized symbolism in the use of color, which time confuses. The sky was then usually grey or blue, sometimes yellow; the water blue; grass green; garments polychromatic; woodwork red lead, pink or yellow. Owing to the manner in which the color was brushed upon the block, few prints are exactly alike, and sometimes great liberty was taken with the color by the printer, most interesting differentiations of color occurring in different prints from the same block. In itself, the color element in the Japanese print is delight – an absolute felicity, unrivalled in charm by the larger means employed in more pretentious mediums. The prints afford a liberal education in color values especially related to composition. A perfect color balance is rarely wanting in the final result, and although certain qualities in this result are in a sense adventitious, yet it should be strongly insisted, after all, that the foundation for the miracles of harmonious permutation was properly laid by the artist himself.

In this wedding of color and gracious form, we have finally what we call a good decoration. The ultimate value of a Japanese print will be measured by the extent to which it distills, or rather exhales, this precious quality called 'decorative'. We as a people do not quite understand what that means and are apt to use the term slightingly as compared with art which has supposedly some other and greater mission. I – speaking for myself – do not know exactly what other mission it legitimately could have, but I am sure of this, at least – that the rhythmic play of parts, the poise and balance, the respect the forms pay to the surface treated and the repose these qualities attain to and impart and which together constitute what we call good decoration, are really the very life of all true graphic art whatsoever. In the degree that the print possesses this quality, it is abidingly precious; this quality determines – constitutes, its intrinsic value.

As to the subject matter of the figure pieces, it is true that the stories they tell are mainly of the Yoshiwara, or celebrate the lover and the Geisha, but with an innocence incomprehensible to us; for Japan at that time – although the family was the unit of her civilization – had not made monopoly of the sex relation the shameless essence of

this institution, and the Yoshiwara was the center of the literary and artistic life of the common people. Their fashions were set by the Yoshiwara. The Geisha, whose place in Japanese society was the same as that of the Greek Hetaira, or her ancient Hindu equivalent, as for instance she appears in the Hindu comedy, the 'Little Clay Cart',[3] was not less in her ideal perfection than Aspasia, beloved of Pericles. The Geisha was perhaps the most exquisite product, scandalous as the fact may appear, of an exquisite civilization. She was in society the living Japanese work of art: thoroughly trained in music, literature and the rarest and fairest amenities of life, she was herself the crowning amenity and poetic refinement of their life. This all must recognize and comprehend; else we shall be tempted by false shames and Puritan prejudices to resent the theme of so many of the loveliest among the prints, and by a quite stupid dogmatism disallow our aesthetic delight in their charm. But we have very likely said enough of the print itself; let us pass on to consider what it has already done for us and what it may yet do. We have seen that this art exists – in itself a thing of beauty – inspired by need of expressing the common life in organic terms, having itself the same integrity, considered in its own nature, as the flower. Caught and bodied forth there by human touch is a measure of that inner harmony which we perceive as a proof of goodness and excellence.

It exists, a material means for us to a spiritual end, perhaps more essentially prophetic in function than it was to the people for whom it came into candid and gracious being. It has already spoken to us a message of aesthetic and ethical import. Indeed, its spirit has already entered and possessed the soul and craft of many men of our race and spoken again through them more intimately and convincingly than ever. That message we recognize in more familiar accents uttered by Whistler, Manet, Monet, the 'Plein air' school of France – Puvis de Chavannes, Boutet de Monvel – and through them it has further spread its civilizing, because its conventionalizing, simplifying, clarifying influence to the arts and crafts of the occident on both sides of the Atlantic. Every dead-wall in the land bears witness to the direct or indirect influence of this humble Japanese art of the people; for it has given us what we sometime ago called 'poster art'. Because of it, in England Aubrey Beardsley and his kith lived and wrought. Modern France, the first to discover its charm, has fallen under its spell completely; French art and Parisian fashions feel its influence more from year to year. The German and Austrian secessionist movement owes it a large debt of gratitude. Yet the influence of this art is still young. The German mind has only recently awakened to its significance, and proceeds now with characteristic thoroughness to ends only half discerned. It has spread abroad the gospel of simplification as no other modern agency has preached it, and has taught that organic integrity within the work of art itself is the fundamental law of beauty. Without it work may be a meretricious mask with literal suggestion or sensual effect, not true art. That quality in the work which is 'real' escapes and the would-be artist remains where he belongs – outside the sanctuary. The print has shown us that no more than

[3] Note: Translated in the Harvard Oriental Series.

a sand bank and the sea, or a foreground, a telegraph pole and a weed in proper arrangement, may yield a higher message of love and beauty, a surer proof of life than the sentimentality of Raphael or Angelo's magnificent pictorial sculpture. Chaste and delicate, it has taught that healthy and wholesome sentiment has nothing in common with sentimentality, nor sensuous feeling with banal sensuality; that integrity of means to ends is in art indispensable to the poetry of so-called inspired results; and that the inspiring life of the work of art consists and inheres, has its very breath and creative being within the work itself; an integrity, in fine, as organic as anything that grows in the great out-of-doors.

Owing to its marked ethnic eccentricity, this art is a particularly safe means of cultivation for us, because the individual initiative of the artist is not paralyzed by forms which he can use as he finds them, ready made. It may become most useful on this very account, as a corrector of the fatal tendency to imitation – be the antidote to the very poison it might administer to the weak and unwary – to that corrupting, stultifying, mechanical parasitism that besets and betrays so often to his ruin, in these days of hustle and drive, the eager and ambitious artist. For the architect, particularly, it is a quickening inspiration, without attendant perils, owing to its essentially structural character and diverse materials and methods. To any and all artists it must offer great encouragement, because it is so striking a proof of the fact readily overlooked – that to the true artist his limitations are always, if but understood and rightly wooed, his most faithful and serviceable friends.

If, then, there is a culture we might acquire whereby the beautiful may be apprehended as such and help restore to us the fine instinctive perception of and worship for the beautiful which should be our universal birthright instead of the distorted ideas, the materialistic perversions of which we are victims, we assuredly want to know what it is and just how it may be had. Nothing at this moment can be of greater importance to us educationally. For the laws of the beautiful are immutable as those of elementary physics. No work sifted by them and found wanting can be a work of art. The laws of the beautiful are like the laws of physics, not derived from external authority, nor have they regard to any ulterior utility. They preexist any perception of them; inhere, latent and effective, in man's nature and his world. They are not made by any genius, they are perceived first by the great artist and then revealed to mankind in his works. All varieties of form, line or color, all tendencies in any direction have, besides what value they may have acquired by virtue of the long cultural tradition recounting back to prehistoric man, a natural significance and inevitably express something. As these properties are combined, arranged and harmonized, expression is gained and modified. Even a discord is in a sense an expression – an expression of the devil or of decay. But the expression we seek and need is that of harmony or of the good: known otherwise as the true, often spoken of as the beautiful, and personified as God. It is folly to say that if the ear can distinguish a harmonious combination of sounds, the eye cannot distinguish a harmonious combination of tones or shapes or lines. For in the degree that the ear is sensitive to sound – to the extent that it can appreciate the harmony of tones – in even a larger

degree the eye will see and appreciate, if duly trained to attend them, the expression of harmonies in form, line and color purely as such; and it is exactly harmonies of this kind, merely, which we find exemplified and exquisitely elucidated in Japanese prints.

Rhythmical and melodious combinations of tone otherwise only 'noise' have portrayed the individualities of great souls to us – a Bach, Beethoven or a Mozart; and while the practice of no musical rule of three could compass their art or sound the depths of their genius, there are definite laws of harmony and structure common to their art which are well known and systematically taught and imparted. So the mysterious impress of personality is revealed in certain qualities of this unpretentious art, as any even cursory observer must note, in the works of Harunobu, Shunsho, Kiyonaga, Hokusai, and Hiroshige.

The principles underlying and in a sense governing the expression of personal feeling and the feeling of personality as expressed in these prints, or for the matter of that in any veritable work of art, have now been clearly formulated anew for many of us by assiduous study of their works. Questions of aesthetics may no longer be so readily referred to with flippancy, as mere negligible 'matters of taste'. Aside from their ethnic character – the fact that the individuality of these expressions may be but the color, so to say, of some Japanese artist's soul – such expressions do convey an ideal of the conditions they seek to satisfy, for the simple reason that the expression was the sought and wrought response to spiritual need, which nothing less or else could satisfy. Just as Beethoven at his keyboard imposed upon tone the character of his soul, so by these simple colored drawings a similar revelation is achieved by the Japanese artist through the medium of dye stuffs and graven lines applied to sensitive paper, putting together its elements of expression in accord with brain and heart, attaining to beauty as a result in so far as the artist was true to the limitations imposed upon him by the nature of the means he employed. He might merely characterize his subject and possess little more than the eye of the great craftsman; or he might idealize it according to the realizing insight of the great artist; but in either case to the degree that the colors and lines were true to material and means delightfully significant of the idea, the result would be a creative work of art.

Now, all the while, just as in any musical composition, a conventionalizing process would be going on. To imitate that natural modeling of the subject in shade and shadow – to render realistically its appearance and position – would require certain dexterity of hand and a mechanic's eye certainly. But in the artist's mind there was a living conception at work – the idea; the revelation of the vision by means of the brush and dye stuffs and paper applied to engraved wooden blocks, with strict regard and devout respect for the limitations of materials, and active sympathy making all eloquent together; eloquent, however, in their own peculiar fashion as graven lines on sensitive paper which has received color from the variously tinted blocks and wherein this process is frankly confessed: the confession itself becoming a delightful poetic circumstance. There results from all this a peculiar, exquisite language not literature telling a story regardless of the conditions of its structure. For a picture

should be no imitation of anything, no pretended hole in the wall through which you glimpse a story about something, or behold winter in summer or summer in winter. 'Breaking Home Ties', for instance, or any of its numerous kith and kin cannot be dignified as art. There are many degrees of kinship to 'Breaking Home Ties' not so easy to detect, yet all of which bear the marks of vulgar pretense. The message of the Japanese print is to educate us spiritually for all time beyond such banality.

Not alone in the realm of the painter is the message being heeded, but also in that of the musician, the sculptor and the architect.

In sculpture the antithesis of the lesson is found in the 'Rogers Groups'; literal replicas of incidents that as sculpture are only pitiful. Sculpture has three dimensions, possibilities of mass and silhouette, as well as definite limitations peculiar to itself. To disregard them is death to art. The Venus, the Victory, classics living in our hearts today, and a long list of noble peers, are true sculpture. But the slavish making of literature has cursed both painter and sculptor. They have been tempted to make their work accomplish what literary art may achieve so much better – forcing their medium beyond its limits to its utter degradation. And this is as true of decorative art and in a sense true of architecture. General principles deduced from this popular art of the Japanese apply readily to these problems of right aesthetic conventionalization of natural things, revealing the potential poetry of nature as it may be required to make them live in the arts. This culture of the East therefore brings to us of the West invaluable aid in the process of our civilization. We marvel, with a tinge of envy, at the simple inevitableness with which the life-principle in so slight a thing as a willow wand will find fullness of expression as a willow tree – a glorious sort of completeness – with that absolute repose which is as of a destiny fulfilled. Inevitably the secret of the acorn is the glory of the oak. The fretted cone arises as the stately pine, finding the fullness of a destined life in untrammeled expression of its life-principle simply, naturally and beautifully. Then we go to Nature that we may learn her secret, to find out that there has been laid upon us an artificiality that often conceals and blights our very selves, and in mere course of time and the false education of our mistaken efforts, deforms past recognition the life-principle originally implanted in us for our personal growth as men and our expressive function as artists.

We find and feel always in Nature herself from zero to infinity, an accord of form and function with life-principle that seems to halt only with our attempted domestication of the infinite. Society seems to lose or at least set aside some rare and precious quality in domesticating or civilizing – no – that is, in this conventionalizing process of ours which we choose to call civilization. Striving for freedom we gain friction and discord for our pains. The wisest savants and noblest poets have therefore gone direct to Nature for the secret. There they hoped against hope to find the solution of this maddening, perplexing problem; the right ordering of human life. But however much we may love oak or pine in a state of nature their freedom is not for us. It belongs to us no longer, however much the after-glow of barbarism within us may yearn for it. Real civilization means for us a right conventionalizing of our original state of nature. Just such conventionalizing as the true artist imposes on natural forms.

The lawgiver and reformer of social customs must have, however, the artist soul, the artist eye in directing this process, if the light of the race is not to go out. So, art is not alone the expression, but in turn must be the great conservator and transmitter of the finer sensibilities of a people. More still: it is to show those who may understand just where and how we shall bring coercion to bear upon the material of human conduct. So the indigenous art of a people is their only prophecy and their true artists their school of anointed prophets and kings. It is so now more than ever before because we are further removed from Nature as an original source of inspiration. Our own art is the only light by which this conventionalizing process we call 'civilization' may eventually make its institutions harmonious with the fairest conditions of our individual and social life.

I wish I might use another word than 'conventionalizing' to convey the notion of this magic of the artist mind, which is the constant haunting reference of this paper, because it is the perpetual insistent suggestion of this particular art we have discussed. Only an artist, or one with genuine artistic training, is likely, I fear, to realize precisely what the word means as it is used here. Let me illustrate once more. To know a thing, what we can really call knowing, a man must first love the thing, which means that he can sympathize vividly with it. Egypt thus knew the lotus, and translated the flower to the dignified stone forms of her architecture. Such was the lotus conventionalized. Greece knew and idealized the acanthus in stone translations. Thus was the acanthus conventionalized. If Egypt or Greece had plucked the lotus as it grew, and given us a mere imitation of it in stone, the stone forms would have died with the original. In translating, however, its very life's principle into terms of stone well adapted to grace a column capital, the Egyptian artist made it pass through a rarefying spiritual process, whereby its natural character was really intensified and revealed in terms of stone adapted to an architectural use. The lotus gained thus imperishable significance; for the life-principle in the flower is transmuted in terms of building stone to idealize a need. This is conventionalization. It is reality because it is poetry. As the Egyptian took the lotus, the Greek the acanthus, and the Japanese every natural thing on earth, and as we may adapt to our highest use in our own way a natural flower or thing – so civilization must take the natural man to fit him for his place in this great piece of architecture we call the social state. Today, as centuries ago, it is the prophetic artist eye that must reveal this natural state thus idealized, conventionalized harmoniously with the life-principle of all men. How otherwise shall culture be discerned? All the wisdom of science, the cunning of politics and the prayers of religion can but stand and wait for the revelation – awaiting at the hands of the artist 'conventionalization', that free expression of life-principle which shall make our social living beautiful because organically true. Behind all institutions or dogmatic schemes, whatever their worth may be, or their venerable antiquity, – behind them all is something produced and preserved for its aesthetic worth; the song of the poet, some artist vision, the pattern seen in the mount.

Now speaking a language all the clearer because not native to us, beggared as we are by material riches, the humble artist of old Japan has become greatly significant

as interpreter of the one thing that can make the concerns, the forms, of his everyday life – whether laws, customs, manners, costumes, utensils or ceremonials – harmonious with the life principle of his race – and so living native forms, humanly significant, humanly joy giving – an art, a religion, as in ever varied moods, in evanescent loveliness he has made Fujiyama – that image of man in the vast – the God of Nippon.

> Frank Lloyd Wright: *The Japanese Print.*
> *An Interpretation*, New York 1912
> [new edn 1967], 3–32, 65–8

SERGEI EISENSTEIN

The cinematographic principle and the ideogram

It is a weird and wonderful feat to have written a pamphlet on something that in reality does not exist. There is, for example, no such thing as a cinema without cinematography. And yet the author of the pamphlet preceding this essay[1] has contrived to write a book about the *cinema* of a country that has no *cinematography*. About the cinema of a country that has, in its culture, an infinite number of cinematographic traits, strewn everywhere with the sole exception of – its cinema.

This essay is on the cinematographic traits of Japanese culture that lie outside the Japanese cinema, and is itself as apart from the preceding pamphlet as these traits are apart from the Japanese cinema.

Cinema is: so many corporations, such and such turnover of capital, so and so many stars, such and such dramas.

Cinematography is, first and foremost, montage.

The Japanese cinema is excellently equipped with corporations, actors, and stories. But the Japanese cinema is completely unaware of montage. Nevertheless the principle of montage can be identified as the basic element of Japanese representational culture.

Writing – for their writing is primarily representational.

The hieroglyph.

The naturalistic image of an object, as portrayed by the skilful Chinese hand of Ts'ang Chieh 2650 years before our era, becomes slightly formalized and, with its 539 fellows, forms the first 'contingent' of hieroglyphs. Scratched out with a stylus on a slip of bamboo, the portrait of an object maintained a resemblance to its original in every respect.

But then, by the end of the third century, the brush is invented. In the first century after the 'joyous event' (A.D.) – paper. And, lastly, in the year 220 – India ink.

A complete upheaval. A revolution in draughtsmanship. And, after having undergone in the course of history no fewer than fourteen different styles of handwriting,

[1] Eisenstein's essay was originally published as an 'afterword' to N. Kaufman's pamphlet, *Japanese Cinema* (Moscow, 1929).

the hieroglyph crystallized in its present form. The means of production (brush and India ink) determined the form.

The fourteen reforms had their way. As a result:

In the fierily cavorting hieroglyph *ma* (a horse) it is already impossible to recognize the features of the dear little horse sagging pathetically in its hindquarters, in the writing style of Ts'ang Chieh, so well-known from ancient Chinese bronzes.

But let it rest in the Lord, this dear little horse, together with the other 607 remaining *hsiang cheng* symbols – the earliest extant category of hieroglyphs.

The real interest begins with the second category of hieroglyphs – the *huei-i*, i.e., 'copulative'.

The point is that the copulation (perhaps we had better say, the combination) of two hieroglyphs of the simplest series is to be regarded not as their sum, but as their product, i.e. as a value of another dimension, another degree; each, separately, corresponds to an *object*, to a fact, but their combination corresponds to a *concept*. From separate hieroglyphs has been fused – the ideogram. By the combination of two 'depictables' is achieved the representation of something that is graphically undepictable.

For example: the picture for water and the picture of an eye signifies 'to weep'; the picture of an ear near the drawing of a door = 'to listen';

a dog + a mouth = 'to bark';

a mouth + a child = 'to scream';

a mouth + a bird = 'to sing';

a knife + a heart = 'sorrow,' and so on.

But this is – montage!

Yes. It is exactly what we do in the cinema, combining shots that are *depictive*, single in meaning, neutral in content – into *intellectual* contexts and series.

This is a means and method inevitable in any cinematographic exposition.

. . .

It is uncertain in Japanese writing whether its predominating aspect is as a system of characters (denotative), or as an independent creation of graphics (depictive). In any case, born of the dual mating of the depictive by method, and the denotative by

purpose, the ideogram continued both these lines (not consecutive historically but consecutive in principle in the minds of those developing the method).

Not only did the denotative line continue into literature, in the *tanka*, as we have shown, but exactly the same method (in its depictive aspect) operates also in the most perfect examples of Japanese pictorial art.

Sharaku – creator of the finest prints of the eighteenth century, and especially of an immortal gallery of actors' portraits. The Japanese Daumier. Despite this, almost unknown to us. The characteristic traits of his work have been analyzed only in our century. One of these critics, Julius Kurth, in discussing the question of the influence on Sharaku of sculpture, draws a parallel between his wood-cut portrait of the actor Nakayama Tomisaburō and an antique mask of the semi-religious Nō theater, the mask of a Rozo.

The faces of both the print and the mask wear an *identical expression*. ... Features and masses are similarly arranged although the mask represents an old priest, and the print a young woman. This relationship is striking, yet these two works are otherwise totally dissimilar; this in itself is a demonstration of Sharaku's originality. While the carved mask was constructed according to fairly accurate anatomical proportions, the proportions of the portrait print are simply impossible. The space between the eyes comprises a width that makes mock of all good sense. The nose is almost twice as long in relation to the eyes as any normal nose would dare to be, and the chin stands in no sort of relation to the mouth; the brows, the mouth, and every feature – is hopelessly misrelated. *This observation may be made in all the large heads by Sharaku.* That the artist was unaware that all these proportions are false is, of course, out of the question. It was with a full awareness that he repudiated normalcy, and, while the drawing of the separate features depends on severely concentrated naturalism their proportions have been subordinated to purely intellectual considerations. *He set up the essence of the psychic expression as the norm for the proportions of the single features.*

Is not this process that of the ideogram, combining the independent 'mouth' and the dissociated symbol of 'child' to form the significance of 'scream'?

Is this not exactly what we of the cinema do temporally, just as Sharaku in simultaneity, when we cause a monstrous disproportion of the parts of a normally

flowing event, and suddenly dismember the event into 'close-up of clutching hands', 'medium shots of the struggle', and 'extreme close-up of bulging eyes', in making a montage disintegration of the event in various planes? In making an eye twice as large as a man's full figure?! By combining these monstrous incongruities we newly collect the disintegrated event into one whole, but in *our* aspect. According to the treatment of our relation to the event.

The disproportionate depiction of an event is organically natural to us from the beginning. Professor Luriya, of the Psychological Institute in Moscow, has shown me a drawing by a child of 'lighting a stove'. Everything is represented in passably accurate relationship and with great care. Firewood. Stove. Chimney. But what are those zigzags in that huge central rectangle? They turn out to be – matches. Taking into account the crucial importance of these matches for the depicted process, the child provides a proper scale for them.[1]

The representation of objects in the actual (absolute) proportions proper to them is, of course, merely a tribute to orthodox formal logic. A subordination to an inviolable order of things.

Both in painting and sculpture there is a periodic and invariable return to periods of the establishment of absolutism. Displacing the expressiveness of archaic disproportion for regulated 'stone tables' of officially decreed harmony.

Absolute realism is by no means the correct form of perception. It is simply the function of a certain form of social structure. Following a state monarchy, a state uniformity of thought is implanted. Ideological uniformity of a sort that can be developed pictorially in the ranks of colors and designs of the Guards regiments ...

Thus we have seen how the principle of the hieroglyph – 'denotation by depiction' – split in two: along the line of its purpose (the principle of 'denotation'), into the principles of creating literary imagery; along the line of its method of realizing this purpose (the principle of 'depiction'), into the striking methods of expressiveness used by Sharaku.[2]

And, just as the two outspreading wings of a hyperbola meet, as we say, at infinity (though no one has visited so distant a region!), so the principle of hieroglyphics, infinitely splitting into two parts (in accordance with the function of symbols),

[1] It is possible to trace this particular tendency from its ancient, almost pre-historical source ('... in all ideational art, objects are given size according to their importance, the king being twice as large as his subjects, or a tree half the size of a man when it merely informs us that the scene is out-of-doors. Something of this principle of size according to significance persisted in the Chinese tradition. The favourite disciple of Confucius looked like a little boy beside him and the most important figure in any group was usually the largest') through the highest development of Chinese art, parent of Japanese graphic arts: '... natural scale always had to bow to pictorial scale ... size according to distance never followed the laws of geometric perspective but the needs of the design. Foreground features might be diminished to avoid obstruction and overemphasis, and far distant objects, which were too minute to count pictorially, might be enlarged to act as a counterpoint to the middle distance or foreground.'

[2] It has been left to James Joyce to develop in *literature* the depictive line of the Japanese hieroglyph. Every word of Kurth's analysis of Sharaku may be applied, neatly and easily, to Joyce.

unexpectedly unites again from this dual estrangement, in yet a fourth sphere – in the theater.

Estranged for so long, they are once again – in the cradle period of the drama – present in a *parallel* form, in a curious dualism.

The *significance* (denotation) of the action is effected by the reciting of the *Joruri* by a voice behind the stage – the *representation* (depiction) of the action is effected by silent marionettes on the stage. Along with a specific manner of movement this archaism migrated into the early Kabuki theater, as well. To this day it is preserved, as a partial method, in the classical repertory (where certain parts of the action are narrated from behind the stage while the actor mimes).

But this is not the point. The most important fact is that into the technique of acting itself the ideographic (montage) method has been wedged in the most interesting ways.

. . .

So, montage is conflict.

As the basis of every art is conflict (an 'imagist' transformation of the dialectical principle). The shot appears as the *cell* of montage. Therefore it also must be considered from the viewpoint of *conflict*.

Conflict within the shot is potential montage, in the development of its intensity shattering the quadrilateral cage of the shot and exploding its conflict into montage impulses *between* the montage pieces. As, in a zigzag of mimicry, the *mise-en-scène* splashes out into a spatial zigzag with the *same* shattering. As the slogan, 'All obstacles are vain before Russians,' bursts out in the multitude of incident of *War and Peace*.

If montage is to be compared with something, then a phalanx of montage pieces, of shots, should be compared to the series of explosions of an internal combustion engine, driving forward its automobile or tractor: for, similarly, the dynamics of montage serve as impulses driving forward the total film.

Conflict within the frame. This can be very varied in character: it even can be a conflict in – the story. As in the 'prehistoric' period in films (although there are plenty of instances in the present, as well), when entire scenes would be photographed in a single, uncut shot. This, however, is outside the strict jurisdiction of the film-form.

These are the 'cinematographic' conflicts within the frame:

Conflict of graphic directions.

> *(Lines – either static or dynamic)*

Conflict of scales.
Conflict of volumes.
Conflict of masses.

> *(Volumes filled with various intensities of light)*

Conflict of depths.

And the following conflicts, requiring only one further impulse of intensification before flying into antagonistic pairs of pieces:

Close shots and long shots.

Pieces of graphically varied directions. Pieces resolved in volume, with pieces resolved in area.

Pieces of darkness and pieces of lightness.

And lastly, there are such unexpected conflicts as:

Conflicts between an object and its dimension – and conflicts between an event and its duration.

These may sound strange, but both are familiar to us. The first is accomplished by an optically distorted lens, and the second by stop-motion or slow-motion.

The compression of all cinematographic factors and properties within a single dialectical formula of conflict is no empty rhetorical diversion.

We are now seeking a unified system for methods of cinematographic expressiveness that shall hold good for all its elements. The assembly of these into series of common indications will solve the task as a whole.

Experience in the separate elements of the cinema cannot be absolutely measured.

Whereas we know a good deal about montage, in the theory of the shot we are still floundering about amidst the most academic attitudes, some vague tentatives, and the sort of harsh radicalism that sets one's teeth on edge.

To regard the frame as a particular, as it were, molecular case of montage makes possible the direct application of montage practice to the theory of the shot.

And similarly with the theory of lighting. To sense this as a collision between a stream of light and an obstacle, like the impact of a stream from a fire-hose striking a concrete object, or of the wind buffeting a human figure, must result in a usage of light entirely different in comprehension from that employed in playing with various combinations of 'gauzes' and 'spots.'

Thus far we have one such significant principle of conflict: *the principle of optical counterpoint.*

And let us not now forget that soon we shall face another and less simple problem in counterpoint: *the conflict in the sound film of acoustics and optics.*

Let us return to one of the most fascinating of optical conflicts: the conflict between the frame of the shot and the object!

The camera position, as a materialization of the conflict between organizing logic of the director and the inert logic of the object, in collision, reflects the dialectic of the camera-angle.

In this matter we are still impressionistic and lacking in principle to a sickening degree. Nevertheless, a sharpness of principle can be had in the technique of this, too. The dry quadrilateral, plunging into the hazards of nature's diffuseness ...

And once again we are in Japan! For the cinematographic method is used in teaching drawing in Japanese schools.

What is our method of teaching drawing? Take any piece of white paper with four corners to it. Then cram onto it, usually even without using the edges (mostly greasy from the long drudgery!), some bored caryatid, some conceited Corinthian capital, or a plaster Dante (not the magician performing at the Moscow Hermitage, but the other one – Alighieri, the comedy writer).

The Japanese approach this from a quite different direction: Here's the branch of

a cherry-tree. And the pupil cuts out from this whole, with a square, and a circle, and a rectangle – composition units:

He frames a shot!

These two ways of teaching drawing can characterize the two basic tendencies struggling within the cinema of today. One – the expiring method of artificial spatial organization of the event in front of the lens. From the 'direction' of a sequence, to the erection of a Tower of Babel in front of the lens. The other – a 'picking-out' by the camera: organization by means of the camera. Hewing out a piece of actuality with the ax of the lens.

However, at the present moment, when the centre of attention is finally beginning, in the intellectual cinema, to be transferred from the materials of cinema, as such, to 'deductions and conclusions,' to 'slogans' based on the material, both schools of thought are losing distinction in their differences and can quietly blend into a synthesis.

Several pages back we lost, like an overshoe in a street-car, the question of the theater. Let us turn back to the question of methods of montage in the Japanese theater, particularly in acting.

The first and most striking example, of course, is the purely cinematographic method of 'acting without transitions.' Along with mimic transitions carried to a limit of refinement, the Japanese actor uses an exactly contrary method as well. At a certain moment of his performance he halts; the black-shrouded *kurogo* obligingly conceals him from the spectators. And lo! – he is resurrected in a new make-up. And in a new wig. Now characterizing another stage (degree) of his emotional state.

Thus, for example, in the Kabuki play *Narukami*, the actor Sadanji must change from drunkenness to madness. This transition is solved by a mechanical cut. And a change in the arsenal of grease-paint colors on his face, emphasizing those streaks whose duty it is to fulfil the expression of a higher intensity than those used in his previous make-up.

This method is organic to the film. The forced introduction into the film, by European acting traditions, of pieces of 'emotional transitions' is yet another influence forcing the cinema to mark time. Whereas the method of 'cut' acting makes possible the construction of entirely new methods. Replacing one changing face with a whole scale of facial types of varying moods affords a far more acutely expressive result than

does the changing surface, too receptive and devoid of organic resistance, of any single professional actor's face.

In our new film [*Old and New*] I have eliminated the intervals between the sharply contrasting polar stages of a face's expression. Thus is achieved a greater sharpness in the 'play of doubts' around the new cream separator. Will the milk thicken or no? Trickery? Wealth? Here the psychological process of mingled faith and doubt is broken up into its two extreme states of joy (confidence) and gloom (disillusionment). Furthermore, this is sharply emphasized by light – illumination in no wise conforming to actual light conditions. This brings a distinct strengthening of the tension.

Another remarkable characteristic of the Kabuki theater is the principle of 'disintegrated' acting. Shocho, who played the leading female rôles in the Kabuki theater that visited Moscow, in depicting the dying daughter in *Yashaō* (*The Mask-Maker*), performed his rôle in pieces of acting completely detached from each other: Acting with only the right arm. Acting with one leg. Acting with the neck and head only. (The whole process of the death agony was disintegrated into solo performances of each member playing its own rôle: the rôle of the leg, the rôle of the arms, the rôle of the head.) A breaking-up into shots. With a gradual shortening of these separate, successive pieces of acting as the tragic end approached.

Freed from the yoke of primitive naturalism, the actor is enabled by this method to fully grip the spectator by 'rhythms,' making not only acceptable, but definitely attractive, a stage built on the most consecutive and detailed flesh and blood of naturalism.

Since we no longer distinguish in principle between questions of shot-content and montage, we may here cite a third example:

The Japanese theater makes use of a slow tempo to a degree unknown to our stage. The famous scene of hari-kiri in *Chushingura* is based on an unprecedented slowing down of all movement – beyond any point we have ever seen. Whereas, in the previous example, we observed a disintegration of the transitions between movements, here we see disintegration of the process of movement, viz., slow-motion. I have heard of only one example of a thorough application of this method, using the technical possibility of the film with a compositionally reasoned plan. It is usually employed with some purely pictorial aim, such as the 'submarine kingdom' in *The Thief of Bagdad*, or to represent a dream, as in *Zvenigora*. Or, more often, it is used simply for formalist jackstraws and unmotivated camera mischief as in Vertov's *Man with the Movie-Camera*. The more commendable example appears to be in Jean Epstein's *La chute de la Maison Usher* – at least according to the press reports. In this film, normally acted emotions filmed with a speeded-up camera are said to give unusual emotional pressure by their unrealistic slowness on the screen. If it be borne in mind that the effect of an actor's performance on the audience is based on its identification by each spectator, it will be easy to relate both examples (the Kabuki play and the Epstein film) to an identical causal explanation. The intensity of perception increases as the didactic process of identification proceeds more easily along a disintegrated action.

Even instruction in handling a rifle can be hammered into the tightest motor-

mentality among a group of raw recruits if the instructor uses a 'break-down' method.

The most interesting link of the Japanese theater is, of course, its link with the sound film, which can and must learn its fundamentals from the Japanese – the reduction of visual and aural sensations to a common physiological denominator.

So, it has been possible to establish (cursorily) the permeation of the most varied branches of Japanese culture by a pure cinematographic element – its basic nerve, montage.

And it is only the Japanese cinema that falls into the same error as the 'leftward drifting' Kabuki. Instead of learning how to extract the principles and technique of their remarkable acting from the traditional feudal forms of their materials, the most progressive leaders of the Japanese theater throw their energies into an adaptation of the spongy shapelessness of our own 'inner' naturalism. The results are tearful and saddening. In its cinema Japan similarly pursues imitations of the most revolting examples of American and European entries in the international commercial film race.

To understand and apply her cultural peculiarities to the cinema, this is the task of Japan! Colleagues of Japan, are you really going to leave this for us to do? [1929]

<div align="right">

Afterword to N. Kaufman,
Yaponskoe Kino, Moscow, 1929.
Ed. and tr. Jay Leyda,
New York and London [1951]
1964, 28–44

</div>

ALBERT C. BARNES

Matisse and the Japanese tradition

The principal and most direct Oriental influence upon Matisse seems to have been that of Japanese prints. Two circumstances probably explain this influence: first, Matisse is by nature a decorator and a colorist with a predilection for strange colors and bizarre combinations; second, at the beginning of his career, Japanese prints, screens and fans were the vogue in France, and had been drawn upon by many of the most important artists of the nineteenth century for decorative elements which became firmly embedded in the impressionist and post-impressionist traditions. Actual Japanese prints and fans are frequently reproduced in the work of Manet, Whistler, van Gogh, and many others; and decorative features characteristic of the Japanese abound in Degas and Gauguin, and occur, though less frequently, in Renoir, Cézanne and their contemporaries. This was a genuine assimilation of the fundamental plastic principles of the Oriental tradition; it swung the pendulum away from Courbet and his antecedents and introduced the Oriental element into the art of the era established by the painters of about 1870. It was into this congenial environment that Matisse was born, and it was to the Oriental strain that his own psychological temperament most naturally responded. An estimate of the value of his achievements in this field may be best undertaken by a brief consideration of the characteristics of Japanese

prints, some of which they share with other forms of Oriental art, and of the debt owed them by the important painters of the late nineteenth century.

Among the outstanding features of Japanese prints are the following: highly decorative design; vivid contrasts of bright and light colors; extensive use of black in lines and in areas; contrast of coloured and blank areas; patchwork organization of color-areas; simplified drawing; miniature-quality; fine, continuous, clean-cut linear arabesques; watercolour quality of color, profusion of decorative motifs.

The degree of Japanese influence in the work of the painters of 1870 and later is an index of each man's general interest and of his creative ability. In Whistler, for example, the Japanese elements stand out as eclectic devices and specious decoration. Degas, a much greater artist, owes to the Japanese the quality of his arabesques and much of the decorative character of his linear elements; minor influences from the same source are perceptible in his compositional grouping, in the pose of his figures, and in his selection of subject-matter. In most of Manet's work the predominance of Velásquez's and Hals's influences tends to obscure the Japanese character which is often pervasive and generalized, but is also specifically apparent in the decorative simplified drawing, in the use of black, in the flat color-areas which help to convert volumes into silhouettes, and sometimes in the specious resort to actual Japanese objects, such as fans and prints. Van Gogh at times made the actual reproduction of Japanese prints fit well into his decorative design, and he also made a legitimate plastic use of such Japanese traits as the chirographic linear arabesques, the arabesque arrangement of floral decoration in the background and, more pervasively but less frequently, the tones and relations of colour. In Gauguin, the Japanese feeling is more a flavor, and is due to the exotic quality of his color and his quasi-arabesque patterns. In Monet, Sisley and Renoir, a Japanese strain is likewise indicated by the frequency of fluid arabesques, decorative lines, and the homogeneity of color in foreground, middle ground and distance, though in them the influences have been so thoroughly assimilated that the Japanese thread is barely perceptible in the general fabric.

More than any of the foregoing, Matisse, because of his intense interest in bold decoration and exotic color, responded naturally and inevitably to the influence of Japanese prints. None of the Japanese characteristics is reproduced literally but many are unmistakably recognizable as ingredients in a new form. The influence is apparent in his work of all stages but more constantly, and as a leaven to more numerous and more complex and varied decorative ideas, in his later work. The identifying marks of the influence are found in the daring contrasts between exotic colors, the prevalence of linear patterns and the decorative treatment of space and composition.

Many characteristics of Matisse's color separate him from the impressionists and ally him to the Japanese. His color is less solid, more on the surface than the impressionists', it is brighter and more vivid, it lacks the fluidity of tone that makes colour-chords, it is set in more positive and vivid contrasts, and it appears in bolder and more definite patterns. The Japanese strain in his color comes occasionally from the light delicate tones of the early prints but more frequently from the later type with gaudy colors, so popular in Paris towards the end of the nineteenth century. The

color-relationships in both the early and late prints are repeated by Matisse in color-ensembles sometimes very close to the originals. Point by point comparison between a late print and a painting by Matisse shows that both are compositions of color-compartments characterized by daring contrasts between exotic colors and by the prevalence of bands, stripes and arabesques. More specifically, almost identical tones of blue, green, lavender-coral, yellow, tan, gray, rose and brown enter into similar relationships in each; Matisse's thin washes of paint almost reproduce the tonal lightness and delicacy of the print; the screen in the painting, divided into sections to give the effect of paneling, is not unlike the banded background of the print. With all these points of similarity, however, in their totality the two are completely distinguished: the colors are used in different proportions in each, and the principal tone in the Matisse is a lavender-rose, in the print, a bright green. Similar parallels between paintings by Matisse and Japanese prints which have close resemblances in detail but equally significant differences in total form could be multiplied almost indefinitely.

Besides the color-tones and relations which Matisse takes from Japanese prints, he incorporates in his form several other of their distinctive characteristics. As in Japanese prints, areas of dull color with arid surface are frequently introduced in an ensemble dominated by bright and vivid colors without diminishing the appeal of the color-effect as a whole. Areas of either solid or attenuated black, and effects of dramatic black-and-white contrast occur both in Matisse and the Japanese prints, and in both they are focal in the rhythmic organization of the picture. In the prints the black areas are either flat or uniform or striated with fine, closely-paralleled curves of lighter tone; in Matisse their execution is practically always in the manner of Manet, as is sometimes too their rich and luminous tone-quality. Notwithstanding all these points of resemblance, the color-ensembles of Matisse acquire an identity of their own by changes in the quality of the color and in the manner of this application. His color is usually brighter and more animated because of the sensuous quality of the pigment; color-areas are made less bleak by their internal lighting and brushwork; contrasts are more vivid, and color-patterns bolder and more striking. The difference in color-effect is due also in part to the thicker pigment in Matisse's paintings and to his accentuated spots of sunlight alternating with the relatively broad areas of light that are common to both forms.

Another constant feature of Japanese prints is the accentuated linear pattern formed by contour-lines which define color-compartments. In the adaptation of this feature, Matisse uses broader and heavier lines, he reduces their number and degree of continuity and varies their character even in a single picture. This greater variety of line is especially noticeable in the faces, which the Japanese usually draw with the same thin continuous line as that used in the rest of the composition. The nearest effect to this Japanese use of line is found in Matisse's engravings, lithographs and pen-and-ink drawings.

The decorative arabesques of Japanese prints made by patterns of lines in draperies, by floral decorations, by shape and movement of color-areas, by pose of figures, also reappear in Matisse's paintings, but they are fewer in number and their linear contour

is less precisely defined. As in the prints, however, the arabesques are organized in rhythmic patterns very frequently contrasted and interrelated both with other arabesques and with more static angular motifs such as directly vertical, oblique or horizontal bands and stripes.

The ubiquitous bands and stripes in Japanese prints give rise to a great variety of decorative patterns, as they do also in Matisse's work, and by very similar ways and means. In both forms we find, for example, a background-setting consisting of a series of narrow stripes adjacent to broader bands ornamented with motifs which suggest medallions or flags; a set of vertical bands contrasted with horizontal and oblique stripes; a long vertical band at one extreme side of the composition playing an emphatic rôle in the organization of the pattern and of the space-relations; or curvilinear floral motifs on bands effecting very decorative contrasts of color and pattern. The bands in the prints may represent sections of a room, or they may be areas of bright color bearing Japanese script and suspended in space, isolated in representative value from the rest of the subject-matter but very active in the pattern. Matisse varies the procedure by converting more numerous actual objects, figures, draperies, landscapes, into bands, or by decorating them with larger and more loosely drawn motifs. When these bands are decorated with superposed patterns, the motifs are sometimes Japanese in effect; sometimes they hark back to a Persian rug or tile. Neither the Persian quality nor Matisse's floral-shaped motifs made by irregular dabs of color, which supplant the script of the prints, alter the basically Japanese influence.

The Japanese origin is equally obvious in Matisse's decorative treatment of shutters, windows, mirrors, pictures on walls, and in his manifold compositional and decorative use of screen, door and balcony. His practice of juxtaposing a series of areas, each decorated with a different type of angular, rosette- or arabesque-pattern contrasting in colour and size, is less specifically Japanese because it occurs with equal frequency in Persian miniatures and Chinese painting. His treatment of space is at various times near to three types of space-composition clearly discernible in Japanese prints, viz., a) perspective in the foreground, rendered by means of a series of parallel oblique lines which increase the bizarre pattern of the composition; b) organization of the perspective of an interior in three planes which come to a meeting point in the far background, and form a sort of inverted pyramid of space in which the compositional units are arranged; c) roominess in the spacing of figures and objects in an interior, and compactness of the planes in decorative objects in the background, resulting in an effective contrast in the total space-composition.

Mattisse's drawing of figures also recalls at times that in Japanese prints in the graceful fluid pose of head and body, occasionally in the large oval outline of face with comparatively small features, and in the general use of a single type of facial expression in different figures. He avoids literal duplication of the Japanese face by substituting for its characteristic fine and usually continuous lines, a set of looser, broader, more varied and interrupted lines, and a more pronounced pattern of features into which enter elements taken from the Egypto-Roman, Byzantine and Manet traditions. Similarly, his drawing of trees is often Japanese in its decorative linear curves, or in

its union of angular-curvilinear patterns and softly-shaded bloblike color-areas which have undulating edges. The general drawing of the trees, either in curvilinear patterns or in broad areas, is much looser in Matisse than in the prints, and the technique is generally derived from the impressionists and post-impressionists. Occasionally, too, Matisse obtains by scraped paint a surface-quality of pigment quite similar to the dry, smooth-grained effect in the Japanese prints.

Matisse's utilization of these Japanese features, numerous as they are, is genuinely creative: they are generalized and so thoroughly incorporated in his own form that they rarely reappear unaltered. In fact, this generalization and assimilation of the Japanese influence is so complete that a trained observer could look at scores of Matisses without conscious reference to Japanese prints. The miniature-quality of the prints is lacking, Matisse's drawing is broader and looser, and much of what is most significant and distinctive in his work has no counterpart in the Japanese. In other words, the new effects secured are not at all limited by Japanese forms.

Albert C. Barnes and Violette de Maza, *The Art of Henri Matisse*,
Merion, Pennsylvania [1933, 1959] 1963, 57–64.

BIBLIOGRAPHY

The works that have been of most use to the author, apart from those mentioned in the text, are listed below. For the rest, the reader is referred to the comprehensive bibliographies in two books by John Rewald, *The History of Impressionism* (New York 1946, etc.) and *Post-Impressionism, from Van Gogh to Gauguin* (New York 1956, etc.), and to the works marked below with an asterisk (*).

Bibliography from 1975 to 1990 will be found in Gabriel P. Weisberg and M. L. Yvonne, *Japonisme, an Annotated Bibliography*, New York, 1990.

JAPANESE PRINTS

Louis Aubert: *Les Maîtres de l'estampe japonaise*. Paris 1914

Ludwig Bachhofer: *Die Kunst der japanischen Holzschnittmeister*. Munich 1922

Samuel Bing: *Exposition de la gravure japonaise*. Catalogue. Ecole des Beaux-Arts, Paris 1890

(ed.) *Le Japon Artistique. Documents d'Art d'Industrie*. 1888–91

Laurence Binyon and J. J. O'Brien Sexton: *Japanese Colour Prints*. London [1923, 1954], 1960

Willy Boller: *Meister des japanischen Farbholzschnitts*. Berne 1947

Arthur Davison Ficke: *Chats on Japanese Prints*. London 1915; 2nd edn Rutland (Vermont) 1958

Tadamasa Hayashi: *Dessins, estampes, livres illustrés du Japon*. Catalogue. Paris 1902

Rose Hempel: *Japanische Holzschnitte – Sammlung Scheiwe*. Münster 1957 and Wolfsburg 1959

Ukiyo-e – Sammlung Scheiwe. Essen 1972

Jack R. Hillier: *Die Meister des japanischen Farbendrucks*. London and Cologne 1954

The Japanese Print. A New Approach. London 1960

Owen E. Holloway: *Graphic Art of Japan*. London 1957

Richard Lane: *L'Estampe japonaise*. Paris 1962

Paul-André Lemoisne: *L'Estampe japonaise*. Paris 1914

*Muneshige Narazaki: *The Japanese Print. Its Evolution and Essence*. Tokyo 1966, 2nd edn 1973

Harry Packard: *Images du temps qui passe*. Catalogue. Musée des Arts Décoratifs, Paris 1966

*Harold P. Stern: *Masterprints of Japan*. New York 1969

Seiichiro Takahashi: *Traditional Woodblock Prints of Japan*. New York 1973

Vignier and Inada: *Estampes Japonaises au Musée des Arts Décoratifs*. Catalogue. Paris
 1909–14
 Vol. 1, *Estampes Japonaises Primitives;* Vol. 2, *Harunobu, Koriusai, Shunshō;* Vol.
 3, *Kiyonaga, Bunchō, Sharaku;* Vol. 4, *Utamaro;* Vol. 5, *Yeishi, Chōki, Hokusai;*
 Vol. 6, *Toyokuni, Hiroshige*
Frank Lloyd Wright: *The Japanese Print, an Interpretation*. New York 1967

EAST AND WEST

Theodore Bowie: *East–West in Art: Patterns of Cultural and Aesthetic Relationships*.
 Bloomington 1966
Ernest Chesneau: 'Le Japon à Paris'. In *Gazette des Beaux-Arts,* 1878, 385 ff., 841 ff.
Colta Feller Ives: *The Great Wave*. New York 1974
Clay Lancaster: *The Japanese Influence on America*. New York 1963
Louis V. Ledoux: *Japanese Prints in the Occident*. Tokyo 1941
Emil Preetorius: *Gedanken zur Kunst*. Munich 1947
 Geheimnis des Sichtbaren. Munich 1963
Leopold Reidemeister: *Der Japonismus in der Malerei und Graphik des 19. Jahrhunderts*.
 Catalogue. Jagdschloß Grunewald. Berlin 1965
Benjamin Rowland: *Art in East and West*. Boston 1954, 2nd edn 1964
Ernst Scheyer: 'Far Eastern Art and French Impressionism'. In *The Art Quarterly,*
 1943
*Dietrich Seckel: *Einführung in die Kunst Ostasiens*. Munich 1960
Yujiro Shinoda: 'Degas, der Einzug des Japanischen in die französische Malerei'.
 Dissertation, Cologne 1957
*Michael Sullivan: *The Meeting of Eastern and Western Art*. London 1973
Yvonne Thirion: 'Le Japonisme en France dans la seconde moitié du XIXᵉ siècle à
 la faveur de la diffusion de l'estampe japonaise.' In *Cahier de l'Association
 Internationale des Etudes Françaises,* June 1961, no. 13, 117–30
*Gabriel P. Weisberg, Phillip D. Cate *et al.*: *Japonisme*. Catalogue. The Cleveland
 Museum of Art, Cleveland 1975
*Siegfried Wichmann (ed.): *Weltkulturen und moderne Kunst. Die Begegnung der
 europäischen Kunst und Musik im 19. und 20. Jahrhundert mit Asien, Afrika,
 Ozeanien, Afro- und Indo-Amerika. Ausstellung veranstaltet vom Organ-
 isationskomitee für die Spiele der XX. Olympiade*. Munich 1972.
Chisaburoh F. Yamada: *Mutual Influences between Japanese and Western Art*.
 Catalogue. National Museum of Modern Art. Tokyo 1968

MOVEMENTS IN EUROPEAN ART

René Brimo: *L'Evolution du goût aux Etats-Unis*. Paris 1938
Jean Cassou, Emile Langui and Nikolaus Pevsner: *Durchbruch zum 20. Jahrhundert*.
 Munich 1962

Lilli Fischel: 'Von der Bildform der französischen Impressionisten.' In *Jahrbuch der Berliner Museen*, 15, Berlin 1973, 58–154

Pierre Francastel: *Peinture et société. Naissance et destruction d'un espace plastique.* Lyon 1951

Willy Geismeier (ed.) *Stilkunst um 1900 in Deutschland.* Catalogue. Staatliche Museen zu Berlin, Kunstgewerbemuseum, Kupferstichkabinett und Sammlung der Zeichnungen, Nationalgalerie. Berlin 1972

Robert John Goldwater: *Primitivism in Modern Painting.* New York 1938

Richard Hamann und Jost Hermand: *Stilkunst um 1900.* Berlin 1967

Fritz Hermann: 'Die "Revue blanche" und die Nabis'. Dissertation, Zurich 1959, Munich 1959

Hans H. Hofstätter: *Geschichte der europäischen Jugendstilmalerei. Ein Entwurf.* Cologne 1963

 Jugendstil-Druckkunst. Baden-Baden 1968

Jean-Daniel Ludmann: *Les Ballets russes de Sergej Diaghilev, 1909–1929.* Catalogue. Ancienne Douane. Strasbourg 1969

Stephan Tschudi Madsen: *The Sources of Art Nouveau.* New York 1956

Guy Michaud: *Message poétique du symbolisme.* 4 vols. Paris 1947

*Robert Schmutzler: *Art Nouveau – Jugendstil.* Stuttgart 1962

Jean Sutter: *Les Neo-Impressionistes.* Neuchâtel 1970

Werner Weisbach: *Impressionismus.* Berlin 1911

Paul Wember: *Die Jugend der Plakate.* Krefeld 1961

SELECTED *JAPONISANT* ARTISTS IN EUROPE (IN ALPHABETICAL ORDER)

Since 1966 the following studies have appeared in the Italian series 'Classici dell' arte Rizzoli'. Most have text in German, English or French.

 F. Minervino: *Degas.* Vol. XLV, Milan 1970

 G. M. Sugana: *Gauguin.* Vol. LXI, Milan 1972

 Paolo Lecaldano: *Van Gogh.* Vols. LI–LLI, Milan 1972

 S. Orienti: *Manet.* Vol. XIV, Milan 1967

 Maria Grazia Ottolenghi: *Mondrian.* Vol. LXXIX, Milan 1974

 Luigina Rossi Bortolatto: *Monet.* Vol. LXII, Milan 1972

 Dora Vallier: *Henri Rousseau.* Vol. XXIX, Milan 1969

 André Chastel: *Seurat.* Vol. LV, Milan 1972

 G. M. Sugana: *Toulouse-Lautrec.* Vol. XXXI, Milan 1969

Arsène Alexandre: *The Decorative Art of Léon Bakst.* New York 1973

Brian Reade: *Aubrey Beardsley.* Catalogue. Victoria and Albert Museum. London 1966

Fritz Novotny: *Cézanne und das Ende der wissenschaftlichen Perspektive.* Vienna 1938

Sergei Eisenstein: *Film Form and the Film Sense.* Cleveland 1964

Jacques Damase: *L'œuvre gravé de James Ensor*. Geneva 1967

Jean de Rotonchamp: *Paul Gauguin*. Paris 1925

Douglas Cooper: *Gauguin*. Catalogue. Tate Gallery, London 1955

Yvonne Thirion: 'L'influence de l'estampe japonaise dans l'œuvre de Gauguin.' In *Gazette des Beaux-Arts*, 48, 1956, 95–114

H. R. Rookmaaker: *Gauguin and 19th Century Art Theory*. Amsterdam 1972

Elizabeth Aslin: 'The Furniture Designs by E. W. Godwin.' In *Victoria and Albert Museum Bulletin*, Vol. III, 1967, no. 4, 145–54

Marc-Edo Tralbaut: 'Van Gogh's Japanisme.' In *Mededeelingen, Dienst Schoone Kunsten*, The Hague, No. 2/3, 1954

Kurt Badt: *Die Farbenlehre van Goghs*. Cologne 1961

Marc Roskill: *Van Gogh, Gauguin and the Impressionist Circle*. London 1970

F. Lanier Graham: *Hector Guimard*. Catalogue. Museum of Modern Art. New York 1970

Fritz Novotny and Johannes Dobai: *Gustav Klimt*. Salzburg 1967

Thomas Howarth: *Charles Rennie Mackintosh and the Modern Movement*. London 1952

Andrew McLaren Young: *Ch. R. Mackintosh*. Catalogue. Victoria and Albert Museum. London 1968

Gustav Vriesen: *August Macke*. 2nd enlarged edn. Stuttgart 1957 [1st edn 1953]

John Richardson: *Manet*. London 1967

Marcel Guérin: *L'œuvre gravé de Manet*. Paris 1944

William C. Seitz: *Claude Monet, Seasons and Moments*. Catalogue. Museum of Modern Art, New York 1960

Günter Busch: *Edvard Munch. Das zeichnerische Werk*. Catalogue. Kunstmuseum, Bern 1970

*Ursula Perucchi-Petri: *Die Nabis und Japan. Das Frühwerk von Bonnard, Vuillard und Denis*. Munich 1976

John Rewald (ed.): *Camille Pissarro, Lettres à son fils Lucien*. Paris 1950

Klaus Berger: *Odilon Redon. Fantasy and Colour*. London and New York 1965

Françoise Cachin: *Paul Signac*. Paris 1973

Henri Zerner: *James Joseph Tissot*. Catalogue. Museum of Art. Rhode Island School of Design, Providence 1968

Bettina Spannstra-Polak: *De Grafiek van Jan Toorop*. Catalogue. Rijksmuseum Amsterdam 1969

Edouard Julien: *Dessins de Toulouse-Lautrec*. Monaco 1942

Fritz Novotny: *Toulouse-Lautrec*. London 1969

Maxime and Charles George: *Félix Vallotton. Catalogue raisonné de l'œuvre gravé et lithographié*. Geneva 1972

Henry van de Velde: *Zum Neuen Stil*. Munich 1955

Hans Curjel (ed.): *Henry van de Velde. Geschichte meines Lebens*. Munich 1962

S. Kaplanova: *Mikhail Aleksandrovitch Vrubel*. Leningrad 1975

Denys Sutton: *Nocturne. The Art of James McNeill Whistler*. London 1963

John Sandberg: 'Japonism and Whistler'. In *Burlington Magazine*, November 1964, 500–7

AESTHETIC ISSUES

Rudolf Arnheim: *Art and Visual Perception*. Berkeley, Cal., 1954
*Herschel B. Chipp: *Theories of Modern Art*. Berkeley, Cal., 1969
Konrad Fiedler: *Schriften über Kunst*. Munich 1913
Pierre Francastel: *Nouveau dessin, nouvelle peinture*. Paris 1946
Joseph Gantner: ' "L'Immagine del Cuor." Die vorgestaltenden Formen der Phantasie und ihre Auswirkung in der Kunst.' In *Eranos-Jahrbuch* xxxv, 1967
Heinrich Lützeler: *Abstrakte Malerei, Bedeutung und Grenze*. Gütersloh 1969
Fritz Novotny: *Über das Elementare in der Kunstgeschichte*. Vienna 1968
*Aaron Scharf: *Art and Photography*. London 1968

INDEX

References in square brackets refer to illustrations.

DATE DUE

APR 2 2 2004			